The Aztec Empire

The Aztec Empire

Curated by Felipe Solís

GuggenheimMUSEUM

Published on the occasion of the exhibition
The Aztec Empire
Curated by Felipe Solís

Solomon R. Guggenheim Museum, New York
October 15, 2004–February 13, 2005

The Solomon R. Guggenheim Museum gratefully acknowledges the
assistance of CONACULTA-INAH in organizing the loans from Mexico.

 CONACULTA · INAH

This exhibition is organized by the Solomon R. Guggenheim Museum in
collaboration with the Consejo Nacional para la Cultura y las Artes (CONACULTA)
and the Instituto Nacional de Antropología e Historia (INAH).

Major sponsors of this exhibition are

 Banamex
citigroup

Televisa

Additional support provided by

PEMEX **MEXICO**
Tourism Board

This exhibition has also been made possible in part by an indemnity from the
Federal Council on the Arts and the Humanities, together with the generous
support of the Leadership Committee for *The Aztec Empire*, GRUMA, ALFA,
and Con Edison.

Transportation assistance provided by **AeroMexico**

Media support provided by Thirteen/WNET.

Special thanks to the Embassy of Mexico in the U.S., the Embassy of the
United States in Mexico, and the Consulate General of Mexico in New York.

ISBN: 0-89207-321-7 (hardcover)
ISBN: 0-89207-322-5 (softcover)

Guggenheim Museum Publications
1071 Fifth Avenue
New York, New York 10128

Hardcover edition available in the U.S. through
D.A.P./Distributed Art Publishers
155 Sixth Avenue, 2nd floor
New York, New York 10013
Tel: (212) 627-1999; Fax: (212) 627-9484

Printed in Hong Kong

Translations from Spanish to English by Eriksen Translations Inc.

Cover, front: Xiuhtecuhtli, Aztec, ca. 1500 (detail of cat. no. 1);
and back: Coatlicue, Aztec, ca. 1500 (detail of cat. no. 2)

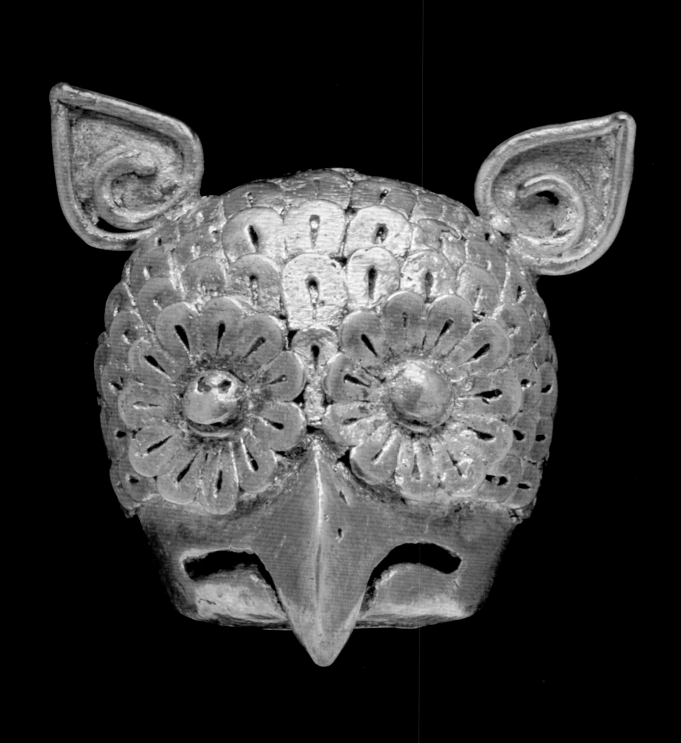

Contents

Preface

THE VISUAL NARRATIVE UNFOLDING BEFORE VISITORS TO THE EXHIBITION *THE AZTEC EMPIRE* EXPOSES SOME OF THE hidden recesses of an essentially religious and military culture that lived in splendor and disappeared tragically. In less than one hundred years, the Aztecs managed to erect a unique empire from a vastly stratified society, as well as to create a strict educational system and solid agricultural economy. They formed strategic military alliances, conquered domains near and far, imposed a harsh tributary system, and established an intricate network of trade and commerce. Perhaps even more noteworthy was the level of aesthetic excellence the Aztecs achieved in stone, feather, and metalwork, in ceramics, architecture, chronicles, and poetic utterances—to mention only some of the skills that formed the "vital energy" impregnating their life, as the critic Paul Westheim has written.

Nourished by the cultural legacy of their predecessors, such as the Olmec, Teotihuacan, and Toltec peoples; imbued with the wisdom culled from subjugated provinces; and influenced by the craftsmanship of the few peoples who defied them and maintained their independence, such as the Purepecha (Tarascans), the Aztecs excelled in a wide range of disciplines. Reflecting a close relationship with nature and the gods of a vast pantheon, these disciplines included observation of the celestial bodies; botany and herbal medicine; mathematics and pictographic writing; monumental architecture and art. The comprehensiveness of the exhibition enriches our understanding of this extraordinary Mesoamerican civilization, whose veneration of the sun flooded sacrificial stones with the blood of its victims. In stark contrast, those who carved these very stones would refer to friends as "perfumed flowers."

It has been a great honor for the Consejo Nacional para la Cultura y las Artes and the Instituto Nacional de Antropología e Historia to collaborate with the Guggenheim. The presentation of extraordinary archeological objects and masterpieces of the pre-Hispanic world at the Solomon R. Guggenheim Museum in New York provides an invaluable tool for gaining a greater appreciation of the cultural legacy that is a source of pride for all Mexicans.

When considering the works on view, it is easy to concur with Henry Moore, the renowned British sculptor of universal resonance, who spoke of Mexican stone sculpture's "truth to material, its tremendous power without loss of sensitiveness . . . its approach to a full three-dimensional conception of form." The dawning of the sixteenth century brought with it the fall of the Aztecs, but their brilliant and powerful creations remain and will, to paraphrase Westheim, prove impervious to time and the notions of space and subject matter. Their songs still resonate—the remains of the Templo Mayor, the fragments, many colossal in scale, of an art whose disquieting beauty filled the teeming horizon of an empire that dominated Central Mexico.

Sari Bermúdez
President, Consejo Nacional para la Cultura y las Artes (CONACULTA)

Preface

MYTH, AS TERRITORY OF THE HUMAN CONDITION, IS UNDOUBTEDLY THE MOST EFFECTIVE MEANS FOR EXPRESSING the unique nature of a culture. Although it may seem to repeat certain universal types and forms, myth establishes the distinctions and boundaries between self and other. It is the place where historic and social identities are constructed, where the imagination recasts life in symbolic dimensions.

Mythic narrative explains geographies and times; points to origins, impulses, and even timeless preoccupations; provides a life source for literature and innumerable signs and symbols for the creative works of a community; as well as indicating—through deities, other beings, and a specialized vocabulary of representations—the realm where sacred and profane intersect. Imagined personal and collective destinies imbue history with meaning. Immediate frontiers between myth and reality evaporate.

Myth is the most salient indicator of the life and death of the Aztec world, the final chapter in ancient Mexican history. It provided the substance for the primordial covenant between the war and sun god Huitzilopochtli and his people, which was established at the outset of a long pilgrimage to the land that would become the navel of the world and bring forth, beginning in the fourteenth century, the unforgettable grandeur of Tenochtitlan. And it explains the impulse that led the Aztecs, in their precipitous path toward empire, to conquer numerous peoples over the span of mere decades. This same mythology, which had justified political attitudes and military campaigns, inevitably underlay the terror the Aztecs had of the return of Quetzalcoatl, the deity they fatally supposed was incarnated in the form of the conquistadors.

As a sign of veneration, the sun was to be provided with the sacred food of blood, thus ensuring the celestial being's dominance over the nocturnal elements and continuity in its daily course. Not without drama, the Aztecs' fulfillment of their destiny took the form of hegemony in dealing with other humans and gratitude toward the divinities. Aztec religiosity, originally a principle for social cohesion, also provided the outlines for an extraordinarily original aesthetic. Most compellingly evidenced in the architecture and urban planning of the final pre-Hispanic century, this aesthetic also led to a flourishing in the arts and professions devoted to working with stone, ceramics, cotton, animal skins, paper, and feathers.

Conceived within a framework that is both aesthetic and archeological, *The Aztec Empire* is specifically directed to the sensibilities of New York's museum-going public. In terms of the number and quality of the pieces included—most of which are from the collections of the Instituto Nacional de Antropología e Historia—this exhibition marks a milestone in the international exhibitions of pre-Hispanic art presented over the years. It is organized around specific themes, following a chronology from the origins of Aztec civilization to the time of first contact with the European world.

The mysterious interplay between the objects and modern perceptions imbues them with an unsettling beauty. The awe aroused by this imperial art is a sign of its timeless and primal power. In this sense, the Aztecs are our own contemporaries.

Sergio Raúl Arroyo
Director General, Instituto Nacional de Antropología e Historia (INAH)

BANAMEX IS VERY PROUD TO PARTICIPATE AS A MAJOR SPONSOR OF *THE AZTEC EMPIRE* EXHIBITION, THE MOST comprehensive survey of the art and culture of the Aztecs ever assembled outside Mexico.

Since Banamex was founded in 1884, its history has been closely related to the history of Mexico. But it has always been much more than a bank. With the conviction that businesses have a social responsibility, Banamex has participated in many activities that go far beyond financial matters. Through the programs carried out by its cultural, social, and ecological foundations, the bank supports culture and art, social development, and the conservation and protection of the environment.

This year Banamex celebrates its 120th anniversary—an important achievement and also an excellent opportunity to emphasize the bank's commitment to supporting and promoting Mexican art and culture. At the same time, sponsoring this superb exhibition at the Guggenheim Museum in New York is part of an effort to build bridges of mutual understanding between two countries whose historical relationship has become increasingly close in economic and social terms, especially during the last decade.

Banamex's integration into Citigroup brings the best of the world to Mexico and allows taking the best of Mexico to the rest of the world. Consequently, the bank is delighted to support the Solomon R. Guggenheim Foundation in its presentation in New York of an unparalleled exhibition that brings together more than four hundred works drawn from major collections in the United States and Mexico.

Manuel Medina-Mora
Chief Executive Officer

Televisa

TELEVISA PROUDLY SPONSORS THE EXHIBITION *THE AZTEC EMPIRE* AS PART OF ITS COMMITMENT TO PROMOTING and sharing its Mexican heritage.

Grupo Televisa is one of the world's largest Spanish-language television producers. Televisa's productions are broadcast on its four networks in Mexico. Much of this programming content reaches Spanish-speaking communities in the United States through Univision, and in countries in Latin America, Asia, Europe, and Africa through other licensing agreements. Televisa is also involved in satellite and cable television, the Internet, publishing, movies, radio, and live entertainment.

Fundación Televisa focuses on enhancing the nutrition, health, and education of children, and promoting values such as honesty, generosity, responsibility, and respect through high-impact social-awareness campaigns. Televisa's foundation is also committed to preserving and promoting Mexico's artistic heritage, as well as to generating more interchanges between our culture and other cultures around the globe.

It is in this vein that we are pleased to support *The Aztec Empire*, a groundbreaking exhibition at the Guggenheim Museum in New York that will shed new light on a magnificent civilization.

Emilio Azcárraga Jeán
Chief Executive Officer

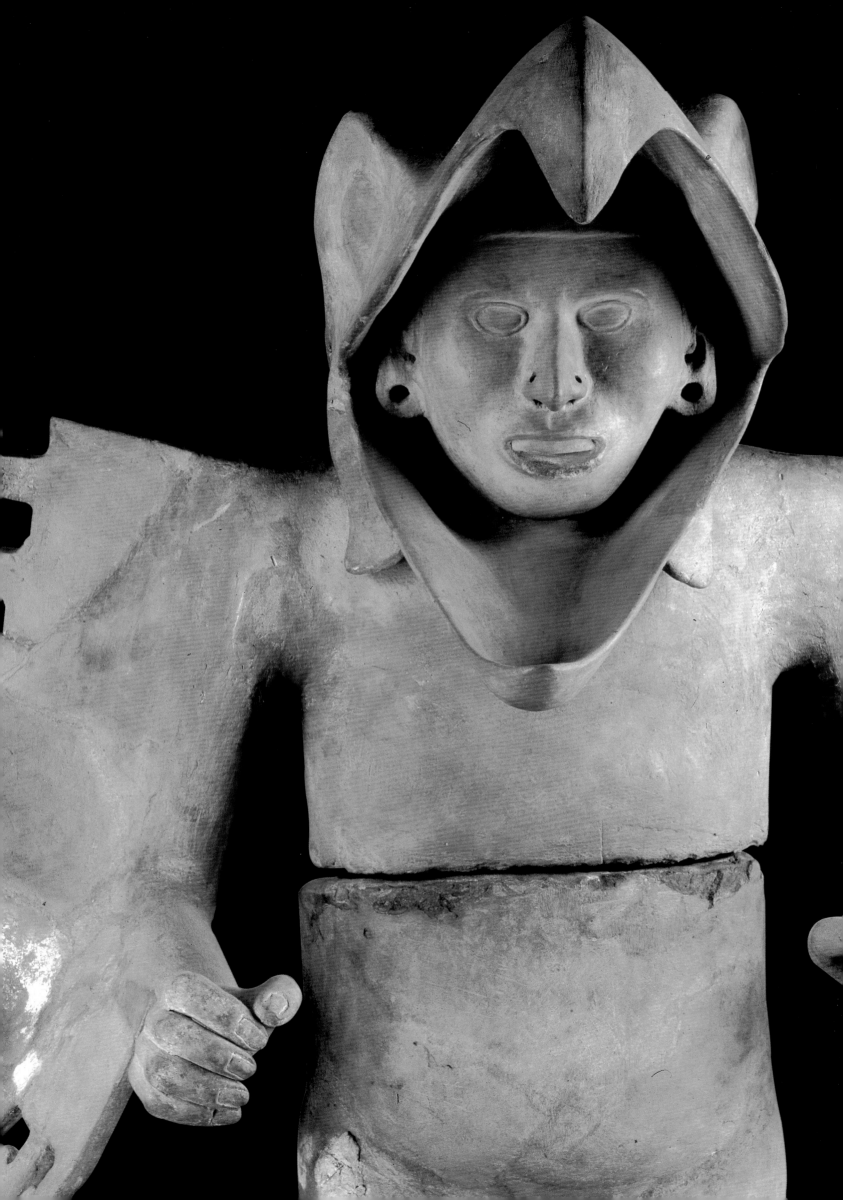

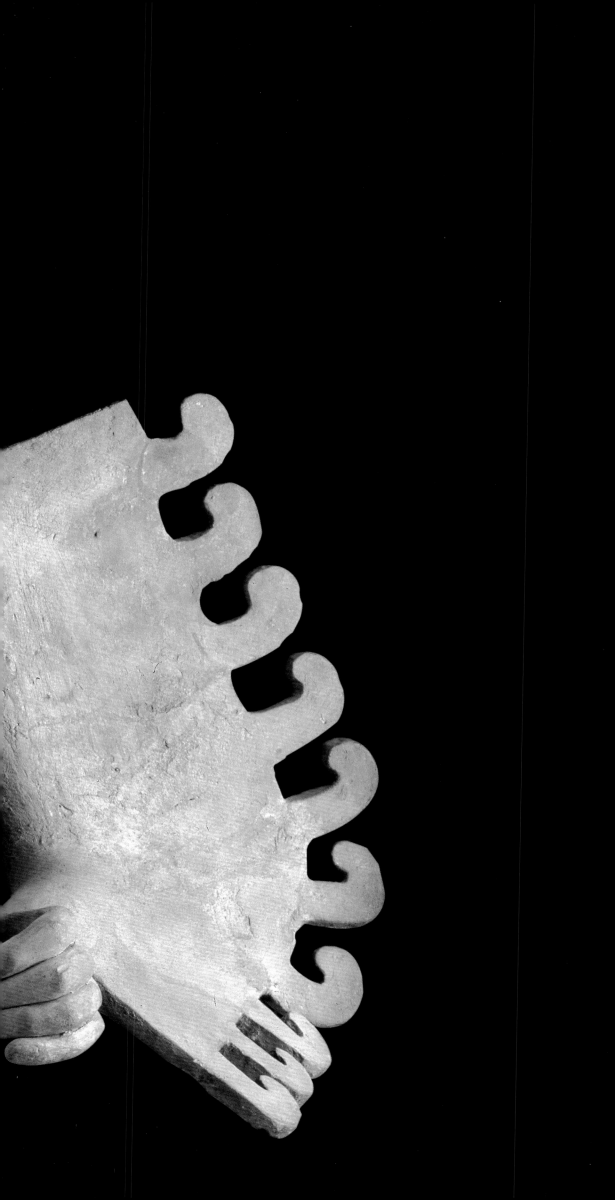

Project Team

Guggenheim Museum

Executive Staff
Thomas Krens, Director
Lisa Dennison, Deputy Director and Chief Curator
Anthony Calnek, Deputy Director, Communications and Publishing
Judith Cox, Deputy Director, Special Projects
Dane Solomon, Deputy Director, Corporate Development and Global Marketing
Marc Steglitz, Deputy Director, Finance and Operations
Gail Scovell, General Counsel

Art Services and Preparations
Scott Wixon, Manager of Art Services and Preparations
Barry Hylton, Senior Exhibition Technician
Derek DeLuco, Technical Specialist
Mary Ann Hoag, Lighting Designer

Conservation
Leslie Ransick Gat, Project Conservator
Amy Jones, Assistant Project Conservator
Eleonora Nagy, Sculpture Conservator

Construction
Michael Sarff, Construction Manager
William Ragette, Lead Carpenter

Development
Anne Bergeron, Director of Institutional and Capital Development
Kendall Hubert, Director of Corporate Development
Gina Rogak, Director of Special Events
Helen Warwick, Director of Individual Development
Pepi Marchetti Franchi, Executive Associate, Director's Office
Debbie Ahn, Manager of Membership
Penelope Betts, Manager of Corporate Membership
Stephen Diefenderfer, Special Events Manager
Hillary Strong, Manager of Corporate Sponsorship
Cecilia Wolfson, Manager of Individual Giving
Beth Allen, Corporate Development Associate
Peggy Allen, Special Events Coordinator
Julia Brown, Membership Coordinator
Pallavi Yalamanchili, Individual Giving Coordinator
Annie Donohue, Membership and Individual Giving Assistant
Graham Green, Intern, Director's Office

Education
Kim Kanatani, Gail Engelberg Director of Education
Pablo Helguera, Senior Education Program Manager, Public Programs
Sharon Vatsky, Senior Education Program Manager, School Programs
Sarah Selvidge, Project Intern

Exhibition Design
Ana Luisa Leite, Manager of Exhibition Design
Melanie Taylor, Exhibition Design Coordinator
Carolynn Karp, Exhibition Design Coordinator
Clare O'Ferral, Intern

Exhibition Management
Karen Meyerhoff, Managing Director for Exhibitions, Collections and Design
Marion Kocot, Project Manager
Mariluz Hoyos, Project Assistant
Marion Kahan, Exhibition Program Manager
Carmen Aneiros, Project Consultant

Fabrication
Peter B. Read, Manager of Exhibition Fabrications and Design
Stephen M. Engelman, Technical Designer/Chief Fabricator
David Johnson, Chief Framemaker

Richard Avery, Chief Cabinetmaker
Edward Cunningham, Cabinetmaker
Sam Green, Cabinetmaker
Douglas Hollingsworth, Cabinetmaker
Christopher Powell, Cabinetmaker
Robert Ebeltoft, Metal Fabricator
Christopher George, Metal Fabricator
Joseph Taylor, Metal Fabricator

Facilities
Brij Anand, Director of Facilities
Ian A. Felmine, House Electrician

Finance
Amy West, Director of Finance
Christina Kallergis, Budget and Planning Analyst

Graphic Design
Marcia Fardella, Chief Graphic Designer
Cassey Chou, Senior Graphic Designer
Concetta Pereira, Production Supervisor
Christine Sullivan, Graphic Designer
Janice Lee, Graphic Designer

Legal
Brendan Connell, Associate General Counsel

Marketing
Laura Miller, Director of Marketing
Ashley Prymas, Marketing Manager

Photography
David M. Heald, Director of Photographic Services and Chief Photographer
Kim Bush, Manager of Photography and Permissions

Public Affairs
Ann Edgars Associates
Jennifer Russo, Public Affairs Coordinator

Publications
Elizabeth Levy, Director of Publications
Elizabeth Franzen, Managing Editor
Melissa Secondino, Production Manager
Lara Fieldbinder, Production Assistant
Edward Weisberger, Editor
Meghan Dailey, Associate Editor
Stephen Hoban, Assistant Editor
Kate Norment, Project Editor
Laura Morris, Editor
Jennifer Knox White, Editor

Registrar
Meryl Cohen, Director of Registration and Art Services
Lisa Lardner, Associate Registrar
Maria Paula Armelin, Project Assistant Registrar
Abigail Hoover, Registrar Assistant

Retail Development and Purchasing
Ed Fuqua, Book Buyer
Gianmarco Leoncavallo, Product Development Manager
Katherine Lock, Retail Buyer

Security
Rob Romenecki, Director of Security

Visitor Services
Stephanie King, Director of Visitor Services
Yseult Tyler, Manager of Visitor Services

Mexican Cultural Institutions

Consejo Nacional para la Cultura y las Artes (CONACULTA)
Sari Bermúdez, President

Instituto Nacional de Antropología e Historia (INAH)
Sergio Raúl Arroyo, Director General
Moisés Rosas, Technical Secretary
Luis A. Haza, Administrative Secretary
José Enrique Ortiz Lanz, National Coordinator of Museums and
 Exhibitions
María del Perpetuo Socorro Villarreal Escárrega, National Coordinator
 for Legal Matters
Gerardo Jaramillo, National Coordinator for Communications and
 Publishing
Elvira Báez García, Director of International Exhibitions
Miguel Ángel Fernández, Management Consultant
Jacqueline Correa, Project Coordinator

Felipe Solís, *Museo Nacional de Antropología*

Juan Alberto Román Berrelleza, *Museo del Templo Mayor*

Jacinto Chacha-Antele, *Centro INAH Hidalgo*
Sergio Rasgado Flores, *Museo Regional de Hidalgo "Ex Convento de
 San Francisco"; Museo de Sitio de Tepeapulco; Museo Arqueológico
 de Tula "Jorge R. Acosta"*

Eduardo López Calzada, *Centro INAH Oaxaca*
Jesús Martínez Arvizu, *Museo de las Culturas de Oaxaca; Museo
 Frisel Mitla*

Yolanda Ramos, *Museo Regional de Puebla*

Maribel Miró, *Centro INAH Estado de México*
Laura Elena Mata, *Museo de las Culturas Mexicas "Eusebio Dávalos"*

Eugenio Mercado, *Museo Regional Michoacano "Dr. Nicolás Calderón"*

Daniel Goeritz, *Centro INAH Veracruz*
Vicente Hernández, *Museo Baluarte de Santiago*

Martelva Gómez, *Museo Regional de Guadalajara*

Miguel Fernández Félix, *Museo Nacional del Virreinato*

Milena Koprivitza, *Museo Regional de Tlaxcala*

Contributing Institutions
Claudio X. González, Mauricio Maillé, Diana Mogollón, *Fundación
 Cultural Televisa*

Carolina Monroy del Mazo, *Instituto Mexiquense de Cultura, Gobierno del
 Estado de México*
Martín Antonio Mondragón, *Museo Arqueológico del Estado "Dr. Román
 Piña Chán"*
Ramiro Acevedo, *Centro Regional Cultural Apaxco*

Baltazar López Martínez, *Museo Municipal Arqueológico de Tuxpan*

Cándida Fernández, María del Refugio Cárdenas, *Fomento Cultural
 Banamex, A.C.*

Roxana Velásquez Martínez del Campo, *Museo Nacional de Arte*

María Ascensión Morales, *Museo Universitario de Ciencias y Arte*

Enrique Norten (TEN Arquitectos) + J. Meejin Yoon

Enrique Norten
J. Meejin Yoon
Clara Sola-Morales Serra
Tim Morshead
B. Alex Miller
Shuji Suzumori
Carl Solander
Fernanda Chandler
Mariana de la Fuente
Angela Co

Catalogue

LANDUCCI
Editorial Coordination
Sandro Landucci Lerdo de Tejada
Lucinda Gutiérrez
Mariel Rodríguez Sánchez, Assistant
Luis García, Assistant
Aldo Plazola, Assistant

Design
Arturo Chapa

Photography
Michel Zabé
Enrique Macías Martínez, Photography Assistant

Prepress
Arturo Chapa/Landucci

INAH
Editorial Coordination
Felipe Solís
Roberto Velasco Alonso

Editorial Supervision
Gerardo Jaramillo

Lenders to the Exhibition

American Museum of Natural History, New York
Brooklyn Museum, New York
Centro INAH del Estado de México, Toluca
Centro Regional Cultural Apaxco
The Cleveland Museum of Art
Dumbarton Oaks Research Library and Collection, Harvard University,
 Washington, D.C.
The Field Museum of Natural History, Chicago
Fomento Cultural Banamex A.C., Mexico City
Fundación Cultural Televisa, Mexico City
The John Carter Brown Library at Brown University, Providence
The Metropolitan Museum of Art, New York
Museo Arqueológico de Tula "Jorge R. Acosta," INAH
Museo Arqueológico del Estado "Dr. Román Piña Chán," Teotenango
Museo Baluarte de Santiago, INAH, Veracruz
Museo de las Culturas de Oaxaca, INAH
Museo de las Culturas Mexicas "Eusebio Dávalos," INAH, Acatlán
Museo de Sitio de Tepeapulco, INAH
Museo del Templo Mayor, INAH, Mexico City
Museo Municipal Arqueológico de Tuxpan
Museo Nacional de Antropología, INAH, Mexico City
Museo Nacional de Arte, Mexico City
Museo Nacional del Virreinato, INAH, Tepotzotlán
Museo Regional de Guadalajara, INAH
Museo Regional de Hidalgo "Ex Convento de San Francisco," INAH,
 Pachuca
Museo Regional de Puebla, INAH
Museo Regional de Tlaxcala, INAH
Museo Regional Michoacano "Dr. Nicolás Calderón," INAH, Morelia
Museo Universitario de Ciencias y Arte, UNAM, Mexico City
Museum of Art, Rhode Island School of Design, Providence
Museum of Fine Arts, Boston
National Museum of the American Indian, Smithsonian Institution,
 Washington, D.C.
Peabody Museum of Archaeology and Ethnology, Harvard University,
 Cambridge
Peabody Museum of Natural History, Yale University, New Haven
Philadelphia Museum of Art
Princeton University Art Museum
Saint Louis Art Museum
Yale University Art Gallery, New Haven

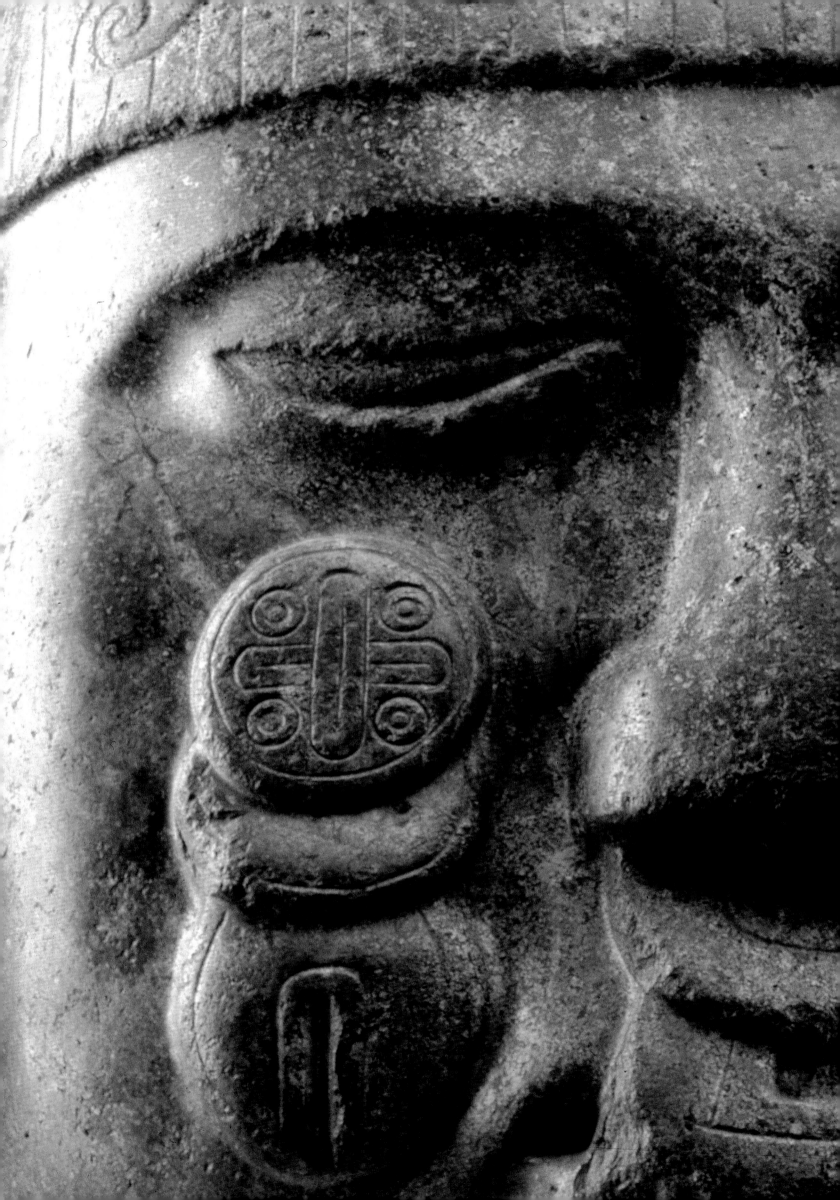

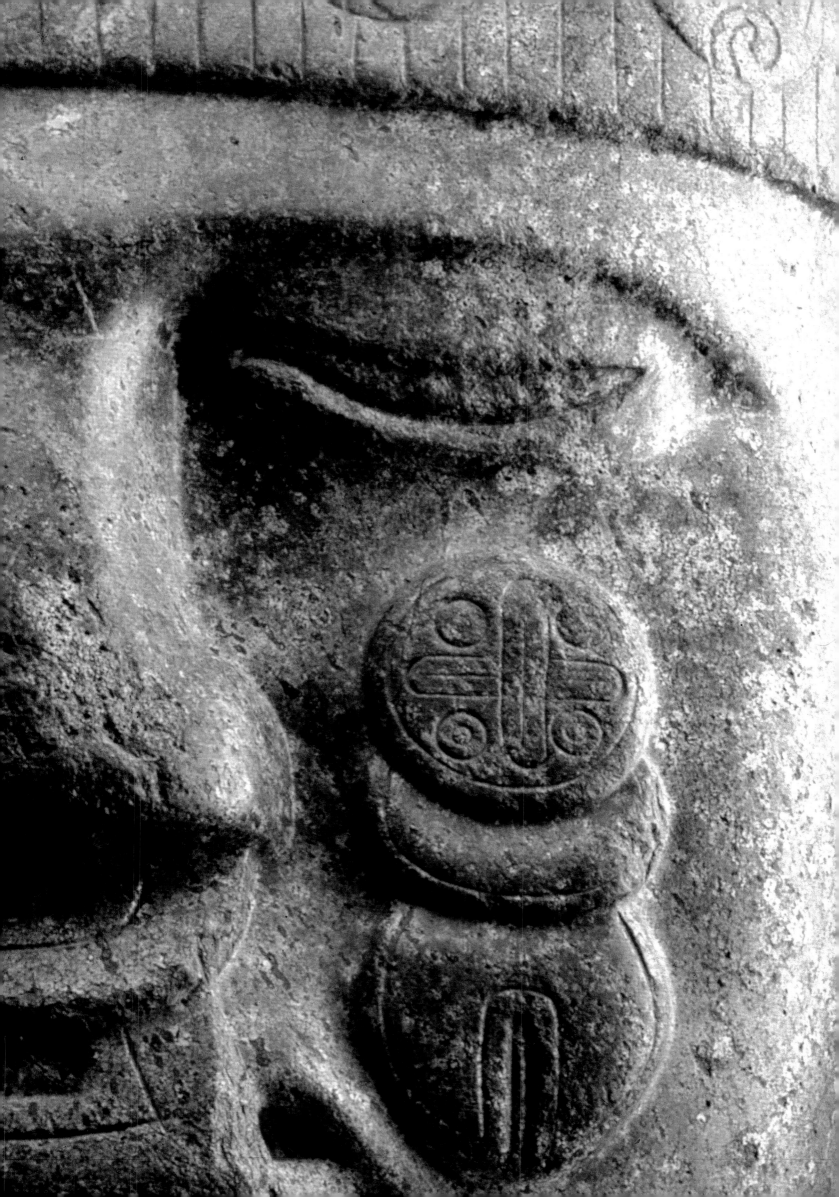

Foreword

THE AZTEC EMPIRE REPRESENTS THE MOST EXTENSIVE AND HISTORICALLY ACCURATE SURVEY OF THE ART AND culture of the Aztecs and their contemporaries ever assembled outside Mexico. The Aztecs, the nomadic culture that dominated Central Mexico at the time of the Spanish Conquest, founded Tenochtitlan, modern-day Mexico City, in 1325. Fearless warriors and pragmatic builders, they created a vast empire during the fifteenth century and were the most documented culture in the Americas at the time of European contact in the sixteenth century. This exhibition presents the extraordinary works of art created by the Aztecs as well as by the peoples they conquered, and the cultures that preceded them in Mesoamerica.

Though perhaps unexpected, this project is nonetheless a natural fit within the scope of the Guggenheim's global program. Our institution is primarily devoted to modern and contemporary visual culture, but from time to time we have presented major exhibitions focused on classical, and even ancient, art. Exhibitions like *Africa: The Art of a Continent* (1996), *China: 5,000 Years* (1998), and *Brazil: Body and Soul* (2001–02) have given us the opportunity to explore a broad array of artistic traditions. They have greatly expanded the vision of the Guggenheim, providing intriguing contrasts with our contemporary programming, while also reflecting the context from which today's art has emerged. *The Aztec Empire*, like *Brazil*, exemplifies a profound desire by the Guggenheim to explore the rich cultural narratives that have emerged from Latin America. As the United States and Mexico develop closer ties economically, the opportunity for cultural communication increases and, in fact, becomes increasingly important.

The Aztec Empire was inspired by a major exhibition at the Royal Academy of Arts, London, called simply *Aztecs*. When I visited the show, I was captivated by the extraordinary objects on view, and instantly thought that they would be stunning in the context of the Guggenheim's Frank Lloyd Wright building in New York. When, soon thereafter, I met Sari Bermúdez, Mexico's culture minister, we discussed the possibility of another, larger show devoted to the Aztecs. It quickly became clear that there was only one person who could serve as curator for such an important project, Felipe Solís, Director of the Museo Nacional de Antropología in Mexico City. Dr. Solís's project for the Guggenheim presentation is ambitious—to provide not only a thorough representation of Aztec society at the zenith of the empire, but also to suggest the context for its development, expansion, and influence. This exhibition transcends the stereotypical portrayal of the Aztecs as fierce conquerors to present their many positive achievements.

The largest and most important section of the exhibition is devoted to the Templo Mayor, the heart of the Aztec culture and an active archaeological site in the center of Mexico City. Excavations of the Templo Mayor throughout the twentieth century, but especially since 1978, have yielded a rich and significant trove of sculptures, reliefs, religious artifacts, and ceremonial objects—some of which have never been shown in Mexico and will be seen here by the general public for the first time. The final section of the exhibition includes objects and works of art from the time of the European conquest, and reflects the destruction of Aztec society as well as the appropriation and utilization of its artifacts, both religious and secular.

The exceptional quality of this exhibition reflects personal support and cooperation at the highest levels of the Mexican government. From my first conversations with Sari Bermúdez, she has proven an invaluable champion of the project. *The Aztec Empire* is organized with the support of the Consejo Nacional para la Cultura y las Artes (CONACULTA) and the Instituto Nacional de Antropología e Historia (INAH) of Mexico. In her position as President of CONACULTA, Sari effectively mobilized the ministry on the project's behalf, and we are deeply

grateful to her and her staff for their unfailing support. Jaime Nualart, Technical Secretary and former Director General for International Affairs, was instrumental in coordinating preliminary discussions, and his successor, Alberto Fierro, Director General for International Affairs, CONACULTA, continued to provide encouragement. At INAH, Sergio Raúl Arroyo, Director General, Moisés Rosas, Technical Secretary, and José Enrique Ortiz Lanz, National Coordinator of Museums and Exhibitions, have provided valuable assistance and support. The administrative organization of the project at INAH was the direct responsibility of Elvira Báez García, Director of International Exhibitions, and Jacqueline Correa, Project Coordinator, and we are appreciative of their constant guidance and cooperation. The Foreign Ministry also supported this exhibition through the good offices of the Ambassador of Mexico to the United States, the Honorable Carlos de Icaza, together with Cultural Attaché Alejandro Negrín; we would like to extend our gratitude for their support. I extend my personal thanks to the Honorable Arturo Sarukhan, Consul General of Mexico in New York, who provided advice and consultation at important stages of the project. We are grateful to Rodolfo Elizondo Torres, Secretary of Tourism, for his steadfast support of this project. Our gratitude also goes to the Honorable Anthony Garza Jr., U.S. Ambassador to Mexico, together with Jefferson Brown, Minister Counselor for Press and Cultural Affairs, Marjorie Coffin, Cultural Attaché, and Bertha Cea Echenique, Senior Cultural Affairs Specialist, of the U.S. Embassy in Mexico City, for their enthusiasm and constant support.

To design the exhibition in New York, the Guggenheim has enlisted the talents of Enrique Norten, founder and principal of TEN Arquitectos (Taller de Enrique Norten Arquitectos), a firm that has altered the face of Mexico City, as well as the international perception of Mexican architecture, since its founding in 1985. Norten was joined in this effort by J. Meejin Yoon, architect, designer, and educator. For *The Aztec Empire,* the designers introduce a single bold design element into the classic white wall interior of Frank Lloyd Wright's landmark building: an undulating ribbon wall covered with gray wool felt. The serpentine wall, absorbing light and sound, renders the space a deep and mute environment. As it bends and peels to accommodate the various scales of work on view, the wall creates new spatial experiences along the ramps. By focusing on the experience of perimeter and periphery, as opposed to the center, the project accommodates the curatorial themes of the exhibition, while at the same time providing a smooth and nonuniform system for displaying the array of artifacts selected by Dr. Solís. The staff of TEN Arquitectos has been tireless in their efforts, and particular thanks are due Clara Sola-Morales Serra in New York.

The exceptional collaborative experience of the project extends beyond the efforts of the curator to include the scholarship within this publication. Dr. Solís's editorial approach and academic standing enabled the inclusion of scholarly essays by eminent Mexican and U.S. authorities, and the book promises to become a major reference on the subject. In addition to original texts by Dr. Solís, and Roberto Velasco Alonso, curatorial assistant, we are indebted to the distinguished authors who have contributed to this volume. We are also pleased to collaborate with Landucci Editores on the publication of this catalogue.

Although a large part of the work on view in *The Aztec Empire* is the result of generous loans from Mexican institutions made possible through CONACULTA-INAH, the exhibition also includes more than sixty major Precolumbian works from museums in the United States. These complement and complete the curator's portrayal of the Aztec people and provide a greater awareness of the riches in domestic collections. The lenders are listed elsewhere, and we are indebted to them for their cooperation and enthusiastic support of the project.

The complexity of this exhibition presented unusual challenges, and its spectacular realization is the result of the work of all the departments of the Guggenheim Museum. We thank in particular the personnel listed in the Project Team. Special thanks also go to Lisa Dennison, Deputy Director and Chief Curator; Marc Steglitz, Deputy Director for Finance and Operations; Karen Meyerhoff, Managing Director for Exhibitions, Collections and Design; Kendall Hubert, Director of Corporate Development; Marion Kocot, Project Manager; and Mariluz Hoyos, Project Assistant, for their steadfast professionalism on all stages of the project.

An exhibition of this magnitude could not take place without the generous support of our sponsors. In particular, we thank major sponsors Banamex and Televisa, whose commitment to the support and preservation of Mexican art and culture is longstanding. At Banamex, Manuel Medina-Mora, Chief Executive Officer, must be thanked for his commitment in realizing this project. In addition, Jorge Hierro Molina, Executive Director of Institutional Relations; Cándida Fernández de Calderón, Director of the Banamex Cultural Foundation; and Hermelinda Caceres Gil, Exhibitions and International Projects Coordinator, brought great creativity and dedication to this project. We also extend our sincerest gratitude to Televisa, under the leadership of Emilio Azcárraga Jeán, Chief Executive Officer, for providing invaluable support that makes it possible to share this remarkable culture with diverse audiences. In addition, Claudio X. González, President, together with Mauricio Maillé, Visual Arts Director, and Diana Mogollón, all of the Televisa Foundation, demonstrated an inspiring commitment to this exhibition.

Significant additional support was provided by PEMEX; in particular, we are indebted to Raúl Muñoz Leos, Chief Executive Officer, and Octavio Aguilar Valencuela, Corporate Director of Administration, for their dedication to this project. The Mexico Tourism Board also deserves special recognition; we are most thankful to Francisco J. Ortiz, Chief Executive Officer, together with his team, Alejandro Muñoz Ledo, Head of Promotional Division, Guillermo Ohem Ochoa, Director for the Americas, and Marisa Isabel Lopez, Director, Northeast Region, New York office, for their support. We would also like to express our gratitude to Fernandez Flores, Chief Executive Officer of Aeromexico, for much-needed transportation assistance, with special thanks to Augusto Fernandez Kegel, Vice President for Marketing and E-Business, and Maricela Moreno Cardentti, Advertising and Corporate Image Director.

This exhibition has also been made possible in part by an indemnity from the Federal Council on the Arts and the Humanities. We would also like to thank the individuals of the Leadership Committee for *The Aztec Empire* as well as participating sponsors GRUMA, ALFA, and Con Edison for additional critical support helping make this exhibition possible. Finally, we are grateful to Thirteen/WNET for media support allowing audiences to learn about the importance of the Aztecs.

Indeed, it is due to the tireless efforts and generosity of so many individuals and organizations that the Guggenheim is able to present *The Aztec Empire*, and to present the achievements of this great culture. The objects gathered together for this exhibition are extraordinary in aesthetic terms as well as for the sophisticated and hierarchical society they represent.

Thomas Krens
Director, The Solomon R. Guggenheim Foundation

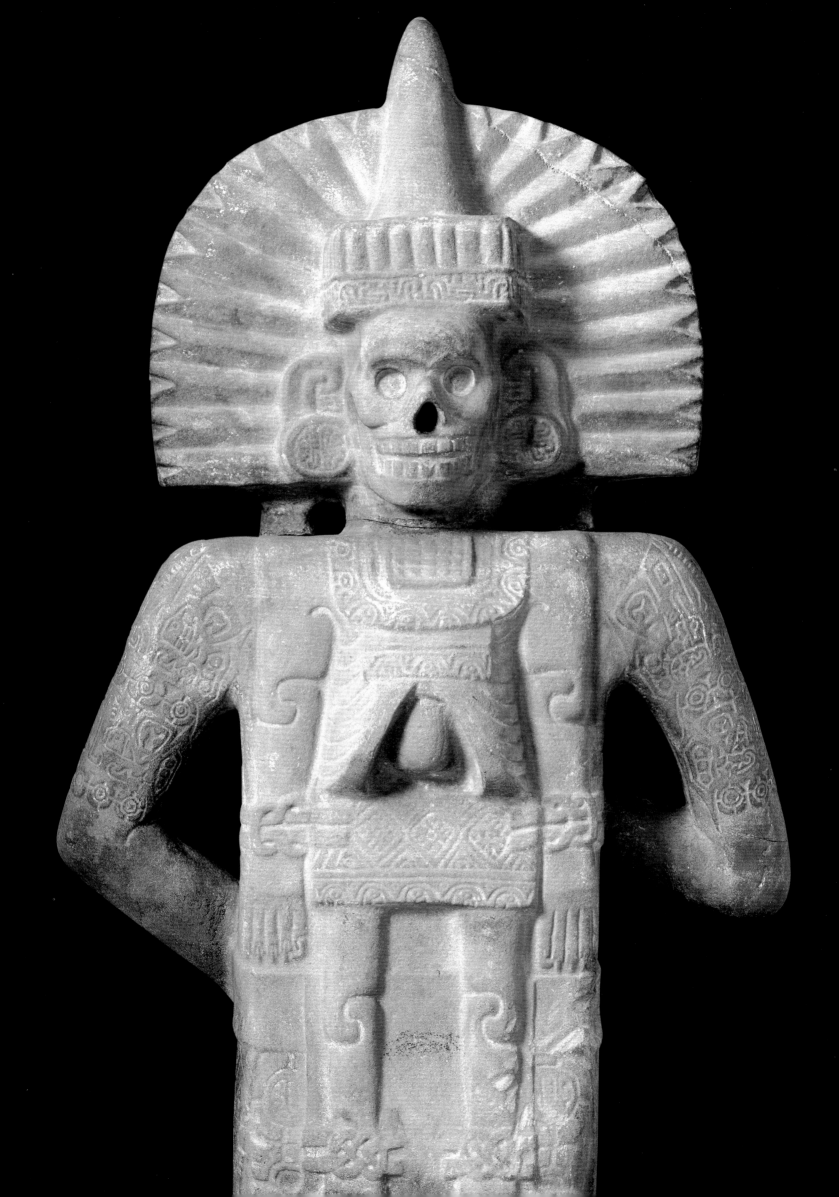

Introduction

Introduction

Felipe Solís

THE PUBLIC HAS GREETED THE ART OF PRE-HISPANIC MEXICO WITH ENTHUSIASM AND A SENSE OF wonder and awe, as has been demonstrated by the tremendous success of exhibitions presented in the world's most cosmopolitan capitals since the first half of the twentieth century. In this respect, the opportunity to bring together an exquisite selection of objects for *The Aztec Empire*, which re-creates the splendor of the final chapter of the indigenous world of Mexico, represents a momentous occasion.

Among the works united here are monumental sculptures, reliefs, polychrome ceramics, musical instruments, objects carved from jade and wood, as well as ornaments and jewelry wrought from shell, turquoise, and gold. All of them evoke the historical processes and lifestyles of the Aztecs and the various peoples and societies that existed alongside them during a glorious period of wealth, power, and majesty.

This exhibition comes out of the research and publications by specialists in the art and culture of this final chapter of Mesoamerican history, the basis for which are indigenous codices and the chronicles written by Europeans in the early sixteenth century. *The Aztec Empire* has been conceived in order to provide a holistic vision, allowing viewers, as they proceed through the exhibition, to simultaneously contemplate and examine artworks created by the inhabitants of Mexico-Tenochtitlan alongside those of other contemporaneous cultures. Visitors will be able to compare tremendously innovative indigenous styles, as expressed in the diverse forms and unique ornamental devices particular to the various societies in which they originated. The monumental space afforded by the Solomon R. Guggenheim Museum will also allow commonalities to be traced through the so-called international style of the Late Postclassic period—evidenced in some of the extraordinary masterpieces on display—which became consolidated around the time the Aztec empire was established. This style is characterized by a complex universe of symbols executed with similar artistic means, through which the different indigenous peoples could recognize one another and participate in a common artistic language, despite the fact that they may not have been able to communicate via spoken language.

We trust that visitors encountering the art of the Aztecs will have an extraordinary experience in witnessing firsthand the principal features of the culture's astounding, multifaceted universe. When one considers what makes this vision of the cosmos unique and different from our culture's, its forms emerge with an indescribable power. Indeed, creating a dialogue between past civilizations and a contemporary public has not been an easy process, although there are many precedents for such an undertaking.

The first modern attempts by Westerners to understand indigenous art occurred in the nineteenth century, as travelers, including some well-known artists, journeyed to Mexico during the period of revolution and independence

1. Xiuhtecuhtli
Aztec, ca. 1325–1521

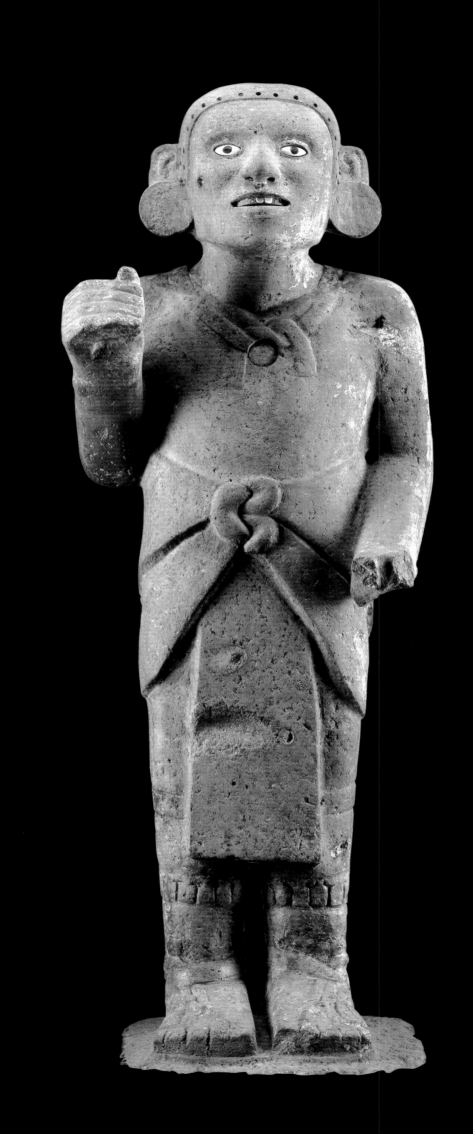

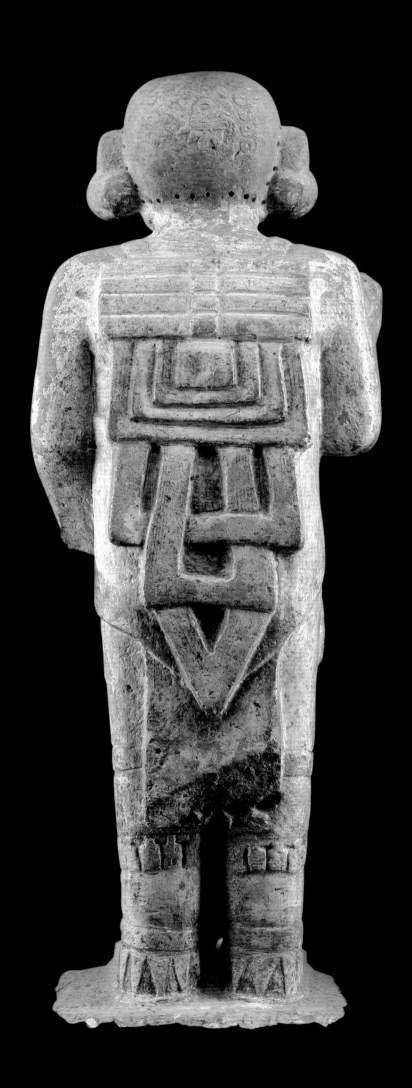

Rear view of cat. no. 1

and its first decades as a republic. These travelers illustrated their tales with images of ancient cities in ruins, monuments, and rare and mysterious objects, all of which sparked the interest of Europeans and Americans to follow in their footsteps and to collect similar treasures. Among the most famous accounts are the books of John L. Stephens, illustrated by Frederick Catherwood, which are devoted to the mysterious world of the Maya; and the works of Guillaume Dupaix, which were unfortunately published very late and thus had less of an impact than Stephens's works. Dupaix's writings provided detailed evidence of Mexico's enormous archaeological wealth, particularly in the central region and the valleys of Oaxaca and Palenque. The bibliography of travel literature would later be enriched by William Bullock's contributions, which primarily detail Aztec archaeology, while Eduard Muhlenpfordt and Carl Nebel dedicated their efforts to Oaxaca, the Gulf Coast, and Mexico City. Baron Alexander von Humboldt—a pioneer in his field—collected codices that had been stored in European libraries and exhibited them together with archaeological pieces, some of which he himself had obtained in Mexico.

Finally, we are indebted to Pietro Gualdi for conceiving the first Mexican museum, located in the courtyard of the Universidad Nacional Autónoma de México, where the first monoliths to be discovered, beginning in 1790 in Mexico City's Great Plaza and in the atrium of the cathedral, were displayed. These include the enormous sculpture Great Coatlicue, the first monument to emerge during that period of improvements to the urban infrastructure of Mexico City; and the Stone of Tizoc, originally called the Stone of Sacrifices.

It was during the nineteenth century that the pre-Hispanic world gained exposure through the publication of superb etchings, while the phenomenon of archaeological collecting appeared. This was practiced institutionally within Mexico and privately by individuals from the United States and nations in Europe, particularly by the English, Germans, Swiss, and French. Although their activities were undertaken without any governmental oversight, the objects they unearthed eventually enriched the museums of their respective countries of origin, where they were considered the creations of a distant, exotic, and primitive world.

The Museo Nacional de México was moved in 1866 from its quarters at the university to a baroque palace located along the southern side of the Palacio Nacional. The museum's new home had been devoted in colonial times to the smelting of precious metals and the minting of coins. This move was made to obtain more space for exhibiting archaeological and historical pieces. The great monuments were now displayed in the central courtyard, while smaller sculptures, ceramics, tools, and ornamental objects were housed in the rooms on the palace's upper floor. It was at this venerable institution that Mexican archaeological research began and the first school of museology, which has since brought the country great prestige, was established.

The Gallery of Monoliths opened in 1888 in the museum's largest exhibition space. This was the most significant event in the revalorization of Mexico's pre-Hispanic past. The construction of the gallery had been motivated by the desire to create a protective environment for the Sun Stone, which for nearly a century had been displayed outdoors, embedded in one of the towers of the city's Metropolitan Cathedral. The most important works of sculpture that the museum had collected to date were exhibited around the stone, among them the Great Coatlicue and hundreds of stone figures, ballcourt rings, reliefs, altars, and vessels, most from the Aztec period, that had been discovered underneath the modern capital and at other major settlements in the Valley of Mexico. Aztec artworks and archaeology thus regained their visual power through the display of compelling images of ancient gods and related cult

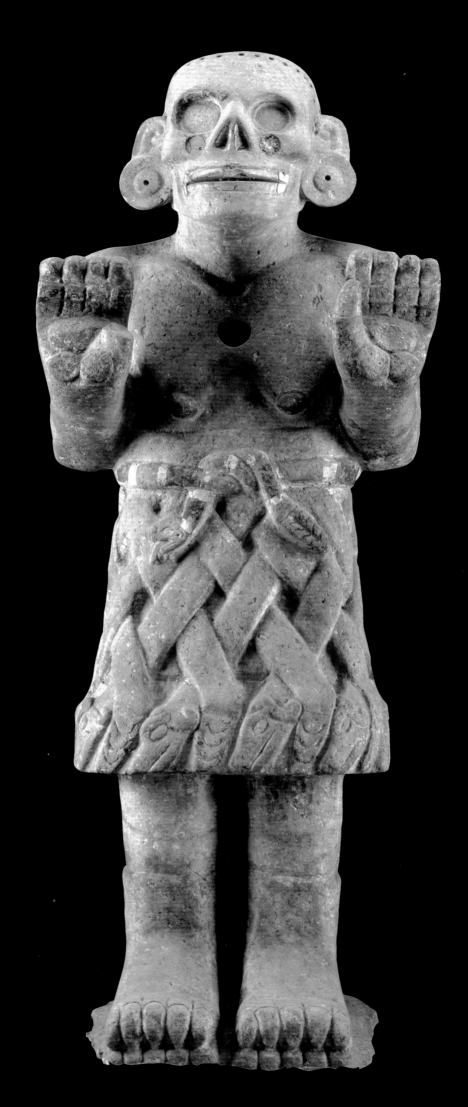

2. Coatlicue, front and rear views
Aztec, ca. 1500

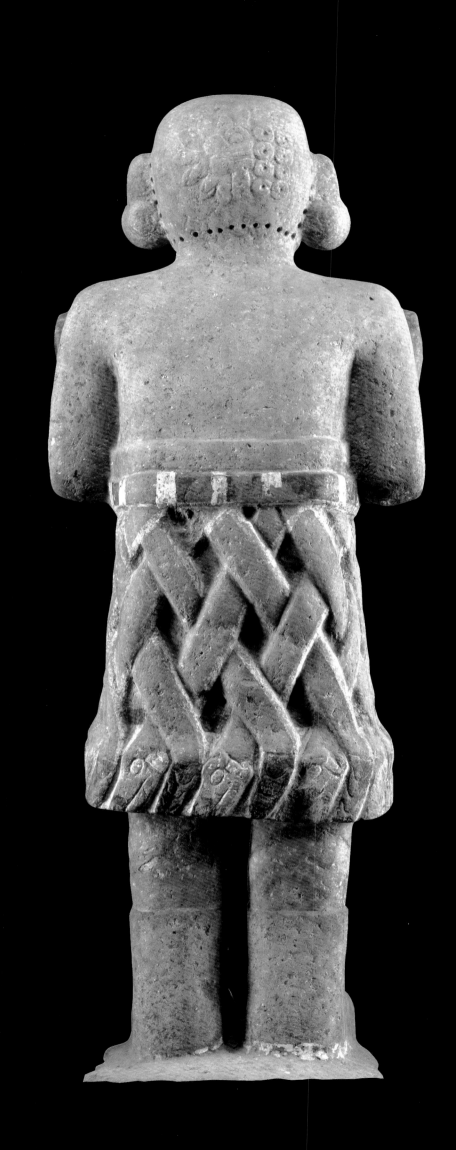

objects, which had been lost during the centuries following the Spanish Conquest of Mexico-Tenochtitlan.

International validation of indigenous art, however, would have to wait until the twentieth century. This occurred only in 1940 with the opening of *Twenty Centuries of Mexican Art* at the Museum of Modern Art, New York, which was presented in collaboration with the government of President Lázaro Cárdenas. This remarkable exhibition was the first outside Mexican territory to bring together artworks from the three major periods of the country's history: Precolumbian, colonial, and modern. The exhibition met with overwhelming success, as did the catalogue, which included writings by Alfonso Caso and served as a guidebook for appreciating the most important treasures of ancient Mexico. It was the first time that this museum space, which was devoted to major works of international modern art, had experienced such a triumphant invasion.

The impact caused by Mexican archaeology was felt not only by museum visitors in New York. It was also of particular importance for the shift among Mexican intellectuals in their attitude about works from the Precolumbian period, which were now considered to be expressions of high aesthetic value. This change was evident in the publication of the book *Arte prehispánico de México* in 1946, whose broad dissemination led to a new level of appreciation in Mexico for indigenous creations.

Considering such changes, Caso, who had joined the staff of the Museo Nacional de México around 1950, transformed the Gallery of Monoliths into the first exhibition space devoted specifically to the art and culture of the Aztecs. The gallery was intentionally named the Mexica Hall to link the name Mexica—which, along with Tenochca and Aztec, has been used to identify the people who founded Mexico-Tenochtitlan—with the actual name of the country, serving by extension as a reference to the identity of all Mexicans. The Mexica Hall thus established our most distant origins of national identity.

Many were introduced to Mexico's Precolumbian art through the efforts of Fernando Gamboa. In the two decades following the New York exhibition, Gamboa tested the waters beyond the Americas, daring to bring to Europe an even larger contingent of works, in this case a polished selection of archaeological objects that gave the public a chance to appreciate the richness and drama of pre-Conquest art. The formula that had proved so popular in New York was repeated: Pre-Hispanic art was shown with works from the colonial period and postrevolutionary Mexico. This exhibition, which traveled to Paris, London, and Stockholm, was another huge success, representing a triumph for Mexican art. For the first time European audiences were able to experience Mexico's most varied artistic expressions, in an amazing collection of pre-Hispanic works that offered both specialists and the uninitiated an opportunity to explore their elegant forms and profound symbolism. The event triggered enormous interest in the indigenous peoples who had created these works. This reassessment of ancient Mesoamerican art was followed by two highly significant cultural events that demonstrate the process of reevaluating the most important collections of Mexican art in the United States.

The first was the inauguration at Dumbarton Oaks in Washington, D.C., in 1962, of a section devoted to Precolumbian art, exhibiting the extraordinary collection of Robert Woods Bliss, which had been on view at the National Gallery of Art since 1947. The second was an exhibition entitled *Before Cortés: Sculpture of Middle America*, which opened in 1970 at the Metropolitan Museum of Art in New York, commemorating the institution's first centennial. The exhibition was used as a pretext for moving the objects comprising the Nelson A. Rockefeller Collection, formerly

in the city's now defunct Museum of Primitive Art, into a new wing designed specifically for the art of the Americas, Africa, and Oceania.

The first circuit of traveling exhibitions of Mexican art concluded with the opening of the new Museo Nacional de Antropología at its present site in Chapultepec Park in Mexico City, which took place on September 17, 1964. The inauguration of this extraordinary structure, the design for which was based on a highly advanced architectural and museological concept, accorded each cultural region and archaeological period its own space, thus showing visitors the specific technological advances and artistic features of the diverse peoples who inhabited ancient Mexico. Located in the center of the structure, the Mexica Hall was considered the principal attraction for those visiting the museum. The gallery's location, at the end of a long reflecting pool, was meant to evoke the original site of the glorious Mexico-Tenochtitlan, which was built on the islets in Lake Tetzcoco. Architect Pedro Ramírez Vázquez, the creator of this magnum opus, conceived the Mexica Hall in monumental dimensions to imbue the space with the character of a temple. The height and volume of the exhibition space allowed visitors to suitably appreciate the grandeur of Aztec monumental sculpture, most notably the Sun Stone, which was placed at the end of the central nave, in front of a white marble wall and set on a marble platform, thus transforming the piece into an altar devoted to Mexican indigenous national identity.

After its opening the Museo Nacional de Antropología quickly became a tourist attraction for those seeking to learn about the richness of Mexican archaeology, especially its artistic expressions. The museum's design had international impact, influencing the transformation of exhibition spaces in many other museums with collections of Precolumbian Mexican art. In many cases disparaging allusions to primitive art, which had held fast until this time, were dropped.

The event that brought the world's attention to Aztec art, to the creations of the "People of the Sun," was without a doubt the discovery in 1978 of the sculpture of the goddess Coyolxauhqui, which later led to the development of the Templo Mayor Project. For twenty-five years now this project has made extraordinary archaeological discoveries that have astonished people across the globe. Its researchers continue to contribute to the knowledge and dissemination of information about the founders of Mexico's first capital.

In 1980 a public eager to learn about and enjoy the discoveries that had been unearthed at the Templo Mayor had the opportunity to visit a related exhibition presented at the Palacio de las Bellas Artes in Mexico City. Including any number of objects of delicate beauty and powerful symbolism, this was the first of numerous exhibitions to display the advances made in archaeological research. Since then the interest in Aztec art has led to other exhibitions, which besides presenting objects from the Templo Mayor explored themes relating to the culture of Tenochtitlan's people. These exhibitions were noteworthy for the sheer volume of artifacts displayed, some being shown for the first time outside their original locations.

In 1982 we sent the exhibition *The Aztec Civilization* to Japan, where it was presented in Sendai and Nagoya. During the curatorial process we selected important artistic and archaeological objects that had previously remained in storage, hidden from the eyes of the public. These works were now considered key pieces in the redesign of the Mexica Hall at the Museo Nacional de Antropología.

The exhibition *Glanz und Untergang des alten Mexiko: Die Azteken und ihre Vorläufer*, which opened in 1986, brought the art of ancient Mexico to Europe and Canada, highlighting works of the Aztec world. *Art of Aztec Mexico: Treasures of*

Tenochtitlan, presented in 1983 at the National Gallery of Art, Washington, D.C., and *Aztec: The World of Moctezuma,* which opened in 1992 at the Denver Museum of Natural History, were particularly significant because in them the art of the Aztecs was not immersed within a context of other Mesoamerican objects. At last, the final indigenous development in Mexico prior to the arrival of the Spaniards was presented on its own.

In the 1990s the Museo Nacional de Antropología once again saw the need to share its collections in the form of new touring exhibitions. Beginning its successful tour at the Metropolitan Museum of Art in October 1990, *Mexico: Splendors of Thirty Centuries*—later continuing on to San Antonio and Los Angeles—was organized once again around the holistic concept of Mexican art broken down into three main periods. As its point of reference, the exhibition used the most significant archaeological sites in Mesoamerica: La Venta, Izapa, Teotihuacan, Monte Albán, Palenque, El Tajin, Chichen Itza, and Mexico-Tenochtitlan.

In the same year the Museo Nacional de Antropología organized the exhibition *Precolumbian Art of Mexico,* which traveled to Paris, Madrid, Berlin, London, and Tokyo between 1990 and 1992, providing the public with the chance to view a selection of works of the highest artistic quality from Mesoamerica—with examples from all cultural areas and archaeological periods—as well as from the north of Mexico. The exhibition was hailed by international critics as a microcosm of the museum in Chapultepec Park traveling the world.

In 1999, during the first phase of renovation and redesign of the Museo Nacional de Antropología, we made profound changes to the Mexica Hall, which would allow nearly eight hundred objects to be displayed. Subsequently, with the experience acquired over many years of research and museum undertakings, we developed, together with Professor Eduardo Matos Moctezuma, the exhibition *Aztecs,* which was presented in 2002 at the Royal Academy of Arts, London. This exhibition united objects from numerous museums in Europe, Mexico, and the United States; in particular, the assemblage of a large number of pre-Hispanic and colonial codices was a rare event and gave the exhibition its unique identity.

The most demanding critics considered *Aztecs* to be the second-most important exhibition of non-Western art—ranking behind only the legendary *Treasures of Tutankhamun*—to be presented in Europe, for its relevance, the high quality of the works selected, and its popularity among specialists and the general public alike. *Aztecs* continued to garner very favorable reviews when the next year it traveled to Germany, where it was presented in Berlin and Bonn. Prior to leaving the European continent, the loans from Mexico in the original exhibition were joined with objects from Italian collections, thus forming *Treasures of the Aztecs,* a new presentation that delighted visitors to the Palazzo Ruspoli, Rome, in the first half of 2004.

These are the signal events that have preceded the extraordinary showing of *The Aztec Empire,* now on view at the Guggenheim Museum. The exhibition focuses on the expansion and culmination of two powerful empires: the Aztec and the Purepecha (Tarascan), who dominated much of Mesoamerica during the second half of the fifteenth century and the first two decades of the sixteenth. The splendors of these two indigenous cultures are indeed made palpable by the very works presented to viewers. The most complex political entity considered is the Triple Alliance, better known as the Aztec empire, whose works make up the core of this exhibition. Originally a confederation of three emerging city-states, headed by Mexico-Tenochtitlan, this coalition dominated the central, southern, and eastern

regions of Mesoamerica. It achieved and maintained this power through military conquests, the imposition of a strict tribute system, and the dissemination of its language, Nahuatl. Moreover, it reinforced its preeminence through a common artistic language that transcended linguistic barriers.

During the Postclassic period the most highly prized of metals, gold, was considered to be a material originating in the sun, and its use was thus restricted to the ruling class and nobility exclusively. Visitors to this exhibition will have the extraordinary opportunity to come face to face with the most important collection of gold jewelry from Precolumbian Mexico ever displayed in the United States. More significantly, *The Aztec Empire* allows us to bear witness to a time when artists expressed through physical objects the essence of the world around them, their culture's creation myths, and their people's close relationship to the sacred universe, with all its dualities of life and death, night and day, creation and destruction.

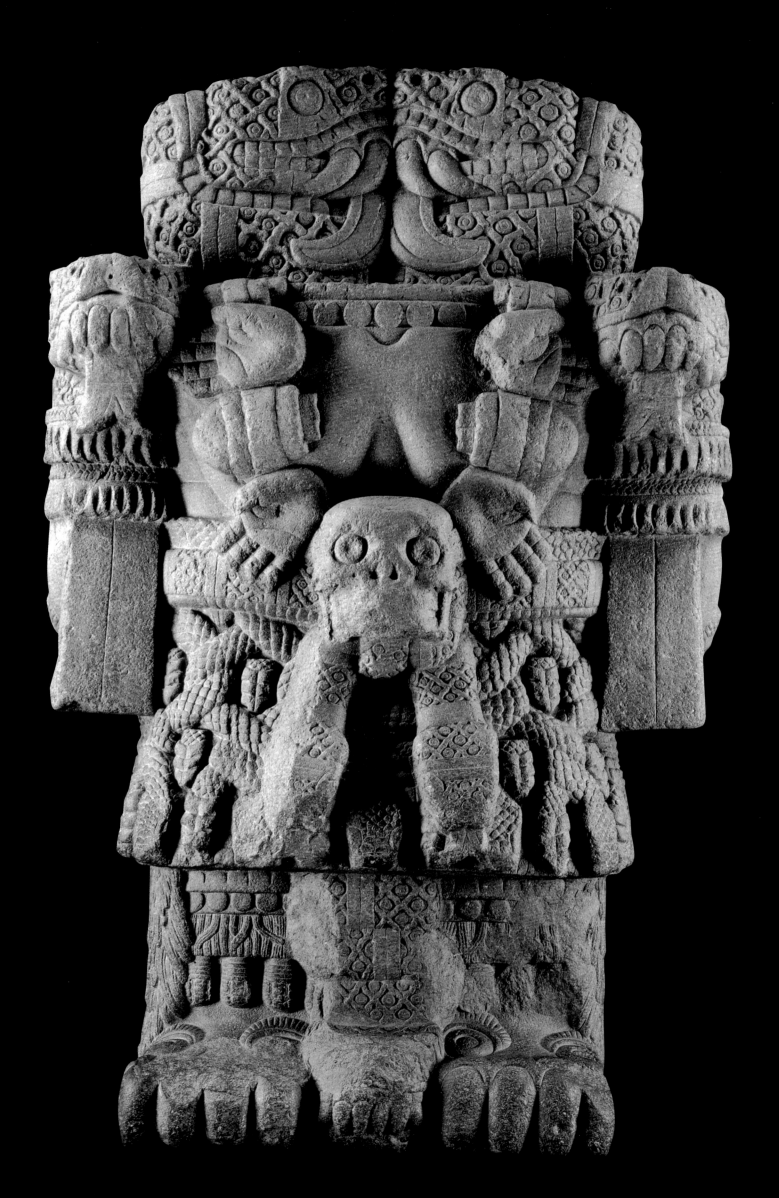

Art in the
Aztec Empire

Traces of an Identity

Beatriz de la Fuente

> Mexican art is a novelty in the field of universal culture and even in Mexican culture. . . . Through its manifestations it summarizes and synthesizes the entire history of our becoming who we are. To try to understand Mexico without including its art is to eliminate the most fertile source for understanding what we are.—Justino Fernández[1]

UNDERSTANDING HUMANKIND THROUGH ITS CREATIVE OUTPUT HAS BEEN THE TASK OF ART history since it came into being as a discipline. Through artistic manifestations, this branch of history seeks to understand the human being as the creator of images. Such images narrate stories of times and places both near and distant.

Not all the creations that we today consider artistic ones were the subject of art-historical inquiry from the inception of the discipline; only two centuries now separate us from its beginnings as a field of knowledge. When art history began within the Western tradition, its self-defined task was building an understanding of certain works, the majority of which originated in the West. Under such conditions were terms, methodologies, and strategies developed for delving deeply into the meanings of such objects.

It is sufficient to recall books with such titles as *The History of World Art*, in which the artworks of the "world" were limited to surveys starting with the cave paintings at Lascaux and Altamira and ending with the European and United States avant-garde. The art of Asia, Africa, and Latin America was omitted or at best included as an appendix in a comparatively small number of pages. However, when the communications media flourished in the late nineteenth century, that narrow Western world became aware of the vastness of human expression. Thus its horizons were broadened, and it began to investigate the artistic possibilities of other previously ignored work. In the eyes of the nascent discipline of art history, many non-Western objects suggested a complex and fertile discourse.

The "new" forms were different from the familiar and accepted canon. For this reason, those terms, methodologies, and strategies developed to solve art-related questions had to be extended, adapted, and reinvented to take into account the problems presented by the recently accepted artworks. Because of art's potential to provide information, there was now access to knowledge previously unimagined about the people who created these works and about their historical and cultural circumstances. In that way, art history, eager to decode information, changed in keeping with the demands of the works and their roots in different times and latitudes in the course of human development.

Consistent with the original purposes of studying art history, these "other works," among them objects produced in ancient Mexico, have slowly been incorporated into the universe of this humanistic inquiry. Before they were considered within this sphere, their history had been long and eventful; yet it took centuries before their expressive qualities and originality acquired a

Sun Stone, or Aztec Calendar.

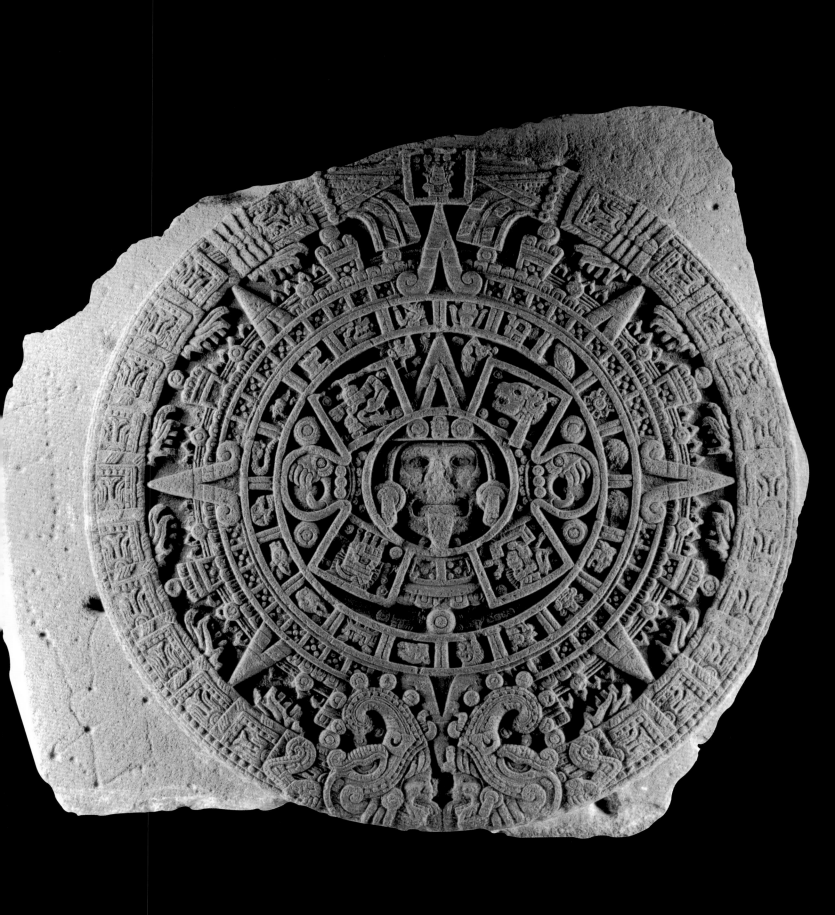

preeminent place in Mexican art, and their universal quality was recognized.

The history of rejection and acceptance of the works created by the peoples of Mesoamerica before the Spanish Conquest clearly illustrates the alternation of scorn and comprehension accorded by Western culture. It is common knowledge that in the sixteenth century the gates of the old continent were opened onto a new, enigmatic, mysterious world.[2] This parallel world awakened the curiosity, wonder, uneasiness, and interest of everyone who arrived. As a result of the Conquest, Mesoamerica was revealed to the eyes of the West through the diversity and abundance of its creations. Through architecture, sculpture, mural painting, ceramics, and other forms, the artistic project of ancient societies became a fertile field—unexplored, ambiguous, confusing, and seductive.

The spaces, volumes, times, textures, lines, colors, rhythms, and movements of the "new" objects unfolded and thereby suggested a language of their own, which appealed to the senses of those accustomed to perceiving in another way. These properties revealed the difference and otherness of an art that expected to open up a dialogue with those looking at it. Deciphering the meaning of those forms has been the task of diverse eras, people, and lines of thinking, from the Conquest to the present day. In transition to the legitimation of pre-Hispanic art, terms such as *pagan* and *exotic* have been used to describe its forms and qualify its meanings.

A good thread to follow in search of viewpoints about Precolumbian art is Justino Fernández's book *Estética del arte mexicano* (1972).[3] In his eagerness to cross the threshold into the past by means of art, the author went back to the sixteenth century. There he confronted the critics of various times to discover their particular contributions to the construction of ideas about the art of ancient Mexico. He found that this artwork was highly disputed, with judgments falling between wonder and fright, praise and scorn. Out of the polyphony he was able to discern two main camps among the critics: those who privileged the craftsmanship and mastery of the works in spite of their diabolical meanings, and those who were wholly focused on the symbolic and religious ideology of the works, overlooking the matter of whether they adhere to Western notions of naturalism. Mesoamerican artworks took on the meanings of the times in which they were studied, described, and argued over. Therefore, in some cases, the critics resorted to comparisons with non-American civilizations such as the Egyptian, Assyrian, and Etruscan.

Fernández's peregrinations are confusing and complicated, and the author was not always able to reconcile form and content. The voice of Manuel Gamio in *Forjando patria* (1916), however, suggested the conjunction of both the signifier (form) and the signified (content), an effort necessary for arriving at the broadest understanding of indigenous art.[4]

Today art historians still face considerable challenges. Other disciplines can help scholars by providing new perspectives and encouraging them to formulate better questions. Coming from the multidisciplinary approach, advances in the intellectual and emotional comprehension of art of the Mexican past have led to a broader acceptance of non-Western art. This new vision, a true opening up of the world, is one of the signs of modernity.[5]

The evaluation of pre-Hispanic art and its inclusion in the worldwide historical-critical consciousness are relatively new developments that began to gather steam in the late nineteenth century. Those intensive processes have revealed how indigenous art enriched our past and established our cultural history in a centuries-long continuum, among its other contributions. However, as George Kubler pointed out in 1991, we still vacillate between isolation and dissemination, between unity and diversity within Precolumbian art.[6] In recent years we have witnessed a new desire to understand this art, to grasp its original meanings wherever possible, and to disentangle its religious and cosmological messages.

The process of understanding the art of non-Western peoples has radically changed our knowledge of world art. How this occurred would be an excellent example for a dialectical study. The development of art in the modern age led to a reevaluation of non-Western art, which in turn steered the development of modern art. It is well to remember here the rise of the twentieth-century avant-garde, rooted in Post-Impressionism and branching out through Expressionism, Fauvism, Cubism, and Surrealism. André Breton had an engaged interest in indigenous Mexican art, of both past and present, and believed he saw in Coatlicue an illustration of the "convulsive beauty" foreshadowing Surrealism.[7]

Longevity is among the greatest virtues of all ancient art, but it also presents the first obstacle to be overcome in understanding the past: the problem of temporal distance.[8] Navigating among the difficulties is possible if we pay attention to the *trace*, the term used by Paul Ricoeur to designate the representation of what has disappeared. According to the philosopher, the only reference point we have from the past lies in the trace; therefore, the knowledge we have about the past can only come from a reconstruction of the information the trace provides. Insofar as art's trace acquires an intratemporal nature that allows it to belong to all times, to be understood in all epochs, the original time in which it was made can be re-created. This capacity to transcend the constant barrier of time's passage turns art into a link between past and present, even if there is a lack of written data to back its creation, as is the case for the majority of Precolumbian objects.

The presence of diverse, multifaceted expression is no longer a novelty in either Mexican or universal culture. Precolumbian art is one of the foundations shoring up national identities. The enormous value of the legitimation of Aztec art and of its

existence in time lies in its presence both as art objects and as an expression of humanity.

"I am other!" said Arthur Rimbaud, in a pronouncement that was already an expression of modernity and general knowledge. Indeed, we are those others. Art functions as a channel of communication; it serves to integrate. In art we can recognize ourselves individually and together, as if in a dialogue between our heads and our hearts.

Mexica-Aztec Art

From the vast body of art produced in Mesoamerica, Mexica-Aztec art stands out as uniquely confident.[9] In the first place, it—together with Olmec art—is primarily a volumetric sculptural form. That the viewer can contemplate sculpture in the round from different angles allows for a different kind of perception than reliefs require. Second, we can observe within the diverse forms of Mexica art the profound maturity and self-awareness of a creative people.

As we know from varied studies based on early colonial texts, the defining traits of Mexica art were achieved because of the culture's belief in a conceptual and metaphoric pairing, the "dialogue between head and heart" and the fashioning of a "deified heart." The objective was to reach a perfect equilibrium between the dual, opposed elements that could be found throughout the universe. This came together through the ideal of knowledge to which the Mexica aspired, which was called *toltecayotl*. The person who had a dialogue with his or her own heart was known as a *toltecatl*, today called an "artist." Once his or her creative goals were reached, the artist transcended the sphere of the gods in order to fulfill the tasks revealed by these gods. The artist went to the essence of things to learn from them and teach others about that intimate dialogue. The goal was to preserve the status quo, that is, the present existence of the universe, by giving thanks to and propitiating the spiritual powers. The tangible results of these divine apprenticeships can still be admired in countless works in different mediums: architecture, ceramics, sculpture, lapidary art, literature, painting, manuscripts, silverwork, and textiles.

With this foundation, Mexica art acquired its distinctive note and its originality within the realm of Mesoamerican art, specifically through the remarkable power of its represen-tations. This force was grounded in an unquestionably vital spirit that lay on the thin line between a longing for pleasure and the anxiety of a people confronted by the end of time. In other words, Nahua works spoke of the people's connection to the future of the cosmos, and the deified heart submitted itself in eternal gratitude to the gods. In the Mexica vision of the cosmos, the human being was essential.

Formal qualities and communicative energy, united, underlie the vitality of Mexica art. Most of these works make use of common geometric figures: rectangular, polyhedral, and pyramidal prisms; cones and their various combinations; spheres; ovoids. Images are created through a wise handling of forms and an absolute control over materials, as well as an inexhaustible desire to express the nuances of lives held in check. Although objects may wound space, with elements projecting outward, they cannot change it, because they are frozen in time. They advance in space but only so far; except for the rare exception, their movement is stopped in its tracks or forced to retreat, contained without expansion, without taking any risks. The limits of stone, fired clay, wood, or any other material constrain the forms, as if they had been taken prisoner and were struggling to escape. Thus Mexica artworks are imbued with an accumulation of contained emotions that seek integration into the universal; perhaps human time and space aspire to sacred realms outside time and space.

As in the rest of Mesoamerican art, Mexica objects fall into basic groups defined by their type of figuration: human, zoomorphic, vegetal, and hybrids. Yet another group is made up of barely insinuated scenes. Because both formal and thematic variations abound, and countless artworks were produced, here I will discuss only some key examples of the aforementioned types. Most of these are sculptures executed in stone.

The Eloquence of the Cosmology

If we start from the proposal that art speaks of the way its creators perceived their place in the world, several Mexica examples quickly come to mind. Perhaps the best known is the Sun Stone. It is well-known that the relief represents the fifth sun and the entire cosmos. The predominant forms are concentric rings, which contain the very universe from its nucleus (the innermost ring) to its limits (the outermost ring). The deity's face occupies the center, and to his sides we can see his hands or claws that imprison hearts. The god appears within the *ollin* sign (which means "movement"), four rectangular panels that converge in a circle, like the blades of a fan. These panels include signs for the various "suns" or preceding eras. This set is encircled by a ring that includes the glyphs representing the twenty days. Surrounding that is another ring, with solar symbols and rays that cross the borders of the circles. The outermost ring consists of two enormous *xiuhcoatl*, or fire serpents, whose heads face one another in the lower part of the monument; from their open mouths emerge the faces of other gods. Thus the universe is quadripartite and dynamic, even if bounded by circular contours—ultimately contained by the *xiuhcoatl*, which also reflect the universe's dual aspect.

Among additional examples of outstanding Mexica sculpture are representations of the hungry goddess, Tlaltecuhtli, who was believed to live in the lower part of the cosmos. She can be seen carved on the bottom of many sculptures, hidden from human sight but omnipresent to the gods and in direct contact with them. She is like contained energy that is invisible to humans

Following pages: The Gallery of Monoliths at the Museo Nacional, Mexico City.

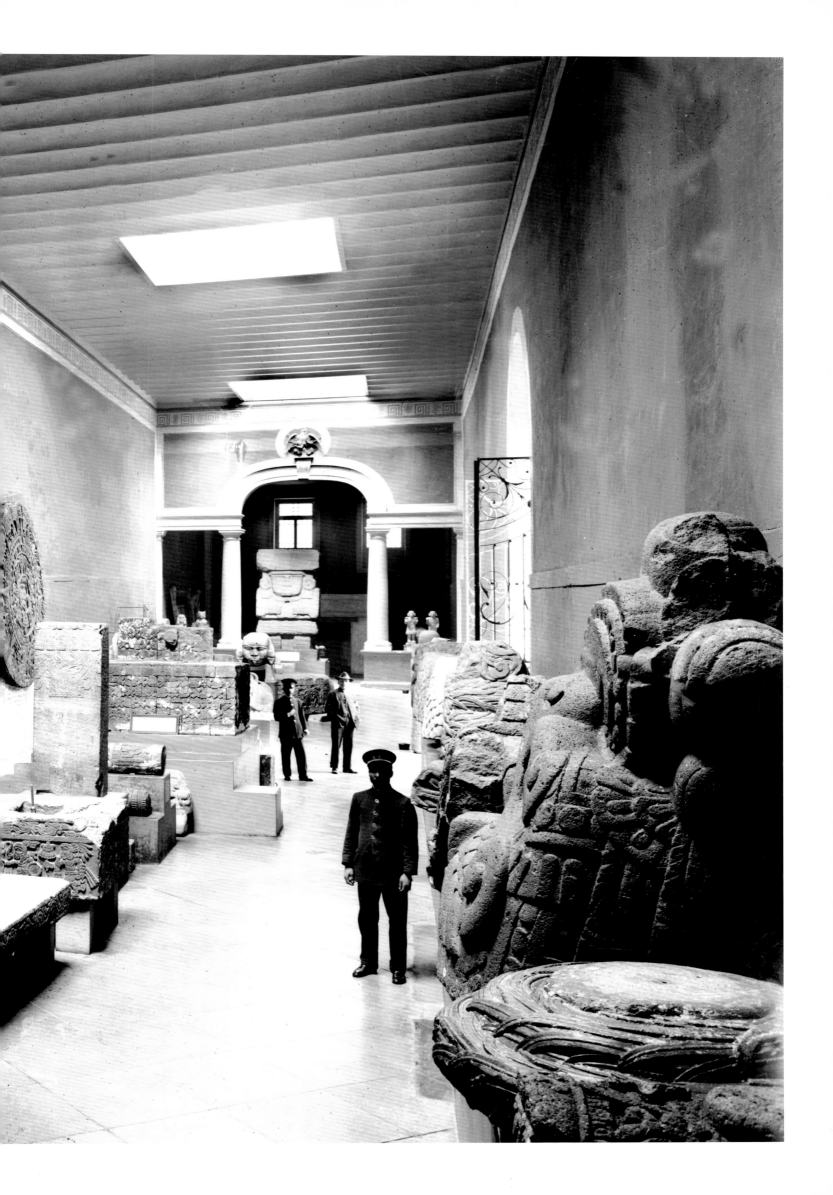

but lies within the power of the carved stone. Tlaltecuhtli is noteworthy for her sprawling posture: her arms and legs open, her head thrown back. Her hair is curly and disheveled, full of spiders and scorpions that crawl through the down on her head. The divinity's face is hybrid, since she is sometimes human, sometimes a fantastic animal with open snout and huge eye-teeth. The deity opens her jaws and sticks out her tongue, a gesture that transforms her into the personification of a knife, with eyes and teeth. In many examples her hands and feet have threatening, feline claws. A skull-and-crossbones design is typical of her clothing.

This divine image of Tlaltecuhtli is unique to Mexica art, yet common within it. It accentuates feelings contained, but on the point of exploding. Her pose in most sculptures suggests an unequal struggle to free herself from the surrounding rock, which confines and compresses her, as if it were keeping her small. It is no coincidence that this is the deity of the earth, both creator and destroyer, who accepts no restrictions, not even in her images. Indeed, she attempts to emit a war whoop—shown by the knife—through that terrible, open snout.

One of the most magnificent forms in Mexica statuary is the embodiment in stone of cosmology itself, the Great Coatlicue. Her pyramidal, cruciform body combines human and animal elements, including two serpents face-to-face instead of a head; female breasts, soft but not spent; a necklace of hands and hearts; and feline claws instead of hands and feet. Skulls, feathers, snails, and serpents make up part of her attire. Her figure is erect, defiant before all creation, bespeaking the great mother who feeds and destroys. It also represents a challenge to the time and space the goddess creates, disrupting and containing them within herself. Thus her image gives physical form to abstract concepts.

This great sculpture of Coatlicue succeeds in communicating the metaphysical and supernatural power of the gods, in addition to the Mexica vision of the cosmos overall. Her image is the sensation of terribleness cast in stone. It makes the intangible concrete and brings the past back to life. It conforms to space and time, yet simultaneously destroys both to create them anew, challenging their eternal flow. A vital challenge set in stone, the image of Coatlicue can conquer its own universe.

Another fundamental figure in this vision of the cosmos is Coatlicue's dismembered daughter, Coyolxauhqui. As a mutilated, quartered goddess, she attains in death a dynamic position through the *ollin* symbol, as can be seen in a relief from the foot of the Templo Mayor at Tenochtitlan. In the Mexica myth her body was cut up by her brother Huitzilopochtli, who wielded a terrible weapon, in the form of a *xiuhcoatl*. As a result of this harsh treatment, her extremities are splayed like fan blades in the relief. We can also recognize elements identifying her as a chthonic divinity, that is, a progenitor. Her belly sags from having given birth numerous times and her breasts have

fallen through nursing countless children. In another sculpture of Coyolxauhqui, a freestanding work quite different from the Templo Mayor relief, she is depicted without a body. Instead she has only a head, from whose severed neck spews, instead of blood, the sign for Atl Tlachinolli (water and fire). The sign is the war cry of Cihuacoatl Quilaztli—Coatlicue's advocate—and the four Tezcatlipocas, among them the brother who murdered Coyolxauhqui.

In these two most famous images of Coyolxauhqui, the goddess represents a death that is in opposition to life yet also leads to life. Thus the grandiosity of the two works discussed here is not limited to their formal treatment but encompasses the deeply rooted religious symbols of the Mexica people. They speak of the outcome of an imbalanced struggle between the beginning and end of life, rendered in cosmic rather than human terms: the battle between life and death, day and night, light and darkness, masculine and feminine. Coyolxauhqui is the woman-goddess, the divine daughter who is mutilated but not conquered, and the one who is victorious in defeat.

Coyolxauhqui is the paradigm of the Cihuateteo, the women-goddess warriors who were part of Huitzilopochtli's entourage. Yet she does not prefigure these warriors; for her mother, Coatlicue, had already done so. Representations of such major goddesses always show them kneeling, with skeletal faces but inquiring eyes. Their long hair is curly, as it is with all the gods of death and the underworld, and they are dressed only in skirts. With cats' claws instead of hands, they crouch like feline predators ready to pounce on a victim or eagerly tear at the air. Although expectant, they are restrained, intent upon taking action at just the precise moment, not before. It was believed that at the end of the fifth sun, they would descend from the sky, transformed into hungry jaguars, and devour humankind. With the Cihuateteo, the life cycle comes full circle, from the creation to the end of the universe. These deities also delimit the space and time within which other gods may act.

Other Deities

The gods seem to comprise a single system, to which elements may be added or subtracted to define them or expand the pantheon. Most are young women, kneeling or seated on their claws. Those depicted seated usually rest their hands on their knees. Only a few dare to be shown nude, at least in the torso. That timid nudity is associated with Xochiquetzal, who exposes her breasts to the open air and adorns her head with garlands of flowers.

Chalchiuhtlicue can be identified by her simple garments, a *quechquemitl* (a short, triangular cape) and a skirt. Her headdress consists of two tassels that hang on either side of her face; she wears a paper fan at the nape of her neck, typical of the deities of water and fertility. The goddess's various identities are shown by changes of posture and different attributes in

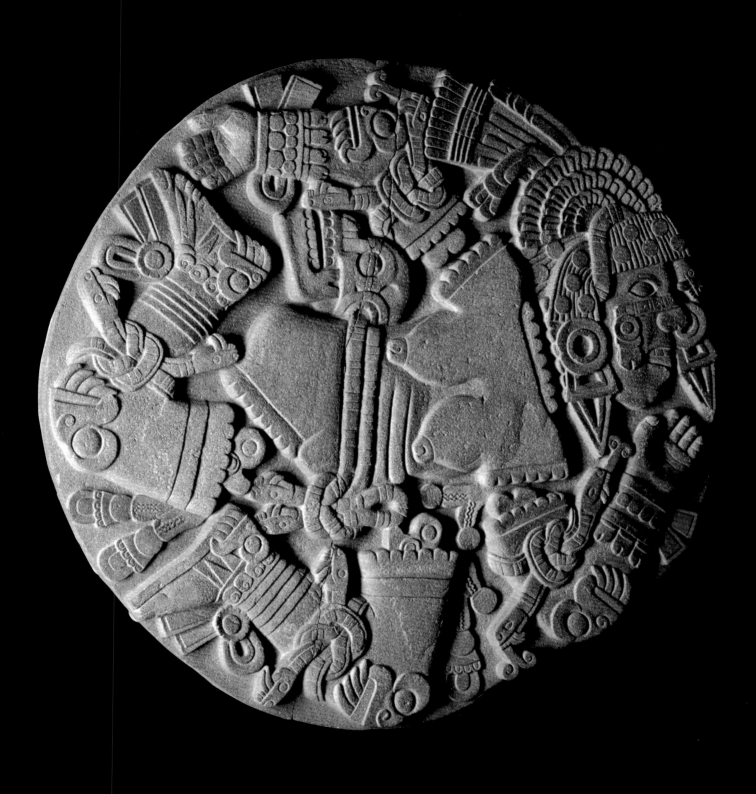

Coyolxauhqui Stone from the Templo Mayor,
Mexico City.

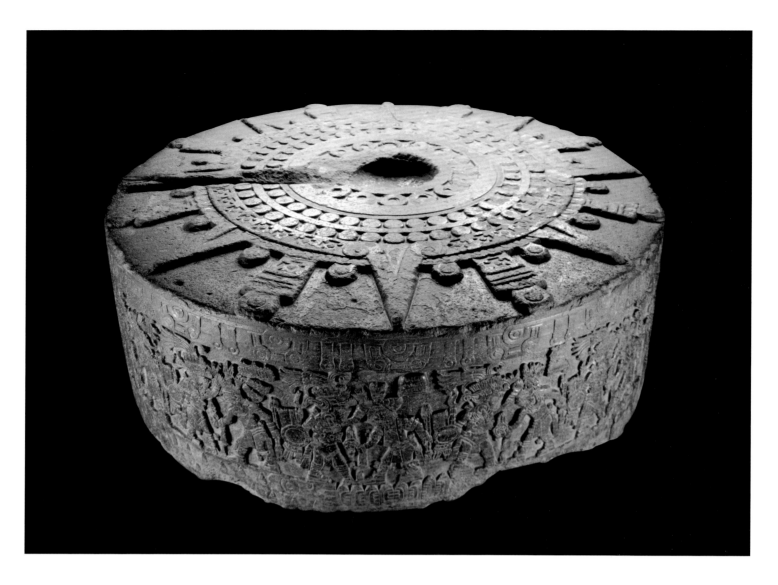

particular sculptures. If she is walking, carrying two pairs of corncobs, she is Xilonen; she may have nude or covered breasts. If the paper fan is replaced by a rectangular headdress with four flowers or small rings of folded paper, then she represents Chicomecoatl.

Those are the three basic types of young goddesses. In fact, Mexica sculptures of women are always goddesses, never humans. The female condition is of no interest except in its sacred capacity as the great mother in all its countless variations.

Males in Mexica sculpture, on the other hand, may be gods or humans. They are almost all young, lacking individuality and any particular expression. Generally reduced to the body's essential features, these sculptures usually lack indications of musculature, although they indicate the clavicles and the bones of the wrists, ankles, and knees. The bodies primarily serve to support the heads, which are conventionalized although closely linked to the structure of the human face. These faces are always oval-shaped, with almond eyes, straight noses with wide nostrils, narrow lips, and mouths slightly open, usually showing the teeth. Both eyes and teeth may be inlaid with conch or obsidian. Emotions or definite expressions are usually absent from these depictions; the faces seem distant from reality. Yet it is worth remembering that such an impression may be attributable to the bare stone, from which painting has disappeared along with the attire made of perishable materials, hair, and headdresses.

Although the schematic bodies and different postures of both sexes barely manage to offset the lack of explicit emotions and the resulting sense of absence or distance, the forms nevertheless reveal a very special kind of expressiveness, a metaphysical attachment to life. The principle of duality and opposites is concentrated in every sculpture that is fully in the Mexica style. These have great power and dramatic tension, which are accented by the specific features of the faces; mouths are held open, fixed in a moving expression; tension is just barely controlled. In addition, particular postures and a variety of attire and adornments finely tune the elements identifying particular types or deities. These patterns equally permeate images of women and men—divine and human—young and old. The old can always be recognized by their facial wrinkles and marked ribs.

A pleasant deity, Ehecatl-Quetzalcoatl was frequently represented. He is immediately identifiable from the treatment of the mouth, which resembles a bird's beak. Otherwise, he takes human form and is seminude and sometimes bearded. He may be standing or seated; his figure may have either a foot or the head turned to one side. If the god takes the form of a spider monkey, it is still composed in a human posture, almost always dancing. For this reason, he is often related to Xochipilli, god of happiness, art, and the renewal of life. The representations of monkeys are bold enough to show movement and even dance steps. Without a doubt, the monkey manifestation endows the

Stone of Tizoc.

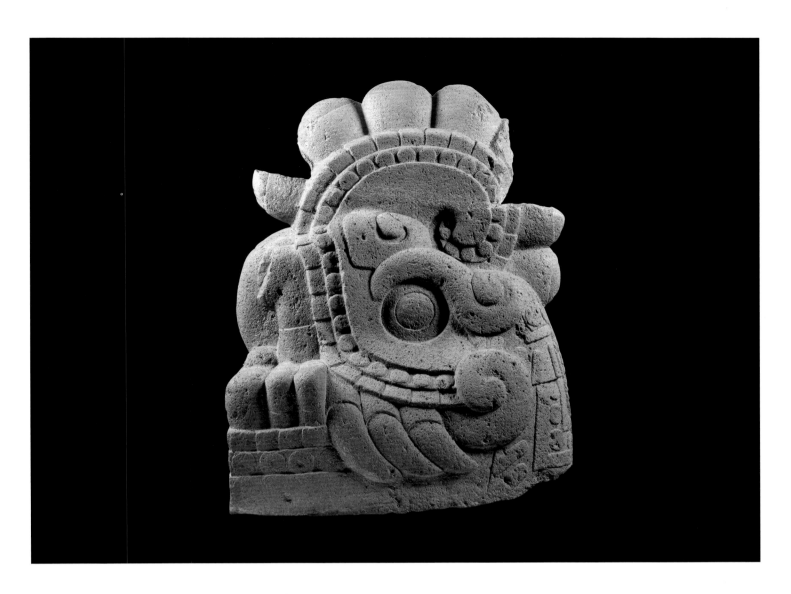

sculptures with a greater freedom of articulation in the torso and the extremities. We can thus differentiate these renditions from the static, anthropomorphic images of the same god. In the static works, even though the god's arms may be apart from the body, the sculptures remain immobile, failing to penetrate the space around them.

Likewise, many representations of Xipe Totec exist; in them, his figure is straight and proud, and is easily recognized by his costume of human skin. Another common subject is Xiuhtecuhtli, who, seated and submerged in profound, cosmological thought, lives at the center of the universe. He can be distinguished by the headdress decorated with a band of disks and a scroll on his forehead, a kind of schematic bird's head. The image of Xiuhtecuhtli is also adorned with a pair of small cubes, on his ears, from which fabric appears to fall, and with a paper fan worn at the nape of the neck. In some examples he is bearded. Also unmistakable are depictions of Huehueteotl, the only old god, who has been carrying a brazier on his head and shoulders since time immemorial.

There are other variations of anthropomorphic figures that emphasize the human face or head. These are masks that follow the canonical features discussed above and are identified only by their associated signs, which appear on the works themselves. Tezcatlipoca's smoke and mirror; the date 9 Wind for Ehecatl-Quetzalcoatl; and the double masks representing Xipe Totec in the skin of a sacrificed person are examples.

But none of these sculptures—whether bodies, heads, or masks—shouts, is prone to outbursts, or changes its emotions. Instead, all offer the certainty of life through the stillness, calmness, and depth of space and time. Perhaps they reflect the contemplative life that seeks the dialogue between head and heart, as the *toltecayotl* recommends.

While the images discussed above are based in the human form, another type of sculpture hails from a mythological zoology. Some of these figures rank as gods. There is nothing silent or empty about these works; individually or as a group, they speak of the profound link between the sacred and human spheres, and recall the deep relationship between humankind and nature.

Among serpentine forms, the *xiuhcoatl*, the fire serpent encountered above, is depicted with clawed front paws. Its head is distinctive, because an attachment, studded with what are known as "star glyphs," projects upward and backward from the tip of its snout. Its body is usually covered with designs of butterflies and tongues of fire. Its tail is represented as a series of trapezoids in groups of two or three, finishing in a triangle. This is the burning weapon with which Huitzilopochtli killed his enemies, the complement to the Atl Tlachinolli.

The *ahuitzotl* (water dog) is a mammal whose back and tail are made of water; on the end of its tail there is a tiny human hand. This figure typically appears as sculpture, both in relief and in the round, but is shown in codices as well. These

Xiuhcoatl.

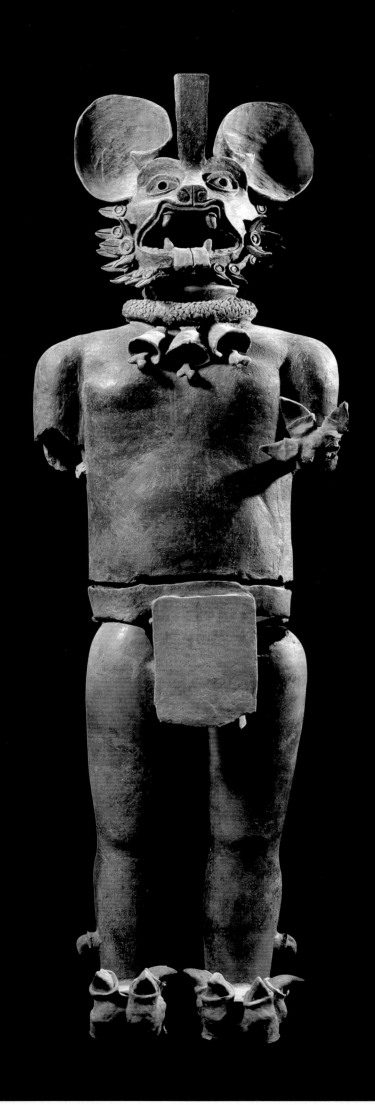

creatures are dangerous, as they can pull people into the water—with that little hand—and drown them. They also let out war cries. The *ahuitzotl* is representative of the animated, imaginary zoology of Mexica sculpture.

A magnificent sculpture of fired clay that represents an anthropomorphic bat must also be mentioned in this section. It came from the excavation of the Templo Mayor. With a distinctive nose and large ears, the wingless bat stands with its feet solidly on the ground and the claws facing frontward. It has elements that link it to the gods of death by flaying, such as its necklace and the snails hanging from it. This is another threatening image that was an integral part of the dualities of the Mexica people's lives.

Living Mortals

In Mexica sculpture, human beings are given special attention, but are robbed of individuality; they can be recognized by their symbols or emblems. Many of these portrayals are of young men, commoners known as *macehualtin*, who are barefoot and dressed only in short loincloths knotted in the front. Their unadorned short hair reinforces their plebeian status. They maintain an upright posture, even if they are squatting. One or both hands is usually extended partially closed; if the figures are standard bearers, the hands are hollowed out to hold flagpoles. Another type of *macehual* is identifiable by the placement of the hands on the knees and, in some examples, crossed arms supporting the elbows.

The famous naturalistic head of an eagle warrior is understood as the Mexica ideal of a human being. Simplified and generalized, its features were not drawn from real models. Overall, as a work of art, it is eloquent in its containment of force, as if the warrior were overlooking a battlefield and confidently thinking of his upcoming victory.

With similar formal and conceptual qualities, another eagle warrior—this one, however, is a whole figure assembled from ceramic parts—shares the expression of community in that it is not a particular individual but rather a common type. Its body is inclined forward, the face framed by a bird's head helmet. The wings can be seen atop the figure's arms, and the talons are at the height of the knees. (This sculpture now lacks the original paint covering it.) None of these elements masks the vital impulse of that dialogue between head and heart. Knowing that he will be part of the cosmic order once the dialogue has borne fruit, the figure is suspended in divine revelation.

The few depictions of elderly figures known can be distinguished by the wrinkles lining their faces. The torsos of some of these sculptures show clear vertebrae and pronounced ribs. Indeed, their backs are bent, either because age or physical disability has overtaken them or because they have lived through many experiences. Figures of both the old and the young bespeak a conquering people sure of itself and of its role in the cosmos. Taken together, all these sculptures attest to Mexica pride in their having been chosen by the gods to feed and conserve the universe.

Plants and Animals

In spite of this emphasis on humans, the Mexica still took special care in creating sculptures of plants and animals. Although flora and fauna are rendered in an abbreviated manner, the essential forms of such works leave no room for doubt about the identity of their subjects. A great many sculptures show the same proximity to visual reality whether they are carved of stone, shell, bone, or wood or are molded or modeled in clay. However, we do not witness in them a desire to precisely reproduce a model. Examples represent, with singular sureness, stretched-out cats, sitting dogs, leaning rabbits, and coiled serpents. While their creators were completely confident in their figural representation, they never followed the path of direct mimesis.

What distinguishes Mexica sculptors from those in other parts of Mesoamerica was their will to extract, with unequaled mastery, what is fundamental in the natural forms that surrounded them. The exceptional quality of their production stems from this desire. Sculptures of fleas and locusts therefore remain wonderful objects both for the small size of the original creatures and for the way in which they capture the insects' essence, amplified in stone. (Even their color is suggested through the choice of stone: black for the flea, red for the locust.) In other examples, such as portrayals of butterflies and spiders, the abstraction of forms leads to beings that bear little resemblance to the originals. They may have altered features or ones added that do not belong to that particular animal.

Among the body of works depicting fauna, representations of reptiles are paradigmatic. Serpents are undoubtedly the subjects portrayed most like the real creatures. Their heads, scales (whether carved or painted), and rattles are rendered in detail. The forked tongues project out of their mouths, which also display eyeteeth. All these elements, along with the body positions, whether coiled or alert, make the ophidians one of the most extraordinary groups within Mexica sculpture.

Similar qualities can be found in the marvelous vegetal sculptures, especially gourds and cacti, made with fine, colored stones that accentuate the liveliness of their forms. These sculptures demonstrate a savvy mixture of edges and curves, concave and convex areas, which gives form to the plants. The purity of their lines shows a determination to express the animated nature of plants. Once again, Mexica sculptures here display both the extraordinary sensitivity and complete confidence of their creators. Vegetal and animal sculptures represent vitality captured in stone, the intimate and indissoluble union between formal demands and symbolic aspirations. These works reflect the determination and confidence implicit in Mexica art.

Figure of a bat god from the Templo Mayor.

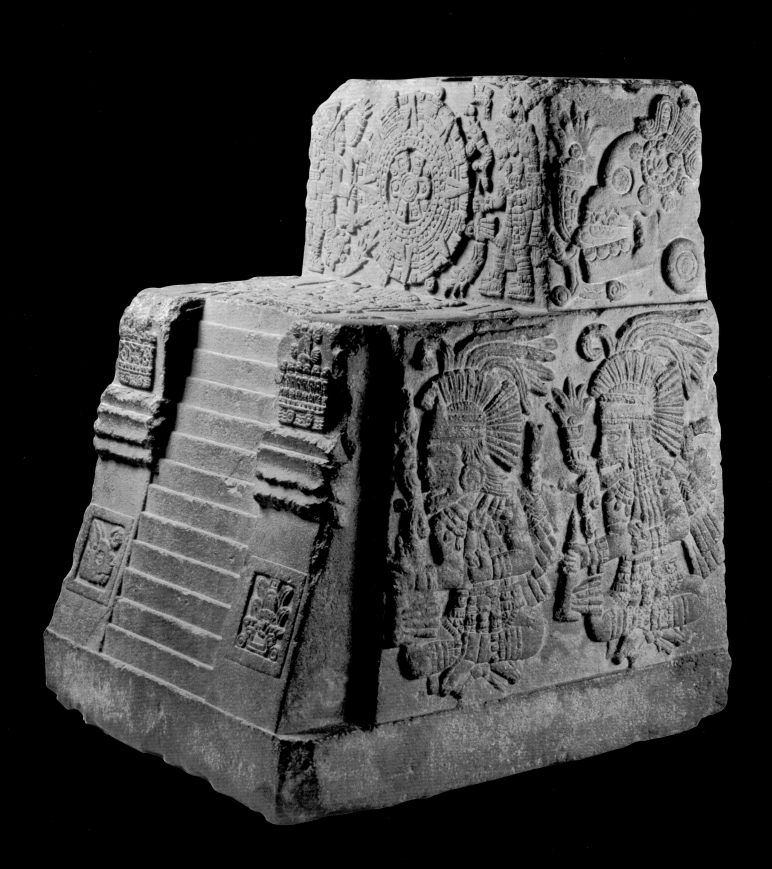

Teocalli of the Sacred War.

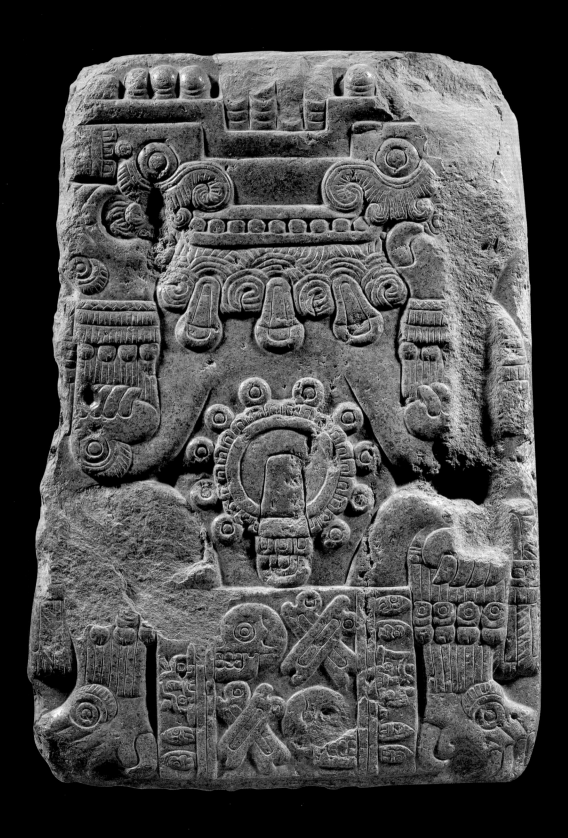

Tlatecuhtli.

Union of the Human and the Divine

There are many other examples of the same desire for expression. Reliefs with varied subject matter interweave mythical and historical matters and show divinities living side by side with humans. Relevant works are the Teocalli of the Sacred War, the Stone of Tizoc, and the Stone of Motecuhzoma.

The Teocalli of the Sacred War, replete with complex iconography, simulates the plinth of a pyramid with steps and symmetrical framing, and, at the top, an altar. On its sides, there are images of gods and people in the garb of gods as well as ritual instruments including arrows, shields, *xiuhcoatl*, *cuauhxicalli* (eagle vessels), and *zacatapayolli* (balls of dried grass used to gather sacrificial blood). On the back side is the emblem of Tenochtitlan, an image of Cihuacoatl as an eagle, emitting a war cry, on top of a nopal, as is described in Mexica literature. Scholars believe the monument commemorates the government of Motecuhzoma II, a dedication at Mexico's Templo Mayor, or a Binding of the Years or New Fire ceremony. It is also said that this object was Motecuhzoma II's throne.

Carved in relief, the Stones of Tizoc and Motecuhzoma are large cylinders conveying historical subjects. Based on conventional formal language, both celebrate their governments' conquests; their historical nature is indicated by the signs associated with various victories. The image of the sun appears on the upper, horizontal surfaces of both works, and we can see conventional figures of the rulers Tizoc or Motecuhzoma I, repeated numerous times, in the side reliefs. They are dressed as warriors and gods. The warlike attire, particularly the smoking mirror that is shown on the head or replacing a foot, identifies them with incarnations of Tezcatlipoca. The leaders hold various captives by their hair. Based on the accompanying glyphs, the captives can be recognized as symbolic images of vanquished cities.

Mexica visual arts reflect the lively confidence of their creators and of a conquering people. The will of the gods was limited by the vicissitudes of the people who glorified them. For this reason, it was not important to artists to personalize the deities they were representing; individuals and their gods only existed to the extent they were redeemed within the society that elevated them.

Mexica art is a victory cry. It is the dominant Ehecatl-Quetzalcoatl; it is Coyolxauhqui dismembered but not defeated; it is the defiant Coatlicue. It is the assured voice of a conquering people. This quality is what makes it so different from other artistic expressions of ancient Mexico.

There is no room for doubt in Mexica art; confidence is absolute. This can be seen in the precision of the locust, in the coiled serpent, in the impassive, distant standard bearer, and in the images of Tizoc and Motecuhzoma I. Overall, Mexica sculpture is an expression of power, of the certainty that this people will be defined forever as who they are now. Given that the art is neither personalized nor individualized, it established itself as the single voice of a community united for purposes of domination and to tell the truths of its existence.

To reach these objectives and strengthen an extraordinary artistic will, the Mexica turned to the fine modeling of stone, achieving textures of great eloquence, reinforced by lively colored and inlaid surfaces. The sculptural techniques demonstrate the great sensitivity and profound knowledge the Mexica achieved through the dialogue between head and heart, the *toltecayotl*, and through deepening themselves from within. Ranging from the most sincere verisimilitude to the most pronounced abstraction, the visual arts created by this community emphasize the culture's vigorous and expressive nucleus: the force of life itself.

Undoubtedly, beyond its forms, materials, and subjects, what is most impressive is the profound capacity for communication and deep feeling permeating all Mexica art, especially sculpture. To receive its message, we must put aside all Western prejudices that suggest that "beauty" must be the indispensable parameter for such communication. Mexica art speaks in its own language, which is simultaneously specific and universal. Its forms are self-referential, bounded, and compact, awaiting the detonator that will expose their most profound meanings. They strive to contain the emotions that are fully integrated within them. Moreover, the works do not interrupt the space or time that surrounds them; rather they freeze space and time for eternity.

In both form and content, this art manifests an enjoyment of life that required sacrifices to achieve fullness. The works express a fatal anxiety that could be controlled through the revelatory dialogue between god and human. They are works that reveal constrained feelings and beliefs, which are neither common to the world's greater cultural heritage nor foreign to humanity's evolution. They comprise a collective cry that, once emitted, dominates living beings and offers certainty to human existence. This dialogue is the product of deep reflection transformed into a formal and symbolic language and concentrated into refined works that still speak to us today. Half a millennium later, the dialogue still bears fruit, making us participants in an ancient vision of the cosmos and allowing Mexica art to remain vital and universal.

To Felipe Solís

Notes

1. Justino Fernández, *Estética del arte mexicano* (Mexico City: Universidad Nacional Autónoma de México, 1972), p. 9.

2. See Fernández, *Estética del arte mexicano.*

3. Ibid.

4. Cited in ibid., p. 45.

5. See Beatriz de la Fuente, "El arte prehispánico: Un siglo de historia," in *Memorias de la Academia Mexicana de la Historia correspondiente a la Real de Madrid* (Mexico City: Academia Mexicana de la Historia, 1999), pp. 79–100.

6. George Kubler, *Aesthetic Recognition of Ancient Amerindian Art* (New Haven: Yale University Press, 1991).

7. See ibid., pp. 95, 96; Beatriz de la Fuente, "La crítica y el arte prehispánico," in *Las humanidades en México, 1950–1975* (Mexico City: Universidad Nacional Autónoma de México, Consejo Técnico de Humanidades, 1978), pp. 93–101; and Beatriz de la Fuente, "El arte prehispánico visto por los europeos del siglo XIX," *Revista de la Universidad de México* (Mexico City) 29 (Dec. 1983), pp. 2–7.

8. See Paul Ricoeur, *Tiempo y narración,* vol. 3, *El tiempo narrado* (Mexico City: Siglo XXI, 1996), p. 840.

9. Mexica is the proper name for this people; the name Aztec, however, is in popular usage.

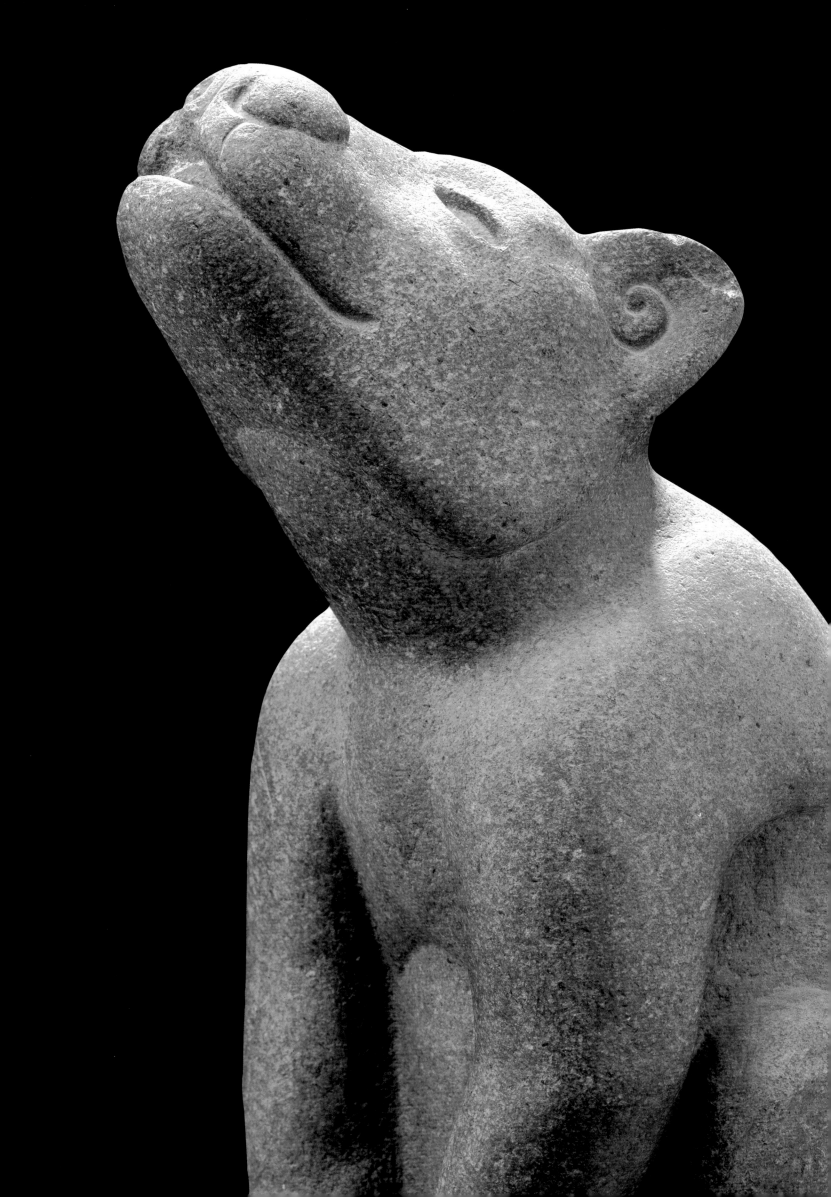

The Aztecs and
the Natural World

The Basin of Mexico as a Habitat for Pre-Hispanic Farmers

William T. Sanders

THE BASIN OF MEXICO IS A GREAT ELEVATED PLAIN SURROUNDED ON THREE SIDES BY A HIGH MOUNTAIN wall—on the east by the Sierra Nevada, on the west by the Sierra de las Cruces, and on the south by the Sierra Ajusco—and by a series of low, discontinuous ranges of hills to the north. The mountain wall reaches a maximum elevation of slightly below 6,000 meters at Ixtaccihuatl and Popocatepetl, two snowcapped volcanoes in the southeast. The three mountain ranges have numerous peaks with elevations in the 3,000 to 4,000 meter band, and the basin floor, in the center, has an elevation of 2,236 meters above sea level. The basin extends approximately 120 kilometers from north to south and 70 kilometers from east to west.

Before the construction of the Gran Canal, the basin was a closed hydrographic unit. Melt water from snowfields, springs, and runoff from the summer rains all flowed into hundreds of permanent and seasonal streams before draining into a chain of lakes at the center of the basin. The lakes nearly traverse the basin from north to south. Colonial documents refer sometimes to three lakes, at times as many as six (based on artificial divisions such as dikes), but during part of the year they formed a single sheet of water, located at varying elevations. To the north was Lake Xaltocan (or Lakes Xaltocan-Zumpango); at the center was Lake Tetzcoco (or Lakes Mexico-Tetzcoco); and to the south was Lake Xochimilco (or Lakes Chalco-Xochimilco).

Lake Xochimilco was located 3 meters higher than Lake Tetzcoco and drained into it. Because of this outlet, which apparently functioned all year, and the presence of numerous springs along the southern shore, the water was fresh and covered by floating vegetation ("so thick one could walk on it"[1]). Lake Tetzcoco, the lowest lake, was extremely saline and the ultimate destination of all drainage. Lake Xaltocan drained into it only seasonally and was therefore more saline than Lake Xochimilco, except for small areas near local springs. In the nineteenth century, the lakes covered an average area of approximately 1,000 square kilometers, or one-eighth of the surface of the basin. The average contour of the shore of Lake Tetzcoco was 2,240 meters above sea level, although this varied from season to season and year to year. The lakes were shallow, between 1 to 3 meters in depth. During the dry season, they frequently shrank in surface area so that canoe traffic from lake to lake was interrupted for short periods.

Rainfall is sharply seasonal in the basin and is concentrated in the months from June through September. Rains usually begin in May and decrease sharply in October, with approximately five-sixths of the total annual rainfall occurring between May 1 and October 1. The inception and closure of the rainy season vary considerably from area to area and year to year, however. Hailstorms are common during the rainy season, but a snowfall would be an extraordinary event. Drainage from rainfall is vigorous and destructive, and the seasonal streams have cut canyonlike beds, called *barrancas*, throughout the basin.

Mean annual rainfall varies from south to north and from basin floor to adjacent slopes. Rainfall in the northern part of the basin floor ranges from 500 to 600 millimeters per year, and at the center from 650 to 750 millimeters; in the south,

averages as high as 1,100 millimeters are recorded. Rainfall for the adjacent slopes, particularly on the middle flanks of the major ranges, is markedly heavier than that on the plain, but there is little data for these areas. Averages of around 1,400 millimeters have been recorded for the slopes in the southeast. Internal droughts are common in the north and central parts of the basin during the rainy season, but no recent cases of complete failure of the rainy season as a whole are known.

Considering only mean annual rainfall, the southern part of the basin is the most favorable part for maize cultivation without irrigation. In the central and northern parts of the basin, even where soils are deep and loamy in texture, maize cultivation without irrigation is possible but crop security is low and production varies considerably from year to year. Yields are generally significantly improved (in many areas doubled) by irrigation. All over the basin, irrigation is absolutely necessary for effective maize agriculture where soils are 1 meter or less deep, since the high elevation corresponds with a higher rate of transvaporation.

The modern peasant population of the basin resides within a contour strip ranging from 2,240 to 2,800 meters above sea level. There is no permanent population of subsistence farmers above 2,800 meters, and those communities that lie between 2,600 and 2,800 meters have an economy based partly on grazing and lumbering. The primary factor that limits the upward expansion of agriculture seems to be the temperature regime. Maize, the staple crop, is especially susceptible to frost damage, notably during the early phase of its growth. (The same is true of nearly all of the secondary pre-Hispanic cultivates as well.) At elevations below 2,800 meters, frosts normally begin in October and last until the beginning of March. The inception and cessation dates of the frost season, however, vary as much as the rains do. In occasional years, frosts begin as early as September or as late as December and may last through March or even April. Below 2,600 meters, local elevations seem to offer more favorable conditions for agriculture than the plains proper, since frosts tend to settle in the lower areas. Above 2,800 meters, the normal frost-free season is too short for dependable maize cropping. Particularly disastrous for agriculture based only on rainfall is a combination of a late inception of the rainy season and an early frost season, since crop planting must be delayed, causing plant growth to be retarded so that the early frosts cause heavy damage. Of course, too early a planting is risky as well.

Most soil maps classify the soils of the basin into a major soil grouping called "soils of calcification." Generally, they have great natural fertility. The overall impression is that local differences in soil types between 2,240 and 2,800 meters bear little relation to agricultural productivity. Much more important are variations in soil depth and texture, because these soil characteristics are those most closely related to the problem of water conservation. Soil depth, which varies considerably throughout the basin, has a striking effect on agricultural production, particularly in the drier center and north. The least productive part of the basin is undoubtedly the north, where the mean annual rainfall is lower than in the center or the south. Maize cultivation is exceedingly precarious in this area.

With respect to soil texture, loamy, friable, loose-textured soils are the most common throughout the basin and are ideal for primitive agriculture. They are, however, extremely susceptible to erosion. Sandy and clay-textured soils do occur in localized areas, the former in eroded slopes where the finer soil particles have been washed out, the latter especially near the lakeshore and alongside streams. Above 2,600 to 2,800 meters, podzol soils—which form under colder, more moist climates with conifer forest vegetation and tend to be more acid and heavily leached of nutrients—predominate. These are notoriously poor soils for agriculture and are a further factor limiting the upward expansion of agriculture in the region.

It is difficult to reconstruct the natural vegetation of the basin, since at least 4,000 years of agricultural exploitation have completely removed it from the belt of peasant occupation. Small areas of relatively unaltered vegetation suggest that there was probably a gradual shift from broadleaf forest in the south to xerophytic or scrub forest in the north. Between 2,600 and 4,500 meters, conifer forest is the dominant vegetation; above that are strips of alpine meadow or tundra and finally, in the southeast, snowfields.

A brief survey of the geography of the Basin of Mexico reveals a number of significant factors with respect to its utilization during the pre-Hispanic period by a farming population equipped with neolithic tools and simple transportation methods and having a cereal (maize) as a staple food:

1. Between 2,240 and 2,600 meters, the permanent removal of natural vegetation presented no serious obstacle to the Mesoamerican farmer, even with his primitive technology (in contrast to the tropical lowlands of Mesoamerica). Furthermore, the soils were easily cultivated using neolithic tools and were generally fertile and capable of sustained cultivation with modest application of simple soil-restoration techniques (such as animal and vegetable fertilizers, crop rotation, short-phase fallowing, intercropping, floodwater and permanent irrigation, and terracing). There was, however, a high percentage of sloping terrain, where soils were markedly susceptible to erosion, and constant effort was required to control this destructive process.

2. Without irrigation, the rainfall-temperature regime was favorable to maize cultivation only in the south. In the central and northern parts of the basin, the combination of early frosts and retarded rains, plus internal droughts, made maize cropping difficult and crop loss frequent.

3. In a number of areas, springs were available for permanent irrigation, and the numerous *barrancas* could be used for

floodwater irrigation. Such systems required intensive land use, heavy expenditure of labor, and suprafamily, often supracommunity, cooperation to maintain, construct, and operate. Since the summer rains generally provided adequate moisture in areas with moderately deep to deep soils, the primary need was for a preplanting irrigation that enabled the farmer to get a head start on the rainy season, giving the plant more time for growth before the arrival of the fall frosts.

4. The lakes were an enormously significant resource for a population with few domestic animals and no beasts of burden. Most of the major population centers were located near the shores or within the lakes in 1519, and the lakes provided a natural highway system linking all parts of the basin. The lakes were also an important source of protein foods and of other products, especially salt. Furthermore, the freshwater Lake Xochimilco was nearly covered by artificial islandlike gardens called chinampas, which were the most intensively cultivated and productive lands in Mesoamerica and provided much of the surplus foods for the support of urban communities.

5. Above 2,600 to 2,800 meters, the pre-Hispanic population had an easily available source of forest products for construction, household technology, transportation, and medicine.

6. The considerable variability in geographical characteristics within the basin—in the amount and distribution of rainfall, vegetation, topography, soil depth, water resources, elevation, and spatial position with respect to mountain passes and lakeshores—along with the distribution of specialized resources (salt, clay, obsidian, lumber, limestone, and so on) stimulated local specialization and trade.

As a habitat for the development of a highly productive agricultural system, the Basin of Mexico offered enormous potential, but it also presented serious problems for dependable year-after-year production, particularly of annual grain crops, due to variations in rainfall and temperature. The major solution to this problem was irrigation from a permanent water source.

With respect to permanent spring-based irrigation systems, we have detailed data on two: the San Juan Teotihuacan and Tetzcoco Piedmont (Amanalco) systems. The Teotihuacan springs system is apparently dying, according to data showing that the output of water has steadily declined over the past fifty years. In the 1920s, the flow of water at the springs was estimated to be 1,000 liters per second.[2] In 1956, at which time the springs were used to irrigate 3,652 hectares of land, the springs had a flow of 580 liters per second.[3] In the early 1960s, the flow of water was estimated at only 540 liters per second.[4] Finally, a 1968 publication by the Secretaría de Recursos Hidráulicos showed that the output had dropped to below 400 liters per second.[5] (Current data also show greater month-to-month variability than previously.)

The major cause of the declining output of the Teotihuacan springs over this period was the perforation of artesian wells, both within the Valley of Teotihuacan and in the bed of Lake Tetzcoco. Furthermore, between 1521 and 1820 enormous amounts of land eroded in the valley as a result of the abandonment of agricultural lands on the piedmont (due to population decline from disease) and their subsequent conversion to grazing lands. What effect this erosion had on spring flow is unknown, but there may have been even more water in the system in 1519 than in 1920.

What was the agricultural significance of the two systems in 1519? On the basis of patterns of land use in the Valley of Teotihuacan today (where land is devoted either to maize or to a humidity-demanding commercial crop like alfalfa), one could argue that 100 percent of the irrigable land was devoted to maize production. One could also assume that 80 percent of caloric intake was derived from maize, and that, based on the size and weight of the pre-Hispanic Mesoamerican, the average per capita daily need was 2,000 kilocalories. Taking the average yields from permanently irrigated land for the Aztec period (1,400 kilograms per hectare for the alluvial plain and 1,000 kilograms per hectare for the piedmont areas) and assuming that the permanent water resources were maximized and that all the land was planted in basic grains, then the permanently irrigated land of the two systems (9,700 hectares) would have sustained a maximum population of 116,000 people.

However, even though springs are very abundant in the Basin of Mexico, they are highly localized and restricted in distribution, limiting the successful implementation of spring-based irrigation over much of the surface area. According to the 1968 publication by the Secretaría de Recursos Hidráulicos cited previously, the total flow of water in Zones I to XI in 1962 was 6,193 liters per second. Zones X and XI lie outside the natural drainage region of the Basin of Mexico and are not discussed here. Zone I is the southwest and south-central shore areas of Lake Xochimilco. Approximately one-third of the total basin spring flow, or 2,684 liters per second, occurred in this area, and because of this extensive flow, as well as the higher rainfall in the southern area of the basin and the higher elevation of the lake floor, almost 100 percent of the water of Lake Xochimilco was fresh. Furthermore, an additional 837 liters per second flowed into the southeast lakeshore, in Zone VIII, bringing the total flow of water in this part of the Basin of Mexico to almost 50 percent of the total spring flow of the basin. With respect to the potential of these water resources for permanent irrigation, unfortunately the Sierra Ajusco almost reaches the lakeshore in the southwest and south-central portions, leaving only small areas of alluvial plain for irrigation. Furthermore, the majority of the spring flow, including the major spring source at Tulyahualco, runs directly into the lake (because much of the flow occurs at the base of the Sierra Ajusco, well below the piedmont). In contrast, an extensive alluvial plain occurs along the southeast shore of Lake Xochimilco, and the spring flow in

Following pages: Alonso de Santa Cruz, Map of Mexico City, 1550s. Adela Breton (facsimilar).

that area would have been available for large-scale irrigation of the plain and nearby piedmont.

Zones II and III (the areas west and north of Lake Tetzcoco) are unusually well endowed with spring sources, with a total flow of 1,142 liters per second in 1962. In this area are six major perennial streams that collect water from these springs. In addition, there are extensive areas of alluvial plain adjacent to the lakeshore. Approximately 25 percent of the surface of the region could have been irrigated from spring sources—that is, virtually all of the lakeshore and riverine alluvium, plus large areas of terraced fields on hillsides.

Zone IV, the Cuauhtitlan region, is also well endowed with springs, with a flow of approximately 899 liters per second in 1962, and with extensive irrigable alluvial plains. Zone V, in the northeastern portion of the basin, had virtually no spring flow in 1962 (19 liters per second); furthermore, it is an area with shallow soils, even in the alluvial plain. Zones VI and VII, the Valley of Teotihuacan and the adjacent Tetzcoco region, had a total flow of 572 liters per second in 1962. The capacity for the development of a large-scale irrigation system in this area was evaluated above, in the discussion of the Teotihuacan and Tetzcoco springs.

If we assume that the decline in water flow observed in the Teotihuacan and Tetzcoco springs during the twentieth century occurred throughout the Basin of Mexico, these 1962 totals could be at least doubled, or more likely increased by a factor of two and a half, to estimate total water flow during the Aztec period. This gives us a figure of 12,000 to 15,000 liters per second. Of this, approximately 60 percent—or 7,200 to 9,000 liters per second—flowed into areas of high agricultural potential. Utilizing the ratio of liters per second to irrigable land observed in the Valley of Teotihuacan, we can calculate the irrigable area—for permanent, spring-based irrigation—for all the zones of the basin during the Aztec period as approximately 42,000 to 52,000 hectares.

Another technique of moisture maintenance for maize production existed during the Aztec period: floodwater irrigation. In this system, the water supply derived directly from rainfall is supplemented during the rainy season by water from canals fed by the numerous barrancas in the basin. At the end of the growing season, fields are flooded to store water in the subsoil for the spring planting. This is often combined with a special technique of planting called cajete, in which shallow pits are excavated down to the subsoil during the planting season, and the seeds are planted in this humid soil. The pits are then partially filled with dry soil to seal off the moisture.

With respect to floodwater irrigation, it is difficult to assess the maximal capacity of this resource. In a 1963 publication by the Instituto Mexicano de Recursos Naturales Renovables, the average total annual precipitation for the Basin of Mexico was calculated at 6,717,000,000 cubic meters.[6] Of this, 4,704,000,000 cubic meters filtrated into the soil (of which 133,000,000 cubic meters flowed to the surface in the form of springs) and

343,000,000 cubic meters flowed through the barranca-river systems. However, these figures refer to the present-day drainage basin, a combination of artificial and natural drainage systems that drain an area of 9,600 square kilometers. We have roughly calculated the surface drainage of our smaller region at 70 percent of the latter figure, or 240,100,000 cubic meters. (In fact, it would be a little higher, since the areas that were included in the institute's study but are excluded from ours, such as the Apan Basin, have an average annual precipitation that is comparable to the drier regions of the basin.) Since irrigation water is used for very different purposes, dependent on the season, we must break this total figure down by season. The ratio of rainfall in the Basin of Mexico according to season, beginning with winter and ending with fall, is approximately 1:4:10:5. This means that approximately 12,000,000 cubic meters flows during the winter, 48,000,000 cubic meters during the spring, 120,000,000 cubic meters during the summer, and 60,000,000 cubic meters during the fall.

The winter flow would have limited use for agriculture. The spring flow could theoretically be used for the same purpose as permanent irrigation—that is, for preplanting (with the difference that the local variability, year to year, would be very high). Taking the average measure of 1,200 cubic meters of water per irrigation per hectare of land, theoretically the spring flow in the basin could be used to irrigate 40,000 hectares of land. Summer irrigation is used primarily as a supplement, and the flow for this function could be used to provide water for 100,000 hectares. During the fall, contemporary farmers use floodwater not so much for the standing crop, but as a technique of water storage for the spring planting. We estimate that 50,000 hectares of land could theoretically be irrigated for this purpose. What the data suggest, then, is that approximately 40,000 hectares of land could be provided with water for a preplanting irrigation in the spring, and that the same land could be given two to three irrigations during the summer growing season to supplement the rains and an additional irrigation in the fall for water storage in the subsoil for the following year. In fact, the figures for preplanting irrigation would be somewhat lower than this, since some of the rainfall during the spring season would fall at widely spaced intervals, and in such small amounts, that there would not be enough buildup of water behind dams to allow simple gravity irrigation. Furthermore, much of the rain falls in areas where irrigation is unnecessary or where topographic situations would have made irrigation unfeasible with pre-Hispanic technology.

The conditions described for the Basin of Mexico pertain to most of the entire Central Plateau, where approximately three million people resided in 1519. Ecologically, the Basin of Mexico was a unique region within the Central Plateau, however, because of the presence of lakes. The lake system enormously enhanced the potential of supplying major urban concentrations with basic goods. The Spaniards were astonished at the scale of canoe transportation in and around the city of

Map of the Valley of Mexico.

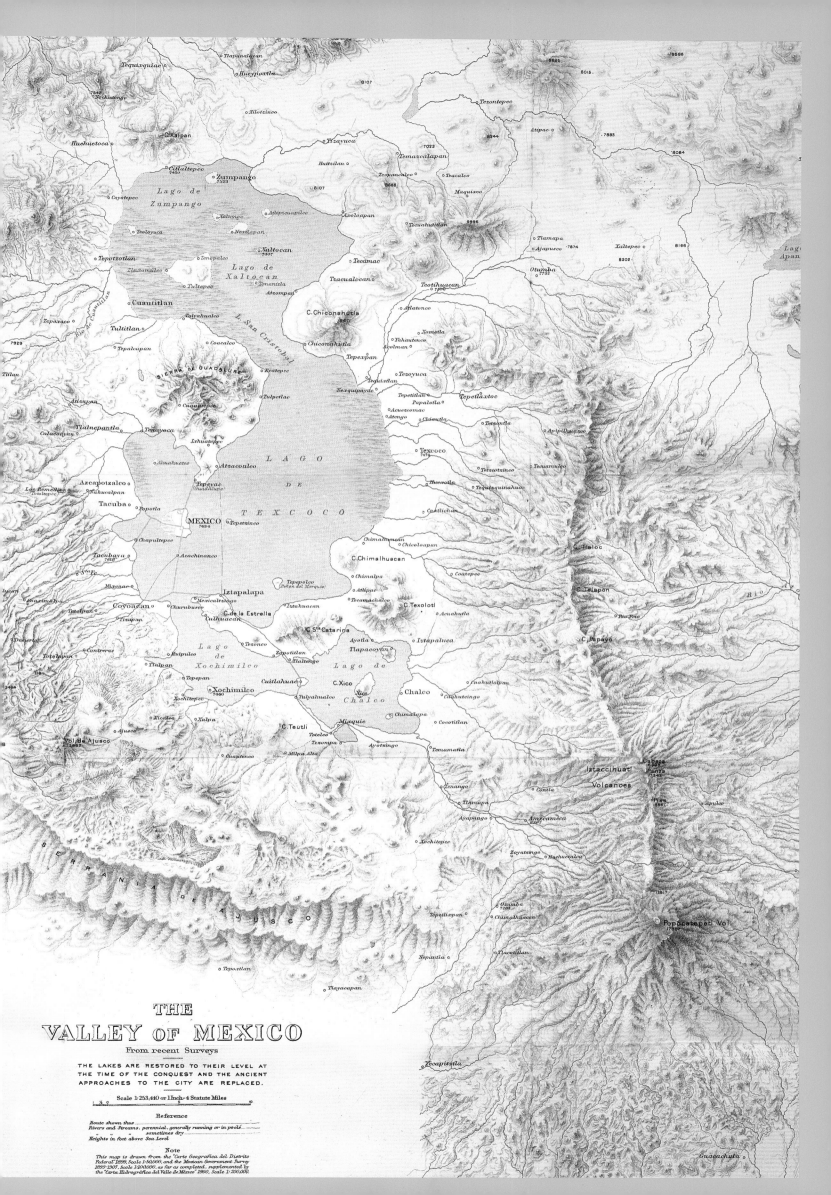

THE
VALLEY of MEXICO

From recent Surveys

THE LAKES ARE RESTORED TO THEIR LEVEL AT
THE TIME OF THE CONQUEST AND THE ANCIENT
APPROACHES TO THE CITY ARE REPLACED.

Scale 1/253,440 or 1 Inch = 4 Statute Miles

Reference

Route shown thus
Rivers and Streams, perennial, generally running or in pools
 sometimes dry
Heights in feet above Sea Level

Note

This map is drawn from the "Carte Geografica del Distrito
Federal" 1899, Scale 1/50,000, and the Mexican Government Survey
1899-1907, Scale 1/100,000, as far as completed, supplemented by
the "Carta Hidrográfica del Valle de México" 1900, Scale 1/200,000.

Tenochtitlan in 1519. In an economy without domestic animals of traction, all goods had to be carried on the human back. Canoe transportation magnified a single burden bearer's capacity to haul goods by a factor of twenty. The lakes also provided an abundance of natural protein-rich foods to supplement the maize diet. These included algae, fish, amphibians, ducks, and insect eggs and larvae, and these were all consumed by the native population. In addition, the colonization of the lakes for agriculture, through the development of a drained-field system, supported both the dense farming population and the large urban population. In its broadest and simplest sense, the term "drained-field system" refers to a technique by which low-lying, poorly drained areas are converted to productive farmland by the large-scale construction of a grid of ditches to lower the water table. The final two hundred years of pre-Hispanic history witnessed the extraordinary application of the principle of drained-field agriculture to the chain of lakes of the Basin of Mexico. The Aztecs referred to the cultivation plots within the lakes as chinampas (enclosures), because the edges were protected by placing closely spaced wooden stakes, embedded into the lake bottom, around each plot. Furthermore, the borders of the chinampas were planted with huejote trees to help consolidate the soil edge, again adding to the impression of an enclosure.

A great deal of misunderstanding and inaccurate description has characterized the literature on chinampa agriculture.[7] Some of the Spanish accounts describe chinampas as floating gardens—that is, as rafts of soil that could be paddled around the lakeshore and into the city so that produce could be sold directly from the field to the marketplace. What everybody agrees upon is that a chinampa was a relatively small and narrow plot of land, located within a lake and surrounded by water, and that the soil was exceptionally fertile. This combination of soil fertility and nearby water resources permitted an unusual productivity. Large areas of the lake bed were converted to grids of abundant, densely concentrated plots of lands separated by narrow canals.

How the chinampas were made has always been an interesting question. In 1912, a Spanish agronomer, Miguel Santamaria, was contracted by the Mexican government to study the chinampas south of Mexico City. The primary objective of this study was to analyze the productivity and future of these lands as a major resource for the production of food for the expanding city. Based on local informants' recollections (there is no evidence that he actually witnessed the process), Santamaria described the conversion of the lake bed to agricultural land as follows:

> To start the manufacture of a chinampa, the first step is to look for a cimiento [literally, a basement]. This operation is very easy and consists of sounding the bottom of the canal with an oar [paddle] until a point of lesser depth is located. Then with the same paddle they find the limits of this cimiento, marking its perimeter with carrizos [long stakes].
>
> Above this cimiento, they place stratas of earth and césped [aquatic vegetation] until they raise it above water level.
>
> The césped grows in the so-called ciénagas [shallow swampy sections of the lake], which occupy large areas, and consists of a mass of aquatic plants, especially the lirio [lily—Hitckoria coerules], which grows in such compact masses that one can easily walk on them without sinking.
>
> To use this césped, they cut it with shovels or cogs.
>
> The earth used in making the chinampa is taken from ancient chinampas that . . . have grown so high above the water that they are difficult to cultivate [i.e., to irrigate; the growth of the chinampa is due to the practice of adding mud and aquatic vegetation periodically to fertilize it].
>
> Once the chinampa being made has reached a height of 20–25 centimeters above water level, they plant cuttings of sauce or huejote [a type of willow that grows to considerable height but does not cast much shade as its branches grow almost vertically] around the edges, in order to consolidate the soil [i.e., prevent erosion]. The cuttings are planted at intervals of 4–5 meters.
>
> Once the sauces are planted, the chinampa is ready for cultivation.[8]

Santamaria's description suggests a major difference between chinampas and drained fields in general, in that chinampas were artificial lands entirely created by human effort.

On the basis of eye-witness accounts dating from the time of the Conquest, and most particularly from the abundant data gathered during the early colonial era (including that contained in the Relaciones geográficas, the response by local officials to a questionnaire sent to the Spanish colonies by Philip II of Spain in 1580), it is clear that virtually all of Lake Xochimilco had been converted to chinampa agriculture by 1519. The cultivators lived primarily in communities on the lakeshore, but also on natural and artificial islands within the lake, as well as on the chinampa plots themselves.

In the mid-1960s, Pedro Armillas conducted extensive surveys over the desiccated beds of Lake Xochimilco. The results were startling and exciting. Over most of the area, indications of chinampas occurred in the form of patterns of linear features visible in aerial photographs. In a number of areas, however, particularly north and east of Xochimilco, in an area that had not suffered destruction from plowing, he found surviving remains of actual chinampa fields and intervening canals in a grid pattern. Armillas published a map detailing his findings in 1971. He estimated the total area occupied by Lake Xochimilco in 1519 at 15,000 hectares. In his surface survey, Armillas noted a number

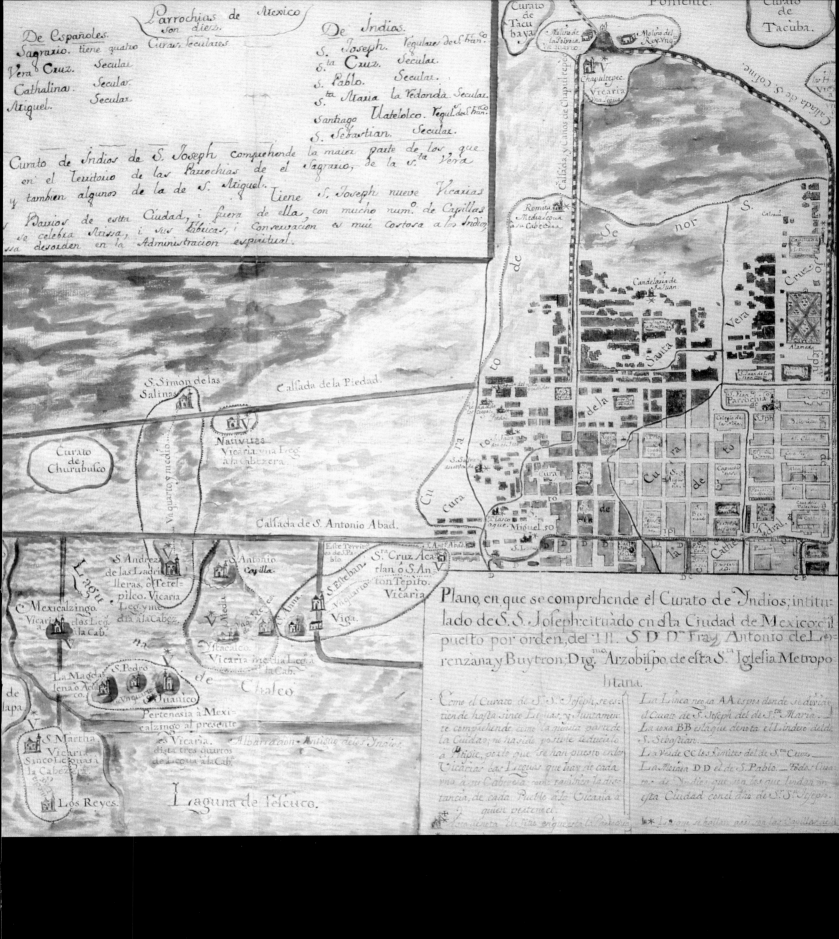

Map of Mexico City, 1768.

Following pages: José María Velasco, *The Valley of Mexico*, 1875.

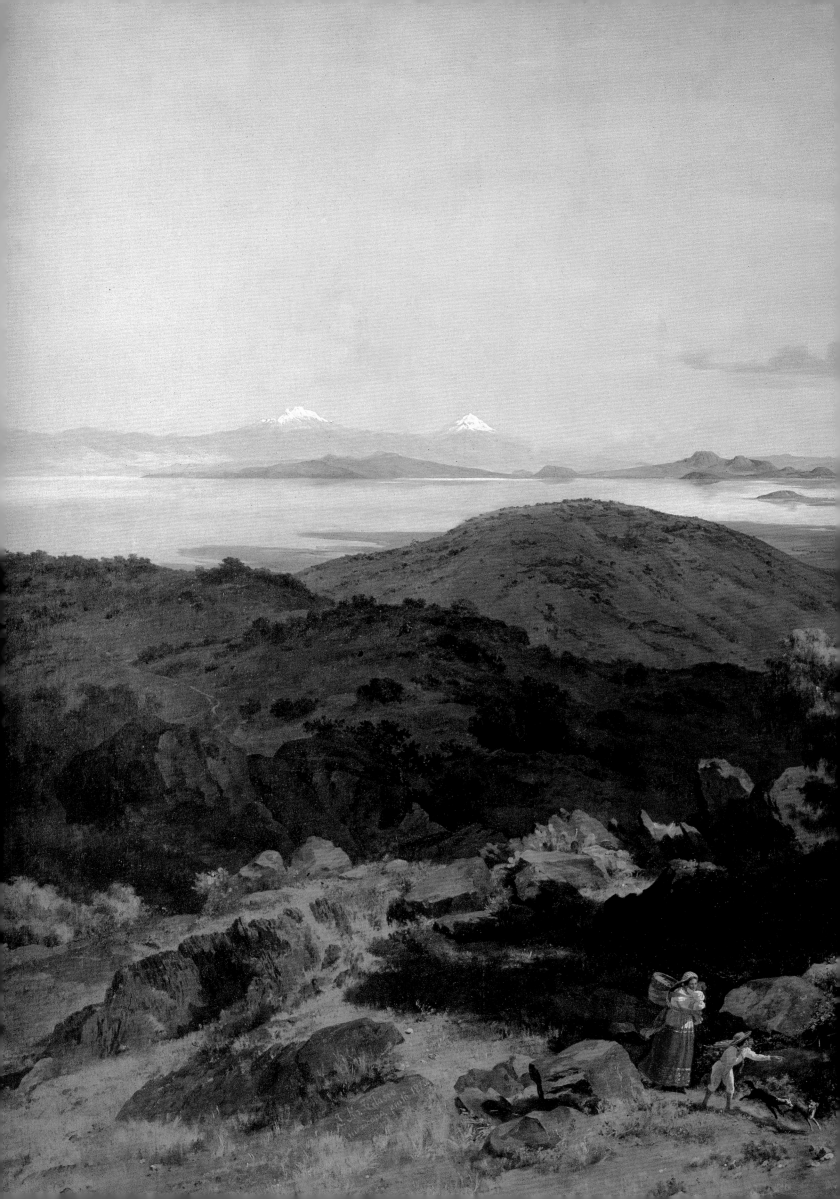

of small areas within the lake bed as well as a relatively large area north of the island of Xico where he found no evidence of *chinampa* agriculture; from this, he estimated the actual area occupied by *chinampas* as 12,000 hectares, of which 9,000 hectares was cultivable land and the rest intervening canals and large navigation canals.

One of the most spectacular aspects of *chinampa* agriculture during the pre-Hispanic period, and apparently occurring primarily in the fifteenth century, was the expansion of this type of agriculture into the western third of saline Lake Tetzcoco (that part of the lake referred to as Lake Mexico). A major question is how much of the surface of the western bay of Lake Tetzcoco was occupied by *chinampas* in 1519. We know from documentary data that the towns of Coyoacan, Huitzilopochco, Mexicaltzingo, and Ixtapalapan all had extensive areas of *chinampas* dedicated to garden cropping. With respect to the balance of the area, Luis Gonzalo Aparicio's 1973 map locates twenty island communities whose economy was apparently dependent on *chinampa* and/or salt production. Half of these were found south of Tenochtitlan, and considering the additional presence of the four lakeshore communities noted above, it is virtually certain that this entire area had been converted to *chinampa* farming by 1519. The total area occupied by *chinampas* in Lake Tetzcoco was probably in the neighborhood of 3,000 hectares, or 2,250 hectares of cultivable surface.

The total cultivable surface for *chinampa* agriculture in the basin, then, was approximately 11,000 hectares. Of this, we would calculate that approximately 3,000 to 4,000 hectares (that is, all of the *chinampas* in Lake Tetzcoco plus some of the *chinampas* in Lake Xochimilco) were dedicated to garden cropping and the balance to the production of staple crops. The approximately 7,500 to 8,500 hectares of remaining garden surface would have produced 22,500 to 25,500 tons of maize and/or grain amaranth, based on yields for the twentieth century (3,000 to 4,000 kilograms per hectare). Some 32,000 people resided in the southern lake area in 1568, and this calculates to 65,000 in 1519. If all of the residents in this area obtained their maize only from the *chinampas* (this is unlikely, since many of them had other lands on the lakeshore), they would have consumed 10,400 tons of maize, leaving a surplus of 15,500 tons. This surplus would have fed an additional 100,000 people—presumably many of the residents of the urban communities within and around the shore of Lake Tetzcoco.

The processes and mechanisms by which 20,000 hectares of lake were converted into perhaps the most productive agricultural land in human history—certainly in the history of Mesoamerica—remain a major avenue for research. The ethnohistorian Angel Palerm dedicated much of his professional life to this subject. His findings suggest the extraordinary skill and capacity of the pre-Hispanic population of the Basin of Mexico to mobilize labor. The solution to the problem of protecting garden lands from periodic floods and salinization was the construction of a vast system of dikes, particularly in Lake Tetzcoco, where salinization was a serious threat, but also in the southern lakes, where the gardens were vulnerable to flooding. A remarkably complex system of water control—an impressive example of public-work construction—was in place in 1519. Palerm estimated that the total length of the system was approximately 80 kilometers. The causeways projected approximately 1 to 1.5 meters above the lake level, so the total height of the *chinampas* was somewhere between 2 and 4.5 meters. The width of each plot ranged from 8 to 20 meters.

In summary, the management of the lacustrine environment of the Basin of Mexico was one of the most impressive achievements of ecological adaptation in human history. Because of the great variety in temperature, precipitation, and water availability, the Central Plateau area was an extremely complex natural environment, and this complexity had dramatic effects on land use and cultural evolution. There was also a geological complexity, which had a major impact on the availability of natural resources other than agricultural land. Obsidian, for example, was found only in northeastern Puebla and the northeastern parts of the Basin of Mexico. Salt was found along the shores of the saline lakes, limestone in the northwestern part of the basin and adjacent areas in the state of Hidalgo, and wood only at the highest elevations (particularly during the Aztec period, when the population was very dense). Clay for ceramics was found in a great number of areas but was highly localized in its specific distribution. Finally, at the lower elevations, frost-intolerant crops—including tropical fruits and even cacao, cotton for cloth, and bark from the fig tree for paper—were found. These variations led to a complex development of local specialization and exchange networks, and these elements in turn had a profound effect on political evolution and urbanization.

Notes
1. Miguel Santamaria, *Las chinampas del distrito federal* (Mexico City: Secretaría de Fomento, 1912), p. 25.
2. Manuel Gamio, *La población del Valle de Teotihuacan*, 3 vols. (Mexico City: Secretaría de Agricultura y Fomento, 1922).
3. William T. Sanders, "The Central Mexican Symbiotic Region," in G. R. Wiley, ed., *Prehistoric Settlement Patterns in the New World* (New York: Wenner-Gren Foundation for Anthropological Research, 1956), pp. 115–27.
4. Rene Millon, C. Hall, and M. Diaz, "Conflict in the Modern Teotihuacan Irrigation System," *Comparative Studies in Society and History* 4, no. 4 (1962), pp. 394–521.
5. *Boletin hidrologico resumen* (Comisión Hidrologica de la Cuenca del Valle de México, Secretaría de Recursos Hidráulicos), no. 1 (1968).
6. *Mesas redondas sobre problemas del Valle de México* (Mexico City: Instituto Mexicano de Recursos Naturales Renovables, 1963).
7. R. C. West and Pedro Armillas, "Las chinampas de México," *Cuadernos americanos* 50 (1950), pp. 165–92.
8. Santamaria, *Las chinampas del distrito federal* (trans. author).

The Harmony between People and Animals in the Aztec World

Mercedes de la Garza

FOR INDIGENOUS MESOAMERICANS, THE EXPERIENCE AND CONSCIOUSNESS OF THE ANIMAL world were very different from that of the modern Western city dweller. The city dweller has lost the one link with the surrounding world that could be most enriching: the capacity for wonder, admiration, and reverence for the natural world. The indigenous person, by contrast, thought about him- or herself as being closely linked to animals, plants, rocks, and even objects created by people, to which were attributed a spirit and will similar to that of humans.

For the indigenous person, the natural world was not something to be manipulated, exploited, and destroyed by humans at their pleasure, as it has been for Western culture. Rather it was a sphere populated by supernatural powers and forces with which people had to forge ties, necessary for the survival of humankind and for the conservation of nature, and as the context in which sacred beings manifested themselves.

Thus the consciousness of that sphere alien to humans was a religious experience. For the Aztecs, animals embodied divine energy because they possessed vital forces and physical powers beyond that of humans, such as flying, having claws, and surviving underwater. In particular, some animals were considered to be extraordinary beings that revealed the sacrosanct. They therefore became symbols of natural bodies and elements (such as stars and rain) and of the levels of the universe in which divine forces materialized.

To name several examples, the rabbit represented the moon and, therefore, female fertility, as in various other cultures. Among the animals linked with water were the frog, fish, and snail, which also symbolized fecundity. A mythological aquatic animal known as the *ahuitzotl* had characteristics of the otter, monkey, and possum, as well as a hand on the tip of its tail, which it could use to drown people. Lizards and crocodiles were symbols of the cosmos's terrestrial level. Associated with the underworld were nocturnal animals such as the owl, believed to be the messenger of the god of death, Mictlantecuhtli. Insects such as the cricket, centipede, and spider were allied with the earth god, Tlaltecuhtli, and with evil shamans who sent disease and death. The indigenous writer Hernando Alvarado Tezozomoc wrote that the shaman Malinalxochitl "makes people eat snakes . . . and owls, then calls out all the centipedes and spiders and turns into a witch. . . . [She is] a terrible rogue."

Animals were associated with temporality, as guardians of the lapses of time. An animal alter ego was assigned to every person, together with the sacred influences that acted upon him or her, based on the day of birth according to the ritual calendar. This alter ego shared that person's fate and harbored a part of his or her spirit until death. Some people who had several of the most powerful animal companions, such as the jaguar, puma, and the coyote, were able to transform themselves into those animals at will when in a state of sleep or ecstatic trance. These people were the sorcerers or shamans.

3. Eagle
Aztec, ca. 1500

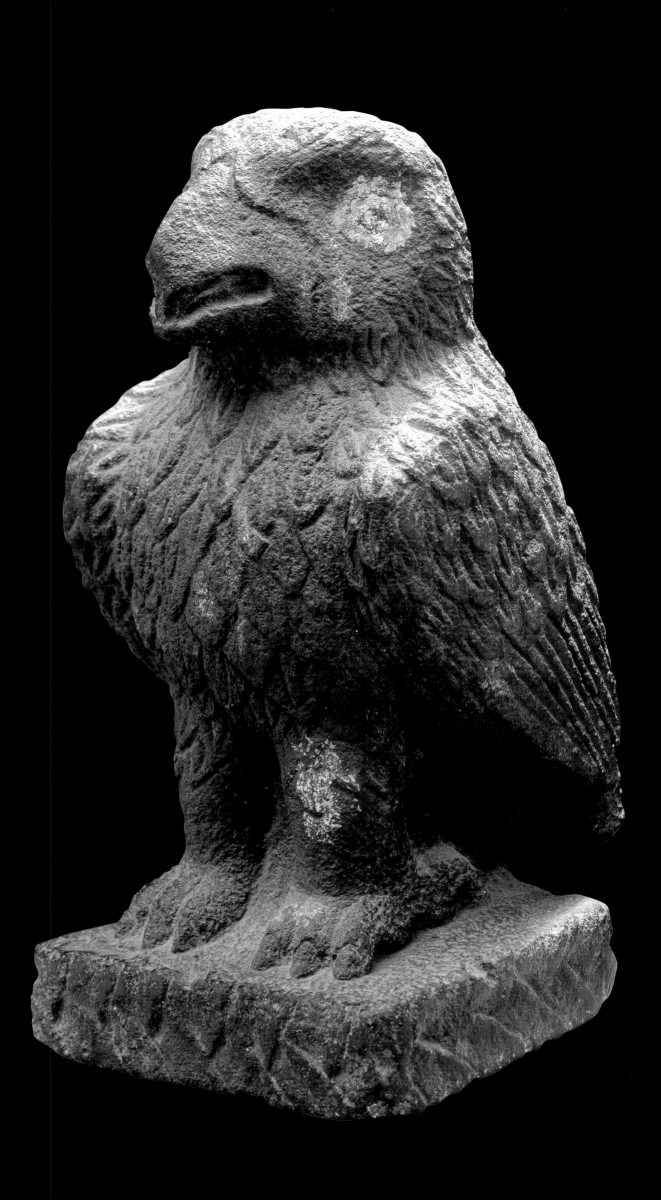

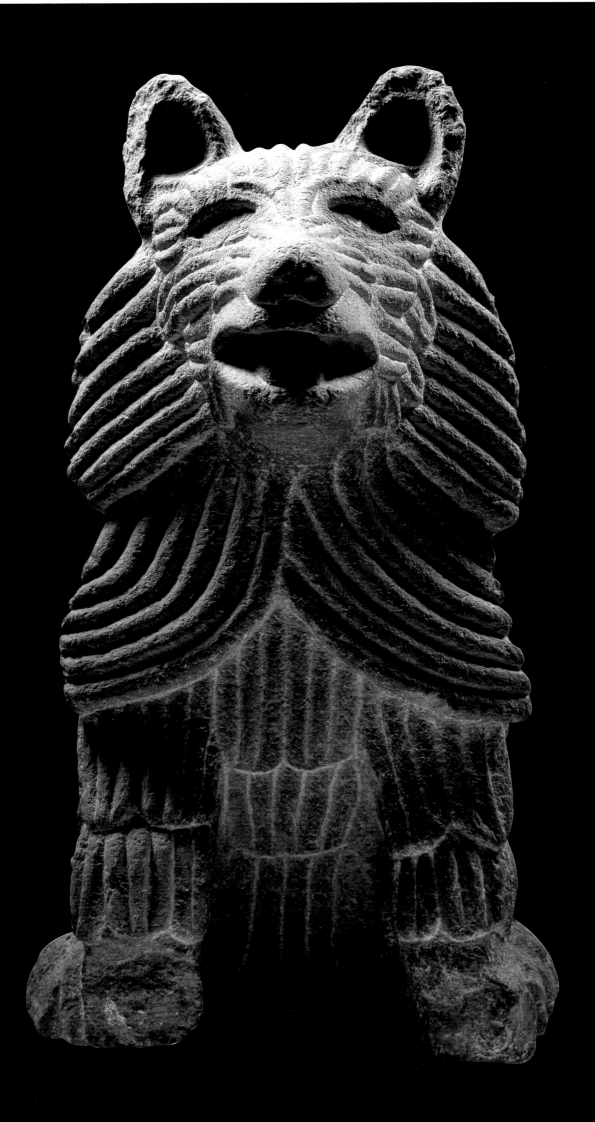

4. Coyote
Aztec, ca. 1500

Among indigenous groups there were also domestic animals, cared for by the women. Ritual foods were cooked from the meat of some of these creatures, such as the turkey, dog, and deer. Others were raised to be sold or eaten, and some were kept as pets, for example, songbirds. Macaws, parrots, and monkeys, which were brought from jungles in the southeast of Mesoamerica, also served as pets. The birds' feathers, however, could be used for making clothing. In addition, monkeys had symbolic significance and were associated with happiness, games, and dance. They were represented in sculpture playing or dancing, and were shown with symbols of Xochipilli, god of happiness, or of Quetzalcoatl, the plumed serpent.

Dogs were animals used in sacrifices to the gods, and were eaten not as ordinary food but as ritual food. The spirit of the dog had the task of transporting its master's spirit to the underworld after death. The dog was also linked to the ritual calendar, the sky, and the sun's fire: The feast of the god of fire, Xiuhtecuhtli, was held on day 3 Dog of the ritual calendar. In certain sacrificial rites, a dog was substituted for a human being as a victim.

Of the various kinds of dogs living among the indigenous people, the *xoloitzcuintli* was special. Missing teeth and with a higher than normal temperature, this hairless dog was not considered a breed at the time, but rather an abnormality. It could be born in the same litter as regular dogs. (The *xoloitzcuintli* belonged to the genus *Canis africanus*, but resulted from a mutation in a heterozygotic gene. It is now recognized as an official breed.) Because of the *xoloitzcuintli*'s association with the underworld, he was the god Xolotl, the twin brother of Quetzalcoatl. While Xolotl symbolized the planet Venus as the evening star, Quetzalcoatl was Venus as the morning star. Together, they exemplified the harmony of opposites, which is central to Aztec thinking.

Other important animals were the jaguar, the serpent, and the solar birds, the hummingbird and eagle; the hummingbird represented the fertilizing power of the sun, and the eagle was the main symbol of the Aztecs. The jaguar was one of the most important symbols of the dark side of life, the kingdom of mystery, and the irrational and destructive forces of evil and death. Its skin represented the night sky splotched with stars; it was also seen as a manifestation of the sun on its voyage through the underworld. According to Aztec myths, the jaguar was an animal from a prior world, a primordial and chaotic time, in which it destroyed human beings. In addition, it was the alter ego of powerful men and evil shamans.

The serpent was the incarnation of water, earth, the underworld, blood, female and male fertility, life, death, and immortality due to its unique change of skin. In short, it was a symbol of the life and death energies that ruled the cosmos. It was thus associated with the most important gods, who were sometimes manifest as fantastic beings formed by the combination of features of several animals, like the feathered serpent. Expressing the conjunction of heaven and earth and thus the harmony of opposites, the feathered serpent was the main religious symbol of Mesoamerica. For the Aztecs, it was the manifestation of the god Quetzalcoatl (Quetzal Serpent), the creator god, who was associated with wind and water.

The hummingbird was thought to possess supernatural powers. It was simultaneously a sexual symbol and the incarnation of warriors who had died in battle and of those who had been sacrificed. The hummingbird was the symbolic animal of the god Huitzilopochtli, as well as his father. In an Aztec myth, Coatlicue, the mother of Huitzilopochtli, puts a ball of hummingbird feathers in her lap and becomes pregnant. When the god is born, his left leg is feathered.

The eagle, for its capacity to fly above the clouds and approach the sun, as well as for its golden plumage, was considered an incarnation of fire and of the sun itself. Its descent at great speed—diving on its prey—represented light falling on the earth, the

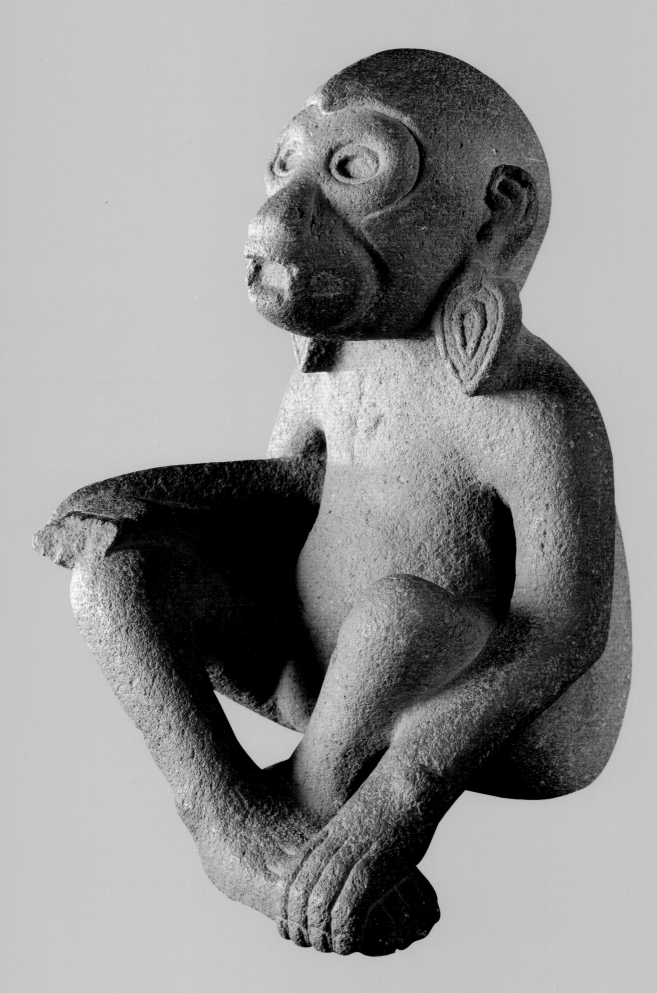

5. Seated monkey
Aztec, ca. 1200–1521

arrival of vital energy, and the life-giving power of the sun. Yet the eagle was also thought to have a nocturnal, malevolent side, which was rooted in its excess of valor, lack of moderation, pride, and cruelty. Thus it symbolized both the dominant, tyrannical father and the rapacious conqueror.

The all-encompassing meanings of the eagle explain why it was the supreme symbol of the Mexica-Aztecs, the most powerful of the Nahua groups in the central highlands. The species that especially embodied the essential values of that people seems to have been the royal or golden eagle (*Aquila chrysaetos*), an extraordinary, majestic bird with a wingspan of more than two meters.

The eagle primarily represented the warrior character of the Aztecs, conceived as a sacred mission and as force, aggressiveness, power over others through war, and a desire to occupy the center of the cosmos, like the sun. The eagle also represented death, which generated the life of the universe: the autosacrifice a human made in order to sustain the gods with one's own blood.

In the myth of the founding of Tenochtitlan, the Aztec capital, the eagle played a central role because it was the sign that the god Huitzilopochtli gave the people to indicate the site where their city should be founded. They saw an eagle atop a great nopal, with its wings stretched out toward the sun, taking the fresh air of the morning and devouring a serpent.

The data from written sources are confirmed by remarkable sculptures, which, in addition to their aesthetic value, demonstrate the main symbols of Aztec thinking and culture. Among these works, the monument known as the Teocalli of the Sacred War is particularly important. On the back of this monument, the eagle is shown on the prickly pear; in its beak it bears the Atl Tlachinolli, the symbol for water and fire; and the nopal is growing from the chest of the god of death, Mictlantecuhtli. The meaning of the work is cosmological, since the god of death represents the underworld; the nopal, earth; and the eagle, the sky.

The earth-sky duality appears elsewhere in Mexica symbology through the jaguar and the eagle, representing the nocturnal sun and diurnal sun, respectively. It was a nocturnal sun when traveling through the underworld, and a diurnal sun when traversing the sky. They were two aspects of the same star; thus both were symbols of the warriors who served the sun.

Another exceptional artwork, in which the Mexica concept of a sacred war is presented, is the wood Huehuetl of Malinalco. (*Huehuetl* means drum.) Carved in relief in the top and bottom registers are representations of an eagle and a jaguar bearing sacrificial flags and dressed in warrior attire. In the top register there is also an Eagle Lord with his wings intertwined and outstretched. His face emerges from the eagle's beak, which is open toward the sky. We can discern at his sides the man's arms and legs. This appears to be a clear depiction of both the mystical meaning of the eagle warrior and of the initiate's spiritual elevation, as he receives sacred powers from the sun.

The preceding discussion confirms that animals played a central role in the life of the Aztecs. These indigenous people had a consciousness or knowledge of the cosmos very different from ours. In light of this difference, it would be erroneous to call them "ecologists," but we must recognize that rather than bringing about the extinction of species, they had sufficient wisdom to preserve the harmony between humankind and the natural world.

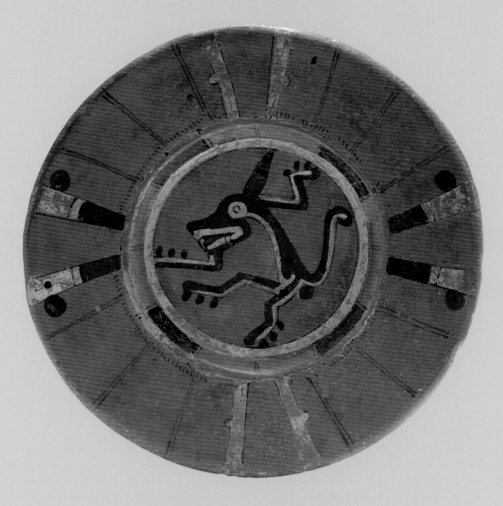

6. Polychrome plate
Cholollan, ca. 1325–1521

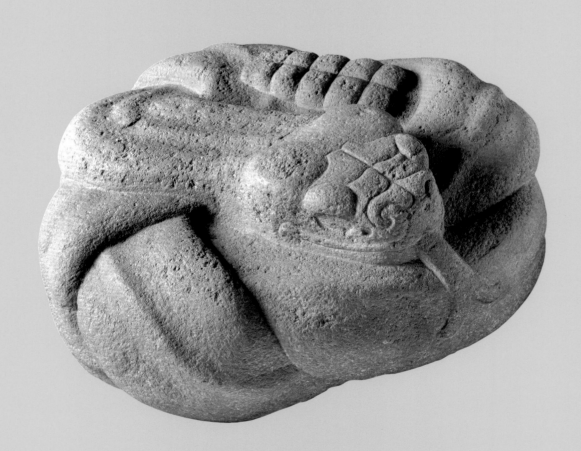

7. Serpent
Aztec, ca. 1500

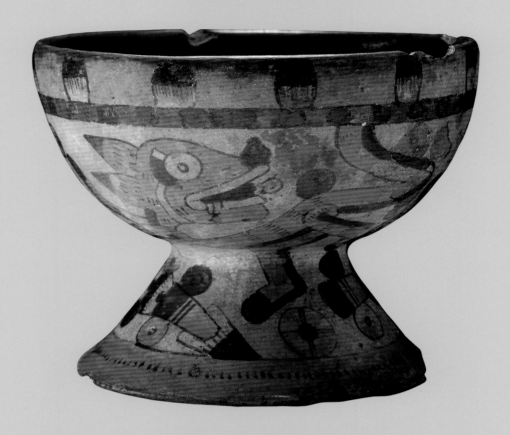

8. Polychrome goblet
Cholollan, ca. 1325–1521

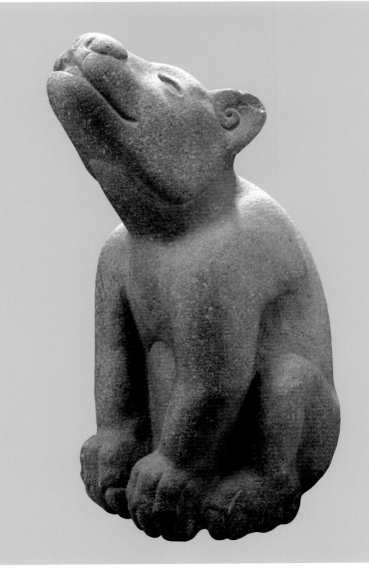

9. Dog
Aztec, ca. 1500

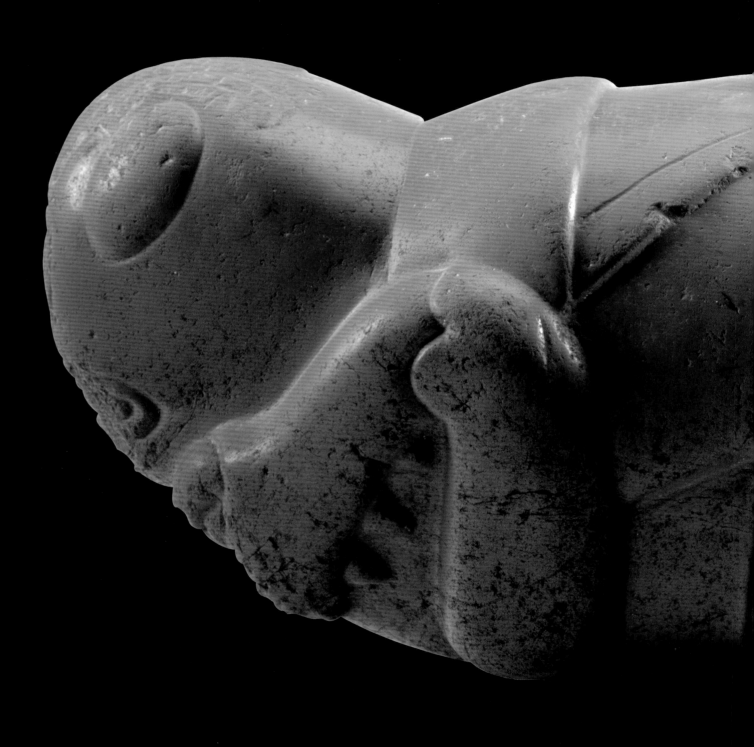

10. Grasshopper
Aztec, ca. 1500

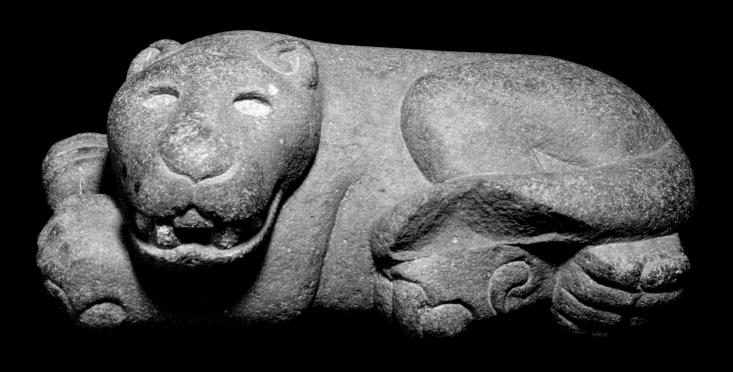

11. Reclining jaguar
Aztec, ca. 1440–1521

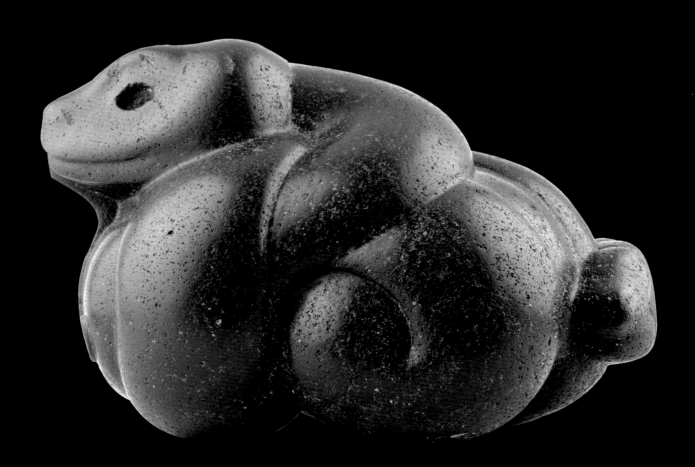

12. Serpent
Aztec, ca. 1500

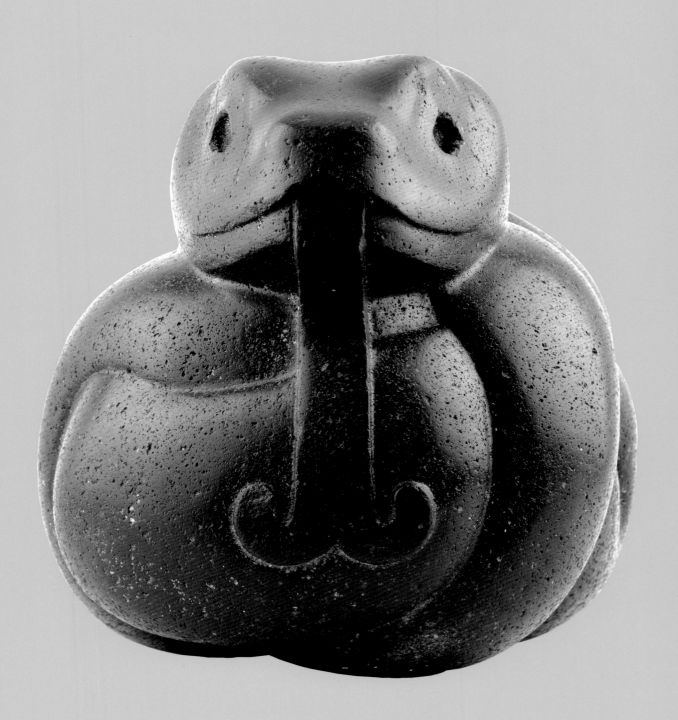

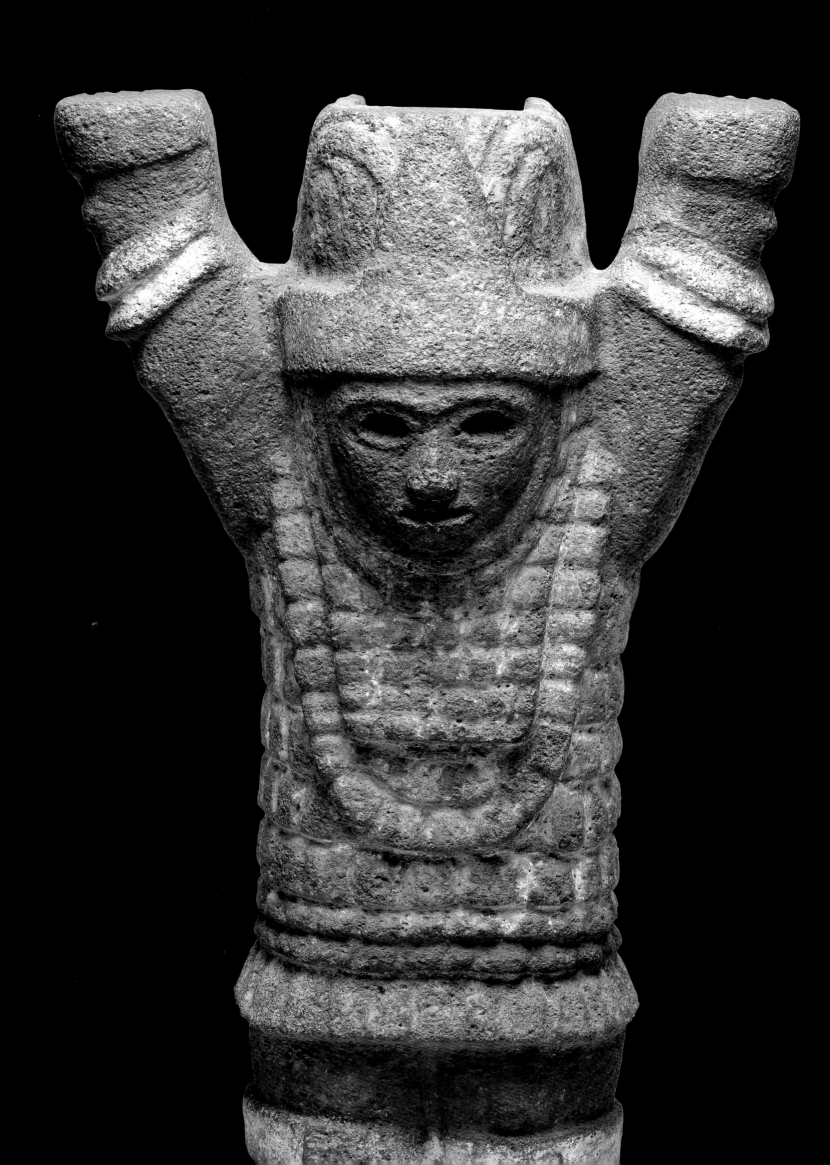

The Aztecs and
Their Ancestors

Precolumbian Man and His Cosmos

Felipe Solís

IN THE SIXTEENTH CENTURY, THE AZTECS, ALONG WITH OTHER NAHAUTL SPEAKERS FROM neighboring towns, related various stories to explain the origin of their universe to the Spanish conquistadores who had just reached the new world. They told of the gods' participation in an act of creation in which a basic event was the birth of the human race, to which they proudly belonged. Most versions of the stories that have survived are written in Nahuatl, their original language, and some are in Spanish. A magnificent visual summary of this myth can be seen in the central design of the extraordinary unfinished monolith called the Sun Stone, which was discovered in December 1790 in the course of paving the main plaza in Mexico City.

Eras Preceding the Aztecs and the Birth of the Fifth Sun

There are images describing the original myth that survived the catastrophe of the Conquest, sculpted on extraordinary monuments. Among these, the central relief on the Sun Stone is outstanding. In one of its versions, the original myth is defined as the myth of the five suns,[1] in which the sequence of creation and destruction of prior ages, to reach the fifth age, is explained. The origin of each era was attended by the participation of a significant deity, each of whom symbolized, as a deity per se, one of the four basic elements of nature. Thus, each "sun" had its own particular inhabitants and plants that would be destroyed by catastrophic events generated by the very element that made it a force in the creation.

As could be expected, there are profound differences among the various written sources and the archaeological monuments, mainly in the order or sequence of the ages. We believe that the emphasis on sun or water in the creation stories found in some colonial manuscripts reflects the profound influence of biblical explanations of the creation. For this reason, we consider the pristine story contained in the relief on the Sun Stone, and on its altar of the four ages, the most reliable source. Here the order begins with Nahui Ocelotl (4 Jaguar) and reaches Nahui Atl (4 Water), including the four extremes of the universe, concluding with Nahui Ollin (4 Movement), the fifth creation, which is shown in the center of the stone.[2]

The task of forming the first sun fell to Tezcatlipoca, ancestral deity of war, spiritual power of darkness, and one of the symbols of the earth. The star that would light that age would be a ferocious feline; therefore it was named Nahui Ocelotl (4 Jaguar). The giants known as Quinametin were the inhabitants of this era and their food, gathered in the wild, was called *chicome malinalli*, a calendrical name used to describe a certain variety of pine nuts. This sun, linked with the color black, lasted 676 years; at the end of this period, formidable jaguars came down to earth and devoured all the giants.[3] The Aztecs said that the enormous bones discovered in the fields under cultivation and in the hills

tenochtitlan

colhuacan. pueblo. tenayucan. pueblo.

(paleontological remains of Pleistocene fauna) were reliable evidence of the gods' first experiment to create life on earth.

The second sun was created by Quetzalcoatl, the plumed serpent and adversary of the deity of war. This era was a heavenly body called Nahui Ehecatl, "four wind," whose color is yellow. Of the food that sustained the people of this era, we only know its calendrical identity, Matlactlomome Coatl (12 Serpent), with no specification of its botanical species. The chroniclers attribute the creation of one age to the destruction of the previous one, precipitated by fights between the deities. Thus, the first sun or era ended after Quetzalcoatl gave Tezcatlipoca a tremendous beating, and the second age ended when the god of darkness gave a mighty kick to the plumed serpent, leading to its terrible end by the force of hurricane winds. The survivors of that era, which lasted 364 years, were turned into monkeys.

Tezcatlipoca takes revenge in his work as a creator and introduces Tlaloc, the god of rain, as the creator of the third age, called Nahui Quiahuitl (4 Rain.) What is enigmatic about this creation is that its ruling element was fire; thus, its color is red, and its destruction is described as a catastrophic rain of fire. This could be a reference to the terrible eruptions of the volcano Xitle, which destroyed most of the southern part of the Valley of Mexico, where Cuicuilco flourished at one time. The third age lasted 312 years, and its people ate *ace centli*, a wild grass whose calendrical name was Chicome Tecpatl (7 Flint). When this cycle ended with the rain of fire described above,

the survivors turned themselves into birds and butterflies.

Next it falls to Chalchiuhtlicue, she of the jade skirts, goddess of water, and companion of Tlaloc, to constitute the fourth sun, which illuminated that age. This time, it was made of that valued liquid without which life cannot exist. The presence of the female deity in the act of creation was thanks to the patronage of Quetzalcoatl, as one more stage in his eternal confrontation with Tezcatlipoca. That era lasted 676 years, and its inhabitants ate a wild variety of maize called *cincocopi*, whose calendrical name is Nahui Xochitl (4 Flower). White was its dominant color. That era concludes with a disastrous flood that caused even the mountains to disappear, covering everything with water for fifty-two years. Finally the sky fell on the earth, and any humans who survived turned themselves into fish and other aquatic animals.

In its wisdom, the myth of the suns shows the conjunction of the four elements that are fundamental to life in the universe, the origin of the colors that rule the directions of the *axis mundi*, as well as the origin of some animals (monkeys, fish, birds, and butterflies) that lived in the fifth creation. Everything is being prepared for the birth of the heavenly body that will illuminate the time of the Aztecs.

The five-era creation story recalls other universal creation myths, in which the people from all continents have explained a creation process that occurs in the darkness of the eternal night. On this occasion, all the gods met in Teotihuacan for the

Page from the *Codex Boturini*, ca. 1170–1355.

purpose of choosing who among them would have the honorable mission of lighting up the world anew. The first to respond was Tecuciztecatl, god of earth, He of the Conch Shell; to balance the sacred act of the gods, they sought another candidate for the supreme sacrifice. In the absence of any volunteer offering to do this, they inquired about the god who was the least revered and most humble of all, Nanahuatzin, a deformed religious spirit, covered with sores, who accepted the mandate. Both Tecuciztecatl and Nanahuatzin prepare themselves for the ceremony for four days by lighting the ritual bonfire that they would sacrifice themselves into. The gods invited Tecuciztecatl to be first to throw himself into the fire, and he hesitated—an unforgivable act of cowardice. The self-sacrifice falls to Nanahuatzin, who throws himself on the pyre and is transformed into a radiant disk, the final sun of the fifth era. Envious, Tecuciztecatl then throws himself on the sacred fire, becoming another resplendent disk. At that moment, one of the gods grabs a rabbit by the ears and throws it into the face of Tecuciztecatl, extinguishing his light and heat. Thus, he remained in the condition of a moon, with the imprint of the animal on his face, and, as a punishment, he is condemned to follow behind the sun.

The sun was finally formed, but it remained immobile in the sky. Faced with this problem, the gods sent an eagle, the star's *nahual* (guardian spirit), to inquire about the cause of such a disastrous event. The sun agreed to move in exchange for the hearts and blood of all the gods at the meeting in Teotihuacan, given in sacrifice. Once they carried out the collective sacrificial ceremony, Tonatiuh then began to travel his route from east to west, creating life in the fifth era. From the passage of the sun through the celestial vault comes the name Ollin Tonatiuh, sun of movement, whose calendrical name Nahui Ollin (4 Movement) would become a metaphor of existence itself.

The Fifth Sun, the Days, and the Calendar

The complex chronographic relief carving in the Sun Stone summarizes the succession of the five eras. On the ends of the fan blades that make up the sign, we recognize the sequence of the suns of earth, wind, rain, and water. In the central circle, the face of Tonatiuh is complemented with the numeral 4 through an equivalent number of *chalchihuitls*, or symbols of preciousness. Tonatiuh's tongue is turned into Tecpatl, holding human hearts in its claws. We can see a sequence of the twenty symbols of the calendar in a ring around the sun of the fifth era. This reminds us that beginning with the creation of this new era, the sequence of days and nights as well as the movement of the sun generate the calendar. From that time on, the time that is running is the Aztecs' time.

Separation of Earth and Sky

Other stories tell that some time after the sky fell on the earth, Quetzalcoatl and Tezcatlipoca turned themselves into two gigantic serpents, holding the goddess Tlalteutl (another name for Tlaltecuhtli) by her extremities, breaking her into two segments (some considered this god male and others believed her to be female). One piece constitutes the celestial planes, and the other makes up the earth, strictly speaking. The text, in archaic Nahuatl, states: "Then, that done, to compensate said goddess for the injury those two gods had done to her, all the gods came down to console her and ordered that from her would spring forth all the fruit needed for human life." To do this, from her hair the gods made trees, flowers, and grasses; from her skin, the finest of grass and little flowers; from her eyes, wells, fountains and small caves; from her mouth, great rivers and caverns; from her nose, mountains and valleys. Sometimes at night, this goddess cried, inconsolable in her desire to eat human hearts. As long as she was not given the hearts, she did not wish to give fruit, until she was finally irrigated by human blood.[4]

The People of the Fifth Creation

With the fifth era, the sun was finally illuminating the thriving earth, and the gods conferred one more time to discuss who would live in the new creation. Once again it was up to Quetzalcoatl to seek out the remains of ancient humankind. To do this, he had to penetrate the underworld, gradually descending through the various planes until he arrived at the deepest level, home of Mictlantecuhtli and Mictlancihuatl, the couple who ruled that realm of darkness. The plumed serpent began his search, according to some indigenous chroniclers, accompanied by his *nahual*, a devotee of the god that has the faculty to enter the underworld without dying and thus return to the surface. The creator god requested the precious bones of ancestral generations from the lord of the world of the dead, who responded: "On one side are the bones of men, and on the other side, the bones of women." So Quetzalcoatl took them and mixed them up, and carried this mess away.[5] The lord of the underworld soon repented and ordered animals from the dark regions to pursue Quetzalcoatl and excavate hollows in the subsoil. In running to escape, he fell into one of these traps, scattering the bones over the soil, whereupon they were chewed by quails. When Quetzalcoatl regained consciousness, he sensed the urgency and decided to perform the act of creation in that very place, the underworld. He requested help from the goddess Cihuacoatl, the female serpent (called Quilaztli in the chronicles). She ground the bone fragments and deposited them in a sacred receptacle, upon which Quetzalcoatl spilled drops of his own blood from his penis; the resulting mixture created the humans of the fifth era. Finally, the god made a hole through which these people could exit and populate the universe.

Maize, the Food of the New Human Race

On Tlalticpac (earth), human beings were now placed in a favorable environment surrounded by animals and vegetation, but the matter of basic food was then considered. The gods once again asked about what people would eat, and once more, Quetzalcoatl would act in favor of the people. The god slowly observes a red ant carrying maize to the interior of the Tonacatepetl, the sustenance mountain where grain was stored. He questions the insect about the source of the seeds, but the ant does not tell him. Thus, the god comes up with a curious strategy; he turns himself into a black ant and manages to deceive the red ant, who takes him to the sacred mountain where the maize kernels are kept. From that time on, this would be the food of the humans, created by Quetzalcoatl himself.

The pre-Hispanic peoples bore witness to the inextricable link between men and their search for and acquisition of basic food. Maize is a plant invented by the Mesoamericans, who selected and crossbred varieties of *teozintle* and other wild maize until they arrived at the maize we know today, with nutritious kernels that can be eaten. Seed maize is carefully deposited in a hole made in the soil using the *coa*, a curved staff used for sowing. Agricultural workers must constantly clear the fields of wild plants that impede its growth, because in the early stages, the stalks are incapable of making their way through the weeds.[6] Similarly, in the mythical creation story, the mixture made with ancestral bones and the seminal blood of Quetzalcoatl sought its exit through the hole he made. In their early stages, humans, like maize, would require care in order to reach maturity; it is fitting that their food would be the kernels of the prodigious plant.

The Origin of the Aztecs and their Neighboring Peoples

In addition to ancient stories, the *Codex Boturini* (1520–40; also called the *Tira de la peregrinación*, or peregrination painting), one of the best-known of these pictographic books, describes the mythic place where the Aztecs and other groups that populated the central area of Mexico settled. They placed this site to the north of the universe and called it Aztlan, the place of the color white. It is described as an island in the middle of a lake or inlet, which they crossed to terra firma in canoes. From there, they undertook the long journey that would lead them to the place determined by their god/guide, where they would build their future capital, Tenochtitlan. Other documents consider the great cave within Chicomoztoc, "mountain of the seven caves," to be the more important ancestral site. Characterized by its curved promontory, this cave is made up of seven internal cavities where the seven main groups that populated the Anahuac Valley at a given time were believed to have originated.

Some historians claim that the area is called Aztlan-Chicomoztoc. In fact, the first plate of the *Codex Boturini*, a document of Aztec affiliation, shows the island and the expanse of water, distinguishing it from a pyramid with the water reed, the sign of *acatl*. It is surrounded by six houses, presumed to be neighborhoods into which the lakeside city was divided. A figure paddling a canoe in search of land represents the migratory group that began its long journey in the year Ce Tecpatl (1 Flint) to later reach Teoculhuacan, the hill with the curved protuberance. This hill has a cave with images in its interior of Huitzilopochtli (Hummingbird on the Left), who tells them that he will guide them to the place in which they will impose domination on the universe. Next are pictured the eight groups that will accompany them for a while during their migration, including the Matlatzinca, Tepaneca, Tlahuica, Chalca, and Huexotzinca. This codex explains the Aztecs' place of origin and their encounter with their god/guide, who accorded them privileged status, choosing them as the historic people who would conclude their wanderings by founding Mexico-Tenochtitlan. But it also extended the Aztlan-Chicomoztoc origin to peoples that were their neighbors in the central area of Mesoamerica but did not share their messianic destiny.

The *Historia Tolteca-Chichimeca*, a manuscript created in the mid-sixteenth century by people who lived in Coatlinchan on the eastern bank of the Tetzcoco Lake basin, provides the most impressive image we have of Chicomoztoc.[7] In the rendering, the sacred mountain can be recognized from its hump, shown as a curving figure; the surroundings are characterized by an abundance of desert plants, such as the barrel cactus, nopal (prickly pear), and maguey. Amid the vegetation, a priest disguised as a wolf or coyote lights the new fire. In the womb-like cave of origins we can see the seven chambers and images of the different Chichimec peoples born there, identified by their place names. In the exit pathway are footprints indicating the movement of a population, suggesting origin and return.

In Teotihuacan, the renowned site where the creation of the fifth sun took place, a cave was discovered in the subsoil of the Pyramid of the Sun, the earliest ritual plinth on that site, dating from around the beginning of the Christian era. Certainly the importance of this city for societies of its period as well as those that preceded it may be attributed to the vast size of its constructions. Even as ruins, these evidence the force and dominance of one of the most powerful indigenous states of Mesoamerica. A natural cave of volcanic formation with a deep chamber is located almost in the center of the Pyramid of the Sun. Its access gallery has an irregular shape, winding from the entrance, which is practically at the starting point of the platform attached to the western part of the plinth. Beneath an initial layer, after the first pathway, two additional cavities were excavated on either side; the gallery continues to the back, where the space broadens into four cavities more like ritual chambers that recall the silhouette of a flower with four petals. Among other ideas, this design symbolizes the indigenous *axis mundi*, a horizontal plane with four directions and a center.

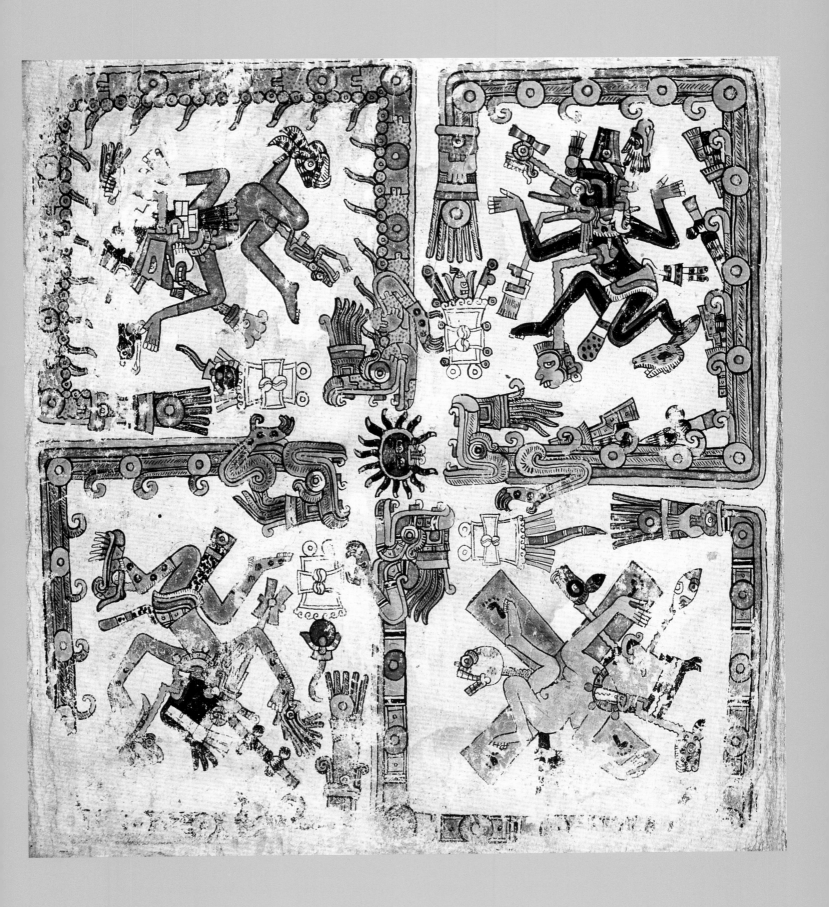

Page from the *Codex Borgia*, late 15th century.

In some codices, Teotihuacan can be identified by the existence of caves under the pyramids,[8] evidence that people in the Postclassic and early colonial periods had knowledge of these sacred caves. Thus, we may consider this and other caves to be the empirical proof for naming this as the mythical creation of the fifth sun. The indigenous *tlacuilos* (scribes) who illustrated texts by the friar Diego Durán[9] re-created Chicomoztoc in a peculiar way. In Durán's codex (1579–81), the seven caves are separated from each other and vaguely recall the silhouettes of the hills, in the pre-Hispanic style. The original families are located in its interior, and the passage, rendered with European-style perspective, is filled with flowering plants. The *Tovar Codex* (1583–87),[10] a document very close to Durán's, illustrates this same passage, distancing itself even further from the pre-Hispanic tradition. The seven caves are shown enclosed by stones, with people inside, and the vegetation is simply ornamental and recalls a thicket.[11]

Among the illustrations that enrich Durán's descriptions, the indigenous artists included one that shows the migration of the Teochichimeca, departing Chicomoztoc from the head of the monster depicted with its jaws open. As the first hunters, they bear their offensive arms—bows and arrows—and have the characteristic netted hair that identifies them. The animal figure looks canine,[12] a curious image of Tlaltecuhtli that had thus already been created in the early colonial period as a reinterpretation of the earthly beast Cipactli. In the pre-Hispanic pictographs, however, it has a monstrous face with eyes bulging out, teeth sharpened like rows of sacrificial knives, and a thorny body that recalls Cipactli, the original creature that could have been a lizard or a crocodile.

Structure of the Universe from Indigenous Point of View

Like many peoples in the history of the world, the inhabitants of Mesoamerica, particularly the Aztecs, interpreted their natural environment as a universe constructed through the action of the gods. For them, this primarily meant Tezcatlipoca and Quetzalcoatl, who, as discussed above, split the body of the ancestral god Tlaltecuhtli. This led to the creation of sky and earth, with the underworld below. Fray Bernardino de Sahagún gathered from the indigenous peoples a description of the trip that led the deceased toward Mictlan, where Mictlantecuhtli and his wife Mictlancíhuatl were located. The rites began with serious lectures given to the deceased by their relatives:

> You have already gone to the darkest place, which has neither light nor windows, and you must never leave there or come back. . . .
>
> Then the old people and paper officials cut and straightened and attached the paper required, . . . they took the deceased and shortened his legs,

dressed and tied [the deceased] in the paper; . . . saying. . . .

> This is what you need to pass amid two mountains, one after the next;
>
> This is what you need to pass through the road where there is a snake guarding the road.
>
> This is what you need to pass through where there is a green wall lizard called Xochitonal;
>
> This is what you need to pass through eight plateaus; . . .
>
> This is what you need to pass through eight [mountain] passes; . . .
>
> This is what you need to pass through the knife-edged wind, called Itzehecayan, because the wind was so strong that it carried rocks and pieces of knives. . . .
>
> In addition, they made the deceased take along a small dog with reddish fur, and around its neck they put a loose cotton cord; they said that the deceased swam on top of the dog when they passed through one river in hell, called Chiconahuapan. . . .
>
> When the deceased arrived before . . . Mictlantecuhtli, they offered and presented to him the papers they were carrying.
>
> After four years have elapsed, the deceased leaves and goes to the nine hells, where a broad river flows through and passes by. There are dogs living and walking around on the bank of the river, which the deceased crosses over, swimming on top of a little dog.
>
> They say that upon arriving at the riverbank referred to above, the deceased looks at the dog; if it recognizes its master, it jumps into the river and swims to where his master is, and carries him on its back. . . .
>
> Thus, in this place . . . which is called Chiconaumictlan, the deceased end their lives and pass away.[13]

In the Aztec geometry of the universe, there were thirteen vertical planes above the earth and nine planes in the underworld. Some scholars envision this like two stepped pyramids, the underworld being the smaller of the two, in an inverted position, representing the heavens, in such a way that the vertices of both pyramids meet and constitute earth level.[14] The anonymous indigenous painters whose illustrations appear in the *Codex Vaticanus* (also called the *Codex Ríos*, ca. 1570–95)[15] also re-created a vertical vision of the cosmos, indicating the terrestrial band Tlalticpac (earth) with eight levels below and twelve above. The matter of adjusting the number of levels above and below to reach the sum of nine plus thirteen has

Carved stone atlantes from the pyramid complex at Tula.

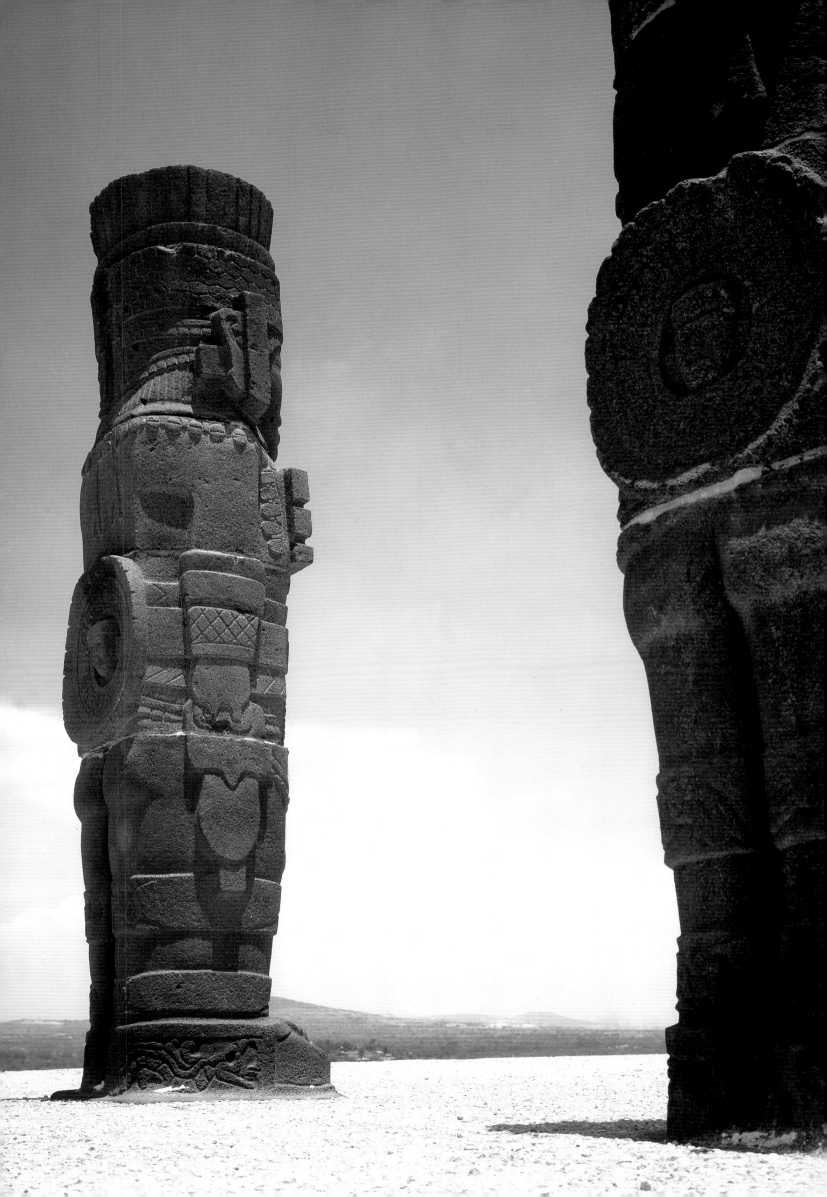

given rise to various hypotheses and discussions over the long history of research on Precolumbian Mexican religion. Generally, the version deemed to be most current and accepted is that set forth by Alfredo López Austín,[16] who proposes a full reading and ordering of the underworld's levels, or planes, using Tlalticpac as the first level:

Codex spelling/ proposed reading	Translation	Proposed order
Tlalticpac/Tlalticpac	Earth	1st level
Apano huaya/ Apanohuayan	Water passageway	2nd level
Tepetli monanamycia/ Tepetl monanamicyan	The hills are found	3rd level
Yztepetl/Iztepetl	Hill of obsidian	4th level
Yeehecaya/Itzehecayan	Place of obsidian wind	5th level
Pancoecoetlacaya/ Pancuecuetlacayan	Place where flags flutter	6th level
Temiminaloya/ Temiminaloyan	Place where people are in a great hurry	7th level
Teocoylqualoya/ Teyollocualoyan	Place where people's hearts are eaten	8th level
Yzmicilanapochcaloca/ Itzmictlanapochcalocan	Place of the obsidian of the dead; place with no opening to let out smoke	9th level

Regarding the set of heavens that make up the celestial sphere, López Austín believes that counting should begin from the heaven of Tlalocan and the moon. He also proposes that the highest level represented in the *Codex Vaticanus*, the Omeyocan, be counted twice because it is a place of duality; thus, it constitutes the twelfth and thirteenth heavens:[17]

Codex spelling/ proposed reading	Translation	Proposed order
Homeyoca/Omeyocan	Place of duality	13th and 12th heavens (9th and 8th higher heavens)
Teotl tlatlauhca/ Teotl tlatlauhca	God who is red	11th heaven (7th higher heaven)
Teotl cocauhca/ Teotl cozauhca	God who is yellow	10th heaven (6th higher heaven)
Teotl yztaca/ Teotl iztacca	God who is white	9th heaven (5th higher heaven)
Yztapal nanazcaya/ Itztapalnacazcayan	Place that has corners made of obsidian slabs	8th heaven (4th higher heaven)
Ylhuicatl xoxouhca/ Ilhuicatl xoxouhca	Heaven that is green	7th heaven (3rd higher heaven)
Ylhuicatl yayauhca/ Ilhuicatl yayauhca	Heaven that is blackish	6th heaven (2nd higher heaven)
Ylhuicatl mamaluacoca/ Ilhuicatl mamalhuacoca	Heaven of the turn-around	5th heaven (1st higher heaven)
Ylhuicatl huixtutla/ Ilhuicatl huixtotlan	Heaven, place of salt	4th heaven (4th lower heaven)
Ylhuicatl tunatiuh/ Ilhuicatl Tonatiuh	Sun heaven	3rd heaven (3rd lower heaven)
Ylhuicatl iztlalicoe/ Ilhuicatl Citlalicue	Heaven of Citlalicue (She of the Skirt of Stars)	2nd heaven (2nd lower heaven)
Ylhuuicatl tlalocaypanmeztli/ Ilhuicatl Tlalocan ihuan metztli	Heaven of Tlalocan and the moon	1st heaven (1st lower heaven)

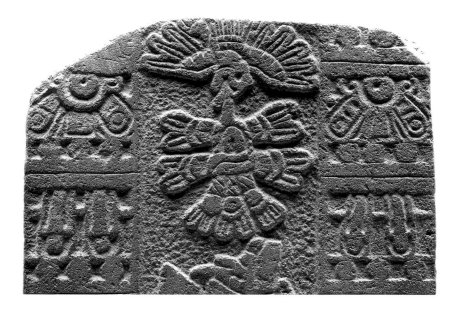

As archaeological witness to this vertical perception of the celestial planes, we have the Stone of the Heavens, a sculpture in the form of a rectangular prism. On one of its larger sides we see a sequence of bands with stars like stellar eyes and indigenous representations of the planet Venus. In this setting, there is a kind of central pathway through which images of the pre-Hispanic deities go up and down, along with the silhouette of an eagle holding a bundle of victims in its beak.[18]

In addition to Mictlan, there were various other places to which the deceased were directed. Outstanding for its peculiarity was Chichihuacuauhco, the nursemaid tree. This vegetal site is represented only in the *Codex Vaticanus*;[19] the unusual representation of a tree has the characteristic pre-Hispanic pattern in which plants have their roots uncovered. In the codex, this tree is designated Chichiualquauitl, "the milk tree," and according to notes made by Fray Pedro de los Ríos:

> This was the third place passed through by spirits of this life, to which went only those children who died without having reached the age of reason. They pretend it is a tree that dripped milk, where they took all the children who died at that age, because the devil is so envious of God's honor that even in this, it wanted to emulate God. As our sacred wise men say, this is the limbo for children who die unbaptized, or uncircumcised, under the old law, or without the virtue of a sacrifice made by an indigenous person. This is what they made these poor people believe: that there was this place for their children, and they added another error, which was persuading them that these children (*angelitos*) would have to leave that place to repopulate the world after it was destroyed for the third [originally: second] time, and they thought it must have already been destroyed, because the two [times] had already occurred.[20]

Based on the information provided in the *Florentine Codex*, Miguel León-Portilla argues that the Chichihuacuauhco is in the Tamoanchan, "our place of origin."[21]

The Horizontal Plane and the Surface of the Earth

In the story that explains the creation of the horizontal plane, the original divine couple are participants: Ome Tecuhtli and Ome Cihuatl, located on the cusp of the celestial planes, in Omeyocan. Because of their constant activity as creators, they generate the four Tezcatlipocas, their children, who incorporate the boundaries of the quadripartite vision of the cosmic universe. Each one is characterized by a specific color, which will give an identity to the region each one must build: Tlatlauhqui Tezcatlipoca, the smoking mirror, red in color; Yayauhqui Tezcatlipoca, the real Tezcatlipoca whose characteristic color is black; Quetzalcoatl Yohualli Ehecatl, the plumed serpent, night wind, linked to the color white; and Omitecuhtli Maquizcoatl Huitzilopochtli, the emaciated man, the two-headed serpent, the southern hummingbird, or Hummingbird on the Left, to which the color blue or green is attached.[22]

This horizontal vision of the universe was shared by all the Mesoamerican people. The Mayas represented it in the *Codex Tro-Cortesianus* (also called the *Codex Madrid*).[23] These representations have a quadripartite design with the couples in the four corners; in the center, the cosmic *ceiba* tree with igneous elements is surrounded by the names of the twenty days of the ritual calendar. The best-known representation of the horizontal plane is in the *Codex Fejérváry-Mayer* (dated before 1521).[24] The design recalls a Greek cross, with narrower bands for the diagonals with curved borders that resemble petals and a rectangular panel in the center. Reading counterclockwise, from the upper right, the design begins with the direction east, called Tlapcopa or Tlahuilcopa, on the side with the light, with the cosmic tree, Xiloxochitl, that has beautiful flowers on which is positioned a *quetzal*. The patrons of this direction are Itztli, the divine knife, and Tonatiuh, the sun god. The colors of the east are red and yellow, tonalities that characterize the sun;[25] for this reason, it is considered to be the house of the sun, Tonatiuh Ichan, through which it is raised in the firmament. Thus, here Quetzalcoatl reappears in his role as the planet Venus.

To the left is north, where the spiny *pochote* grows, above which is a falcon. The deities who rule this direction are Tepeyollotl, the heart of the hill, and Tlaloc, deity of rain. Mictlampa is the name designating north; it is considered the

divine plain par excellence, and it is said that this is where the deceased begin their trip to the underworld. Its color is black.

The lower part is west, with the *huisache* on which you can see a hummingbird. This is the region of the women Cihuatlampa; so the patrons are the goddesses Chalchiuhtlicue, she of the jade skirt, and Tlazolteotl, the female patron of the sexual act. The color white defines this direction, where the sun ends its daily trip before going through the hole in the east.

On the right is south, the region of the colors blue and green, where the cocoa tree grows, on which sits a parrot. The deities that rule the south are Mictlantecuhtli, the underworld patron, and Centeotl, the god of maize.

The central region, which would complete this horizontal vision of the universe as the fifth direction, is the domain of Xiuhtecuhtli, the god of fire with his offensive arms or weapons, defined by the four currents of blood that evoke the sacred food of the cosmos.

It should be noted that this pictographic document was executed by peoples of the central/eastern region of the valleys of Puebla, and Tlaxcala and the region bordering Oaxaca, particularly the Mixteca. This was the reason for the peculiar association of the direction south with the kingdom of the dead and the north with Tlaloc, linked with the ideas of Tlalocan, where the abundant rains gave rise to a surplus of food and flowers all year round.

For the Aztecs, north is the cold plains, populated with xerophytic vegetation, where the frozen wind blows, Mictlampa Ehecatl. Therefore, they considered north to be the direction of origin, the source of the people who populated the earth, which was also the way to Mictlan. In the south, meanwhile, from the perspective of the Lake Tetzcoco basin, are the valleys of the *tierra caliente* (hot lands), where the indigenous domains of Cuauhnahuac (Cuernavaca) and Huaxtepec flourished, with moderate temperatures. These lands are characterized by their fertility and abundance of crops. As the majority of scholars agree in their analysis of these explanations of the cosmos,

there was not just one single perception of the universe; perceptions were many and constant. The creation was mentally and physically re-created when circumstances so required.

We are familiar with several images of the Mexica-Aztec vision of the cosmos. In the *Codex Mendoza* (1541–42),[26] they re-created the foundation of their city-state, Mexico-Tenochtlitlan, which occurred in the indigenous year Ome Calli (2 House, or 1325). Once again, the island was marked out as a quadrangular plane with four directions and related corners. There they found the symbol promised by the god who patronized the start of their migration. At the center, the icon: the *tenochtli*, the nopal flowering out of a rock, on which an eagle is positioned with wings extended, under which is the symbol of war, the *chimalli*, an indigenous shield, with arrows behind it in a horizontal position. The borders of the future city that would be the capital of the Aztec empire are defined as bands of water. These bands show that the quadripartite space lies within an *anahuac*, or circle of water, which surrounds the land (Aztlan was also an island in the middle of a lake). The division into the four sectors corresponding to the regions indicated in the *Codex Fejérváry-Mayer* is once again shown by bands of water, but in a transverse position.

We know that when the founding of the city took place, Tenoch, the guide/chief, placed the various segments of the Aztec migratory group into four sectors: to the east, Acacitli and Cuapan; to the north, Ocelapan, Tecineuh, Xocoyotl, and Tenoch himself; to the west, Xiuhcaqui and Atototl; and, finally, to the south, Ahuexotl and Xomimitl. The Tlatelolca who came with the group from Aztlan adapted to the site Tenoch designated for them as a place to settle, and thirteen years later, in 1338, they founded their own capital city Mexico-Tlatelolco.

When the Aztecs reached the pinnacle of their power and glory, they sculpted extraordinary monuments in volcanic rock, confirming their dominion of the known universe that originated in their city, the very center of the *axis mundi*. The Stone of Tizoc, located in the western part of the sacred site of the

Page from Fray Bernardino de Sahagún, *Florentine Codex*, also known as *Historia general de las cosas de la Nueva España*, 1575–77.

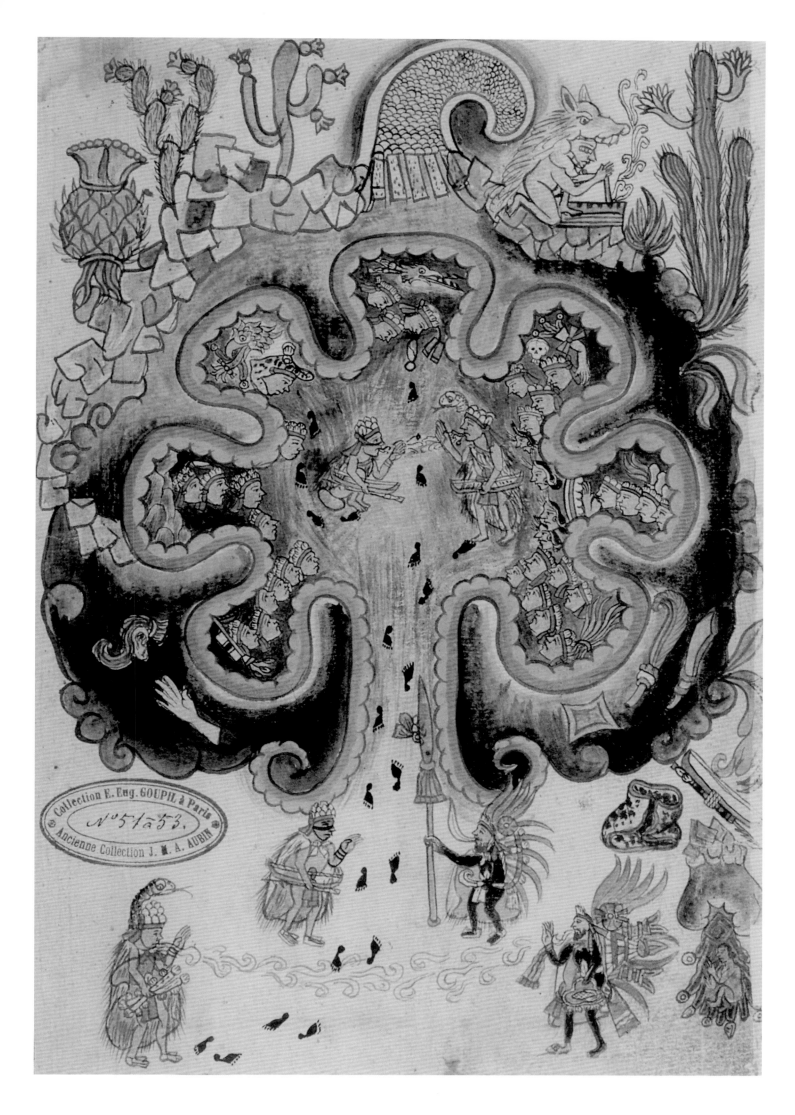

Page from the *Historia Tolteca-Chichimeca*, 1550–70.

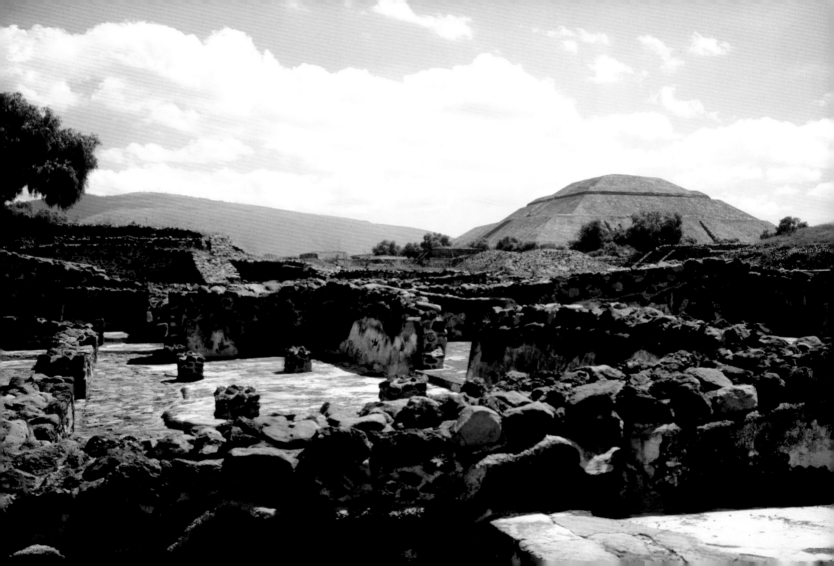

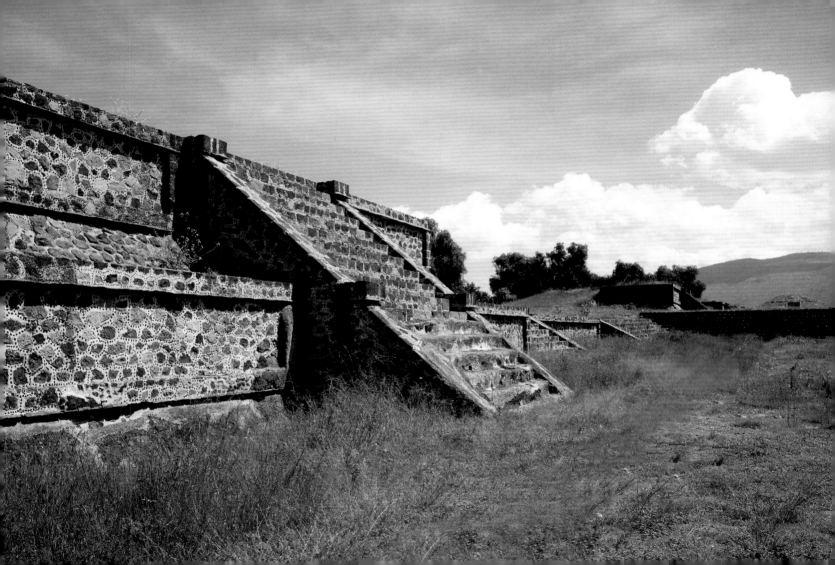

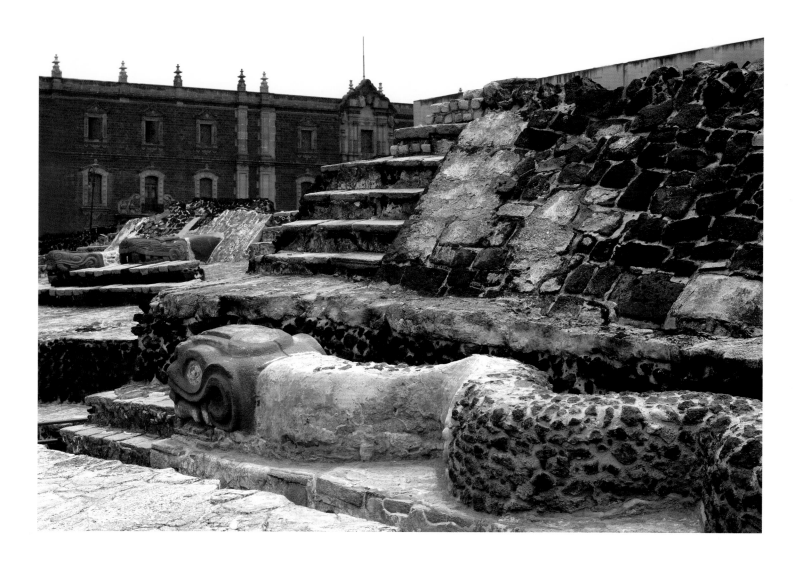

Templo Mayor, is the best example. On its curved side, this monolith in the form of an enormous cylinder shows the vertical vision of the cosmos. On the base, earth is represented by Tlaltecuhtli-Cipactli, the monster that holds men on its back, its body covered in thorns that outline four threatening jaws indicating the four directions of the universe. In the central band of the relief, we see fifteen scenes, each one representing the most significant military conquests carried out by the Aztecs. These conquests were conducted by rulers from Acamapichtli to Tizoc in every direction illuminated by the rays of the sun. This is confirmed by the upper strip on the side, a celestial band with stars and symbols of the planet Venus. It supports an enormous design carved on the upper side of the monolith of the solar disk with four rays radiating in the four directions of the cosmos. Like Temalacatl, it was designed as a sacrificial altar for the Tlacaxipehualiztli, where they confronted prisoners of war captured during the wars of conquest.

López Austín, following the stories of the chroniclers, shows that the pre-Hispanic peoples imagined a separation of the earth and the sustenance of the celestial sphere through four cosmic trees located on the borders of the universe, which they uprooted from the underworld. The Aztecs turned this vision into a material reality by placing sculptures on the borders of the island of Tenochtlitlan in the form of cacti, which also served as boundary stones. On their bases, each one bears the name of Tenoch, the founder of the city. This symbolic reading was fleshed out by imagining, in the center, the sacred nopal that grows out of a rock, upon which an eagle sits devouring a serpent. The mythic construction was perfect: the rock cactus supported the weight of the celestial band, and, at the convergence of the four directions, the symbol identifying the Aztec people as Tenochca supported the sun/eagle, its supreme deity, through the sacred food, the prickly pear/hearts, obtained from the conquered peoples.

Above: Templo Mayor, Mexico City.

Notes

1. *Códice Chimalpópoca: Anales de Cuanhtitlan y leyenda de los soles*, facsimile, Primo Feliciano Velázquez, ed. (Mexico City: Imprenta Universitaria, 1945), pp. 119–42.

2. The paintings in *Historia de los Mexicanos* coincide with this sequence. See Ángel María Garibay Kintana, *Historia de los Mexicanos* (Mexico City: Editorial Porrúa, 1965), pp. 21–90.

3. The image of one of these giants was re-created in the early part of the Colonial period. See *Codex Vaticanus 3738*, facsimile, Ferdinand Anders, Cansen, and Reyes García, eds. 1996, f.4v.

4. Garibay Kintana, *Historia de México*, p. 108.

5. Described in the *Codex Chimalpopoca*, p. 120.

6. Felipe Olguín Solís, *La Cultura del Maíz* (Mexico City: Clío, 1998), pp. 11–17.

7. Doris Heyden, *Historia Tolteca-Chichimeca* (Copenhagen: 1942), f. 16 r.

8. *Codex Xolotl*, in Heyden, 1998, p. 25.

9. Diego Durán, *Historia de las Indias de Nueva España e Islas de Tierra Firme* (*Codex Durán*) 2 vols. (Mexico City: Colección Cién de México, 1995).

10. Juan de Tovar, *Manuscrit Tovar: Origines et croyances des Indiens du Mexique*, Jacques Lafaye, ed. (Graz: Akademie Druck Verlagsanst, 1972).

11. Ibid., plate I, p. 238.

12. *Codex Durán*, plate 3.

13. Bernadino Sahagún, *Historia General de las Cosas de Nueva España*, (México City: Editorial Porrúa, 1997), pp. 205–07.

14. Luis Barjau, El mito mexicano de las edades (Mexico City: Juarez Autónoma Universidad Juárez Autónomade Tabasco, 1998), p. 17.

15. *Codex Vaticanus*, plates 1v–2r.

16. Alfredo López Austín, *Cuerpo humano e ideología: Las concepciones de los antiguos nahuas* (Mexico City: Universidad Nacional Autónoma de México, Instituto de Investigaciones Antropológicas, 1984), p. 63.

17. Ibid.

18. *Dioses del México Antiguo*, exh. cat., Antiguo Colegio de San Ildefonso (Mexico City: UNAM, Ediciones del Equilibrista, S.A. de C.V. and Turner Libros S. A., 1996), p. 41.

19. *Codex Vaticanus*, plate 3v.

20. Ibid., pp. 50–51.

21. Miguel León-Portilla, *De Teotihuacán a los Aztecas: Antología de fuentes e interpretaciones históricas* (Mexico City: Universidad Nacional Autónoma de México, 1983), p. 209.

22. Salvador Mateos Higuera explains that the first to be born showed the color red and was therefore nicknamed Tlatlauhqui; the second was black, and was called Yayauhqui; the third was born white and had to be named Iztac Tezcatlipoca, the white mirror, identified with Quetzalcoatl, symbol of the beautiful; and the last was born without flesh, was only bones, and they called him Omitecuhtli, the man of bones, better known as Huizilopochtli, and the color of his skin had to be blue. Salvador Mateos Higuera, *Enciclopedia gráfica del México*, 4 vols. (Mexico City: Secretaría de Hacienda y Crédito Público, 1992–94), vol. II, p. 11.

23. *Codex Tro-Cortesianus* [*Codex Madrid*] (Graz: Akademische Druck-u. Verlagsanstalt, 1967), pp. 75–76.

24. *Códice Fejérváry-Mayer: El Libro de Tezcatlipoca, señor del tiempo*, facsimile, Ferdinand Anders, Maarten Jansen, and Gabina Aurora Pérez Jiménez, eds. (Mexico City: Fondo de Cultura Económica, 1994), p. 1.

25. A microscopic analysis of the pigments used to paint the Sun Stone confirmed that the only colors originally covering its surface were red and ochre. This corresponds with information in the codices and in the chronicles.

26. *Codex Mendoza* (Mexico City: San Angel Ediciones, 1979), folio 2r.

Origins and Forms of Art
in the Aztec Empire

Felipe Solís

THE EXTRAORDINARY ARTISTIC AND SYMBOLIC REPERTORY THAT CHARACTERIZED THE ART OF THE Aztec world comes from different traditions, some of considerable antiquity. The artisans of the Postclassic period recovered original models in situ in the ruins of their ancestral cities, mainly Teotihuacan and Tula. Teotihuacan was considered to be the place of origin of the fifth sun and thus the site of creation, and was therefore regarded as supremely sacred. The Aztecs carried out excavations of the ruins there and recovered ceramics, carved stone figures, and valuable masks, which they gave as offerings to the gods at the Templo Mayor. They often embellished these objects with paint or other ornamentation, reusing them to connect their present with the past. They also copied the architectural forms and bright polychrome mural decoration of Teotihuacan in the buildings in their own capital, Mexico-Tenochtitlan, adding animal figures sculpted in stone to constructions as the ancients did. One important example of continuity is the serpent heads that begin and end the framework around both sides of the stairways of the Templo Mayor.

The Aztec presence in the city of Tula was unique. In the course of migrating from Aztlan, the Aztecs had settled in the remains of the abandoned city for at least two decades. The ruins retained signs of their original greatness, including sculptures of ancient deities and columns in the form of serpents as well as images of powerful ancestral warriors, which archaeologists have called caryatids or atlantes. These figures were designed to support the temples that were built, according to legend, by Quetzalcoatl himself. Forms and styles from even more distant times were familiar to the Aztecs as well. In fact, when the Aztec armies expanded into far-off territories, they obtained as tribute cast-off items from the Olmec period (ca. 1300–400 B.C.) and material evidence of other cultures that preceded them. The Mezcala was one such culture, which flourished in the valley of the Mezcala River. Among the objects recovered there were anthropomorphic figures and curiously simple masks with a geometric orientation that approaches abstraction.

Given the importance the Aztecs placed on the past, there was nothing unusual about their plans to evoke the ancient city of Tula in Mexico-Tenochtitlan. Once again, there would be a grand metropolis covered with stones decorated with eagles and jaguars. Atlantes would cover the horizontal space (the *axis mundi*) and there would be new renditions of the *chacmools* (ritual attendants) associated with fire and water and bearing the insignia and ornamentation of the rain god Tlaloc.

By the fifteenth century A.D. the Aztec empire was flourishing in various indigenous capitals of the central valleys of Mexico, such as Tetzcoco, Xochimilco, and Calixtlahuaca. During their ascendancy the Aztecs also fostered

13. Sculpture of a king
Huaxtec, 13th or 14th century

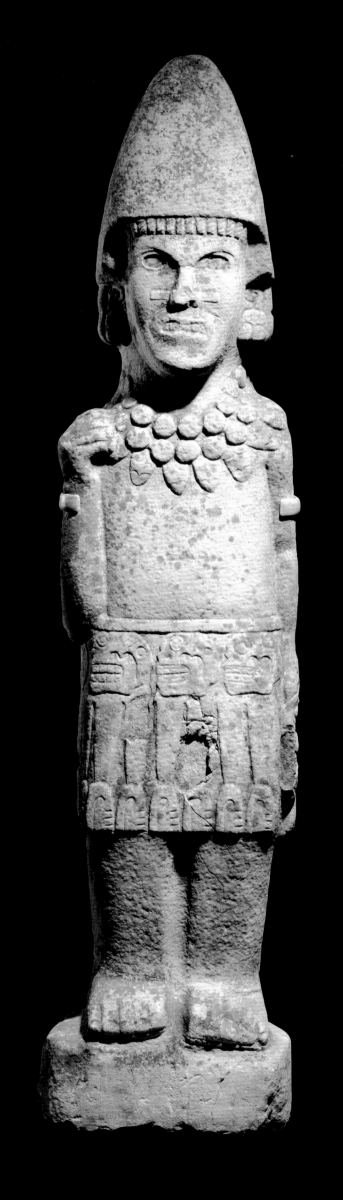

artistic developments. This was particularly true for sculptors of the period who developed new formal designs, creating images of men and women that would signify each new era. Depictions of male figures were imbued with the maturity associated with procreation and sustaining the family and the state. Thus, these sculptures present the forms of young adult men, their sexual organs discreetly hidden by a simple *maxtlatl*, a garment that was strictly masculine. Depictions of females were different: Because sculptors felt bound to exalt young matrons as fertility symbols, they were shown with bared breasts. In reality, women did not reveal themselves in this way, with the exception of some people from the coast of Oaxaca and Guerrero, who maintained this ancestral tradition.

Many stone images also honor women's garments of the period. By way of a skirt, a wrap called a *cueitl*, in a range of designs, was used to cover the lower part of the body and held in place with a sash, while a very long blouse called a *huipil* covered the torso. As there were a great number of people from other regions of Mesoamerica living in Mexico-Tenochtitlan and neighboring cities, it was not unusual to see a wide variety of female garments. One was the *quechquemitl*, a peculiar article of clothing with a rhomboid shape and a hole in the center through which a woman put her head. It fell as a triangle, in front and back, allowing free movement of the wearer's arms.

In the Aztec period, young adulthood was considered the most significant stage of manhood; however, sculptors also rendered images of old men as well as older women, treating them differently in accordance with their sex. In sculptures of older men, only the faces were covered with wrinkles. Occasionally, the eyeteeth were prominently featured and the incisor teeth were missing to denote age, but the bodies look vigorous; perhaps these images were meant to show men's aspiration not to lose their sexual prowess with the passage of time. Depictions of older women include wrinkled faces; flaccid breasts indicate the effects of childbearing and nursing on the female body.

In the monumental sculptures that undoubtedly served a ritual purpose, these basic formal models depicting the sexes were embellished with many other garments and ornaments for representing the various deities. Thus, the effigies were transformed into personifications of the gods, indicating the importance the human figure had acquired. Sculptors were expressing themselves more freely than they previously had, exploring the mystery of rendering human movement. They extended the standard sculptural repertory, daring to show figures on bent knee or seated in a lotus or half-lotus position in addition to more traditional, rigid poses accentuated by vertical or seated positions. The Olmec had achieved formal liberation of the human body two millennia earlier by turning the torso in the famous sculpture known as The Wrestler (600–400 B.C.), and Aztec sculptors rediscovered this technical and artistic advance by turning the heads of some figures to one side. This style reached its fullest expression in the Dancing Monkey sculpture (ca. 1500), which turns its body in a spiral movement.

The artistic modes of the Aztecs influenced the people they conquered. Sculptures in the Aztec style were placed alongside indigenous images and representations by the Huaxteca and Totonaca from the Gulf Coast, the Mixteca of Oaxaca, and peoples in the state of Guerrero. The Aztec style, which became known as the international style, allowed its practitioners to integrate the various forms of visual communication prevalent during the epoch into a cohesive approach.

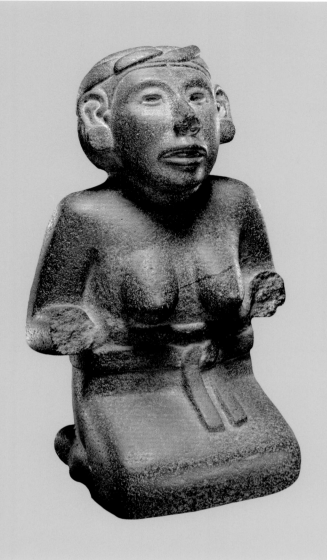

Clockwise from top left.

14. Female anthropomorphic
sculpture
Aztec, ca. 1200–1521

15. Macehual
Aztec, ca. 1500

16. Old man
Aztec, ca. 1500

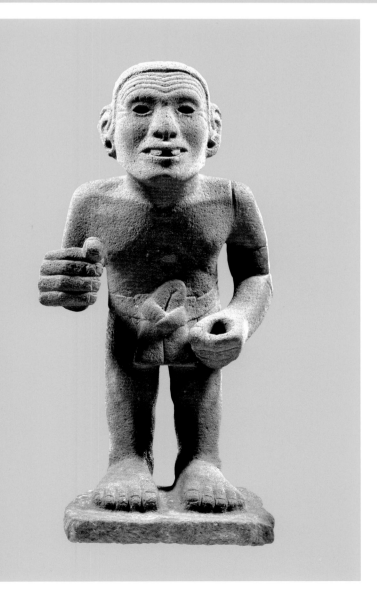

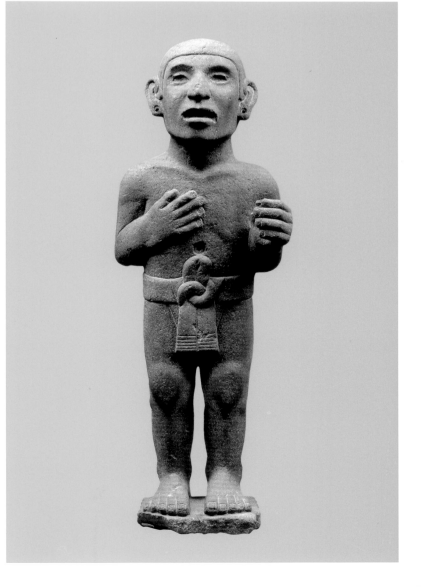

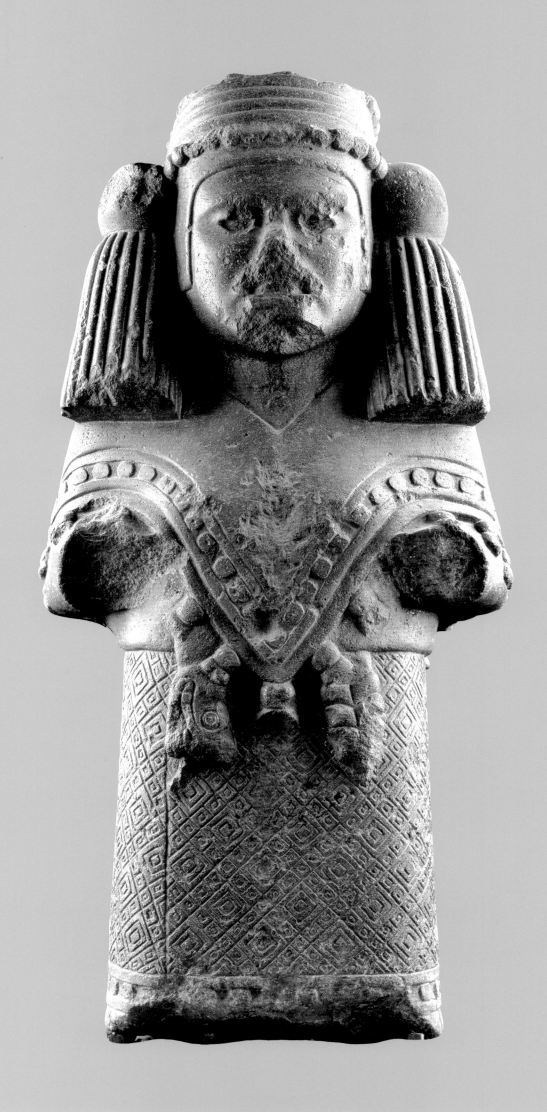

17. Chalchiuhtlicue
Aztec, ca. 1500

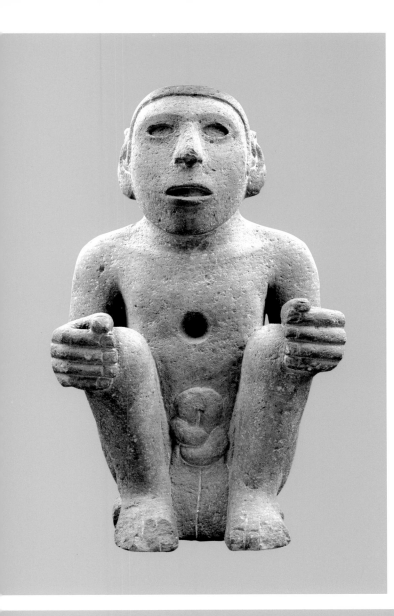

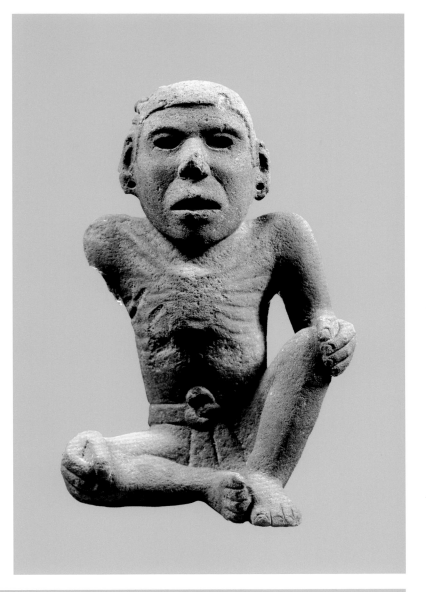

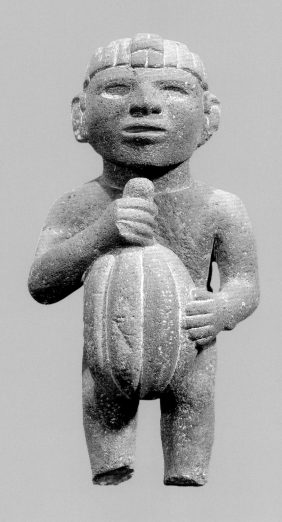

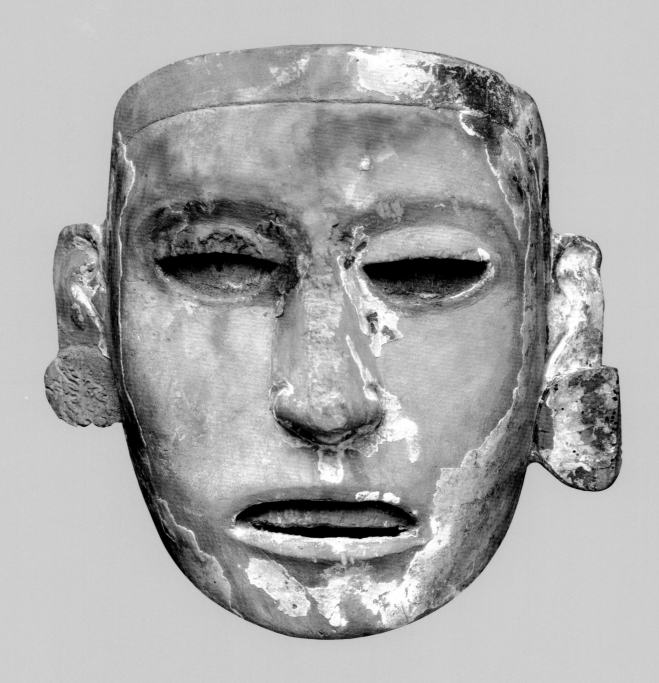

Facing page, clockwise from top left:

22. Female anthropomorphic sculpture
Aztec, ca. 1500

23. Male anthropomorphic sculpture
Aztec, ca. 1500

24. Anthropomorphic figure
Huaxtec, ca. 1500

25. Fertility goddess
Aztec-Matlatzinca, ca. 1500

21. Mask
Eastern Nahua-Mixtec, ca. 1500

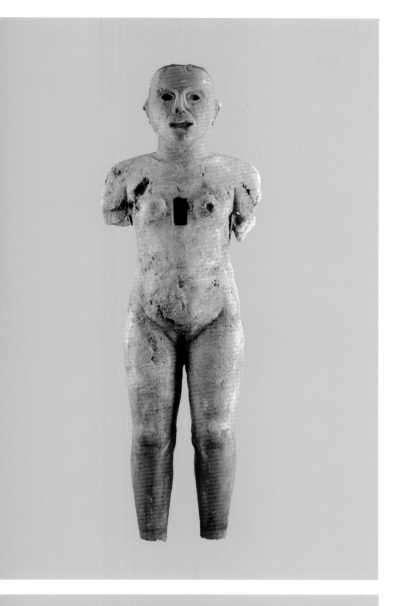
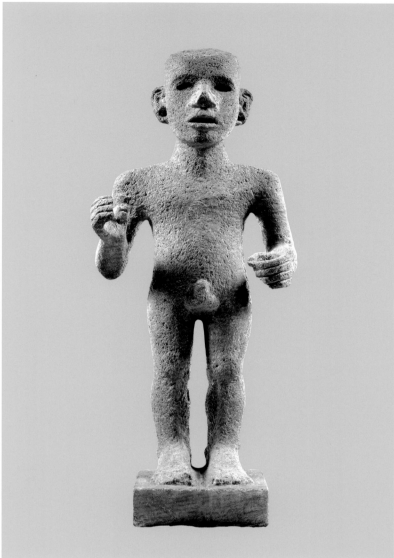
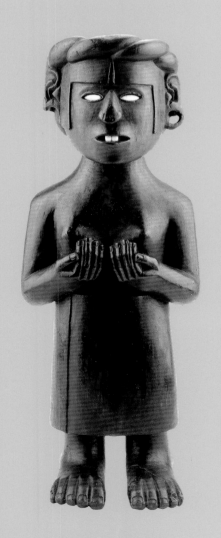
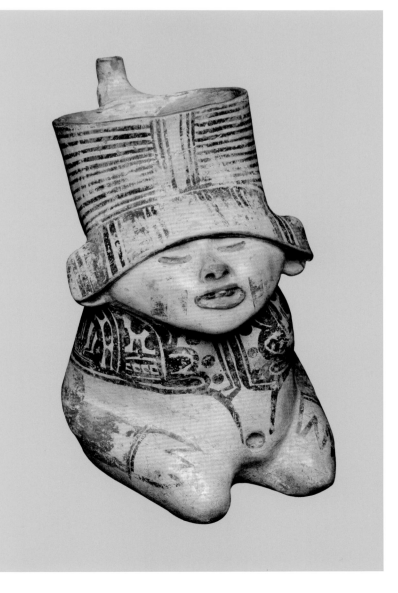

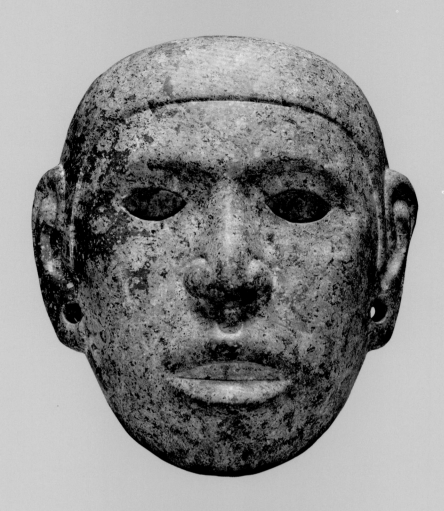

26. Anthropomorphic mask
Aztec-Gulf Coast, ca. 1450–1521

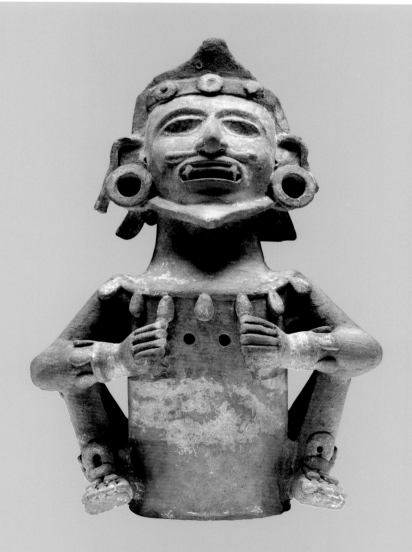

27. Xantil
Mixtec, ca. 1250–1521

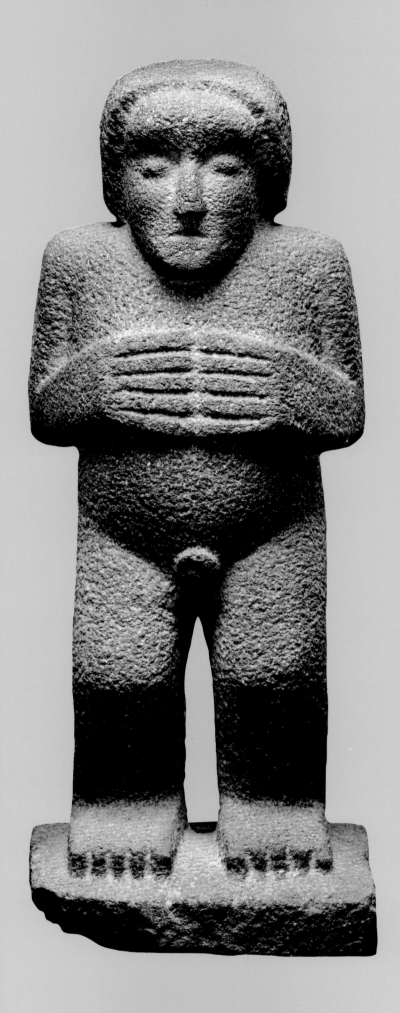

28. Anthropomorphic sculpture
Tarascan, ca. 1500

The Olmec

Ann Cyphers

THE STORY OF CREATION AS TOLD BY THE OLMEC WILL NEVER AGAIN BE HEARD. ALSO LONG forgotten is their true name, as the term "Olmec" ("inhabitant of the rubber country") is borrowed from a culture that many centuries later inhabited the same land in the southern Gulf Coast lowlands in the Mexican states of Tabasco and Veracruz. Without surviving written documents, knowledge of America's earliest civilization must be gleaned from the pieces that have survived the ravages of time in an unforgiving tropical environment. The ephemeral nature of most Olmec remains challenges archaeologists to discover their meaning and function, but luckily their splendid stone sculptures survive intact, bearing immutable testimony to ancient aristocratic beliefs.

Between 1500 and 400 B.C., the Olmec exploited their jungle-covered surroundings with means that, though primitive, were apparently quite fruitful, since food production sustained significant population concentrations (more than 10,000 people) in and around each of the regional capitals of San Lorenzo and La Venta. The intense consumption of fish, turtle, freshwater shrimp, and other aquatic resources obtained in the bounteous rivers, lakes, swamps, and floodplains was complemented by root crops, maize, palm, squash, chilies, and beans, as well as deer and other hunted fauna. The high grounds safe from flooding were used for swidden (slash-and-burn) agriculture, and recession techniques were implemented in the floodplains.

The first Olmec monumental stone sculptures, fashioned between 1200 and 1000 B.C. for the most privileged social sector, embody numerous concepts about rulers and the political structure, origins, social relations, and religion. Carefully devised images destined to aid in managing and disseminating the Olmec leaders' worldview were ostentatiously produced in basalt, a sacred volcanic stone. The transport of these monuments from basalt sources in the neighboring Tuxtlas mountains to the capitals, a distance of 60 to 100 kilometers, required the efforts of hundreds, perhaps thousands, of subjects. It is staggering to imagine the human exertion and organization involved in moving even the minimum volume of stone—150 cubic meters, or 450 tons—required for making the 159 monuments present in the San Lorenzo region between 1200 and 800 B.C.

Among the heaviest of all monuments are the large thrones (previously called "altars"), each weighing more than 22 tons. Each sculpture was not only a monument to a particular ruler, but also an icon of the office held by that ruler. The size of these cyclopean symbols of individual rulers, also icons of the office, was clearly related to the magnitude of the sovereign's power, since the larger the monument, the greater the human exertion required for its transport.

Colossal heads are often considered the hallmark of Olmec art and culture. Their size, in contrast to that of thrones, does not always reflect the intensity of sovereign power, as many were not sculpted from raw rock in the distant basalt

29. Male anthropomorphic sculpture
Olmec, ca. 800 B.C.

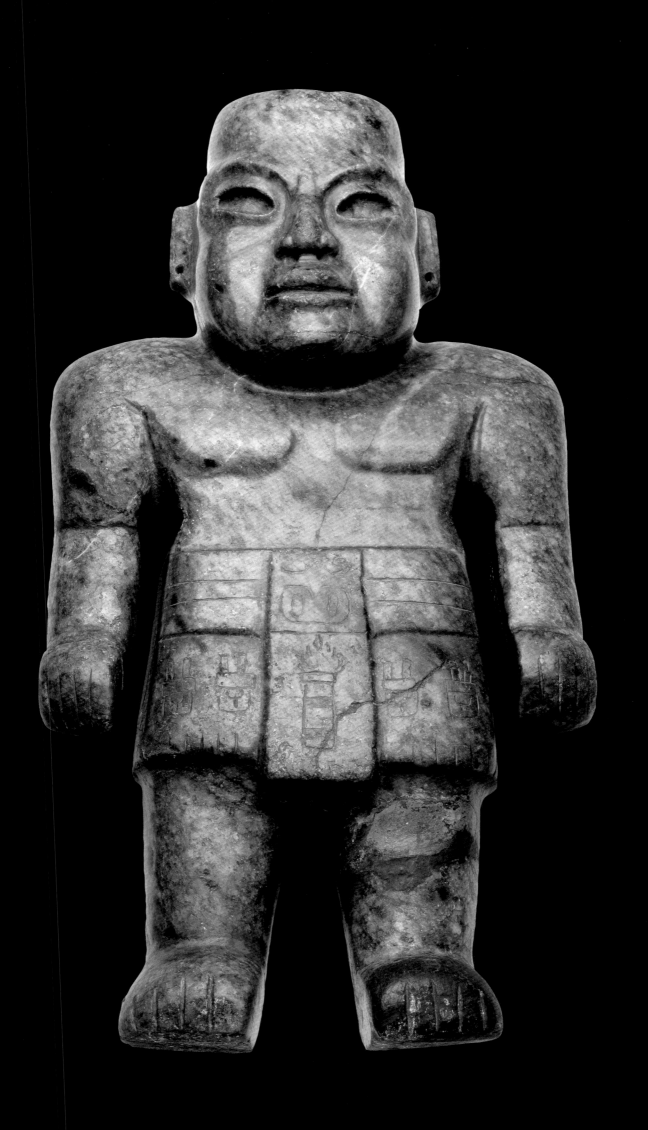

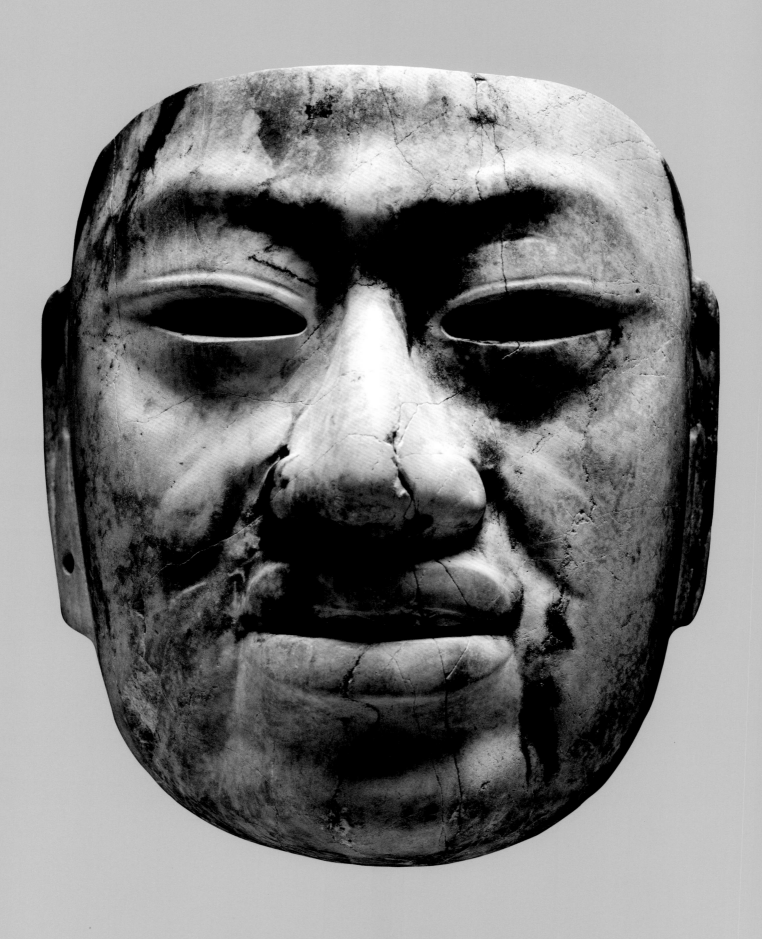

30. Mask
Olmec, ca. 1150–550 B.C.

flows. Rather, some were made from previously existing monuments, such as thrones, and thus did not entail transport from afar. The production of nine colossal heads—each a portrait of a ruler—near the end of San Lorenzo's period of maximum florescence, 1200–800 B.C., seems an impressive feat; nonetheless, since each head was sculpted from a recycled monument, this allegorical commemoration constituted a singularly fictitious display of power by waning rulers, who perhaps could not mobilize sufficient labor for long-distance conveyance.

Olmec rulers considered themselves the descendants of specific sacred ancestors who dwelled in the underworld. The concept of divine right is patent on the front of large thrones where a seated ancestor emerges from a niche symbolizing the origin cave, the mouth of the earth monster deity and the entrance to the underworld. In elite society, it is likely that social position was defined by the genealogical distance to the apical lineage ancestor. Hierarchically ordered lineages ranged from royal and aristocratic ones to those lacking a real or fictive blood relationship to a divine precursor.

Olmec art abounds in human figures depicting ideal physical forms. Robust bodies and chubby faces with squared jaws, down-turned mouths, and slit eyes are salient elements of figures represented in monumental art, whereas bodies may be slender in small greenstone objects. Another major theme in Olmec art is thought to be shamanistic in nature. Fantastic figures with gradations of anthropomorphic, zoomorphic, or unnatural qualities may represent stages in the ritualistic transformation process. Embedded in a social and political milieu charged with mysticism, transformation rites provided the means to commune with the supernatural, as did the ceremonial ballgame, in which the cosmic battle between the sun and darkness was reenacted.

The Olmec succeeded in uniting the vast coastal region in social, political, and economic networks. Terrestrial and water routes formed their elaborate communication and transportation system; long artificial causeways built next to rivers were likely used as docks for dugout canoes. The difficult but vital task of governing strategically located villages founded in remote portions of the vast landscape was achieved through a vertical and horizontal web of social and political relations and a cohesive ideology. The distribution of utilitarian and luxury resources took place in the regional network as well as with places as far away as El Salvador. Among the items traded was obsidian, a volcanic glass used for practical and ceremonial purposes, which was obtained from more than twenty quarries located in Central Mexico and Guatemala. Iron ores, used for adornments, tools, and ceremonial objects, were acquired from Chiapas and Oaxaca. Native petroleum resources, such as bitumen (used as a sealant and resin), were traded locally and to distant places. Small statues, plaques, personal adornments, and axes made from various kinds of greenstone procured from sources in Guatemala and Mexico were widely exchanged outside the Gulf Coast region.

Olmec ways of life and worldview did not completely disappear from Mesoamerica when this culture drew to a close around 400 B.C. Like the Aztecs, their origin myth was set in caves; the succession and legitimating of dynastic rulers was based on divine genealogical rights; they occupied a region with abundant water and built transportation architecture; a complex subsistence system based on agriculture, hunting, fishing, and collecting underwrote the production of important craft commodities, which were used in long-distance exchange; and the ritually and politically significant ballgame embodied ideological elements related to celestial struggles similar to those in Aztec cosmology. As the first dominant cultural group in Mesoamerica, the Olmec were key contributors to fundamental cultural processes implicated in the early development of Mesoamerican historical traditions, and their influence was felt both near and far.

Teotihuacan

Linda Manzanilla

WHEN THE AZTECS ARRIVED IN THE BASIN OF MEXICO, TWO PROMINENT CULTURES—THE TOLTEC and Teotihuacan states—were collapsing or had already collapsed there. The earlier of these, Teotihuacan, had dominated the economics, politics, and symbolism of Central Mexico during the first six centuries A.D. Its capital, a huge metropolis that controlled important resources such as obsidian (the basis of its technology), was a planned urban site, a multiethnic city, a crafts center, and a sacred place, conceived as a model of the Mesoamerican cosmos. Because it was a prestigious crafts center and a sacred city, some archaeologists since the 1960s have proposed that the mythical Tollan (the archetypal city) was Teotihuacan and not Tula, the seat of the Toltec empire, as was long believed.

When the volcanic eruptions of the first century devastated the southern part of the Basin of Mexico and the slopes of Popocatepetl, many sites were deserted, their inhabitants fleeing to different regions. One such region was the Valley of Teotihuacan, where the Pyramid of the Sun was built in the second century as a temple of fertility intended to appease the violent fire gods. The city of Teotihuacan eventually covered 20 square kilometers, the construction material being quarried from underground tunnels. The city had an urban grid with a main north-south axis, the Street of the Dead. An east-west axis originated from the Ciudadela and Great Compound, perhaps emulating a former east-west street that had departed from the Pyramid of the Sun.

Throughout Mesoamerica, the cosmos was conceived as three superimposed levels: at the bottom, the underworld; in the middle, the earth, divided into the four quarters of the universe; and at the summit, the sky. The symbolism of the quartered world found expression in various forms. Many references to the number four are found in Teotihuacan: The four-petaled flower may have been the glyph of the city; the pre-Hispanic tunnel excavated by the Teotihuacanos under the Pyramid of the Sun ends in a four-petaled chamber; the palace of Xalla, just to the north of the Pyramid of the Sun—perhaps a decision-making compound—had a central plaza with four structures, each directed to a cardinal point, around a central temple; and it is possible also that the city was coruled by four lords.

Many elements of urban planning were present in this orthogonal city: streets and avenues arranged on a grid, a well-planned drainage system, large basins for the storage of water, a center that included the main religious and administrative structures, multifamily house-compounds, and distinct wards for people of various trades or places of origin (such as the Oaxaca and merchants' wards, as well as, possibly, a small Michoacan enclave). The architectural style of the *tablero-talud* (in which a sloping wall, the *talud*, leads up to a flat table, the *tablero*), already present in the Formative sites of the Valley of Puebla-Tlaxcala, was reproduced in most of the constructions throughout Teotihuacan. It was then adapted to regional styles throughout Mesoamerica.

31. Goddess figure (Chalchiuhtlicue)
Teotihuacan, ca. 250–650

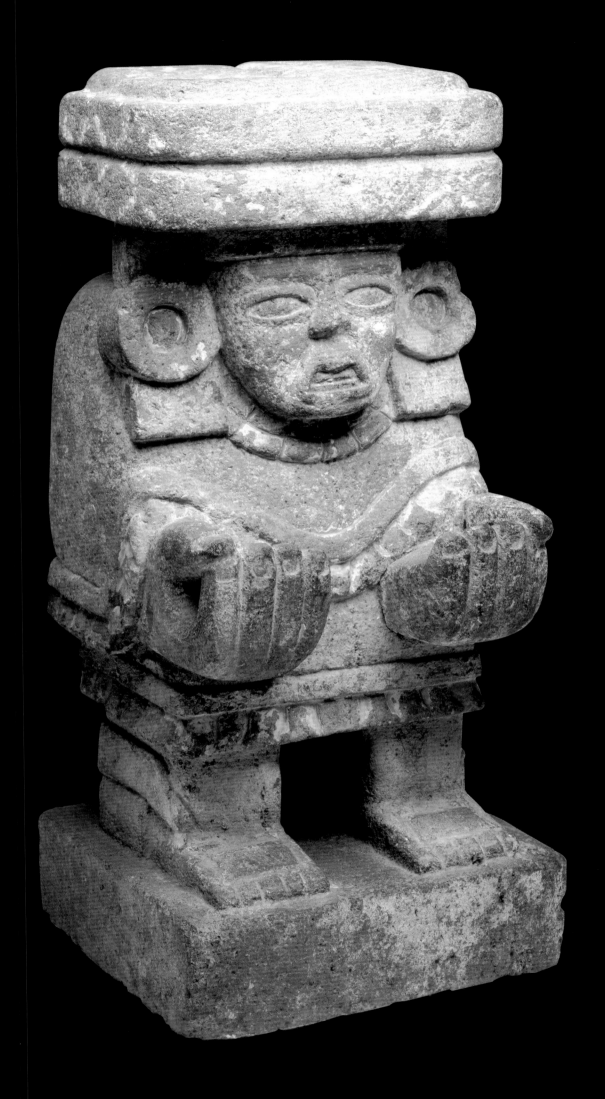

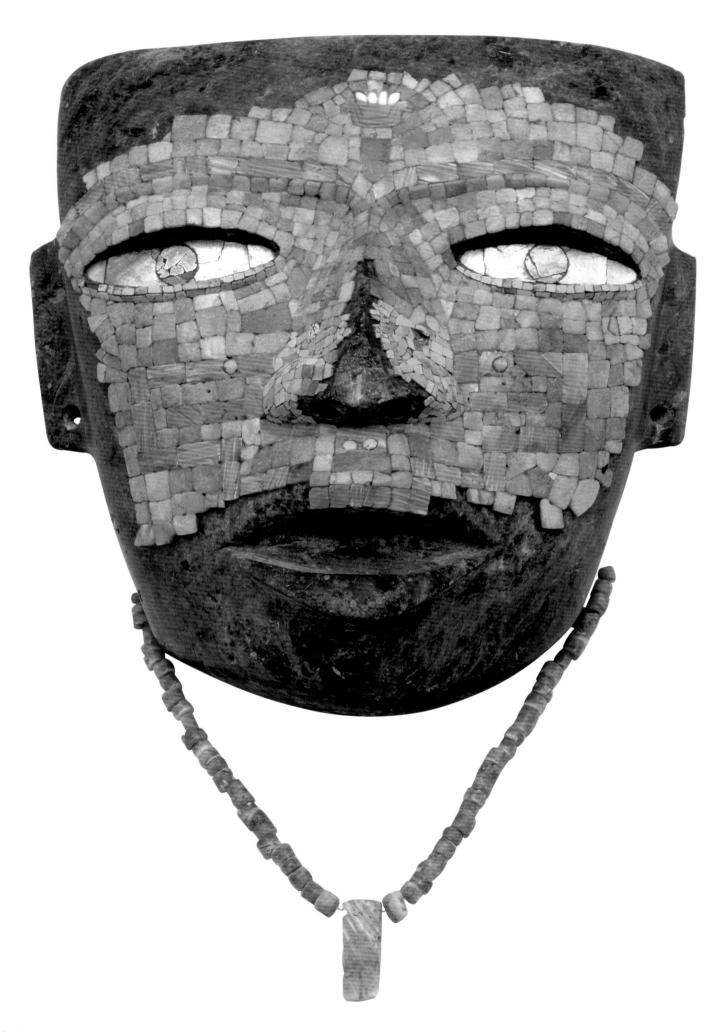

32. Anthropomorphic mask
Teotihuacan, ca. 450

In Tenochtitlan, the Aztecs copied this style in some constructions of the sacred precinct to recuperate Teotihuacan's past. The division of Teotihuacan into four quarters and its organization of wards may also have been emulated in Tenochtitlan.

Teotihuacan housed around 125,000 inhabitants, most of whom were bureaucrats, craftsmen, or constructors. Among the craftsmen were different groups of potters manufacturing diverse wares, obsidian knappers, craftsmen polishing stone tools for grinding or woodworking, lapidaries, tailors, shell workers, and so on. Some of their products, such as painted stucco tripod vessels or green obsidian prismatic blades, traveled far in Mesoamerica. Others, such as funerary masks, have not been found in situ but are largely known from private collections.

The Valley of Teotihuacan was profusely occupied by the Aztecs, who built houses on top of the ancient city, and there is evidence of the extensive disturbance of Classic contexts by these Postclassic inhabitants, particularly in the periphery of Teotihuacan, either to extract stone for the construction of new buildings or to recuperate objects such as vessels, masks, portrait figurines, and other items (like those found in the Templo Mayor in Tenochtitlan). Throughout Mesoamerica, strict rules governed the placement of such objects—in front of temple stairs or in temples themselves, for example—but Teotihuacan objects such as portrait figurines are also commonly found in agricultural fields and other secular sites. Excavations inside quarry tunnels behind the Pyramid of the Sun, where Aztec food-preparation areas were found, likewise uncovered Teotihuacan portrait heads, perhaps used as small idols.

After Teotihuacan fell around 550–600, the quarry tunnels that had been excavated to extract the volcanic scoria to build the ancient city were occupied by post-Teotihuacan groups: the Coyotlatelco, Mazapa, and Aztecs. The *Codex Xólotl* depicts the two main pyramids (Sun and Moon) on top of a "cave" with a person inside. It is likely that this figure represents the oracle mentioned in the *Relaciones geográficas.* The last Aztec *tlatoani,* Motecuhzoma II (reigned 1502–20), visited Teotihuacan to be invested of the power to rule and to consult the oracle.

When the Aztecs arrived, they interpreted the city of Teotihuacan—already an archaeological site—as the mythical place where the gods assembled and sacrificed themselves to create the fifth sun. Thus, Teotihuacan was conceived as a place of beginning for the Late Postclassic groups of the Basin of Mexico. It was visited as a sacred place, a site of pilgrimage. The Postclassic tradition attributed to giants the construction of the metropolis. The Aztecs named the site (Teotihuacan, meaning "the place where persons were converted into gods"), as well as the main constructions and axes (the Pyramid of the Sun, Pyramid of the Moon, and the Street of the Dead). The Aztecs symbolically derived their ancestry from both Tula and Teotihuacan, but it was Teotihuacan that inaugurated the era of large capitals in and around the Basin of Mexico, including the Aztec capital of Tenochtitlan.

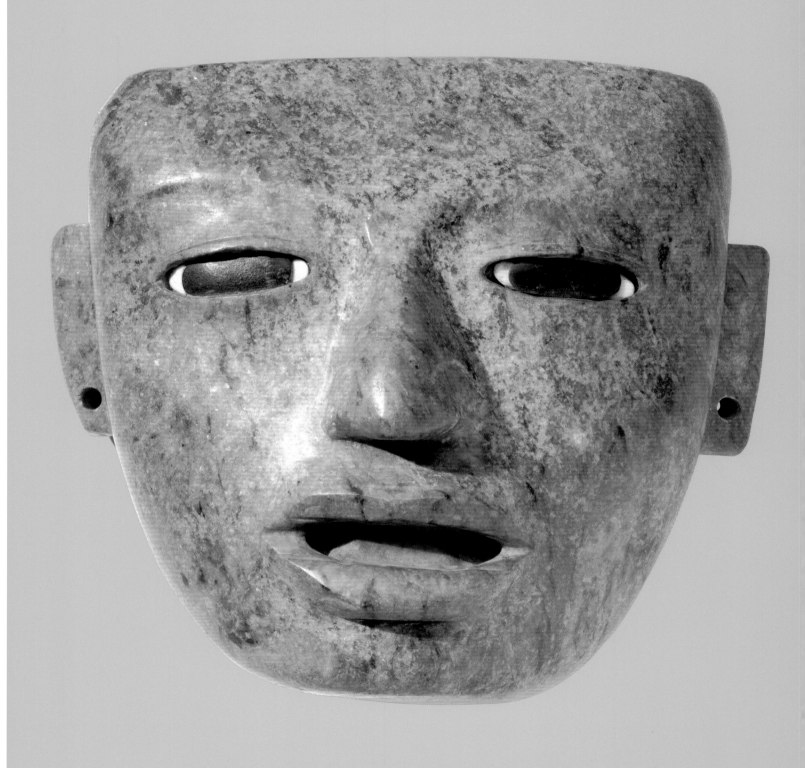

33. Face panel
Teotihuacan, ca. 1–800

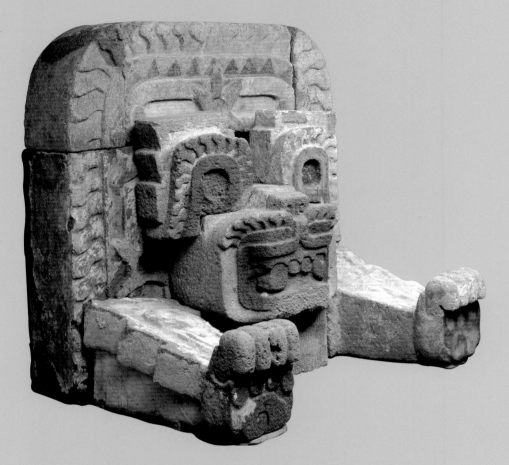

34. Jaguar architectural element
Teotihuacan, ca. 400

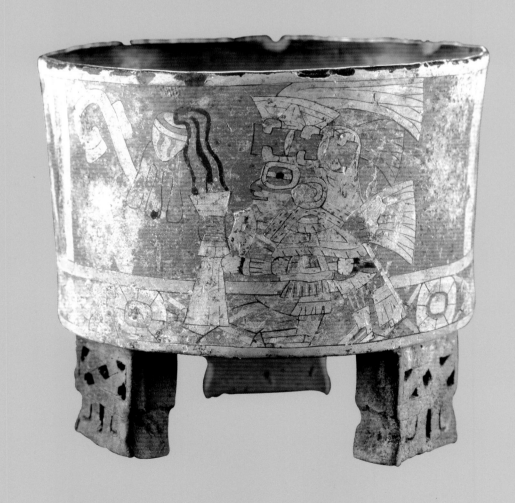

35. Polychrome tripod vase
Teotihuacan, ca. 450

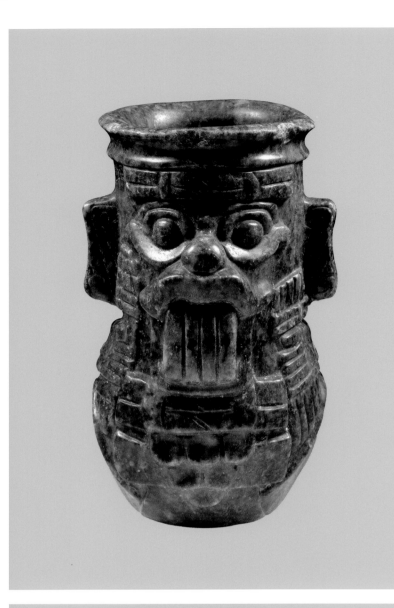

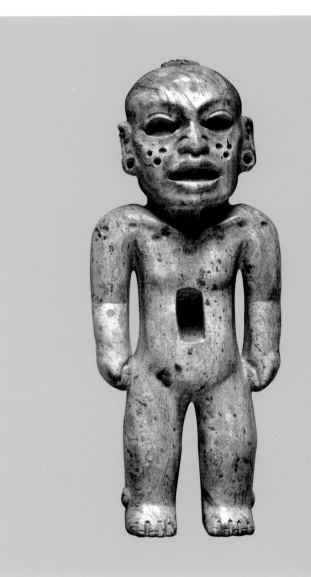

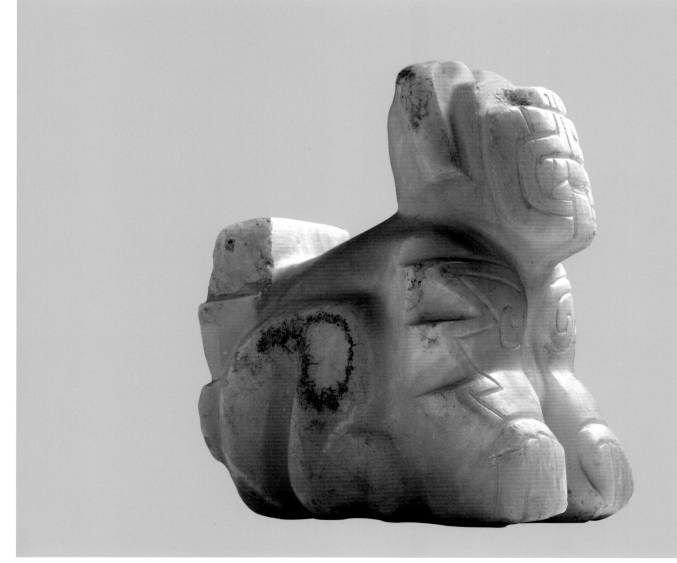

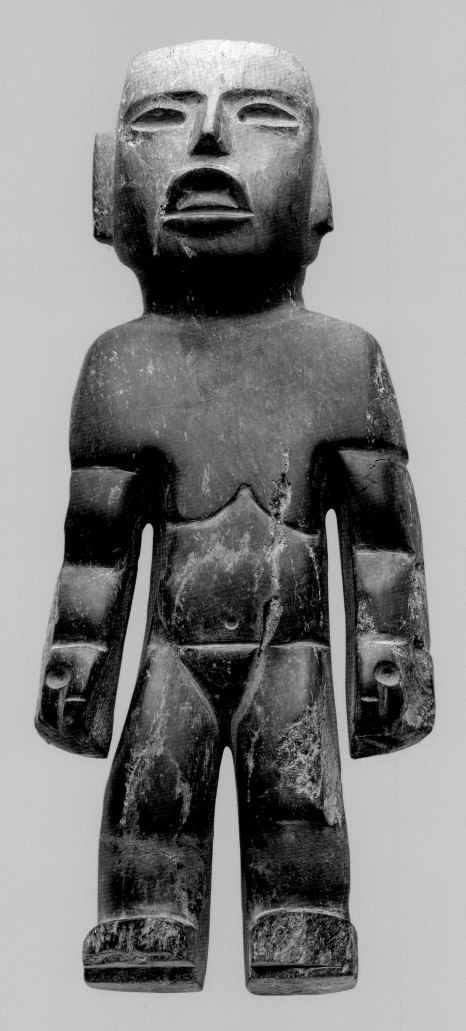

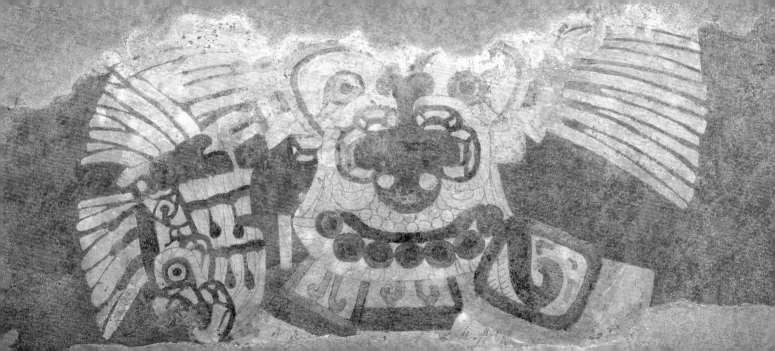

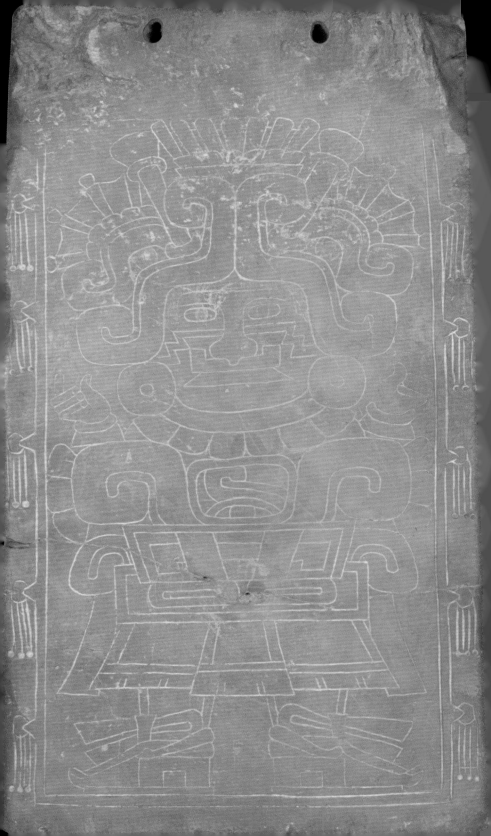

Tula and the Tolteca

Richard A. Diehl

THE AZTECS INHERITED A RICH CULTURAL AND ARTISTIC TRADITION FROM THEIR PREDECESSORS. While many elements of this tradition were basic to all Mesoamerican cultures, Aztec leaders deliberately chose certain others in an effort to establish real or invented kinship with glorified ancestors. As Leonardo López Luján recently observed, these efforts included the reuse of older objects, often obtained through excavations into ruined buildings, and the imitation or replication of ancient forms. While some of these borrowings reached back 3,000 years, others drew on more recent cultures—most significantly, the giant Classic period metropolis at Teotihuacan and the smaller but ideologically charged ruins at Tula, the ancient Toltec capital located 70 kilometers north of Tenochtitlan.

Tula occupied a defensible ridge overlooking the confluence of the Tula and Rosas rivers. Founded during Central Mexico's "dark ages" following the demise of Teotihuacan, Tula emerged as Mesoamerica's largest city and the seat of an extensive empire by A.D. 1100. The Aztecs considered the Tolteca to have been renowned artisans, builders, warriors, merchants, and philosophers.

At its height, Tula covered 13 square kilometers and had more than 50,000 inhabitants living in tightly packed multifamily compounds surrounding the main ceremonial precinct on the bluff overlooking the rivers. The precinct contained temples, palaces, and other public buildings that formed the stage on which Toltec elites enacted public life and formulated state policy.

Terraced square or rectangular platforms (often referred to, mistakenly, as "pyramids") topped with flat-roofed masonry buildings were the most common Toltec architectural form. One unusual structure, located at the north edge of the city, incorporated round sections, which suggests that it was dedicated to the Mesoamerican deity Quetzalcoatl in his guise as the wind god Ehecatl. Public buildings included temples, ballcourts, skull racks, small open-air adoratories, "palaces" that probably served as meeting halls for local and foreign dignitaries, and elite residences. Masonry columns supported the roofs of most public buildings, although Pyramids B and C, Tula's two largest buildings, employed round stone drums carved in the likeness of atlantean Toltec warriors. Smaller stone sculptures included bench facade tablets depicting ceremonial scenes, wall plaques, roof ornaments, small atlantean altar supports, and recumbent *chacmool* sculptures thought to have served as sacrificial altars. Plain or carved tablets covered with stucco and, at times, polychrome paint decorated the exterior walls of platforms. Those on Pyramid B depict jaguars, coyotes, eagles, and vultures, perhaps emblematic of Toltec warrior societies, alternating with a fantastic creature that combines human, feline, and avian characteristics. A freestanding *coatepantli* (snake wall) covered with carved polychrome panels on both sides closed off the northern side of Pyramid B. Four hundred years later, the Aztecs replicated Toltec architectural forms and layouts, and even some of their decorative motifs, in the heart of Tenochtitlan.

42. Cuirass
Toltec, ca. 900–1200

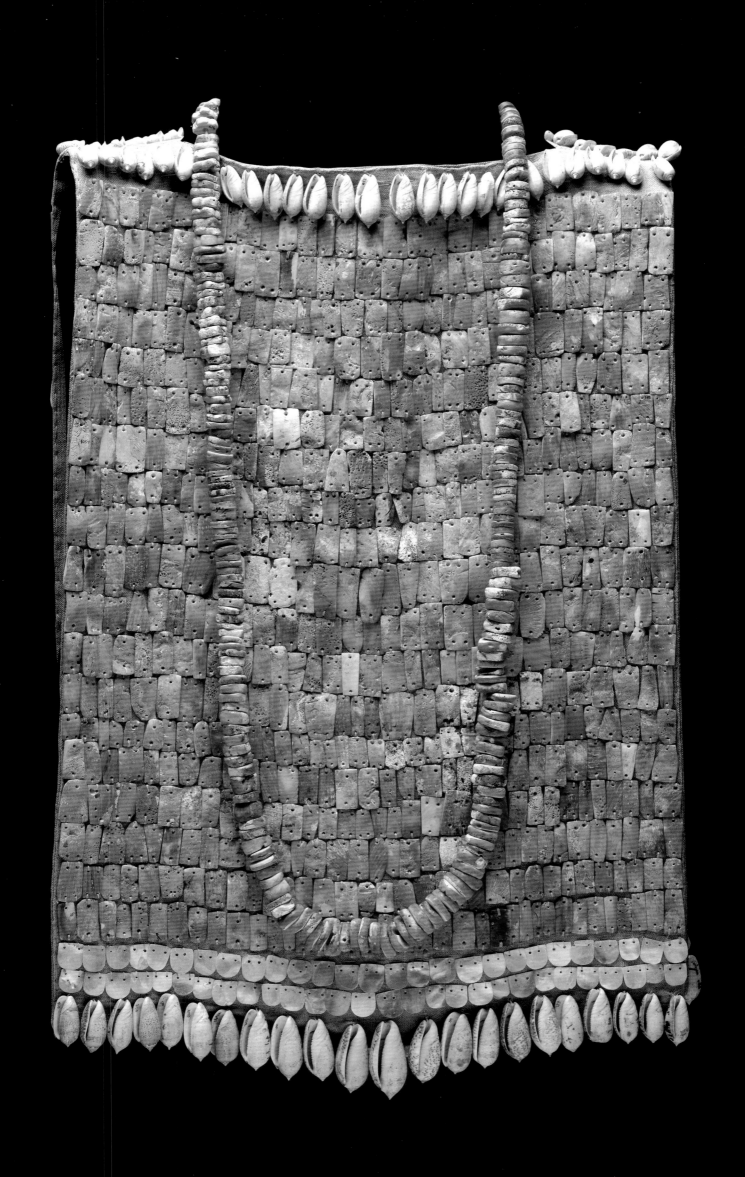

43. Disk
Toltec, ca. 900–1200

Toltec art is often characterized as "crude" and "stiff," attributions that reflect the materials used as much as the skills of the artisans. Nevertheless, even the most avid Toltec enthusiast must concede that while Aztec forms and style were often grounded in Toltec prototypes, Aztec artisans far surpassed their Toltec ancestors' best efforts.

Toward the end of the twelfth century, the Toltec empire disintegrated and Tula was abandoned. The facts of the matter are largely unknown, to say nothing of the causes. Legendary accounts written down by sixteenth-century Spaniards talk of intrigue and internal conflicts among factions, cloaked in a confusing overlay of myths about a struggle between good and evil. The most common of these has the deity Quetzalcoatl, or a priest or ruler who carries his name, defeated or shamed by the dark forces of Tezcatlipoca, god of night and sorcerers. Quetzalcoatl flees to the east and either sails off to Yucatan on a raft of serpents or becomes the planet Venus, promising to return someday.

The archaeological evidence for Tula's demise is not much more enlightening than the legends. Parts of the city apparently were sacked and burned, but these events may have postdated the actual abandonment by decades. Systematic looting of building facades, sculptures, and burial offerings complicate the matter. Graves inside "altars" in house patios were destroyed and their contents removed when the houses were abandoned, but these acts could represent reverential rituals on the part of the departing residents or desecration and plunder by invaders. Later peoples did systematically mine abandoned buildings for sculptures and facade tablets, often leaving offerings of Aztec-style pottery and stone sacrificial knives on the building surfaces.

Although Toltec art and architecture exerted a considerable influence on metropolitan Aztec culture, the culture of the Aztecs was much more than an expanded and refined version of what had existed a few centuries before. Aztec populations were far larger, and Aztec society presumably more complex, than those of the Tolteca. Furthermore, we lack reliable information on many aspects of Toltec life, making it dangerous to compare the two societies in matters such as craft organization, commerce, politics, governance, militarism, religion, philosophy, and worldview. Aztec society must have confronted different and perhaps far greater challenges than those confronted by the Tolteca. Such challenges surely summoned forth institutions that arose out of the Aztec experience rather than any harking back to the past. However, Aztec rulers never lost sight of their Toltec ancestors. When their most sacred idols were in danger of falling into Spanish hands, they are said to have hidden them in a cave near Tula, never to be seen again.

44. Chacmool
Toltec, ca. 1100

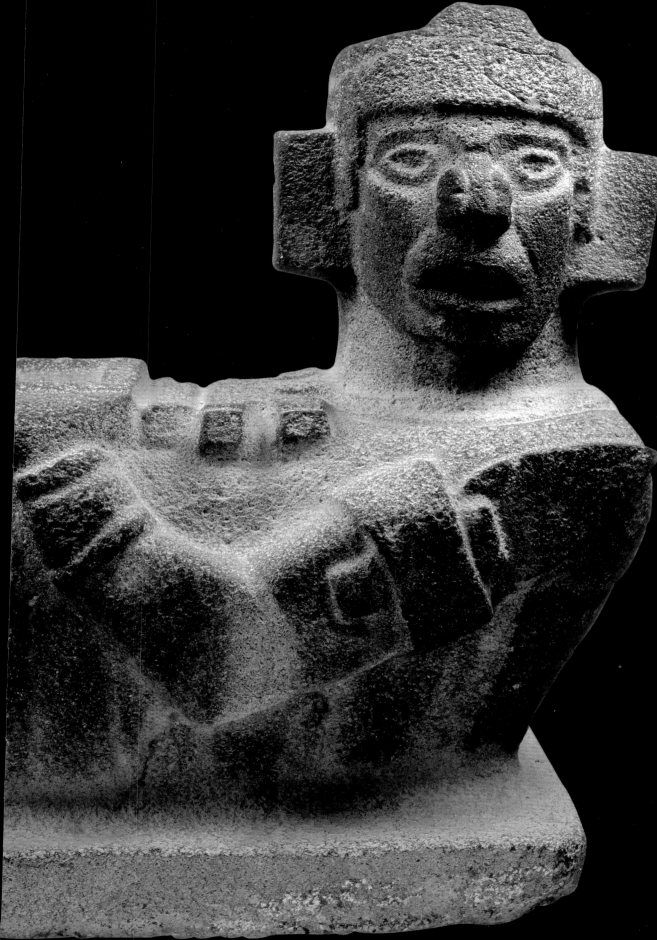

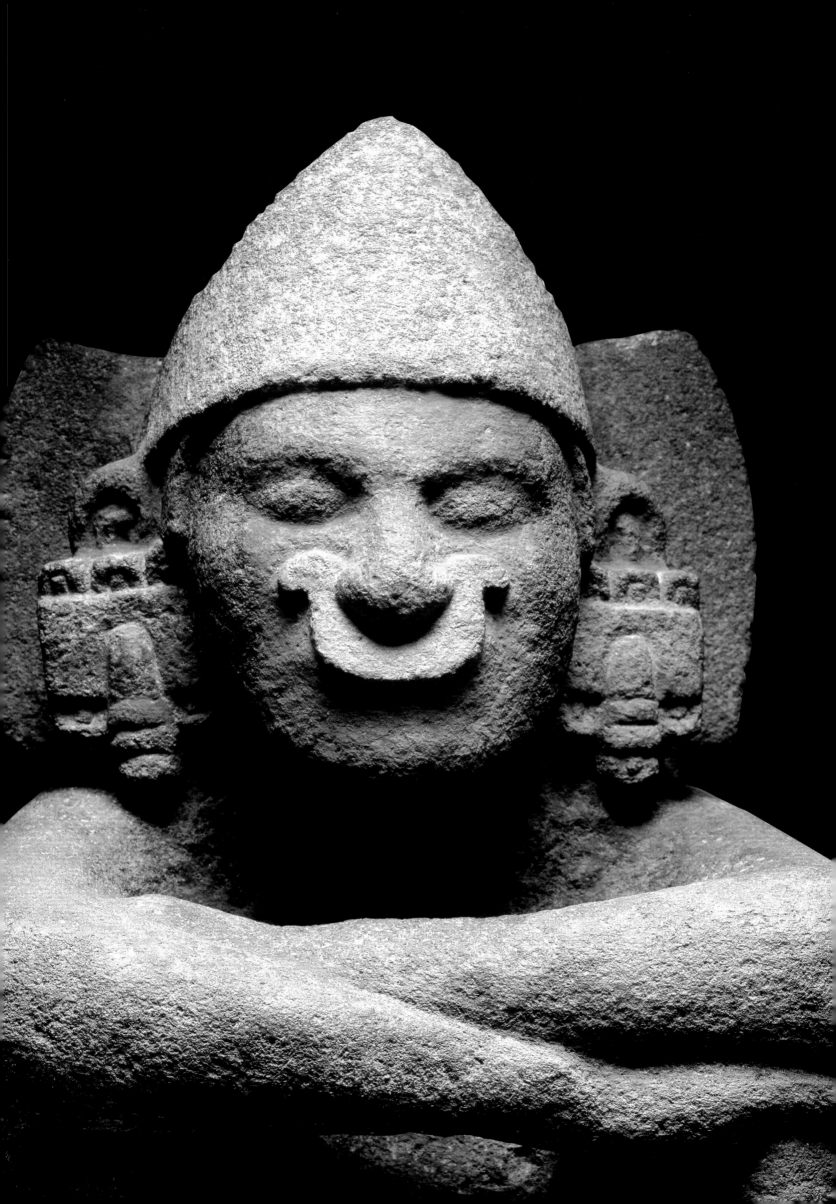

The Templo Mayor

Excavations at the Templo Mayor

Eduardo Matos Moctezuma

AT DAYBREAK ON FEBRUARY 21, 1978, AN EXTRAORDINARY DISCOVERY WAS MADE IN DOWNTOWN Mexico City: Workers from the Compañía de Luz y Fuerza (Light and Power Company), carrying out installation work at the corner of calle de Guatemala and calle de Argentina, came across a relief-covered stone in their path. Realizing that it could be an ancient sculpture, they stopped work and the following day notified the Departamento de Rescate Arqueológico (Archaeological Recovery Department) of the Instituto Nacional de Antropología e Historia (INAH). Department members knew immediately that this was a very important relief and commenced archaeological recovery without delay.

By February 23, it had been determined that the sculpture included a face in profile with adornments on the head. Work continued for another four days, eventually revealing an enormous monolith, 3.25 meters in diameter, with a representation of a decapitated and dismembered nude female carved in relief. Felipe Solís, visiting the site, confirmed that this was a depiction of the Aztec moon goddess, Coyolxauhqui, who, according to myth, was killed by her brother Huitzilopochtli, god of sun and war, following a desperate battle on the mythic hill known as Coatepetl.

From this startling discovery, the Templo Mayor Project was begun. For the next five years, under the auspices of INAH, I directed an interdisciplinary team consisting of archaeologists, biologists, chemists, historians, and physical anthropologists dedicated to unearthing the Templo Mayor and nearby buildings in order to understand the several stages of construction of the temple and the Aztec people themselves. In the process, we found around a hundred offerings that had been placed in honor of the temple and the gods who presided over it: Tlaloc, deity of rain, and Huitzilopochtli. Scholars have noted the dramatically new perspective offered to Aztec studies by the project's findings. Felipe Solís, for example, has stated that research about the Aztecs can be divided into two parts: before and after the Templo Mayor excavations. It must not be forgotten, however, that important discoveries were also made centuries ago. Little by little, the Aztec past has been revealed by the important pieces that have been found and that have enriched our knowledge of the Aztec people.

In 1790, on the orders of Count Revillagigedo, viceroy of Mexico, work began in the Zócalo (main square) of Mexico City to install water pipelines and to pave the plaza. During these operations, various Aztec sculptures were unearthed, among them the famous statue of Coatlicue, the mother goddess, discovered on August 13, 1790, and the Sun or Calendar Stone, found on December 17 of the same year. A contemporary account of these events appears in Antonio de León y Gama's famous work *Descripcion histórica y cronológica de las dos piedras*:

I was . . . moved to write this in order to reveal to the literary world

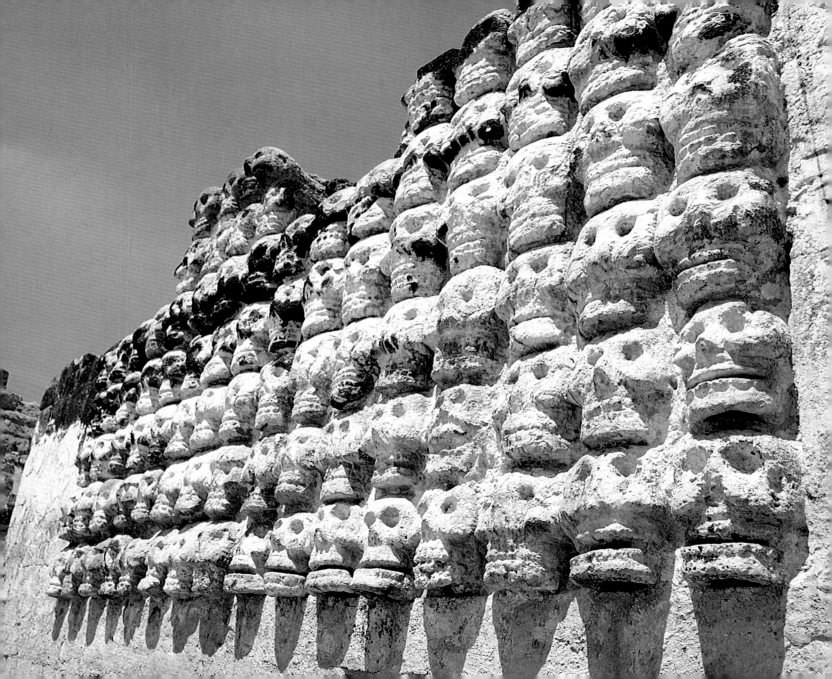

some of the vast knowledge that the Indians of the Americas possessed in arts and sciences in the time of their heathendom, so it will be known how falsely these enemies of our Spaniards are accused of being irrational or simple, in this way discrediting the glorious feats performed [by the Spaniards] in the conquest of these kingdoms. This written account and the pictures of the figures presented here will show that the people who made the original figures were superior artisans, although they had no knowledge of iron or steel; they carved statues of hard rock with great perfection in order to represent their feigned images, and created other architectural works, using as tools for these labors different stones that were even harder and more solid, instead of tempered chisels and steel like axes.[1]

The German explorer Baron Alexander von Humboldt, who visited Mexico in 1803, was particularly interested in archaeological sites and pre-Hispanic monuments, relating his experiences in his *Views of the Mountain Ranges and Monuments of the Indigenous Peoples of America*. Among the sculptures he discusses are the ones discovered in the Zócalo in 1790, including the Coatlicue stone, which had been moved to the Real y Pontificia Universidad on orders of the viceroy, who had had it measured, weighed, and sketched before having it buried in one

of the halls of the university over fears on the part of the clergy that such a "strange sculpture" could provoke antagonistic ideas. Von Humboldt relates:

> Count Revillagigedo, Viceroy, had this monument transferred to the University of Mexico, which he considered the most proper place to conserve one of the rarest remains of American antiquity. The professors, at that time Dominican priests, did not want to exhibit this idol to the Mexican youth, so they buried it again in one of the halls of the building, at a depth of half a meter. Consequently, I would not have been able to examine it if Don Feliciano Marín, then Bishop of Monterrey, had not been going through Mexico on his way to his diocese and, listening to my pleas, asked the rector of the university to have it dug up.[2]

Many years passed before planned excavations in the center of Mexico City were undertaken, although when foundations were dug for buildings, fortuitous discoveries occasionally shed light on pre-Hispanic structures. A major find was made in 1825, when the head of Coyolxauhqui sculpted in diorite was uncovered. Antonio Peñafiel states that this was unearthed below a house on calle de Santa Teresa (now the continuation of calle de Guatemala, east of the Zócalo).[3] This building was the

property of the Convento de la Concepción, and the piece was donated by the abbess to the National Museum.

In 1897, some carved stone pieces were found at the intersection of the Portal de Mercaderes (now the west side of the Zócalo) and calle de Tlapaleros (now calle de 16 de Septiembre), in the southwest corner of the Zócalo. One of these sculptures measured 1.65 meters long, 1.22 meters wide, and 68 centimeters high and had on its sides, carved in relief, armed warriors with serpents above their heads. Another sculpture, 60 centimeters high, was carved with representations of the four suns, or cosmogonic ages, that were believed to have preceded the creation of the fifth sun or the present world.

Leopoldo Batres, who examined remains found beneath calle de Escalerillas (Guatemala) in 1900, described the objects in his *Archaeological Explorations in Escalerillas Street, City of Mexico.* Batres mistakenly locates the Templo Mayor under the Catedral and gives it a southward orientation, even though, as with most pre-Hispanic temples, it actually faces west.

In 1901, during work directed by Porfirio Díaz, Jr., under the patio of the Marquis del Apartado's home—at the corner of calle de Relox (Argentina) and calle de Cordobanes (Donceles)—part of a stairway running from east to west was found, together with a serpent's head with a "4 Reed" glyph carved in relief and a great stone sculpture in the form of a jaguar. In the same place, in 1985, another sculpture representing an eagle was discovered, and is now in the collection of the Museo del Templo Mayor.

Among the most important archaeological investigations carried out in 1913 in the Zócalo area was that undertaken by Manuel Gamio at the corner of calle de Seminario and calle de Santa Teresa. Excavation became possible when a building was demolished, and as a result the southwest corner of the Templo Mayor was discovered. Gamio included various specialists in this project, resulting in expert work on several different aspects of the findings. For instance, Hermann Beyer studied the banquette decorated with warriors and Moisés Herrera classified the flora and fauna.

In 1933, when some buildings were demolished at the corner of calle de Guatemala and calle de Seminario, in the same block as the Catedral—opposite the area investigated by Gamio twenty years earlier—a team led by architect Emilio Cuevas excavated the vacant lots. Architectural features of particular interest found by Cuevas included a very elaborate balustrade and part of a stairway, perhaps belonging to the platform that supported the Templo Mayor in one of its latest stages of construction. Hugo Moedano and Elma Estrada Balmori explored this platform in 1948, finding that it was decorated in the middle of the south facade with snakes' heads, a great serpent's head, and a brazier.

Objects from the ancient city have continued to be unearthed. In 1964, I excavated a decorated altar on calle de Argentina, where a magnificent mural depicting Tlaloc was found on one of the sloping walls. Eduardo Contreras discovered an important offering within the pyramidal structure of the

Templo Mayor in 1966. In 1967, work on the Mexico City subway began in the Zócalo area and resulted in much new information about the ancient city. In 1973, the Archaeological Recovery Department of INAH dug test pits in the parking lot of the Secretaría de Hacienda on calle de Guatemala. Some small altars were found, but unfortunately they had been largely destroyed during the construction of the parking lot. A year later, excavations in the Patio de Honor of the Palacio Nacional unearthed the remains of some columns that had probably belonged to Hernán Cortés's palace. A circular pre-Hispanic altar was also discovered in the rear courtyard of the Palacio Nacional.

In 1975, the Departmento de Monumentos Prehispanicos started the Basin of Mexico Project. Its purpose was to control the constant and anarchic growth of the city and to halt the destruction of archaeological remains. The metropolitan area was divided into four sections, each consisting of a number of zones and under the supervision of a different team of specialists. At the Catedral, work was carried out by archaeologists under the supervision of Constanza Vega. Here, beneath the Catedral, some Aztec buildings and ceramic remains were found. The most interesting discovery was part of a wall inscribed with a glyph that may correspond to the Temple of the Sun. By 1991, excavations under the Catedral had uncovered several buildings in the ceremonial precinct of Tenochtitlan, including the ballcourt. Shrines, offerings, and drains were also found, and several construction phases of the Templo Mayor were located, dating between approximately 1450 and 1500.

Another major find took place in 1988, when a great circular sculpture was discovered. The sun appears in the upper part of the stone, which is surrounded by depictions of the military victories of Motecuhzoma I (reigned 1440–69). The sculpture was located opposite the front steps of the temple honoring Tezcatlipoca, the remains of which are beneath calle de Moneda at the Arzobispado building.

Ten years prior to this, however, work had begun on the Templo Mayor Project. This new undertaking incorporated the Museum of Tenochtitlan Project, which had commenced the previous year with the aim of excavating the area where remains of the Templo Mayor had been found and then setting up a museum at the site illustrating all aspects of the ancient city. The excavations of the Templo Mayor Project would eventually uncover at least seven distinct stages of construction.

Stage I (1325)
Archaeologists have not yet uncovered the site of the first shrine built in Huitzilopochtli's honor, but historical sources state that the god ordered the first temple to be built of wood, reeds, and mud. Fray Diego Durán describes how this temple was erected. His description suggests that it was very small:

"Let us all go, and, in that place where the prickly-pear cactus grows, build a small chapel where our god may now rest; though it cannot be made of stone let it be made of wattle and daub, since that is all we can do for the time being." Then everyone went very willingly to the place where the prickly-pear cactus grew, and, cutting down thick grasses from the reeds that grew next to the cactus, they built a square base, which was to serve as the foundation of the chapel for the god to rest in; and so they built a poor but pretty little house . . . covered with the reeds they gathered from the water itself. . . . [T]hey were so poor, destitute, and fearful that they built even that small mud hut in which to place their god in fear and trepidation.[4]

Recent studies have shown that a solar eclipse took place in 1325, a very significant symbolic event in ancient Mexico. Eclipses were thought to be battles between the sun and the moon from which the sun emerged triumphant. Struggles between the powers of day and night were related in Aztec myths, including the story most closely associated with the Templo Mayor: the battle between Huitzilopochtli and Coyolxauhqui.

Stage II (ca. 1390)
This stage of construction is associated with the shrines to Tlaloc and Huitzilopochtli erected atop the Templo Mayor. The lower part of the temple could not be excavated because it lies below groundwater, but the building is calculated to have been around fifteen meters high at this stage. The two shrines at the top, as well as the two stairways that lead to them, are fairly well preserved.

The side dedicated to Huitzilopochtli was found with its sacrificial stone in situ, opposite the entrance to the shrine. Beneath it, an offering of sacrificial knives and green beads was discovered. At the far end of the shrine was a bench on which a statue of the god must have stood. At its feet, under the stucco floor, were two funerary urns. One, made of obsidian, was found to contain a golden bell and a small silver mask, as well as a small number of bones, which showed signs of having been burnt. The second urn, made of alabaster with an obsidian lid, was found nearby. Inside it were burnt bones, a golden bell, two small greenstone disks, ear ornaments, and obsidian disks. Recent studies have shown that the cremated bones inside the two urns are related, and that, given their placement at the feet of the god, they must have belonged to a high-ranking Aztec. The Aztecs were still under the rule of the Tepaneca of Azcapotzalco in 1390, and so we can assume that these remains belong to one of the first three rulers: Acamapichtli (reigned 1376–96), Huitzilihuitl (reigned 1396–1417), or Chimalpopoca (reigned 1417–27). Everything points to the remains belonging

Excavations at the Templo Mayor in 1978 when the

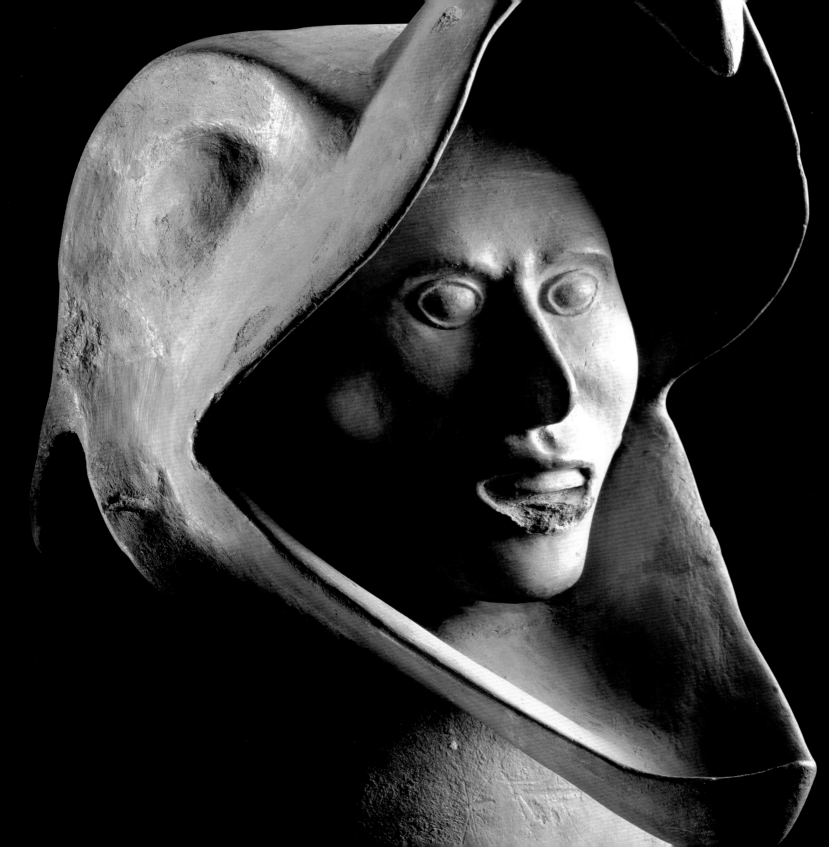

to the last of these. A total of six offerings were found on the Huitzilopochtli side of the temple, of which four were funerary urns. One, a *plumbate* pot (the clay has a metallic sheen) in the shape of a dog, was produced in the southeastern regions of Mesoamerica.

The date given to this stage of construction was taken from a "Rabbit 2" glyph found on the highest step, on the same axis with the sacrificial stone, which corresponds to the year 1390.

On the Tlaloc side, a recumbent figure with a container on its stomach, a statue known as a *chacmool*, lies opposite the entrance to the shrine. This has been identified as Tlaloc. The pillars that form the entrance to the shrine still have the remains of painted decoration on them. On the front are black circles resembling eyes, under each of which is a blue stripe; beneath these blue stripes are two horizontal red stripes attached to vertical black-and-white stripes. Remnants of paintings of a yellow figure with ornaments on the forearms are at the back of each pillar. The figure, who is depicted walking on a blue line that may represent water, is associated with the gods of maize. As in the Huitzilopochtli shrine, there is a bench at the far end of the chamber; here another sculpture of Tlaloc would have stood. Four offerings were found on this side of the temple, three of them inside the shrine. Under the sculpture of the *chacmool*, an offering of fifty-two green obsidian knives (fifty-two was the number of years in the Nahua "century") and forty-one stone beads of the same color was discovered.

There were no marine remains found in any of the offerings uncovered. This is not surprising, given the date ascribed to this stage, as the Aztecs were still under the control of Azcapotzalco at this time and had not yet begun the expansion that would lead them to dominate part of both coasts.

Stage III (ca. 1431)
This stage of construction completely covered Stage II and the various unsuccessful attempts that had been made to build the temple. The date assigned to this stage is derived from the inscription "4 Reed," carved on a stone set into the rear wall at the base of the temple platform on the Huitzilopochtli side, which corresponds to the year 1431. Since the building grew considerably in size with this stage of construction, it is likely that a large number of workers were already available at this time and therefore that Tenochtitlan had taxpayers who were obliged to pay both in kind and in labor. Indeed, in 1428, under the rule of Itzcoatl (reigned 1427–40), the Aztecs had freed themselves from the yoke of Azcapotzalco, creating the Triple Alliance with Tetzcoco and Tlacopan.

Among the most significant finds at this stage were eight recumbent sculptures—some life-size—found on the stairway on the Huitzilopochtli side of the temple. I believe these stone figures represent the Huitznaua, warriors from the south against whom the god of war had to do battle after his birth at Coatepetl. This opinion is based on the fact that some of the figures have a cavity in their chest containing a greenstone, like a heart, while others have their arms crossed over their chest, as if to protect their heart. (According to the story of Huitzilopochtli's birth, the triumphant god ate the hearts of the Huitznaua after defeating them in battle.) Furthermore, several of the figures wear a *yacameztli*, or lunar nose-ring, which is associated with the gods of pulque (a drink made from fermented cactus sap) and the moon.

Recumbent figures were also found on the stairway on the Tlaloc side of the temple: one represents a figure with half its body painted black and the other half painted red. Another piece found on the Tlaloc side was the body of a stone serpent with a face emerging from the jaws of an animal.

A total of thirteen offerings associated with this stage of construction were discovered. Some contained the remains of marine animals; one of these, found at the rear of Stage III on the Tlaloc side, contained a sawfish saw and shells, along with a magnificent blue-painted pot with the raised face of Tlaloc.

Stages IV and IV(a) (ca. 1454)
These stages are attributed to Motecuhzoma I, under whose rule the Aztec empire continued to expand, as is evident in the materials excavated. The richness of the building at this stage is made clear by its symbolic and decorative elements, such as the great braziers and the serpents' heads found toward the center of the north and south faces and at the back of the temple platform. The braziers on the Huitzilopochtli side, characterized by a bow tied to the front, stood on either side of a serpent's head. The ones on the Tlaloc side, in the shape of large pots with the face of the god on the front, still have some of their original painted decoration.

The expansion of this stage of construction, referred to as Stage IV(a), did not involve all four sides of the building, but only the main facade. It is characterized by a very large number of offerings, a strong presence of fish remains, coral, and shells, and a significant quantity of items from the region of Mezcala—now the state of Guerrero—south of Tenochtitlan. The presence of Mixtec stone figures known as *penates* indicates that part of the region of Oaxaca was also ruled by Tenochtitlan at this time.

In Chamber I, on the Huitzilopochtli side, was found a figure identified as Mayahuel, god of pulque, made from a large piece of greenstone that undoubtedly came from the south of Mesoamerica. Chamber II, situated at the center of the stairway leading to the Tlaloc shrine, contained a large quantity of Mezcala-style masks. Another important offering was found in Chamber III, on the Tlaloc side, which contained two multicolored pots with images of Chicomecoatl, goddess of foodstuffs and sustenance. Between the two pots were discovered feline remains and a large quantity of objects and animals from both the coast and the highlands.

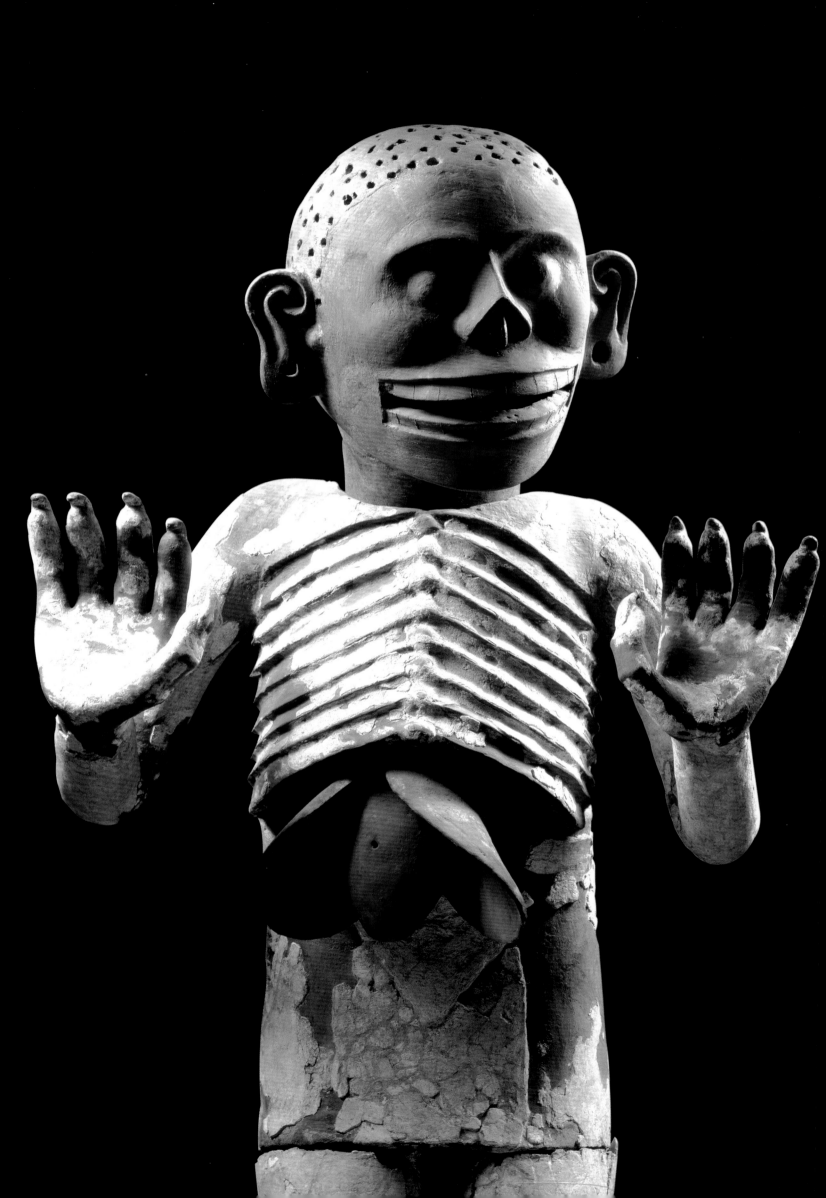

Stage IV(b) (ca. 1469)

This stage, a partial extension to the western side of the Templo Mayor, its main facade, is attributed to Axayacatl, who came to the throne of Tenochtitlan in 1469 and remained in power until 1481. The dating of this stage is derived from a "3 House" glyph found on the south face of the temple base. Under Axayacatl, the Aztec empire conquered several regions and was defeated only when it tried to overcome the Tarascans of Michoacan. One of the most significant conquests was that of Tlatelolco in 1473; the commercial success of this market town must have made it a tempting prospect for the people of Tenochtitlan.

The architectural remains of this stage of construction consist of the main platform on which the temple base sat. This platform has five steps leading up from the ceremonial square, which is composed of a paved surface. The front steps have no central division, as can be seen on those leading to the upper part of the temple, but are interrupted only by a small altar, in line with the center of the Tlaloc side. The altar is known as the Altar of the Frogs because it is decorated with two of these animals, which are linked to the god of water.

Toward the middle of the steps, on the Huitzilopochtli side, an enormous sculpture of Coyolxauhqui was found. Various offerings with rich contents are associated with this goddess, among them two funerary urns made of orange clay and covered with lids, which contained the cremated bones of two adult males. Tests carried out on the bones showed that they might have belonged to people involved in military activities, since there was clear evidence of musculature on the bones. Furthermore, the urns were decorated with images of gods armed with spear-throwers and spears. Because of their placement beneath the platform on the side of the temple dedicated to Huitzilopochtli, very close to the sculpture of Coyolxauhqui, a goddess who died in combat, it has been suggested that the remains belong to high-ranking soldiers injured in the war against Michoacan and brought to Tenochtitlan to die.

Serpents' heads rested on the platform on either side of each of the two stairways leading to the shrines of Tlaloc and Huitzilopochtli. The two on the side devoted to the water god differ from those on the side of the war god. In between the two central heads were offerings, two of which stood out from the others because they were placed in stone boxes with lids. Inside each of the offerings, along with greenstone beads, were thirteen Mexcala-style figures arranged in a row facing south. The southward direction of the universe was ruled by the god Huitzilopochtli, who was closely connected to this quadrant in accordance with the movement of the sun.

At the north and south ends of the platform, chambers with floors paved in marble were found. Two enormous serpents' bodies met on the platform, one looking north and the other south. Between them was a serpent's head. The three snakes still bear some of their original painted decoration.

The majority of the offerings uncovered during the Templo Mayor excavations were found in Stage IV(b), confirming that Tenochtitlan was at the height of its success and in full military expansion at this time. The number of tributary towns had increased, and the contents of the offerings reflect this expansion, both in the types of animals sacrificed and in the objects deposited. The Templo Mayor had increased in size and in splendor, reflecting the empire's military might.

Stage V (ca. 1482)

The part of the main platform upon which the Templo Mayor sat is all that remains of this stage, which is thought to date to the rule of Tizoc, who reigned from 1481 to 1486. The platform retains some of the stucco that covered it, and four offerings were found within.

The building known as the House of Eagles, north of the Templo Mayor, may also have been constructed at this time. Here superb clay sculptures of eagle warriors were found, as well as sculptures of skeletons and two life-size representations of the god Mictlantecuhtli, lord of the underworld. The building itself consists of a vestibule area with pillars, and a rectangular chamber. A short corridor leads to an internal patio with rooms at the north and south ends. The whole complex has stone benches decorated with processions of warriors, still in their original colors. The decorations throughout, including the representations of eagle warriors, skeletons, and Mictlantecuhtli, are all associated with war.

Stage VI (ca. 1486)

This stage is attributed to Ahuitzotl, who ruled from 1486 to 1502. The edifice was extended on all four sides at this time. The main platform supporting the temple, one of the excavated remains, is characterized by decoration on the balustrades of the east-facing stairway consisting of a molding made up of three elements. This stage is important because it brought to light various shrines surrounding the Templo Mayor.

The Red Temples, the two shrines found on the north and south sides of the Templo Mayor respectively, are both east-facing and both have a vestibule with a circular altar at the center. Each vestibule is made up of two walls topped by a stone hoop also painted red; the walls are decorated with paint. An offering containing a considerable number of musical instruments, both sculptural and real, was found on the upper part of the south temple. Among the other items discovered in the temples were large painted ceremonial knives. A study carried out on these shrines shows that they were related to Macuilxochitl, god of flowers, plants, song, dance, and games.

The Red Temple on the north side of the Templo Mayor, also known as Shrine C, is aligned with two other shrines: Shrines A and B. These stand on a paved stone floor that forms the floor of the ceremonial square. Shrine A has two stairways, one fac-

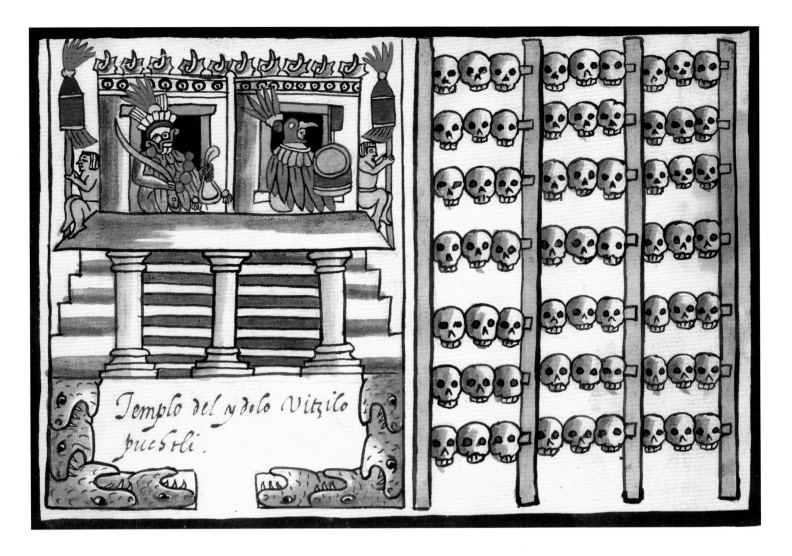

ing west and the other east. There is no particular decoration on its walls. Shrine B has a west-facing stairway and is decorated on its three remaining walls with 240 stucco-covered stone skulls arranged close together like a *tzompantli*, a wooden rack on which the skulls of sacrificial victims were displayed. Thus Shrine B was probably associated with the northern sector of the universe, the region related to death. On the upper part of the shrine were offerings, one of which contained feline remains and objects related to Tlaloc.

Also to the north of the Templo Mayor is the west-facing Shrine D. It is well preserved and has a recess in the floor of its upper story, indicating that it once housed a circular sculpture that was not found during the excavation.

The House of Eagles, discussed in relation to Stage V, was surmounted during Stage VI by another similar building. Only the platform was found, on top of which was a colonial-style patio, which must have belonged to one of Cortés's captains—an example of a pre-Hispanic structure being reused as the foundation for conquistador housing. The platform has a west-facing stairway and is decorated at each end with birds' heads, which still have painted black-and-white feathers and yellow paint on their beaks.

Recent excavations have uncovered part of the stairway that led to the main platform. It was found to be in good condition and various offerings were discovered on it. These correspond to the next stage of construction.

Stage VII (ca. 1502)

What we see of this stage is the main platform on which the Templo Mayor stood. Attributed to Motecuhzoma II (reigned 1502–20), this was the stage that the Spaniards saw and razed to the ground in the sixteenth century. The building extended around eighty-two meters per side and is estimated to have been forty-five meters high. Destroying this architectural mass, of which only the platform exists, must have presented a formidable challenge to the Spaniards. Among the most important offerings found between Stages VI and VII was one containing pieces of paper made from *amate*-tree bark and well-preserved fabrics, which seem to have formed part of the garb of a priest who worshiped Tlaloc.

Almost two centuries passed between the supposed founding of Tenochtitlan in 1325 and the destruction of the Templo Mayor by the Spaniards and their indigenous allies in 1521. Having followed the building's development from its beginning to the grandeur it had attained just before the Spanish invasion, we will now turn our attention to the symbolism of the Templo Mayor, and to the reasons why it was the most important building in the ceremonial complex.

According to the cosmovision of the Aztecs and other Mesoamerican peoples, the universe was divided into three levels, of which the central level—the terrestrial zone—was inhabited by man. Above it were thirteen levels, or skies, the

Page from Juan de Tovar, *Tovar Codex*, also known as *Relación del origen de los Yndios que havitan en esta Nueva España según sus historias*, 1583–87.

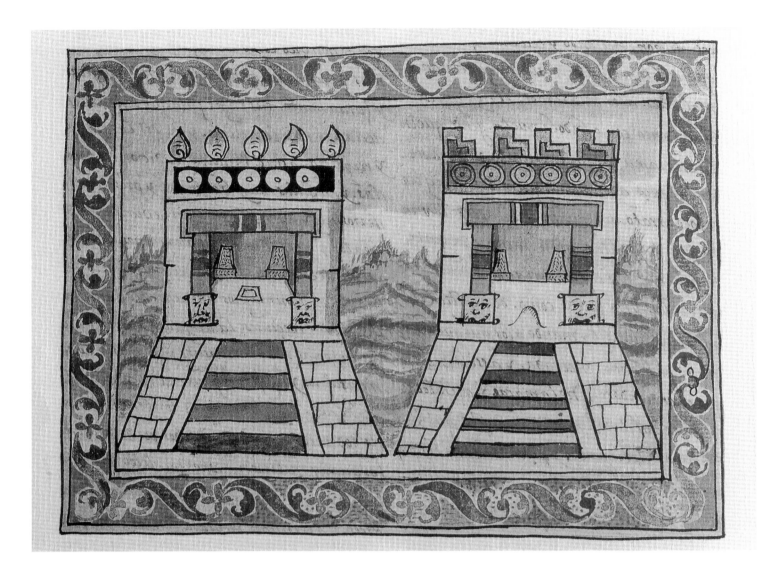

highest being Omeyocan, the place of duality. Below the terrestrial zone was the underworld, consisting of nine levels, the lowest of which was Mictlan, inhabited by Mictlantecuhtli and Mictlancihuatl, the discarnate deities who ruled the world of the dead.

The cardinal points were the four universal directions. Each direction was identified with a god, a plant, a bird, a color, and a glyph. The north, known as Mictlan, was the direction of death and cold. Its glyph was a sacrificial knife (or flint) and it was associated with the colors black and yellow and the xerophyte, a tree native to the region. Mictlan was ruled by the god Tezcatlipoca. The south was the region of dampness, identified by the color blue and ruled by the god Huitzilopochtli. Its glyph was a rabbit, symbol of fertility and abundance. The east, where the sun rises, was the masculine quadrant of the universe and was the path along which warriors, killed in combat or by sacrifice, traveled to accompany the sun from dawn until midday. It belonged to the red Tezcatlipoca or Xipe Totec, identified by this color and by a reed glyph. The west was the female sector of the universe. Women who died during childbirth, which was considered a battle by the Aztecs, accompanied the sun from midday to dusk, when the sun was devoured by the earth (Tlaltecuhtli), passing through the world of the dead until the earth goddess (Coatlicue) gave birth to it again the next morning in the east. The color of the west was white, its glyph was a house, and it corresponded to the god Quetzalcoatl.

The center of this vision of the cosmos was the Templo Mayor, center of centers, the most sacred place, the universal *axis mundi*. It was crossed by both the ascendant and descendant forces and from it departed the four directions of the universe, with the result that it contained the forces of each.

Suggesting the centrality of the gods of rain and war in the Aztecs' worldview, symbolism related to Tlaloc and Huitzilopochtli figured prominently in the architecture of the Templo Mayor and in the elements that surrounded it, from the sculptures with serpents' heads to the braziers that adorned the great platform on which stood the four structures that formed the pyramidal platform, to the upper shrines dedicated to the two deities, painted red and black for Huitzilopochtli, blue for Tlaloc. Each of the temple's two parts corresponded to a specific hill: the Huitzilopochtli side represented Coatepetl, the place where Coatlicue gave birth to the Aztecs' patron god to fight her enemies; the Tlaloc side represented Tonacatepetl, the hill where grains of maize were stored and given to men.

The discovery of the sculpture of Coyolxauhqui on the main platform at the foot of the temple-hill devoted to Huitzilopochtli suggests that this platform represented the terrestrial level of the universe. According to the story of their battle, Coyolxauhqui was captured at the top of Coatepetl by Huitzilopochtli, who beheaded her and threw her body over the side of the hill; the body was dismembered as it fell to the ground. This myth is reproduced on the Huitzilopochtli side of

Page from Fray Diego Durán, *Codex Durán*, also known as *Historia de la Indias de Nueva España e Islas de Tierra Firme*, 1579–81.

the Templo Mayor: the victor sits at the top of the temple-hill, and the vanquished goddess, beheaded and dismembered, lies on the ground below.

The four tiers of the pyramidal platform of the Templo Mayor may thus express celestial levels. At the top, the two shrines dedicated to Huitzilopochtli and Tlaloc are the clearest representation of the life-and-death duality: on one side is the god of the sun and war; on the other is the god of water, fertility, and life. This reflects the essential needs of the Aztecs: war, which provided Tenochtitlan with taxes extracted from the conquered regions, and agricultural produce. Moreover, each side of the building was identified with a place where people went after death: warriors who died in battle or sacrifice accompanied the sun along part of its path and were therefore associated with Huitzilopochtli; people whose death was related to water (from a waterborne disease, drowning, or lightning strike) went to Tlalocan, the place of eternal summer ruled by the god of water. The two sacred hills or mountains represented by the Templo Mayor were one of the first steps a person had to take to reach Mictlan, the place where those who died of any other causes were destined. An Aztec poem speaks of the places where people would go after death:

> Oh, where will I go?
> Where will I go?
> Where is the duality? . . . Difficult, oh so difficult!
> Perhaps everyone's home is there,
> where those who no longer have a body live,
> inside the sky,
> or perhaps the place for those who
> no longer have a body is here on earth!
> Who would say: "Where are our friends?"
> Rejoice!

In this way, the Templo Mayor was the focal point of the Aztec view of the cosmos, the survival of the Aztec people, and the order of the universe, and the unimpeded daily progress of heavenly bodies, including the sun, relied on what it represented.

Notes

1. Antonio de León y Gama, *Descripcion histórica y cronológica de las dos piedras* (Mexico City: Instituto Nacional de Antropología e Historia, 1990).

2. Alexander von Humboldt, quoted in Eduardo Matos Moctezuma, *Las piedras negadas: de la Coatlicue al Templo Mayor* (Mexico City: Consejo Nacional para la Cultura y las Artes, 1998).

3. Antonio Peñafiel, "Destrucción de Templo Mayor de México," in Eduardo Matos Moctezuma, ed., *Trabajos arqueológicos en el centro de la Ciudad de México* (Mexico City: SEP-INAH, 1979), pp. 95–133.

4. Diego Durán, *Historia de las Indias de la Nueva España e islas de la tierra firme*, 3 vols. (Mexico City: Editorial Nacional, 1951).

The Templo Mayor
at Tenochtitlan

Juan Alberto Román Berrelleza

IN MID-NOVEMBER 1519, FROM THE HEIGHTS OF THE MOUNTAINS SOUTHEAST OF THE VALLEY OF Mexico, Hernán Cortés was amazed to observe at his feet a panorama he could never have imagined: an enormous lake with an incredible city rising out of it. This was Tenochtitlan, seat and capital of the Aztecs, the most sophisticated and highly developed empire in pre-Hispanic Mesoamerica just prior to the Conquest. The urban center occupied almost 12 square kilometers and had approximately 200,000 inhabitants.

In the city center, the most remarkable buildings were those found in the sacred precinct, an area of approximately 400 meters per side, where the Aztecs worshiped and venerated their most important gods. On either side were broad and well-built roads that linked the city to the mainland and to the many neighboring peoples located on the shores of the great lake. Bernardino de Sahagún mentions that within the precinct there were approximately seventy-eight buildings, which probably corresponded to an equal number of gods. Standing out among the buildings because of its great height and magnificence was the Templo Mayor, seat of Tlaloc, the god of rain and the earth's fertility, and Huitzilopochtli, the god of sun and war, the Aztecs' main patron gods.

It would not be long before the amazing vision of this city would change dramatically. History tells us that the military conquest of Tenochtitlan, which occurred in the year 1521, was followed by the city's near-total destruction. Tenochtitlan gave way to a new colonial city that would rise there and would become the modern metropolis of Mexico City.

The Origin of the Templo Mayor

The origin of the Templo Mayor goes back to the very founding of the city of Tenochtitlan in A.D. 1325. According to contemporary chronicles, after a long journey, the Aztecs were obligated to build a temple to the god Huitzilopochtli. It was to be erected at the site where they would find a sign that the deity had given the priests: an eagle standing on a nopal (prickly pear) tree, devouring a serpent. The chronicles indicate that initially the Templo Mayor was constructed with impermanent materials, "since that is all we can do for the time being."

After these humble beginnings, however, every Aztec *tlatoani* (ruler) would make it one of his main tasks to enlarge and beautify the "house" of their patron god. This was written in various ethnohistorical sources, which stated that every new governor who acceded to power was obligated to increase the size and beauty of the pyramid-temple, whose grandeur was confirmed by Cortés in one of his letters to Charles V: "There are about forty very tall, beautifully worked towers, and the greatest has fifty steps in the approach to the tower itself; the most important tower is taller than that of the greatest church in Seville."

45. Coyolxauhqui
Aztec, ca. 1500

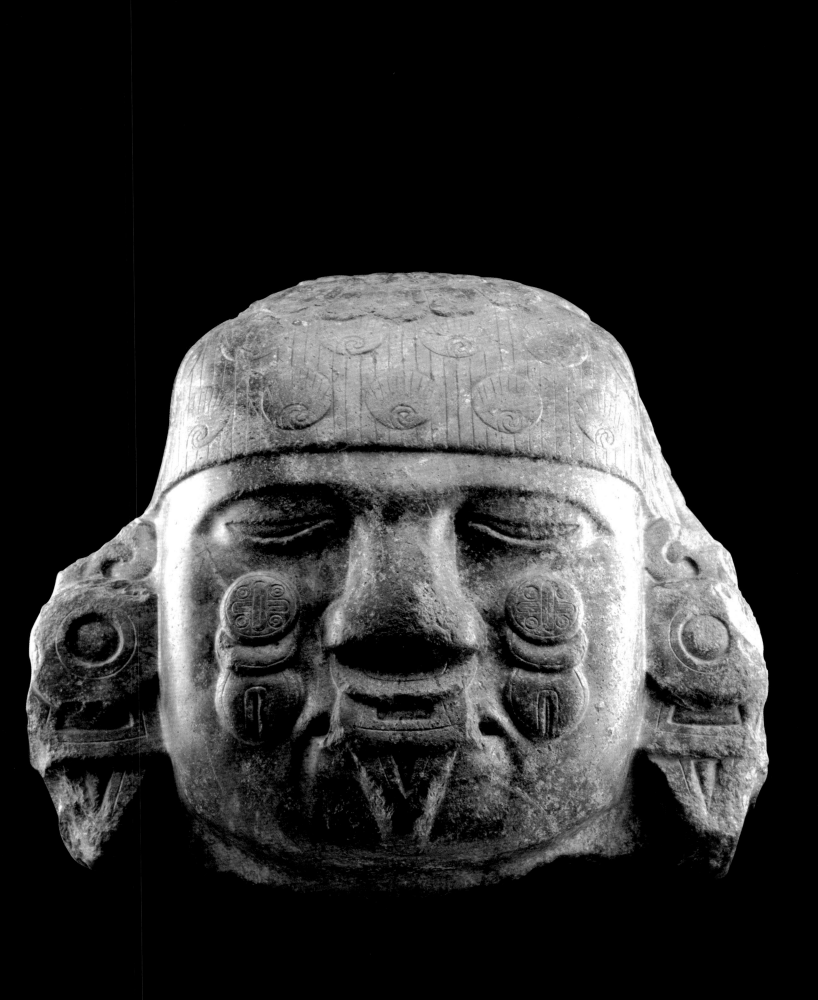

Archaeological Findings

For almost 500 years, the vestiges and structures of the pre-Hispanic edifices remained buried under the foundations of the buildings that occupy the space today. During this long period, there were many attempts to reconstruct and understand what the Spaniards' feverish destruction had wrought. These efforts finally culminated in the launching of the Templo Mayor Project in 1978, which carried out archaeological work for five years under the patronage of the Instituto Nacional de Antropología e Historia (National Institute of Anthropology and History). This work brought to light the architectural remains of the Aztecs' main building, as well as a large quantity of offerings that were placed within. The project also amassed valuable data and information about the ceremonial and ritual activities performed there.

This project confirmed that the Templo Mayor was a building with a quadrangular plan, whose main facade looked toward the west. The base of the pyramid sat on a great platform from which rose four stepped-back tiers with two stairways that led to the upper level, where a temple dedicated to Tlaloc on the north and to Huitzilopochtli on the south were located. Because of floods, structural faults, and sinking and settling, the building had been expanded on seven occasions on the four sides, and the main facade had been added onto four times in successive phases of construction. In addition to determining the building's architectural features, the project established that over a construction period of less than two hundred years, the building had grown to a size of 82 meters per side and an approximate height of 45 meters.

Symbolism of the Templo Mayor

From their beginnings, the Aztec people had proclaimed themselves a warrior group, destined by divine orders to conquer and subjugate other peoples in a broad region of Mesoamerica. While the Aztecs concentrated the center of their imperial force in Tenochtitlan, they also envisioned the city as the center of the world. In the Aztec vision of the cosmos, the Templo Mayor was the symbolic nucleus of the universe. The four horizontal directions of the universe radiated out from the building, corresponding with the four cardinal points, each of which was associated in turn with a god, a color, and a glyph.

The world was also divided vertically, into three great levels that started at the Templo Mayor. The middle level was earth, where humans and all living beings lived. The celestial level, projected upward, was divided into thirteen heavens, the last being the most sacred: Omeyocan (place of duality). Projected downward was the underworld, which was divided into nine levels, the last and deepest one being the dwelling of the gods of death, a place known as Mictlan.

The building was further divided into two parts, one dedicated to the god of water and the other to the god of war. The presence of these gods on the uppermost level of the pyramid-temple symbolically marks the dual economic needs of Aztec society: on the one side, water, as the most essential element for the agricultural production that sustained them; and on the other, war, as the method of subjugating neighboring groups, from whom they demanded tribute and thus stocked the imperial coffers.

Finally, the pyramid-temple represents two hills. On the Tlaloc side was Tonacatepetl, the "mountain of sustenance," which contained all kinds of foods, including maize, that the rain gods would give to humans through good harvests. On the Huitzilopochtli side was Coatepetl, the mythic "mountain of the serpent," birthplace of the god who became protector of the Aztecs after he defeated his sister Coyolxauhqui, who lies at the feet of her conquering brother.

Thus the Templo Mayor represented the Aztec model of the universe, the most sacred place and driving force behind a society that achieved enormous stature in social, political, economic, religious, and military spheres.

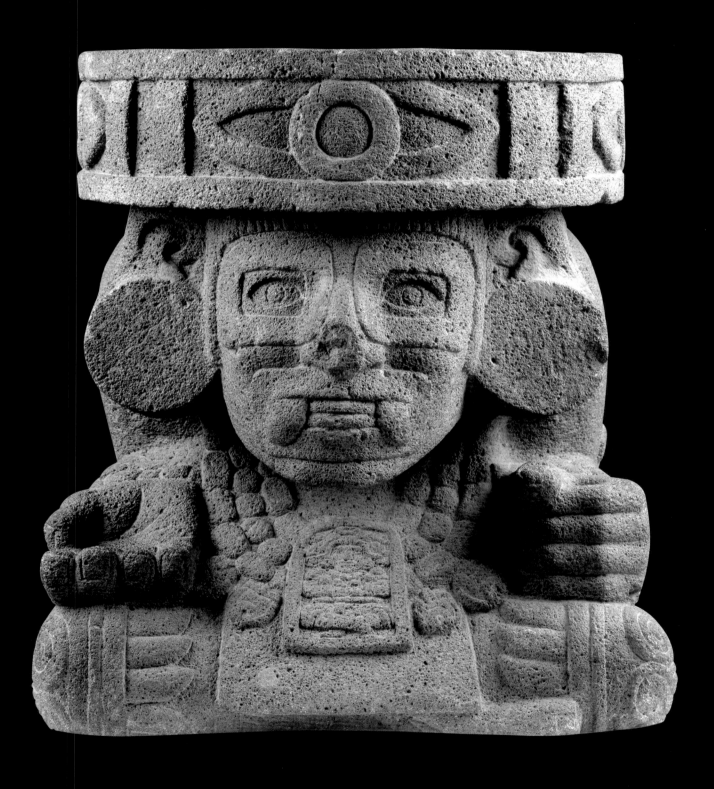

46. Huehueteotl
Aztec, ca. 1486–1502

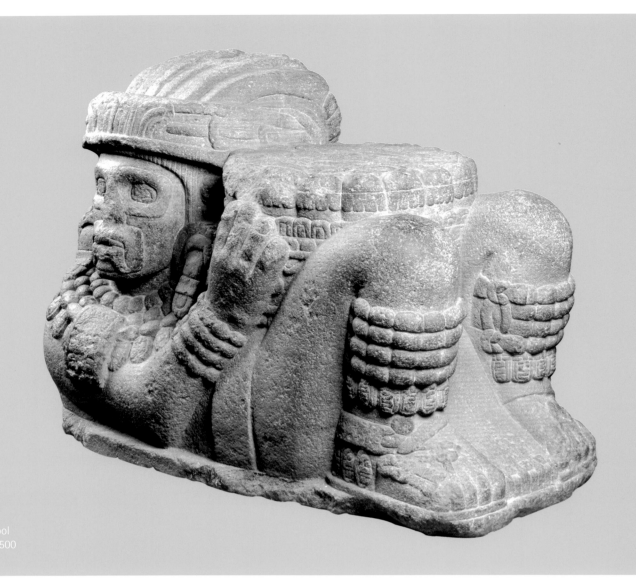

47. Chacmool
Aztec, ca. 1500

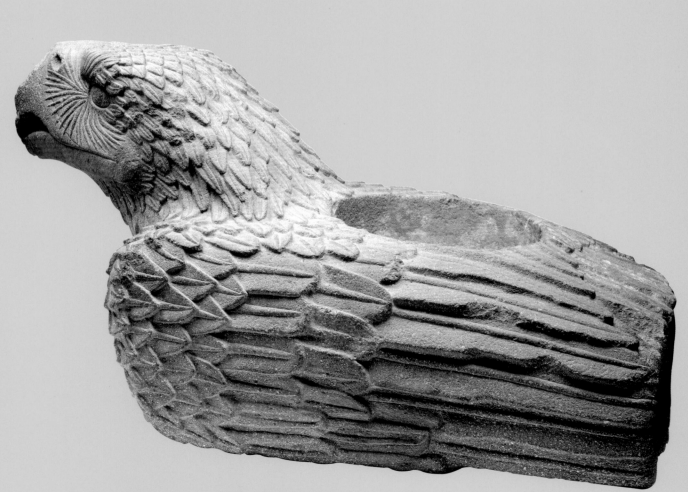

48. Eagle cuauhxicalli
Aztec, ca. 1502–20

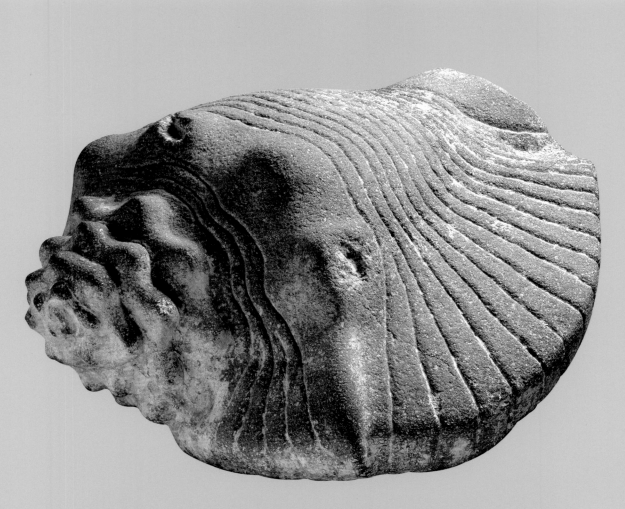

49. Snail shell
Aztec, ca. 1500

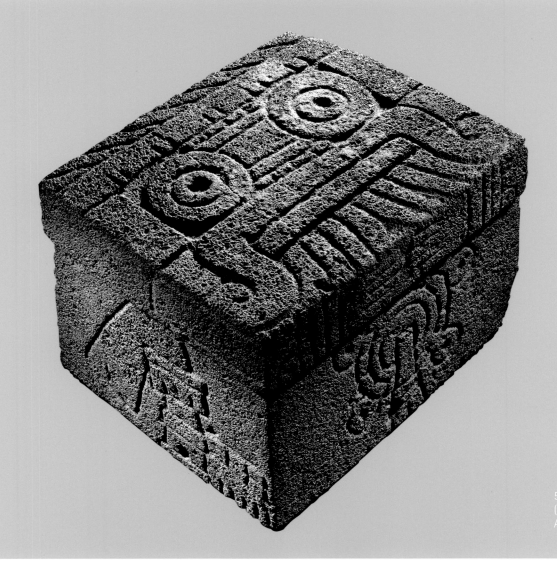

50. Tlaloc casket
(tepetlacalli)
Aztec, ca. 1469–81

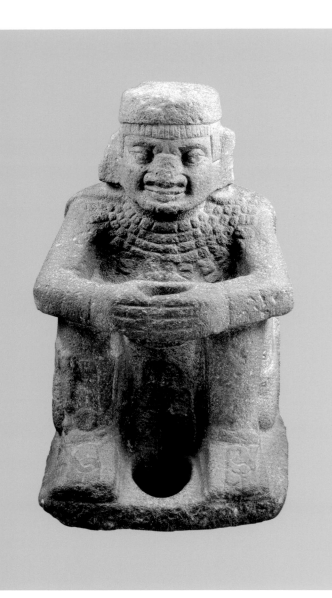

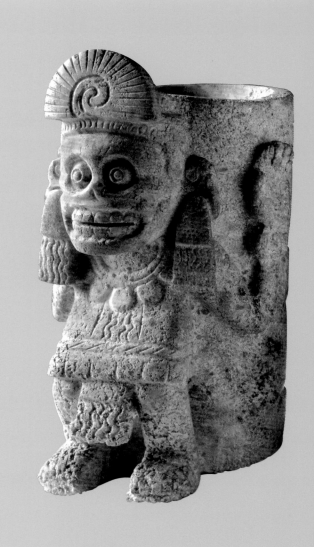

Clockwise from top left:

51. Sad Indian
Aztec, ca. 1500

52. Mictlantecuhtli urn
Aztec, ca. 1500

53. Omexicahuaztli
Aztec, ca. 1250–1521

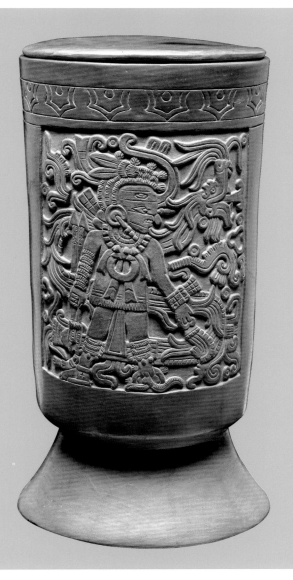

54. Funerary urn
Aztec, ca. 1470

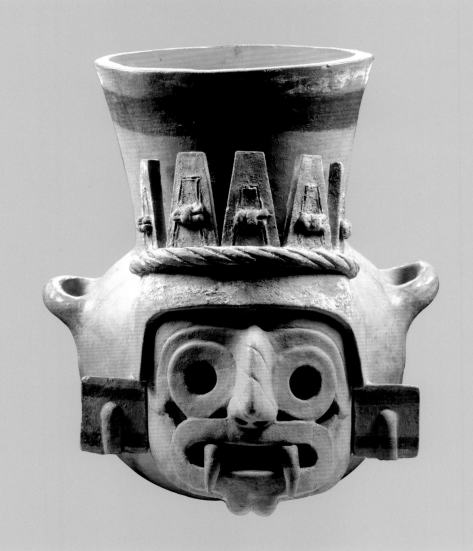

55. Tlaloc pot
Aztec, ca. 1440–69

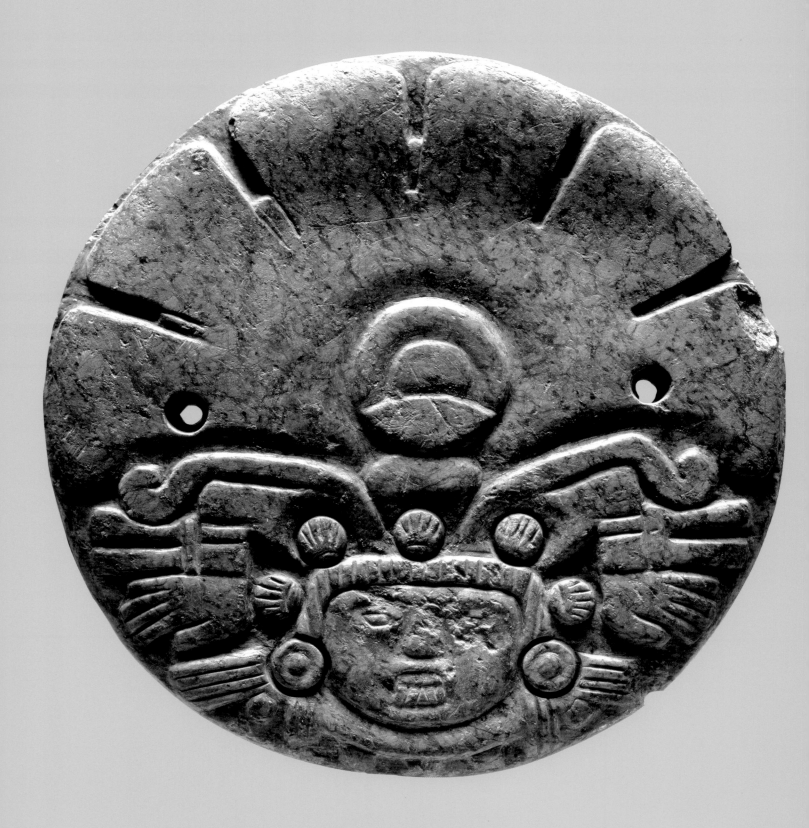

56. Pectoral with a nocturnal butterfly
Aztec, ca. 1500

Facing page, clockwise from top left:

57. Model
Cholollan, ca. 1500

58. Model
Aztec, ca. 1500

59. Model
Cholollan, ca. 1500

60. Model
Cholollan, ca. 1500

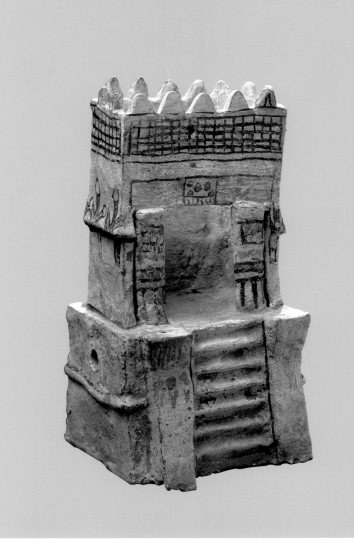

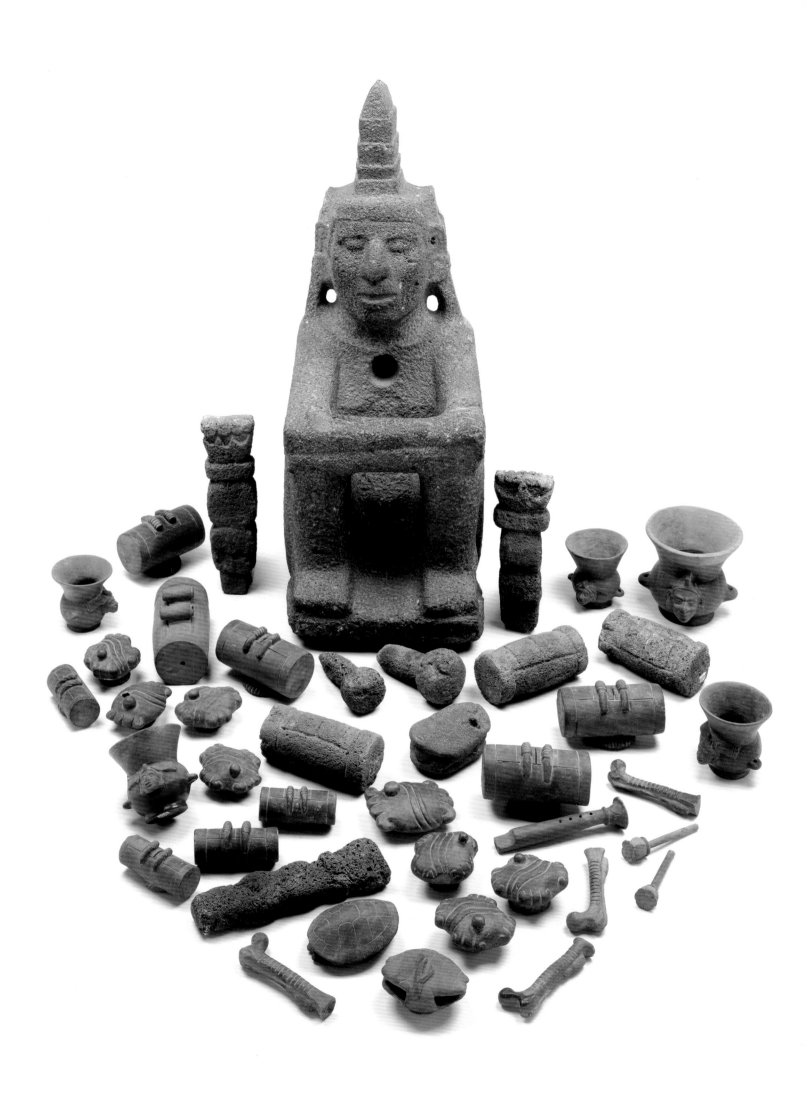

61. Red God offering
Aztec, ca. 1500

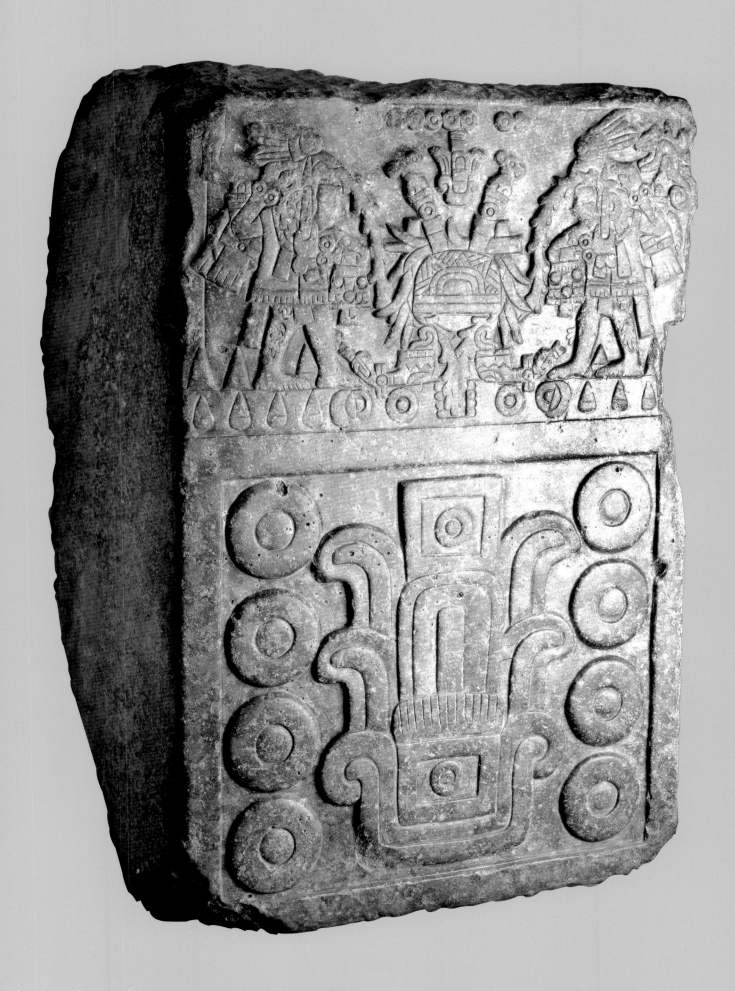

62. Commemorative stone plaque
of the Templo Mayor
Aztec, ca. 1487

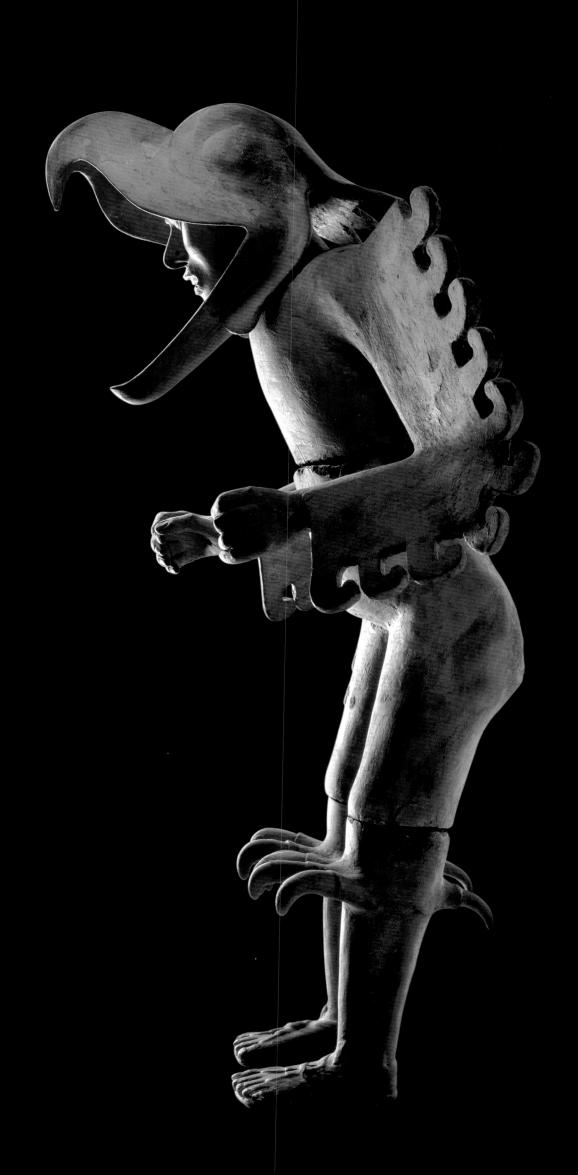

63. Eagle warrior
Aztec, ca. 1440–69

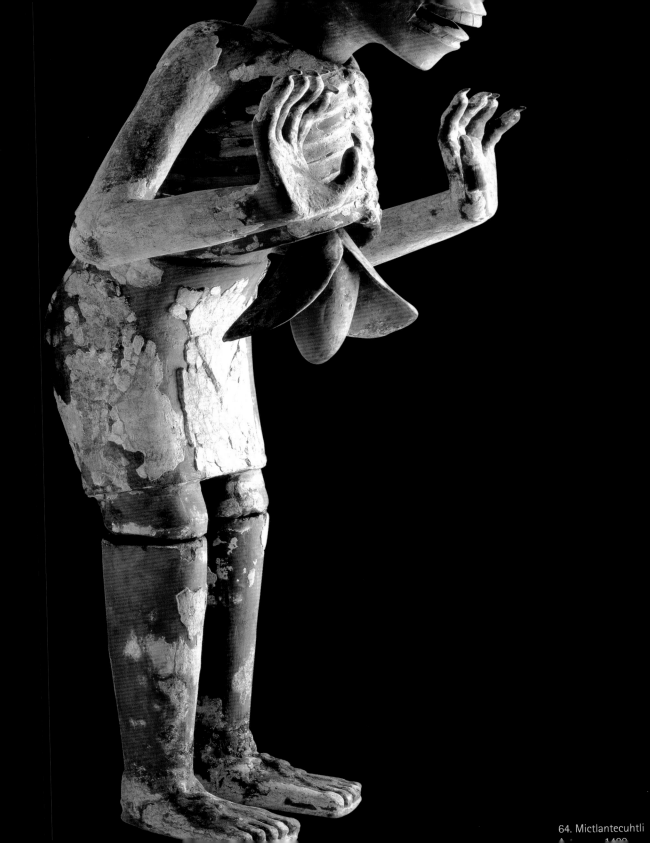

64. Mictlantecuhtli

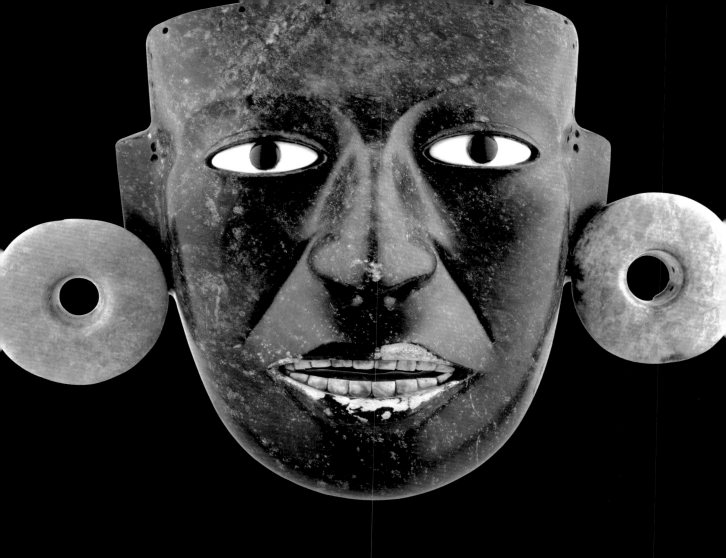

Anthropomorphic mask and ear ornaments
Teotihuacan, ca. 300–600

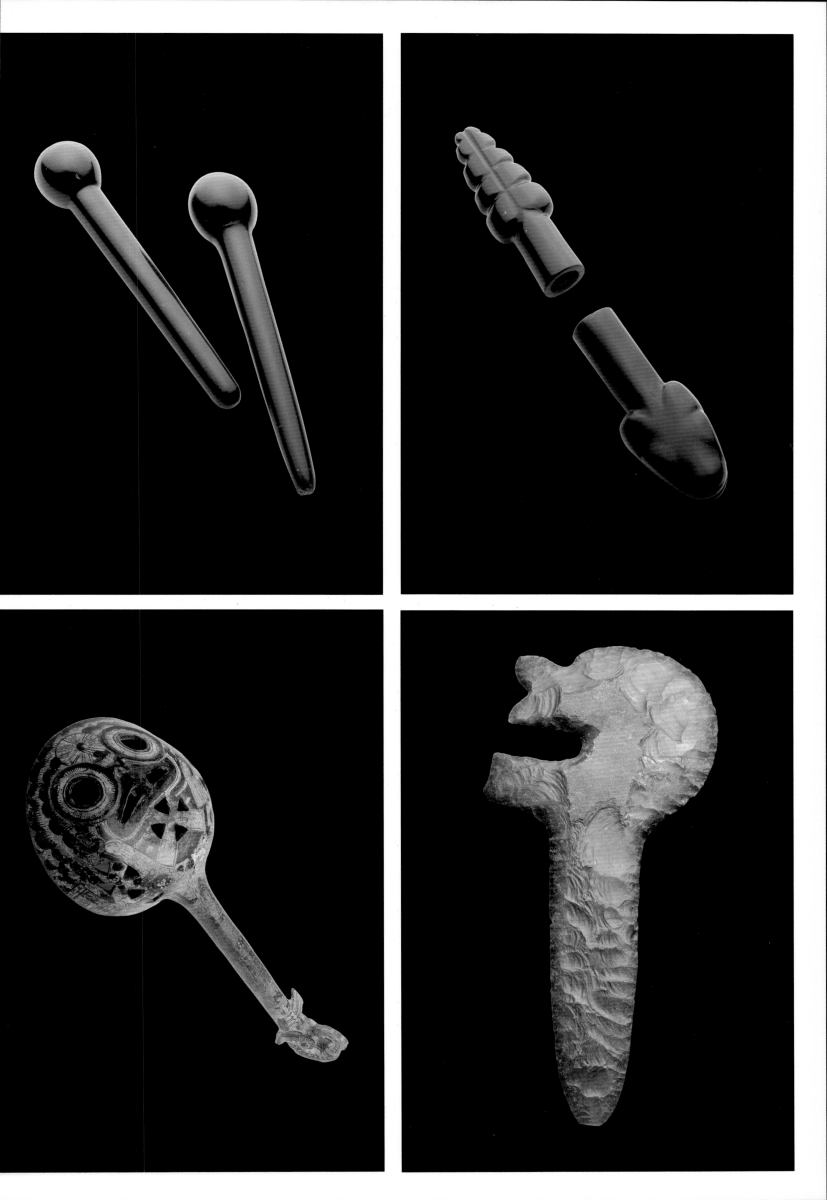

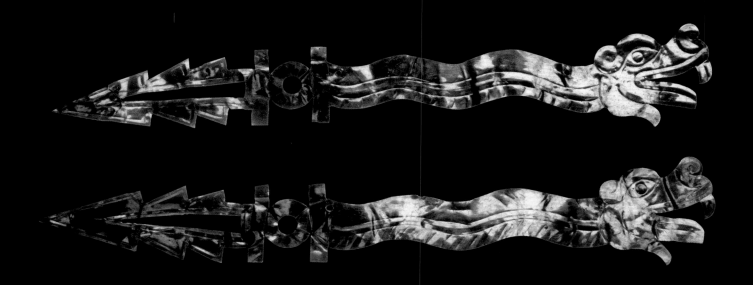

70. Xiuhcoatl
Aztec, ca. 1500

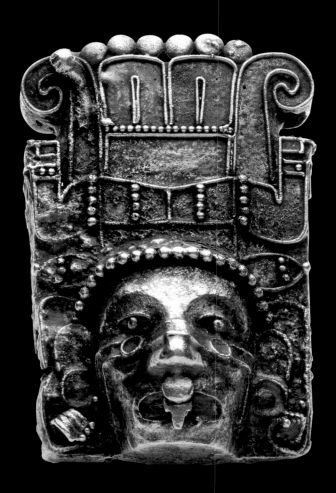

71. Coyolxauhqui
Aztec, ca. 1250–1521

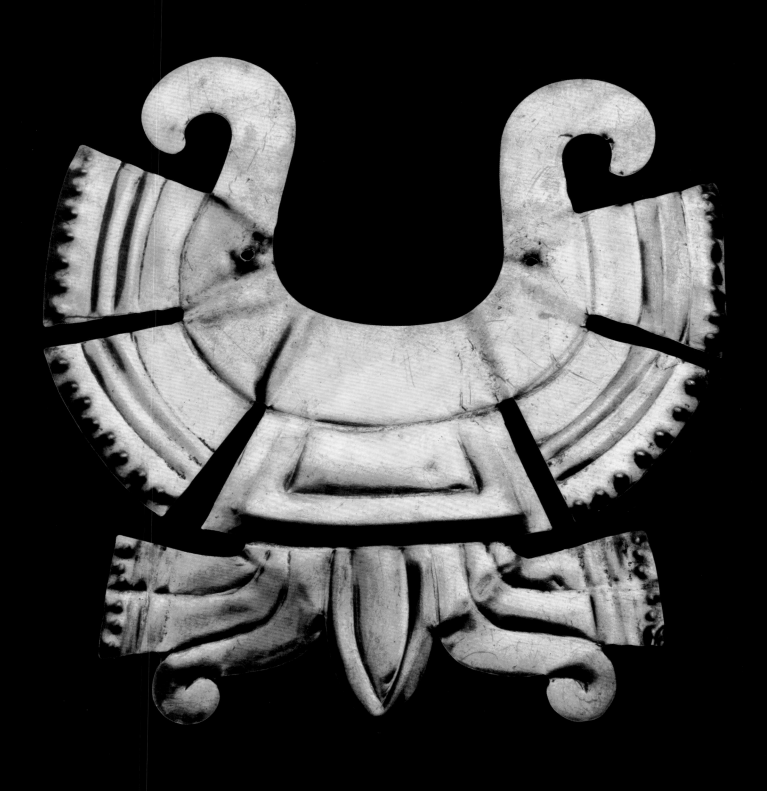

72. Butterfly nose ornament
Aztec, ca. 1500

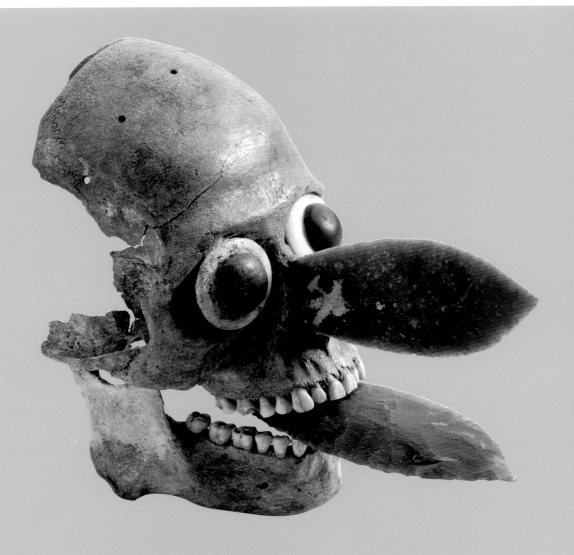

73. Skull mask and knife
Aztec, ca. 1250–1521

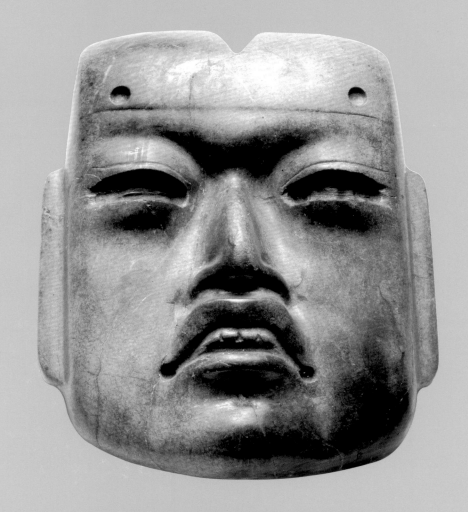

74. Anthropomorphic mask
Olmec, ca. 1100–600 B.C.

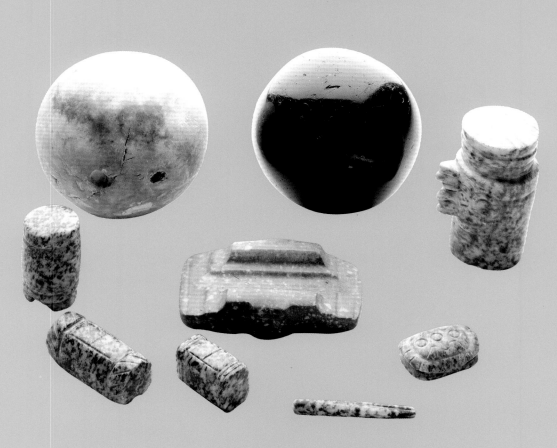

75. Ballgame offering
Aztec, ca. 1500

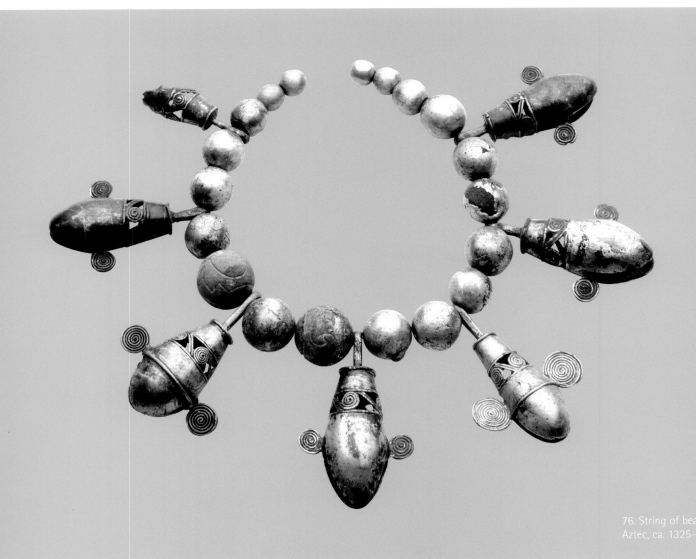

76. String of beads
Aztec, ca. 1325–1521

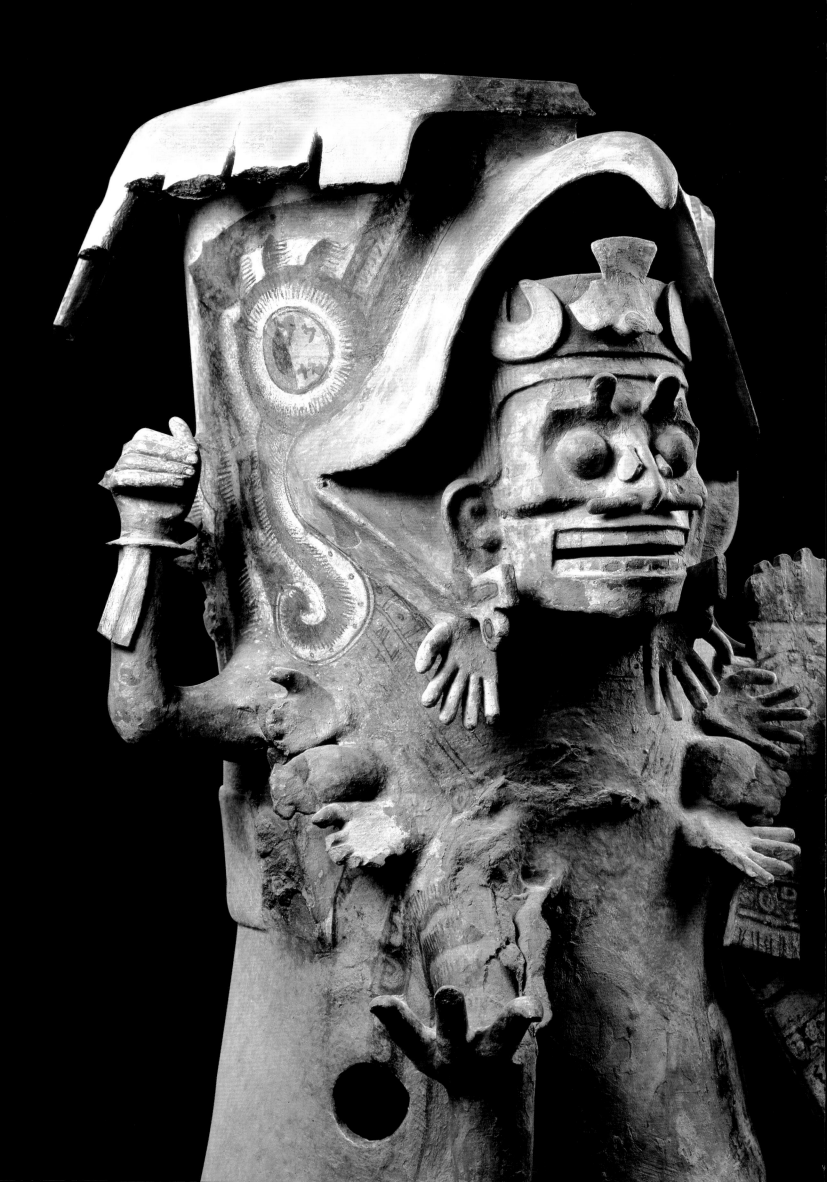

Aztec Religion

Aztec Religion:
Creation, Sacrifice, and Renewal

Karl Taube

DURING THE SIXTEENTH CENTURY, THE SPANISH COLONIZERS OF MEXICO WERE BOTH FASCINATED and horrified by the intensely religious life of the Aztecs. A number of Spanish clerics were intrigued by apparent shared traits, such as the baptism of newborns, oral confession, and the communionlike consumption of god images fashioned from seed. In addition, the early chroniclers wrote approvingly of the strict religious training of children, including the school for elite youths, the *calmecac*. In fact, the Franciscan Colegio de Santa Cruz in Tlatelolco, devoted to the schooling of native children, was based conceptually on this institution. There were, nonetheless, many Aztec traditions that were antithetical to Spanish religious perceptions, including necromancy and the worship of multifarious deities and their graven images. The sixteenth-century chroniclers were especially concerned by human sacrifice, which they often described in explicit detail. The early colonial *Codex Magliabechiano* and the *Codex Tudela* portray gruesome images of "el diablo"—the netherworld death god, Mictlantecuhtli—doused with buckets of human blood. Clearly, such descriptions and illustrations of human sacrifice were used to justify both the Spanish Conquest and the suppression of native religious traditions. Nonetheless, human sacrifice was an important component of Aztec religion, not only as a ritual offering, but also in terms of creation mythology and how the Aztecs saw themselves in relation to the surrounding world.[1]

It is somewhat ironic that many of the sixteenth-century chroniclers who vilified Aztec religious practices also provided detailed perceptions of the Aztec worldview, or cosmovision, including some of the underlying reasons for human sacrifice. Two works probably based on the early research of the Franciscan Fray Andrés de Olmos, the *Historia de los mexicanos por sus pinturas* and the *Histoyre du Mechique*, contain detailed accounts of Aztec creation mythology.[2] The studies by Fray Bernardino de Sahagún, especially the *Primeros memoriales* and the *Florentine Codex*, are unparalleled sources of information concerning Aztec ritual and mythology.[3] The magnificent *Codex Borbonicus*—rendered in an essentially pure Aztec style even though it was painted in the early colonial period—contains detailed portrayals of deities and the ritual calendar, including the New Fire ceremony performed once every fifty-two years. The Borgia Group of pre-Hispanic screenfolds, comprising the *Borgia, Vaticanus B, Cospi, Laud,* and *Fejérváry-Mayer* codices, also illustrate Aztec gods and rites, although they are not painted in the imperial Aztec style found in the *Codex Borbonicus*, and particular deities, such as the maize goddess Chicomecoatl and the tutelary god Huitzilopochtli, are entirely missing from them. Pre-Hispanic Aztec sculpture likewise offers a wealth of vivid material pertaining to gods, ritual, and creation mythology.

Numerous aspects of Aztec religion were innovative and unique, but the Aztecs also took part in the broader traditions of Mesoamerica. Certain Aztec

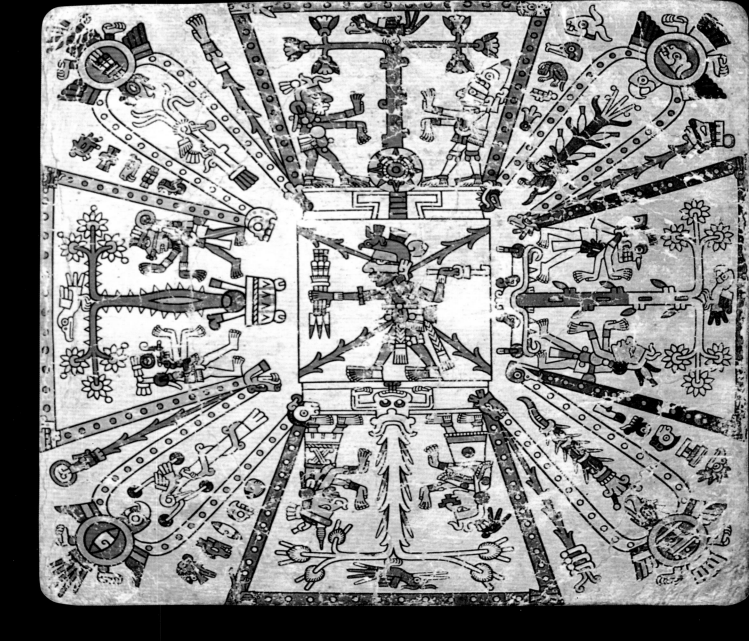

religious traditions, both general and specific, occurred—and still occur—in other cultures of Mesoamerica. Although the Classic Maya (ca. 250–900) possessed an art style strikingly distinct from that of the Aztecs, many traits of their religion, including calendrics, ritual, and mythology, were similar. However, Teotihuacan is the Classic-period culture that most directly relates to Aztec traditions. Located some 50 kilometers north of Tenochtitlan, the future Aztec capital, Teotihuacan exerted a powerful influence over much of Mesoamerica during the Early Classic period (ca. 250–600), and Aztec art and architecture frequently displayed clear evocations of the earlier ancient style of Teotihuacan. In addition, certain Aztec gods, including the plumed serpent Quetzalcoatl, the rain god Tlaloc, and the old fire god Huehueteotl, can be traced to Teotihuacan. According to Aztec mythology, Teotihuacan was the place where the present world began, and it was the canonical source of many Aztec beliefs and ritual practices, including those pertaining to heart sacrifice, sacred bundles, and the origin of music.

A basic concept underlying Aztec religious thought was dualism, including such binary oppositions as life and death, male and female, light and dark, and fire and water. The Aztec supreme god, for example, was Ometeotl, a male and female god who was believed to reside in the uppermost heaven of Omeyocan.[4] The dualistic principles of Aztec religion were by no means conceived of as static; complementary opposites interacted actively, and this dynamic tension was the ultimate and continually abiding source of creation. One Aztec cosmogonic myth described the birth of four original gods from Tonacatecuhtli and Tonacacihuatl—male and female aspects of Ometeotl.[5] In Aztec manuscripts and the Borgia Group, the primordial human couple was depicted beneath a blanket to denote the original act of conception. Another metaphor for this dynamic interaction of creation was war—cosmic battles created through supreme effort and sacrifice. The making of the ordered world out of primordial chaos was seen as an inherently heroic and courageous act. In the same manner, Aztec warriors gave their lives not only for the growth of the Aztec state, but for the continuity of this created cosmos.

The origin of the heavens and earth was often portrayed in Aztec mythology as a cosmic battle between a pair of gods, Tezcatlipoca and Quetzalcoatl. Together, these two beings represented the concept of complementary opposition: Tezcatlipoca was the fateful god of conflict, darkness, and the solid but shifting earth, while Quetzalcoatl was a celestial being of the dawning east and the ethereal but also eternal life force symbolized by breath and wind. Rufino Tamayo vividly portrayed this complementary opposition in his remarkable painting *Duality* (1963–64), with Quetzalcoatl (the plumed serpent) and Tezcatlipoca (the jaguar) locked in battle as opposing forces of day and night.[6]

In the Aztec creation cycle known as the myth of the five suns, the making and destruction of four previous worlds was described in terms of an ongoing cosmic war between Tezcatlipoca and Quetzalcoatl.[7] As symbols of the complementary forces of creation, however, Tezcatlipoca and Quetzalcoatl also acted as allies, much like the hero twins of ancient Maya creation mythology.[8] In one important Aztec creation episode, Tezcatlipoca and Quetzalcoatl were said to have done battle against a monstrous being floating on the primordial sea.[9] This creature, known as Cipactli, was a fishlike crocodile with devouring mouths on its joints. Transforming themselves into serpents, Tezcatlipoca and Quetzalcoatl tore Cipactli in half, one part of the body forming the earth and the other, the sky. From the body of the earth deity, Tlaltecuhtli, the natural world flowered, the eyes forming pools and springs, the mouth becoming rivers and caves, and trees and blossoming plants growing from the flowing hair.[10] As a result, humans had to nourish Tlaltecuhtli with their own hearts and blood to placate the violated earth. Contemporary Nahua, close descendants of the ancient Aztecs, note: "We eat of the earth then the earth eats us."[11]

In Aztec thought, the created universe had three realms. The uppermost was the sky, composed of thirteen levels occupied by particular gods and celestial phenomena, including the sun, stars, and wind. The brilliant, celestial paradise of the sun, Tonatiuh Ilhuican, was the afterlife abode of valiant warriors and women who died in childbirth. The lowest realm of the universe was the nine-leveled underworld, Mictlan, ruled by the crafty death god, Mictlantecuhtli, and his consort, Mictlan-cihuatl. Unfortunate souls who succumbed to sickness or old age went to this dark and dusty region, from which there was no return. However, there was another netherworld region: Tlalocan, paradise of the rain god Tlaloc. Here people who died by drowning or from lightning lived amidst abundant food and vast riches.[12]

Between the underworld and the sky lay the surface of the earth, Tlalticpac, the place of the living. The act of creation had divided the world into four quarters, each with its own symbolic tree. At the center stood a fifth tree, the pivotal *axis mundi*, offering access to both sky and underworld. In the Middle Formative Olmec (900–500 B.C.), the Classic Maya, and the Aztecs, this middle place was often portrayed as maize, much as if the four-cornered world constituted a symbolic corn field.[13] An Aztec casket from Tizapan contains a central greenstone image of the Aztec maize goddess Chicomecoatl, with four other deities—directional aspects of Tlaloc—painted in red, black, yellow, and white on the underside of the capping lid.

Aztec and other Mesoamerican rain gods were commonly quadripartite, representing rains of the four cardinal directions. According to the *Historia de los mexicanos por sus pinturas*, Tlaloc had four water basins, each with a specific type of rain, some of them beneficial and others famine-producing.[14] Pages 27 and 28 of the *Codex Borgia* portray a central Tlaloc surrounded by four Tlaloque, each of whom dispenses either

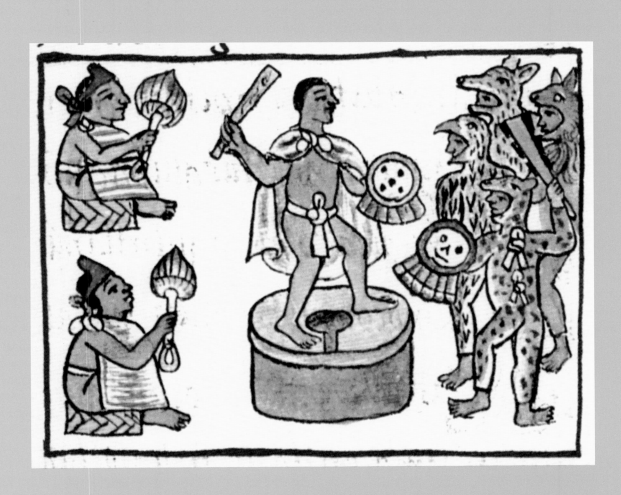

life-giving or destructive rain. The four Tlaloque were also identified with directional mountains, hills and peaks being the dwelling place of the rain gods and the source of water and abundance. Among the Aztecs, the most important mountain pertaining to the rain god was Mount Tlaloc, located east of Tenochtitlan. According to the Dominican cleric Fray Diego Durán, a square stone enclosure atop the summit contained a central image of Mount Tlaloc surrounded by lesser mountains.[15] Archaeological reconnaissance by Felipe Solís and Richard Townsend has documented a series of boulders—one on the eastern side, one on the western side, one at each of the four corners, and one in the center—surrounding a shrine within the enclosure. Townsend notes that this plan is very similar to the arrangement, in the *Codex Borgia*, of a central Tlaloc surrounded by four others at the corners.[16] In the *Primeros memoriales* scene of the sacrificial debt-payment of children to Tlaloc, a victim lies in a stone enclosure atop a hill. Behind the head of the victim, three mountain gods, the *tepictoton*, are shown positioned on three sides of the enclosure; quite possibly this scene refers to Mount Tlaloc and its shrine of directional mountains.[17]

In one version of the Cipactli myth, the creation of the earth was said to have occurred on the first day of the first year.[18] The origin of the world was thus tied to the creation of the calendar—the integration and organization of time and space. One of the most complex portrayals of this cosmological ordering appears on page 1 of the *Codex Fejérváry-Mayer*, where world trees grow toward each of the sides and corners of the quartered world. As in the myth of Tlaltecuhtli, the creation of this ordered space is depicted as the result of cosmic battle and sacrifice[19]: at the outer edges of the plan are the dismembered remains of Tezcatlipoca, the powerful deity embodying conflict and change in the universe.[20] Beginning with the eastern tree at the top of the scene and moving counterclockwise from there, the body parts of Tezcatlipoca lie to the left of each tree—arm, leg, torso, and head. Gouts of blood from the four quarters of the world fall to the central warrior figure, Xiuhtecuhtli, god of time and the pivotal world center.[21]

Aside from illustrating the cosmos, page 1 of the *Codex Fejérváry-Mayer* portrays the combination of two calendrical systems, the 260-day and 365-day years. The eight-lobed band framing the eight world trees denotes the 260-day divinatory or ritual calendar, which combined twenty day names—Tochtli (Rabbit), Atl (Water), Itzcuintli (Dog), and so on—with the numbers 1 to 13. Each of the twenty day names had a specific god and cardinal direction, with the days running in a continuously counterclockwise motion (from east to north and so on). This cycle was combined with the cycle of thirteen numbers, so that a day named 1 Rabbit would be followed by 2 Water, then 3 Dog, for example. The 260-day calendar was divided into twenty thirteen-day *trecena* (weeks), each named by the number 1—

the first numerical position in a *trecena*—along with a specific day name. In addition to the god and directional orientation associated with that day name, each *trecena* was presided over by a pair of gods as well as by another deity; by the birds identified with each of the thirteen day positions; and by an independent sequence of nine deities. Clearly, this calendar was extraordinarily complex, the combinations of gods, numbers, and directions providing nuanced and subtle auguries for the days.

Whereas the 260-day calendar frequently pertained to the private affairs of individuals, such as personal well-being, the outcome of business ventures, or the compatibility of particular spouses, the 365-day calendar expressed the cosmic processes of the sun, the seasons, and the primordial doings of the gods. Since this calendar conformed vaguely to the solar year, many of the deities evoked were beings of agricultural fertility, including maize, the earth, and water. The 365-day calendar was composed of eighteen twenty-day months (often referred to as *veintenas*) and five extra days (the *nemontemi*). During *veintena* celebrations, particular deities were often portrayed by deity impersonators. One of the most striking examples of deity impersonation occurred during the *veintena* called Tlacaxipehualiztli, during which devotees of the god Xipe Totec would don the skins of sacrificial victims. Temporary embodiments of the gods, deity impersonators were frequently sacrificed, releasing the divine spirit so that it could be renewed the following year.[22]

Aside from timing the annual rites and celebrations of the solar year, the 365-day calendar served as the basis for Aztec historical annals. Years were named using the numbers 1 through 13 and four of the twenty day names of the 260-day cycle—Acatl (Reed), Tecpatl (Flint), Calli (House), and Tochtli (Rabbit). Each of these year bearers, as they were called, had its own directional association: east for Reed, north for Flint, west for House, and south for Rabbit. The year bearers are depicted on page 1 of the *Codex Fejérváry-Mayer* as inwardly facing, descending birds, one near each of the four corners of the square. As in the 260-day calendar, the cycle of numbers was combined with the cycle of year bearers, so that 1 Reed would be followed by 2 Flint, 3 House, and so on. The combination of four year bearers and thirteen numbers created a fifty-two-year cycle of distinctly named 365-day years.

Far more than simply marking the succession of years, the Aztec year bearers were tied to basic concepts of Aztec creation and cosmology, as each was identified with a specific directional god and tree that supported the sky.[23] As with other Mesoamerican peoples, the Aztecs considered both spans of time and public offices as *cargos*, heavy burdens to be supported and carried. Although the Aztec deities known as sky bearers had the weighty responsibility of supporting the firmament, they could transform into fierce star demons, the *tziztimime*, during periods of darkness, as in solar eclipses. The *tzitzimime* were sometimes depicted as spiders hanging down from the sky, or as skeletal

beings with sharp talons. In one Aztec scene, a *tzitzimime* shambles in the starry night sky toward the sun god, Tonatiuh.[24] This menacing being recalls the upper portion of the Bilimek Pulque Vessel, which portrays two figures—Ehecatl-Quetzalcoatl and a pulque god—attacking a partially eclipsed sun with wooden clubs and stones.

For the Aztecs, an especially feared calendrical event was the completion of the fifty-two-year cycle, occurring in the *veintena* of Panquetzaliztli during the year 2 Reed. The Aztecs termed this momentous ceremony *xiuhmolpia*, meaning "the binding of the years." The termination of the fifty-two-year cycle appeared in Aztec stone sculpture in the form of wood bundles called *xiuhmolpilli*, each stick symbolically corresponding to a completed year. Although "binding" surely alluded to the tying up of sticks, it probably had other meanings, including the making of a package to carry as a burden and the bundling of the "dead" calendrical cycle.[25] Recalling the Aztec practice of cremating the bound and shrouded dead, wood bundles were cast into a hearth at the Temple of Darkness during *xiuhmolpia*. This act represented the renewal of the cosmos through the making of new fire, an event expressed in terms of a cosmic battle, the forces of darkness and night versus the resplendent sun. In preparation, all fires in the city of Tenochtitlan were extinguished, with the hearthstones, ceramic vessels, and other old objects of the household discarded and replaced. At night, the inhabitants of the city waited anxiously for new fire to be made on the chest of a sacrificial victim atop Huixachtecatl, located to the southeast. If new fire were not created, the world would be destroyed by the *tzitzimime*:

> Thus was it said: it was claimed that if fire could not be drawn, then [the sun] would be destroyed forever; all would be ended; there would evermore be night. Nevermore would the sun come out. Night would prevail forever, and the demons of darkness would descend to eat men.[26]

During this terrifying night, the primordial battle of creation began anew.

As part of the nocturnal New Fire ceremony, the fire priests impersonated the gods as they proceeded to Huixachtecatl; the *Codex Borbonicus* illustrates a priest dressed as Quetzalcoatl leading other godly beings to the pyre at the Temple of Darkness. This nocturnal meeting recalled the mythical creation of the fifth and present sun at Teotihuacan, when the gods convened to light the world anew.[27] By throwing himself into a great pyre, it was said, the humble Nanahuatzin became the sun god, Tonatiuh. Since the haughty but timid Tecuciztecatl hesitated, he became the weaker moon. Out of this fire also emerged the eagle and the jaguar, symbols of the sun and famed Aztec military orders; the code of the courageous warrior, one who

died freely for the empire and the sun, was thus born. After the self-sacrifice of Nanahuatzin and Tecuciztecatl, the sun appeared in the east, but it did not move and follow its path through the sky. To ensure the creation of the world, other gods then sacrificed themselves and offered their hearts to the sun. From their mantles and other remains, priests fashioned the *tlaquimilolli* (sacred bundles).[28]

According to Aztec accounts, the first dawning at Teotihuacan marked the shift from the mythic time of the gods to the world of historical reality.[29] Thereafter, as can be seen in their sacred mortuary bundles and stone images, the gods remained silent and immobile, but, much like honored ancestors, they could be invoked by incense, music, and sacrificial offerings. The clothing and other articles in the *tlaquimilolli* were used for deity impersonation, by which the deities were manifested temporarily in the world of mortals. Elizabeth Boone notes the close relationship between the inert god bundle and the *teixiptla*, the "image" or physical manifestation of the god.[30] The term *teixiptla* also referred to god impersonators—that is, those who wore the mantles and other raiments contained in the *tlaquimilolli*.

This myth of the creation of the fifth world suggests that the Aztec institution of heart sacrifice also began at Teotihuacan. In fact, the ancient art of Teotihuacan contained the first widespread portrayals of sacrificial hearts in Mesoamerica.[31] Moreover, Teotihuacan art and writing portrayed eagles and jaguars devouring human hearts, a convention also known in Postclassic Central Mexico (900–1521). The Aztecs replicated the original sacrifice of the gods with the ritual offering of human hearts to the sun. Hearts were placed in stone sacrificial basins known as *cuauhxicalli*. These vessels were ornamented with portrayals of eagle plumes and human hearts and had an image of the earth deity, Tlaltecuhtli, carved on the underside. The interior displayed a central sign, the glyph Nahui Ollin—the calendrical name of Tonatiuh. Just as the gods presented their hearts to the sun at Teotihuacan, the Aztecs placed sacrificial hearts atop these images of Tonatiuh to revive the dawning sun.

In both form and function, the *xukuri* of the contemporary Huichol of Nayarit closely resemble Aztec *cuauhxicalli*.[32] As well as being used to present sacrificial blood to the gods, they often display images of the sun in their interior. The *xukuri* are related to water, women, and the earth: in one Huichol myth, the womb of the underworld is a blood-filled *xukuri*.[33] Similarly, it is likely that *cuauhxicalli* symbolized the womb and birth canal of the earth, the place from which the sun was daily born. Page 32 of the *Codex Borgia* portrays a birthing figure in the squatting position of Tlaltecuhtli, with the hips depicted as a sacrificial basin lined with flints. In fact, the skirt worn by Tlaltecuhtli frequently resembles a basin, much as if her hips constituted a bowl or a bucket.

The Classic Maya also had sacrificial bowls marked in the interior with solar images, here in the form of the four-lobed *k'in*

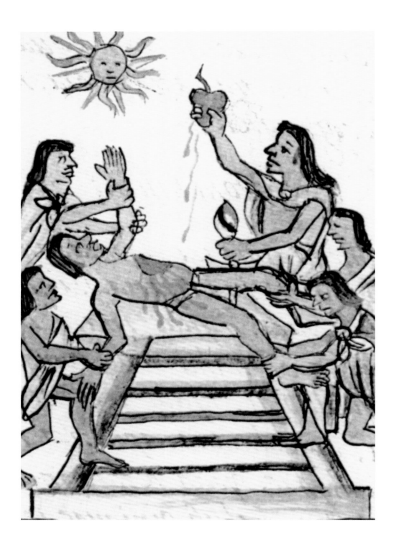

glyph, the Maya sun sign. In Classic Maya art, such bowls commonly appeared as censers containing hearts and other sacrificial offerings. One incised earspool portrays a Maya cosmic monster in the same squatting position in which the later Aztec Tlaltecuhtli was depicted; the hips are portrayed as a solar sacrificial bowl. Like the Aztec *cuauhxicalli*, these Classic Maya bowls also denoted the womb from which the sun emerged.[34]

The sacrificial birth of Tonatiuh at Teotihuacan was a myth shared by many peoples of highland Mexico. However, another creation account, this one referring to the ongoing hegemonic expansion of the Aztec state, was wholly Aztec; the principal characters had no obvious precursors in the art and ideology of Central Mexico. The preeminent character, the fierce and bellicose Huitzilopochtli, served as the solar, tutelary god of the Aztecs and their empire. Also known as the Blue Tezcatlipoca, Huitzilopochtli embodied conflict, strife, and the fate of the Aztec people. Huitzilopochtli was magically conceived while his mother, Coatlicue, was sweeping in her temple. Coatlicue's daughter, Coyolxauhqui, and her four hundred brothers, the Centzon Huitznaua, were enraged by their mother's pregnancy and prepared for battle. However, at his birth Huitzilopochtli emerged fully armed and slew his older siblings at Coatepetl.

Almost a hundred years ago, Eduard Seler suggested that the mythic battle at Coatepetl symbolized the dawning of the sun out of the earth and the defeat of the beings of night and darkness, with Coyolxauhqui being the moon and the Centzon Huitznaua, the innumerable stars.[35] Although the meaning of this episode remains obscure, the 1978 discovery of the Coyolxauhqui monument at the Templo Mayor revealed its central importance in Aztec ideology. Located at the base of the Huitzilopochtli side of the Templo Mayor, the monument features Coyolxauhqui stripped and dismembered, her head and limbs severed from her torso. Clearly, this monument portrays her defeat at Coatepetl, where she tumbled in pieces down the hill. Due to this major discovery, it is evident that the sacrifice of captives atop the Huitzilopochtli side of the Templo Mayor reenacted the defeat of Coyolxauhqui and her brothers: Just as the mythic enemies of Huitzilopochtli were slain at Coatepetl, captives from enemy states were sacrificed and cast down the temple steps.

Directly below the Coyolxauhqui stone lies an earlier version of the defeated goddess rendered in sculpted stucco. As in the stone monument, she is nude and dismembered, her head and limbs cut from the central trunk.[36] However, the stucco example portrays the severed limbs well away from the torso and oriented to the four quarters of the world, recalling both the Tlaltecuhtli myth and the sacrifice of Tezcatlipoca as it appears on page 1 of the *Codex Fejérváry-Mayer*. Coyolxauhqui is rendered as the earth, dismembered and fashioned into a new, ordered world. The birth of Huitzilopochtli was thus associated with the creation of both the Aztec sun and its earthly domain:

Page from Fray Bernardino de Sahagún, *Florentine Codex*, also known as *Historia general de las cosas de la Nueva España*, 1575–77.

from the dismembered Coyolxauhqui and the bodies of vanquished enemies, the Aztec world was made.

The symbolic *axis mundi* of the Aztecs, the Templo Mayor lay at the center of the four quarters not only of the city of Tenochtitlan but of the entire Aztec world. It supported two temples, the southern structure dedicated to Huitzilopochtli and the northern structure to Tlaloc. The two temples have been interpreted in a number of ways—as symbolic of the importance to the Aztecs of both agriculture and war, for example, or of the contrast of ancient traditions to the new Aztec world. The temples have also been interpreted as representing a merging of two distinct mountains, Coatepetl and a mountain of sustenance dedicated to Tlaloc, with Coatepetl relating to the earth's surface and the historical doings of the Aztecs and the mountain of Tlaloc concerning the interior of the mountain and the ancient paradise of Tlalocan.[37] During one of the later renovations of the Templo Mayor, an altar with steep steps, centered at the base of the Tlaloc temple, was added. Topped by a pair of frogs, this altar recalls a description of Tlalocan in the *Primeros memoriales*, according to which two frogs sit atop a wall to mark the entrance to Tlalocan.[38] The frog altar may thus have represented a symbolic entrance to Tlalocan, a realm perhaps thought to have been located in the interior of the Templo Mayor. Many of the rich offerings buried within both sides of the Templo Mayor may well have referred to this paradisiacal place of wealth and plenty. Earlier phases of the Templo Mayor buried by subsequent construction may also have been identified with the realm of Tlaloc and the ancestral past.

Aside from sacrificial offerings, music was also an essential Aztec means of contacting the gods and ancestors. Guilhem Olivier notes that the gods were ritually attracted and compelled using wind instruments, such as conch trumpets and flutes.[39] According to Fray Gerónimo de Mendieta, the priests who fashioned the original *tlaquimilolli* at Teotihuacan sought music to conjure and communicate with the gods after their mass sacrifice.[40] Two related accounts of this mythic origin of music describe either the wind or a priest of Tezcatlipoca traveling across the sea to the house of the sun to obtain music.[41] A version of this episode appears on pages 35 to 38 of the *Codex Borgia*.[42] On page 35, Tezcatlipoca and the wind god, Ehecatl, obtain a bundle from a temple occupied by a figure displaying the attributes of both Tonatiuh and Tlaloc. Page 36 depicts a great stream of wind exiting a red flute at the center of this bundle; the very same flute is played by the god of music, Xochipilli, on page 37. Within the stream of wind appear items related to music and dance, including ceramic and turtleshell drums, flutes, and dance staffs, as well as precious birds and flowers. In addition, there are five images of Quetzalcoatl flying with his eyes shut, denoting death or, more likely, ecstatic trance achieved through music and dance.

The flight of Quetzalcoatl in the *Codex Borgia* scene corresponds well with Aztec concepts of music and conjuring ancestral souls. According to John Bierhorst, the early colonial *Cantares mexicanos* concerned the conjuring of revenants, who descended as birds from the heavens.[43] At times, Aztec *teponaztli* drums portrayed flying individuals similar to the Borgia figure.[44] An excellent example occurs on an Aztec ceramic model of a *teponaztli*. Although this object is not a true *teponaztli*, it is probably still a ceramic drum, the open mouth originally being covered by a skin tympanum. The drum's surface portrays Xochipilli flying in a position almost identical to that of Quetzalcoatl in the *Codex Borgia* image. Both wear the same dance collar of shell tinklers. A similarly flying figure appears on another Aztec drum—this one an actual *teponaztli*—in a band containing flowers and a tropical bird, elements also appearing in the *Codex Borgia* image. Whereas the central scene on one side of this drum portrays the sun engaged in celestial battle, the other side depicts the eagle and jaguar, symbols of the Aztec military orders dedicated to the sun. Bierhorst notes that a central theme of the *Cantares mexicanos* was the summoning of warrior souls from the flower paradise of the sun, a celestial realm closely identified with Teotihuacan, the mythic birthplace of the sun and the eagle and jaguar military orders.[45]

The Aztecs were very aware of their historical past, and many aspects of their religious traditions related mythically to the creation of the present sun at Teotihuacan. Although this episode was clearly tied to Aztec militarism and the solar war cult, it was also connected to the practice of heart sacrifice, the making of sacred bundles, and music. Like the sun, the earth and sky were also created through sacrifice, by the dismemberment of the primordial Cipactli. The birth of Huitzilopochtli similarly involved human sacrifice, and it is likely that this wholly Aztec myth concerned both the origin of the sun and the Aztecs' terrestrial realm. For the act of heart sacrifice, four priests held the limbs of the victim, thereby creating a cosmogram of the four quarters with the victim's heart at the center. In sixteenth-century Yucatan, the four priests who grasped the limbs were referred to as *chakoob*, the four directional rain gods of the Maya.[46] During Aztec rites of sacrifice, conch trumpets and other instruments were played to mark the numinous period of contact with the deities. To the Aztecs, human sacrifice was anything but a mundane event. It was an act that restored the violence of creation, opening a doorway into the original world of the gods.

Notes

1. For a recent discussion of Aztec sacrifice, see David Carrasco, *City of Sacrifice: The Aztec Empire and the Role of Violence in Civilization* (Boston: Beacon Press, 1999).

2. Angel Garibay, *Teogonia e historia de los mexicanos: Tres opusculos del siglo XVI* (Mexico City: Editorial Porrua, 1979).

3. Fray Bernardino de Sahagún, *Primeros memoriales*, trans. Thelma D. Sullivan (Norman: University of Oklahoma Press, 1997); and Fray Bernardino de Sahagún, *Florentine Codex: General History of the Things of New Spain*, 13 vols., trans. Arthur J. O. Anderson and Charles E. Dibble (Santa Fe: School of American Research, 1950–82).

4. The *Histoyre du Mechique* explicitly describes this deity and his/her realm: "In the thirteenth and last [heaven], the highest, there is a god called Ometecuhtli [Ometeotl], which means two gods, and one is a goddess" (Garibay, *Teogonia e historia de los mexicanos*, p. 103, trans. author). For Aztec concepts of dualism, see Miguel Leon-Portilla, *Aztec Thought and Culture: A Study of the Ancient Nahuatl Mind* (Norman: University of Oklahoma Press, 1963); and Alfredo Lopez Austin, *The Human Body and Ideology: Concepts of the Ancient Nahuas*, trans. Thelma Ortiz de Montellano and Bernard Ortiz de Montellano (Salt Lake City: University of Utah Press, 1988).

5. Garibay, *Teogonia e historia de los mexicanos*, p. 23.

6. The portico murals of Structure A at Late Classic Cacaxtla—discovered in 1975, more than ten years after Tamayo painted *Duality*—feature the same dualistic opposition. The Maya eagle warrior of the east stands upon a plumed serpent, while the Mexican jaguar warrior of the west is atop a jaguar serpent; thus the murals depict a plumed serpent of the dawning east and a jaguar serpent of the nocturnal west.

7. For accounts of the five suns myth, see Roberto Moreno de los Arcos, "Los cinco soles cosmogonicos," *Estudios de Cultura Náhuatl* 7 (1969), pp. 183–210; and Henry B. Nicholson, "Religion in Pre-Hispanic Central Mexico," in Robert Wauchope, gen. ed., *Handbook of Middle American Indians*, vol. 10 (Austin: University of Texas Press, 1971), pp. 395–446.

8. For the Maya hero twins, see Michael D. Coe, "The Hero Twins: Myth and Image," in Justin Kerr, ed., *The Maya Vase Book*, vol. 1 (New York: Kerr Associates, 1989), pp. 161–84; Karl A. Taube, *Aztec and Maya Myths* (London: British Museum Press, 1993), pp. 56–67; and Dennis Tedlock, *Popol Vuh: The Definitive Edition of the Mayan Book of the Dawn of Life and the Glories of Gods and Kings* (New York: Simon and Schuster, 1996).

9. Accounts of this episode appear in the *Historia de los mexicanos por sus pinturas* and the *Histoyre du Mechique* (see Garibay, *Teogonia e historia de los mexicanos*, pp. 26, 105, 108).

10. From the two creation metaphors of copulation and violent conflict arises a third, by which the creation of the earth can be seen as a form of cosmic rape. For discussions of the mythic dismemberment of Tlaltecuhtli as rape, see Alma Elizabeth del Rio, *Bases psicodinamicas de la cultura Azteca* (Mexico City: Costa-Amic Editores, 1973); and Michel Graulich, "Myths of Paradise Lost in Pre-Hispanic Central Mexico," *Current Anthropology* 24, no. 5 (1983), pp. 575–81.

11. This statement, by a contemporary Nahua informant of the Sierra de Puebla, was recorded by Tim Knab and cited in Johanna Broda, "Templo Mayor as Ritual Space," in Broda, David Carrasco, and Eduardo Matos Moctezuma, *The Great Temple of Tenochtitlan: Center and Periphery in the Aztec World* (Berkeley: University of California Press, 1987), p. 107.

12. The *Primeros memoriales* contains a remarkably detailed description of a woman traveling to Tlalocan (pp. 179–83). Tim Knab has documented a form of this watery paradise among the contemporary Nahua of the Sierra de Puebla; according to modern belief, this realm occupies the center of the underworld (cited in Broda, "Templo Mayor as Ritual Space," p. 108).

13. For corn and cosmology in Mesoamerican thought, see Karl A. Taube, "Lightning Celts and Corn Fetishes: The Formative Olmec and the Development of Maize Symbolism in Mesoamerica and the American Southwest," in John E. Clark and Mary E. Pye, eds., *Olmec Art and Archaeology in Mesoamerica*, exh. cat. (Washington, D.C.: National Gallery of Art, 2000), pp. 296–337.

14. See Garibay, *Teogonia e historia de los mexicanos*, p. 26. The four large cisterns oriented to the cardinal points atop Tetzcotzingo probably refer to the rains of the four directions. For a description of Tetzcotzingo and the four cisterns, see Richard F. Townsend, *The Aztecs* (London: Thames and Hudson, 1999), pp. 137–44.

15. Fray Diego Durán, *The Book of the Gods and Rites and the Ancient Calendar*, trans. Fernando Horcasitas and Doris Heyden (Norman: University of Oklahoma Press, 1971), p. 156.

16. Richard F. Townsend, "The Mount Tlaloc Project," in David Carrasco, ed., *To Change Place: Aztec Ceremonial Landscapes* (Niwot: University Press of Colorado, 1991), pp. 26–30.

17. Although the *Primeros memoriales* and the *Florentine Codex* describe the mountain sacrifice of children to Tlaloc during the month of Atlcahualo, Durán mentions that the child sacrifices upon Mount Tlaloc occurred during the later month of Ochpaniztli (see Sahagún, *Primeros memoriales*, pp. 55–56; Sahagún, *Florentine Codex*, vol. 2, pp. 1–2, 42–44; and Durán, *The Book of the Gods and Rites*, p. 425).

18. Garibay, *Teogonia e historia de los mexicanos*, p. 105.

19. Since at least the first century A.D., the ancient Maya had portrayed their day names surrounded by a cartouche denoting blood, much as if the days were sacrificed. David Stuart has determined that a text from the recently discovered Late Classic bench from Temple 19 at Palenque refers to the chopping of a mythical reptile, clearly a version of the Cipactli myth. Versions of the Cipactli myth were also present in Late Postclassic Yucatan (see Karl A. Taube, *The Major Gods of Ancient Yucatan* [Washington, D.C.: Dumbarton Oaks, 1992]), pp. 128–31).

20. In the colonial Nahuatl chants recorded by Hernando Ruíz de Alarcón, the surface of the earth is described as a "mirror that gives off smoke," probably an allusion to Tezcatlipoca (see Michael D. Coe and Gordon Whittaker, *Aztec Sorcerers in Seventeenth Century Mexico: The Treatise on Superstitions by Hernando Ruíz de Alarcón* [Albany: State University of New York at Albany, 1982], pp. 131, 304; and Hernando Ruíz de Alarcón, *Treatise on the Heathen Superstitions that Today Live among the Indians to this New Spain*, 1629, ed. and trans. J. Richard Andrews and Ross Hassig [Norman: University of Oklahoma Press, 1984], p. 95).

21. As Susan Gillespie notes, dismemberment was a common metaphor for the creation of the universe and the division of the seasons in native New World mythologies (Susan Gillespie, "Ballgames and Boundaries," in Vernon L. Scarborough and David R. Wilcox, eds., *The Mesoamerican Ballgame* [Tucson: University of Arizona Press, 1991], pp. 317–45).

22. See David Carrasco, *City of Sacrifice*, pp. 130–32.

23. For a discussion of sky bearers, see J. Eric S. Thompson, *Sky Bearers, Colors and Directions in Maya and Mexican Religion* (Washington, D.C.: Carnegie Institution of Washington, 1934), pp. 209–42; and Karl A. Taube, "The Bilimek Pulque Vessel: Starlore, Calendrics, and Cosmology of Late Postclassic Central Mexico," *Ancient Mesoamerica* 4 (1993), pp. 1–15.

24. In a drawing of this scene published by Hasso von Winning (*Pre-Columbian Art of Mexico and Central America* [New York: Harry N. Abrams, 1968], plate 397), the *tzitzimtl* appears to face away from the sun. However, since this is a wraparound image on a cylindrical bone, the figure can be read as facing toward the sun. Given the fundamentally antagonistic nature of the *tzitzimime* in relation to solar light, the latter seems the most likely interpretation.

25. For the mortuary symbolism of year bundles, see Alfonso Caso, *Los calendarios prehispanicos* (Mexico City: Universidad Nacional Autónoma de México, 1967), pp. 129–40.

26. Sahagún, *Florentine Codex*, vol. 7, p. 27.

27. On the New Fire ceremony and the Teotihuacan creation myth, see Karl A.

Taube, "The Turquoise Hearth: Fire, Self Sacrifice, and the Central Mexican Cult of War," in David Carrasco, Lindsay Jones, and Scott Sessions, eds., *Mesoamerica's Classic Heritage: From Teotihuacan to the Aztecs* (Boulder: University Press of Colorado, 2000), pp. 315–16.

28. On the making of god bundles, see Fray Gerónimo de Mendieta, *Historia eclesiastica indiana* (Mexico City: Editorial Porrua, 1980), pp. 78–79.

29. Similarly, in the sixteenth-century *Popol Vuh* of the Quiche Maya, the gods and the spirits of animals were turned into stone at the first dawning of the sun (Tedlock, *Popol Vuh*, p. 161).

30. Elizabeth H. Boone, *Incarnations of the Aztec Supernatural: The Image of Huitzilopochtli in Mexico and Europe* (Philadelphia: American Philosophical Society, 1989), p. 29.

31. For the original identification of heart sacrifice in Teotihuacan art, see Laurette Sejourne, *Burning Water: Thought and Religion in Ancient Mexico* (New York: Vanguard Press, 1956), pp. 119–27.

32. Long ago, Konrad Preuss compared the gourd bowls of the Cora, close neighbors of the Huichol, to the ancient Aztec *cuauhxicalli* (Preuss, "Die Opferblutschale der alten Mexikaner erläuter nach Angaben der Cora-Indianer," *Zeitschrift für Ethnologie* 43 [1911], pp. 293–308). For discussions of Huichol *xukuri*, see Carl Lumholtz, *Symbolism of the Huichol Indians* (New York: American Museum of Natural History, 1900), pp. 161–66; Robert M. Zingg, *The Huichol: Primitive Artists* (New York: G. E. Stechert, 1938), pp. 634–35; and Johannes Neurath, *Las fiestas de la Casa Grande: Procesos rituales, cosmovision y estructura social en una comunidad Huichola* (Mexico City: Instituto Nacional de Antropología, 2002), pp. 175–76.

33. Juan Negrin, *The Huichol Creation of the World* (Sacramento, Calif.: E. B. Crocker Art Gallery, 1975), pp. 82–84.

34. In this regard, it is also noteworthy that Classic Maya elite women were often portrayed wearing the sacrificial offering bowl as a headdress, denoting the relation of this vessel to women. See Karl A. Taube, "The Jade Hearth: Centrality, Rulership, and the Classic Maya Temple," in Stephen D. Houston, ed., *Function and Meaning in Classic Maya Architecture* (Washington, D.C.: Dumbarton Oaks, 1998), p. 464.

35. Eduard Seler, "Eineges über dei natürlichen Grundlagen mexikanisher mythen," *Zeitshcrift für Ethnologie* 39 (1907), pp. 1–41.

36. Eduardo Matos Moctezuma, "Las seis Coyolxauhqui: Variaciones sobre un mismo tema," *Estudios de Cultura Azteca* 21 (1991), pp. 15–30.

37. For a recent discussion of these interpretations of the Templo Mayor, see Carrasco, *City of Sacrifice*, p. 72.

38. Sahagún, *Primeros memoriales*, p. 181. I am indebted to Alan Robinson for mentioning to me the similarity of the Templo Mayor altar to the *Primeros memoriales* account.

39. Guilhem Olivier, "The Hidden King and the Broken Flutes: Mythical and Royal Dimensions of the Feast of Tezcatlipoca in Toxcatl," in Eloise Quiñones Keber, ed., *Representing Aztec Ritual: Performance, Text, and Image in the Work of Sahagún* (Boulder: University Press of Colorado, 2002).

40. Mendieta, *Historia eclesiastica indiana*, p. 80. Excavations in the sacred precinct of Tenochtitlan also suggest that the Aztecs related music to ancient Teotihuacan. Clearly evoking the architectural and mural style of Teotihuacan, the Red Temple structures at Tenochtitlan contained offerings of musical instruments, including miniature forms (see Bertina Olmedo Vera, *Los templos rojos del recinto sagrado de Tenochtitlan* [Mexico City: Instituto Nacional de Antropología e Historia, 2002]; and Leonardo López Luján, "The Aztecs' Search for the Past," in Eduardo Matos Moctezuma and Felipe Solís, eds., *Aztecs* [New York: Harry N. Abrams, 2002]).

41. See Mendieta, *Historia eclesiastica indiana*; and Garibay, *Teogonia e historia de los mexicanos*, pp. 111–12.

42. Karl A. Taube, "The Breath of Life: The Symbolism of Wind in Mesoamerica and the American Southwest," in Virginia M. Fields and Victor Zamudio-Taylor, eds., *The Road to Aztlan: Art From a Mythic Homeland* (Los Angeles: Los Angeles County Museum of Art, 2001), pp. 102–23.

43. *Cantares mexicanos: Songs of the Aztecs*, trans. John Bierhorst (Stanford: Stanford University Press, 1985), p. 19.

44. For examples of flying figures on *teponaztli*, see Marshall H. Saville, The Wood-Carver's Art in Ancient Mexico, exh. cat. (New York: Museum of the American Indian, 1925), plates 33a–b.

45. In addition, it appears that the Aztec concepts of the flower paradise and the relation of warrior souls to birds and butterflies was already present at Teotihuacan (see Janet Berlo, "The Warrior and the Butterfly: Central Mexican Ideologies of Sacred Warfare and Teotihuacan," in Berlo, ed., *Text and Image in Pre-Columbian Art: Essays on the Interrelationship of the Visual and Verbal Arts* [Oxford: BAR International Series, 1983], pp. 70–117; and Taube, "The Turquoise Hearth," pp. 269–340).

46. Alfred M. Tozzer, *Landa's Relación de las cosas de Yucatán: A Translation* (Cambridge, Mass.: Peabody Museum, Harvard University, 1941), pp. 112, 119.

Axis Mundi

Roberto Velasco Alonso

THE AZTECS CONCEIVED OF A COMPLEX ORDERING SYSTEM TO ORGANIZE THE DIFFERENT PLANES and paths of the universe. These planes were interconnected to bring order to the present and can be understood as realities with alignments vertically super-imposed, divided into four sections oriented to the four cardinal directions. Each had a different magnitude, interpolation, and proximity to the various domains comprising the world of humans.

The biggest of these realms was the sphere of the ruler of the universe, Ometeotl (God-Two), a dual principle that both contained and was contained by all aspects of the Aztec worldview. Ometeotl was the primordial axiom whose existence could not be represented (and thus there are only symbolic represen-tations of his perceptible manifestation in the cosmos and/or physical world). He was understood as an all-embracing and all-embraced premise that pre-ceded everything. Ometeotl conceived the four Tezcatlipocas (Smoking Mirrors), among which the contents of the universe were divided and ordered into four directions, each marked by dual divisions of essence and influence, extending inward toward a center. These four divine offspring would impose themselves upon reality from their individual spheres, and each level of subsequent reality would be marked by their own distinct features, which they would create through their smoking-mirror reflection, each of a different color and with a different nature.

Xiuhtecuhtli (Turquoise Lord; god of fire and time), the focus or center where the four directions united, was determined by the balanced meeting of these four possibilities and shared the quintessential characteristics with the primordial sphere, differing only according to longitudinal and temporal rank. The Aztecs believed that this equilibrium was the determining factor for bring-ing order to a given era, and Xiuhtecuhtli was regarded as the ruler of order itself. From this focal fusion, which would be subject to the approval of Ometeotl himself, the four Smoking Mirrors created within the borders of this fifth sphere the original elemental substances—Huehueteotl (fire), Tlaloc and Chalchiuhtlicue (water), and Cipactli-Tlaltecuhtli (earth)—that were preceded by the element of air as Ehecatl-Quetzalcoatl, the White Smoking Mirror.

In the vortex created between essential force and elemental substances (always in dual form), four eras arose, each presided over by a sun, each charged by an element. Earth was the first element to dominate an era, followed by wind, and then fire and water. According to the notion of duality, each era had its own beginning, and once the equilibrium of the reigning element was disrupted, the era suffered a violent end marked by the extermination of humanity or its transformation into various creatures. With the creation of life, there was the need to create death. Nine levels were established beneath the terrestrial plane where existence unfolded. When a human being died, it would encounter the nine requirements that would cause it to shed its singular virtue.

77. Cihuacoatl plaque, detail
Aztec, ca. 1200–1521

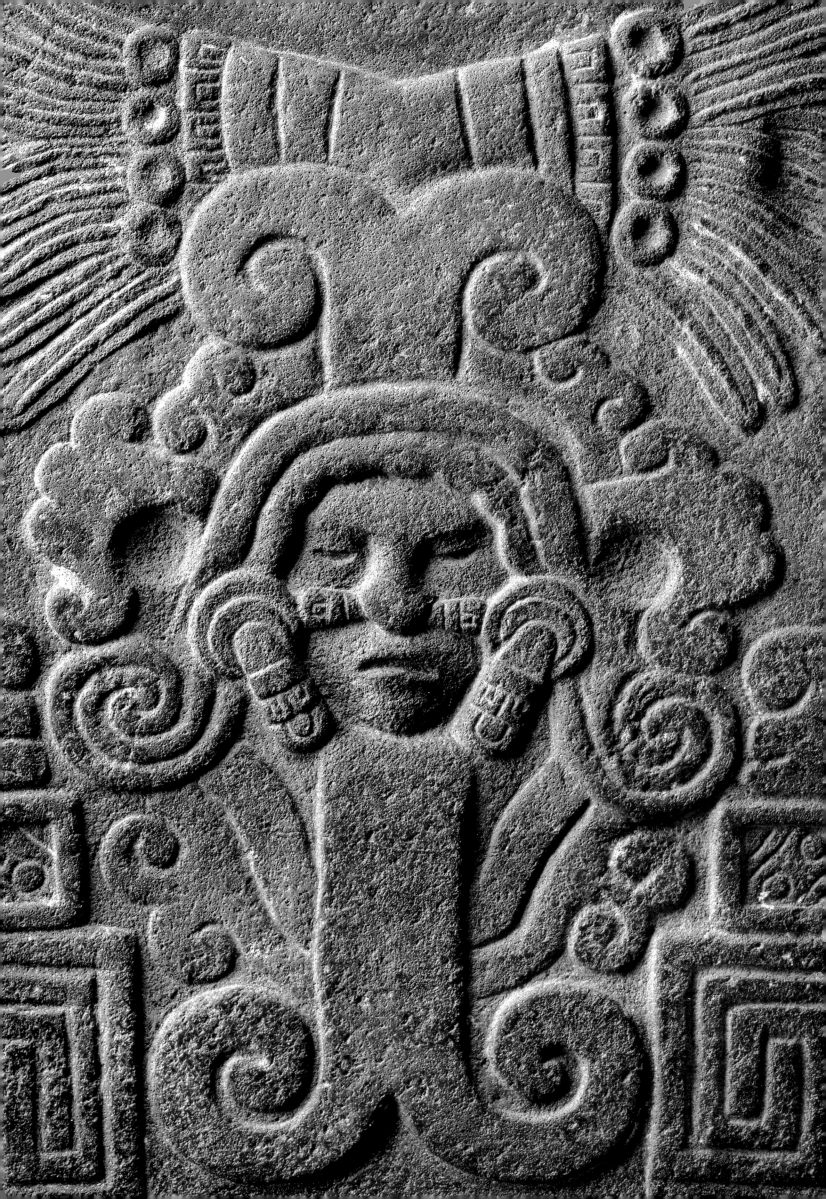

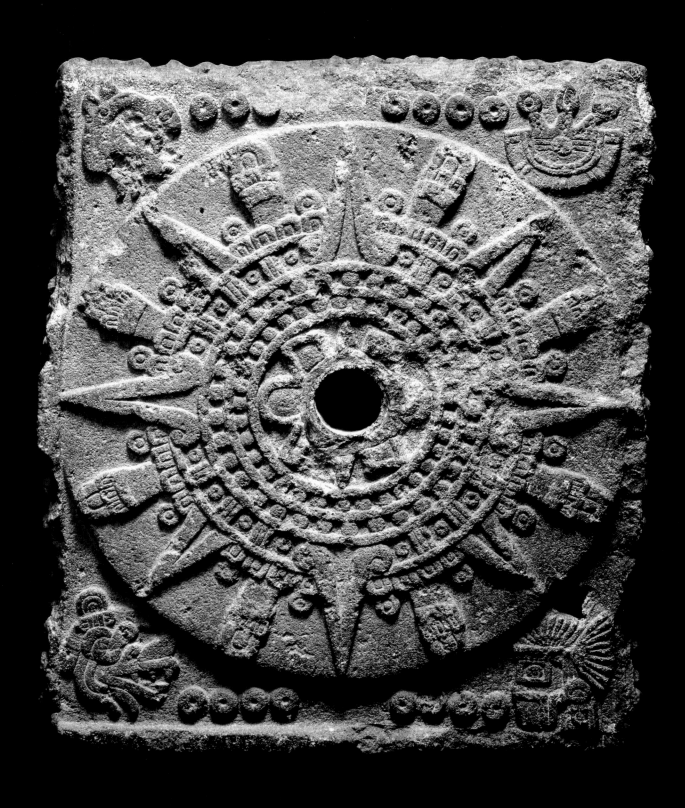

78. Relief of the five ages
Aztec, ca. 1400–1521

This might be understood on an individual level as well: when a being dies, it must deliver nine of its nonmaterial properties that once gave it the virtue of life.

A gathering of all the creative forces in the universe then took place, and they agreed to create a new "sun," and the Smoking Mirrors once again had to return to Ometeotl for consent. First they divided Cipactli-Tlaltecuhtli, erecting the heavens (separated by thirteen levels of proximity) and establishing the earth (with four horizontal, perpendicular influences restricted only by the dual sphere of Ometeotl). This separation was achieved by the establishment of four supports, either in the form of trees, gods, or men, located at the boundaries of the focus or center—the domain of Xiuhtecuhtli.

Then the Smoking Mirrors ordered the Earth to create sustenance for mankind, converting its various parts into mountains, rivers, caves, plants, etc. By weeping, the earth goddess showed her great discontent at having sacrificed its unity, and as a precondition for the continued growth of human nourishments, she required a tribute in the form of human blood and hearts. Thus began the rise of the categorical numina, which represented, through their own immediate proximity, intelligible manifestations of the physical world, such as fertility, caves, and war. In order to bring light and ensure fertility on earth, the gods established the ritual for bringing about the fifth "sun" or era. Once again the Smoking Mirrors, through their numenic entities, vied for dominion over this sun by bloodletting and autosacrifice (not only as a gift of blood, but signifying acceptance of death for the birth of this sun).

Due to the deteriorated state of the astral deity prior to this ritual, it demanded that the gods give up their lives, so that its daily path through the heavens could be maintained. This sun was characterized, first, by the fusion of all essential and elemental vital liquids into a new focus (the gods' renunciation of their state of absolute purity). Secondly, this sun was charged (or defined) by the rotating dominion of the cardinal influences included in every daily completion of its trajectory through the sky, whose charting and measurements were taught to the first human couple. The men of the four previous eras had been formed from the multiple combinations of elemental substances that occurred in those preceding eras. Their bones were jealously guarded by the Lord of Mictlan. Once again Quetzalcoatl, with the help of Xolotl, his proximal deity (but of a lower magnitude), descended into the realm of the dead to retrieve these bones. The divine essence had already departed from the skeletons, and it was the task of this numen to shed its own blood and that of Cihuacoatl to be ground with the bones until it created the mass from which the first human couple of the fifth era would be formed.

They then gave the humans maize, their most perfect form of sustenance, and instructed the people in the arts of divination and the reading of the *tonalamatl* (book of days). With this, a strict retribution covenant was made: veneration for the gods, the use of incense, and the rituals of self-sacrifice or bloodletting. The humans lived in the mythic land of Aztlan, where they reproduced and grew in numbers, until they were instructed to migrate. It was during this long journey that the Aztecs found a new patron to venerate in the sun, with its categorical numen, Huitzilopochtli (Hummingbird on the Left), who was devoted to war. According to the mythic model, immediately after being born, Huitzilopochtli decapitated his sister the moon, Coyolxauhqui (She of the Rattles on her Cheeks), and devoured the blood and hearts of the vanquished lunar army (the countless stars). From then on, he would guide the people, and if they obeyed his will, he promised them the conquest of the world.

As an ultimate reflection of these influences, the Aztecs validated and reinforced this mythic model by orienting the structures of their capital city, and all of their social practices, toward the perceptible cosmic structures, devoting all their tasks to them

and considering themselves as anointed with the duty of providing tribute in the form of blood and hearts. They also devoted themselves to providing sustenance for the other gods. In their ritual center, Mexico-Tenochtitlan, they built temple-pyramids adorned with the symbols related to the residing divinity. They also marked the various moments in which the gods' proximity was made perceptible, namely, those points or times when they became phenomenologically present on Earth.

During the major festivals, rituals were given added spiritual emphasis through instruments and symbols associated with the particular deity being venerated, as well as those associated with his or her path of influence. Due to their knowledge of the *tonalpohualli* (the divinatory calendar), the Aztecs were able to locate themselves within this celestial and temporal cycle with a complete understanding of both the initial point of origin and the rhythms and trajectories of the heavenly bodies, which were also reflected in the physical world. They knew exactly what distal divinities were aligned with what proximal patrons at any given moment. This imbued the ritual with the possibility of creating a portal through which all transcendental manifestations could be briefly focused on a given essential direction (categorical, proximal, numenic, elemental, distal) through its phenomenological presence. This provided the Aztecs with an axis for participating in the sacred, thereby complying fully with their mission in the cosmos: that of erecting, maintaining, and perpetuating the fifth support, the great cosmic tree, among whose deep roots converged a balance of all cardinal influences, and whose branches sheltered the universal birds, who carried the primordial energy of the hearts and blood to its dominant essences.

79. Altar of the sacred tree
Aztec, ca. 1300

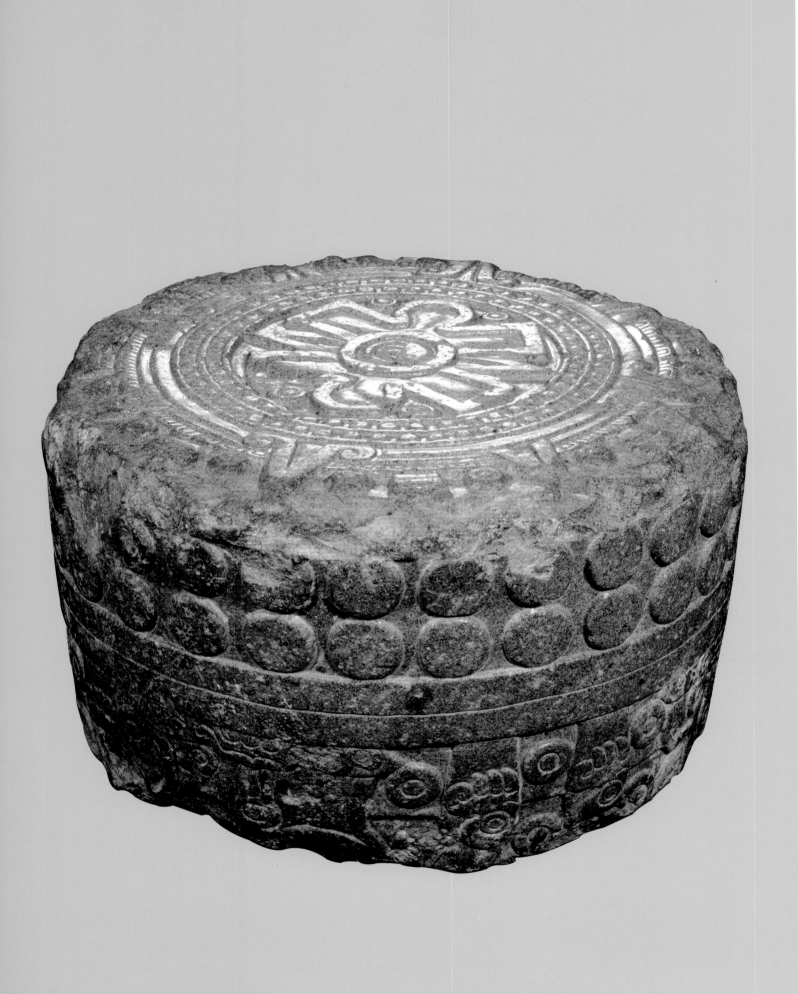

80. Calendar stone
(temalacatl)
Aztec, ca. 1300–1500

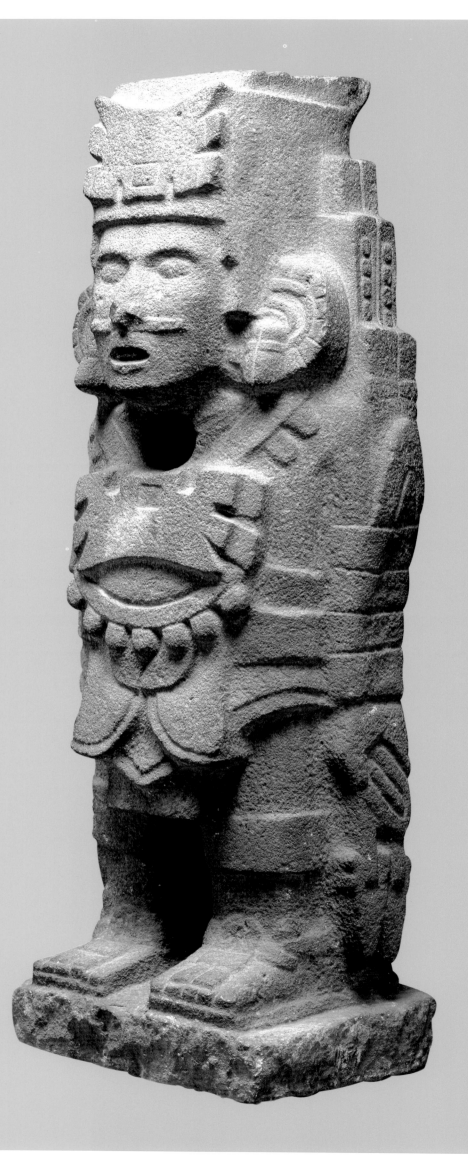

81. Atlantean figure (east)
Aztec, ca. 1500

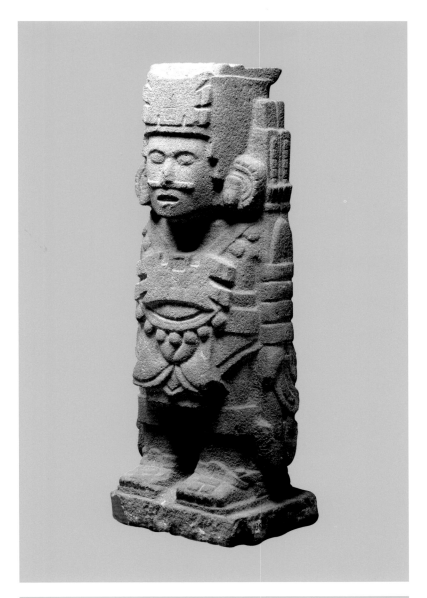

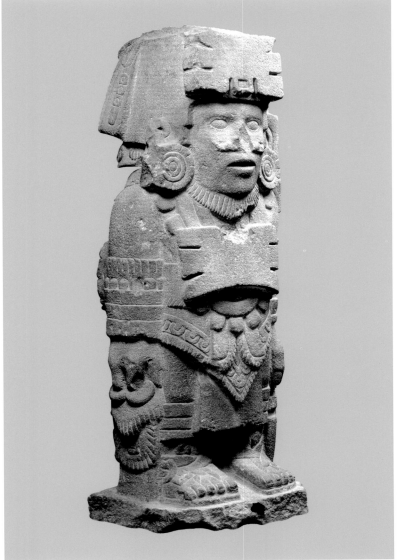

82. Atlantean figure (north)
Aztec, ca. 1500

83. Atlantean figure (center)
Aztec, ca. 1500

Following pages:

84. Atlantean figure (west), detail
Aztec, ca. 1500

85. Atlantean figure (south), detail
Aztec, ca. 1500

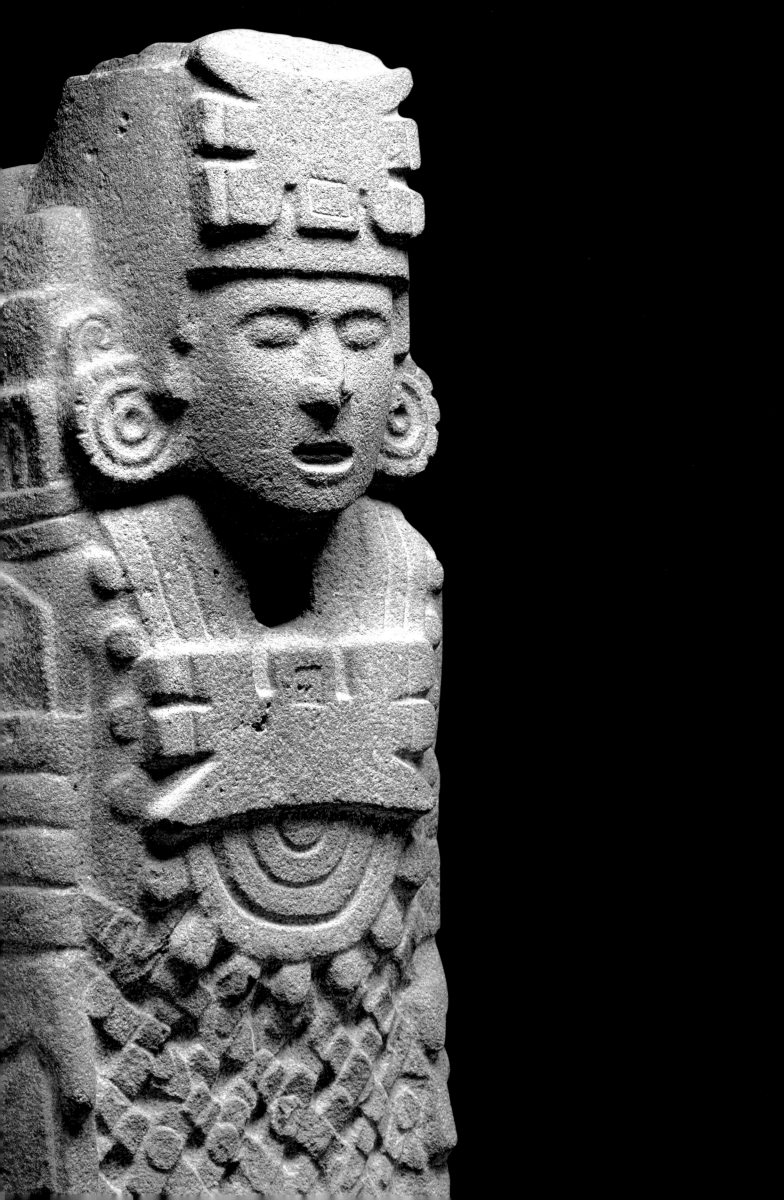

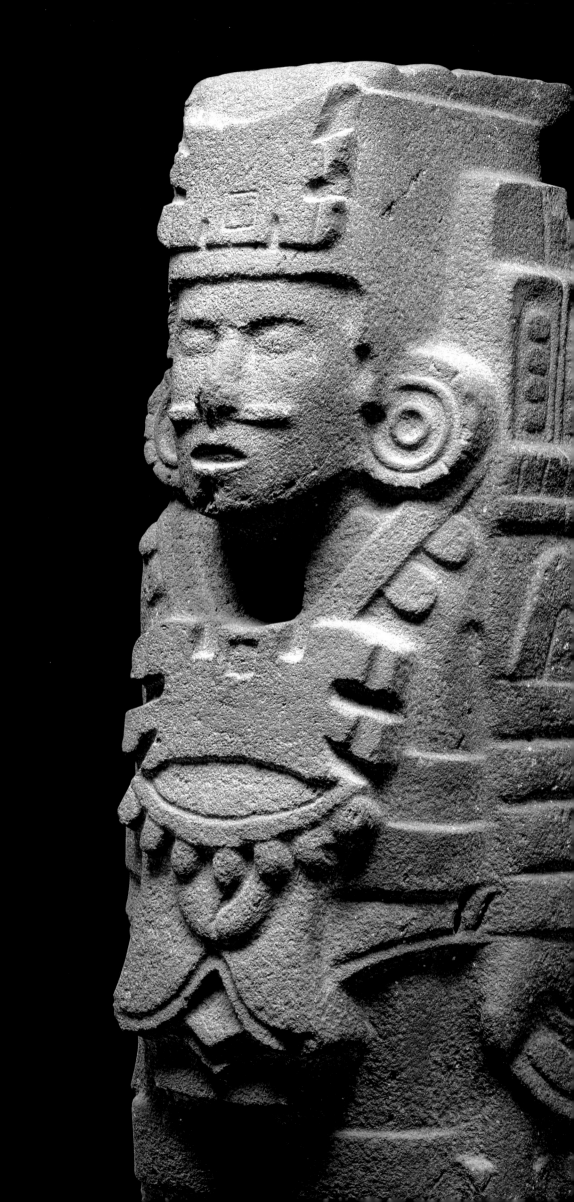

86. Tizapan casket and maize goddess figure
Aztec, ca. 1250–1521

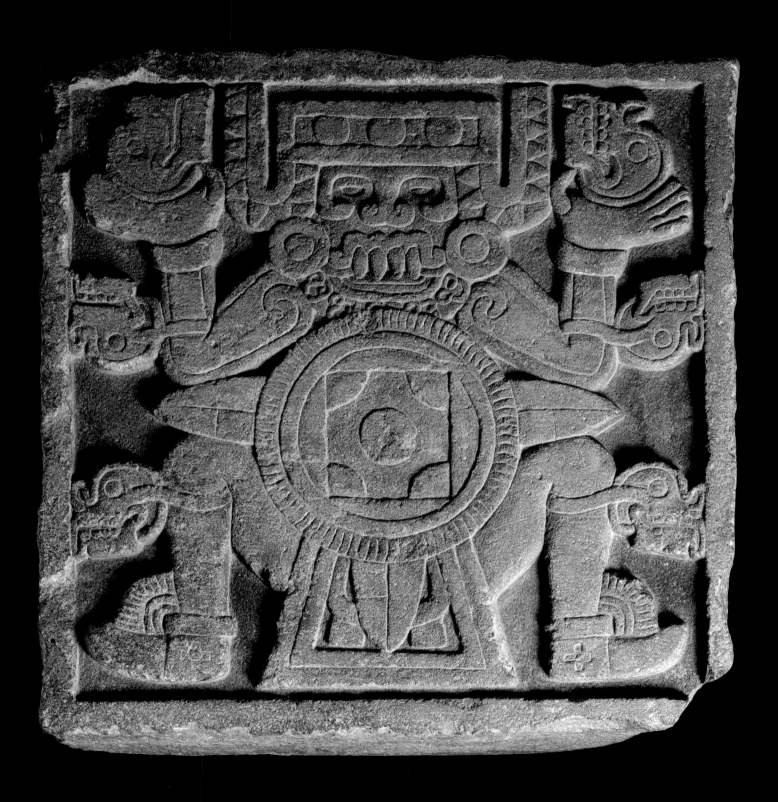

87. Tlaltecuhtli
Aztec, ca. 1200–1521

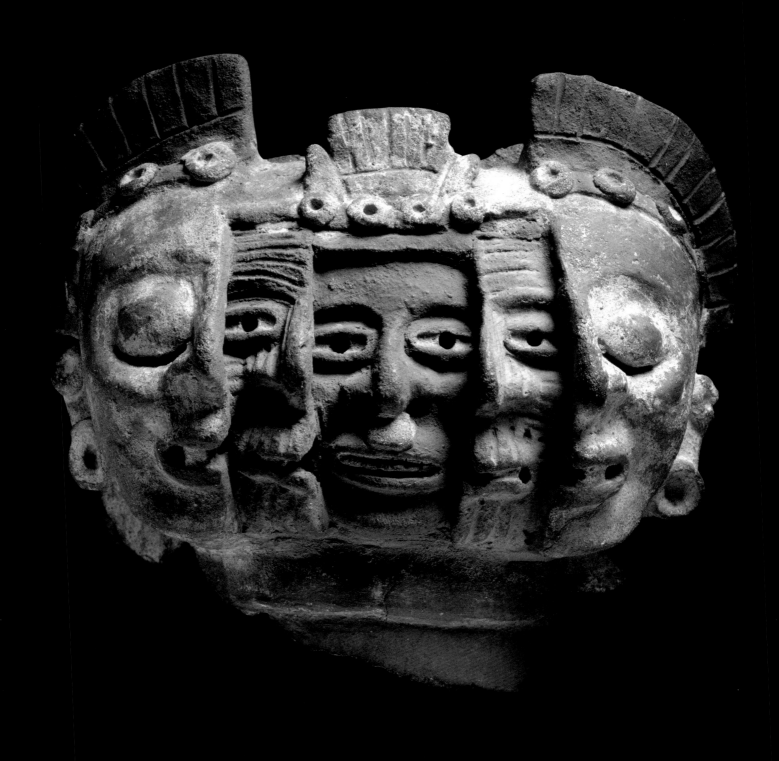

88. Fragment of anthropomorphic
brazier
Aztec, ca. 1300

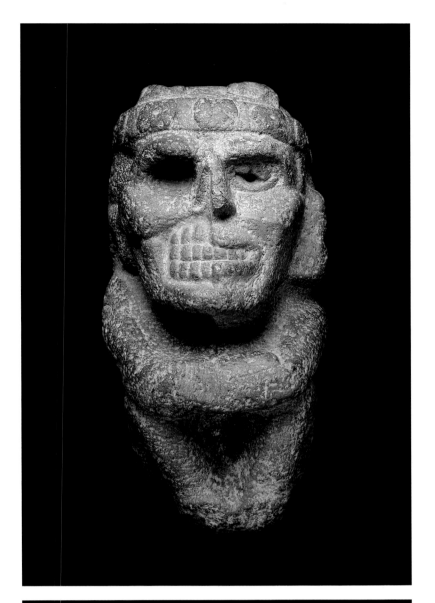

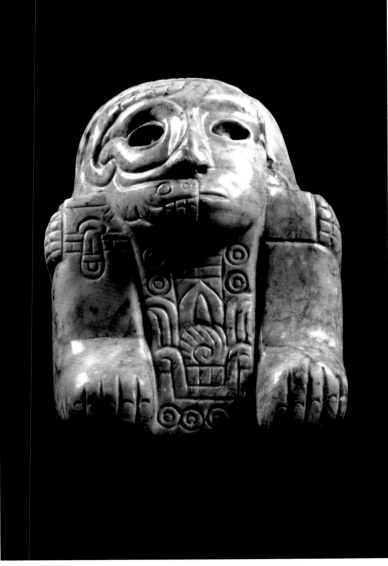

89. Life-death figure
Aztec, ca. 1440–1521

90. Duality
Aztec, ca. 1500

91. Solar disk with calendar date
Aztec, ca. 1500

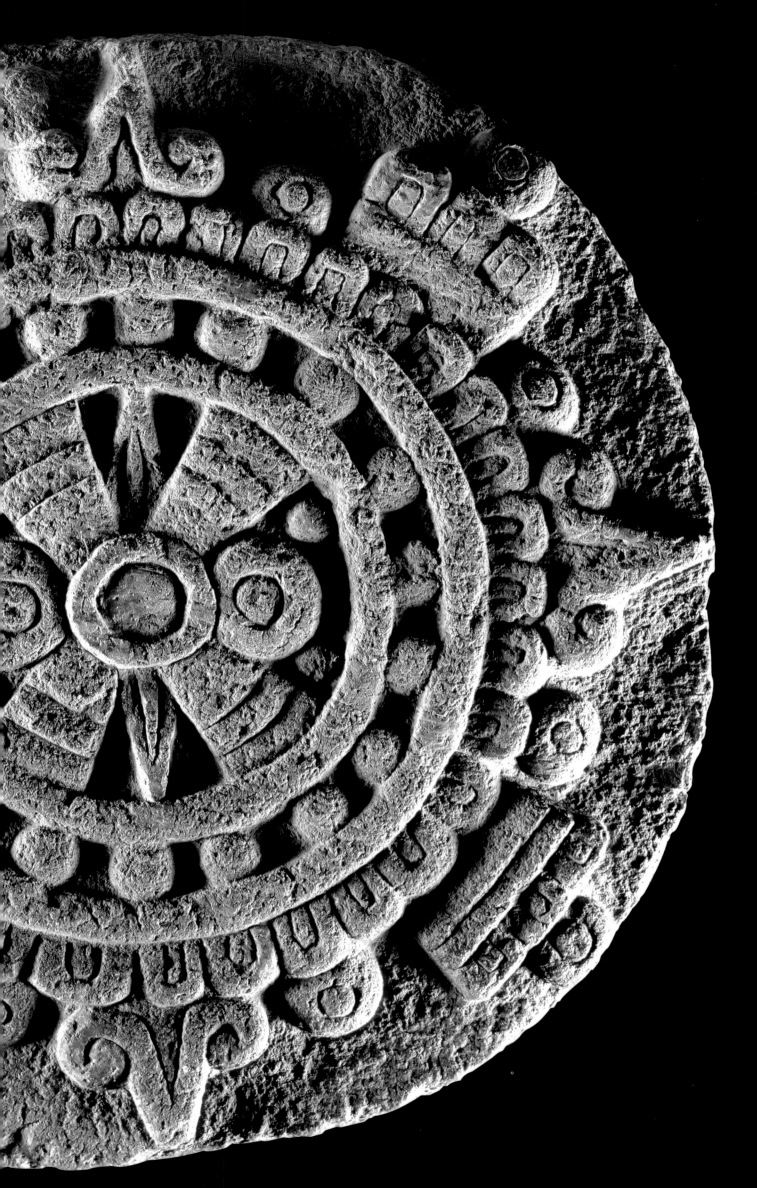

Gods and Rituals

Guilhem Olivier

ANCIENT MESOAMERICAN MYTHS TELL HOW THE SUPREME DIVINE COUPLE CREATED OR BEGAT various gods (two, four, or thirteen, depending on the particular myth) who performed the first rites to thank their creators and acknowledge their superiority. The myths mention prayers and offerings of copal and of blood from auto-sacrifices and from animals immolated in honor of the supreme deities. Other creation myths telling, for example, how the sky and the earth, the sun and the moon were generated also explain the origins of certain rituals. Human sacrifice to feed the sun and the earth is an especially prominent ritual, particularly among the Aztecs.

Besides the mythic prototypes that mortals reenacted during numerous feasts, time was the fundamental element that ruled the entire ritual system. Every ritual had to conform to a precise time frame determined by different calendar calculations. Myths speak of the creation of these calendars by the gods, who were patrons of their many attributes, including individual days, *trecenas* (the thirteen-day weeks), solar, lunar, and Venusian cycles, suns, and eras. Yet the gods themselves were affected by time. They were born, came down to earth, aged, died, and were reborn only on specific dates.

The Mesoamerican belief system was based in two calendars: the *xiuhpohualli*, a solar calendar of 365 days comprising eighteen *veintenas* (months) of twenty days each, plus the *nemontemi*, five extra fateful or dangerous days; and the *tonalpohualli*, a divinatory or ritual calendar of 260 days. The days in this ritual calendar were identified by twenty signs in combination with thirteen numbers. One feast cycle was developed based on the solar calendar; a festival was celebrated in each of the eighteen months. The "movable feasts," by contrast, were celebrated in accordance with the divinatory calendar. When the two calendars coincided, that is every fifty-two years (the so-called Aztec century), the famous *toxiuhmolpia* (the Binding of the Years, or New Fire, ceremony) was carried out.

The *tonalpohualli*, the older of the calendars, was used in reference to birthdays. Its connotations influenced the character and fate of individuals, as well as those of all kinds of beings and other things created, including the gods. Important rituals dedicated to specific gods were held on their individual anniversary dates. The *tonalpohualli* was also used to select the best days for any number of activities, including going on trips, hunting, getting married, performing cures, inaugurating buildings, and enthroning rulers. Such activities were accompanied by complex rituals.

The eighteen feasts of the *veintenas*, ordered according to the solar calendar, were held in tandem with the main agricultural cycles of planting and the harvest. During these feasts, there were reenactments of creation myths (for example, the origin of sacred war) and important events in the history of the people (such as the Mexica-Aztec migration). The different social groups participated in

92. Ehecatl
Aztec, ca. 1500

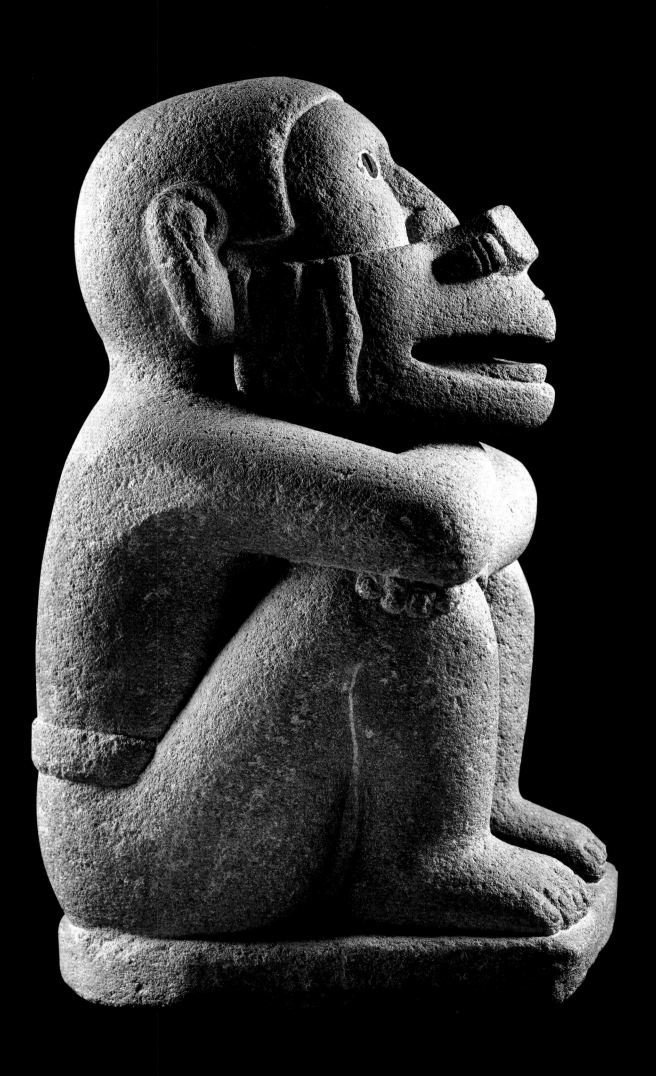

these festivals; whereas some included all the groups, others were more select, as in the case of the veneration of particular patron gods by nobles, priests, artisans, prostitutes, or other subdivisions of Aztec society.

All these celebrations were characterized by a great variety of prayers, chants, processions, dances, offerings, autosacrifices, and sacrifices of animals and people. These last two practices attracted more attention from sixteenth-century conquistadores and monks, and even today's scholars, than any other Aztec ritual. Autosacrifice, the extraction of blood from different parts of one's own body (tongue, penis, ears, legs) with various cutting instruments (awls of bone or obsidian, maguey thorns), was widespread throughout Mesoamerica beginning in Preclassic times. The purposes of this practice were varied: to do penance and have one's offenses forgiven, to acquire merit and thereby prolong one's life, to feed the gods, to boost the fertility of the earth, and so on. There seems to have been a symbolic equivalence between autosacrifice and human sacrifice. While autosacrifice represented a "partial" death, a person could also die symbolically through sacrificing a victim who was believed to be an "image" (*ixiptla*) both of him- or herself and of a particular god.

During the *veintena* of Toxcatl (Dryness), a young warrior representing Tezcatlipoca was sacrificed. This deity was closely linked to royal power and acted as the protector of the ruler, or *tlatoani*. The ruler in turn acted for the god on earth. During this festival, the ruler was the "sacrificer"; in other words, he died or sacrificed himself through the young warrior, who was the image of the god Tezcatlipoca. The shared identity between the sacrificer and the sacrificed is one of the ideological foundations of Mesoamerican sacrifice.

The gods themselves were revived through the sacrifice of their own images. Children, youths, girls, mature women, or old people stood in for the deities for a predetermined time and at the end of that period were sacrificed. To be more specific, the different gods were represented by the appropriate groups: prisoners of war for the warrior gods, Tezcatlipoca and Huitzilopochtli; old people for the god of the underworld, Mictlantecuhtli; young women for the goddess of maize, Chicomecoatl; children to personify the rain god assistants, the Tlaloque. The procedure of a ritual death would also allude to the particular divinity's characteristics. For example, victims were burned in honor of the god of fire, Xiuhtecuhtli-Huehueteotl; skinned for Xipe Totec, whose name means "Our Flayed Lord"; and shot with arrows for the god of hunting, Mixcoatl.

By means of autosacrifice and sacrifice, the sun, earth, and gods were fed. After all, these very gods had given their lives so the stars could move at Teotihuacan, and had given their own blood to create humankind. In Mesoamerican thinking, the idea that life arises out of death was fundamental. A significant example is that bones were considered to be seeds, and it was from those "seeds bones" that living humanity was created. Another essential concept was that the interrelationships between people and gods were governed by exchange. Mortals delivered offerings and sacrifices to the gods, who needed them for their own renewal; in return, the divinities granted humans life and earthly goods.

Parallel to all these majestic public rites, attended by thousands, were numerous private rites performed in various spaces. These occurred in private houses on the occasion of births; in the fields to foster the land's fertility; in caves to thank mountain gods and to ask for rain. Although local authorities participated from time to time, private rites were not carried out under state control. Many of these rites still survive, of course, with some changes, in present-day indigenous communities.

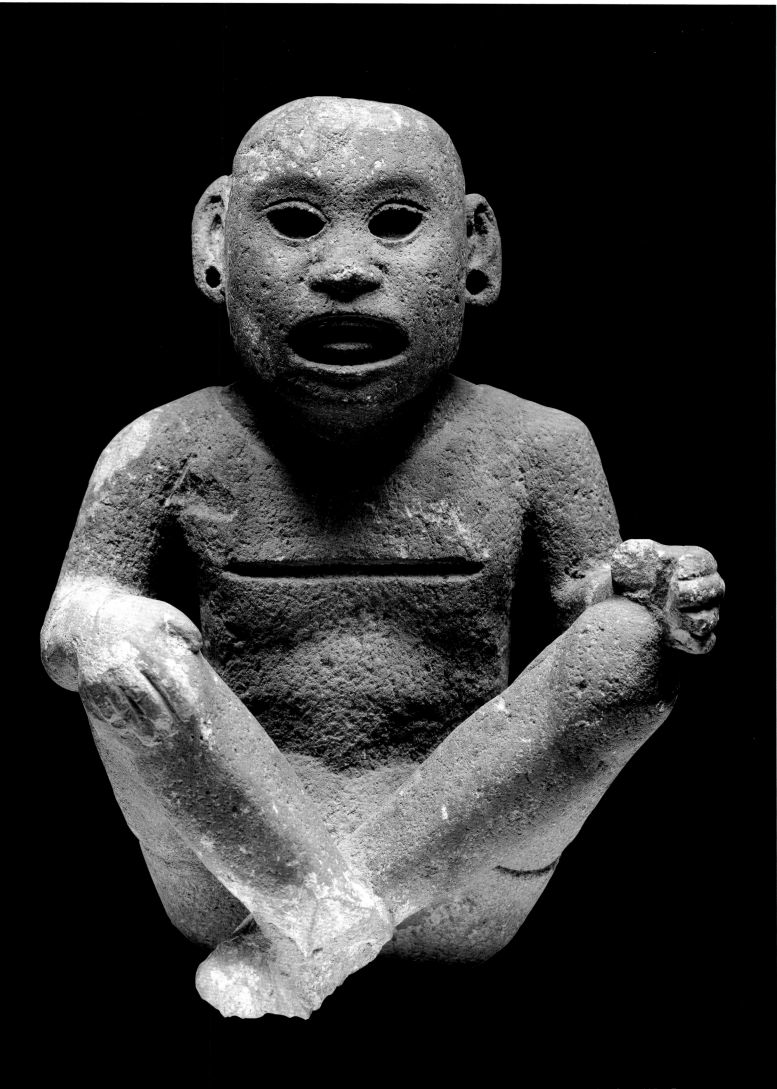

93. Seated Xipe Totec
Aztec-Matlatzinca, ca. 1250–1521

94. Xipe Totec container
Aztec, ca. 1500

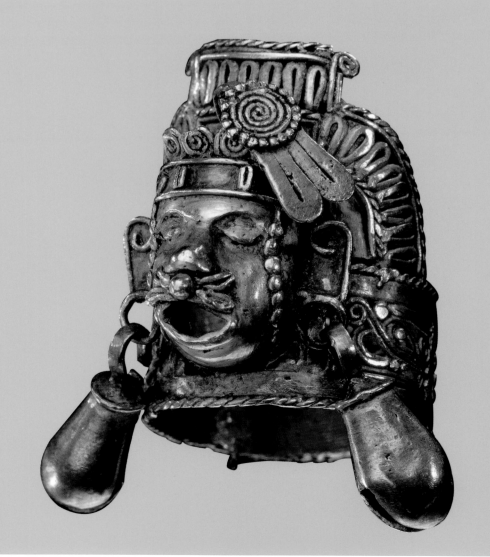

95. Xipe Totec ring
Aztec, ca. 900–1521

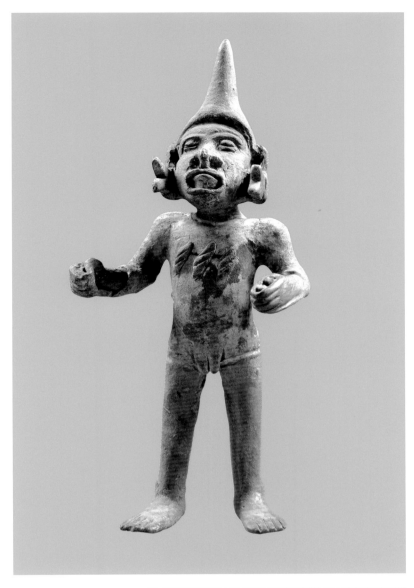

96. Figure of Xipe Totec
Aztec, ca. 1500

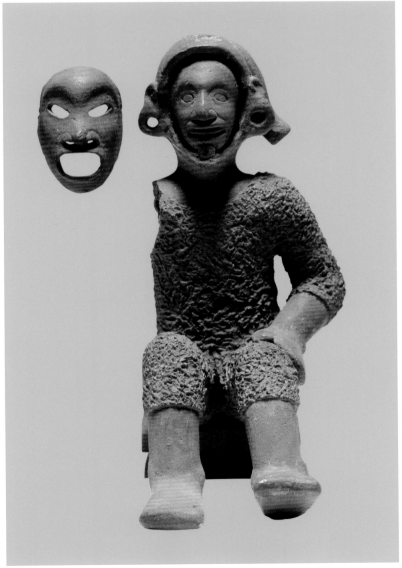

97. Figure of Xipe Totec
Aztec, ca. 1500

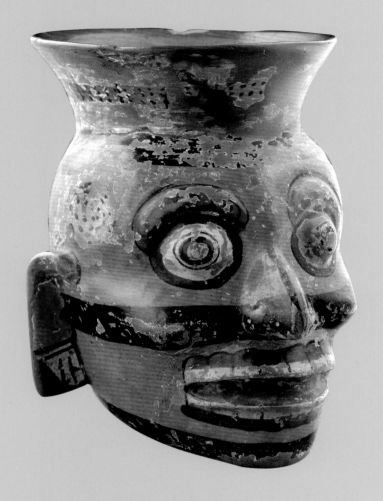

98. Tezcatlipoca effigy pot
Cholollan, ca. 1500

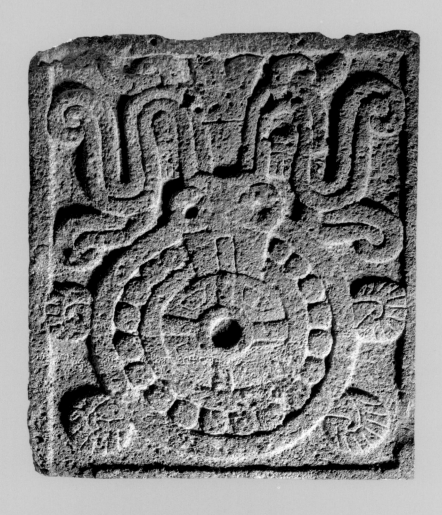

99. Plaque of Tezcatlipoca
Aztec, ca. 1500

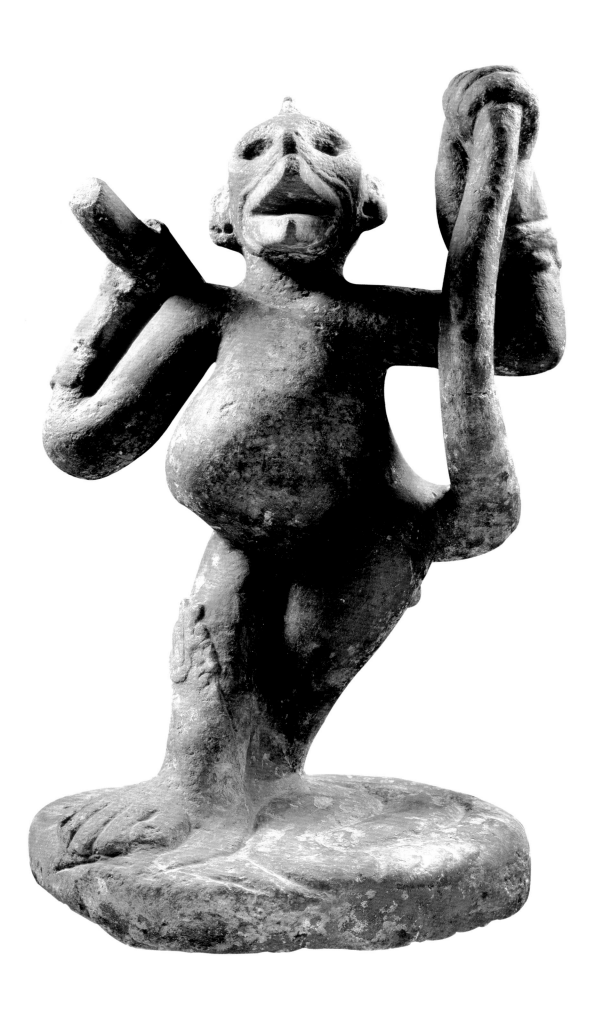

100. Ehecatl monkey
Aztec, ca. 1500

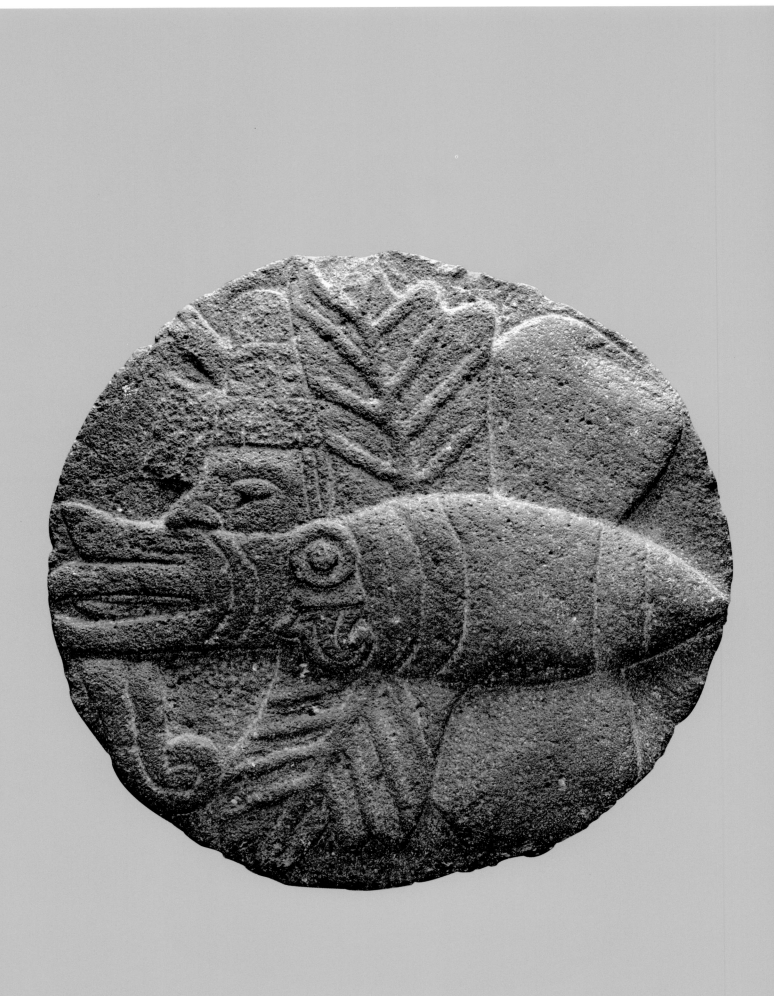

101. Ehecatl insect
Aztec, ca. 1200–1521

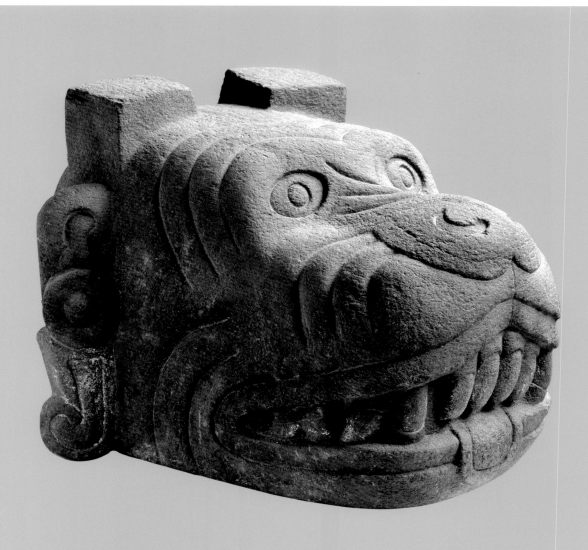

102. Xololtl
Aztec, ca. 1500

103. Quetzalcoatl
Aztec, ca. 1500

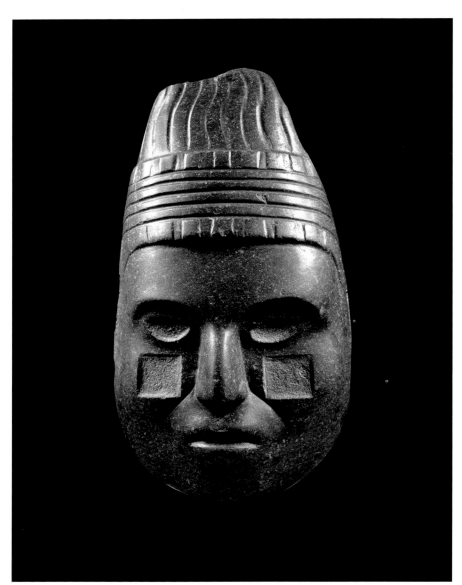

104. Chalchiuhtlicue mask
Aztec, ca. 1500

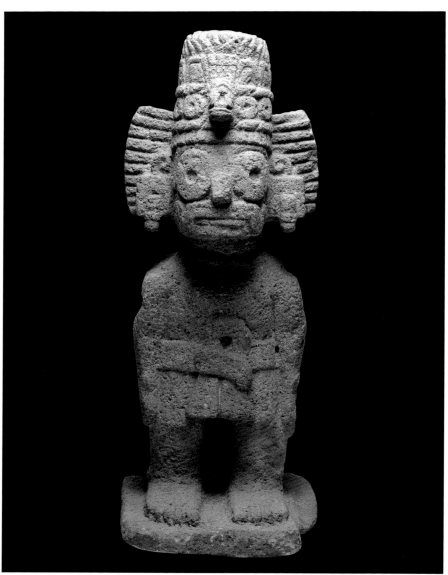

105. Tlaloc
Aztec, ca. 1500

106. Pumpkin
Aztec, ca. 1500

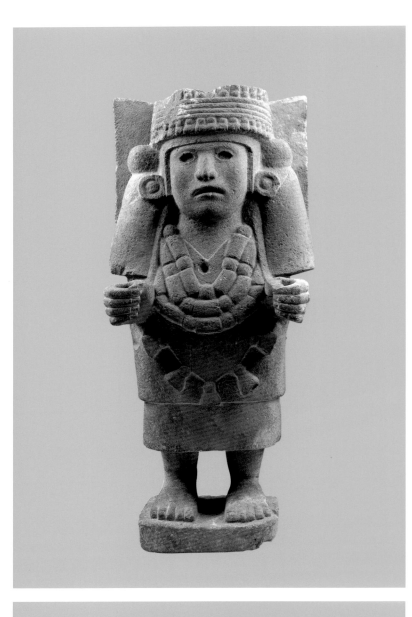

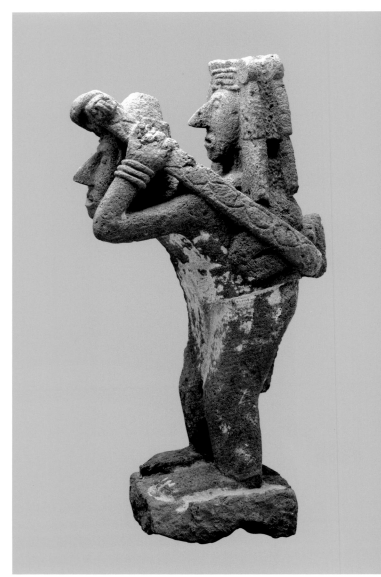

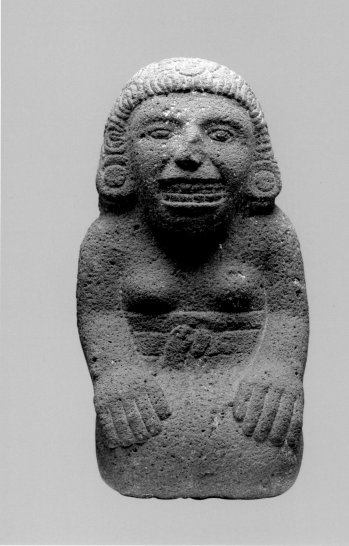

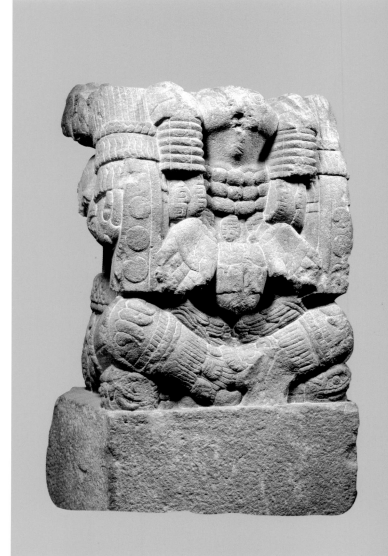

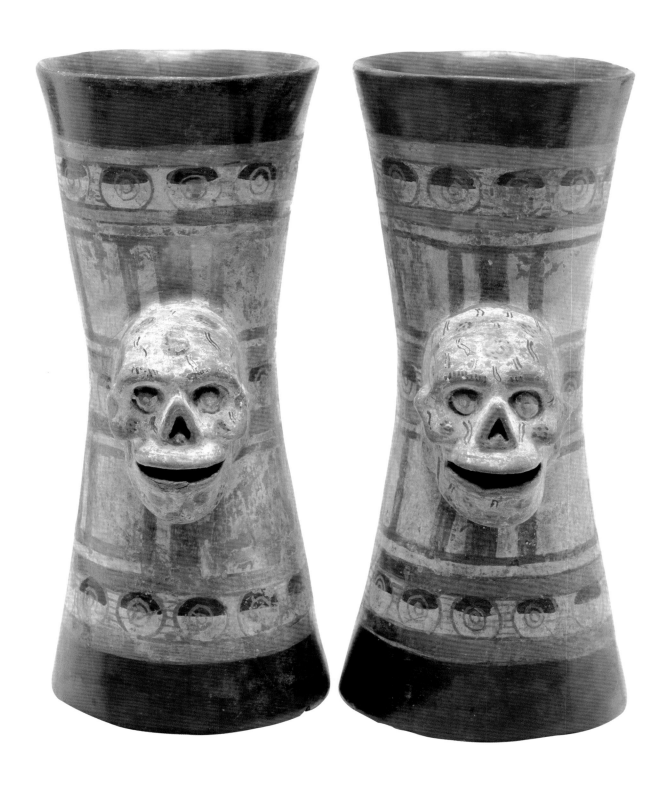

Facing page, clockwise from top left:

107. Agriculture goddess
Aztec, ca. 1500

108. Teomama
Aztec, ca. 1500

109. Tlaltelcuhtli
Aztec, ca. 1500

110. Cihuateteo
Aztec, ca. 1500

111. Skull goblets
Aztec, ca. 1500

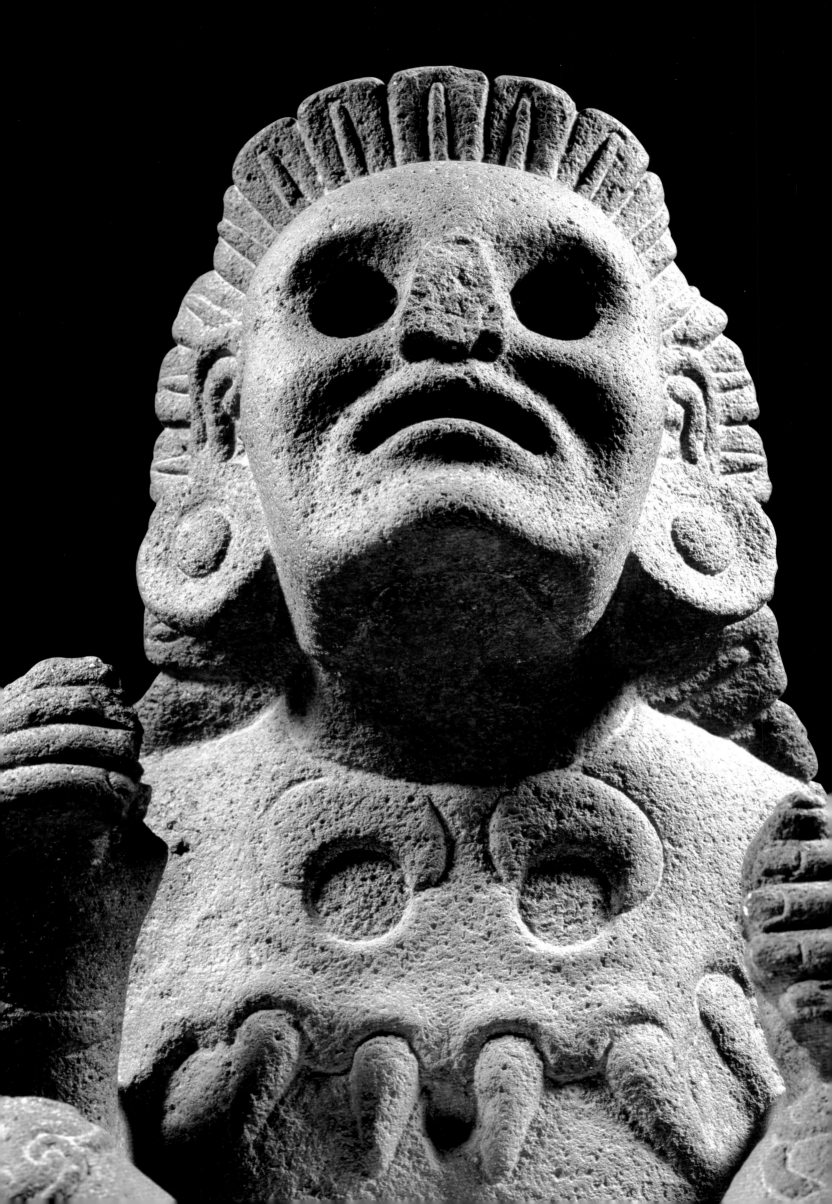

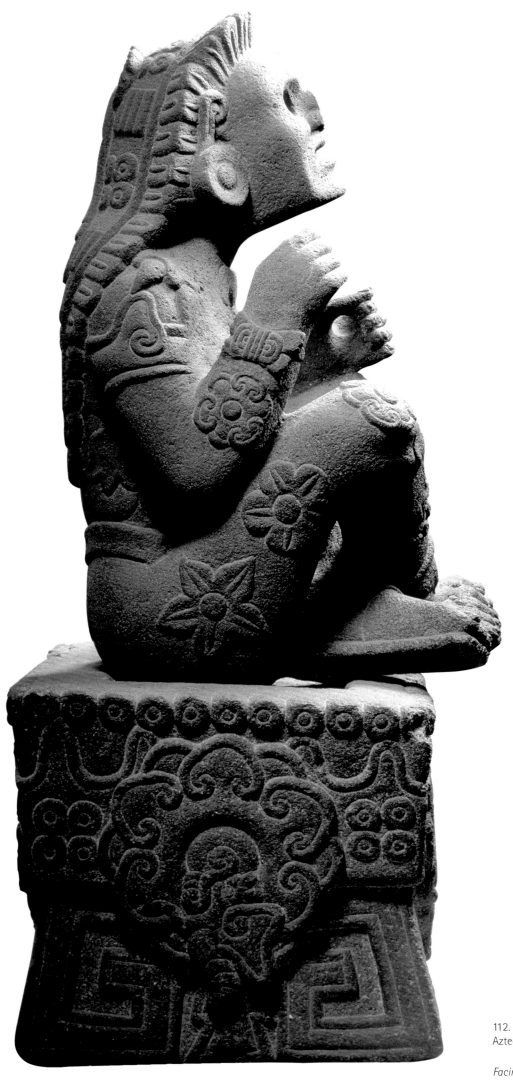

112. Xochipilli
Aztec, ca. 1500

Facing page:

Detail of cat. no. 112

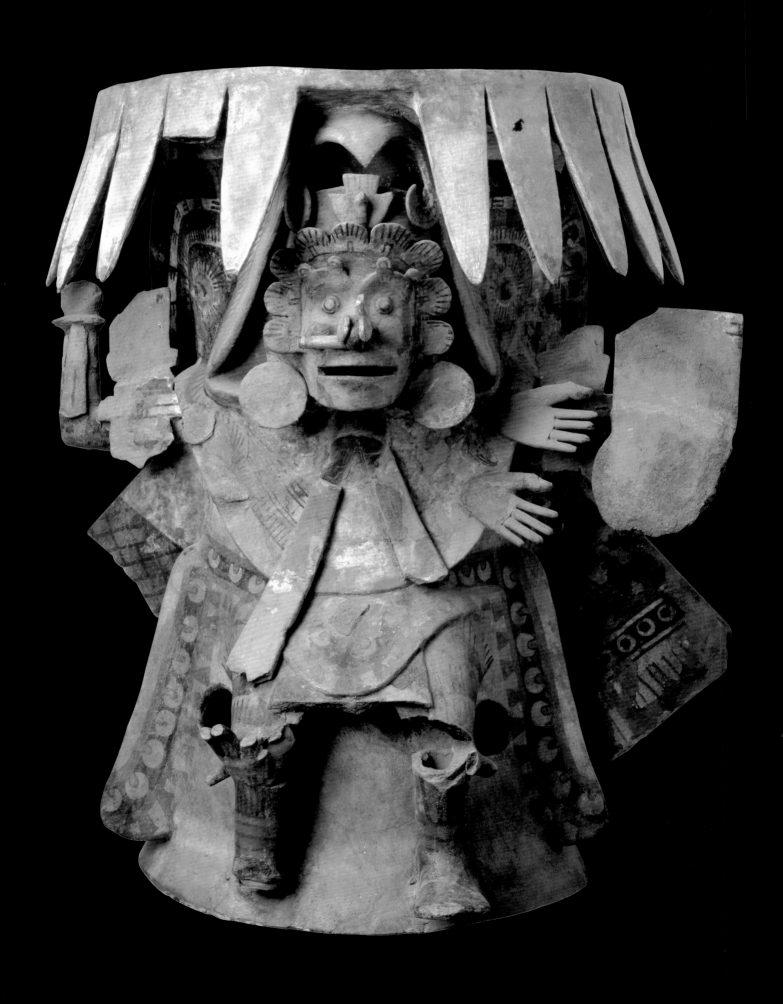

113. Deified warrior brazier
Aztec, ca. 1500

114. Techcatl
Aztec, ca. 1500

115. Autosacrifice casket
(tepetlacalli)
Aztec, ca. 1500

Painted Books
and Calendars

Elizabeth Hill Boone

IN AZTEC MEXICO, WRITING WAS PAINTING, AND KNOWLEDGE WAS RECORDED GRAPHICALLY IN painted books now called "codices." These painted books recorded almost every aspect of Aztec culture. They told of the creation of the world, the beginnings of the Aztecs, and the deeds and conquests of their rulers. Religious books explained the nature of the sacred, how the gods should be worshipped, and how the feasts and religious rituals should be observed. Divinatory codices described which supernatural forces governed the various periods of time, and thus told when the fates were most auspicious for different activities; they indicated how to live a correct life. Practical manuscripts listed tributes and taxes, described the allocation of lands to be farmed, and recorded the cases and decisions of the legal courts. There was little in the life of the Aztec empire that was not addressed in some fashion in the painted books.

The author-painters and reader-interpreters of these books were called *tlamatinime*. They were the sages, the wise men and women who were guardians of community knowledge. It was their task to record in pictographic form the ideals, understandings, and facts of Aztec culture, and it fell to them to read and interpret the painted books for their people. The Aztec writing system was a pictographic system that employed both figural elements and abstract symbols, combining them in structured compositions that themselves carried meaning. Although the figural images generally stood for what they represented, their precise, conventional meanings had to be learned, as did the meaning of the abstract symbols. All were arranged spatially according to a well-developed visual grammar. Physically, the books were usually composed of long pieces of bark paper (*amate*) or deer hide, which were folded back and forth like a screen or accordion to form pages. Sized with gesso to achieve a stiff, gleaming, white surface, they were painted on both sides and preserved between wood covers. Other manuscripts were made of large sheets of bark paper, hide, or woven cotton, on which the painters could extend their pictographic messages into great diagrammatic compositions.

The painted histories were especially important to their communities, for the codices explained the present through its links to the past. The histories indicate how the people came to occupy their territory, from whence they came, and how their relations with the other communities around them were established. Almost all the histories begin in the mythic past, with the Aztecs' departure from their ancient homeland of Aztlan. They then track the long migration to the Valley of Mexico and the great hardships the Aztec people suffered along the way, culminating in the founding of the new capital, Tenochtitlan. Beginning with this momentous founding, the histories then detail the creation and expansion of the empire. They record the successive reigns of rulers, their conquests, and natural phenomena (such as earthquakes and eclipses) that affected the community kingdoms. Usually composed as annals ordered year by

116. Xiuhmolpilli, 1 Death
Aztec, ca. 1500

117. Date stone, 1 Eagle
Aztec, ca. 1500

year in a long continuous line, these histories present the Aztec empire as an ongoing entity that began with Aztlan and continues as long as time itself endures.

As valuable as these histories were for the Aztec rulers, the most vital books for Aztec society as a whole were the religious and divinatory books. These books guided human behavior by indicating how every being and every action was governed by time and the prophetic forces attached to time.

Time for the Aztecs was measured by two interlocking calendrical systems. The seasonal or solar calendar, called the *xihuitl*, was a 365-day cycle composed of eighteen months of twenty days each, followed by five extra days, which were useless and unlucky. This calendar controlled the monthly feasts to the gods and paralleled the agricultural cycles. The more important calendar, however, was the *tonalpohualli* (literally, the "count of the days"), the divinatory or ritual calendar that shaped human fates and actions. It was a cycle of 260 days, composed of twenty day signs linked with thirteen numerical coefficients. Each of the days was assigned one of the twenty symbols and the corresponding name, which followed in a set sequence and then repeated. Each day also had a number from one through thirteen, which likewise repeated. In this way, the day 1 Crocodile was followed by 2 Wind, 3 House, 4 Lizard, and so on.

Four of the day signs (Reed, Flint, House, and Rabbit) linked with their thirteen coefficients also served as the names of years. This meshing of four signs and thirteen numbers created a fifty-two-year cycle, called a *xiuhpohualli*, equivalent to our century. The brilliance of Mesoamerican calendrics is that the *xihuitl* and the *tonalpohualli* cycled together every fifty-two years. Each day had both a place in the solar calendar and a day name in the divinatory calendar, which repeated every fifty-two years, just as the year count repeated every fifty-two years.

The divinatory calendar governed all human and cultural happenings, because each of its parts was associated with and influenced by gods, supernatural forces, cardinal directions, and other qualities. The divinatory codices, called *tonalamatls* (literally, the "book of the days"), recorded these prognosticatory elements and showed how they were attached to the different units of time. Multiple almanacs in the *tonalamatls* pictured the gods and prophetic forces that were associated with the individual day signs, with the day coefficients, with the periods of thirteen days, and with other internal cycles in the divinatory calendar. It was the goal of the calendar priest or daykeeper to consult these different almanacs to discover the multiple influences affecting a particular day or group of days. He or she would identify and interpret the distinct gods, symbols, and elements painted alongside the day glyphs, would weigh and judge their relative merits, and would seek a balanced reading of the fate. Every child had its fate read shortly after birth, and every Aztec consulted the calendar priests at significant moments throughout his or her life. Farmers planted corn according to the fates of the day, just as rulers timed battles to correspond to the dictates of the *tonalamatls*.

Although most of the religious and divinatory books were destroyed as a result of the Spanish Conquest, Aztec secular manuscripts (histories, maps, tribute lists, and the like) continued to be painted and valued for another eighty years, until about 1600. Manuscript painting endured because the Aztecs and Spaniards both recognized the painted books as containers of knowledge and authentic records of Aztec culture.

118. Date stone
Aztec, ca. 1300–1500

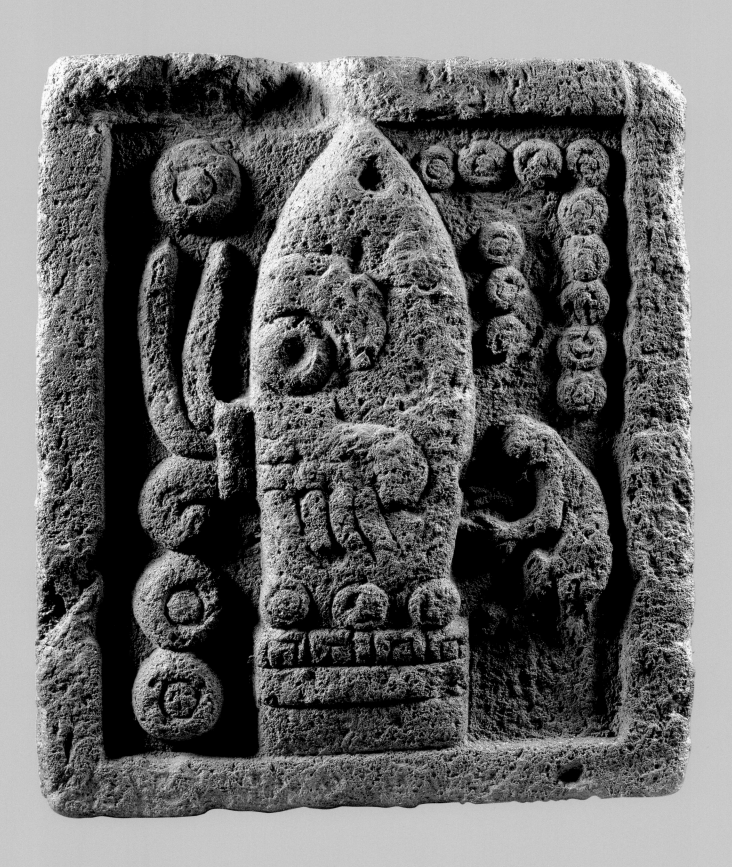

119. Date stone, 3 Flint
Aztec, ca. 1500

120. Altar with calendar dates
Aztec, ca. 1325–1521

121. Xiuhmolpilli
Aztec, ca. 1500

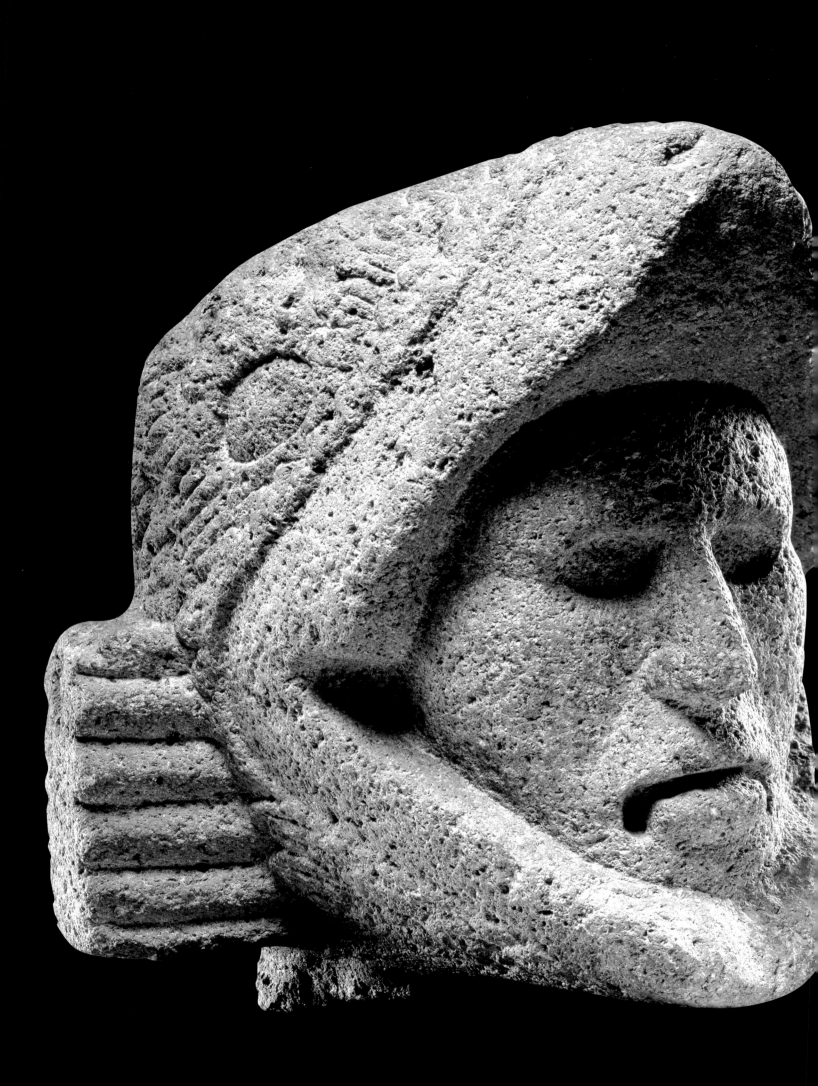

Aztec Society

Nobles and Commoners

Michael E. Smith

AZTEC SOCIETY WAS COMPOSED OF TWO UNEQUAL SOCIAL CLASSES, THE NOBLES AND THE commoners. Although nobles made up less than 5 percent of the population, they were in charge of many aspects of society. They owned the land and controlled the government. Despite the taxes they had to pay to their rulers, nobles were far wealthier than commoners. Commoners, on the other hand, had to provide labor service to nobles, pay taxes to their city-state governments, and obey the laws and rules set by the ruling nobility. This does not mean, however, that Aztec commoners were poor and downtrodden, leading bleak, anonymous lives. We know, for example, that they had access to many fine artistic objects, either as items used in their homes or as public art encountered in the course of their daily lives in Aztec cities.

Distinctions between nobles and commoners influenced many aspects of life and society. A look at the varied lifestyles and social roles of both groups helps us understand the ways art was created and used in the Aztec empire.

The Network of Nobles

The power and wealth of the nobility rested upon their control of land and labor. All the land in a city-state belonged ultimately to the *tlatoani* (ruler), but he granted estates to high lords called *tetecuhtin* (singular: *tecuhtli*) and to important temples. These estates were passed on to the lords' descendants or maintained in perpetuity by the temples. Below the rank of *tecuhtli* was that of *pilli*, a regular noble (plural: *pipiltin*). Most *pipiltin* served a *tecuhtli* or *tlatoani*, often residing in or around his palace. Nobles received specialized training in myths, rituals, calendrics, and other esoteric disciplines, and they learned to read and use painted books (codices) that recorded rituals, dynastic history, and additional information.

The Aztec nobility comprised a hereditary social class; membership was limited to the offspring of two noble parents. Nobles' spouses frequently came from different city-states. In one respect, this was done for simple demographic reasons: Most city-states were small, and their noble classes simply did not have enough members for everyone to find an appropriate spouse. But the marriage of nobles across city-state lines, particularly between royal families, was also a form of diplomacy. Rulers wanted to ally themselves with powerful neighbors, an important goal in the atmosphere of competition and war that existed among the Aztec city-states.

A basic form of marriage alliance was that between a ruler of a less powerful state and a daughter of a more powerful ruler. Indeed, one can trace the rise to power of the Mexica dynasty of Tenochtitlan by noting its patterns of marriage alliances. Before the formation of the empire in 1428, the Mexica rulers tried to advance by marrying the daughters of several powerful cities, including Azcapotzalco and Cuauhnahuac. Once the Mexica ruled the empire, however,

ticocicatzin
ixiuhtzon
ixiuhyacamiuh
ixiuhtil ma
techil navay
ytepohoicpal

a vitzotzin
ixiuhtzon
ixiuh yacamiuh
ixiuhtil ma
techil navayo
ytepohoicpal

motecuçomatzin
ixiuhtzon
ixiuh yacamiuh
ixiuhtil ma
techil navayo
ytepohoicpal

Cuitlaoatzin
ixiuhtzon
ixiuh yacamiuh
ixiuhtil ma
techilnaoayo
ytepohoicpal

quauhtemoctzin
ixiuhtzon
ixiuhyacamiuh
ixiuhtil ma
tochil navayo
ytepohoicpal

motelchiuhtzin
governador

xuchiquentzin
governador

vanitzin

yutl icuçuydolol
acamapichtli
mitl
y yeoahtl ma
itolicpal
Vitziliuh
ycoçoyaoalol
y yeoahl ma
ytoliepal
chimalpopoca
ycoçoyaoalol
y yeoahl ma
ytoticpal
yzcoatzin
ixiuhtzon
ixiuh yacamiuh
ixiuhtilma
tenechil navaya
ytepohoicpal
motecuçoma ylhuicamina
axayacatzin ixiuhtzon
ixiuhtzon ixiuh ya miuh
ixiuh yacamiuh ixiuhtilma
ixiuhtil ma techil navaye
techil navaya ytepohoicpal
ytepohoicpal

the rulers of subordinate city-states vied with one another to marry women from the Mexica dynasty. Nobles practiced polygamy, and many rulers and powerful lords had numerous wives. A shrewd ruler could use strategic marriages to advance his standing and power.

Nobles also engaged in other kinds of activities that cut across city-state borders. One of the best documented of these was attendance at major state ceremonies. Rites of accession, royal funerals, temple dedications, and celebrations of military victory were occasions for nobles from many different city-states to gather and celebrate together. These events included sacrificial rituals, elaborate feasting, public oratory, and the exchange of valuable gifts among nobles. Such ceremonies took place out of public view.

Marriage alliances, diplomatic events, and attendance at state ceremonies all served an important function in Aztec society: They helped link the nobles of the diverse Aztec city-states into a single, tightly integrated social class that transcended the political borders of city-states. These processes operated most intensively within the central highlands, uniting local elites from Tenochtitlan, other parts of the Valley of Mexico, and surrounding regions. Once the Triple Alliance empire was formed by the Mexica, Acolhua, and Tepaneca, its rulers took advantage of these patterns of noble solidarity and instituted a policy of indirect rule in many areas. Local rulers were left in power, and the empire bought their loyalty with gifts, privileges, and other perquisites. When the empire expanded, its rulers put these same processes to work. Conquered rulers were allowed to retain their seats; they were given precious gifts; and they occasionally attended state ceremonies or engaged in marriage alliances with nobles of the Aztec heartland.

Material culture was an important component of the social processes that integrated the Aztec nobility. Many of the gifts exchanged at state ceremonies were valuable items of jewelry and clothing made from exotic lowland materials, such as tropical bird feathers and greenstone. The elaborate clothing worn to such events was expensive and exclusive. One result of this extensive network of elite interaction was the creation of common material styles throughout the diverse regions of the Aztec empire. From buildings and city planning to clothing, jewelry, and painted documents, the material culture of the Aztec empire revealed impressive commonalities over large distances. The nobles' use of objects conforming to shared styles was both a force that contributed to the integration of the Aztec elite network and a by-product of that integration. This latter role of material culture—as a signal of elite social processes—gives the objects reproduced here their great importance to us today.

Aztec cities, to take one example, are remarkable for the consistency of their building forms and styles—as well as of their principles of urban planning—across a large geographical area. One of the best examples is the palace. All known Aztec palaces, royal and nonroyal, conform to a common plan, with rooms built on elevated platforms that surround an enclosed courtyard with a single entrance. Although writers sometimes attribute the similarities of Aztec provincial buildings and city layouts to the imposition of styles by the conquering empire, these common styles in fact predate the formation of the empire by more than a century. They were thus not the products of political coercion but rather of interaction among regional nobles.

Elite interactions led to the production of a common style of painted codices throughout the empire and the appearance of stone sculptures in the Mexica style in provincial cities. At Calixtlahuaca in the Valley of Toluca, for example, a number of Mexica-style sculptures of deities have been excavated, and a stone altar in the same style used in human sacrifices at this city exists as well. Unfortunately, we do not yet know if these were carved in Tenochtitlan and transported to Calixtlahuaca (a distance of some 50 kilometers), carved by local sculptors, or carved locally by sculptors from the imperial capital. That some of the true masterpieces of Aztec art—such as a sculpture of Ehecatl or the Huehuetl of Malinalco—come from provincial areas is material proof of the importance of elite networks in structuring Aztec society and art.

Palaces

While nearly all Aztec palaces conformed to a common layout, they varied greatly in size and elaboration. This differentiation mirrored the variation in wealth and power among Aztec nobles. Provincial *pipiltin* were at the bottom of the noble hierarchy. Although these rural lords were often poorer than some urban commoners (such as merchants and luxury artisans), they had groups of farmers under their control, lived in palaces much larger and more luxurious than the houses of commoners, and participated in the exchanges and interactions of the Aztec elite networks. Archaeologists have excavated several of their palaces, which range in size from 350 to 550 square meters. Artifacts from their garbage deposits suggest that provincial nobles used much the same kinds of domestic objects as commoners, although these nobles had more decorated and imported ceramic serving vessels.

Wealthier and more powerful than nobles of the *pilli* and *tecuhtli* rank, the rulers of provincial city-states controlled larger numbers of subjects—both noble and commoner—and received far greater amounts of tribute and taxes from those subjects. Their palaces were correspondingly larger and more elaborate. The rulers of Calixtlahuaca and Yautepec, for example, lived in palace compounds on the order of 5,000 to 6,000 square meters. These palaces were constructed with fine masonry and had ample lime plaster on floors and walls. Around the requisite large, open courtyards were numerous rooms and chambers for the royal family, servants, warriors, administrators, and others. The palaces also featured altars and shrines.

Page from the *Codex Mendoza*, ca. 1541.

At the top of the hierarchy of nobles were the rulers of the imperial capital cities of Tenochtitlan and Tetzcoco (modern-day Texcoco). (Tlacopan, by comparison, was considerably less powerful and wealthy than its allied capitals.) Although these cities' palaces have not been excavated, written documents give some idea of the size, complexity, and sumptuous nature of these structures. The chronicler Fernando de Alva Ixtlilxochitl, a descendant of the rulers of Tetzcoco, compiled a number of historical accounts a century after the Spanish Conquest. After examining the ruined palace of his ancestors (now destroyed or buried under the modern city), he described it as a huge compound of some 800,000 square meters. Within an outer wall, the palace contained many buildings, gardens, temples, a ballcourt, a zoo, and a marketplace. In addition to the living quarters for the ruler and royal family, there were servants' quarters; a throne room; chambers for judges and officials; a hall for warriors; a section for scientists and musicians and another for poets, philosophers, and historians; archives; and storehouses for weapons, food, and other goods. One can only imagine how elaborate the palaces of the yet more powerful Mexica rulers must have been.

Many of the works of art in this exhibition probably were used in nobles' palaces. The fine jewels of gold, obsidian, and precious stones were most likely worn by nobles. The polychrome ceramic vessels may have been employed to serve meals in palaces, and the flutes and pipes were played in ceremonies that might have been conducted in palaces. On the other hand, commoners also had access to jewelry, vessels, and ritual objects like these. The Aztec nobility did not have a monopoly on valuable objects and fine art.

Commoners' Lives

Just as there was a hierarchy of wealth and power within the nobility, so too did Aztec commoners vary in their wealth, status, independence, and lifestyles. At the bottom of the hierarchy were the tlacotin, or slaves. This was not a large social category, and slavery was not hereditary. People became slaves as punishment for crimes or in order to save themselves during times of famine or crisis. Owners were responsible for feeding and caring for slaves. Most of them labored as domestic servants; female slaves were particularly valued for their skills in spinning and weaving.

The majority of commoners fit in the category known as macehual. This was a highly varied group, but its distinctions do not correspond to clearly labeled subcategories. At the lower end of the scale were rural peasants who were like medieval serfs: heavily dependent upon a lord and without independent access to agricultural land. Higher up within the macehual category were the members of calpullis. A calpulli was a group of families who lived near one another and often shared a common occupation. A calpulli could be a rural village or a

neighborhood within a city. Rural calpulli members had lighter obligations toward nobles than their cousins who did not belong to a calpulli. Theoretically, nobles owned the farmland, but in practice management of the land was left in the hands of a calpulli's governing council. This council assigned plots of land and organized joint tasks. Urban commoners also varied in the extent of their freedoms and economic well-being.

The larger Aztec cities were home to several categories of commoners who stood above the rest in their wealth and status. The pochteca were professional merchants who belonged to exclusive guilds and traded expensive goods over long distances. Some pochteca found employment as agents of rulers, buying and selling on consignment, but most worked as private entrepreneurs. Their trade expeditions, consisting of teams of specialized human carriers and armed guards, could be on the road for months. Because commoners were not allowed to show off wealth, the pochteca usually returned from their expeditions at night, when they could secretly enter their houses (built with high surrounding walls) and escape the notice of nobles. Many of the objects illustrated here, from gold jewelry to polychrome pottery to stone sculptures, were probably bought and sold at some point by the pochteca.

The luxury craft worker was another special category of commoner. The fields of Aztec utilitarian crafts and luxury goods were organized very differently. Practical items like tortilla griddles, baskets, and obsidian tools were produced by part-time specialists who worked out of their homes and sold their products in the markets. Many of these crafters were farmers working in their spare time or during the dry season. Luxury goods—such as stone sculptures, jewelry, and featherwork—on the other hand, were produced by full-time specialists who worked for noble patrons. Although they sold some of their output in the markets, these artisans created most pieces directly for their patrons, who either used the products themselves or presented them as gifts to other nobles. The luxury craft workers were highly skilled, and many of them lived and worked in the royal palace, along with their families (who assisted in the workshops). The pochteca and the luxury craft workers were wealthier than other commoners, and they interacted with nobles on a more regular basis.

Rural commoners, that is, peasants, lived in houses of adobe brick with stone foundations. In provincial areas most of these houses were small, one-room structures, which were arranged in groups of several houses around a common patio. Each structure was home to a family group. Sometimes a big, multigeneration family shared a single house. In Tenochtitlan commoners lived in larger, multiroom structures. The different rooms may have housed separate families, so that a single urban house may have contained numerous residents from several family units. In the provincial city-states, however, commoners' houses were almost identical to those of rural peasants.

In the minds of Aztec nobles, the peasants and other commoners existed to serve them. While the term *macehual* means "subject," commoners varied in their degrees of subjugation, from the heavy burdens of slaves to the relative freedom of merchants. Most commoners, however, had a number of obligations to their lords, first and foremost of which was to provide them with regular tribute payments in goods. Assessed by family, these payments consisted of cotton textiles (a form of money in the Aztec economy), food items, or specific goods produced by the families. Commoners also provided their lords with regular labor service. Men cultivated a lord's land; women spun and wove for him; both sexes worked as domestic servants. Such duties typically rotated among a lord's subjects, with each family contributing several weeks of work per year. These payments of goods and labor, called *tequitl*, were basic obligations of nearly all commoners.

In addition to *tequitl*, commoners were called upon to serve the ruler for various special activities. The Aztecs did not have a standing army, and troops were conscripted for each campaign. When a large project was to be carried out, such as the construction of a temple or canal system, commoners were called up in a labor draft for the task at hand.

Although nobles were in charge of many aspects of society, most commoners had considerable control over their own destinies. Most managed to meet their own basic needs and even to provide themselves with some level of economic comfort in spite of their duties to lords and rulers. The indirect nature of social control in Aztec society and the prevalence of marketplace exchange gave commoners opportunities for economic activity and advancement outside the control of nobles. In daily life, most commoners did not have to interact much with nobles, and they were free to make their own decisions on many matters without worries about interference from their betters.

The Aztecs used several kinds of objects for money, most commonly cacao beans for small purchases, and cotton textiles for larger items. Money was used to buy goods and services in the marketplaces that sprang up each week (the Aztec week was five days long) in most towns and cities. The largest market, located in Tenochtitlan's twin city of Tlatelolco and open every day of the week, overwhelmed the Spanish conquerors with its size, complexity, and good order. Hernán Cortés wrote that 60,000 buyers and sellers attended this market every day. It was organized and run by the *pochteca* merchants, who maintained a judicial court to settle disputes and to try cases arising from economic activities in the market. (Counterfeit cacao beans were a real problem.)[1]

For commoners, the key to advancement via the market system lay in the production of textiles. Aztec women spun and wove cotton cloth in their homes, work they interspersed with other domestic tasks, such as food preparation and child care. Textile production was an important part of the gender identity of Aztec women, both nobles and commoners. Commoner

Page from Fray Bernardino de Sahagún, *Florentine Codex*, also known as *Historia general de las cosas de Nueva España*, 1575–77.

women had little choice in producing textiles, however, since cotton cloth was the major tax item paid to the local ruler—as well as to the emperor. If the women of a household could produce more cloth than its tax obligation, the excess could be exchanged in the market for whatever goods were needed. Virtually every Aztec house excavated by archaeologists has yielded numerous ceramic spindle whorls and small spinning bowls, evidence of cloth production at the household level.

Most goods used in Aztec society, from stone tools to gold jewelry, were bought and sold in the markets. The Spaniards were amazed at the variety of items for sale in the Tlatelolco market, and several commentators produced long lists of these goods. If a commoner wanted obsidian earspools, there was no law prohibiting him or her from buying a pair in the market. Such items were expensive, however, and vendors of exotic jewelry found more customers among the nobility than among the commoners. Nevertheless, many finely made objects that are sometimes labeled "elite" items were in fact used by both nobles and commoners. I have excavated numerous Aztec commoner houses, many of which have yielded complexly polychromed ceramic serving vessels, tools and ornaments of bronze, musical instruments including flutes and whistles, and jewelry of obsidian, rock crystal, and greenstone. The palaces of nobles had large quantities of these items, but such objects were part of the basic domestic inventory of Aztec commoners. Goods like these were even excavated at provincial villages, far from the large cities and central marketplaces.

Nobles, Commoners, and Aztec Art

The social and economic dynamics of Aztec society created conditions in which few material objects were used exclusively by nobles. While we know of a few sumptuary laws—rules limiting certain goods to the nobility—most goods were available in the markets to buyers of any social class. Nevertheless, nobles clearly made greater use of things like gold jewelry, featherwork, and stone sculptures. Many such objects were produced directly for noble patrons, and the nobility could much more comfortably afford to purchase such items in the market. The elaborately polychromed ceramic serving ware of Cholollan, for example, most likely served as the everyday dinnerware of nobles and as the rarely used "fine china" of some commoners.

One of the remarkable characteristics of Aztec art is its widespread distribution across the Aztec empire. Codices, sculptures, ritual items, jewelry, and the like were all used throughout the empire, not just in the capital and a few large cities. Merchants and markets dispersed such goods, and the social interactions of nobles disseminated shared tastes and styles. The combined actions of these two forces distributed the corpus of objects that is known today as Aztec art.

Note
1. It should be emphasized that although the Aztec economy was a *commercialized* one, with prominent roles for money, marketplaces, and merchants, it was not a *capitalist* economy. The major feature of capitalism is wage labor. In the Aztec economy, land and labor were not commodities; they could not be bought and sold like cooking pots, dogs, or obsidian jewelry. Confusing capitalism with commercial institutions, some authors have denied the existence of the latter in ancient economies. The Aztec system was similar to a number of other ancient commercial economies, including those of Mesopotamia, Greece and Rome, and the Swahili of Africa. These can be contrasted with ancient, noncommercial economies like those of the Inca and Egyptian cultures, which lacked both money and markets.

Page from Fray Bernardino de Sahagún, *Florentine Codex*, also known as *Historia general de las cosas de Nueva España*, 1575-77.

229

Everyday Life
in Tenochtitlan

Michael E. Smith

DAILY LIFE EVERYWHERE TAKES PLACE IN A WORLD OF MATERIAL OBJECTS. FROM THE TOOLS people use to the houses they live in to the things they see as they walk down the street, material objects frame human existence. For the inhabitants of Tenochtitlan, many of the material objects that played prominent roles in every-day life were the result of proficient craftsmanship and high aesthetic values. During the day—as people ate their tacos, burned incense to the gods, made purchases in the market, and carried out innumerable other basic activities of daily life—they came across and interacted with numerous objects that today we classify as "art." Aztec art cannot be understood without a consideration of daily life. This text looks at a number of events from the everyday lives of Tenochtitlan's inhabitants, with particular attention to the material objects that people used, encountered, and talked about.

Regular mealtime. The utensils used to prepare and cook food in Aztec kitchens—such as ceramic cooking pots and stone metates to grind maize—were for the most part plain, utilitarian objects rarely classified today as "art." The ceramic vessels used to serve food, on the other hand, were more finely finished, often with colorful surfaces painted in geometric designs using a variety of organic and inorganic pigments. Complexly polychromed plates and bowls were used in the houses of nobles and commoners alike. Excavated Aztec houses are remarkable for the quantity of painted serving dishes and for the variety of decorative styles encountered at a single structure. Each region of central Mexico had its own distinctive, painted serving ware, and these vessels were widely traded between regions. Many Aztec families—both nobles and commoners—must have eaten their dinner from imported, painted vessels.

Feasts. Special-purpose meals punctuated the daily routines of Aztec families. Monthly calendrical ceremonies and life-cycle celebrations, such as weddings and funerals, were occasions for larger groups to gather at the house of a host family. Feasts called for out-of-the-ordinary foods served in special vessels or containers. Cups and goblets were used to drink cacao on festive occasions, and bright red pitchers were used to serve either cacao or pulque. Polychrome serving vessels may have been used at feasts more commonly than at regular meals. An enigmatic vessel form—an oval, bilevel dish on three legs with painted decoration—was perhaps part of a serving set for celebrations.

Domestic rituals. Inside Aztec homes, a series of religious offerings was made, mostly by women. Incense was offered to the gods in long-handled censers similar to those used in temples. Numerous fragments of such censers, lacking the colorful painting of the temple examples but identical in form, have been excavated from the domestic deposits at Aztec houses. These censers were basic household items, as were small clay figurines used in rituals of curing and fertility. Musical instruments, including flutes, whistles, and rattles, were also used in Aztec homes, probably for fundamental ritual events. Some of the

122. Figure of a warrior
Aztec, after 1325

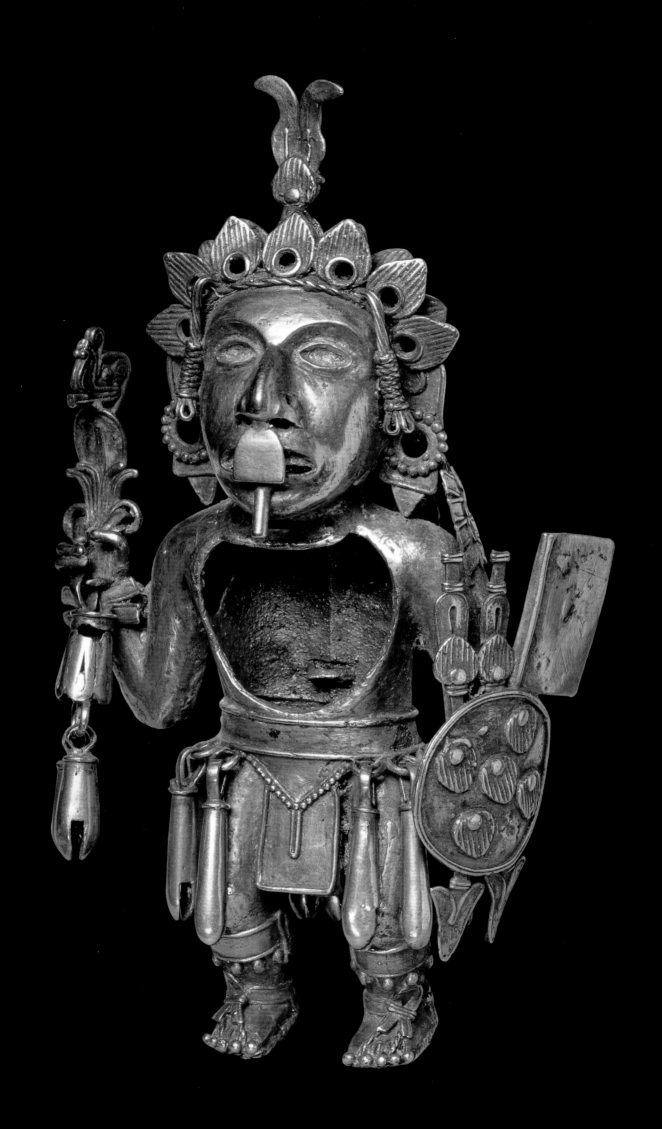

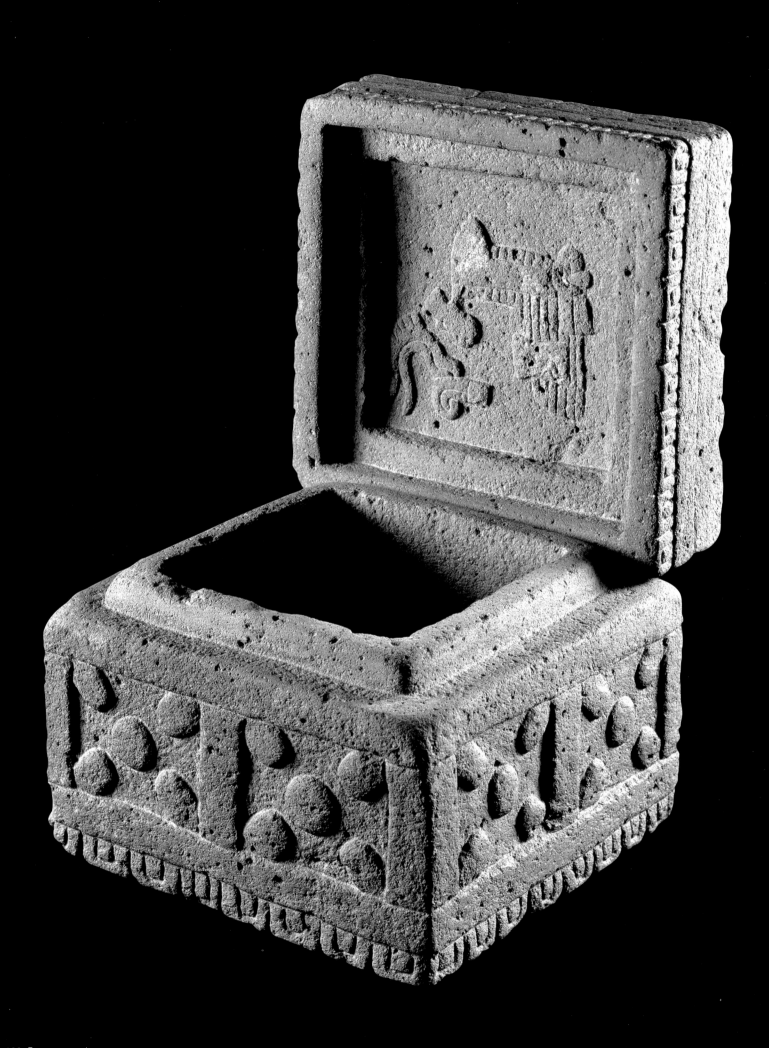

123. Funerary casket
Aztec, ca. 1500

implements of domestic ritual—particularly the long-handled censers—duplicated items used in public rituals. Others—most notably the small clay figurines—were largely restricted to the domestic realm. This suggests that people participated in several different types of household rituals with differing practices and meanings.

Work in the home. Many Aztec craft items were produced within homes. The most widespread and important domestic craft was cloth production; women spun cotton thread and wove it into textiles that were used to pay taxes and to spend as money in the markets. Many other utilitarian goods—pottery, basketry, stone tools—were also produced in Aztec homes by part-time crafters. Family members would then sell these goods in the marketplace. Many luxury goods were produced by specialists who also worked out of their homes, which either were located within royal palaces or were separate dwellings.

A trip to the market. Marketplaces were major components of all Aztec towns and cities. Along with foodstuffs, all kinds of goods, from the fanciest and most expensive luxuries (featherwork and greenstone jewelry) to the most mundane household implements, were for sale in the markets. Only a few goods were restricted by law to the nobility, but most commoners did not have the funds to purchase luxury items very often. Except for the most elaborate offerings from the Templo Mayor and a few other objects, the works in this exhibition probably changed hands one or more times at an Aztec marketplace. Marketing was not only an economic activity but also a social event, a time to meet friends and associates and to catch up on the latest news and gossip. People probably put on their good clothes and perhaps even their jewelry for market day, a weekly occurrence. My excavations at Aztec sites have turned up jewelry (of obsidian, rock crystal, and greenstone) in the houses of both commoners and nobles, objects that were probably obtained at the markets.

A trip to the palace. A trip to the royal palace was probably not as enjoyable as a trip to the market. It was where people paid their taxes, fulfilled their labor duties to the ruler, went to see a judge, and took care of minor administrative matters. Palaces were large complexes, and commoners there on everyday business were able to see neither the interior living quarters of the royal family nor their luxurious furnishings and art objects, such as sculptures and featherwork.

A trip to the temple. Public ceremonies at the numerous temples of Tenochtitlan were regular occurrences. Since few people had time to attend all the ceremonies, individuals probably selected events of particular personal significance. In the temple precincts and on top of the pyramids, large stone sculptures, braziers burning with perpetual flames, and a variety of ritual implements, from long-handled censers to flutes and drums, could be seen by visitors. However, many material objects at Aztec temples were not meant to be seen by casual visitors and supplicants. Some sculptures of deities were buried as offerings; for example, a stone monkey with an Ehecatl mask was buried next to a small circular temple (which can now be seen, restored, in the Pino Suárez metro station in Mexico City), and a life-size Ehecatl sculpture was buried next to a large round temple at Calixtlahuaca. Likewise, many of the elaborate objects excavated at the Templo Mayor were used in ceremonies for restricted audiences and then buried as offerings. Thus they were probably never viewed by anyone other than their creators and a select few priests and nobles.

Daily life in Tenochtitlan took place in a realm of material objects, many of which were finely crafted and aesthetically appealing. Commoners as well as nobles had access to most kinds of Aztec objects and art; items that people did not own or have in their homes were typically on display in public places or in temple compounds. Most of the objects in this exhibition were public art in this sense, and they were used, seen, and discussed by large numbers of people in the course of their daily lives.

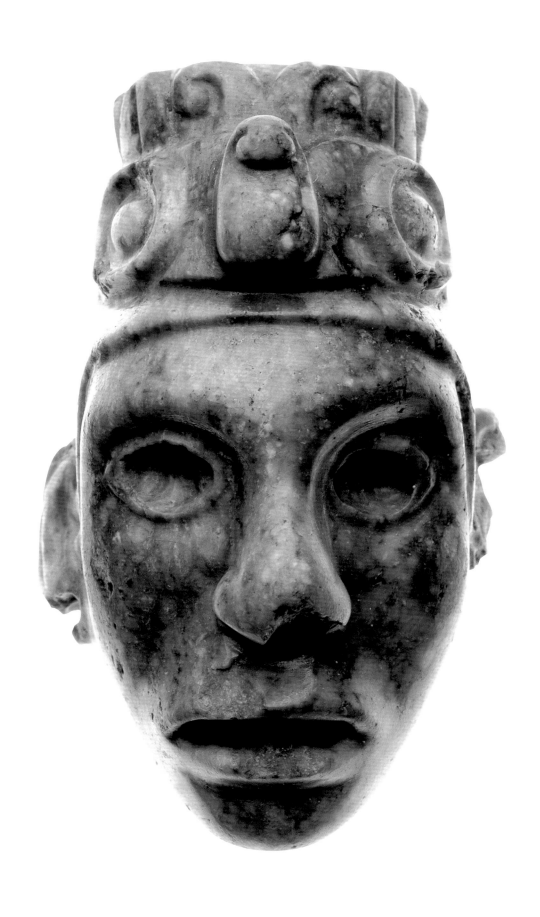

124. Xiuhtecuhtli pendant
Aztec, ca. 1500

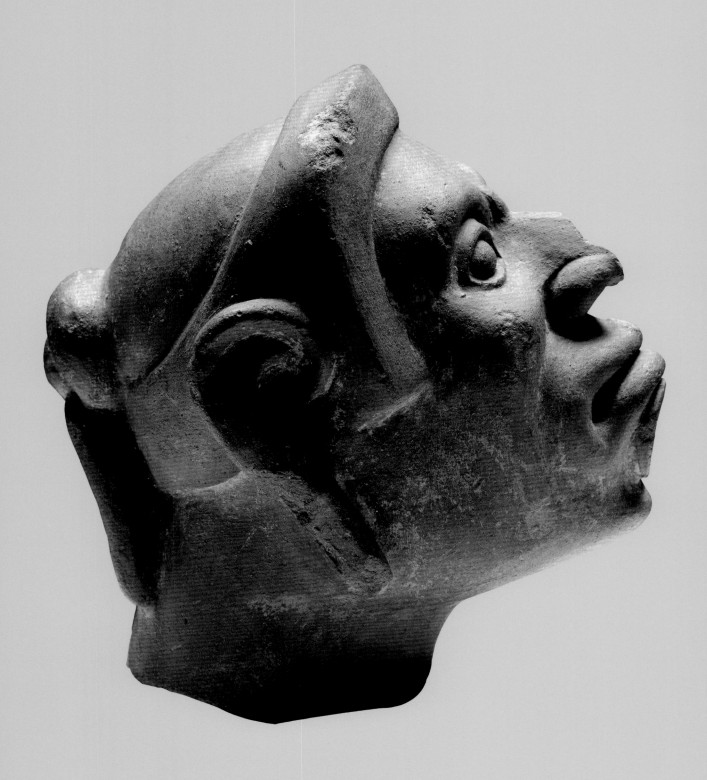

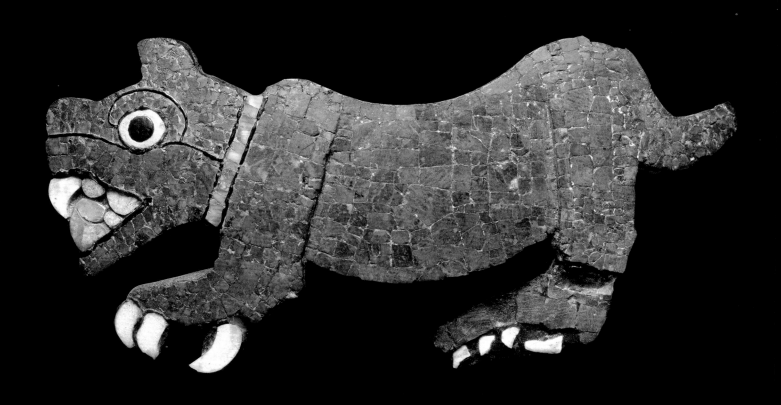

126. Jaguar pectoral
Mixtec, ca. 1200–1500

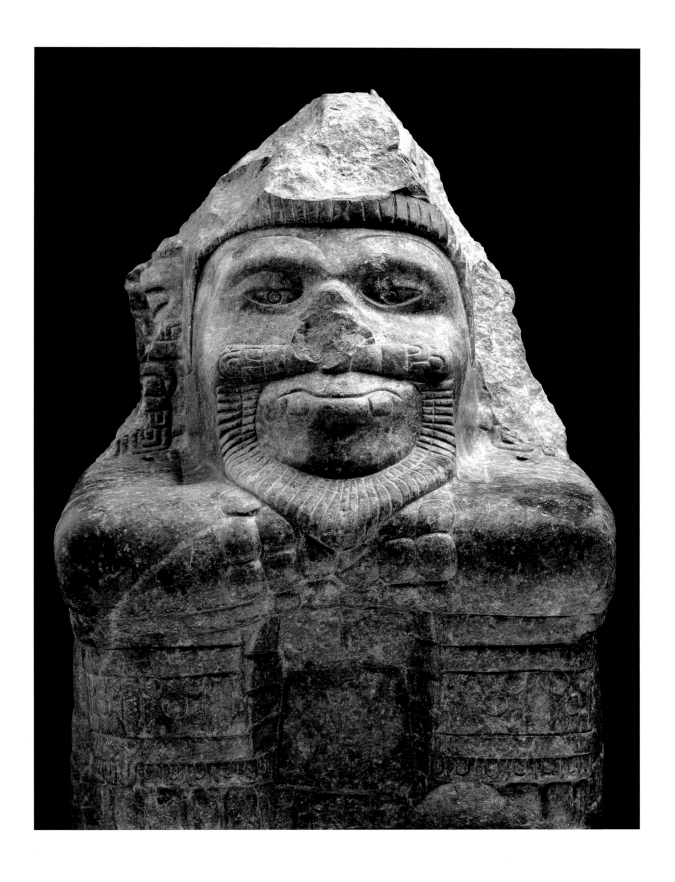

127. Xiuhtecuhtli
Aztec, ca. 1200–1521

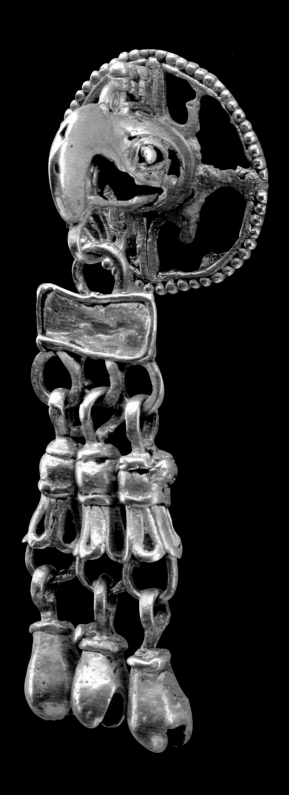

128. Ear ornaments
Aztec-Mixtec, ca. 1400–1500

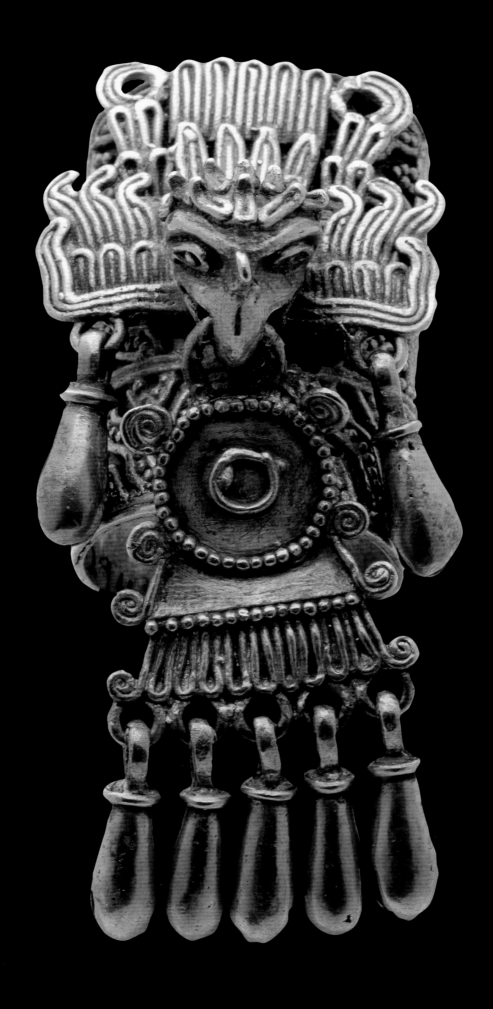

129. Ring with the figure
of a descending eagle
Mixtec, ca. 1325–1521

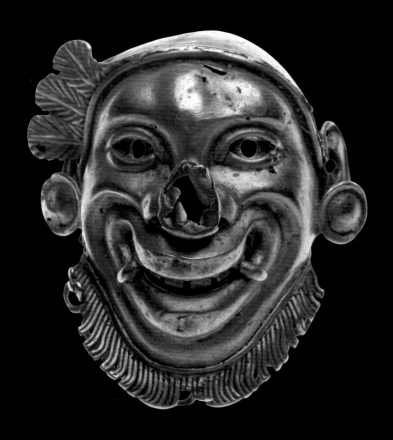

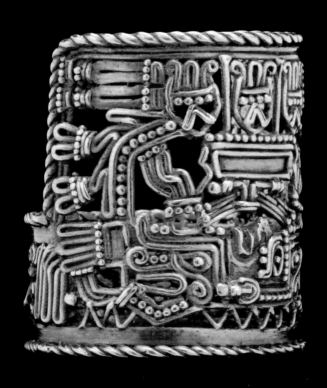

130. Pendant with the
figure of Xiuhtecuhtli
Aztec, ca. 1500

131. Ring with serpents
in filigree
Aztec, 900–1521

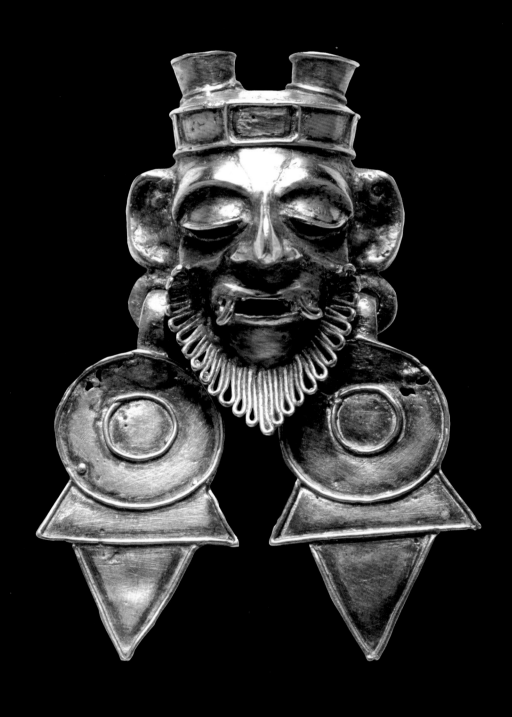

132. Xiuhtecuhtli pendant
Mixtec, ca. 1500

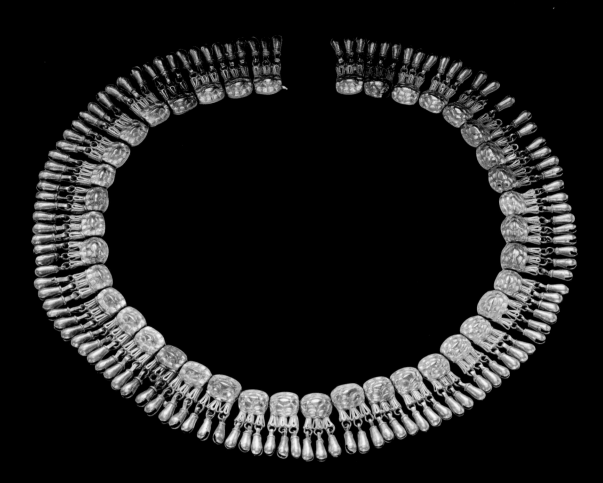

133. String of snail-shaped beads
Aztec-Mixtec, ca. 1300–1521

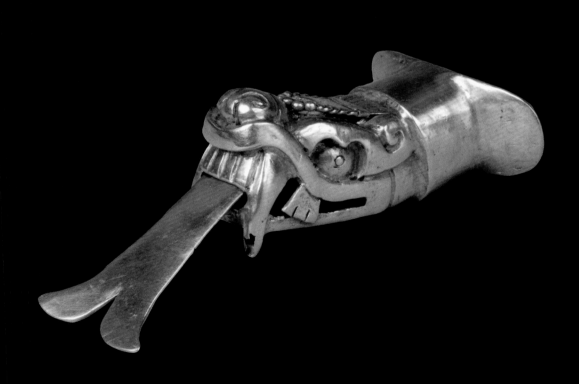

134. Lip-plug in the shape of a
serpent with its tongue out
Aztec, ca. 900–1521

135. Ear ornaments
Mixtec, ca. 1500

136. Pendant with the
head of a cox-cox bird
Mixtec, ca. 1200–1521

Following pages:

137. Ahuitzotl plaque,
detail
Aztec, ca. 1500

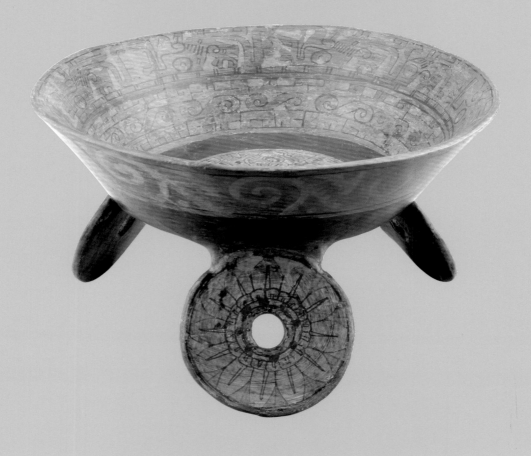

138. Plate tripod
Aztec, ca. 1500

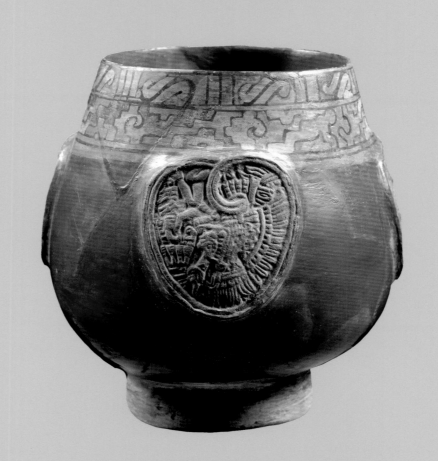

139. Coyote warriors goblet
Aztec, ca. 1500

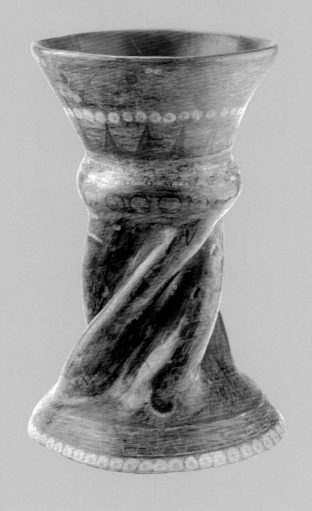

140. Flower goblet
Aztec, ca. 1500

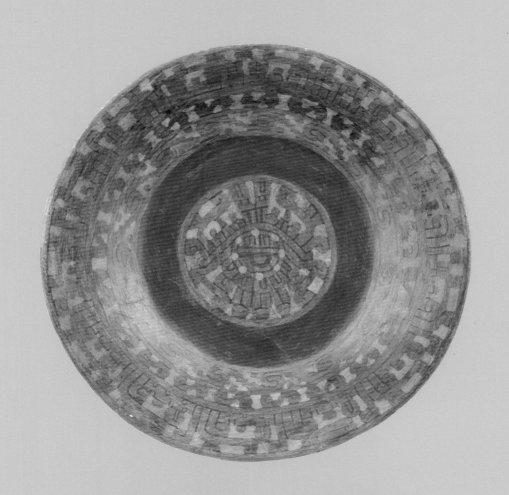

141. Polychrome plate
Aztec, ca. 1250–1500

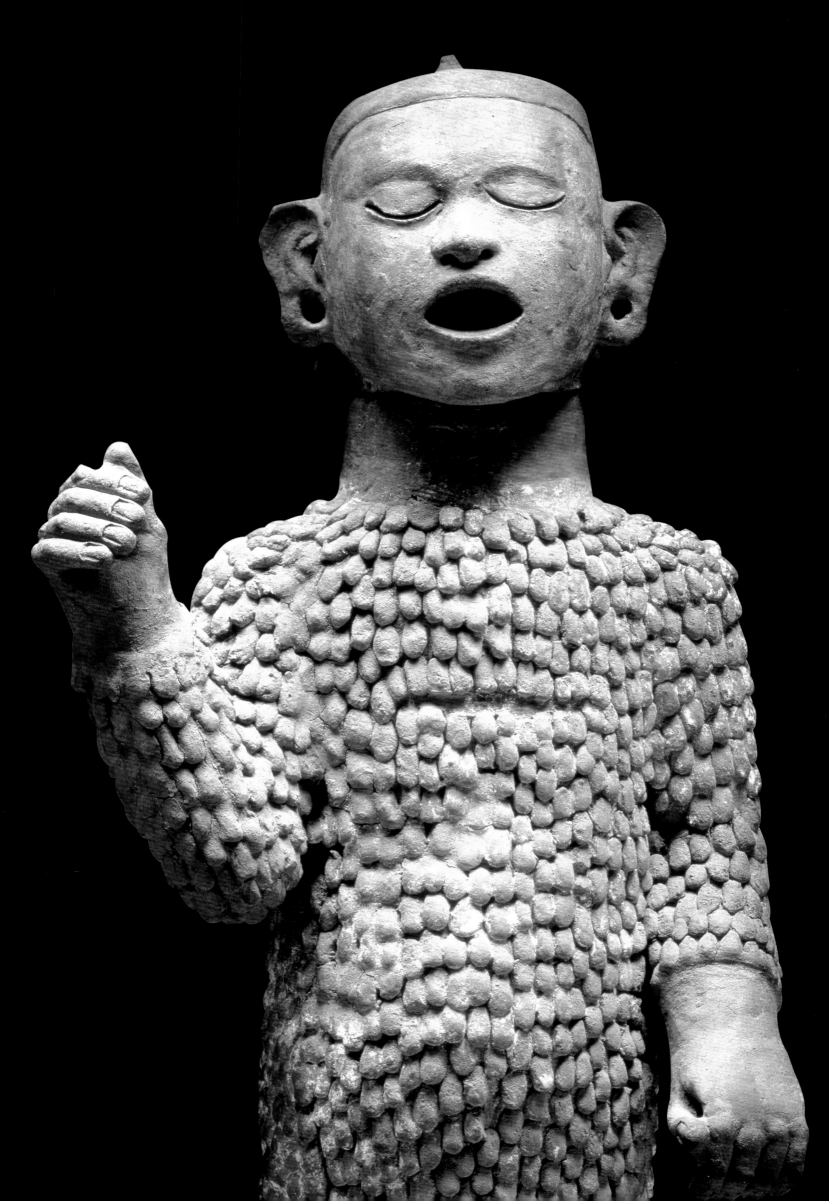

The Aztec Empire

The Aztec Empire

Richard F. Townsend

IN THE CLEAR DAWN OF A NOVEMBER DAY IN THE YEAR 1519, AS THE SUN ROSE OVER THE snowcapped volcanoes east of the Valley of Mexico, illuminating the gleaming lake basin and white pyramid-temples of Tenochtitlan, thousands of people in dugout canoes were swarming to line the long southern causeway leading into the island city. At the center of the capital, in the patio of the royal palace, nobles and warriors were assembling in all their ceremonial finery: brilliant feathers, golden jewelry, obsidian earspools, jade labrets, cloaks with heraldic designs, embroidered loincloths, and high-backed sandals. On the floor of the patio, a splendid litter lay waiting. The *huey tlatoani* (great speaker or ruler), Motecuhzoma II, would soon appear, to be borne by nobles to the wide city plaza in front of the palace. Nearby, to the north, lay the walled ritual precinct with the looming tiers of the Templo Mayor and other tall temples with wide, bloodstained stairways, the ballcourt, council houses, and the fearsome *tzompantli* (skull rack), a tall rack of poles strung with the heads of thousands of sacrificed victims. The royal procession would turn southward, advancing at a stately pace through the silent, respectful throngs toward the place of appointment, where the long causeway reached the imperial city.

A short distance to the south, by the town of Ixtapalapan, a different host was assembling. A high wail of fifes and the beat of marching drums sounded the signal, and the strangers stepped out onto the causeway toward the heart of the Aztec capital. Sunlight glistened on their polished steel armor, and horsemen scouted the vanguard. Then came the waving banner of Spain, followed by files of pikemen, crossbowmen, harquebusiers, and artillerymen, and then the party of Hernán Cortés and his captains. They numbered barely 500. The crowds wondered and whispered, watching the outlandish procession. A disquieting rustle and murmur swept through the throng when they saw a raised White Heron standard leading some 3,000 Tlaxcalan Indian warriors—arch enemies of the Aztecs, now allies of the strangers—forming the rear of the column.

The parties met at the place called Xoloco. Motecuhzoma stepped from his litter, wearing the gold and turquoise diadem of supreme office. Ceremonially supported by nobles, he approached the dismounted Spaniards. Greetings were exchanged in Nahuatl and Spanish, translated by Malintzin, the remarkable high-born Indian lady who became Cortés's consort and was now learning Spanish. Cortés was politely restrained from giving Motecuhzoma a formal embrace, for the Aztec *tlatoani* was considered semidivine by his people; yet he reached out to bestow upon Motecuhzoma a necklace of fine Venetian glass beads strung on gold filament and scented with musk. The parties turned to continue in procession into the city, and, during a pause, Motecuhzoma gestured to a servant, who brought two necklaces of red shells and eight golden shrimps a span long, which Motecuhzoma himself put on Cortés's neck. The strangers were invited to quarter their army in the old royal palace of

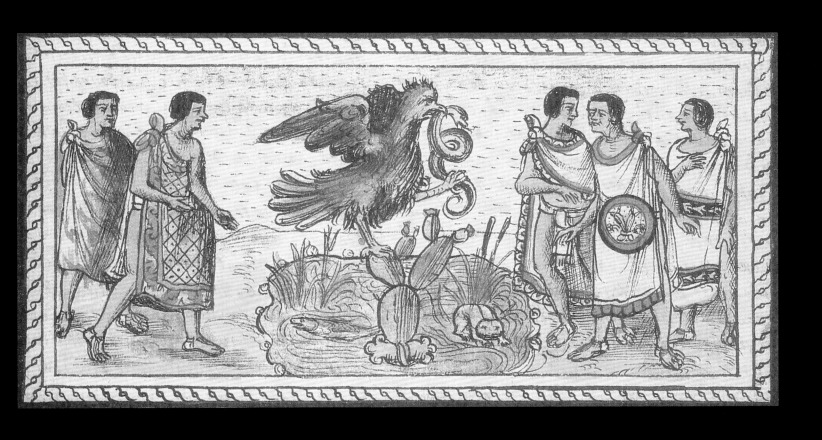

Page from Fray Diego Durán, *Codex Durán*, also
known as *Historia de las Indias de Nueva España
e Islas de Tierra Firme*, 1579–81.

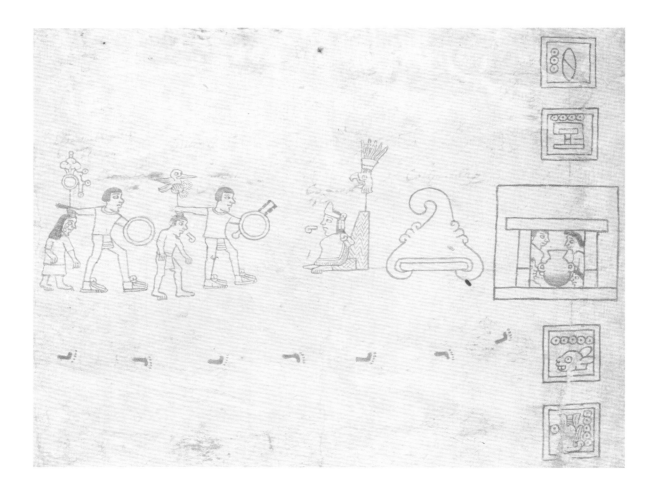

Axayacatl, just east of the ritual enclosure in the middle of Tenochtitlan, where more formal discourses were made before the formalities ended.

Spaniards and Aztecs were both gambling in this meeting, for Cortés and Motecuhzoma had been masking their mutually hostile intentions with diplomatic overtones since first learning of each other in the preceding months. After the Spanish landed at Veracruz, the reception of Aztec ambassadors bearing spectacular gifts and Motecuhzoma's message discouraging a visit only encouraged Cortés to burn his ships and dare to lead his tiny force toward the fabulous city far in the highland interior. Then came his victory over a Tlaxcalan army, when Spanish battlefield discipline combining cavalry, firearms, and close-order drill pikes proved superior against open formations of charging warriors—foes the Aztecs had never vanquished. Cortés's diplomatic genius was subsequently displayed when he succeeded in making the fierce Tlaxcalteca his allies, creating a base for the next stage of the journey. These events were duly reported by spies to Motecuhzoma. The massacre at Cholollan (modern Cholula) followed: secretly directed by Aztec overlords, Cholollan chiefs planned to trap the Spaniards in the narrow streets of their city, assaulting them from rooftops and nullifying their tactics of open maneuver. The plot was discovered, and the hapless Cholollan leaders were killed without quarter in their own city plaza.

When Cortés and Motecuhzoma met at Xoloco, Cortés still held the initiative. Yet it cannot be imagined that Motecuhzoma, a highly successful ruler and warrior, was unduly frightened or superstitiously affected, as was supposed in accounts written years later. In fact, Motecuhzoma was pragmatically reluctant to risk his army in open field combat and had resolved to allow the alien force into Tenochtitlan, where they would be surrounded by some 250,000 to 300,000 people, among them warriors numbering in the tens of thousands. Aztec tactics employed unsuccessfully at Cholollan might be tried again, with the prospect of total success. From Motecuhzoma's outlook, the real threat of Cortés's small force was that it might encourage rebellion among dissident tribute-paying towns in the Aztec empire. For Cortés, the conquest of Tenochtitlan would yield for the crown of Hapsburg Spain an empire surpassing that of ancient Rome.

The Conquest of Mexico has been vividly described by many, beginning with Cortés's *Five Letters of Relation to the Emperor Charles V*, Bernal Díaz del Castillo's classic True *History of the Discovery and Conquest of Mexico*, and, from the Aztec point of view, the narration by Fray Bernardino de Sahagún's Indian informants in book twelve of the *Florentine Codex*. Such records portray one of the most dramatic and moving events in history. The initial months of residence in Tenochtitlan; mounting tensions and the capture and death of Motecuhzoma; the Aztec uprising and the disastrous retreat of the Spaniards and Tlaxcaltecal as they barely escaped from Tenochtitlan by night; their recovery in Tlaxcala; and the renewal of the campaign with allies joining from many Indian communities seeking to overthrow hated Aztec overlords—all led to the final siege and destruction of Tenochtitlan by force and the devastations of starvation, smallpox, and other diseases in August 1521.

The colonial centuries began, with a new form of Hispanic Mediterranean civilization taking shape in association with old indigenous ways of life. From the time of Mexican independence from Spain in 1821 to the present, Mexico has sought to develop a view of the past that acknowledges the heritage of its

Page from the *Codex Boturini*, also known as the *Tira de la peregrinación*, ca. 1520–40.

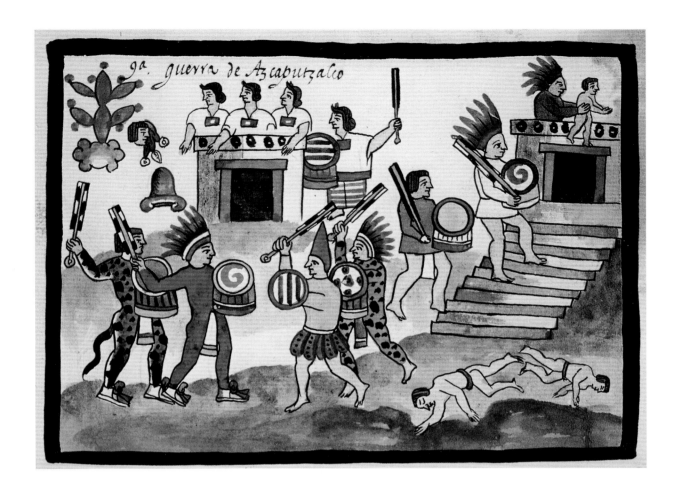

many peoples, among whom the Aztecs have special significance. Archaeological excavations in downtown Mexico City and around the Valley of Mexico continue to reveal foundations of Aztec buildings, sculptures, artifacts, residential and manufacturing sites, and areas of cultivation. These remains are interpreted using archaeological contexts and detailed sixteenth-century records written by Spanish and Indian scholars, as well as information from other, pre-Aztec societies of Mesoamerican civilization whose remains extend well beyond 2000 B.C.

These diverse sources reveal that the drama of the Aztecs' fall was readily matched by that of their extraordinary rise, from an immigrant tribe in the thirteenth century to their position by the time of Cortés's arrival as rulers of an empire covering vast regions of central and southern Mexico. Fearless warriors and practical builders, they created a domain surpassed in size only by the empire of the Incas in Peru. The sacrificial aspects of their religion, with its seeming indifference to human life, appalled and repelled the Spaniards. But, as historical texts and modern archaeology continue to show, beyond the ritualized violence there are more easily apprehended achievements: the formation of a highly specialized and stratified society and an imperial administration; the extension of far-reaching trade networks and tribute systems; the development of a highly productive agricultural economy carefully adjusted to the land; and the adaptation of an ancient, inherited Mesoamerican worldview in intimate contact with the earth, the sky, and the changing seasons. An annual round of agricultural and state rituals provided a powerful means for maintaining social and cultural cohesion, and the brilliant imagery of Aztec art and architecture gave visual expression to an awareness of the interdependence of their imperial society and the larger cosmology of nature.

In the early thirteenth century, the future site of Tenochtitlan was a cluster of unclaimed islands and reedbeds in Lake Tetzcoco, inhabited by the teeming waterfowl and aquatic life of the brackish wetland environment. The southern lake basin, where marshes were fed by freshwater aquifers, had been a prosperous zone of settlement long before the first millennium B.C. Similarly, the well-watered northeastern part of the valley had been densely populated since the flourishing of Teotihuacan, the grandest city of Mesoamerica, between the first and seventh centuries A.D. The prestige and model of Teotihuacan set the course for later urbanism, yet no single city had dominated the basin since the destruction of Teotihuacan's central monuments and its disintegration into smaller townships.

The rise of Toltec Tula between the tenth and twelfth centuries saw the creation of a new military state some 70 kilometers to the north of the valley. Harsh sculptural monuments at Tula speak of a warrior aristocracy seeking wealth and power through the conquest of tribute-paying domains. Their empire may have included parts of the Valley of Mexico, but the slow rhythm of communal life among the small lakeshore towns appears not to have substantially changed. Yet, as had periodically occurred in the past, the valley continued attracting immigrant populations. The violent downfall of Toltec Tula produced refugees and set in motion tribal peoples moving south from desert regions. The histories of incoming groups preserved in pictorial manuscripts and oral traditions recorded by Indian and Spanish historians tended to reflect idealized, "official" migration legends, with formulaic episodes, legendary happenings, and mythic occurrences interwoven with events that may actually have happened in identifiable locations. Such conventions portrayed tribal protagonists as legitimate heirs to a prestigious, hallowed ancestral past.

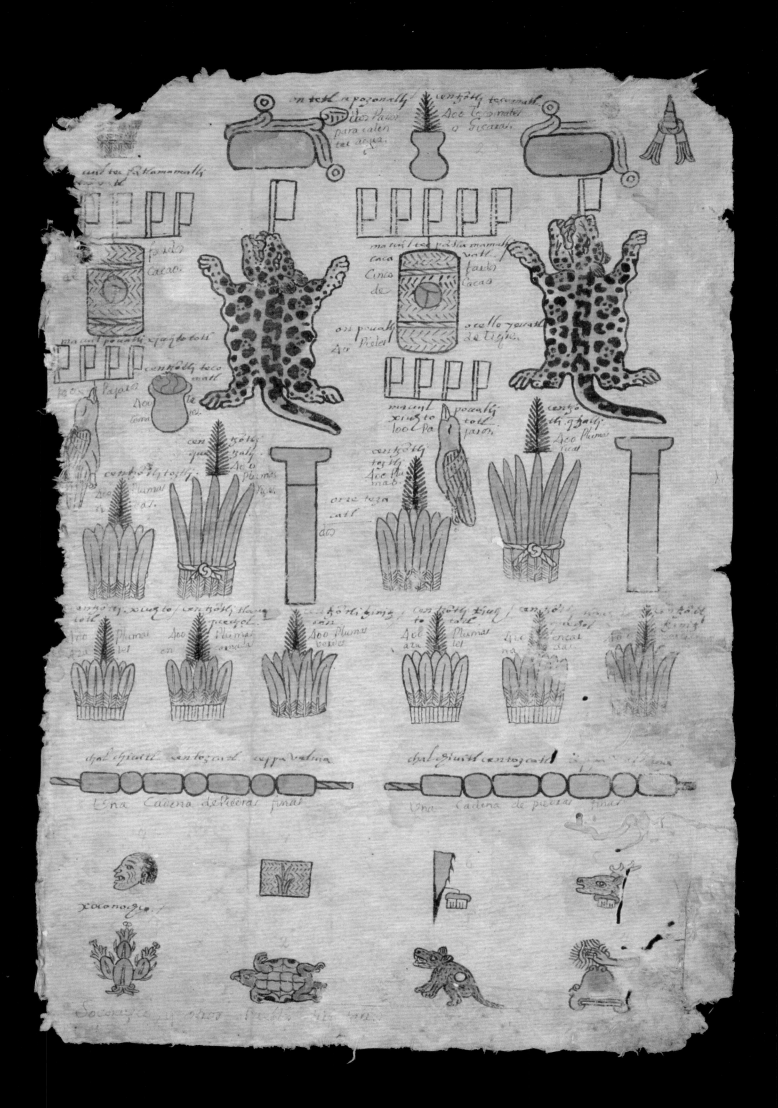

Page from the *Matricula de Tributos*, early 16th century.

Among these groups migrating to the valley, four were to play especially important roles in the rise of the Aztec empire. The first group was the Tepaneca, who probably arrived during the twelfth century, settling among older communities around Tlacopan and Azcapotzalco on the west side of the basin. The second group, the Chichimeca, filtered into the northwestern valley during the thirteenth century, eventually establishing a dynastic seat at Tetzcoco on the less-inhabited eastern side. Tetzcoco was destined to become the second most important city in the basin and a major partner, with Tenochtitlan, in building the Aztec empire. The third group was the Acolhua, who settled the volcanic peninsula dividing the southern and central basin; their principal city was Culhuacan. The last to arrive were the Aztecs, more properly called the Mexica-Aztecs.

Today the term *Aztec* is generically applied to all the peoples of the valley in this last episode of Mesoamerican history, but it is well to remember that the many towns traced origins to different ethnicities, with some communities antedating Teotihuacan itself. The Mexica-Aztec migration legend is a composite of stories assembled long after they arrived and settled; the episodes are not sequential, facts are expressed in metaphoric terms, and there are magical and fabulous events that cannot be explained historically. The story says that the Aztecs originally lived on an island in a lake far to the north. After departing from this island, they were soon joined by a second group, known as the Mexica, led by the chieftain Huitzilopochtli. The most vivid event associated with the migration legend is the magical birth of Huitzilopochtli at Coatepetl (Serpent Mountain), in a remote, mythical time. It is said that an earth temple at the summit of the mountain was kept by an aged priestess, Coatlicue, a metaphoric name for the earth goddess. She is described as the mother of a powerful woman, Coyolxauhqui, and a host of warriors, collectively named the Centzon (Four Hundred) Huitznaua. Coatlicue was sweeping the shrine one day when she was impregnated by a ball of feathers from the sky. This was the supernatural conception of Huitzilopochtli. Her pregnancy threatened the outraged Coyolxauhqui, who summoned the Huitznaua to assault the hill and kill their dishonored mother. However, one of the Huitznaua ran to whisper of the impending attack to Huitzilopochtli in his mother's womb. As the enemy force reached the summit, Huitzilopochtli was suddenly born as an invincible warrior. Wielding a *xiuhcoatl* (fire serpent, or ray of the sun), he dispatched Coyolxauhqui, whose dismembered body rolled down to the base of the mountain. The Huitznaua were scattered with his spearthrower and darts. Eventually, this story became the Mexica-Aztec hero myth and would find powerful symbolic expression in the fierce imagery of the Templo Mayor in Tenochtitlan.

The Mexica-Aztecs wandered across the sere tablelands of north Central Mexico, hunting and gathering yet also some-times settling for years, raising crops of maize, beans, squash, amaranth, chia, chilies, and tomatoes. But they always moved on, curiously propelled by prophecies of their future "imperial" status given by the spirit of Huitzilopochtli through priestly mediums.

The migration entered the realm of history when the tribe arrived in the Valley of Mexico around 1300. Settling by springs at Chapultepec, the primitive Mexica-Aztecs were seen as uncouth and dangerous squatters and were soon violently dispersed by the nearby Tepanec chieftains of Tlacopan and Azcapotzalco. The tribe begged protection from the Acolhua lords of Culhuacan, who granted them land in old lava flows by the brackish shore of Lake Tetzcoco. Courageously, the outcasts adapted to the inhospitable environment and began serving as warriors in petty wars between Culhuacan and its neighbors. Soon they were trading fish, frogs, fowl, and produce in the marketplace and began to intermarry, but the Culhuacan chieftains perceived a future threat and the Mexica-Aztecs were again violently forced to flee, this time to the unclaimed marshy islands offshore. The circumstances were humiliating, and in later years a legend was proclaimed to explain the foundation of Tenochtitlan as the fulfillment of a sacred vision: it was said that long before, Huitzilopochtli had prophesied that an eagle perched on a nopal cactus would signal the place where the wandering tribe should settle; sure enough, the leaders were said to have witnessed this hallowed sign amid the desolate reed-beds. A branch of the tribe established themselves on another island, nearby to the north, where the future town of Tlatelolco would flourish before its forcible incorporation into the larger urban zone of Tenochtitlan during the fifteenth century.

From the outset, the refugees made the best of it. The women established a marketplace, while the men gleaned the lake and continued to serve as occasional warriors for locally quarreling warlords. By the end of the fourteenth century, the Mexica-Aztecs were fatefully bound as tribute payers to the ascendant city of Azcapotzalco. There, the *tlatoani* Tezozomoc, a ruler of ruthless genius, was building the first empire in the region since the fall of Toltec Tula, using flattery, bribery, assassination, and treachery, combined with acute military strategy, to break the balance of power among the contentious small towns of the valley. Requiring warriors from defeated communities as a form of tribute payment, he also motivated them by offering part of the spoils of conquest. The Mexica-Aztecs participated in Tezozomoc's campaigns and learned new levels of intimidation, statecraft, and military organization. Their apprenticeship ended in 1426 when Tezozomoc died; the ruler Itzcoatl of Tenochtitlan, prince Netzahualcoyotl of Tetzcoco, and the dissident Tepanec ruler Tlaluacpan of Tlacopan successfully rebelled, laid claim to the empire, and in 1428 set out to extend their conquests.

First they secured the agricultural southern lake district and

Following pages: Map of Siguenza, from the *Codex Ramirez*, after 1521.

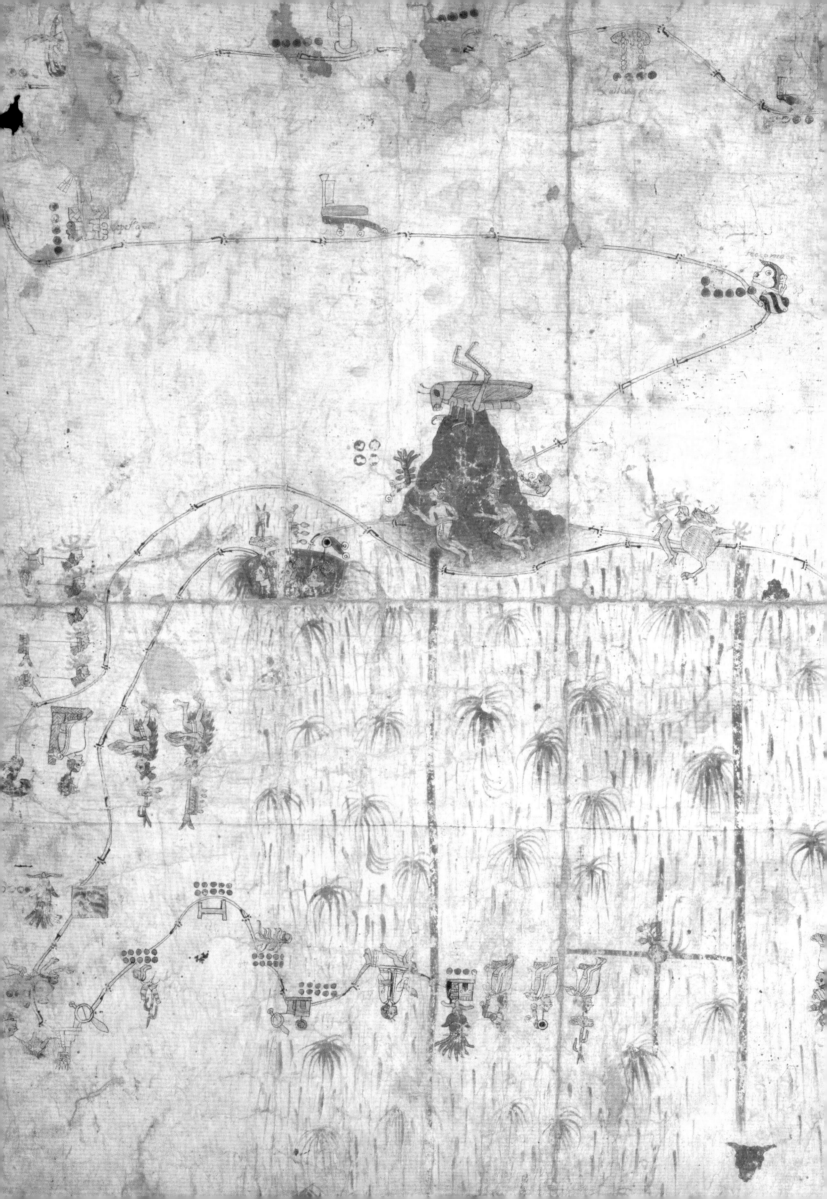

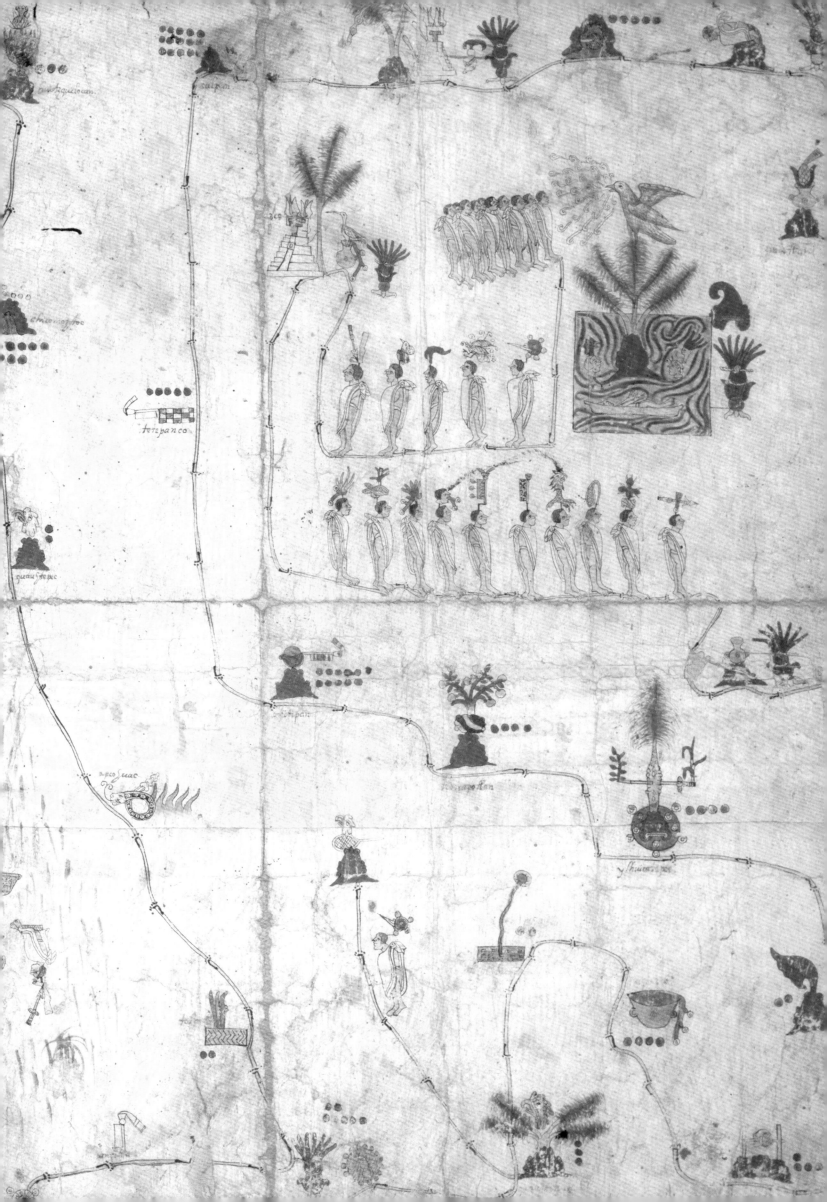

initiated the long-term conversion of marshland into a zone of intensively productive raised-field *chinampas* (from *chinamitl*, fence of cane). These plots of fertile farmland were made by first digging a grid of canals in the shallow marsh, then fencing the resulting rectangles with cane walls and stakes. The enclosures were filled with layers of mud and vegetal matter, creating platforms above water level. Each plot measured some 100 by 10 meters. From canoes in the adjacent canals, the raised fields gave the illusion of floating gardens.

Spheres of influence and rights of conquest were established by the allied leaders for their respective cities. Schedules for tribute payments from subjected communities were affirmed, Tenochtitlan and Tetzcoco each receiving 40 percent of the spoils and Tlacopan, the junior member, receiving the remaining 20 percent. The aims of conquest were unlike those of Old World empires, in that the Aztecs did not primarily seek to incorporate territory or to permanently garrison troops in conquered lands; their aim was to obtain tribute by intimidation if possible or by force and punitive retribution if necessary. The conquest campaigns began extending far beyond the Valley of Mexico, south into the Valley of Cuernavaca, east and northeast to the tropical Gulf Coast, and southwest over the mountains deep into Oaxaca. A pattern was established, to be followed by successive warrior-rulers throughout the fifteenth century and into the reign of Motecuhzoma II (reigned 1502–20). By the late 1430s and into the 1440s, wealth poured into the allied capitals on a regular basis, enabling the rulers and high-ranking warriors to build impressive establishments with elaborate courts through the use of labor and materials from their tributary vassals, and providing for the round of agricultural and state ceremonies, which began to be held with increasing ostentation, public display, and ceremonial gift giving.

Already, the old communal tribal structure of Mexica-Aztec society, with its traditional system of *calpullis* (clans) whose elders participated in an egalitarian form of decision making, was changing as new, stratified socioeconomic classes began emerging. As the rising military class commanded income from conquered lands, they also acquired the power to influence or directly make major decisions and set policy goals, diminishing the governing role of the *calpullis*. A form of aristocracy already existed, for the rulers derived their legitimacy by having requested, from their erstwhile antagonists in Culhuacan, that the prince Acamapichtli (of mixed Mexica and Culhua descent) serve as their *tlatoani* in 1375. The royal family of Culhuacan claimed descent from an old Toltec lineage.

Concentration of power was also accomplished by the ascendant rulers of Tenochtitlan, Tetzcoco, and Tlacopan by means of arranged marriages between their offspring and those of foreign chieftains. The Aztec commanders thus became bonded through kinship with leading families of principal towns in their spheres of influence, enabling them to maintain authority through networks of blood relations. The attendance of lesser lords or their children in the courts of their respective capitals was also required, as this tended to consolidate control and prevent thoughts of insurrection and rebellion. Lesser lords were further obliged to pay homage to their ruler on state occasions and to assist them with men and supplies in war.

In the time of turmoil and rapid change between the late 1420s and 1460s, as Aztec society grew increasingly diverse with residents from different ethnic groups bringing regional customs and mores, Netzahualcoyotl of Tetzcoco (reigned 1431–72) devised standardized laws governing the diverse groups. These laws favored the rule of the state, establishing order by defining behavior and responsibilities through punishments to be meted out with strict impartiality. Rules prescribed exclusive and concrete solutions for specific types of disputes and were mechanically applied with no regard for mitigating circumstances. Yet it was apparent that not everything could be judged in so strictly a legalist manner; it was necessary to keep certain traditional tribal aspects of justice, which held no rigid prescriptions for crime and punishment but handed out justice according to widely held notions of reasonable behavior. Nevertheless, the new codes controlled judges, curbed corruption and other abuses of power, and increased the efficiency of the courts while limiting the influence of dissident lords. The legal system thus contributed to the breakdown of old tribal society and built greater regimentation and submission to centralized state authority. On many levels, the great rulers during this period, from Itzcoatl and Motecuhzoma I of Tenochtitlan (reigned 1427–40 and 1440–69, respectively) to Netzahualcoyotl of Tetzcoco and the lesser lords of Tlacopan, were taking control of the resources of a vast landscape, distributing goods within their hierarchy, and extending their personal power and that of their nations.

The immense, thriving market of Tenochtitlan was located in Tlatelolco, the town forcibly incorporated as a district in the larger city during the reign of Axayactl (reigned 1469–81). Vividly described in Spanish accounts, this most famous market had long attracted local producer-vendors due to the easy transportation of goods over the lake by canoe. There was also trade in luxury merchandise brought far from the confines of the valley by lines of porters led by the long-distance traders called *pochteca*. *Pochteca* acted as agents for the nobility and as independent traders, dealing in tropical feathers, greenstones and turquoise, exotic furs, copper and obsidian, cotton garments, and cacao beans and vanilla for making the beverage chocolate. Their occupation was inherited and they lived in designated wards in Tlatelolco. *Pochteca* administered the market under their own legal system. Trails linked the Aztec capitals to distant ports of trade where warehouses were kept. One major route led to the Gulf Coast and its rivers, into the Peten region of Guatemala, and to the Caribbean coast of Honduras. Another

Detail of the Stone of Tizoc.

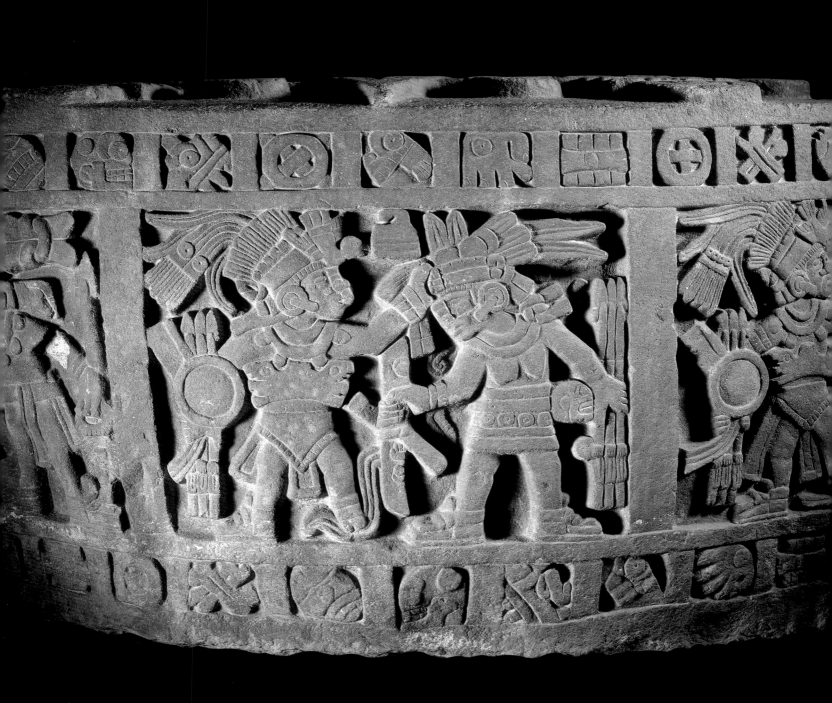

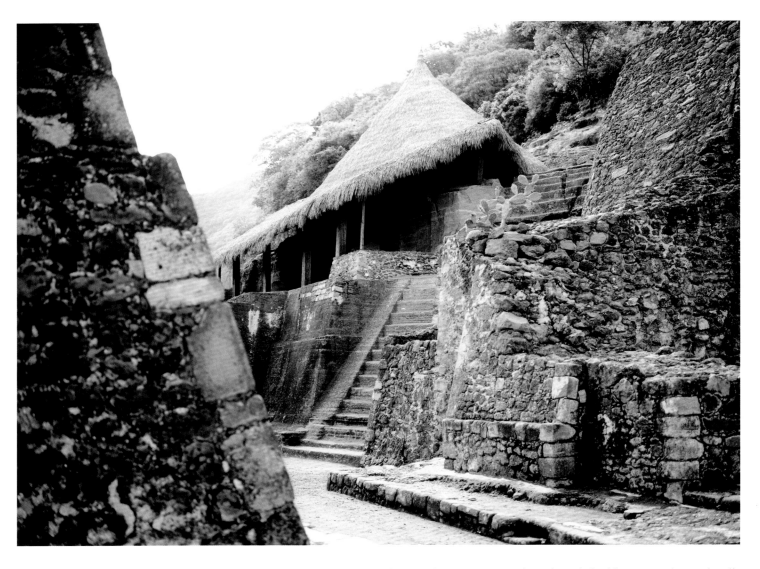

route led down to Oaxaca and across the Isthmus of Tehuantepec, to Xoconochco on the Pacific shore of Guatemala. Traders probably also reached north to mining districts in Querétaro, Zacatecas, and Durango, perhaps even as far as turquoise sources in Cerrillos, New Mexico. However, the *pochteca* were not a rising middle class but a guildlike organization of high-ranking commoners below the nobility. The Aztec market system linked many sectors and regions within a highly commercialized economy, yet it was not wholly a capitalist system: there was no wage labor, land was rarely bought and sold, and investment by nobility or wealthy commoners was limited to *pochteca* expeditions. Commoners and merchants could improve economically but could not rise to higher social positions; the military remained the principal avenue for social, political, and economic advance.

The land and its resources and income from trade and conquest were not the only determining factors shaping Aztec society. The force of an ancient worldview and its powerful expression also maintained Aztec cultural, economic, and social cohesion. Since remote times, the rhythm of Mesoamerican life had been embedded in the land and the changing seasons. The annual cycle of rain and drought determined the activities of farming people as it had for the hunter-gatherers long before. Obtaining food went hand in hand with a sense of periodicity and regular recurrence, and calendrical observations were essential to regulating human participation in the natural environment. The interaction of the community with the deified forces of nature assumed profound significance and was ritually affirmed through festivals held at sacred places in cities and through selected features of the surrounding landscape. Religious functions of rulers and their priests were critical in maintaining these relationships, for they were traditionally obliged to ensure, through sacrificial rites, the regularity of the seasons, the productivity of the land, the fertility of crops and animals, and the well-being of their communities throughout the year.

In Tenochtitlan, Tetzcoco, Tlacopan, and elsewhere, artists, architects, and choreographers of ritual were assigned the task of designing a new, distinctive visual vocabulary to express these ancient cosmological themes in terms of the Aztec city-states and their interests. Tenochtitlan was correspondingly planned as a cosmic diagram, with four avenues leading to the cardinal directions, the east-west line assuming special importance as a reflection of the daily passage of the sun. The great ritual precinct defined the middle, with the Templo Mayor rising in four great tiers as an *axis mundi* between the sky, the earth, and the underworld region. In the reign of Motecuhzoma I, the pyramid was notably enlarged, following the ancient practice of adding a new outer layer. The pyramid was a dual structure with the symbolic configuration of twin sacred mountains. The left (north) half stood as the "mountain of sustenance," supporting the temple of the rain god Tlaloc, representing the seasonal formation of rain clouds on the mountains rimming the valley. The right half represented Huitzilopochtli's mythical mountain Coatepetl and supported the temple of the deified hero. Two

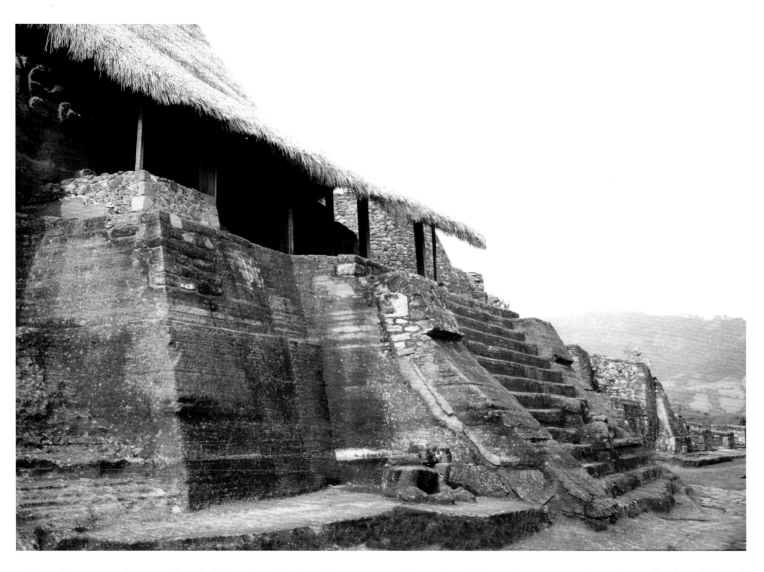

wide stairways on the west facade led to the side-by-side temples on the upper platform of the pyramid. At the foot of the stairway on the Huitzilopochtli side, a sculpture of the dismembered Coyolxauhqui was placed. War prisoners were obliged to walk by this fearful monument on their way up the stairs to be sacrificed. Their blood was intended to fertilize and increase the power of the looming, fetishlike pyramid mountain. During one of the later renovations of the pyramid (date unknown), a colossal head of Coyolxauhqui carved in green diorite was added. Yet the theme of Coatepetl was very old in Mesoamerica and was certainly adapted into the Aztec symbolic vocabulary as one of the ways in which they signaled their position as heirs to the power and prestige of the past.

Cosmic themes were also expressed by imperial commemorative monuments. The Stone of Tizoc and Ahuitzotl portrays the deceased Tizoc (reigned 1481–86) on the left, confronting his successor-brother Ahuitzotl (reigned 1486–1502) on the right. They stand on a strip representing the face of the earth. Twin incense burners rest on the ground before them. Each *tlatoani* pierces his ear, the blood flowing into the open mouth of the earth between the rulers. The large cartouche below has the date 8 Reed (1486), when Ahuitzotl assumed office. The passage of power was thus consecrated and confirmed by ritually feeding the earth, and the earth itself was simultaneously claimed as the Aztec empire.

As the allied capitals grew cosmopolitan with incoming artisans, traders, diplomatic delegations, and others from client

nations, the deities of many peoples also arrived and found expression in the program of annual festivals. The protean variety of these diverse cults reflected the Aztec custom of housing sacred effigies and the ritual bundles of subject nations in a special temple within the principal ceremonial precinct of Tenochtitlan. Yet all these deities reflected the worship of the forces of nature: sun and fire; rain, wind, and groundwater; earth and the fertility of plants. Some of their cult names, in Nahuatl, follow. Tonatiuh was the deified sun, a primary source of life, often depicted as a solar disk with rays to the cardinal directions. The earthly representative of the sun was fire, Huehueteotl, whose annual midnight renewal was celebrated by new fire being kindled on the summit of the hill called Huixachtecatl before being brought down by torch-bearing runners to relight the temples and hearths in all the towns of the basin. Tlaloc was the deity of rain, so named because rain clouds take form upon the summit of the tall highland mountains. Tlaloc's most important festival, in late May or early June, was designed to summon the rainy season: four rulers from the main cities of the valley made a pilgrimage to the remote shrine on the top of Mount Tlaloc, where they ceremonially dressed an effigy of Tlaloc, enthroning him as a sacred *tlatoani*, and made sacrifices and spread out a great feast offering of food. This rite was immediately followed by that of Chalchiuhtlicue, the goddess of groundwater, at a shrine marked out in the middle of Lake Tetzcoco. Ehecatl was the wind that sweeps down with gusts and claps of thunder, bringing curtains of rain. In one

Views of Malinalco.

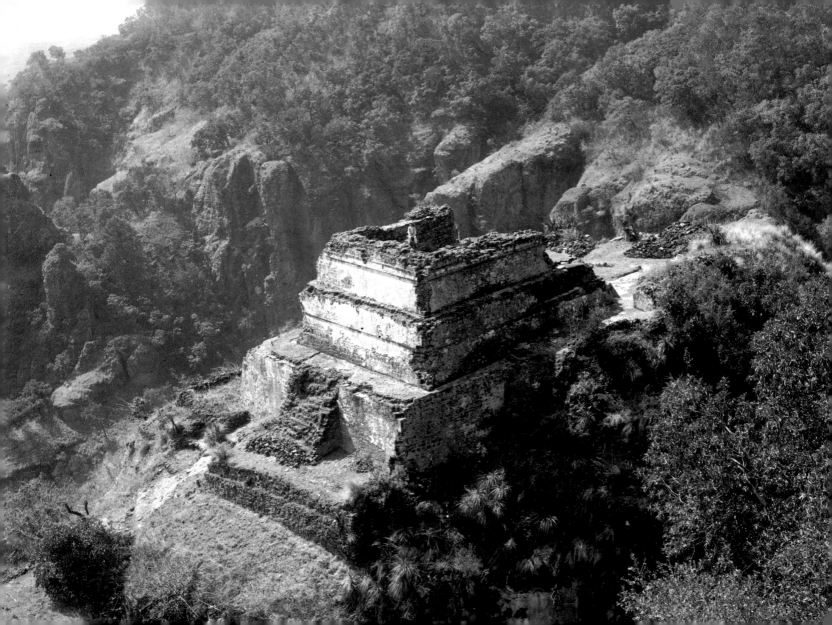

guise, he was represented wearing the bill of an aquatic bird, suggesting the swift flight of wind-borne water; another name associated with these forces was Quetzalcoatl, alluding to the long, iridescent-green quetzal feather, a symbol of royalty and the sweeping, flowing force of wind and water. A title of ruler-ship, the name Quetzalcoatl was also associated with historical or legendary heroes in ancient Mexico. The earth, conceived in female terms, had many titles, among which Coatlicue was well represented. Serpents, spiders, and centipedes were signs of this deity by virtue of their closeness to the earth's surface. The earth is not only a giver of life, the source of fertility, but it also even-tually claims all that grows or walks on its surface; hence the effigies of Coatlicue often display skulls or clawed hands and feet. Tlaltecuhtli was another ritual title for the deified earth, as was Tonantzin. Among the deities of vegetation, Xilonen (from *xilotl*, tender ear of maize, and *nenen*, doll) was essential. She took the form of an adolescent woman holding the first tender green corn of the summer season. These and many other deities were impersonated by masked and ritually attired performers at festival times, and it is these attired impersonators that the Aztec sculptors fashioned as permanent effigies of the gods in the temples and shrines of the city.

In the cities of the Valley of Mexico, the annual cycle of fes-tivals of these deities was principally keyed to the June through September rainy season for planting, cultivating, and harvest, and to the lengthy dry season that followed, which was the time for long-distance trade and war. The year was thus seen in terms of a cycle of life, death, and renewal. As a matter of course, rites of passage marking transitions in individual and collective life were also linked to the annual cycle. In Aztec society, the rites by which rulers were initiated into office were the most spectacu-lar. Coronation rites encompassed vast resources, mobilized hundreds of thousands of people, and unfolded over several months of elaborate pageantry with solemn ceremonies, feasts, and the giving of gifts. From the outset, when the ruler-elect withdrew on a ceremonial retreat, to his public investment with the royal regalia, to the coronation war, the bestowing of emblems of office, and the victory sacrifices of prisoners, the new warrior-king followed the mythic model of the archetype hero Huitzilopochtli slaying enemies on Coatepetl. Without doubt, the vast apparatus of art, architecture, and ritual per-formance created at the imperial capitals played a central and determining role in maintaining the cohesion of Aztec society and state.

When the Mexica-Aztecs and their neighbors migrated into the Valley of Mexico, they were determined to win a place for them-selves in that fertile, luminous setting. Many factors contributed to the subsequent rise of their empire: the role of imaginative and forceful rulers; the extension of tribute networks through force of arms; the creation of a firm agricultural base; the proclamation of laws favoring the centralized rule of the state;

a far-reaching system of trade; the idea of making themselves the new Tolteca in the manner of Tula and Teotihuacan centuries before; and the unifying force of their cosmovision, in which sacrifice answered the need for ritual reciprocity toward the sun, water, earth, and food sources, while also serving to create an obedient and fanatical population inured to bloodshed and war as a way of life. But for all these integrating features, the Aztecs never really outgrew their predatory instincts. They enriched themselves principally by capturing wealth with the menace of violent retribution. Within the expansive dynamic of empire building, there existed a great and constant mass of dis-affection and antagonism. The Aztecs had mastered the arts of war but not those of government. So on that November day in 1519, when the Spanish and allied Tlaxcalan warriors crossed the causeway to meet Motecuhzoma II at the entrance of Tenochtitlan, many subject or threatened people felt a tremor; and in the events that followed, they saw the chance to arise and reclaim their lost pride, property, and power. A seismic upheaval was set in motion. The collapse of the Aztec empire in 1521 was as much an Indian revolt as it was a Spanish conquest.

The Provinces
of the Aztec Empire

Frances F. Berdan

THE AZTEC EMPIRE WAS THE LAST OF THE GREAT MESOAMERICAN EXPANSIONIST POLITIES, dominating Central Mexico from 1430 until its conquest by the Spaniards in 1521. Fundamentally, the empire reflected older Mesoamerican political patterns. It was built on widespread city-state organizations. The three imperial capitals were all at the center of city-states, and the bodies they conquered were likewise city-states of varying sizes and power.

Mesoamerica throughout its history was characterized by dynamic, even volatile, political and military relations. It was a region that experienced the dramatic rise and fall of city-states and of empires. The fluidity of the political situation cannot be overemphasized. City-states fighting each other to the death one year might have been relatively amicable allies the next. A city-state that experienced unpromising beginnings could still develop into a powerful political entity. This was the case with the Aztecs, who began as poor mercenaries in a small, comparatively young city-state yet emerged as military head of the largest empire in Mesoamerica's pre-Hispanic history. The capital city of the Mexica, as these people called themselves, was the huge and impressive Tenochtitlan, which had as many as 250,000 inhabitants in 1519, when the Spaniards arrived.

The Valley of Mexico was the setting for the emergence of this great empire. In the early fifteenth century the valley's strongest polity was Azcapotzalco, to the west of Lake Tetzcoco. The death of that city-state's ruler in 1428 and the subsequent bickering between his power-hungry sons offered the Mexica of Tenochtitlan an irresistible opportunity. They joined with their neighbors, the Acolhua of Tetzcoco, and conquered the divided Azcapotzalco. By adding the Tepaneca of Tlacopan as allies, they established the powerful Triple Alliance.

Now widely known as the Aztec empire, this Triple Alliance began almost immediately to overwhelm its neighbors in the Valley of Mexico. By 1450 it was already making aggressive military moves against city-states beyond the basin. When the Spaniards arrived, the alliance controlled thirty-eight tributary provinces and had established asymmetrical, clientlike relations with city-states in another twenty-three provincial regions. The client states were located at some distance from the imperial core and effectively served to insulate the tributary provinces, which were closer to Tenochtitlan and its allies.

To further their wars of conquest, the Aztecs offered valuable economic and social rewards, such as elaborately decorated capes and specially designed battle costumes, to inspire their warriors in ferocious hand-to-hand combat. (It is unclear if opposition forces were motivated by similar reward arrangements.) In addition, they were usually capable of amassing larger armies than their enemies. The Triple Alliance forces incorporated warriors from already conquered

142. Altar with images of a procession of warriors
Aztec, ca. 1200–1521

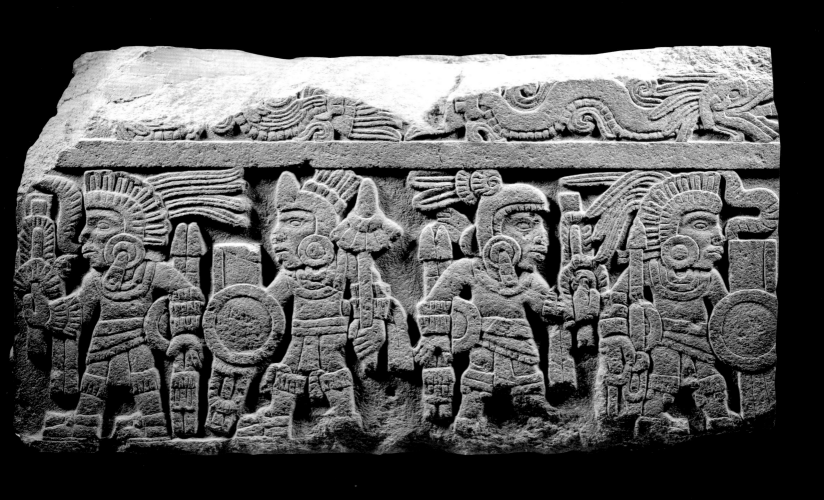

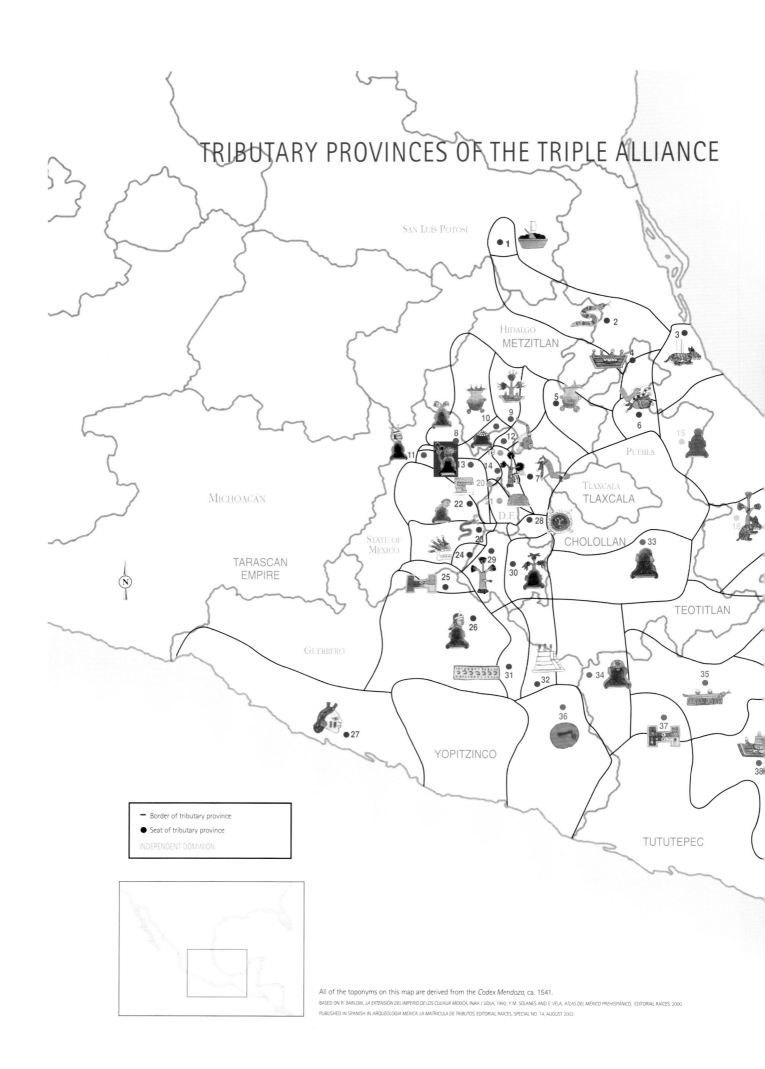

TRIBUTARY PROVINCES OF THE TRIPLE ALLIANCE

San Luís Potosí

1

Hidalgo
METZITLAN

2

3

4

5

6

15

8

9

10

12

PUEBLA

11

13

14

7

TLAXCALA
TLAXCALA

20

MICHOACÁN

22

21

D.F.

28

16

State of
Mexico

CHOLOLLAN

33

23

24

29

TEOTITLAN

25

30

TARASCAN
EMPIRE

N

26

Guerrero

31

32

34

35

36

37

27

YOPITZINCO

TUTUTEPEC

38

Border of tributary province
● Seat of tributary province
INDEPENDENT DOMINION

All of the toponyms on this map are derived from the *Codex Mendoza*, ca. 1541.

BASED ON R. BARLOW, *LA EXTENSIÓN DEL IMPERIO DE LOS CULHUA MEXICA*, INAH / UDLA, 1992; Y M. SOLANES AND E. VELA, *ATLAS DEL MÉXICO PREHISPÁNICO*, EDITORIAL RAÍCES, 2000.

PUBLISHED IN SPANISH IN *ARQUEOLOGIA MEXICA, LA MATRICULA DE TRIBUTOS*, EDITORIAL RAÍCES, SPECIAL NO. 14, AUGUST 2003.

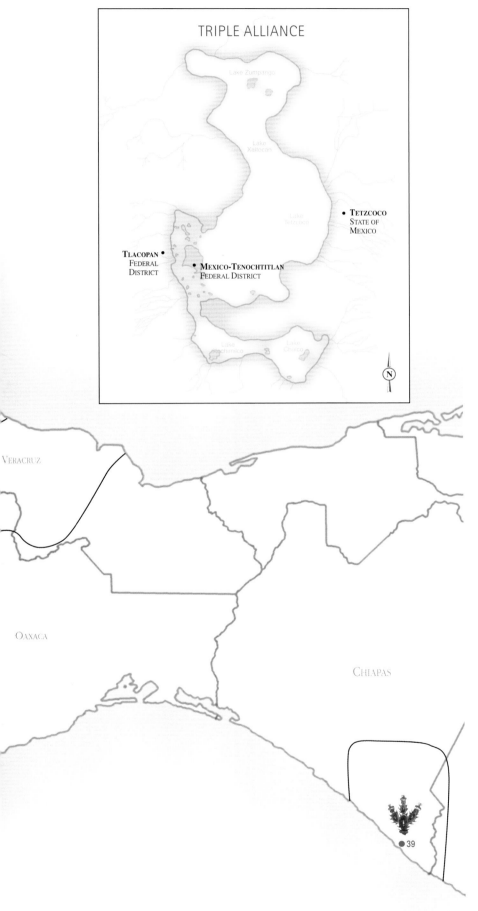

TRIPLE ALLIANCE

Lake Zumpango

Lake Xaltocan

Lake Tetzcoco

• TETZCOCO
STATE OF
MEXICO

TLACOPAN •
FEDERAL
DISTRICT

• MEXICO-TENOCHTITLAN
FEDERAL DISTRICT

Lake Xochimilco Lake Chalco

N

VERACRUZ

OAXACA

CHIAPAS

● 39

TRIBUTARY REGIONS

I. The North
1. Oxitipa, San Luís Potosí (*Codex Mendoza*, folio 57)
2. Tziuhcoac, Veracruz (folio 32)
3. Tuchpan, Veracruz (folio 30)
4. Atlan, Puebla (folio 31)
5. Atotonilco, Hidalgo (folio 10)
6. Tlapacoyan, Puebla (folio 28)
7. Acolman/Acolhuacan, State of Mexico (folio 5)

II. The Ancient Tepaneca Empire
8. Xilotepec, State of Mexico (folio 11)
9. Axocopan, Hidalgo (folio 29)
10. Atotonilco de Pedraza, Hidalgo (folio 30)
11. Xocotitlan, State of Mexico (folio 15)
12. Hueypochtlan, State of Mexico (folio 9)
13. Quahuacan, State of Mexico (folio 12)
14. Quauhtitlan, State of Mexico (folio 8)

III. The Southeast
15. Tlatlauhquitepec, Puebla (folio 29)
16. Cuauhtochco, Veracruz (folio 26)
17. Cuetlaxtla, Veracruz (folio 27)
18. Tochtepec, Oaxaca (folio 48)

IV. The Heart of the Empire
19. Citlaltepec, State of Mexico (folio 17)
20. Petlacalco, State of Mexico (folio 4)
21. Mexico-Tlatelolco, Federal District (folio 3)

V. The Tarascan Frontier
22. Tolloacan, State of Mexico (folio 13)
23. Ocuyllan, State of Mexico (folio 14)
24. Malinalco, State of Mexico (folio 15)
25. Tlachco, Guerrero (folio 16)
26. Tepecoacuilco, Guerrero (folio 17)
27. Cihuatlan, Guerrero (folio 18)

VI. The Southwest
28. Chalco, State of Mexico (folio 21)
29. Cuauhnahuac, Morelos (folio 6)
30. Huaxtepec, Morelos (folio 7)
31. Tlalcozauhtitlan, Guerrero (folio 20)
32. Quiyauhteopan, Guerrero (folio 20)

VII. The Mixteca-Zapoteca Zone
33. Tepeyacac, Puebla (folio 22)
34. Yohualtepec, Oaxaca (folio 20)
35. Coaxtlahuacan, Oaxaca (folio 23)
36. Tlauhpan, Guerrero (folio 19)
37. Tlaxiaco, Oaxaca (folio 47)
38. Coyolapan, Oaxaca (folio 24)
39. Xoconochco, Chiapas (folio 25)

city-states (most from within the Valley of Mexico) in its more distant campaigns, providing substantial rewards for their participation as well. This was one important way in which conquered city-states within and near the Valley of Mexico were more closely integrated into the Triple Alliance's imperial structure and goals than were farther-flung provinces.

Imperial goals were predominantly economic, and the alliance's rulers implemented a variety of military and political strategies to control a vast array of resources. A primary aim was the assurance of a regular and predictable flow of utilitarian and luxury goods into the three imperial capitals. Diverse resources were provided by the tributary provinces brought into the imperial web through military conquest. Some of these goods—such as shimmering tropical feathers, adornments of precious stones, decorated clothing, and cacao—enhanced the sumptuous lifestyle of the ruling elite; others—especially massive quantities of staple foodstuffs—supplied the cities with a hedge against possible famine.

As the empire expanded, a greater variety of goods became available to the imperial rulers. Early conquests in highland regions yielded tribute such as bins of maize and beans, maguey-fiber clothing, honey, and wood products. Later conquests in lowland zones provided payment in cotton and cotton clothing, precious feathers and stones, gold, cacao, and jaguar skins, among other goods. Almost all provinces turned over feathered warriors' costumes; highland peoples would have had to import the tropical feathers to meet these demands. The institution of imperial tribute practices therefore would have stimulated, or at least sustained, established trading patterns.

The Aztec imperial powers developed another significant strategy to achieve their economic goals when, instead of outright conquest, they established clientlike relations with outlying areas. These resembled alliances, yet the power relationships were clearly asymmetrical; this system was more efficient and inexpensive for the imperial rulers. It was understood, however, that the Aztec powers could at any time conquer their clients if it served their economic and military purposes. The Aztecs and the clients exchanged gifts, reflecting a more reciprocal arrangement than the payment of tribute. Clients were also expected to provide the essential service of protection. If a client city-state was located along an important trade route, it assured the safety of Aztec merchants on their dangerous treks; if it was situated close to a critical resource, it protected that resource for the empire; and, most commonly, if a client city-state lay adjacent to an unconquered territory, it maintained the border through intermittent warfare with the enemy in that frontier zone. Combined, these requirements relieved the Aztecs of the need to directly protect and sustain trade routes, critical resources, and volatile imperial borders. Additionally, the client states tended to insulate the tributary provinces from incursions by long-standing enemies.

The empire as a whole was loosely organized. In strategic provinces, and typically in tributary provinces, local city-state rulers retained their right to rule even after being incorporated into the imperial net. This hegemonic arrangement continued as long as tributary obligations were met and the city-states refrained from rebellion. Tribute collectors were usually stationed in conquered regions; less commonly, Aztec governors and garrisons had to be installed.

A more subtle imperial strategy involved establishing marriage bonds between imperial rulers and the ruling houses of conquered or client city-states. In these arrangements, any offspring would carry royal legitimacy from both imperial and local

Page from the *Codex Mendoza*, ca. 1541.

heritages. A future ruler from such a pairing would be enculturated with loyalties to the imperial powers, while also enjoying local support.

The Triple Alliance empire thus employed several strategies for integrating outlying city-states into its political web and achieving its economic goals. They provided economic and social rewards to conquered peoples in the Valley of Mexico for their participation in distant military conquests; they established tributary provinces that paid specified and scheduled tribute; they formed client relations with city-states that were in strategic positions to aid the empire in protecting critical areas; and they arranged elite marriages between imperial and local ruling houses. Nonetheless, the empire experienced numerous rebellions, encouraged by its loose structure. The Mexica emperor Motecuhzoma II, who ruled from 1502 to 1520, spent a great deal of his military resources quelling revolts in already conquered provinces. These were sparked in part by the annoying presence of tribute collectors and the draining tribute payments. In addition, the empire's military energies were devoted to fighting recurring, inconclusive battles with unconquered enemies, such as the Tlaxcalteca. Under these varied pressures, the empire had probably reached its maximum expansion by the time of the Spanish Conquest.

The Population of the Mexico and Toluca Valleys

Perla Valle Pérez

THE SUCCESSIVE ARRIVAL OF TRIBES MIGRATING TO THE VALLEY OF MEXICO CONFIGURED A NEW human geography during the fourteenth and fifteenth centuries. In the northwest, the Chichimeca and Acolhua, tribes of hunter-gatherers, began to settle in the extensive territory of Acolhuacan, where they engaged in continuous intertribal skirmishes. These peoples subsequently founded other urban centers such as Huexotla, Papalotla, and Tepetlaoztoc, while the city of Tetzcoco became increasingly important. They constructed noteworthy hydraulic systems to expand cultivation in the plains near the lakeshores and in the highlands near the mountains bordering the valleys of Puebla and Tlaxcala. During Netzahualcoyotl's reign, Acolhuacan was considered an advanced cultural center because of its achievements in the arts and literature, specialized crafts, and the construction of public works. It had also built up considerable military power, conquering far-off provinces to the east of the valley. Along with the Mexica of Tenochtitlan and the Tepaneca of Tlacopan, the Acolhua would eventually make up the Triple Alliance.

The Tepaneca reached the valley during the thirteenth century, occupying southern sites such as Tacubaya and Coyoacan, around the same time as the Otomi, who settled in various northern areas. When the Otomi retreated toward Xaltocan, the Tepaneca occupied territory to the north and west of the Valley of Mexico, disregarding the prior occupation of these areas, especially Azcapotzalco and Tlacopan, by people who had come from Teotihuacan. Bernardino de Sahagún considered the Tepaneca to be among the Nahua peoples who came from Chicomoztoc. They soon conquered neighboring urban centers both within and beyond the valley—Cuauhtitlan, Xaltocan, and Tepozotlan to the north and Cuitlahuac and Chalco to the far south of the lake area—and established their capital and seat of government in the city of Azcapotzalco. The Aztecs, who settled on the island within the lake, were subjugated by the Tepaneca, forced to pay tribute to them and serve as warriors in their battles of conquest. The Tepaneca controlled most of the valley for several decades during the fourteenth century, and it was not until the early fifteenth century that the Aztecs gained their freedom and participated in the war against Azcapotzalco in which the Tepaneca were conquered.

According to the *Memorial de Culhuacan*, the Culhua settled on the lake on a site near Huixachtecatl, known today as Cerro de la Estrella (Star Hill). The founding of Culhuacan is believed to have taken place in the twelfth century, by which time Xochimilco and Tacubaya were already populated. Other important nearby Culhua urban centers were Ixtapalapan, Mexicaltzingo, and Huitzilopochco, agricultural towns that also produced salt. After the fall of Tula, groups of Tolteca emigrated in various directions; those who reached the Valley of Mexico settled in such places as Chapultepec, Culhuacan, and Huitzilopochco. When the Aztecs reached the valley in the last stage of their peregrinations,

143. Serpent warrior
Matlatzinca, ca. 1500

they were unable to find a suitable territory in which to settle. After being defeated at Chapultepec, they were subjects of Culhuacan for a time, until Tenochtitlan was founded. Every fifty-two years, they held the ceremony of the New Fire on Cerro de la Estrella, with important rites that helped maintain the status of the Culhua among the four peoples that were heirs of the Toltec culture.

The Cuitlahuaca and the Mixquica settled in the towns of Cuitlahuac and Mixquic, respectively, each located on a different strip of land between lakes Chalco and Xochimilco. For the most part, these were insular settlements, with the advantage of being located in a *chinampa* area with irrigation canals adequate for intensive agriculture. Although both tribes spoke Nahuatl, they were from different ethnic groups and had different customs and forms of government: in Cuitlahuac, four urban centers formed a single organization governed by their four representatives, while in Mixquic, there was a sole *tlatoani* (ruler). Both the Mixquica and the Cuitlahuaca continually skirmished with their neighbors, and although the Cuitlahuaca made some limited conquests, they did not manage to expand their territory. The two peoples were conquered by Itzcoatl in the fifteenth century and were still paying tribute to the Triple Alliance when the Spanish conquistadores arrived.

The Xochimilca were one tribe in a larger group of Nahuatl speakers who participated in the migrations, leaving from Aztlan and finally settling in Xochimilco. This urban center had a large territory that extended southeast from the shores of the fresh-water lake bordered by Coyoacan on the west and Cuitlahuac and Chalco on the east. Its power extended south beyond the lakes, to Totolapan, Tlayacapan, and Yecapixtla, an area that included lakeside *chinampas*, highland forests, and several subject towns. The first Xochimilca settlement in the region dated back to the tenth century, after which time they migrated. Because of its contribution to the development of *chinampa* agriculture, Xochimilco was considered the greatest food supplier in the valley, requiring numerous flotillas of canoes to transport its goods. As a town or *altepetl* (city-state), Xochimilco was organized into three urban centers: Tepetenchi, Olac, and Tecpan, with numerous subject districts. It was conquered by Itzcoatl in the fifteenth century; when the Spanish conquistadores arrived in the Valley of Mexico the town was a Tenochtitlan tributary.

The Chalca were next to arrive in the Valley of Mexico after the Xochimilca. According to the *Anales de Cuauhtitlan*, they left Xico in 1150 to found Chalco; the seventeenth-century Nahua historian Domingo Chimalpahin confirms this event but does not specify the year. The Chalca settled well to the southeast of Lake Chalco, in a stretch of land near the Sierra Nevada volcanoes. Due to the continuous arrival of tribes from other regions, their ethnic makeup was very complex; similarly, their political organization required numerous administrative categories and levels of government. Their economy balanced an exploitation of the lake's resources and the cultivation of *chinampas* with local trade. This was carried out at the four major urban centers—Amaquemecan, Tlalmanalco, Chimalhuacan, and Tenanco—and external trade was conducted with other cities in the valley. In 1445, Motecuhzoma I declared war on Chalco, a battle that would continue for more than twenty years, with the ruler relying on the participation of other ethnic groups in the Valley of Mexico to aid in his conquests. After their defeat, the Chalca were subjugated by Tenochtitlan, living under Mexica military rule until the Spanish Conquest.

The Otomi settled not only in urban centers such as Xaltocan, Otumba, and Cuauhtitlan, but also in other locations around the Valley of Mexico: to the north, in the Teotlalpan region; to the west, in the Sierra de las Cruces, a wooded area between the valleys of Mexico and Toluca (Cuauhtlalpan); and to the east, in the Acolhuacan region, which borders the Valley of Tlaxcala. Otomi also lived side by side with Nahua

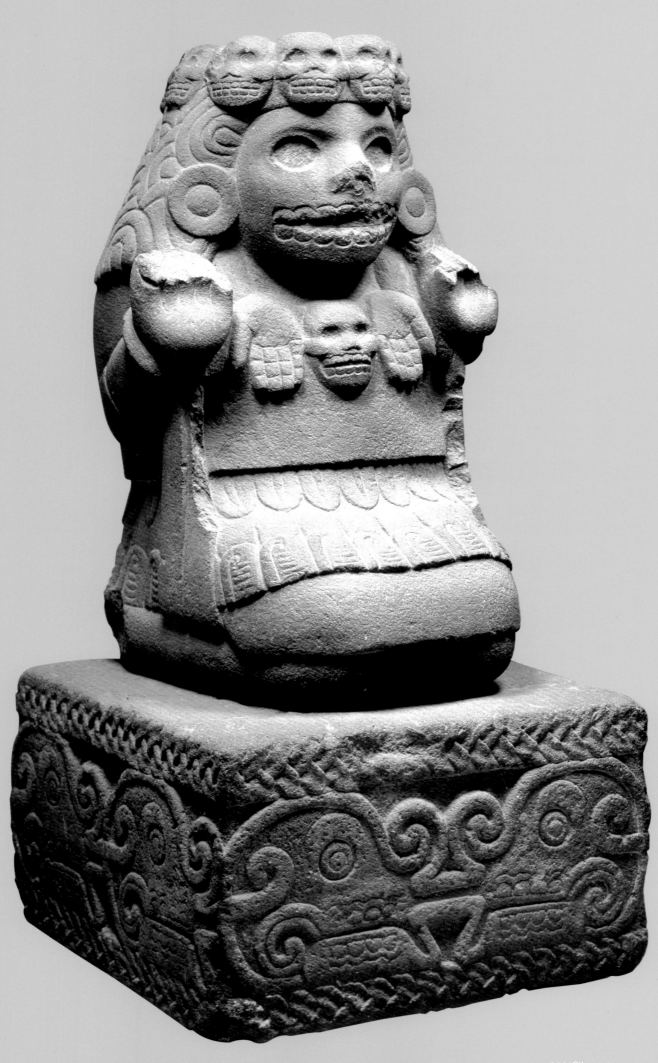

144. Cihuateteo
Aztec, ca. 1500

peoples in other populated areas of the valley: in Tlacopan (Tacuba), Tacubaya, and the area between Tacubaya and Coyoacan. Other Otomi centers developed in the towns of the Sierra de Guadalupe and to the east, in the mountain ranges near Tetzcoco. It is assumed that after the fall of Tula in the thirteenth century, the Otomi migrated eastward into the Valley of Mexico and settled in Xaltocan, which came to be an important city whose hegemony extended east to the Sierra de Puebla and Meztitlan. In the following century, however, Azcapotzalco attacked and conquered Xaltocan, which became a Tepanec dependency, and Azcapotzalco's growing power led to the decline of other sites settled by Otomi. The language of these settlers, who spoke not Nahuatl but Otomi, belonged to the Otomi/Pame linguistic family. Although they were considered underdeveloped by contemporary tribes, they did practice seasonal agriculture as well as hunting, fishing, and gathering, and they made textiles from cotton and tough fibers. In 1519, the Otomi of the Valley of Mexico lived in mountainous regions, marginal areas, and in Nahua towns.

The Tenochca Mexica and the Tlatelolca Mexica migrated together from Aztlan, eventually settling in the Valley of Mexico. Both tribes spoke Nahuatl and were at the same developmental level in terms of material culture and ideology, as indicated in textual sources and pictorial narrations in codices as well as archaeological materials. However, once Tenochtitlan was founded in 1325, the Tlatelolca split off from the Mexica and established the city of Tlatelolco on a nearby site toward the north of the island, divided from the Tenochca by just a channel. For some time, during the period when both were vassals of Azcapotzalco, the two tribes had a similar history, but their paths sharply diverged when the Tlatelolca, who had no government of their own, asked the Tepaneca to provide them with one, which initiated the Tlatelolca lineage. Under Tepanec leadership, the Tlatelolca paid tribute and served as warriors in Tepanec battles until 1428, when the Triple Alliance defeated Azcapotzalco. Once freed from the Tepaneca, they were forced to participate in the imperialistic plans of the Aztecs, such as the famous conquest of Cotastla, a victory that brought fame to the Tlatelolca army. Finally, in 1473, Tlatelolco and Tenochtitlan faced off, and with the Tenochca victory the Tlatelolca lost their independence and their government. The conquerors placed them under military rule subject to Tenochtitlan, and they remained a subjugated people until the arrival of Hernán Cortés. Nonetheless, several sources praise the valor of the Tlatelolca warriors in defending their city during the final battle that led to the downfall of Tenochtitlan in 1521.

145. Quadrangular brazier
Matlatzinca, ca. 1200–1521

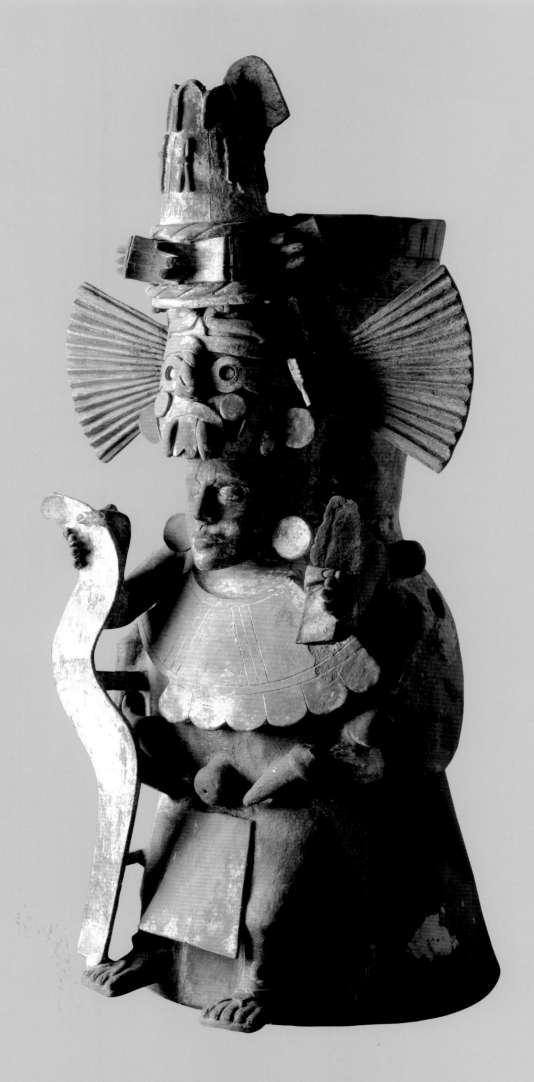

146. Tlaloc ceremonial vessel
Aztec, ca. 1500

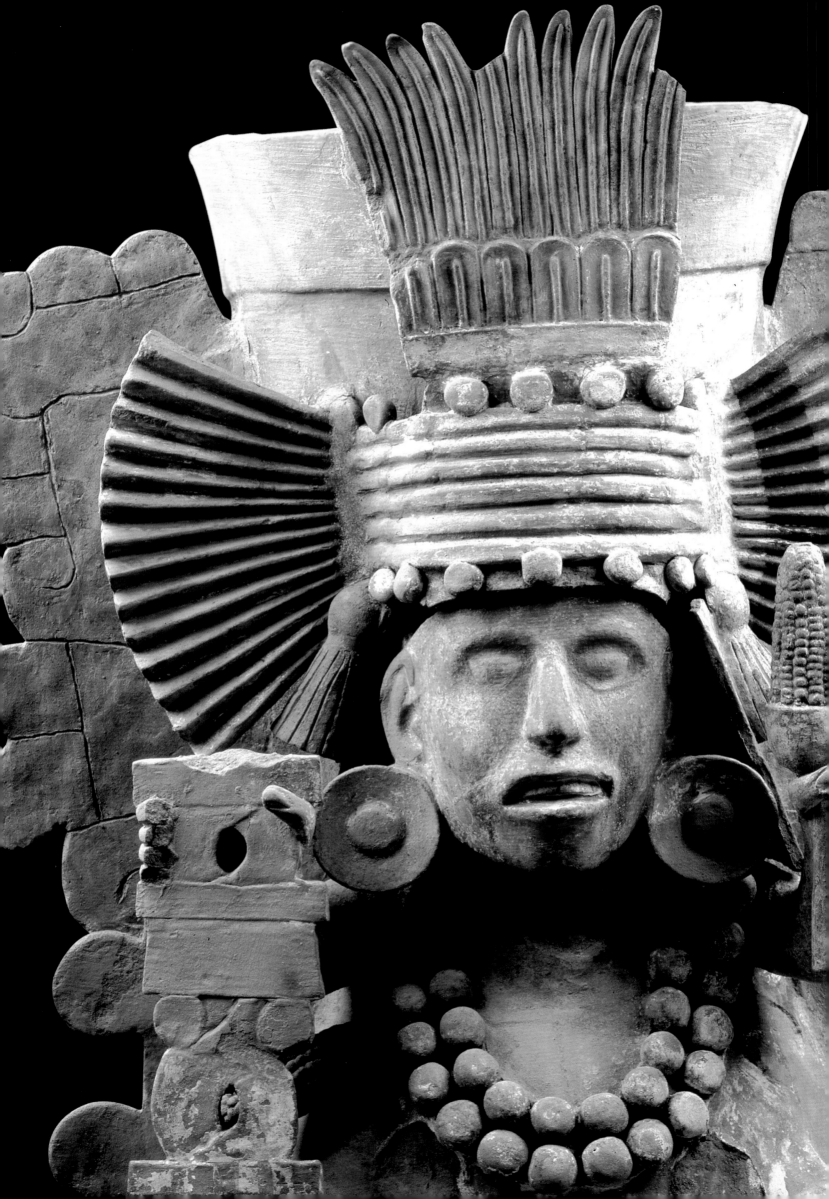

147. Xilonen ceremonial vessel,
detail
Aztec, ca. 1500

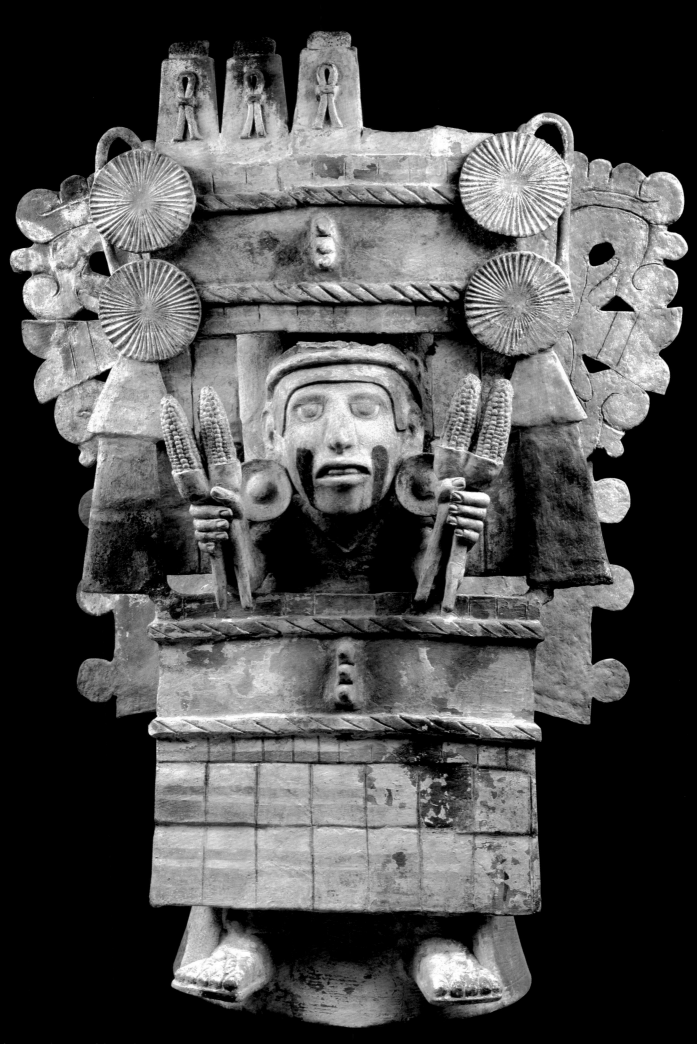

148. Chicomecoatl ceremonial vessel
Aztec, ca. 1500

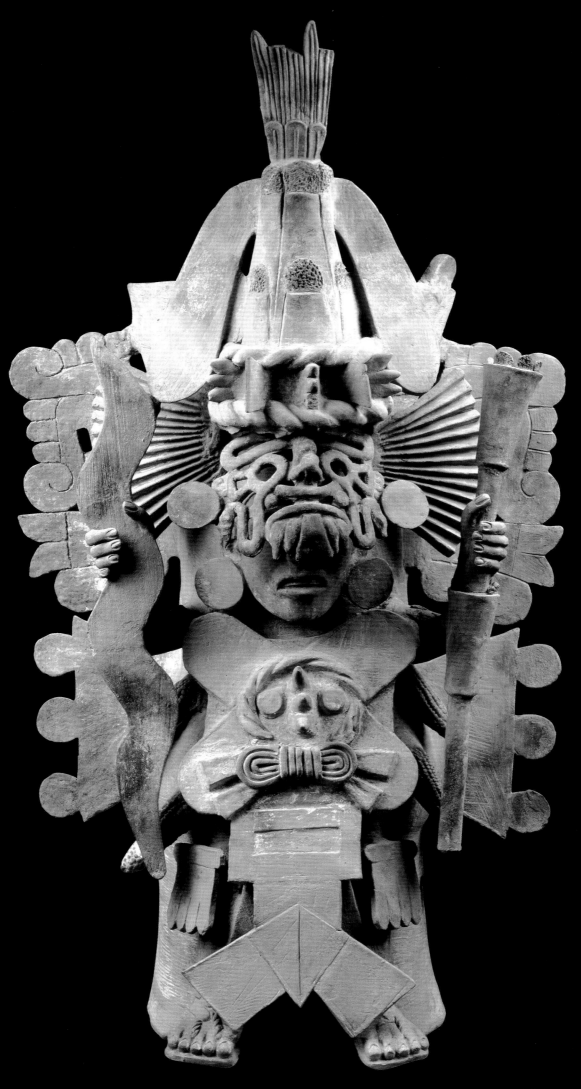

149. Nappatecuhtli ceremonial vessel
Aztec, ca. 1500

The Puebla and
Tlaxcala Valleys

Verónica Velásquez

THE CULTURES OF THE POSTCLASSIC PERIOD EMPLOYED A COMMON ICONOGRAPHY THAT FUSED religious concepts and established the foundations for a worldview shared by the various elites who inhabited the region of Puebla and Tlaxcala during the diaspora that followed the fall of Teotihuacan.

The valleys of Puebla-Tlaxcala are located in a temperate region, bordered by the volcanoes Popocatepetl, Iztaccihuatl, and Malinaltepec. People began to settle the area in the Preclassic period, at such sites as Las Bocas, Tlalancaleca, Xochitecatl, and Tetimpa, which were part of vast trade networks across Mesoamerica.

During the Postclassic period, groups from the Chichimec culture migrated from northern Mexico. These peoples comprised five different tribes, mostly of the Nahuatl language group, and, to a lesser degree, speakers of Otomi and Popoloca. They established settlements of a ceremonial nature along the hilltop ridges of Tlaxcala and eventually created one of the most important domains in Central Mexico.

The Tlaxcala domain, which dominated the valleys of Puebla and Tlaxcala, was organized around four main urban centers, all of which maintained a degree of hostile autonomy from the Triple Alliance. Tlaxcala was associated at various times with Cholollan (modern Cholula) and Huexotzinco, thus forming a type of counter-alliance, which developed into the most powerful and, geographically, the closest enemy of the Triple Alliance. They also allied themselves with the Spanish forces during the defeat of the Mexica-Aztec empire. The wars between the Tlaxcalteca and the Tenochca Mexica continued for a long period, during which the former were cut off from access to a wide range of essential goods such as cacao and salt, as well as luxury items such as silver, cotton, and featherwork.

Cholollan was located in one of the most fertile regions in Mesoamerica, an area that has been continuously inhabited for nearly three thousand years. It was also within one of the principal trading corridors, connecting the Gulf Coast with the Valley of Mexico, Tehuacan, and the Mixteca region in Oaxaca. Made up of more than fifty communities, the city was the most important religious center in Mesoamerica. It was here that an important cult devoted to the worship of Quetzalcoatl developed. Cholollan, which is also famous for its enormous pyramid, was governed by a theocracy of high priests who performed ceremonies and undertook pilgrimages to neighboring kingdoms. Aside from its ritual importance, the city became widely known during the later period of occupation for its production of polychrome earthenware.

This characteristic type of ceramic work, also known as *laca*, serves as one of the identifying elements of the Postclassic period. It features idiosyncratic symbols unique to the ritual practices that had been established over the years in Mesoamerica. Dating from the twelfth or thirteenth century (after the fall of

150. Xipe Totec
Aztec, ca. 1500

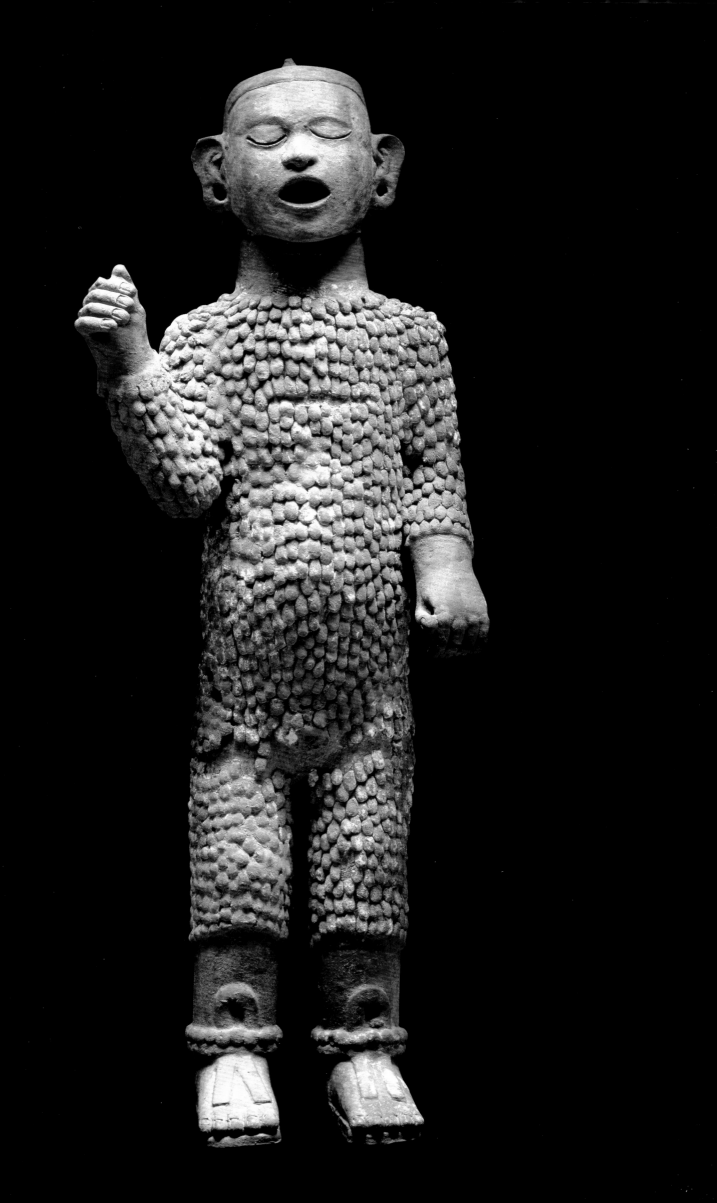

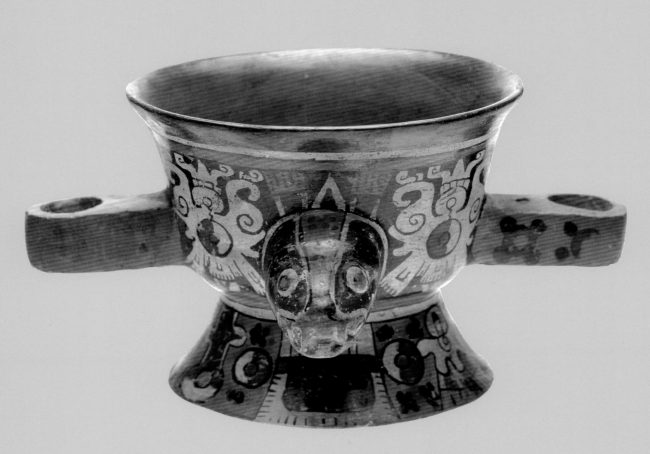

151. Polychrome brazier
Aztec, ca. 1500

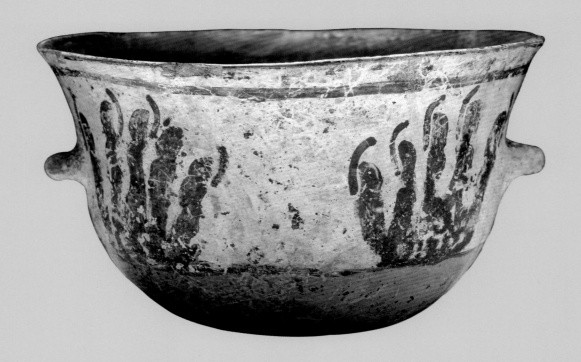

152. Polychrome bowl
Mixtec, ca. 1200–1521

the Toltec state), this style has been found at various sites, from the areas north of Oaxaca to the south of Puebla and Chalco. Due to the formal similarities between this symbolic system and the glyphs and signs found in manuscripts such as the *Codex Borgia*, this style has also been referred to as "codex type." It has been applied in the murals found at Ocotelulco, Tizatlan, Tlaxcala, and Tehuacan Viejo, Puebla, as well as on the fine earthenware produced in these regions. This style spread through the extensive trade in ceramics to such distant areas of Mesoamerica as the Gulf Coast, the Maya dominions, and the Valley of Mexico.

The codex style evolved into a useful means of communicating the interests of various peoples seeking a way to unify ethnically heterogeneous communities. This tradition was evidently quite freely adopted, without any force or imposition, thus explaining its presence at numerous Late Postclassic sites. As some authors have demonstrated, neutron activation analysis of polychrome ceramic remains has allowed for the identification of various production centers: Huexotzinco, Tizatlan-Ocotelulco, the Valley of Mexico, and Tehuacan. Huexotzinco was probably the main production area for the Puebla region.

From the evidence retrieved, we believe that these ceramics may have arrived in Tenochtitlan through trade or as payment of tributes, and that ceramic workshops were found in areas both close to and far away from the imperial capital. Despite distinctions in iconography found on vessels originating in various regions, as well as on those attributed to local workshops, they had a common style, which has been referred to as "international." This style combines the use of red, orange, white, and black pigments to create frets and *xicalcoliuhqui* (stepped frets); zoomorphic representations in such forms as coyotes, serpents, rabbits, deer, and frogs; phytomorphs and fantastic figures; skulls and *chalchihuitl* (symbols of preciousness); deities from the Nahua pantheon; the eye of the night; military and sacrificial motifs; and glyphs or symbolic signs associated with gold, hearts, and blood.

The ritual nature of this ceramic work is undeniable, and it was probably employed in religious and political ceremonies. Incense burners, cups, effigy vessels, and tripod serving bowls with animal or mushroom-shaped supports were used for burning incense, drinking chocolate or pulque, or containing the blood from autosacrifice or bloodletting ceremonies.

Based on the decorative designs found on such vessels, particularly on cups, three possible ceremonial functions have been proposed for these objects: sacrifice, indicated by a band of plumes running along the vessels' outer surface, simulating the form of a *cuauhxicalli* (container for holding sacrificial blood), in which it is possible to identify drops of blood, stellar eyes, and jaguar pelts, all associated with the rituals of Tezcatlipoca; sacred war, implied by the appearance of *chalchihuitls*, which may represent the vessels' intended use for drinking sacred substances such as pulque or blood before entering into battle; and fertility rites.

Although much remains unknown about the function of this earthenware ceramic work in Postclassic societies, we do know that such pieces were used in both religious and military ceremonies, and that their decorative iconography served as a language unifying the elite during a period of diaspora for the peoples of Mesoamerica. This medium allowed them to create a code through which they could establish affiliations to ancient family and state lineages, thus legitimizing their status as rulers.

The Domain
of Coatlalpan

José Luis Rojas Martínez

THE PRESENT-DAY CITY OF IZÚCAR DE MATAMOROS, PUEBLA, IS LOCATED IN A REGION KNOWN IN pre-Hispanic times as Coatlalpan, which translates from the Nahuatl as "in the land of the serpents" or "land of serpents." This area was inhabited by various indigenous settlements and domains concentrated along the Nexapa River basin. Among the more important of these settlements were Epatlan, Tatetla, Tepapayeca, Tlapanala, Tilapan, Citela, Colucan, and Izúcar de Matamoros (or Itzocan), which is described in sixteenth-century ethnohistorical sources as the main urban center of the Coatlalpanecas.

In regard to the cultural development of this area, we must remember that although the presence of humans has been confirmed from very early times in Mesoamerica, only in Coatlalpan have material remains survived from every period of Mexico's pre-Hispanic history.

In texts by such sixteenth-century chroniclers as Tomás de Torquemada, Fray Toribio de Motolinia, and Gerónimo de Mendieta, the large amount of overlapping information indicates that they were based on privileged access to the same first-hand sources, which have unfortunately disappeared. These texts relate how Izúcar de Matamoros was founded in the Postclassic period, during the eleventh century A.D. They report various migrations from Tula, Hidalgo, that would eventually lead to settlements such as Izúcar de Matamoros and Epatlan in the southern region of what is now the state of Puebla. They also mention a group of people related to the Nonohualca-Chichimeca and the route they followed through the areas of present-day Cuernavaca, Amecameca, and Huaquechula, until they finally reached Tehuacan, Puebla. In recounting this migration, the religious chroniclers mention Xelhua as the leader of the group that came to establish Izúcar de Matamoros and other settlements. The nations that inhabited pre-Hispanic Central Mexico were said to have descended from the ancient god Iztac Mixcoatl, a native of the legendary Chicomoztoc ("place of the seven caves"); his sons—Xelhua, Tenuch, Ulmecatl, Xicalancatl, Mixtecatl, and Otomotl—were said to be the founders of these settlements.

Because of its importance and strategic location, the city of Izúcar de Matamoros appears in both pre-Hispanic and colonial cartographic sources, such as the *Historia Tolteca-Chichimeca*, known as *Codex Xólotl*, and territory maps of Cuauhtinchan and Totimehuacan—documents from the Late Postclassic period (1200–1521). It was during this time, as previously mentioned, that migratory waves spread from the northern and central parts of Mesoamerica. Contemporary texts delineate the territorial boundaries of the dominant groups, thus justifying the rights corresponding to the ownership of these large tracts of land. The cartography published in the sixteenth century, the early colonial period, by the Belgian geographer Abraham Ortelius is particularly important in this regard.

As for external influences, two factors were decisive in the development of

153. Beaker with applied figure
Coatlalpaneca, ca. 1500

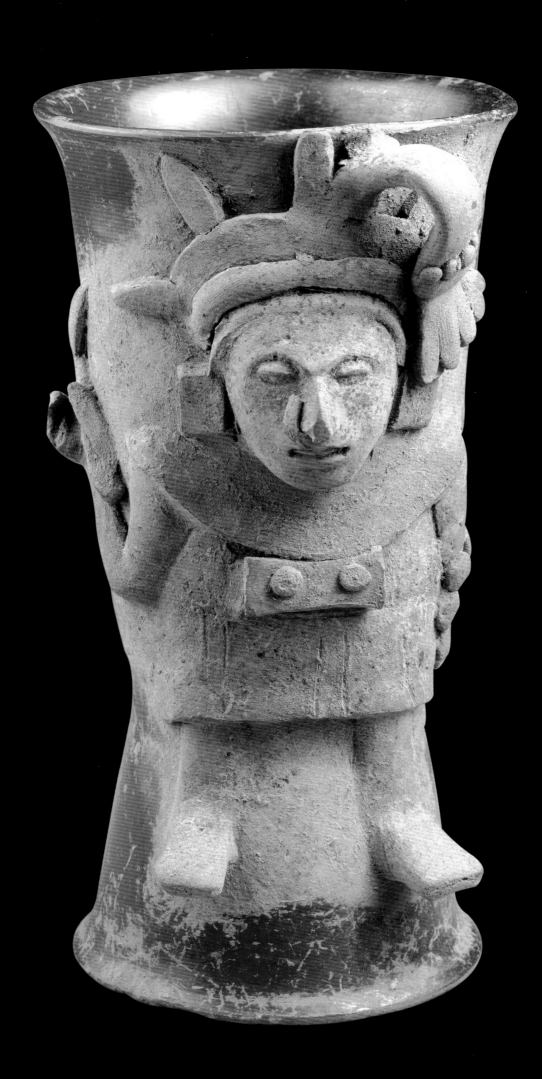

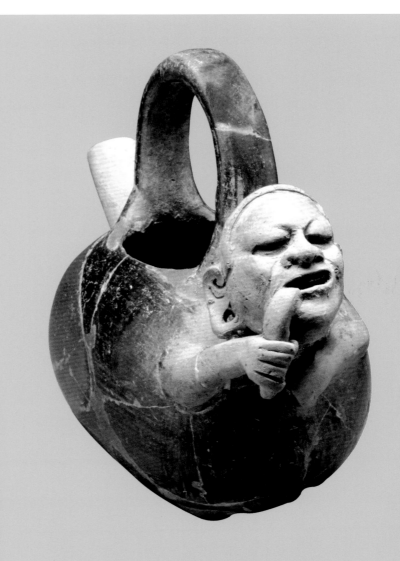

154. Censer
Coatlalpaneca, ca. 1250–1500

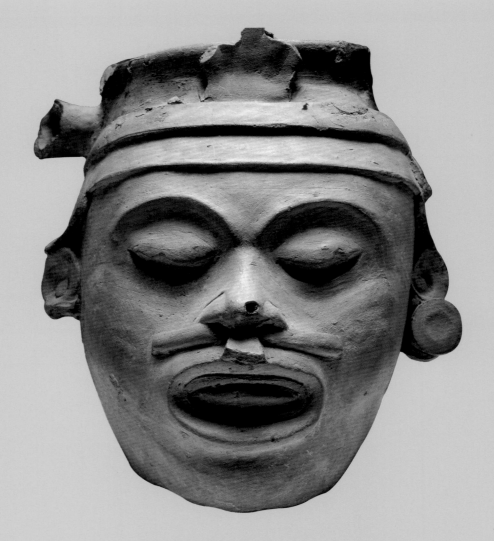

155. Xipe Totec
Coatlalpaneca, ca. 1250–1521

Izúcar de Matamoros. The first was the city's strategic location in the region of Coatlalpaneca, which alone was sufficient for the Triple Alliance to set its sights on this area, as a means of extending its realm of influence and obtaining resources through trade and the levying of tributes. The date of the Triple Alliance's incursion is unknown, but it began sometime during its period of territorial expansion and culminated between the years 1458 and 1466. As an immediate consequence of the invasion, the Coatlalpanecas were forced to pay tribute and Izúcar de Matamoros was absorbed into the Mexica-Aztec tributary province of Tepeyacac.

The main urban center of this province was located at the present-day city of Tepeaca, in the central region of the current state of Puebla. Plate 22 of the *Matrícula de tributos* (*Tribute Register*), which corresponds to page 42-[obverse] of the *Codex Mendoza*, contains a list of the towns in this province. In addition to the products they were required to present to the Triple Alliance, the Coatlalpanecas were forced to provide large contingents of soldiers to fight in the military campaigns undertaken by the Aztec empire in areas to the south and north of Izúcar de Matamoros. These campaigns were critical in conquering additional territory and subduing revolts in Chiapas, Tehuantepec, Oaxaca, Coixtlahuaca, Huexotzinco, Cholollan, and Tlaxcala.

The predominant cultural manifestation of Izúcar de Matamoros was the city's intensive production of ceramic work, which has become widely known through collections formed during the 1960s by the National Museum of Anthropology in Mexico City and through exhibitions at other museums, primarily in Mexico and the United States. Due to the lack of research and publications on this style of ceramics, such pieces have often been mistakenly identified as Toltec or Mexica, overlooking their obvious identification as Coatlalpaneca, or more precisely, from Izúcar de Matamoros.

The singular features of this ceramic style, a determining factor in this group's own cultural identity, include a significant variety of forms and decorative motifs, which were applied on the vessels using a wide range of techniques, such as painting, incising, and stamping. The elements displayed on these ceramic vessels have allowed us to identify their origin and chronology, and have also enabled us to determine the existence of a tradition that was shared by a single group with similar cultural manifestations, whose utterly distinctive style is unique to Izúcar de Matamoros and the Coatlalpanecas.

Among the most important and exceptional examples of this ceramic ware, in both formal and decorative aspects, are those that harmoniously combine graphite black with bright red or cherry red pigments. This combination is found primarily on tripod serving bowls with crenellated, cylindrical, or zoomorphic supports and polished or burnished surfaces, as well as on anthropomorphic effigy vessels, pitchers with raised or protruding central bands of motifs or with incised necks, which were used in devotional ceremonies to Ome Tochtli, the god of pulque. The Coatlalpanecas also crafted ceramic bowls with bottoms decorated with protruding, button-shaped knobs and outer surfaces adorned with incised hook motifs.

These are some of the salient characteristics of one of the Late Postclassic ceramic traditions of Mesoamerica's Central Plateau region. Identification of these elements has helped us to rescue the Coatlalpanecas, "the people of the land of serpents," from oblivion.

The Mixteca

Nelly M. Robles García

THE MIXTECA ARE MEMBERS OF AN ETHNIC GROUP THAT SETTLED IN NORTHERN OAXACA, ONE OF the areas that became home to the high culture of Mesoamerica. They called themselves Ñuu Savi ("people of the rain"), proclaiming their origin in an ancient myth that related how their ancestors emerged out of the legendary trees whose first roots grew from the caves of Apoala, located in what is now Nochixtlan, Oaxaca.

Though relatively little archaeological work has been done in this region, enough information has been gathered to show that the Mixteca created a complex culture and that as they migrated throughout the Valley of Oaxaca and Central Mexico, Mixtec culture had a decided influence on other groups in the area. Mixtec cultural traditions are on a par with other important groups, such as the Zapoteca, the inhabitants of Teotihuacan, and the Maya. The settlements established over time by the Mixteca have recently begun to be documented.

Mixtec artifacts recovered through archaeology are known for the fine finishing techniques employed by the artisans who created them, particularly in works of architecture, jewelry and ornaments made of precious metals, stoneworking, and mural painting. Mixtec artworks, such as the funerary objects found in Tomb 7 at Monte Albán and in Tombs 1 and 2 in Zaachila (all located in the Valley of Oaxaca), were exquisitely designed, and as a whole they conveyed an extraordinary impression of the culture.

Characterized by tremendous religious devotion and a highly cooperative collective spirit, the culture of the late Mixtec era (Late Postclassic, 1250) spread to the Valley of Oaxaca, specifically to Xoxocotlan, on the mountainsides to the south of Monte Albán, and to nearby Cuilapam. Archaeological findings at both sites have uncovered diverse materials associated with Mixtec culture.

The Mixteca were able to settle in Zapotec territory by forming alliances with royal families through marriage and other means. Their relatively late arrival in the Valley of Oaxaca was due partly to the overall dynamics of their culture, dictated by a migratory spirit, an expansionist philosophy in their political domains and kingdoms, and the constant threat posed by the Mexica-Aztecs, who continually sought improved trade and exchange conditions. In addition, other emerging domains forced the Mixtec royal families to seek better ways to expand their territories. They ultimately came to dominate an area that reached from Oaxaca's northeastern border to the Pacific coastal region known as the Costa Chica (home to the Tututepec empire), and west to the territories comprising the modern state of Guerrero.

With their profoundly religious perspective, the Mixtec groups that settled in the Valley of Oaxaca attributed sacred qualities to the ancient city of Monte Albán, an ancestral Zapotec stronghold that had been gradually abandoned beginning in A.D. 850. Mixtec royal remains have been found inside the tomb

156. Xochipilli pectoral
Mixtec, ca. 1200–1521

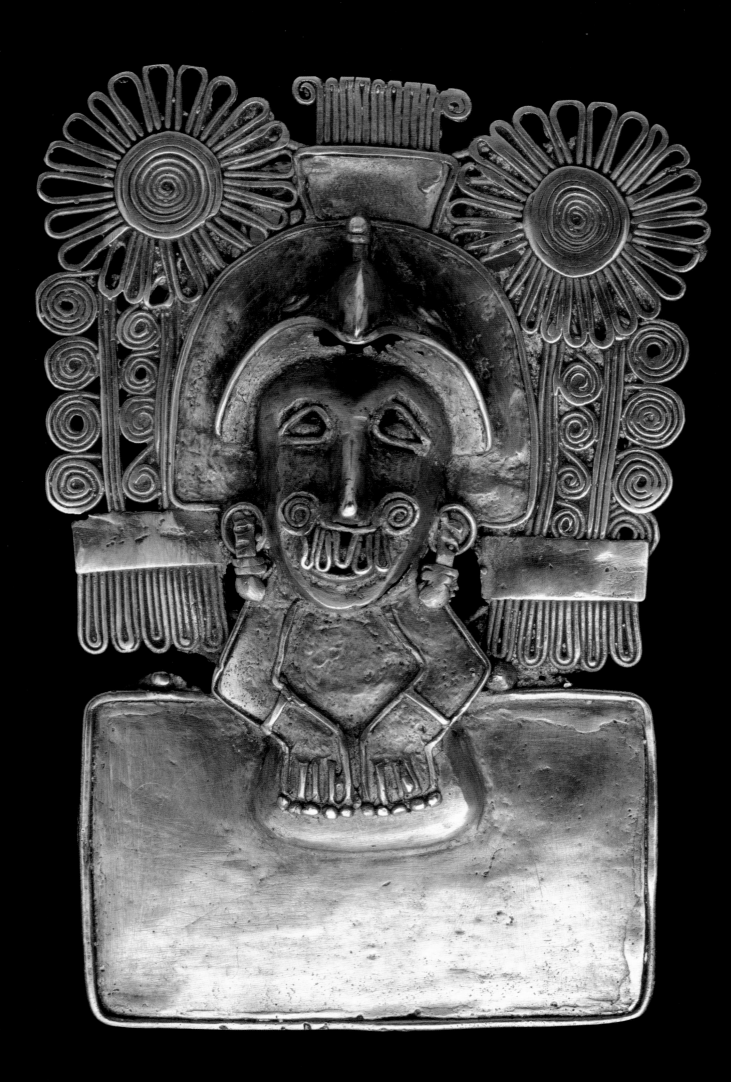

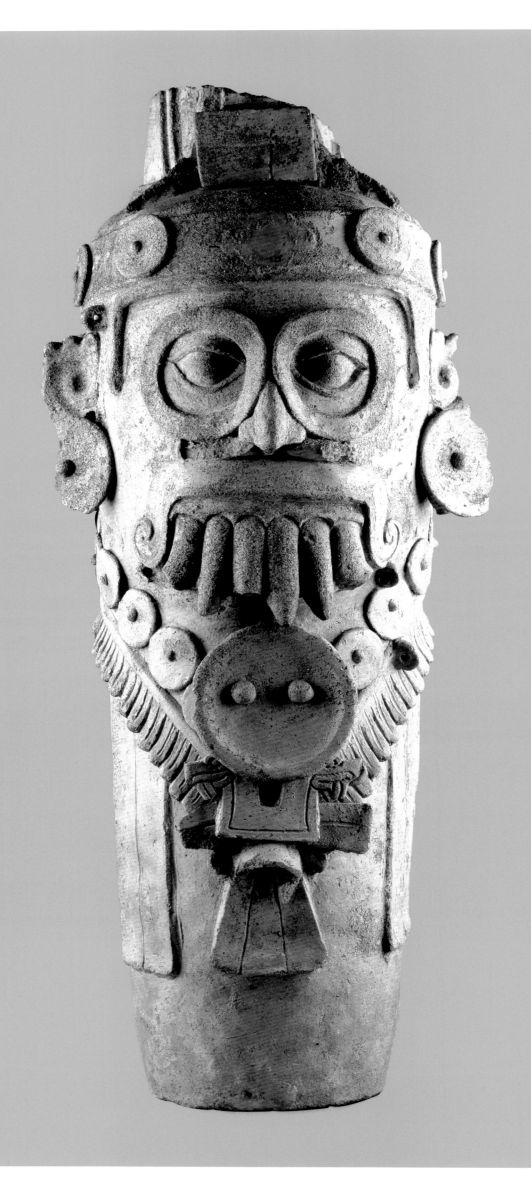

157. Tlaloc
Huave, ca. 1500

known today as Tomb 7, which was constructed by the Zapoteca. The offerings placed inside this tomb to honor the Mixtec dead constitute some of the richest treasures of Mesoamerican history. Currently housed at the Museo de las Culturas de Oaxaca, the objects include gold, silver, and mixed-metal jewelry in traditional filigree designs, created by weaving together metallic threads in an embroidery-like style.

Another Mixtec achievement was the creation of masks using the lost-wax method. This highly complex technique involved coating models with beeswax and then covering them with ceramic molds. When molten metal was poured into the mold, the wax would melt and be "lost." The workmanship on these masks, which represented various deities, was of an extremely high quality. Exotic materials such as alabaster, turquoise, coral, rock crystal, jaguar bones and teeth, conch shells, and pearls were used as the raw material for extraordinary pieces of jewelry and ritual objects that were meant to accompany the dead on their journey to eternity.

Examples of such articles, including a variety of fine precious metalwork objects and ceramics, were found in Tombs 1 and 2 in Zaachila, to the south of Oaxaca. At these and other sites it has been difficult to establish the extent to which the Zapotec and Mixtec cultures had blended with each other. While it is apparent that the Mixteca settled in Xoxocotlan—at the foot of the mountain on the south side of Monte Albán, in the areas of Yucu Saa, Cuilapam, and Zaachila—at other sites it is difficult to determine a Mixtec style that is distinct from that of the Zapoteca. Such is the case of the Postclassic sites of Mitla and Yagul, where there is abundant evidence of Mixtec culture meeting a Zapotec environment—a challenge for archaeologists in their efforts to decipher the origin of specific articles.

The Zapoteca, Mixteca, and Mexica in the Valley of Oaxaca formed a complex social dynamic based on hostile attempts at conquest, strategic alliances, and the defense of territory. This was the situation that greeted the Spanish conquistadores, who found in Oaxaca a territory ripe for domination and settlement. Linguistic evidence indicates that the Mixteca remained in the Valley of Oaxaca for at least part of the colonial period. Eventually, however, the peoples who comprised this magnificent culture retreated to the place of their origin: the high mountains of northeastern Oaxaca, among the clouds, like true lords of the rain.

158. Lip-plug with the figure of a cox-cox bird
Mixtec, ca. 1200–1521

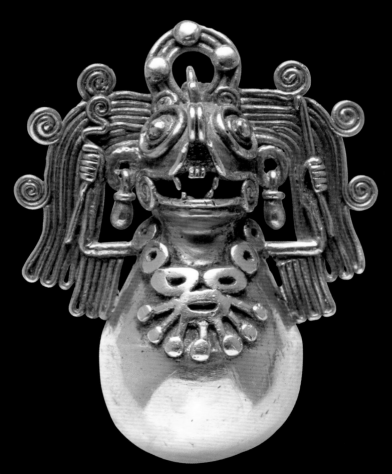

159. Bell pendant with the figure of a bat
Mixtec, ca. 1500

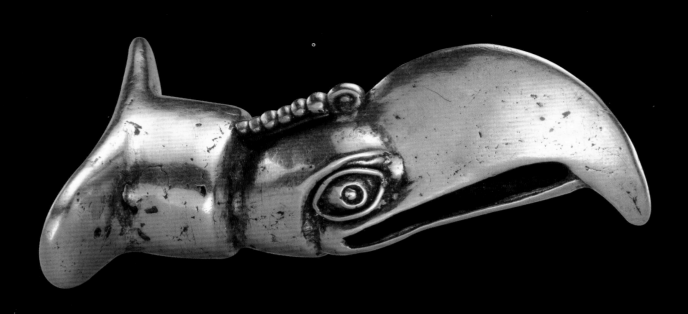

160. Cast gold in the form of a
crested bird's head
Mixtec-Zapotec, ca. 1450

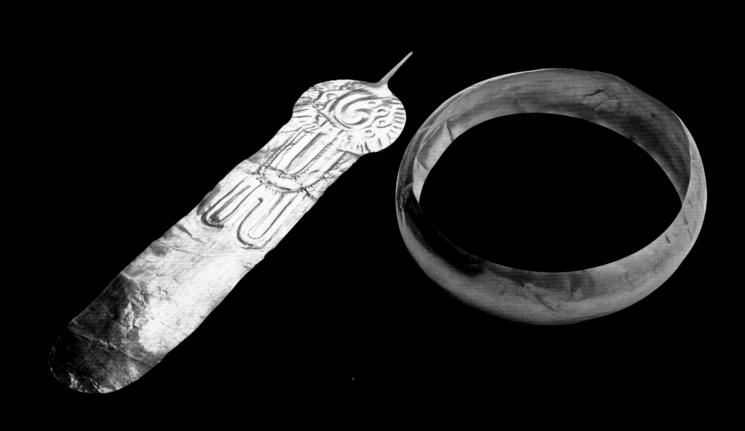

161. Gold sheet shaped as a feather
Mixtec, ca. 1200–1521

162. Head band
Mixtec, ca. 1200–1521

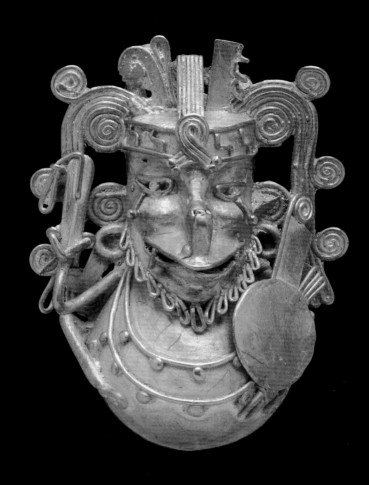

163. Ehecatl bell pendant
Mixtec, ca. 1200–1521

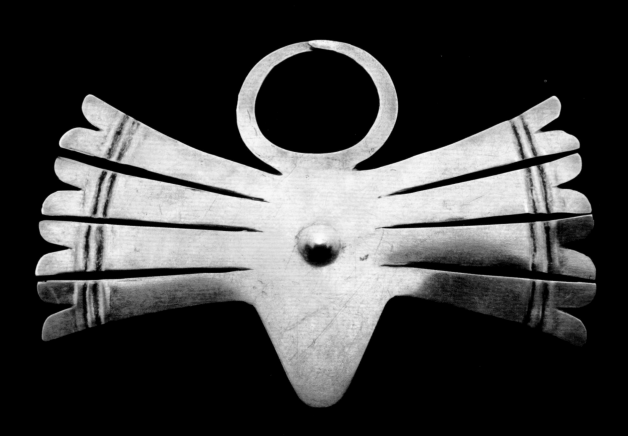

164. Butterfly nose ornament
Mixtec, ca. 1200–1521

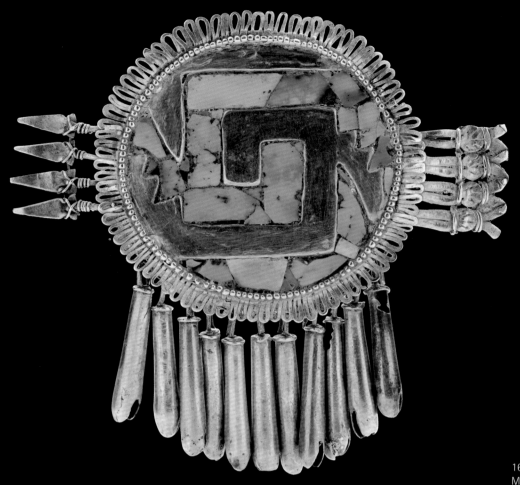

165. Shield pectoral
Mixtec, ca. 900–1200

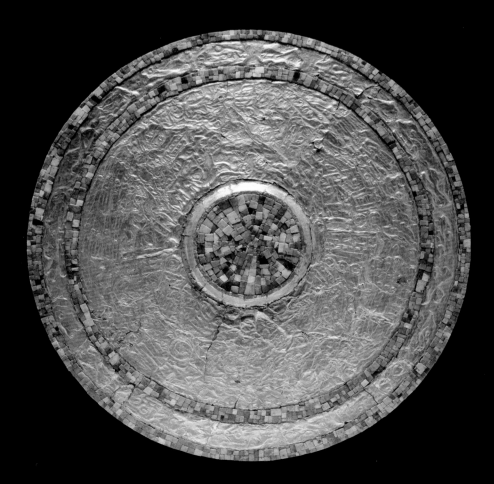

166. Disk
Mixtec, ca. 1325–1521

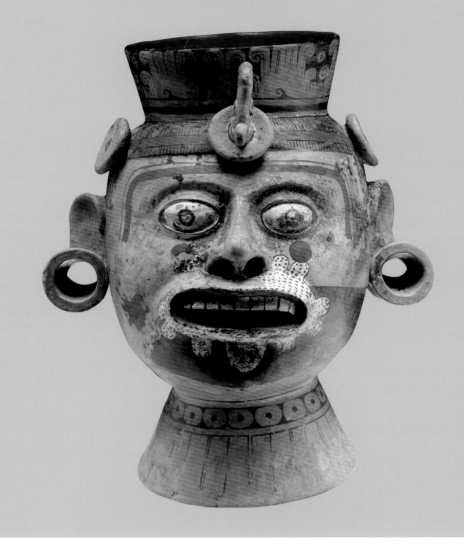

167. Effigy vessel
Mixtec, ca. 1250–1521

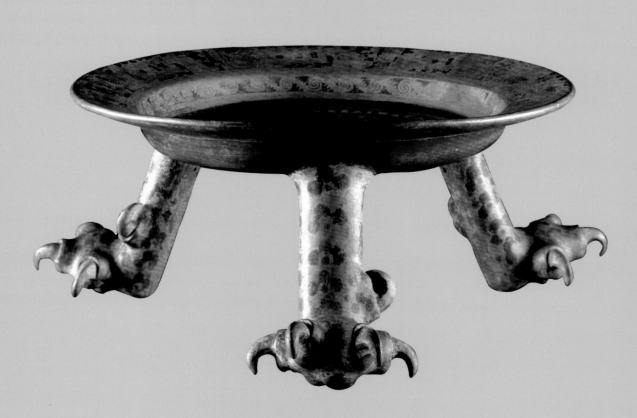

168. Polychrome tripod plate
Mixtec, ca. 1500

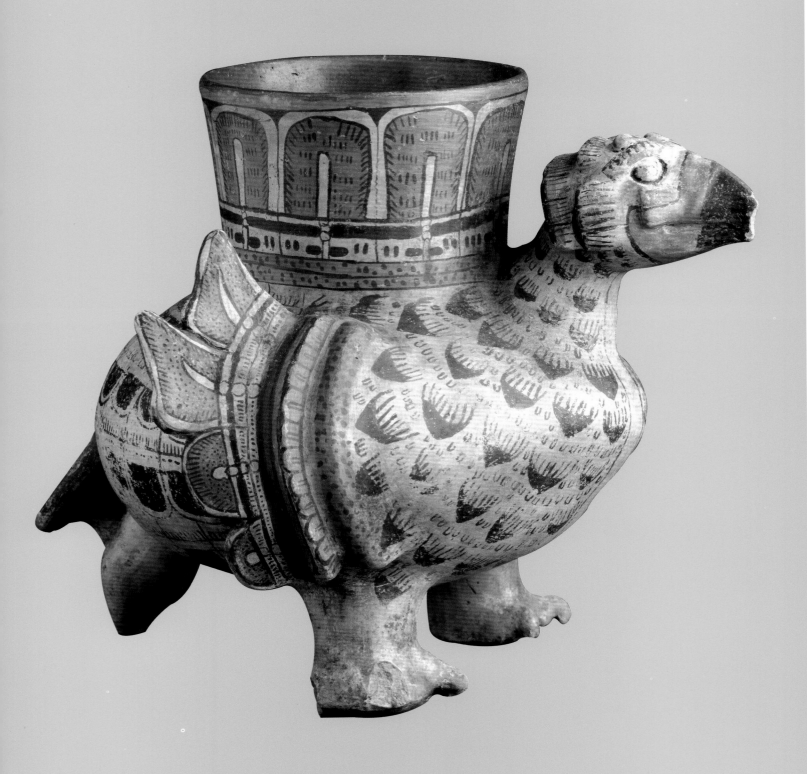

169. Vessel in the form of an eagle
Eastern Nahua, ca. 1450

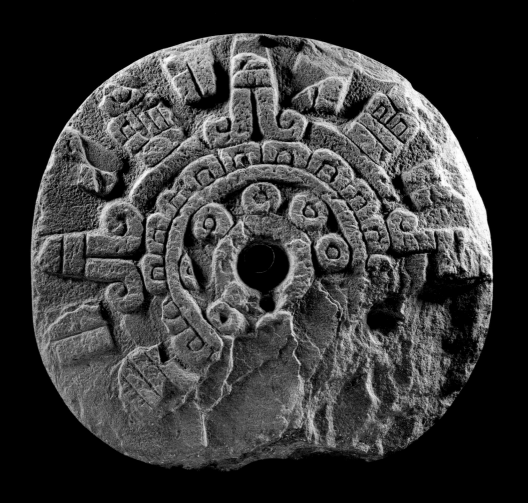

170. Temalacatl
Mixtec, ca. 1250–1521

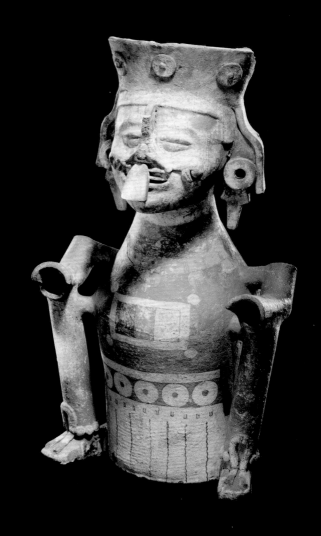

171. Xantil, figure representing the
god Xiuhtecuhtli in seated position
Mixtec, ca. 1000–1521

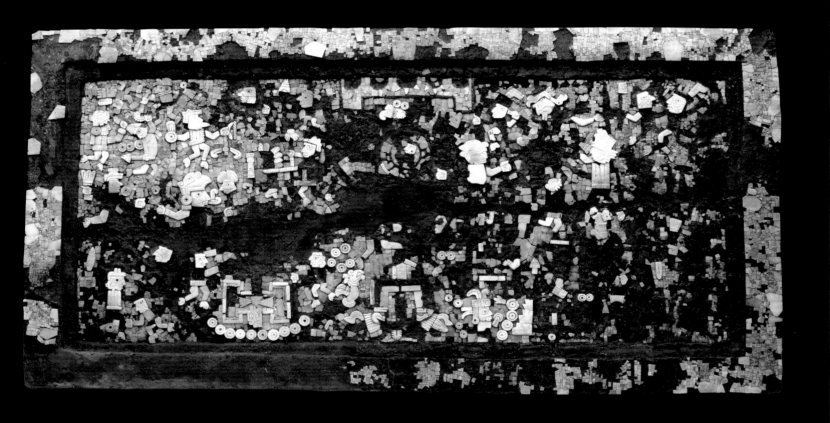

172. Plaque with ritual scenes
Mixtec, ca. 1325–1521

The Huaxteca and
the Totonaca

Felipe Solís

THE EASTERN COASTAL REGION OF MESOAMERICA WAS INHABITED BY VARIOUS PEOPLES WHO were contemporaries of the Aztecs during the late Postclassic period. Among those who were notable for their warlike spirit as well as their dazzling art were the Huaxteca and the Totonaca. While the Huaxteca, linguistically linked with the great Maya family, have a cultural history that dates back to very early times, linguistic studies indicate that the Totonaca are late arrivals, with a culture dating only back to the eighth century A.D., at the earliest.

Nahuatl speakers gave the name Huaxtecapan to the large area that included the central eastern part of the state of San Luís Potosí, the southern part of Tamaulipas to the northern part of Veracruz on the Gulf Coast. The region had a range of ecological environments, from coastal plains and basins of mighty rivers, particularly the Panuco, to vast highlands with tropical climates and the region bordering the eastern Sierra Madre mountains. The Huaxteca adapted to these various ecological niches with extraordinary facility, successfully exploiting the resources offered by the sea, the mountains, and the tropics. Although they never constituted a unified political entity, they achieved a firm cultural identity that went beyond language. They were also recognizable by their religious pantheon and distinctive artworks: sculptures displaying the features of their main deities, ceramic vessels, and ingenious ornaments worked in conch and other shells.

Huaxtec archaeological sites are still called by their ancient names: Tanquian, Tancahuitz, Tamuin, Tamposoque, and Tantoc in today's state of San Luís Potosí, Tabuco in Veracruz, and Tancol in Tamaulipas. Today's country people (*campesinos*) use the word "cues," what the Spaniards called the indigenous pyramids with temples built on top, to refer to the mounds and platforms that constituted Huaxtec religious buildings or constructions in Precolumbian times. This is because of their curious shape, which looks like an elevated cone with rounded corners on its plinth. Important artistic treasures have been discovered in these locations. In Tamuin, a site that was contemporary with the Aztec period, the only mural painting preserved from the Huaxtec world was discovered on an elongated altar. A procession of characters in attire that may represent deities or their personifications, outlined in red, stands out against the whitish stucco layer.

It was in Consuelo, a settlement near Tamuin, where the extraordinary Postclassic sculpture known as The Adolescent—a young nude male figure carrying a child on its back—was discovered. This is one of the most refined works not just of Huaxtec art but of pre-Hispanic Mexican art in general. It is typical of the great majority of Huaxtec sculptures, which show the male sexual organs uncovered, evidence of phallus worship. The cranial deformation and perforations in the ears and nostrils are linked to the aesthetic and ornamental patterns common to this coastal society. Figures known as Old Sowers are also

Detail of cat. no. 177

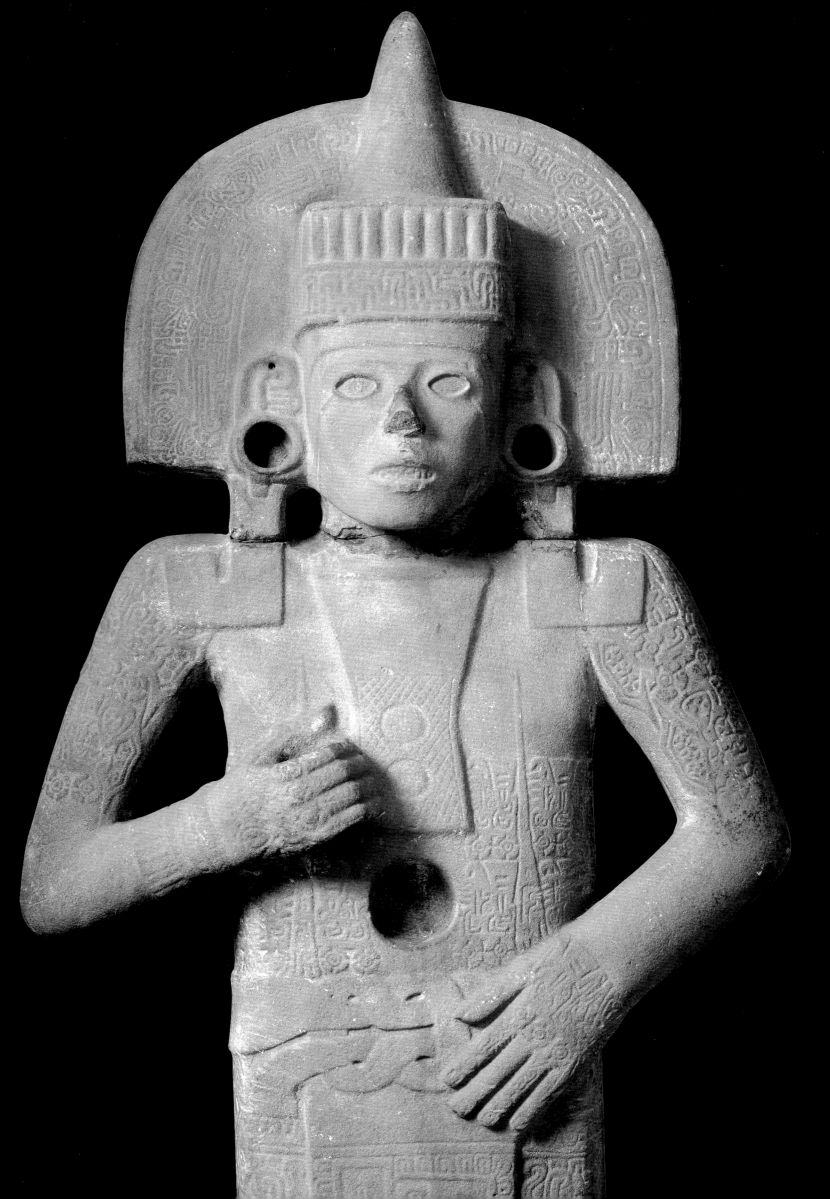

typical. Based on their wrinkled faces, these pieces represent individuals of advanced age who performed rituals with a sacred staff that was used for sowing the earth. Huaxtec sculptures of females are generally shown with nude torsos and both hands placed on their abdomens. With their conical caps, zoomorphic attire, and full, round bodies, they have been identified as Tlazolteotl-Ixcuiname, the goddess who was patron of fertility and an eater of filth. Along with The Adolescent, the most famous Huaxtec sculpture is undoubtedly the Life-Death Figure (Apotheosis), in the collection of the Brooklyn Museum, New York. This figure, set in an elegant hieratic pose, carries a skeleton on its back, which forms part of the ornamentation while adding symbolic value. The sculpture has been interpreted as representing the very essence of duality—life and death, creation and destruction—that is always present according to Meso-american thought.

The ceramic vessels typical of the Huaxteca in the late Postclassic period are styled with brilliant designs in black or dark brown tonalities that stand out against the whitish color of the clay. These tones are consistent on both the traditional globular and phytomorphic forms and those that represent human beings and animals. The creations of these coastal people demonstrate the international style of the period that was dominant throughout most of Mesoamerica. The symbols on their polychromatic vessels would have been recognized by different peoples of the time: solar disks, eagles, and so on. Conches and other shells, which were so abundant on the gulf coasts of Mexico, were used as the raw material for striking objects. The Huaxteca also made earspools or circular disks and elegant breastplates resembling ladles that contain complex ritual scenes bearing a resemblance to images in the codices from other regions in Mesoamerica.

The Totonaca occupied a vast territory known as Totonacapan in the center of Veracruz, extending from the foothills of the eastern Sierra Madres to the coastal plains of the gulf. This people had linguistic links with the Tepehuan, who were their neighbors, and the Zoqueana family, which reached as far as Chiapas. The enigmatic name suggests, according to some authors, the three principal places of their origin.

Totonac objects continued the traditions of societies that previously inhabited the coastal region. Although we do not know the specific identity of those ancestral peoples, they are archaeologically recognized as a Remojadas culture, characterized by the extensive production of figures made of clay decorated with paint made of tar. This very peculiar sculptural artwork reached its most sophisticated level in life-size figures found at the El Zapotal site in Veracruz.

This people also made works in the international style, and their clay sculptures represent deities characteristic of the Aztec world: Tlaloc, Xochipilli, Xipe Totec, Xilonen, and so on. Such figures can be recognized by the attire and ornamentation popular throughout all late Mesoamerica. Some of these stone sculptures appear to have come from the same art workshops in Tetzcoco or in Mexico-Tenochtitlan. However, they survived in smaller numbers than those made of clay. The figures may have been executed by artists from the Nahua world who traveled to the coast, or perhaps the images were reproduced from drawings made in the codices, which could easily have been transported from the center of the Veracruz region.

Two archaeological sites exemplify the Aztec domination in the Totonac region. The first is Cempoala, located to the north of the port of Veracruz. There we recognize the familiar urban pattern, with a walled ceremonial precinct that recalls the Templo Mayor at Tenochtitlan, where the primary ritual constructions are housed. In some instances, we find the typical double pyramid and plinth with a circular plan related to Ehecatl. The second site is Castillo de Teayo, an Aztec military camp with architecture and sculpture typical of the central highland style rendered by coastal artists.

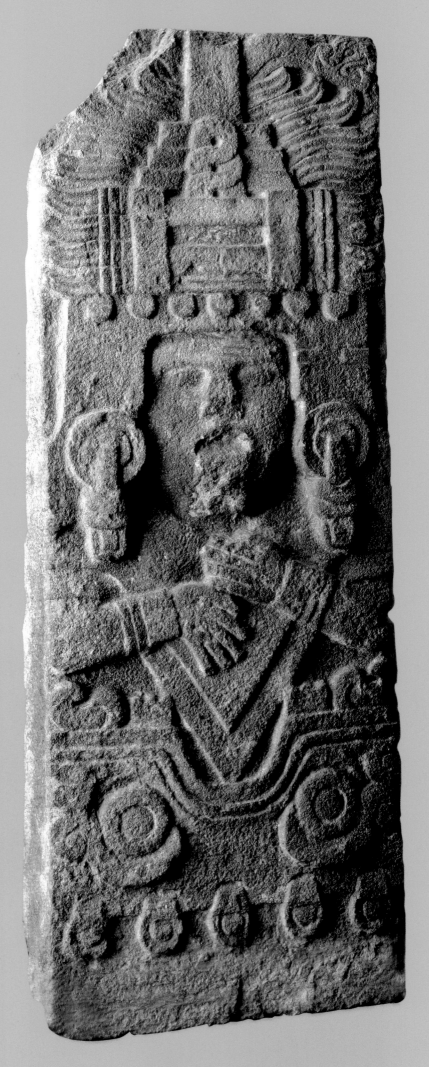

173. Chicomecoatl plaque
Aztec, ca. 1500

174. Anthropomorphic effigy vessel
Huaxtec, ca. 1250–1521

175. Polychrome vessel
Totonaca, ca. 600–900

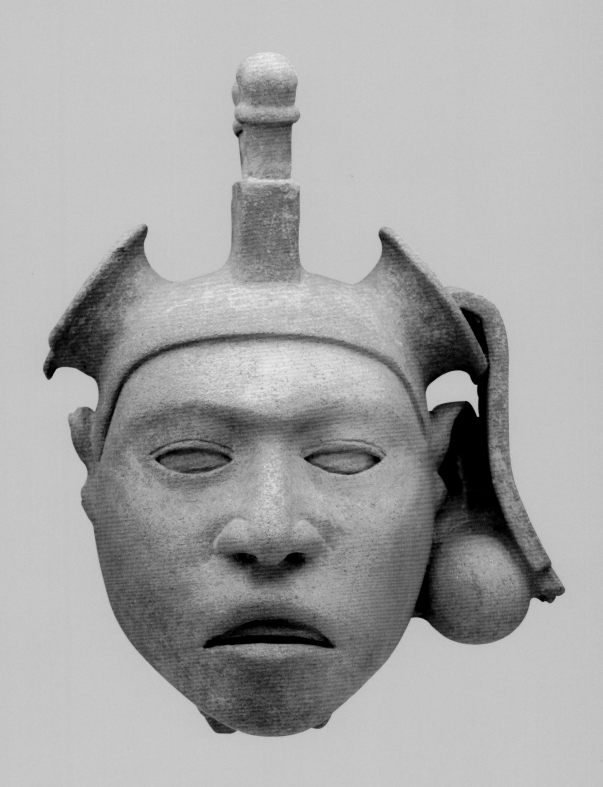

176. Head from figure of a deity
(Macuilxochitl)
Aztec, ca. 1440–1521

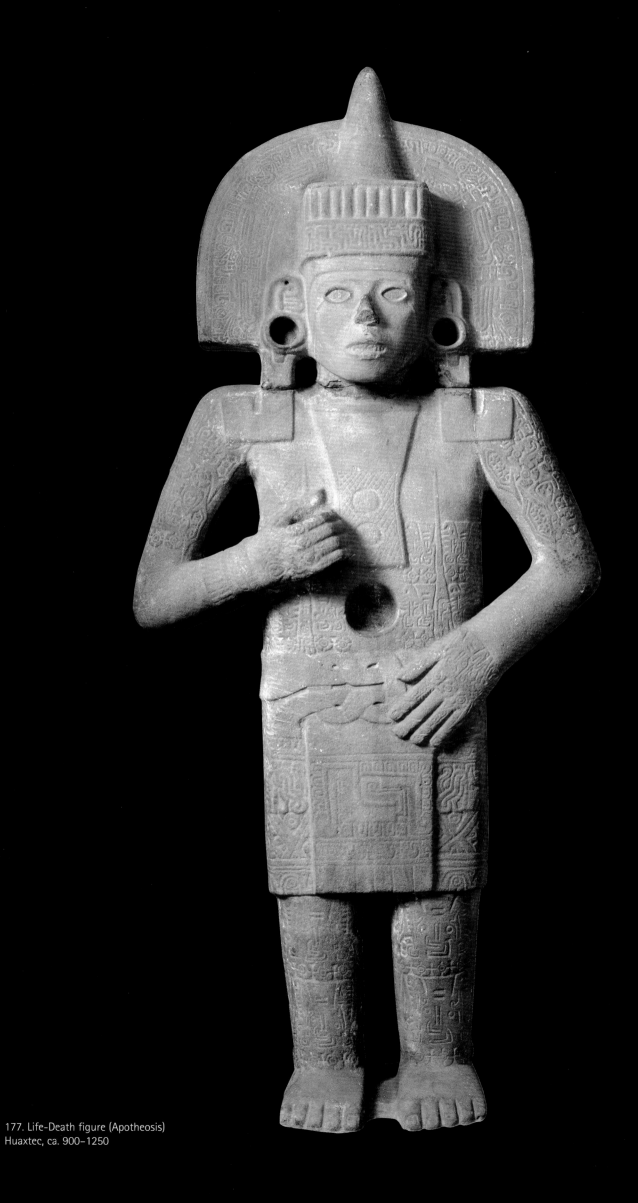

177. Life-Death figure (Apotheosis)
Huaxtec, ca. 900–1250

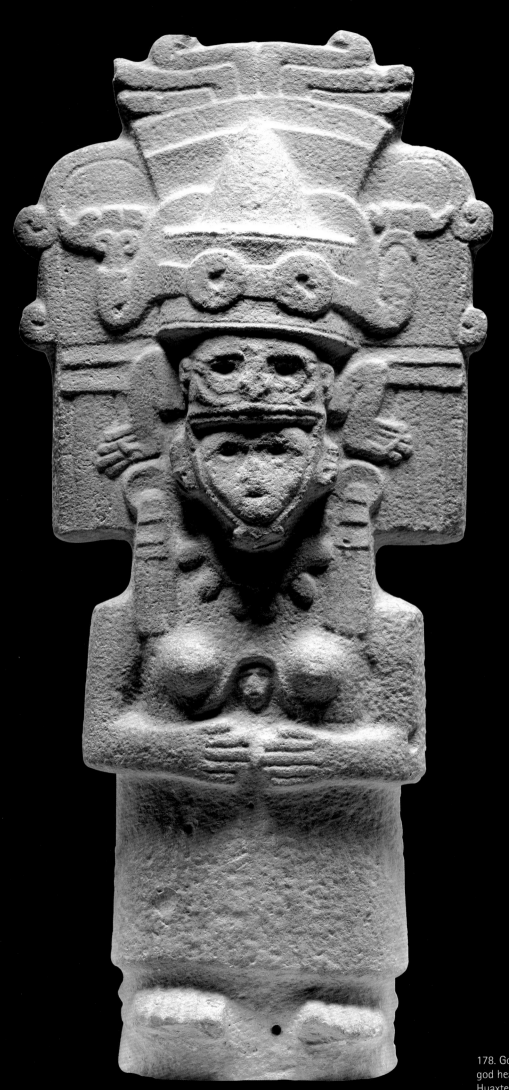

178. Goddess with descending
god headdress
Huaxtec, ca. 1250–1521

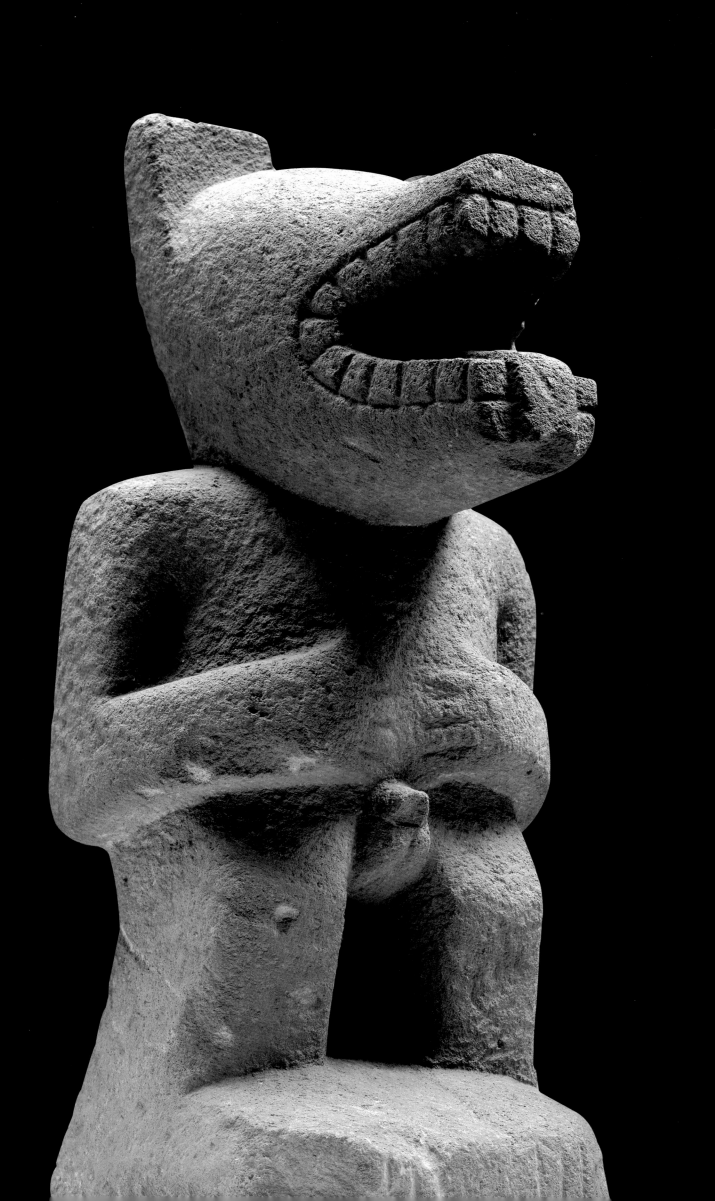

The Tarascan Empire

The Tarascan Empire

Phil C. Weigand

WHEN THE EUROPEANS ARRIVED ON THE SHORES OF MESOAMERICA IN 1519, AMONG THE GREAT polities they encountered north of the Isthmus of Tehuantepec were the Aztecs, who were predominant, the Cholollans and Tlaxcalteca within Central Mexico, and the Purepecha, or Tarascans, as the Spanish called them, to the west. The Aztecs' astounding run of military successes prior to 1519 did not include victories along their western frontier, where a military stalemate with the Tarascans had developed. It is therefore ironic that the Tarascans offered so little resistance when the Spanish penetrated their heartland in 1522. The collapse of the Tarascan empire—occupying roughly the same area as the present-day state of Michoacan—was a walkover compared with what had happened in 1521 when the Aztecs were defeated after the bloody, prolonged siege of Tenochtitlan. Of course, there is an explanation: the Euroafrican diseases, which had already heavily weakened the Aztecs, infiltrated the Tarascan empire prior to the actual presence of Spaniards. Having been brought back to Tzintzuntzan, the Tarascan capital, sometime after 1519, these diseases first appeared at court, thus especially impacting the nobility and military. In 1520, the Tarascan ruler at Tzintzuntzan, Zuangua, was felled by the epidemic then in its incipient stage in West Mexico. The consequent confusion and disorientation in a society so structured in the nobility's favor meant that the capacity to resist was nonexistent by the time the direct confrontation with Europeans materialized in 1522.

The Spanish soon discovered how politically, socially, and militarily advanced the Tarascan state had been. *Relación de Michoacán*, compiled in 1539–41 and among the very first extensive post-Conquest codices documenting pre-Conquest customs, offered the Spanish detailed insights into the social system that was perhaps the most "modern" of those they encountered in Mesoamerica.[1] *Relación* and a number of other codices and primary sources— *Códice de Cutzio* and *Códice de Huetamo* (both 1542),[2] *Lienzo de Jicalán* (ca. 1565; also known as *Lienzo de Jucutacato*),[3] *Códice de Tzintzuntzan* (ca. 1567),[4] *Informe de Vasco de Quiroga* (1533),[5] and *Relaciones geográficas del siglo XVI: Michoacán* (various dates, mostly around 1580)[6]—are the basic historical documents for our present-day understanding of the pre-Conquest Tarascan state and its sociocultural order. The pioneering research published by Nicolás León in 1904 was the first modern attempt at a systematic analysis of the ancient Tarascan social and cultural order.[7]

Although archaeological research concerning the origins of the Tarascans is only a few decades old, there are a growing number of excellent field studies. Complex cultural life began early in Michoacan, as evidenced by the spectacular shaft-tombs, dating from 1800–800 B.C., found in the Jacona-Zamora area.[8] These tombs had rich offerings, often having served as crypts for burials over a long period of time. They clearly indicate the early existence of social systems

beginning to rank or stratify themselves, and which had the power to attract exotica from far away. Simpler versions of such shaft-tombs have been found in various localities in Jalisco.[9]

In later Formative periods (ca. 650 B.C.–A.D. 100), a number of well-developed regional traditions began to flourish. The best known of these is usually called the Chupicuaro culture, largely known from mortuary materials and practices. Recent research has focused upon settlement patterns and architectural complexes,[10] and the site of Loma Alta, near Zacapu, has received an extended amount of attention.[11] What is clear is that by the beginning of the first millennium A.D. sociocultural complexity was increasing and was being consolidated in a series of original and highly distinctive patterns. By the Classic and Epiclassic periods (100–900)—along with the Bajío,[12] the Lerma valley in general,[13] the approaches to the *tierra caliente* (especially the site of Tingambato[14]), and the Jalisco highlands[15]—West Mexico had assumed a character that was quite distinctive from Central Mexico. While this vast region was never isolated from the rest of Mesoamerica, its orientation was obviously toward the western highland lake districts and the Pacific littoral. Influences from the Olmec world were almost nonexistent; some exotica and architectural touches from Teotihuacan were more numerous. During later times, distant exchange relationships reached as far as the Southwestern United States and northernmost South America. Of course, West Mexico participated within Mesoamerica's cultural geography, sharing many basic cosmological concepts with neighbors further east, and was also a full player within the Mesoamerican trade structure.

Archaeology as it applies to the Tarascan origins per se is more problematic.[16] Key sites in the Patzcuaro basin that have received professional attention are Tzintzuntzan, Ihuatzio, and Urichu. Tarascan origins are probably related to two distinct but interrelated phenomena: growing populations throughout the entire region, accompanied in some areas by population nucleation in defendable locations; and, between A.D. 700 and 900 the appearance of metallurgy. While the indigenous cultures of West Mexico were probably already experimenting with copper, a much more advanced technology was clearly introduced from the far older metallurgical traditions of northernmost South America.[17] Hence, metallurgy's rapid adaptation and spread throughout most of West Mexico.[18] Elsewhere, metallurgy, when and where it first appears, promotes revolutionary adaptations; the proto-Tarascan zone would have been no exception. The collapse of Classic civilization in Jalisco, the Teuchitlan tradition, which had spread and affected parts of the Bajío, is probably related in part to the appearance of metallurgy there by around 650–700. West Mexico's reorganization proceeded apace. At the same time as the appearance of metallurgy, another new technology arrived in West Mexico: the bow and arrow.[19] These radical innovations appeared in western

Mesoamerica before the central and southern zones. By 900, West Mexico was in the forefront of Mesoamerica's technological revolution, as it haltingly entered into a metal age, first, as elsewhere in the world, with copper and then, by ca. 1100, bronze. Both metal technologies, plus bow and arrow, must have played a role in the first glimmers of political reorganization in highland Michoacan, which resulted in the Tarascan empire a few centuries later.

Possibly accompanying the arrival of bow-and-arrow technology in West Mexico was the arrival of southern Uto-Aztecan speakers. It is unclear when these migrations, or better said, the linguistic spread of Uto-Aztecan in general, occurred. Many linguists now do not accept what for decades was in fashion as an almost dogmatic assertion: that the speakers of Teotihuacan were Uto-Aztecans. For West Mexico, it is far more likely that proto-Tarascan—which, if Joseph Greenburg is correct, might be related to Chibcha—had a far wider distribution during the first millennium A.D. than it had at the time of the European intrusion. If so, then the new migrants—carrying a version of Nahuatl along the northern frontier (Caxcan) and Totorame elsewhere (including Cora, Tequal, and Huchol as today's only survivors)[20]—into West Mexico may have actually reduced the area of proto-Tarascan speech while, at the same time, stimulating the sociopolitical development of the region that remained. The linguistic arguments are up for further discussion and research, but what is certain is that even in the Tarascan heartland around the Patzcuaro basin there was linguistic and ethnic diversity, probably as early as 1200, just as in much of the rest of Mesoamerica.

Relación de Michoacán offers the official history of the origins of the Tarascan state. While this does not dovetail completely with the archaeological record, it is close enough to confirm the parts where confirmation is most important. Dogma concerning the uniqueness and centrality of the Aztec polity, important as it clearly was, has seriously affected studies of western Mesoamerica. In opposition to such dogmatism, Octavio Paz was severely critical of extending today's political and cultural centralism into the pre-Hispanic past; his two crucial essay collections on cultural history, *Puertas al campo* (1966) and *Posdata* (1970), remain pertinent critiques of this perspective.[21] Nonetheless, according to the prevailing dogma, the entire West Mexican zone had only village levels of social organization, accompanied by interesting but small-scale arts in figurines and other items of material culture; civilization was a gift from Central Mexico, arriving at the beginning of the early Postclassic period (ca. 900) and thus derived from, first, Teotihuacan, and, second, the Tolteca. According to this dogma, the Tarascans were a marginal, barbarous, quasi-Mesoamerican polity, whose emergence was inspired by copying their superior Aztec neighbors. However, as Helen Pollard points out, "This a priori marginalization of the region has impeded research

without reflecting the culture-history dynamics revealed by the available evidence."[22] It is a pity that the overcentralization of policy determining the development of Mesoamerican archaeological research continues to ignore West Mexico.

As Nicolás Léon first emphasized, the emergence of the Tarascan state probably preceded by a short time the emergence of that of the Aztecs. In addition, while at first briefly characterized by a degree of fragmentation, Tarascan was a more unified endeavor, depending far less on alliances and far more on sheer military power and colonization to effect impositions over its neighbors. The official Tarascan history in *Relación de Michoacán* tells us that the Patzcuaro basin was the locale of the first stirrings of imperialism. There, during the first half of the fourteenth century, Tariacuri emerged as the first person who could legitimately claim the title "ruler." He united a number of different, smaller states within the basin, though after his death his accomplishment fell apart due to competition between his heirs. With reunification shortly afterward, Tzintzuntzan definitively surpassed the other centers in the basin, such as Patzcuaro, where Tariacuri had reigned (ca. 1300–1350), and Ihuatzio.

Exactly how Ihuatzio fits into this early picture is not completely clear. According to the royal account of its own history, sometime around 1350 Ihuatzio briefly displaced the first Tarascan capital at Patzcuaro, which itself had displaced Uayameo—the point of origin for what became the Tarascan royal family—about a century earlier. Concerning Uayameo, even the royal accounts are fairly imprecise. Ihuatzio was the capital only during the reign of Hirepan.

Ihuatzio, meaning "place of the coyote," is architecturally quite different from the other major imperial site at Tzintzuntzan. While having structures similar to the *yacatas* for which Tzintzuntzan is famous, the major structures in Ihuatzio have other formats.[23] Ihuatzio had two major periods of occupation, therefore preceding Tzintzuntzan as a complex site in the Patzcuaro basin. The site began around 900 and apparently reached its apogee after 1200, perhaps as late as 1400. Its central precinct area is nucleated and extensive, measuring around 55 hectares, and is dominated by one of the earliest double-pyramid structures in Mesoamerica. While an earlier double-pyramid complex exists in the Lake Chapala basin,[24] the one in Ihuatzio is much more monumental. Huge rectangular plazas, forming monumental processional ways in front of the various pyramid complexes, are enclosed by impressive freestanding walls. Some researchers have interpreted a few of these huge enclosures as ballcourts, but given their width and the sheer size of the interior spaces, this seems improbable. It is possible that, in addition, the upper surfaces of these enclosure walls served as causeways.

A monumental *chacmool* (sculpture of reclining figure holding a bowl) was found associated with one of the secondary plazas. A number of large stone "thrones," in the shape of coyotes, have been located as well. Otherwise, the artifact inventory for the latter period is fully Tarascan: metal objects of copper and bronze (needles, bells, tweezers, adzes, etc.), negative/resist polychrome ceramics, pipes, complex obsidian objects, such as ear and lip plugs, and shell ornaments. When the Spanish arrived, the great lord of Ihuatzio, while related to the royal lineage at Tzintzuntzan, and having important religious and military duties, did not have any tributary communities. The more dispersed sections of the site, while not completely surveyed, may have covered around 125–150 hectares outside the precinct area. The population estimates vary considerably, but 5,000 seems reasonable.

Around 1400, Tzintzuntzan, meaning "place of the hummingbird," became the royal capital and remained so during the most important period of Tarascan expansion. Tzintzuntzan's importance ended only with the Spanish deemphasis of the capital following the murder of the last ruler, Tangaxuan II, in 1530 by Núño de Guzmán, combined with the transfer of colonial administrative power to Patzcuaro in 1540. The final blow came forty years later when the colonial capital was relocated to Valladolid (today's Morelia). Thereafter, Tzintzuntzan progressively degenerated into a village of little regional importance. The site's central sector has been estimated as encompassing 650–750 hectares, the contemporary town of the same name clearly covers sections of the ruin, and the more dispersed sections are hundreds of hectares.[25] The site is estimated to have had a population of from 25,000 to 35,000 when the Spanish arrived in 1522, despite the fact that the Euroafrican epidemic was already raging.

The immense central precinct is dominated by a great platform, protruding as a terrace from a hillside and facing Lake Patzcuaro. The platform measures 450 meters wide, 250 meters deep, and over 10 meters high in most places, thus having an estimated half-million cubic meters of fill. On its upper surface are the famed *yacata* structures. West Mexico had had a unique monumental architectural tradition, based on a concentric circular pattern, long before the *yacata* were conceived,[26] so the architectural innovations so well represented at Tzintzuntzan are not out of context. *Yacatas* are characterized by a stepped and truncated conical structure appended to a rectangular platform, which was in turn accessed by a rear stairway. These structures were faced with beautifully shaped, square volcanic slabs, which often have petroglyphs.

There are five monumental *yacatas* placed at regular intervals atop the base platform. The *yacatas* were dedicated to Curicaueri, a sun god, as well as his four brothers. Atop the *yacatas* were painted, wooden temples, themselves of considerable size. Sacrificial stone altars and skull racks accompanied the structures. Not far from the *yacatas*, a large deposit of human bones, many of them burnt, presumably represent the remains of sacrificial victims. Many of the skull fragments were perforated.

The great platform, in addition to its *yacatas*, also had major burial chambers within which were extremely rich and elaborate offerings. One chamber contained around sixty individuals, most of whom were meant to accompany the prime interred personage into the afterlife. The approach to this precinct is also terraced, part of which constitutes an enormous stairway. From any angle, the complex is extremely impressive and constitutes an unparalleled example of formal architectural design.

The rest of Tzintzuntzan had an extensive array of buildings, including additional temple precincts; a royal palace for the *cazonci* (ruler/emperor); a large marketplace for utilitarian and luxury products; large storehouses; residential areas for other elite families and artisans, especially metal and feather workers; residences and centers for long-distance merchants (who, contrary to Aztec custom, belonged to the nobility); and residences for farmers on the peripheries of the site. Most of the nonelite households in the central part of the city were dedicated to craft production. The center was overwhelmingly oriented to the administration and affairs of the empire, clearly urban in nature, and completely tied to the destiny of the imperial lineage. Overall, the city had a formal plan and configuration but also accommodated the hilly topography of this section of the Patzcuaro basin. While other large sites with some urban characteristics existed within the Tarascan empire, as well as to the northwest in Colima, Nayarit, and Jalisco, Tzintzuntzan was probably the only truly urban center within West Mexico at the time of the Spanish intrusion.

The crafts at Tzintzuntzan were largely for elite consumption among the Tarascans as well as for long-distance trade. Turquoise was popular but did not figure in long-distance trade, either as a product acquired by the royal merchants or in tribute. Instead, it was a commodity that circulated among the elite elements of the population. Long before the Tarascan royal system was organized, turquoise was a major but localized item within the Mesoamerican trade structure. In comparison, while the Aztecs obtained some turquoise in tribute, they too did not acquire this most valued material via their long-distance trade organization, the *pochteca*.[27] The Tarascan artisans set turquoise into both obsidian and silver jewelry. Along with turquoise artistry and metalworking in copper, bronze, silver, and gold, featherworking was extremely important and was a royally sponsored art. Feathers decorated costumes, headdresses, shields, standards, and other elite objects.

Other sites of importance within the Patzcuaro basin were Patzcuaro and Urichu. Little is known of the former since the contemporary city of the same name covers almost all of the ruin, and few salvage efforts have taken advantage of inspecting the profiles of either sewer or water lines or openings left by current construction activities. In contrast, Urichu had been the site of the most scientific excavation and survey project yet generated for the basin.[28]

The Tarascan religious system and ideological structure shared many similarities with neighboring areas of Mesoamerica, though also displaying radical differences with Central Mexico.[29] Naturally, we know most about the state religion. The greatest number of temples apparently were dedicated to Cuerauaperi (earth, fertility, rain, birth, death, and creation goddess), Curicaueri (a sky force: the sun's messenger, fire), and Xaratanga (daughter of the earth creator, wife of the sun, with childbirth and fertility as main themes). Tarascan priesthoods were formidable institutions, dominated by the nobility and organized over time with hereditary offices.

Tarascan militarism carried royal power far afield from the heartlands around the Patzcuaro basin. Secondary centers of administration grew in other areas of Tarascan speech, such as Jacona to the west. Tarascan expansion to the east was limited by a number of factors, the most prominent being the presence of the Aztec-dominated Triple Alliance. The Tarascans also had little success penetrating north of the Lerma River, despite some of their own legends concerning Chichimeca origins; although some groups of Tarascan speech were indeed Chichimeca, this is an unlikely area to look for their overall origins. Expansion to the south and west, however, was another matter. By the early sixteenth century, Tarascan dominance was felt over an area of approximately 75,000 square kilometers, making it the second largest imperial presence in Mesoamerica. Tariacuri united the most important centers of the Patzcuaro basin: Patzcuaro, Ihuatzio, Tzintzuntzan, Urichu, Erongaricuaro, and Pechataro. While this unification did not last beyond his death, apparently it formed the expansionist ideological basis for the next round of conquest under, especially, Tangaxoan I. And it was Tangaxoan I's reforms and social innovations that formed the lasting basis for the Tarascan empire, revolutionizing life throughout West Mexico.

By the mid-fifteenth century, military conquests had become institutionalized and a tribute state had emerged. Expansion quickly filled the area between the Balsas and Lerma rivers, south and north, and west into the central highland lake districts of Jalisco. The Tarascan expansion into the Chapala basin is probably in part responsible for the collapse of the great complexes that had existed there during slightly earlier times. Huge sites, such as San Gregorio, were abandoned. The entire southern shore of the Chapala basin apparently became subject to a Tarascan military march for access to areas further west.[30] By 1460, the Zacatula area on the Pacific coast had been conquered.

By around the 1480s, imperial efforts were being made to penetrate and control the metal-producing areas outside of Michoacan itself. Helen Pollard has convincingly argued that the major impetus for Tarascan expansion outside their original, core lands was embedded in a systematic effort to control as many source areas for copper and tin as possible.[31] This strategy worked well in parts of Jalisco, especially the Tamazula zone, but

Page from Fray Jerónimo de Alcalá,
La Relación de Michoacán, 1539–41.

ran afoul with the attempts to control the small but highly mil-
itarized states further north and west. Ameca and Etzatlan,
despite a number of destructive raids, could not be subdued.
These two sites controlled the rich copper and silver deposits of
the Sierra de Ameca.[32] The political dominance of salt-produc-
ing areas was another Tarascan strategy.[33]

In selected areas, the Tarascans at times instituted a policy
of forced population relocations to help keep conquests securely
in line. While leadership positions were hereditary among the
nobility, the Tarascan ruler generally had the final word, and
local leaders, especially in conquered zones, were chosen by the
ruler. A system of governors evolved that tied local power struc-
tures firmly and directly to the royal lineage at Tzintzuntzan,
and these ties were often reinforced through marriages. While
a great deal of autonomy existed, the ruler had the often exer-
cised right to overrule any local decision. Political power was
systematically centralized to a degree not seen in most other
areas of Mesoamerica. In addition, the ruler occasionally divid-
ed military and civil authorities in certain localities.

Aside from the flow of luxury goods desired by both sides,
the Tarascan-Aztec frontier was characterized, from probably
around 1440 until the Spanish intrusion, by almost continuous
hostilities.[34] Luxury items, especially turquoise and metal arti-
facts, were highly desired in Central Mexico. If these commodi-
ties did indeed cross the militarized and hostile frontier
between the two empires, then clearly royal trading organiza-
tions were not involved on either side. A more logical route for
the flow of such items might have been down the Pacific littoral
or via Oaxaca, and then to Central Mexico as either trade or
tribute. Groups of Otomi were possibly involved in the cross-
frontier trade as well. Despite the hostile environment between
the two empires, or perhaps because of it, there were official
ambassadors exchanged between the polities. We know for cer-
tain about only one such ambassador from Tarascan, as he was
present in Tenochtitlan in 1519, witnessing the first phase of
that city's collapse.[35] It was apparently he and his party who
carried the first Euroafrican sicknesses back to Tzintzuntzan.

Generally, it was military confrontation that distinguished
the frontier situation and interempire affairs. The Tarascans
built a great fortress at Taximora, which managed to defy all
attempts by the Aztecs at conquest and to block with a degree
of effectiveness Aztec attempts to penetrate much beyond. The
Aztecs, despite all their might and military reputation, simply
did not have the capacity to defeat or inflict lasting damage on
the Tarascan polity.

At the time of the Spanish intrusion into West Mexico, there
probably were around two million people within this general
area.[36] The Tarascans controlled only a fraction of that popula-
tion, perhaps a quarter or, at most, a third. They did not have
anywhere near the demographic potential of the polities of
Central Mexico. In addition, urbanism in West Mexico in general

View of a lake in Michoacan.

and within the Tarascan realm in particular had not come close to the levels within Central Mexico. Tzintzuntzan was probably the only center within the Tarascan realm that was a true city, though other centers or areas outside the Tarascan area of dominance, such as Etzatlan, the Nayarit coast, and the valley of Colima, had large population concentrations. Despite these differences, the Tarascans were able to organize an effective military and economic system that dominated much of West Mexico and was successful in keeping the neighboring Aztec empire at bay. The Tarascan military was dedicated to winning battles, and, unlike the Aztecs, the ceremonial elements of battle were not as important to the Tarascans; their systematic use of archers was another difference between their military organization and that of the Aztecs. The Tarascan imperial administration was centralized and coordinated to a degree not seen within the Aztec realm. Its polity was a fitting conclusion to a long series of complex sociocultural developments within West Mexico.

Notes

Conversations, held over many years, with Shirley Gorenstein, Helen Pollard, Brigitte Boehm, Efrain Cárdenas, and Eduardo Williams have been crucial for my understanding of the Tarascan polity. Of course, many of the interpretations and any errors are my sole responsibility. The Colegio de Michoacán has supported my research efforts for the past fifteen years.

1. *Relación de Michoacán: Relación de las ceremonias y rictos y población y gobernación de los indios de la provincia de Michoacán* (Zamora: El Colegio de Michoacán and El Gobierno del Estado de Michoacán, 2000).

2. Hans Roskamp, *Los códices de Cutzio y Huetamo: Encomienda y tributo en la tierra caliente de Michoacán, siglo XVI* (Zamora: El Colegio de Michoacán and El Colegio Mexiquense, 2003).

3. Hans Roskamp, "Historia, mito y legitimación: El Lienzo de Jicalán," in Eduardo Zarate, ed., *La tierra caliente de Michoacán* (Zamora: El Colegio de Michoacán and El Gobierno del Estado de Michoacán, 2001), pp. 119–51.

4. Pablo Beaumont, *Crónica de Michoacán* (1778–1780) (Mexico City: Archivo General de la Nación, 1932).

5. J. Benedict Warren, "Informe de Lic. Vasco de Quiroga. . .," *Anales del Museo Michoacano* (1989), pp. 30–52.

6. René Acuña, *Relaciones geográficas del siglo XVI: Michoacán* (Mexico City: Universidad Nacional Autónoma de México, 1987).

7. Nicolás Léon, *Los tarasco* (Mexico City: Museo Nacional, 1904). For care in preparation and readability, León's classic works remain interesting and pertinent to this day.

8. Arturo Oliveros, "Las tumbas mas antiguas de Michoacán," in Jaime Figueroa, ed., *Historia general de Michoacán*, vol. 1, pt. 2, "Época prehispánica" (Morelia: Gobierno de Michoacán, 1989), pp. 121–34.

9. Phil C. Weigand and Christopher Beekman, "The Teuchitlán Tradition: Rise of a Statelike Society," in Richard Townsend, ed., *Ancient West Mexico: Art and Archaeology of the Unknown Past* (Chicago: Art Institute of Chicago, 1998), pp. 35–51.

10. Veronique Darras and Brigitte Faugere, "Cronología de la cultura chupícuaro: Estudio del sitio La Tronera, Puruguita, Guanajuato," in Eduardo Williams, Phil C. Weigand, Lorenza López, and David Grove, eds., *Arqueología del Occidente de México: Nuevos datos, futuras direcciones* (Zamora: El Colegio de Michoacán, Foundation for the Advancement of Mesoamerican Studies, and La Secretaría de Cultura del Estado de Jalisco, forthcoming).

11. Charlotte Arnauld, Patricia Carot, Marie France, and Fauvet Berthelot, *Arqueología de las lomas en la cuenca lacustre de Zacapu, Michoacán, México, Cuadernos de estudios michoacanos*, no. 5 (Mexico City: Centre Français d'Etudes Mexicaines et Centramericaines, 1993).

12. Efrain Cárdenas, *El Bajio en el clásico: Análisis regional y organizacion política* (Zamora: El Colegio de Michoacán, 1999).

13. Eduardo Williams and Phil C. Weigand, eds., *Arqueología y etnohistoria: La región del Lerma* (Zamora: El Colegio de Michoacán and Centro de Investigación en Matemáticas, 1999).

14. Román Piña Chán, *Exploraciones arqueológicas en Tingmabato, Michoacán* (Mexico City: Instituto Nacional de Antropología e Historia, 1982).

15. Phil C. Weigand, *Evolución de una civilización prehispánica: Arqueología de Jalisco, Nayarit y Zacatecas* (Zamora: El Colegio de Michoacán, 1993); and Phil C. Weigand, "Architecure of the Teuchitlán Tradition of the Occidente of Mesoamerica," *Ancient Mesoamerica* 7, no. 1 (1996), pp. 91–101.

16. The most complete and recent summaries for all aspects of the region's archaeology are Helen Pollard, *Tariácuri's Legacy: The Prehispanic Tarascan State* (Norman: University of Oklahoma Press, 1993); Helen Pollard, "Estudio del surgimiento del estado tarasco: Investigaciones recientes," in Eduardo Williams and Phil C. Weigand, eds., *Arqueología del Occidente y Norte de Mexico* (Zamora: El Colegio de Michoacán, 1994), pp. 29–63; Shirley Gorenstein, "Settlements of the Protohistoric Tarascan Core," in Michael Foster and Phil C. Weigand, eds., *The Archaeology of West and Northwest*

Mesoamerica (Boulder, Colo.: Westview Press, 1985), pp. 117–30; Shirley Gorenstein and Helen Pollard, *The Tarascan Civilization: A Late Prehispanic Cultural System, Vanderbilty University Publications in Anthropology,* 28 (Nashville, 1983); Eduardo Williams, "Los tarascos y sus antepasados: Una perspectiva antropológica," in Brigitte Boehm, ed., *El Michoacán antigüo* (Zamora: El Colegio de Michoacán and El Gobierno del Estado de Michoacán, 1994), pp. 169–83; Eduardo Williams, "Desarrollo cultural en las cuencas del Occidente de México: 1500 a.C.–1521 d.C.," in Eduardo Williams and Phil C. Weigand, eds., *Las cuencas del Occidente de México: Época prehispánica* (Zamora: El Colegio de Michoacán and Centro Francés de Estudios de Mexicanos y Centroamericanos, 1996), pp. 15–59; for the northern frontier, Brigitte Faugere-Kalfon, *Entre Zacapu y Río Lerma: Culturas en una zona fronteriza, Cuadernos de estudios Michoacanos* (Mexico City: Centre Français d'Etudes Mexicaines et Centrameriaines, 1996); and, for the trans-Tarascan zone to the west, Phil C. Weigand and Acelia García, *Tenamaxtli y Guaxicar: Las raíces profundas de la rebelión de Nueva Galicia* (Zamora: El Colegio de Michoacán and La Secretaría de Cultura del Estado de Jalisco, 1996).

17. Dorothy Hosler, *The Sounds and Colors of Power: The Sacred Metallurgy of Ancient West Mexico* (Cambridge: MIT Press, 1994).

18. Phil C. Weigand, "La arqueología de Jalisco vista desde el colapso de la tradición Teuchitlan," in Phil C. Weigand, ed., *Estudio historico y cultural sobre los huicholes* (Colotlán: Universidad de Guadalajara, Campus Universitario del Norte, 2002), pp. 157–78.

19. Ibid.; and Phil C. Weigand, "La antigüa ecumene mesoamericana: Un ejemplo de sobre-especialización?" *Relaciones* 21, no. 82 (2000), pp. 39–58.

20. Totorame is related most closely to other southern Uto-Aztecan subfamilies, such as Tarachitan and Tepiman. Weigand and García, *Tenamaxtli y Guaxicar*; and Robert González, Phil C. Weigand, and Acelia García, *El Templo/Convento de la Concepción de Etzatlán, Jalisco y su contexto prehispánico, Coleccion patrimonio cultural* (Guadalajara: La Secretaría de Cultura del Estado de Jalisco, 2000).

21. Octavio Paz, *Puertas al campo* (1966; Mexico City: Editorial Seix Barral, 1972); and Octavio Paz, *Posdata* (Mexico City: Siglo Veintiuno Editores, 1970).

22. Helen Pollard, "Michoacán Region," in Susan Toby Evans and David Webster, eds., *Archaeology of Mexico and Central America: An Encyclopedia* (New York: Garland Publishing Inc., 2001), p. 464.

23. There has been recent research at Ihuatzio by Efrain Cárdenas and Eugenia Fernández, but these studies remain unpublished. The best published descriptions are Alfonso Caso, "Informe preliminar de las exploraciones realizadas en Michoacán," *Anales del Museo Nacional de Arqueología, Historia y Etnografía,* no. 6 (1929), pp. 446–52; and Jorge Acosta, "Exploraciones arqueológicas realizadas en el estado de Michoacán durante los años de 1937 y 1938," *Revista mexicana de estudios antropológicos* 3 (1939), pp. 85–99; also see Ignacio Marquina, *Arquitectura prehispanica,* Instituto Nacional de Antropología e Historia, Memoria 1 (Mexico City, 1951).

24. Phil C. Weigand and Acelia García, "La arquitectura prehispánica y la secuencia cultural en la cuenca de Chapala, Jaliso: Observaciones preliminares," in Williams and Weigand, eds., *Las cuencas del Occidente de México: Época prehispánica* (Zamora: El Colegio de Michoacán and Centro Francés de Estudios Mexicanos y Centroamericanos, 1996), pp. 293–323.

25. The most complete descriptions of this site's architecture are M. Castro-Leal, Clara Díaz, and M. T. García, "Los tarascos," in Figueroa, *Historia general de Michoacán,* vol. 1, pt. 2, pp. 193–304; R. Cabrera Castro, "Tzintzuntzan: Decima temporada de excavaciones," in *Homenaje a Román Piña Chán,* Universidad Nacional Autónoma de México, Serie Antropológica, no. 79 (Mexico City, 1987), pp. 531–65; and Helen Pollard, "An Analysis of Urban Zoning and Planning in Prehispanic Tzintzuntzan," *Proceedings of the American Philosophical Society* 121, no. 1 (1977), pp. 46–69; also see Williams, "Los tarascos y sus antepasados"; and Marquina, *Arquitectura prehispanica.* Much of the original and earlier excavation materials have never been fully

published. Contemporary Tzintzuntzan was the focus for one of West Mexico's few ethnographic classics, a study that also records much of the more recent history of the site as well: George Foster, *Empire's Children: The People of Tzintzuntzan,* Smithsonian Institution, Institute of Social Anthropology, Publication no. 6 (Mexico City: Imprenta Nuevo Mundo, 1948); reprinted in Spanish by El Colegio de Michoacán, 2000.

26. Weigand, "Architecure of the Teuchitlán Tradition."

27. Phil C. Weigand and Acelia García, "A Macroeconomic Study of the Relationships between the Ancient Cultures of the American Southwest and Mesoamerica," in Virginia Fields and Victor Zamudio-Taylor, eds., *The Road to Aztlán: Art from a Mythic Homeland,* exh. cat. (Los Angeles: Los Angeles County Museum of Art, 2001), pp. 184–95.

28. Pollard, *Tariácuri's Legacy.* Aside from some minor ceremonial buildings, Pollard concentrated much of her research on residential areas, offering for the first time detailed archaeological views of this category of material.

29. Aside from the primary documentation of *Relación de Michoacán,* one of the best accounts of Tarascan religion remains that in León, *Los tarasco.*

30. Weigand and García, "La arquitectura prehispánica."

31. Helen Pollard, "The Political Economy of Prehispanic Tarascan Metallurgy," *American Antiquity* 52, no. 4 (1987), pp. 741–52.

32. Weigand and García, *Tenamaxtli y Guaxicar.*

33. Eduardo Williams, *La sal de la tierra: Etnoarqueologia de la producción salinera en el Occidente de México* (Zamora: El Colegio de Michoacán and La Secretaría de Cultura del Estado de Jalisco, 2003).

34. Pollard, *Tariácuri's Legacy.*

35. J. Benedict Warren, *The Conquest of Michoacán: The Spanish Domination of the Tarascan Kingdom of Western Mexico, 1521–1530* (Norman: University of Oklahoma Press, 1985).

36. Donald Brand, "Ethnohistorical Synthesis of Western Mexico," *Handbook of Middle American Indians,* vol. 11, "Archaeology of Northern Mesoamerica" (Austin: University of Texas Press, 1967), pt. 2, pp. 632–56.

Tarascan Art

Roberto Velasco Alonso

THE TARASCAN EMPIRE EXHIBITED COUNTLESS HISTORICAL PARALLELS AND RELIGIOUS SIMILARITIES to that of the Aztecs. Both peoples founded and settled their cities after prolonged migrations conducted, they believed, in accordance with their gods' wishes. Since they reached lands inhabited by groups in contact with the Tolteca, the Tarascans and the Aztecs adopted many characteristic Meso-american forms and symbols. Like the Aztecs, the Tarascans made efforts to expand their sphere of control through coercion, under the influence of the bellicose character of their religion overall and specifically of their patron god, Curicaueri. Their commercial and political aspirations gave rise to continuous skirmishes along the extensive border they shared with the Aztec empire.

Although the Tarascans appeared late in the development of Mesoamerican cultures (1250–1521 B.C.), their recognition and use of this broad region's system of symbols rooted them firmly within its traditions. As told by their European chronicler Fray Jerónimo de Alcalá in the *Relación de Michoacán*, the Tarascans recognized Nahuatl-speaking people as the original inhabitants of the lands around Lake Patzcuaro, the site of their flourishing culture. On the other hand, in the Aztecs' ancestral memory, the Tarascans were among the other six tribes living alongside them in the mythical land of Chicomoztoc. They believed the Tarascans to have abandoned the site before the departure of four of the five Nahua groups, including the Aztecs.

Although there is no convincing evidence about this supposed common origin and the Aztecs' and Tarascans' different linguistic identities, archaeological remains of their cities show a close ancestral link through religion. Their beliefs must have been assimilated into their cultures many years before both groups were fully settled in their respective lake regions. In fact, in the ceremonial precincts that survived the Conquest, the Tarascan pyramidal structures—called *yacatas*—are composite in plan: that is, a circular base is next to, and attached to, a rectangular one; each superimposed layer of stone is smaller than the one beneath it. On top of each circular section there would have been a simple wood shrine with a palm roof, positioned to face the rising sun. In the Aztec region of influence, there were pyramidal structures with very similar characteristics, dedicated to the creator god who governed the wind. These pyramids, by contrast, supported temples of stucco-covered stone with polychrome sections, which, like their Tarascan counterparts, were generally oriented toward the east.

The austerity of its architecture also characterizes the major arts of the Tarascan empire in West Mexico. From it we can surmise that these people were marked by pragmatism, as is reflected in their techniques for building temples. This trait is also exemplified in the paucity of decorative elements in their sculpture and architecture clearly demonstrated in the simple symbols used in their stone monuments. Surviving examples show a distinct tendency toward geometric forms, characterized by strong cutting and pronounced edges.

179. Warriors
Tarascan, ca. 1250–1521

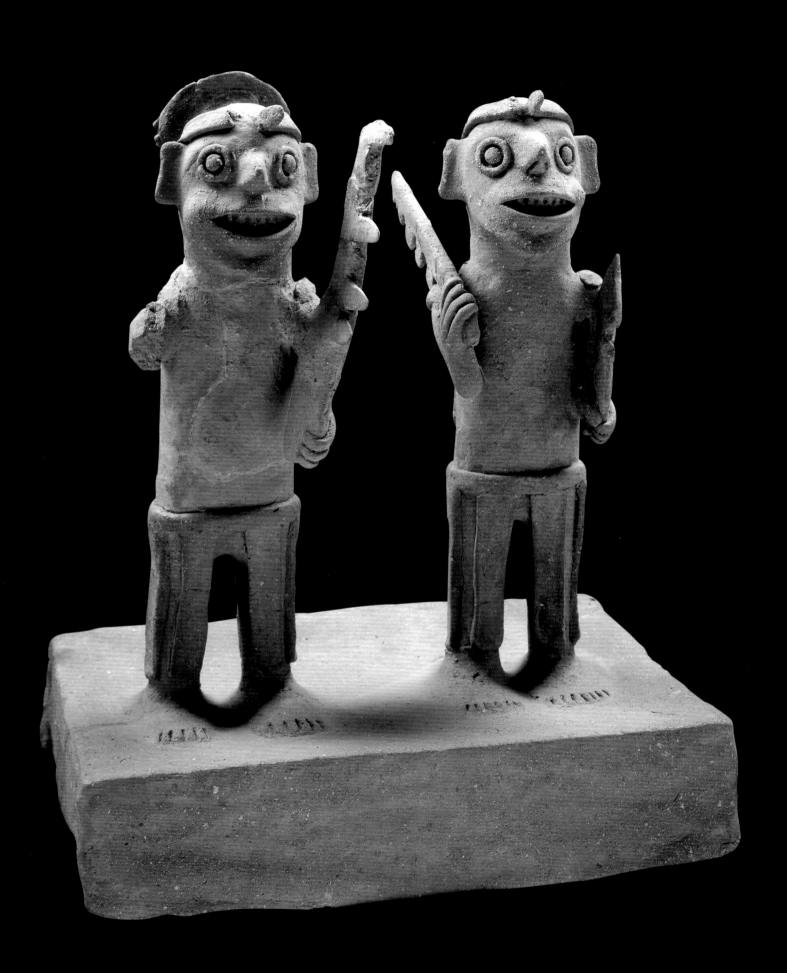

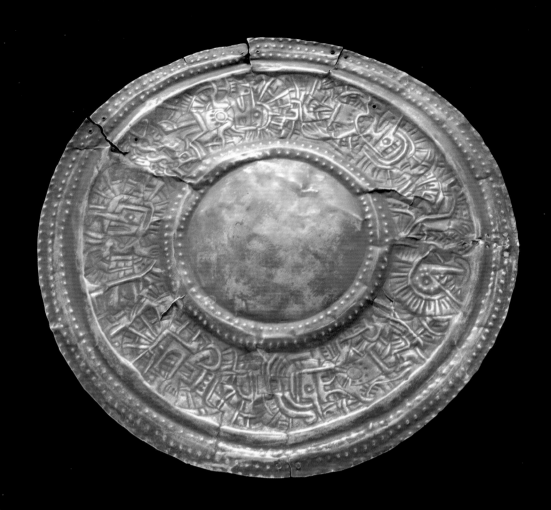

180. Copper disk
Tarascan, ca. 1250–1521

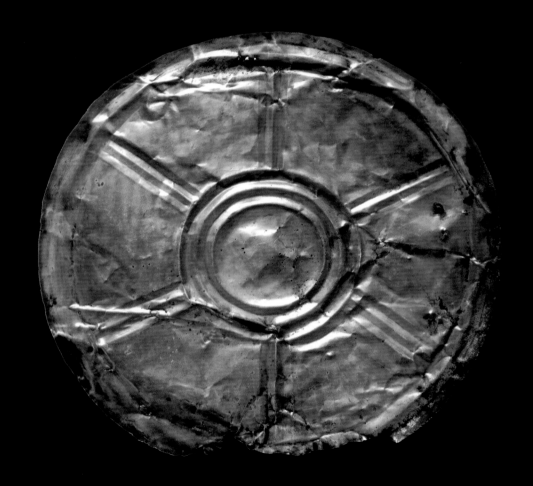

181. Disk
Tarascan, ca. 1250–1521

The human figure sculpted in stone manifests the Tarascans' self-conception and the features that notably distinguish this culture from its counterpart to the east, centered in Mexico-Tenochtitlan. In Tarascan art full nudity in male figures is the rule, not the exception. To viewers of the time, the clear emphasis of the genital area would have suggested the power of fire. This element, governed by Curicaueri, was thought of as a desirable, germinating force. The eyes and mouths of figures were carved directly into the stone, without inlays of shell and obsidian, as was the custom in the Central Basin. Somewhat similarly, thumbs and big toes were not distinguished from the other digits: All five fingers and toes are shown at the same angle.

Outstanding in Tarascan artistic production is its version of the *chacmool* (an anthropomorphic figure reclining on its back, which served as an altar-table); two types are known. The life-size type supports a rectangular platform, has a distinct facial expression, and is adorned only with anklets. The second variant is of smaller dimensions and greater rigidity, clearly adhering to the limitations of the rectilinear block from which it was carved. Examples of both types wear the hairstyle characteristic of warriors. Just like their equivalents in the eastern part of pre-Hispanic Mexico, these altars were understood to be the bearers of a message that transcended the terrestrial plane. Thus the warrior was selected as the being best suited to deliver such a highly valued offering.

Another element that was widely diffused during the Late Postclassic period is the sacrificial stone, which in the Tarascan style has the form of a reclining coyote with rough features and flexed feet; this form is closely linked to the object's function of supporting a sacrifical victim while the heart was removed. A zoomorphic throne (a form very popular among the Maya and Tolteca, although depicting different animals) is quite an interesting variation for its choice of subject: Rendered as a coyote standing on its four paws, it is panting, with its mouth open and tongue hanging out. Such representations of coyotes may be the most expressive of all Tarascan stone sculpture.

By contrast ceramics, the lapidary arts, and metalwork were the mediums used for the culture's most refined creations, which are comparable to the works of the greatest Mesoamerican artisans. Tarascan potters created magnificent designs for their ritual vessels, produced in an extraordinary range of forms and the most varied sizes. We still know very little about their symbology. Because of the excellent polish and colorful polychromy of their finish, these vessels are considered on a par with the most sophisticated ceramic traditions of their time. The Tarascans are also recognized for their long, elegant clay pipes.

Among the finest examples of yet another distinctive Tarascan art form, jewelry, are the delicate pieces fashioned in red and black obsidian. In spite of the fragile, brittle nature of volcanic glass, some beautiful, obsidian earspools and lip-plugs have survived to this day. They testify to the great labor necessary to achieve their exceptional translucence, which is enlivened by turquoise plaques inlaid in the center and, in other examples, settings of hammered gold.

In working metal, the Tarascans used various techniques to create a great variety of designs, forms, and utensils. Among the methods were hammering, lost-wax casting, forging, and filigree. They also applied gold plate to copper, which called for an exacting chemical process. The range of items executed in metal, such as awls, needles, axes, bells, repoussé disks, and pectorals, permeated all spheres of daily life from early in Tarascan history. Perhaps this work is most representative of their imperial bloc, as it was shaped by a culture highly focused on production control and political domination, relegating to a lower order the refinement of sculptural techniques and ornamental architecture.

This collective identity forged Tarascan thinking and reflects the effectiveness of its

182. Coyote
Tarascan, ca. 1250–1521

183. Feather
Tarascan, ca. 1250–1521

cosmological strategy at the societal level, which was a process abruptly interrupted by the Conquest. Their system shows a secular advance characteristic of the Bronze Age in this region of the Americas. Perhaps if the discovery of the New World had been delayed, when the Spaniards arrived on the eastern shores of Mexico they might have heard not of the glories of the Aztecs but of great dominions in the west, where the sun set in the lands of the warrior sun, son of Curicaueri. Had there been more time, in an epic battle Curicaueri might have defeated the Aztec god Huitzilopochtli, the left-handed sun. The followers of the victorious god—in accordance with his wishes—might have built a city dedicated to his greatness on the shores of Lake Patzcuaro.

184. Throne in the shape of a coyote
Tarascan, ca. 1250–1521

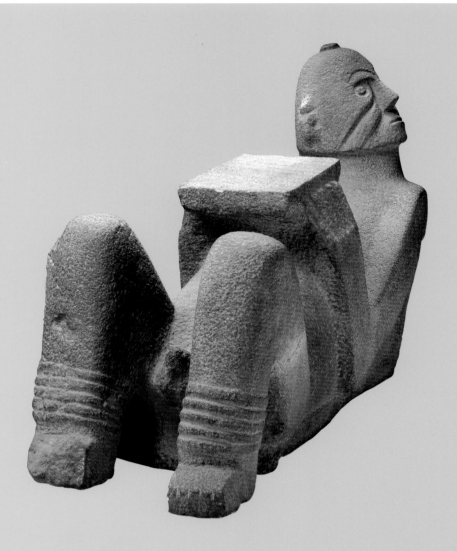

185. Chacmool
Tarascan, ca. 1250–1521

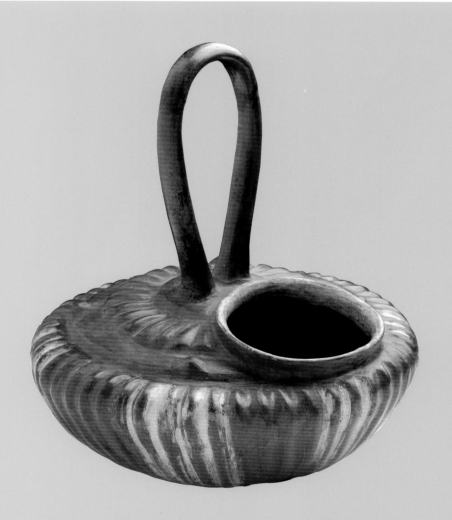

186. Polychrome pot with handle
Tarascan, ca. 1250–1521

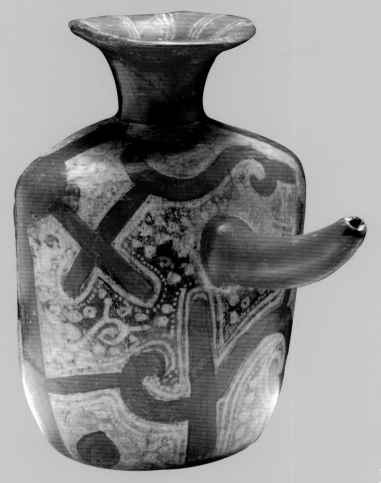

187. Polychrome vessel with spout
Tarascan, ca. 1250–1521

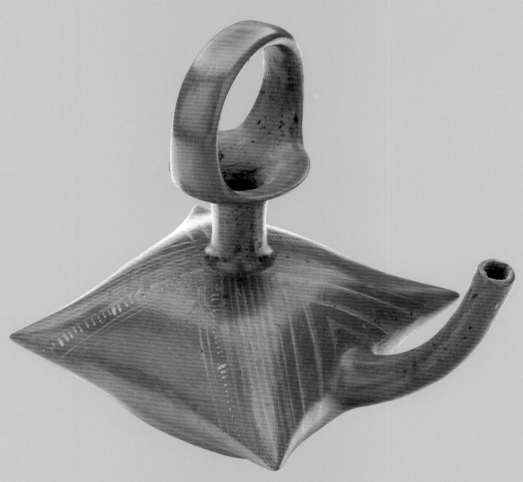

188. Polychrome vessel
Tarascan, ca. 1250–1521

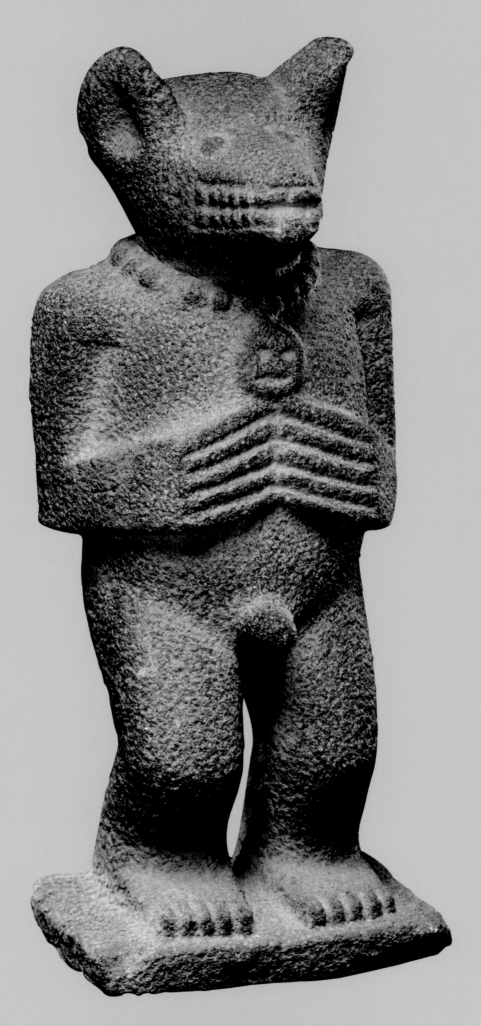

189. Coyote sculpture
Tarascan, ca. 1200–1521

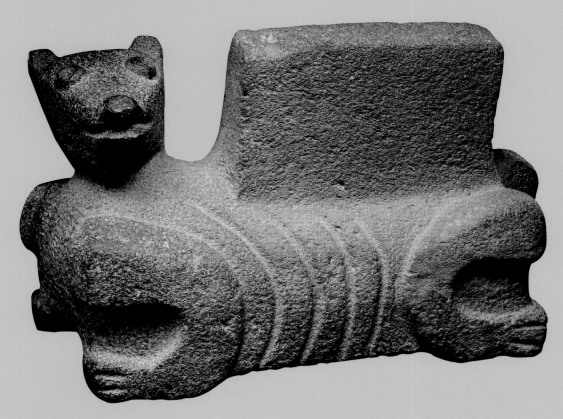

190. Techcatl in the shape of an animal
Tarascan, ca. 1200–1521

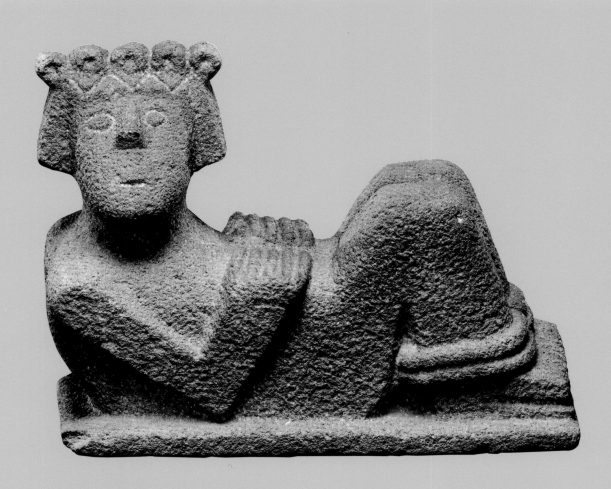

191. Chacmool
Tarascan, ca. 1200–1521

The Fall of
the Empires

The Conquest as Seen by the Mexica-Aztecs

Miguel Léon-Portilla

IT IS OFTEN SAID THAT THE HISTORY OF WARS AND OTHER CONFRONTATIONS IS WRITTEN BY THE winners. So it was with the Conquest of Mexico. Hernán Cortés wrote long letters to Emperor Charles V describing his own deeds,[1] as did other conquistadores such as Bernal Díaz del Castillo, author of the *True History of the Discovery and Conquest of Mexico.*[2]

But in this case, the vanquished—the Mexica-Aztecs and others—also wrote about their own disgraceful fate. Fray Juan de Torquemada in his major work, *Monarquía Indiana*, published in 1615, wrote of the massacre at the Templo Mayor of Tenochtitlan: "I have a history in Nahuatl [the Mexican language], well written by an Indian who says that he was present there when he was still young, and wrote it later, when he learned how to write."[3] There are several other native testimonies of the vanquished, among them those transcribed by Fray Bernardino de Sahagún's scribes around 1554 and included in the *Florentine Codex.*[4] The *Annals of Tlatelolco*, an older manuscript, also includes an account of the Conquest,[5] as do a number of pictoglyphic documents or codices, such as the *Lienzo de Tlaxcala* and the *Codices Azcatitlan, Mexicanus, Telleriano-Remensis, Vaticanus A, Moctezuma, Aubin,* and *Tepechpan.*[6] Although such records were forgotten for many years, more recently they have been brought back to light.

Here I will present some of the testimonies that described the most dramatic episodes of this confrontation, which dealt a mortal blow to the Mesoamerican civilization.

Were they prophecies a posteriori? Priests and sages among both the Mexica and the Maya spoke of portentous happenings preceding the arrival of the Spaniards, which may be interpreted as a prologue to the story. Here is one of the omens:

> The people heard in the night the voice of a weeping woman, who sobbed and sighed and drowned herself in her tears. This woman cried: "O my sons, we are lost. . .!" Or she cried: "O my sons, where can I hide you . . .?"[7]

A messenger from the Gulf Coast reported seeing boats as large as towers or small mountains floating on the sea. Upon hearing this news, the Aztec ruler, Motecuhzoma II, became deeply concerned:

> Other messengers told him how they had made the journey, and what they had seen, and what food the strangers ate. Motecuhzoma was astonished and terrified by their report, and the description of the strangers' food astonished him above all else.
>
> He was also terrified to learn how a tube of metal [a cannon]

Page from Fray Diego Durán, *Codex Durán*, also known as *Historia de las Indias de Nueva España e Islas de Tierra Firme*, 1579–81.

roared, how its noise resounded, how it caused one to faint and grow deaf. The messengers told him: "A thing like a ball of stone comes out of its entrails. It comes out shooting sparks and raining fire. The smoke that comes out with it has a pestilent odor, like that of rotten mud. Their deer carry them on their backs wherever they wish to go. These deer, our lord, are as tall as the roof of a house.

The strangers' bodies are completely covered, so that only their faces can be seen. Their skin is white, as if it were made of lime. They have yellow hair, though some of them have black. Their beards are long and yellow, and their moustaches are also yellow.

When Motecuhzoma heard this report, he was filled with terror. It was as if his heart had fainted, as if it had shriveled. It was as if he were conquered by despair.[8]

Despite Motecuhzoma's efforts to dissuade the Spaniards from marching to Tenochtitlan, the Aztec metropolis, Cortés mobilized some of his men and Indian allies. En route he met the Tlaxcalans, who were friendly toward him and would prove to be a great help in his confrontation with the Mexica:

The lords of Tlaxcala went out to meet the Spaniards, bringing many things to eat: hens and hens' eggs and the finest tortillas. They said to the strangers: "Our lords, you are weary."

The strangers replied: "Where do you live? Where are you from?"

They said: "We are from Tlaxcala. You have come here, you have entered our land."

Then they guided them to the city; they brought them there and invited them to enter. They paid them great honors, joined with them as allies and even gave them their daughters.

The Spaniards asked: "Where is the City of Mexico [Tenochtitlan]? Is it far from here?"

They said: "No, it is not far, it is only a three-days march. And it is a great city. The Mexica are very brave. They are great warriors and conquerors and have defeated their neighbors on every side."[9]

Accompanied by several thousand Tlaxcalteca, the Spaniards entered the city of Chololan (modern Cholula), where, according to Cortés and his Tlaxcalan friends, the people were conspiring to trap and kill the Spaniards. Anticipating the assault, the Spaniards attacked and massacred the Cholollans.

The Spaniards continued their march, finally arriving at Tenochtitlan, where Motecuhzoma received Cortés and his men and lodged them in a palace:

Thus Motecuhzoma went out to meet them, there in Huitzillan. He presented many gifts to the Captain and his commanders, those who had come to make war. He showered gifts upon them and hung flowers

Above and facing page: Pages from Fray Diego Durán, *Codex Durán*, also known as *Historia de las Indias de Nueva España e Islas de Tierra Firme*, 1579–81.

around their necks; he gave them necklaces of flowers. Then he hung gold necklaces around their necks and gave them presents of every sort as gifts of welcome.

When Motecuhzoma had given necklaces to each one, Cortés asked him: "Are you Motecuhzoma? Are you the high ruler? Is it true that you are Motecuhzoma?"

And he answered: "Yes, I am Motecuhzoma." Then he stood up to welcome Cortés; he came forward, bowed his head low and addressed him in these words: "Our lord, you are weary. The journey has tired you, but now you have arrived on the earth. You have come to your city, Mexico. You have come here to sit on your throne, to sit under its canopy.

"The kings who have gone before, your representatives, guarded it and preserved it for your coming. The kings Itzcoatl, Motecuhzoma the Elder, Axayacatl, Tizoc, and Ahuitzotl ruled for you in the City of Mexico. The people were protected by their swords and sheltered by their shields.

"Did the kings know the destiny of those they left behind, their posterity? If only they are watching! If only they can see what I see!

"No, it is not a dream. I am not walking in my sleep. I am not seeing you in my dreams. I have seen you at last! I have met you face to face! I was in agony for five days, for ten days, with my eyes fixed on the Region of the Mystery. And now you have come out of the clouds and mists to sit on your throne again."[10]

During the Spaniards' stay in the metropolis, Cortés was called away to Veracruz. In his absence, Cortés's captain Pedro de Alvarado ordered the massacre of a group of Mexica during a great feast at the Templo Mayor, an attack that enraged the Indians. When Cortés returned to Tenochtitlan, he contemplated what had happened and decided to try to escape from the city with his men. The fleeing Spaniards were discovered and attacked by the Mexica, and many of them were killed. The text begins by describing the events at the feast:

At this moment in the feast, when the dance was loveliest and when song was linked to song, the Spaniards were seized with an urge to kill the celebrants. They closed the entrances and passageways, all the gates of the patio. They posted guards so that no one could escape, and then rushed into the sacred patio to slaughter the celebrants.

They ran in among the dancers, forcing their way to the place where the drums were played. They attacked the man who was drumming and cut off his arms. Then they cut off his head, and it rolled across the floor.

They attacked all the celebrants, stabbing them, spearing them, striking them with their swords. They

attacked some of them from behind, and these fell instantly to the ground with their entrails hanging out. Others they beheaded.

Some Mexica attempted to force their way out, but the Spaniards murdered them at the gates. Others climbed the walls, but they could not save themselves. Those who ran into the communal houses were safe there for a while.

The blood of the warriors flowed like water. The stench of blood and entrails filled the air. The Spaniards ran into the communal houses to kill those who were hiding. They ran everywhere and searched everywhere; they invaded every room, hunting and killing.

When the news of this massacre was heard outside the sacred patio, a great cry went up: "Mexica, come running! Bring your spears and shields! The strangers have murdered our warriors!"

The Spaniards immediately took refuge in the palace. They began to shoot at the Mexica with their iron arrows and to fire their cannons and arquebuses. And they shackled Motecuhzoma in chains. . . .

The first alarm was raised by a woman who was drawing water at the edge of the canal. She cried: "Mexica, come running! They are crossing the canal! Our enemies are escaping!"

Then a priest of Huitzilopochtli shouted the call to arms from the temple pyramid. His voice rang out over the city: "Captains, warriors, Mexica! Our enemies are escaping! Follow them in your boats. Cut them off, and destroy them!"

When they heard this cry, the warriors leaped into their boats and set out in pursuit. The boatmen paddled with all their might; they lashed the water of the lake until it boiled. The boats converged on the Spaniards from both sides of the causeway, and the warriors loosed a storm of arrows at the fleeing army.[11]

Escaping from the Mexica, the Spaniards took refuge among their allies in Tlaxcala, where they prepared themselves for their return to Tenochtitlan. Motecuhzoma died when the Spaniards' escaped from the city and was succeeded by Prince Cuitlahuac, but he soon fell victim to the smallpox epidemic that had been introduced among the Mexica. Prince Cuauhtemoc was then elected to govern the Mexica nation, and it was he who led the resistance to the Spaniards' siege of the city:

And now the Spaniards came back again. They marched here by way of Tezcoco, set up headquarters in Tlacopan and then divided their forces.

The first battle began outside Tlatelolco, either at the ash pits or at the place called the Point of the Alders, and then shifted to Nonohualco. Our warriors put the enemy to flight and not a single Mexica was killed. The Spaniards tried a second advance but our warriors attacked them from their boats, loosing such a storm of arrows that the Spaniards were forced to retreat again.

The Spaniards now decided to attack Tenochtitlan and destroy its people. The cannons were mounted in the ships, the sails were raised, and the fleet moved out onto the lake. The flagship led the way, flying a great linen standard with Cortés's coat of arms. The soldiers beat their drums and blew their trumpets; they played their flutes and chirimias and whistles.

When the ships approached the Zoquiapan quarter, the common people were terrified at the sight. They gathered their children into the canoes and fled helter-skelter across the lake, moaning with fear and paddling as swiftly as they could. They left all their possessions behind them and abandoned their little farms without looking back.

When the Mexica discovered that the shots from the arquebuses and cannons always flew in a straight line, they no longer ran away in the line of fire. They ran to the right or left or in zigzags, not in front of the guns. If they saw that a cannon was about to be fired and they could not escape by running, they threw themselves to the ground and lay flat until the shot had passed over them.

The heaviest fighting began when the Spaniards entered Nonohualco. None of our enemies and none of our own warriors escaped harm. Everyone was wounded, and the toll of the dead was grievous on both sides. The struggle continued all day and all night. At last the Spaniards were too exhausted to keep on fighting. After one final attempt to break the Mexica ranks, they withdrew to their camp to rest and recover.[12]

After eighty days of siege, Tenochtitlan fell to the Spaniards and Cuauhtemoc surrendered. The heartbreaking grief of the vanquished is expressed in laments:

All these misfortunes befell us.
We saw them
and wondered at them;
we suffered this unhappy fate.[13]

Nothing but flowers and songs of sorrow
are left here in Mexico and Tlatelolco,
where courage is manifest.
It is good to know, Giver of Life,
that you look after us,
although we, your servants, will perish.
You have scattered your servants in Tlatelolco,

Page from the *Codex Moctezuma*, 16th century.

our cries of grief rise up,
our tears rain down
for Tlatelolco is lost.
Mexica women
have gone into the water,
so it is,
but we, where will we go?
Oh our friends!

The Mexica are deserting
the city of Mexico,
which is now in flames
and all is destruction;
this you have done,
Giver of Life.

Remember Mexica
that He has sent down to us
his wrath, his fear.
Weep and learn, oh our friends,
that with these disasters
we have lost the Mexican nation.

The water has turned bitter,
our food is bitter
these are the acts of the Giver of Life.[14]

These are among the Mexica testimonies of astonishment and sorrow that stand alongside Spanish accounts of the Conquest of Mexico. These views from the vanquished form an epic poem, a classic elegiac expression that has become part of a truly universal literature.

Notes
1. Hernán Cortés, *Cartas y documentos*, ed. Mario Hernández Sánchez-Barba (Mexico City: Librería Porrua, 1969).
2. Bernal Díaz del Castillo, *Historia verdadera de la conquista de la Nueva España*, ed. Joaquín Ramírez Cabañas, 2 vols. (Mexico City: Editorial Porrua, 1955).
3. Fray Juan de Torquemada, *Monarquía Indiana*, ed. Miguel León-Portilla, 7 vols. (Mexico City: Universidad Nacional Autónoma de México, Instituto de Investigaciones Históricas, 1975–83), vol. II, p. 225 (trans. author).
4. Fray Bernardino de Sahagún, *Florentine Codex: General History of the Things of New Spain*, trans. Arthur J. O. Anderson and Charles E. Dibble, 13 vols. (Santa Fe: School of American Research, 1950–82).
5. The account of the Conquest included in *The Annals of Tlatelolco* has been translated into English by Angel Garibay and Lysander Kemp and appears in Miguel León-Portilla, ed., *The Broken Spears* (Boston: Beacon Press, 1992).
6. These manuscripts are described in Donald Robertson, *Mexican Manuscript Painting of the Early Colonial Period: The Metropolitan Schools* (New Haven: Yale University Press, 1959).
7. *Florentine Codex*, book 12, fol. 2v.
8. Ibid., fol. 11r–v.
9. Ibid., fols. 15v–16r.
10. Ibid., fols. 24v–25r.
11. Ibid., fols. 32r–34r.
12. Ibid., fols. 67v–68r.
13. *Annals of Tlatelolco*, fol. 33.
14. Manuscript of Mexican songs, preserved at the National Library, Mexico, fol. 6r.

Pages from Fray Pedro de Gante,
Testerian Catechism, 16th century

The Spanish Conquest of Tenochtitlan

Pablo Escalante Gonzalbo

MOTECUHZOMA II WAS CONVINCED THAT HIS PEOPLE WOULD BE DEFEATED IF THEY OPPOSED THE Spaniards, and thus he decided to receive the strangers peacefully. Hospitality, however, was not enough to keep war from his city. During the conquistadores' sojourn in Mexico as guests of Motecuhzoma, some of Hernán Cortés's officials became alarmed when seeing young Mexica-Aztecs dancing in the courtyard of the Templo Mayor at Tenochtitlan. They perceived a threat in this display, which was nothing more than a group of scantily clad boys and musicians playing drums, and killed them all. Enraged, the Mexica took up arms, renounced their emperor, and pelted him with stones when he appeared on a balcony to plead with them once again not to enter into battle.

As a result of these events, the Spaniards were besieged and cut off from their supplies. They decided to escape the city in late June 1520. Many were captured during their attempt to flee and were later sacrificed. Others died in the battles that erupted along the city's canals, and there were some who drowned, weighed down by the gold they had concealed in their clothing. Only a third of the Spanish force managed to escape.

With the defeat and expulsion of the Spaniards, the phase of tenuous interaction between the foreigners and the native population ended. Formal war began, guided by the Spanish aim of conquering Mexico. Within a year, Cortés had managed to multiply his alliances with indigenous caciques of the Valley of Mexico and nearby areas, and had drafted a strategy for laying siege to the city by both land and water. In the meantime, smallpox, which had infected the Mexica before the conquistadores fled Tenochtitlan, continued to decimate the city's people. Among its victims was Cuitlahuac, Motecuhzoma's successor.

In an alliance with the Tlaxcalateca, Totonaca, Tetzcocans, Chalca, and other groups, the Spaniards began their attack on the twin islands of Tenochtitlan and Tlatelolco at the end of May 1521, and by August 13 of the same year had captured Cuauhtemoc, who had ascended the throne after Cuitlahuac's death.

Along with the great valor and courage displayed by both opponents, the miseries that generally accompany war also prevailed: fear, cruelty, and desperation. The resistance of the Mexica continued almost inexplicably: They lacked potable water, staggered with hunger among the corpses of friends and relatives, and looked on helplessly as their women fell into the enemy's hands. Despite the advantage of their greater numbers and access to fresh food, the Spaniards suffered the agonies of war as well. Among them were wounds and exhaustion, the panic wrought by seeing comrades captured by Mexica warriors, and the horror of witnessing these prisoners being offered in sacrifice, the victims' heads later displayed along the *tzompantli* (skull rack) in the Templo Mayor.

Each time Cortés and his men laid siege to one of the islets that made up the city's neighborhoods, they destroyed its buildings and used the debris to fill in the canals and thus facilitate the Spanish force's movement over land. In the

192. Atrium cross
Colonial, ca. 1600

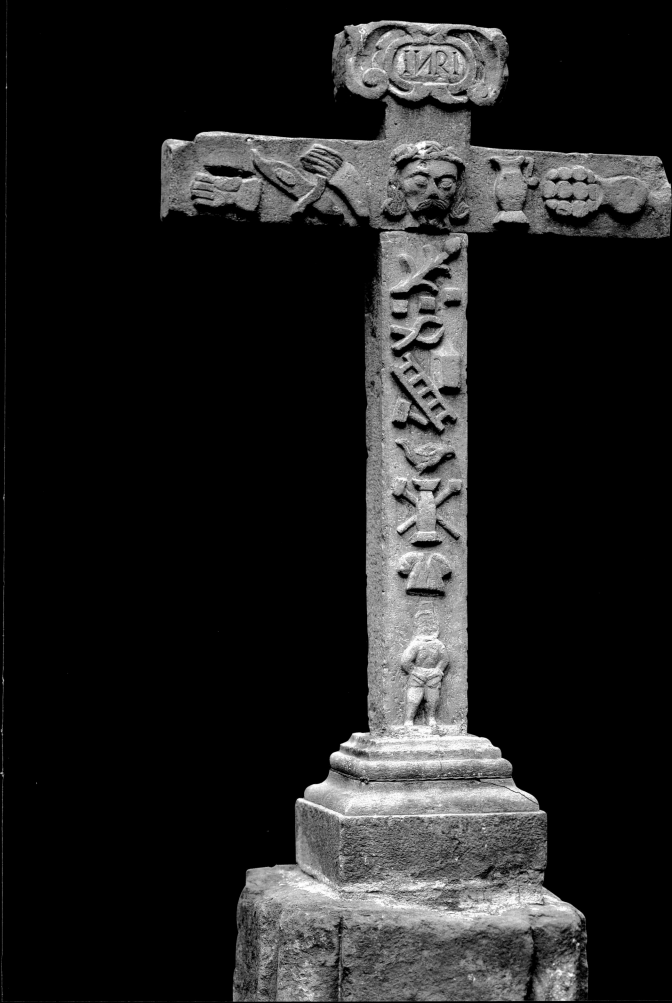

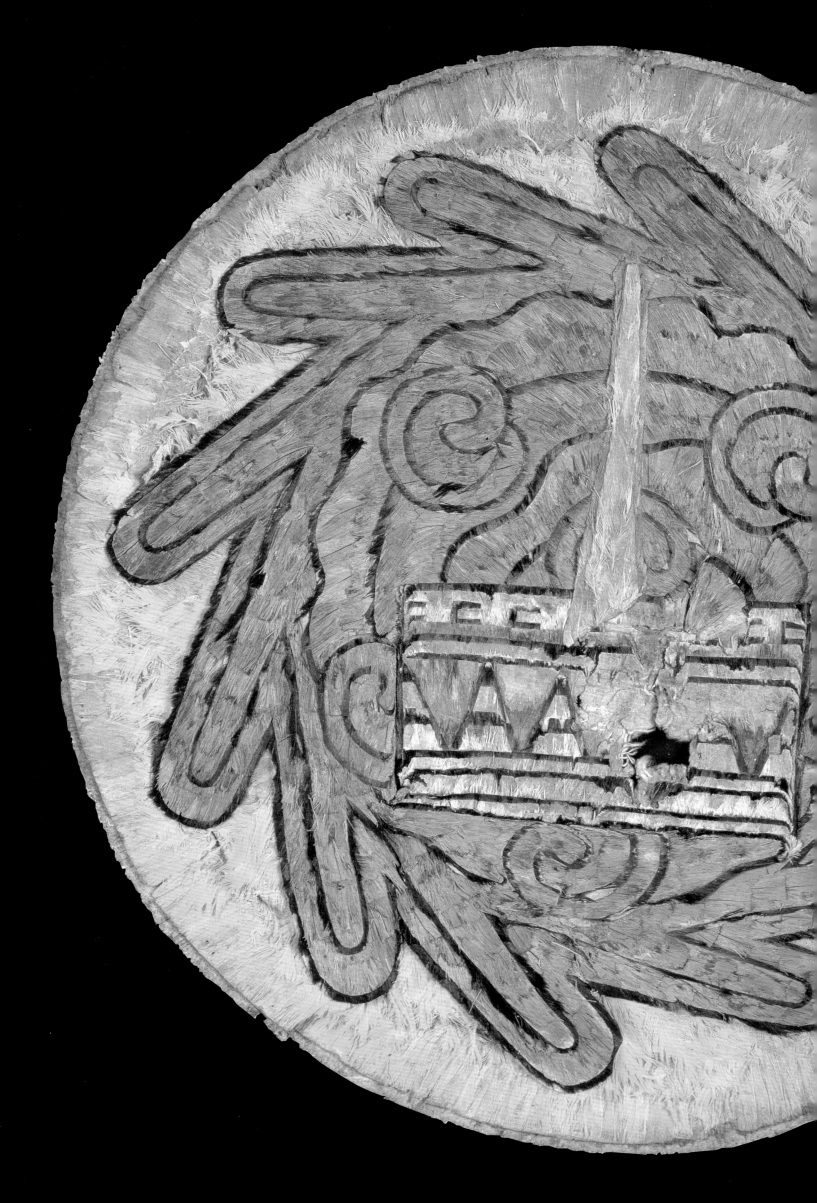

193. Chalice lid
Colonial, ca. 1540

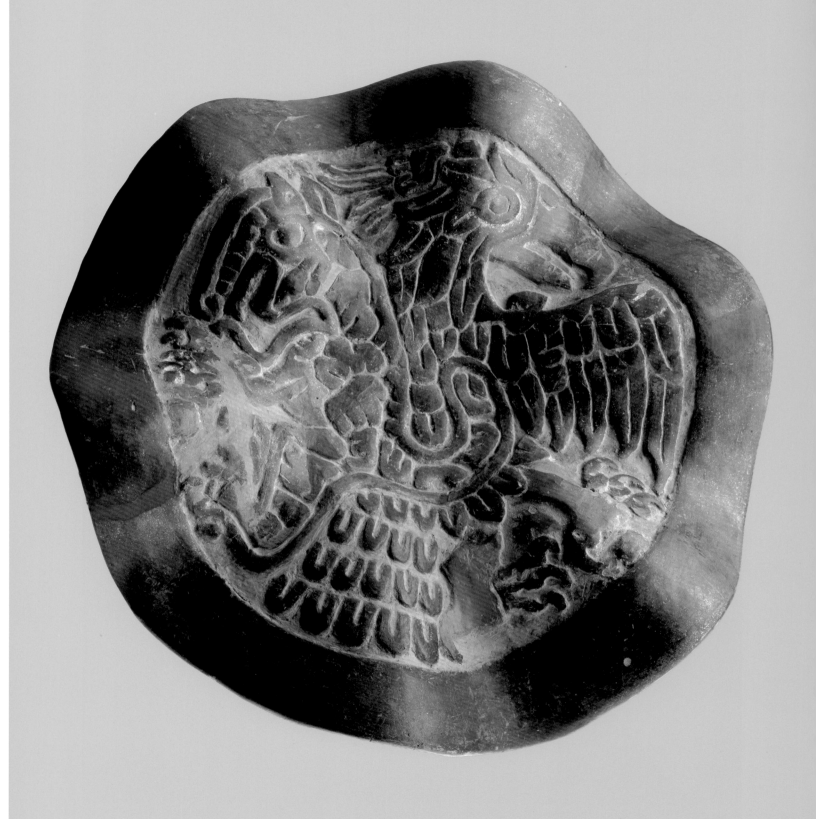

194. Ceremonial tripod plate
Aztec-Colonial, ca. 1530

end, Tenochtitlan was transformed into a squalid swamp immersed in brackish water and covered with cadavers. The city had to be temporarily abandoned, while the tasks of draining and cleaning, burying the dead, and reestablishing the flow of drinking water were accomplished.

Cortés temporarily established his headquarters at Coyoacan, along the southern shore of Lake Tetzcoco. From there he gave instructions for preparing the terrain of Tenochtitlan for a new city. Its center was to be cleared to make room for Spanish structures, which were to be laid out in a grid, and the indigenous neighborhoods, outside the Spanish core, were to be divided among the former four districts of Tenochtitlan.

The buildings and monuments of the Nahua metropolis were thus replaced by the palaces, fortifications, and churches of the Spaniards. However, it should be noted that not all cities in Mesoamerica were so quickly obliterated. When Antonio de Mendoza, the first viceroy of Mexico, made a tour of New Spain in 1535, he was surprised to find that, fifteen years after the Conquest, most of the other pre-Hispanic cities and religious centers still remained intact. The viceroy supposed, probably justifiably, that Cortés had preserved certain buildings as reminders of the splendors of the old civilizations, which would in turn suggest to New Spain's residents that the Conquest had been a courageous undertaking and its success a glorious achievement. Over the course of his administration, Mendoza proceeded with the systematic destruction of pyramids and temples throughout New Spain.

The stone obtained from the demolition of indigenous structures was always used in the foundations of new buildings, and thus provided considerable savings in labor. However, this was not the only reason for recycling stones. Some in the religious orders felt it advisable to keep fragments of indigenous sculptures visible, so that they might give lasting testimony to the triumph of the true god over the false ones. Today vestiges of those "vanquished" sculptures can still be seen in houses, churches, and convents.

Aside from the military defeat and destruction of the Mesoamerican civilizations, we should remember that the encounter between the Spanish and the indigenous people was, in many respects, a rich and creative one. Two of the most important results of their meeting were the development of a strongly syncretic Christian liturgy and, especially, the creation of artworks that reflect both traditions, which have been called "Indo-Christian."

In this intercultural dialogue, which may be likened to that of medieval Toledo, friars and Indians studied, translated, and exchanged ideas about their own respective traditions. This interchange—prevalent most notably at the Colegio de Santa Cruz in Tlatelolco—together with numerous missionary efforts led to concrete results. Among them were the inclusion of indigenous dance traditions, instruments, ornamentation, and imagery in Christianity, as well as the acceptance of pre-Hispanic symbols, such as the jade bead, or *chalchihuitl*, which would now be used to signify the precious blood of Christ and the holy water of baptism.

This attitude of hybridization, favorable to the coexistence of both traditions, explains why a great *cuauhxicalli* (eagle vessel) used to hold human hearts during sacrifices at the Templo Mayor in Tenochtitlan could be converted into a baptismal font. According to an explanation provided by the Dominican friar Diego Durán, "It is fitting that this vessel, which held blood of humans sacrificed to the devil, is now a font of the Holy Spirit, where the souls of Christians may be cleansed."

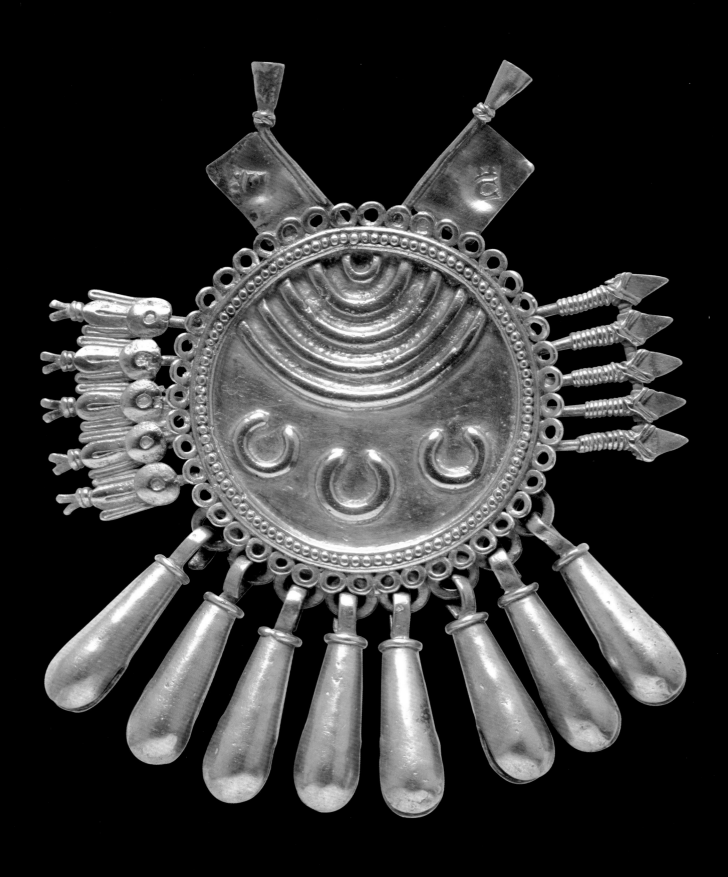

195. Pendant in the shape of a shield
Aztec-Mixtec, ca. 1500

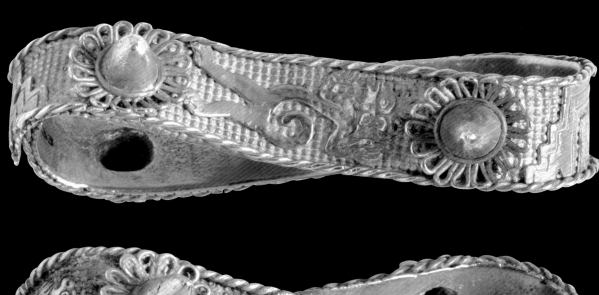

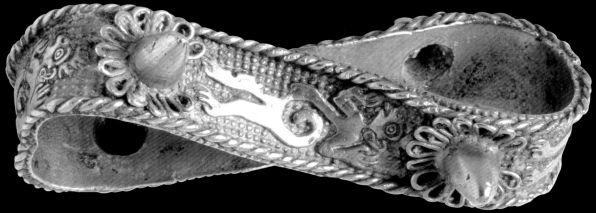

196. Bracelets
Aztec-Mixtec, ca. 1500

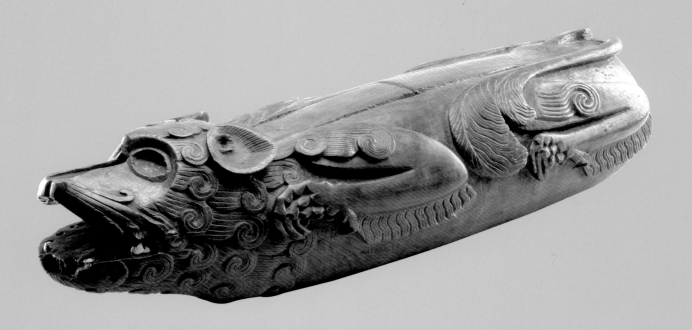

197. Teponaztli
Colonial, ca. 1521–1600

198. Mirror or portable altar
Colonial, ca. 1521–30

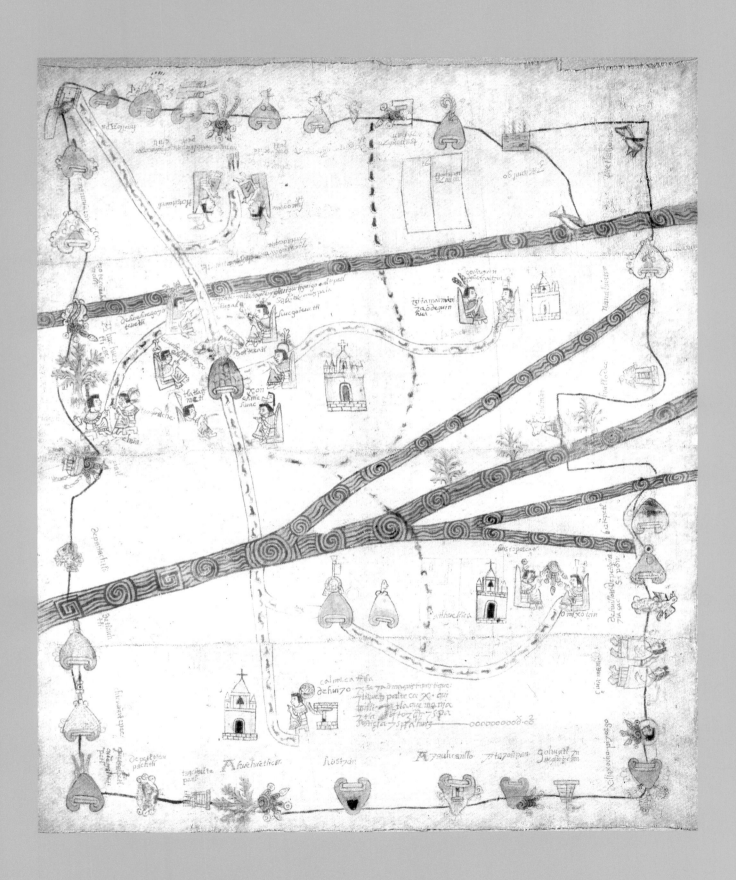

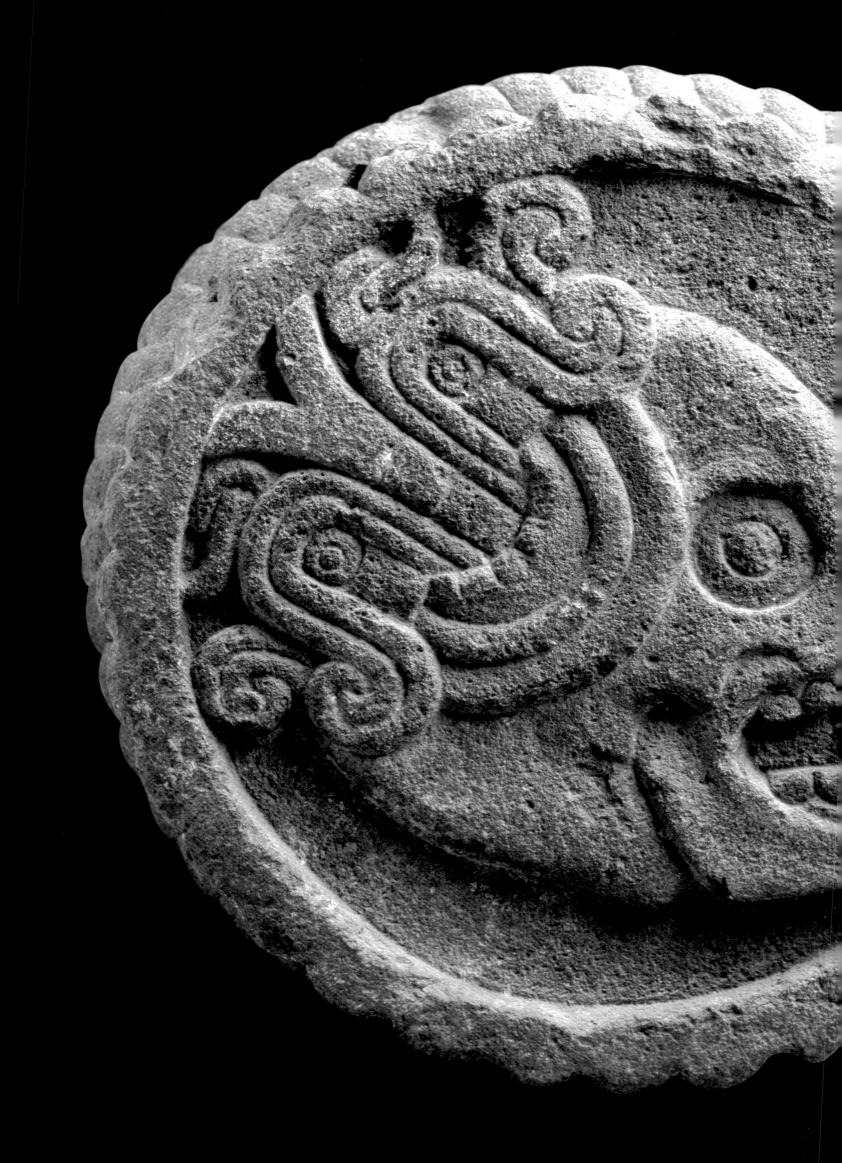

Catalogue Checklist
and Bibliography

Catalogue Checklist

8
Polychrome goblet
Cholollan, ca. 1325–1521
Fired clay and pigment, 12 x 15.2 cm
Museo Nacional de Antropología, INAH, Mexico City 10-223731

9
Dog
Aztec, ca. 1500
Stone, 47.5 x 20 x 29 cm
Museo Regional de Puebla, INAH 10-203439

10
Grasshopper
Aztec, ca. 1500
Carnelian, 19.5 x 16 x 47 cm
Museo Nacional de Antropología, INAH, Mexico City 10-220929

11
Reclining jaguar
Aztec, ca. 1440–1521
Stone, 12.7 x 27.9 x 14.6 cm
Brooklyn Museum, New York, Carll H. de Silver Fund 38.45

12
Serpent
Aztec, ca. 1500
Stone, 31 x 44 x 24 cm
Museo Nacional de Antropología, INAH, Mexico City 10-220932

13
Sculpture of a king
Huaxtec, 13th or 14th century
Stone, 165.6 x 37.5 x 19.1 cm
Brooklyn Museum, New York, Frank L. Babbott Fund 39.371

14
Female anthropomorphic sculpture
Aztec, ca. 1200–1521
Stone and trace pigment, 54 x 34 x 22 cm
American Museum of Natural History, New York 30.1/1201

15
Macehual
Aztec, ca. 1500
Stone, 80 x 28 x 19 cm
Museo Nacional de Antropología, INAH, Mexico City 10-220926

16
Old man
Aztec, ca. 1500
Stone, 48 x 23 cm
Museo Nacional de Antropología, INAH, Mexico City 10-220145

17
Chalchiuhtlicue
Aztec, ca. 1500
Diorite, 85 x 37 x 25 cm
Museo Nacional de Antropología, INAH, Mexico City 10-82215

18
Macehual
Aztec, ca. 1500
Stone, 63 x 20 cm
Museo Nacional de Antropología, INAH, Mexico City 10-620964

19
Hunchback
Aztec, ca. 1500
Stone, 33 x 17 x 12 cm
Museo Nacional de Antropología, INAH, Mexico City 10-97

20
Man holding a cacao pod
Aztec, ca. 1440–1521
Stone and pigment, 36.2 x 17.8 x 19.1 cm
Brooklyn Museum, New York, Museum Collection Fund 40.16

21
Mask
Eastern Nahua-Mixtec, ca. 1500
Wood with traces of gesso, gold leaf, and hematite, 20.5 x 20.2 cm
Princeton University Art Museum, Gift of Mrs. Gerard B. Lambert y1970-111

22
Female anthropomorphic sculpture
Aztec, ca. 1500
Stone, 146 x 40 x 25 cm
Museo Nacional de Antropología, INAH, Mexico City 10-81543

23
Male anthropomorphic sculpture
Aztec, ca. 1500
Stone, 55 x 20 x 15 cm
Museo Nacional de Antropología, INAH, Mexico City 10-1121

24
Anthropomorphic figure
Huaxtec, ca. 1500
Fired clay, 24 x 22 x 16 cm
American Museum of Natural History, New York 30.2/4200

25
Fertility goddess
Aztec-Matlatzinca, ca. 1500
Wood and shell, 40 x 15 x 10 cm
Museo Nacional de Antropología, INAH, Mexico City 10-74751

26
Anthropomorphic mask
Aztec–Gulf Coast, ca. 1450–1521
Stone, 17 x 18.5 x 9.3 cm
American Museum of Natural History, New York 30/11847

27
Xantil
Mixtec, ca. 1250–1521
Fired clay, 40 x 28 x 18 cm
Museo Nacional de Antropología, INAH, Mexico City 10-13518

28
Anthropomorphic sculpture
Tarascan, ca. 1500
Stone, 56.5 x 22.5 x 18.5 cm
American Museum of Natural History, New York 30/2461

29
Male anthropomorphic sculpture
Olmec, ca. 800 B.C.
Greenstone and cinnabar, 52 x 29 cm
Museo Regional de Puebla, INAH 10-203321

30
Mask
Olmec, ca. 1150–550 B.C.
Jadeite with black inclusions, 21.6 x 19.4 cm
Museum of Fine Arts, Boston, Gift of Landon T. Clay 1991.968

31
Goddess figure (Chalchiuhtlicue)
Teotihuacan, ca. 250–650
Volcanic stone with traces of pigment, 92.1 x 40.6 x 41.3 cm
Philadelphia Museum of Art, The Louise and Walter Arensberg Collection 1950-134-282

32
Anthropomorphic mask
Teotihuacan, ca. 450
Stone, turquoise, obsidian, and shell, 21.5 x 20 cm
Museo Nacional de Antropología, INAH, Mexico City 10-9630

33
Face panel
Teotihuacan, ca. 1–800
Granite, 20.3 x 10.2 x 25.4 cm
Philadelphia Museum of Art, The Louise and Walter Arensberg Collection 1950-134-947

34
Jaguar architectural element
Teotihuacan, ca. 400
Stone, stucco, and pigment, 96.5 x 97.5 x 74.5 cm
Museo Nacional de Antropología, INAH, Mexico City 10-626269 0/10

35
Polychrome tripod vase
Teotihuacan, ca. 450
Fired clay, stucco, and pigment, h. 15 cm, diam. 16.5 cm
Museo Nacional de Antropología, INAH, Mexico City 10-79930

36
Tlaloc vase
Teotihuacan, ca. 400
Greenstone, 24.5 x 14 cm
Museo Nacional de Antropología, INAH, Mexico City 10-9626

37
Penate
Teotihuacan, ca. 400
Greenstone, 25.5 x 10.2 cm
Museo Nacional de Antropología, INAH, Mexico City 10-2562

38
Jaguar
Teotihuacan, ca. 100–600
Tecalli onyx, 19.9 x 13.5 x 15 cm
Museo Nacional de Antropología, INAH, Mexico City 10-78331

39
Penate
Teotihuacan, ca. 100–600
Greenstone, 48 x 12 x 8 cm
Fundación Cultural Televisa, Mexico City REG 21 PJ 43

40
Fragment of a mural painting
Teotihuacan, ca. 100–600
Stucco and pigment, 77 x 162.5 x 8 cm
Museo Nacional de Antropología, INAH, Mexico City 10-357205

41
Plaque with an image of a goddess with a reptile-eye glyph
Teotihuacan, ca. 250–700
Pale green, translucent onyx, 29.4 x 16.5 x 3.5 cm
The Field Museum of Natural History, Chicago 23913

42
Cuirass
Toltec, ca. 900–1200
Spondylus shell, mother of pearl, and snail shells, 37 x 110 x 3 cm
Museo Regional de Hidalgo "Ex Convento de San Francisco," INAH, Pachuca 10-568994 0/2

43
Disk
Toltec, ca. 900–1200
Wood, turquoise, shell, coral, and resin, diam. 35 cm
Museo Nacional de Antropología, INAH, Mexico City 10-564025

44
Chacmool
Toltec, ca. 1100
Stone, 85 x 120 x 54 cm
Museo Arqueológico de Tula "Jorge R. Acosta," INAH 10-215198

45
Coyolxauhqui
Aztec, ca. 1500
Diorite, 80 x 85 x 68 cm
Museo Nacional de Antropología, INAH, Mexico City 10-220918

46
Huehueteotl
Aztec, ca. 1486–1502
Stone, 60 x 57.3 x 56 cm
Museo del Templo Mayor, INAH, Mexico City 10-212978

47
Chacmool
Aztec, ca. 1500
Stone, 74 x 108 x 45 cm
Museo Nacional de Antropología, INAH, Mexico City 10-10941

48
Eagle cuauhxicalli
Aztec, ca. 1502–20
Stone, 76 x 82 x 139 cm
Museo del Templo Mayor, INAH, Mexico City 10-252747

49
Snail shell
Aztec, ca. 1500
Stone, stucco, and pigment, 105 x 75 cm
Museo Nacional de Antropología, INAH, Mexico City 10-213080

50
Tlaloc casket (tepetlacalli)
Aztec, ca. 1469–81
Stone, 69 x 58 x 38 cm
Museo del Templo Mayor, INAH, Mexico City 10-168850 0/2

51
Sad Indian
Aztec, ca. 1500
Stone, 102 x 60 x 57 cm
Museo Nacional de Antropología, INAH, Mexico City 10-81660

52
Mictlantecuhtli urn
Aztec, ca. 1500
Alabaster, 16.5 x 11 cm
Museo Nacional de Antropología, INAH, Mexico City 10-168816

53
Omexicahuaztli
Aztec, ca. 1250–1521
Stone and stucco, 10 x 30 cm
Museo del Templo Mayor, INAH, Mexico City 10-251274

54
Funerary urn
Aztec, ca. 1470
Fired clay, h. 53 cm, diam. 17 cm
Museo del Templo Mayor, INAH, Mexico City 10-168823 0/2

55
Tlaloc pot
Aztec, ca. 1440–69
Fired clay, 35 x 35 x 31.5 cm
Museo del Templo Mayor, INAH, Mexico City 10-220302

56
Pectoral with a nocturnal butterfly
Aztec, ca. 1500
Greenstone, diam. 13.5 cm
Museo Nacional de Antropología, INAH, Mexico City 10-162943

57
Model
Cholollan, ca. 1500
Fired clay and pigment, 39.5 x 23 cm
Museo Regional de Puebla, INAH 10-496916

58
Model
Aztec, ca. 1500
Fired clay and pigment, 32 x 16.5 x 19.5 cm
Museo Nacional de Antropología, INAH, Mexico City 10-223673

59
Model
Cholollan, ca. 1500
Fired clay and pigment, 39 x 24 x 15.5 cm
Museo Nacional de Antropología, INAH, Mexico City 10-496915

60
Model
Cholollan, ca. 1500
Fired clay and pigment, 28 x 14.5 cm
Museo Regional de Puebla, INAH 10-496914

61
Red god offering
Aztec, ca. 1500:

Red god, Xochipilli-Mauilxochitl
Stone, 97.2 x 35.5 x 34.5 cm
Museo Nacional de Antropología, INAH, Mexico City 10-222236

Drum vessel
Fired clay, h. 12.5 cm, diam. 9 cm
Museo Nacional de Antropología, INAH, Mexico City 10-50694

Sound stone
Fired clay, 6 x 11.3 x 10 cm
Museo Nacional de Antropología, INAH, Mexico City 10-992

Turtle
Stone, 8 x 10 x 14 cm
Museo Nacional de Antropología, INAH, Mexico City 10-220132

Teponaztli
Fired clay, 12.5 x 8 x 17 cm
Museo Nacional de Antropología, INAH, Mexico City 10-3845

Teponaztli
Fired clay, 10.8 x 8 x 17.2 cm
Museo Nacional de Antropología, INAH, Mexico City 10-3846

Omexicahuaztli
Fired clay, 5.7 x 16 cm
Museo Nacional de Antropología, INAH, Mexico City 10-981

Sound stone
Fired clay, 7.5 x 10.2 x 11.5 cm
Museo Nacional de Antropología, INAH, Mexico City 10-10790

Sound stone
Fired clay, 5.5 x 9.7 x 11 cm
Museo Nacional de Antropología, INAH, Mexico City 10-3836

Teponaztli
Fired clay, 12.5 x 8 x 17 cm
Museo Nacional de Antropología, INAH, Mexico City 10-3842

Sound stone
Fired clay, 6.8 x 11.6 x 9.6 cm
Museo Nacional de Antropología, INAH, Mexico City 10-991

Xicahuaztli
Stone, 8.1 x 4 x 29.6 cm
Museo Nacional de Antropología, INAH, Mexico City 10-41701

Omexicahuaztli
Fired clay, 6.1 x 16.2 cm
Museo Nacional de Antropología, INAH, Mexico City 10-223800

Xicahuaztli
Stone, 11 x 5 x 31.5 cm
Museo Nacional de Antropología, INAH, Mexico City 10-41700

Drum vessel
Fired clay, h. 13 cm, diam. 11.7 cm
Museo Nacional de Antropología, INAH, Mexico City 10-220151

Teponaztli
Fired clay, 12 x 20 x 12 cm
Museo Nacional de Antropología, INAH, Mexico City 10-3847

Sound stone
Fired clay, 6.6 x 9 x 12 cm
Museo Nacional de Antropología, INAH, Mexico City 10-3839

Xicahuaztli
Stone, 9.5 x 35.5 cm
Museo Nacional de Antropología, INAH, Mexico City 10-41699

Teponaztli
Stone, 10 x 19 cm
Museo Nacional de Antropología, INAH, Mexico City 10-41837

Teponaztli
Fired clay, 11.6 x 16.9 x 8.5 cm
Museo Nacional de Antropología, INAH, Mexico City 10-2424

Teponaztli
Stone, 10 x 19 cm
Museo Nacional de Antropología, INAH, Mexico City 10-41932

Teponaztli
Stone, 9.3 x 19.5 cm
Museo Nacional de Antropología, INAH, Mexico City 10-41839

Turtle shell
Fired clay, 10.5 x 13.5 cm
Museo Nacional de Antropología, INAH, Mexico City 10-333158

Teponaztli
Fired clay, 6.7 x 13 cm
Museo Nacional de Antropología, INAH, Mexico City 10-3843

Drumstick
Stone, 13.5 x 9.3 cm
Museo Nacional de Antropología, INAH, Mexico City 10-594440

Flute
Fired clay, 5.1 x 21.3 cm
Museo Nacional de Antropología, INAH, Mexico City 10-333157

Drum vessel
Fired clay, h. 17.3 cm, diam. 18.4
Museo Nacional de Antropología, INAH, Mexico City 10-79900

Drumstick
Stone, h. 17.5 cm, diam. 7.5 cm
Museo Nacional de Antropología, INAH, Mexico City 10-563530

Drum vessel
Fired clay, h. 12.2 cm, diam. 12.2 cm
Museo Nacional de Antropología, INAH, Mexico City 10-50698

Rattle
Fired clay, 3.5 x 12.3 cm
Museo Nacional de Antropología, INAH, Mexico City 10-10630

Sound stone
Fired clay, 7 x 10 x 12 cm
Museo Nacional de Antropología, INAH, Mexico City 10-3837

Sound stone
Fired clay, 6 x 10 x 14 cm
Museo Nacional de Antropología, INAH, Mexico City 10-3841

Teponaztli
Fired clay, 6.9 x 5 x 12 cm
Museo Nacional de Antropología, INAH, Mexico City 10-3844

Teponaztli
Fired clay, 5.4 x 4.6 x 12.4 cm
Museo Nacional de Antropología, INAH, Mexico City 10-2423

Sound stone
Fired clay, 7.5 x 9.6 x 11 cm
Museo Nacional de Antropología, INAH, Mexico City 10-3838

Omexicahuaztli
Fired clay, 5.6 x 16 cm
Museo Nacional de Antropología, INAH, Mexico City 10-980

Drum vessel
Fired clay, h. 11.3 cm, diam. 11 cm
Museo Nacional de Antropología, INAH, Mexico City 10-50711

Omexicahuaztli
Fired clay, 5.7 x 16.4 cm
Museo Nacional de Antropología, INAH, Mexico City 10-2428

Teponaztli
Fired clay, h. 11, diam. 8.5 cm
Museo Nacional de Antropología, INAH, Mexico City 10-996

Turtle shell
Fired clay, 5.5 x 6.4 x 11.5 cm
Museo Nacional de Antropología, INAH, Mexico City 10-2425

Rattle
Fired clay, 3 x 14.5 cm
Museo Nacional de Antropología, INAH, Mexico City 10-15726

62
Commemorative stone plaque of the Templo Mayor
Aztec, ca. 1487
Greenstone, 92 x 62 x 30 cm
Museo Nacional de Antropología, INAH, Mexico City 10-220919

63
Eagle warrior
Aztec, ca. 1440–69
Fired clay, stucco, and paint, 170 x 118 x 55 cm
Museo del Templo Mayor, INAH, Mexico City 10-220366

64
Mictlantecuhtli
Aztec, ca. 1480
Fired clay, stucco, and paint, 176 x 80 x 50 cm
Museo del Templo Mayor, INAH, Mexico City 10-264984

65
Anthropomorphic mask
Teotihuacan, ca. 300–600
Greenstone, shell, obsidian, and coral, 21 x 20.5 x 14 cm
Museo del Templo Mayor, INAH, Mexico City 10-220037

Ear ornaments
Teotihuacan, ca. 300–600
Greenstone, diam. 6 cm each
Museo del Templo Mayor, INAH, Mexico City 10-220032 0/2

66
Scepter
Aztec, ca. 1325–1418
Obsidian, 9.4 x 1.9 x .9 cm
Museo del Templo Mayor, INAH, Mexico City 10-263826

Scepter
Aztec, ca. 1325–1521
Obsidian, 9.2 x 1.8 x 1 cm
Museo del Templo Mayor, INAH, Mexico City 10-265172

67
Scepter shaped as a serpent
Aztec, ca. 1325–1481
Green obsidian, head: 2.3 x 1.3 x 6.7 cm; rattle: 2.5 x 1.5 x 7.3 cm
Museo del Templo Mayor, INAH, Mexico City 10-262756 0/2

68
Anthropomorphic eccentric
Aztec, ca. 1500
Obsidian, 47.5 x 22.5 x 10 cm
Museo Nacional de Antropología, INAH, Mexico City 10-393945

69
Polychrome incense burner
Aztec, ca. 1250–1521
Fired clay and pigment, 22 x 63 cm
Museo de las Culturas de Oaxaca, INAH 10-104216

70
Xiuhcoatl
Aztec, ca. 1500
Gold, 16 x 1 cm
Museo Nacional de Antropología, INAH, Mexico City 10-594810

Xiuhcoatl
Aztec, ca. 1500
Gold, 16.5 x 1 cm
Museo Nacional de Antropología, INAH, Mexico City 10-3302

71
Coyolxauhqui
Aztec, ca. 1250–1521
Gold, 5 x 4 x 1.5 cm
Museo Nacional de Antropología, INAH, Mexico City 10-3322

72
Butterfly nose ornament
Aztec, ca. 1500
Gold, 7.5 x 7.7 cm
Museo Nacional de Antropología, INAH, Mexico City 10-220922

73
Skull mask
Aztec, ca. 1250–1521
Human skull, silex, shell, and pyrite, 23 x 12 x 17 cm
Museo del Templo Mayor, INAH, Mexico City 10-220253

Knife
Aztec, ca. 1469–81
Flint, 15 x 5.5 x 1.3 cm
Museo del Templo Mayor, INAH, Mexico City 10-263616

74
Anthropomorphic mask
Olmec, ca. 1100–600 B.C.
Greenstone, 10.2 x 8.6 x 3.1 cm
Museo del Templo Mayor, INAH, Mexico City 10-168803

75
Ballgame offering
Aztec, ca. 1250–1521:

Miniature huehuetl
Greenstone, 2 x 3 cm
Museo Nacional de Antropología, INAH, Mexico City 10-222322

Miniature huehuetl effigy of Macuilxochitl
Greenstone, h. 10 cm, diam. 5 cm
Museo Nacional de Antropología, INAH, Mexico City 10-222323

Pendant shaped as a ballgame court
Greenstone, 11 x 7 cm
Museo Nacional de Antropología, INAH, Mexico City 10-222325

Miniature drumstick
Greenstone, 7 x 1 cm
Museo Nacional de Antropología, INAH, Mexico City 10-222318

Miniature turtle shell
Greenstone, 4.5 x 3 cm
Museo Nacional de Antropología, INAH, Mexico City 10-222320

Miniature huehuetl
Greenstone, 2.5 x 4 x 2 cm
Museo Nacional de Antropología, INAH, Mexico City 10-222321

Miniature teponaztli
Greenstone, 2.5 x 6.5 x 3 cm
Museo Nacional de Antropología, INAH, Mexico City 10-222317

Symbolic ball
Obsidian, diam. 11.5 cm
Museo Nacional de Antropología, INAH, Mexico City 10-222327

Symbolic ball
Alabaster, diam. 11 cm
Museo Nacional de Antropología, INAH, Mexico City 10-222326

76
String of beads
Aztec, ca. 1325–1521
Gold and silver, 3.9 x 1.5 cm
Museo del Templo Mayor, INAH, Mexico City 10-252891 0/26

77
Cihuacoatl plaque
Aztec, ca. 1200–1521
Stone, 61 x 44.5 x 15 cm
Museo Nacional de Antropología, INAH, Mexico City 10-81787

78
Relief of the five ages
Aztec, ca. 1400–1521
Gray basalt, 54.6 x 45.7 x 25.6 cm
Peabody Museum of Natural History, Yale University, New Haven
YPM. ANT.19231

79
Altar of the sacred tree
Aztec, ca. 1300
Stone, 58 x 72 x 67 cm
Museo Nacional de Antropología, INAH, Mexico City 10-81641

80
Calendar stone (temalacatl)
Aztec, ca. 1300–1500
Greenstone, h. 49.5 cm, diam. 83.8 cm
Philadelphia Museum of Art, The Louise and Walter Arensberg Collection
1950-134-403

81
Atlantean figure (east)
Aztec, ca. 1500
Stone, 122 x 42 x 39 cm
Museo Nacional de Antropología, INAH, Mexico City 10-81767

82
Atlantean figure (north)
Aztec, ca. 1500
Stone, 120 x 42 x 37 cm
Museo Nacional de Antropología, INAH, Mexico City 10-81768

83
Atlantean figure (center)
Aztec, ca. 1500
Stone, 119 x 48 x 34.5 cm
Museo Nacional de Antropología, INAH, Mexico City 10-48555

84
Atlantean figure (west)
Aztec, ca. 1500
Stone, 120 x 41 x 39 cm
Museo Nacional de Antropología, INAH, Mexico City 10-9774

85
Atlantean figure (south)
Aztec, ca. 1500
Stone, 119 x 38 x 34 cm
Museo Nacional de Antropología, INAH, Mexico City 10-81769

86
Tizapan casket
Aztec, ca. 1500
Stone, stucco, pigment, and jade, 19.5 x 20 x 20 cm
Museo Nacional de Antropología, INAH, Mexico City 10-28018 0/2

Maize goddess figure
Aztec, ca. 1250–1521
Greenstone, 8 x 4 x 4 cm
Museo Nacional de Antropología, INAH, Mexico City 10-594419

87
Tlaltecuhtli
Aztec, ca. 1200–1521
Stone, 62 x 61.5 x 54 cm
Museo del Templo Mayor, INAH, Mexico City 10-262523

88
Fragment of anthropomorphic brazier
Aztec, ca. 1300
Fired clay and pigment, 18 x 22 x 9 cm
Museo Universitario de Ciencias y Arte, UNAM, Mexico City 08-741814

89
Life-death figure
Aztec, ca. 1440–1521
Stone, 26.7 x 14 x 15.6 cm
Brooklyn Museum, New York, Purchased with funds given by The Henfield
Foundation 64.50

90
Duality
Aztec, ca. 1500
Greenstone, 9.5 x 8 x 9 cm
Museo Nacional de Antropología, INAH, Mexico City 10-9683

91
Solar disk with calendar date
Aztec, ca. 1500
Stone, h. 11 cm, diam. 46 cm
Museo Nacional de Antropología, INAH, Mexico City 10-13570

92
Ehecatl
Aztec, ca. 1500
Stone and obsidian, 48 x 18 x 23 cm
Museo Nacional de Antropología, INAH, Mexico City 10-48

93
Seated Xipe Totec
Aztec-Matlatzinca, ca. 1250–1521
Stone, h. 41 cm
Museo Arqueológico del Estado "Dr. Román Piña Chán," Teotenango A-51956

94
Xipe Totec container
Aztec, ca. 1500
Fired clay and pigment, h. 25 cm, diam. 48.5 cm
Museo Nacional de Antropología, INAH, Mexico City 10-594908

95
Xipe Totec ring
Aztec, ca. 900–1521
Gold, 3.2 x 2.5 x 1.8 cm
National Museum of the American Indian, Smithsonian Institution,
Washington, D.C. 20/6218

96
Figure of Xipe Totec
Aztec, ca. 1500
Fired clay, 15.5 x 5 x 3 cm
Museo Nacional de Antropología, INAH, Mexico City 10-333856

97
Figure of Xipe Totec
Aztec, ca. 1500
Fired clay, 12 x 5.5 x 8 cm
Museo Nacional de Antropología, INAH, Mexico City 10-116778 0/2

98
Tezcatlipoca effigy pot
Cholollan, ca. 1500
Fired clay and pigment, 14.5 x 17.5 x 17 cm
Fundación Cultural Televisa, Mexico City REG 21 PJ 71

99
Plaque of Tezcatlipoca
Aztec, ca. 1500
Stone, 63 x 53.5 x 16 cm
Museo Arqueológico del Estado "Dr. Román Piña Chán", Teotenango A-66602

100
Ehecatl monkey
Aztec, ca. 1500
Stone and pigment, 60 x 37 x 33 cm
Museo Nacional de Antropología, INAH, Mexico City 10-116784

101
Ehecatl insect
Aztec, ca. 1200–1521
Stone, h. 3.5 cm, diam. 18.2 cm
American Museum of Natural History, New York 30/8003

102
Xololtl
Aztec, ca. 1500
Stone, 48 x 59 x 70 cm
Museo Nacional de Antropología, INAH, Mexico City 10-116545

103
Quetzalcoatl
Aztec, ca. 1500
Stone, 28 x 45 x 45 cm
Museo Nacional de Antropología, INAH, Mexico City 10-81678

104
Chalchiuhtlicue mask
Aztec, ca. 1500
Diorite, 33 x 17.5 x 10 cm
Museo Nacional de Antropología, INAH, Mexico City 10-15717

105
Tlaloc
Aztec, ca. 1500
Stone, 101 x 39 x 35.5 cm
Museo Nacional de Antropología, INAH, Mexico City 10-222273

106
Pumpkin
Aztec, ca. 1500
Diorite, 16 x 17 x 36 cm
Museo Nacional de Antropología, INAH, Mexico City 10-392922

107
Agriculture goddess
Aztec, ca. 1500
Stone, 70 x 24 x 21 cm
Fundación Cultural Televisa, Mexico City REG 21 PJ 4

108
Teomama
Aztec, ca. 1500
Stone and stucco, 72 x 22 x 37 cm
Museo Regional de Hidalgo "Ex Convento de San Francisco," INAH, Pachuca
10-214568

109
Tlaltelcuhtli
Aztec, ca. 1500
Stone, 93 x 57 x 34 cm
Museo Nacional de Antropología, INAH, Mexico City 10-81265

110
Cihuateteo
Aztec, ca. 1500
Stone, 62 x 31 x 43 cm
Museo Nacional de Antropología, INAH, Mexico City 10-81570

111
Skull goblet
Aztec, ca. 1500
Fired clay and pigment, h. 30 cm, diam. 12.5 cm
Museo Nacional de Antropología, INAH, Mexico City 10-77820

Skull goblet
Aztec, ca. 1500
Fired clay and pigment, h. 30 cm, diam. 12.5 cm
Museo Nacional de Antropología, INAH, Mexico City 10-3344

112
Xochipilli
Aztec, ca. 1500
Stone and red pigment, 115 x 53 x 43 cm
Museo Nacional de Antropología, INAH, Mexico City 10-222116 0/2

113
Deified warrior brazier
Aztec, ca. 1500
Fired clay and pigment, 91 x 76 x 57.5 cm
Museo Nacional del Virreinato, INAH, Tepotzotlán 10-133646

114
Techcatl
Aztec, ca. 1500
Stone, 94 x 80 x 28 cm
Museo Nacional de Antropología, INAH, Mexico City 10-81578

115
Autosacrifice casket (tepetlacalli)
Aztec, ca. 1500
Stone, 21 x 32 x 32 cm
Museo Nacional de Antropología, INAH, Mexico City 10-466061

116
Xiuhmolpilli, 1 Death
Aztec, ca. 1500
Stone, l. 61 cm, diam. 26 cm
Museo Nacional de Antropología, INAH, Mexico City 10-220917

117
Date stone, 1 Eagle
Aztec, ca. 1500
Stone, 24 x 24 x 9.5 cm
Museo Nacional de Antropología, INAH, Mexico City 10-223606

118
Date stone
Aztec, ca. 1300–1500
Igneous rock, 33 x 30.5 x 10.2 cm
Philadelphia Museum of Art, The Louise and Walter Arensberg Collection
1950-134-374

119
Date stone, 3 Flint
Aztec, ca. 1500
Stone, 37 x 31 x 15 cm
Museo Nacional de Antropología, INAH, Mexico City 10-46541

120
Altar with calendar dates
Aztec, ca. 1325–1521
Stone, 22 x 36 x 28 cm
Museo de las Culturas Mexicas "Eusebio Dávalos," INAH, Acatlán 10-40513

121
Xiuhmolpilli
Aztec, ca. 1500
Stone, 38.3 x 30 x 22.3 cm
Fundación Cultural Televisa. Mexico City REG 21 PJ 9

122
Figure of a warrior
Aztec, after 1325
Cast gold-silver-copper alloy, 11.2 x 6.1 cm
The Cleveland Museum of Art, Leonard C. Hanna, Jr., Fund 1984.37

123
Funerary casket
Aztec, ca. 1500
Stone, 22 x 24 x 24 cm
Museo Nacional de Antropología, INAH, Mexico City 10-223670 0/2

124
Xiuhtecuhtli pendant
Aztec, ca. 1500
Greenstone, 7.5 x 4.5 x 3.5 cm
Museo Nacional de Antropología, INAH, Mexico City 10-594485

125
Head of a warrior
Aztec, ca. 1500
Fired clay, 19.5 x 15.3 cm X 18.8 cm
Museo Nacional de Antropología, INAH, Mexico City 10-392909

126
Jaguar pectoral
Mixtec, ca. 1200–1500
Wood, stone, and shell, 7.6 x 17.1 x 3.2 cm
Saint Louis Art Museum, Gift of Morton D. May 163:1979

127
Xiuhtecuhtli
Aztec, ca. 1250–1521
Greenstone, 59 x 41 x 35 cm
Museo del Templo Mayor, INAH, Mexico City 10-264985

128
Ear ornaments
Aztec-Mixtec, 15th–16th century
Cast gold, 6 cm each
The Metropolitan Museum of Art, New York, The Michael C. Rockefeller Memorial
Collection, Purchase, Nelson A. Rockefeller Gift, 1967 1978.412.200 a,b

129
Ring with the figure of a descending eagle
Mixtec, ca. 1325–1521
Gold, 5.8 x 2 cm
Museo de las Culturas de Oaxaca, INAH 10-106165

130
Pendant with the figure of Xiuhtecuhtli
Aztec, ca. 1500
Gold, 4 x 3.5 x 2 cm
Museo Nacional de Antropología, INAH, Mexico City 10-8543

131
Ring with serpents in filigree
Aztec, ca. 900–1521
Gold, h. 2.2 cm, diam. 1.8 cm
National Museum of the American Indian, Smithsonian Institution,
Washington, D.C. 16/3447

132
Xiuhtecuhtli pendant
Mixtec, ca. 1500
Gold, 6 x 4 x 1.5 cm
Museo de las Culturas de Oaxaca, INAH 10-105429

133
String of snail-shaped beads
Aztec-Mixtec, ca. 1300–1521
Cast gold, 8 x 3 x 2.5 cm
Dumbarton Oaks Research Library and Collection, Harvard University,
Washington, D.C. PC.B.104

134
Lip-plug in the shape of a serpent with its tongue out
Aztec, ca. 900–1521
Gold, 6.8 x 8.2 x 5.3 cm
National Museum of the American Indian, Smithsonian Institution,
Washington, D.C. 18/756

135
Ear ornaments
Mixtec, ca. 1500
Gold, h. 1.3 cm, diam. 3.9 cm each
Museo de las Culturas de Oaxaca, INAH 10-105428 0/2

136
Pendant with the head of a cox-cox bird
Mixtec, ca. 1200–1521
Gold, 1.5 x 1.3 x 2 cm
American Museum of Natural History, New York 30/10741

137
Ahuitzotl plaque
Aztec, ca. 1500
Stone, 73.5 x 72 x 24 cm
Museo Nacional de Antropología, INAH, Mexico City 10-81550

138
Tripod plate
Aztec, ca. 1500
Fired clay and pigment, h. 7 cm, diam. 32 cm
Museo Nacional de Antropología, INAH, Mexico City 10-580947

139
Coyote warriors goblet
Aztec, ca. 1500
Fired clay and pigment, h. 15.5 cm, diam. 15 cm
Museo Nacional de Antropología, INAH, Mexico City 10-116788

140
Flower goblet
Aztec, ca. 1500
Fired clay and pigment, h. 28.5 cm, diam. 18 cm
Museo Nacional de Antropología, INAH, Mexico City 10-116786

141
Polychrome plate
Aztec, ca. 1250–1500
Fired clay and pigment, diam. 22 cm
Museo Nacional de Antropología, INAH, Mexico City 10-116504

142 (not in the exhibition)
Altar with images of a procession of warriors
Aztec, ca. 1250–1521
Stone, 65 x 160 x 118 cm
Museo Nacional de Antropología, INAH, Mexico City 10-1155

143
Serpent warrior
Matlatzinca, ca. 1500
Stone, 52.5 x 29 x 19 cm
Museo Arqueológico del Estado "Dr. Román Piña Chán," Teotenango A-52207

144
Cihuateteo
Aztec, ca. 1500
Stone, 112 x 54 x 53 cm
Museo Nacional de Antropología, INAH, Mexico City 10-9781

145
Quadrangular brazier
Matlatzinca, ca. 1200–1521
Fired clay, 15 x 31 cm
Museo Arqueológico del Estado "Dr. Román Piña Chán," Teotenango A-51999

146
Tlaloc ceremonial vessel
Aztec, ca. 1500
Fired clay and pigment, 112 x 51 x 53 cm
Museo Nacional de Antropología, INAH, Mexico City 10-575578

147
Xilonen ceremonial vessel
Aztec, ca. 1500
Fired clay and pigment, 99 x 60 x 49 cm
Museo Nacional de Antropología, INAH, Mexico City 10-583437

148
Chicomecoatl ceremonial vessel
Aztec, ca. 1500
Fired clay and pigment, 106 x 72 x 51 cm
Museo Nacional de Antropología, INAH, Mexico City 10-571544

149
Nappatecuhtli ceremonial vessel
Aztec, ca. 1500
Fired clay and pigment, 121 x 66 x 48 cm
Museo Nacional de Antropología, INAH, Mexico City 10-571285

150
Xipe Totec
Aztec, ca. 1500
Fired clay and pigment, 97 x 43 x 20 cm
Museo Regional de Puebla, INAH 10-203061

151
Polychrome brazier
Aztec, ca. 1500
Fired clay and pigment, 12 x 23.5 x 20 cm
Museo Nacional de Antropología, INAH, Mexico City 10-78081

152
Polychrome bowl
Mixtec, ca. 1200–1521
Fired clay, h. 9.8 cm, diam. 17.8 cm
Museo Nacional de Antropología, INAH, Mexico City 10-393491

153
Beaker with applied figure
Coatlalpaneca, ca. 1500
Ceramic with black and red slip, h. 19.4 cm, diam. at rim 10.2 cm
Princeton University Art Museum, Gift of the Hans A. Widenmann, Class of 1918, and the Dorothy Widenmann Foundation y199327

154
Censer
Coatlalpaneca, ca. 1250–1500
Fired clay and pigment, 6 x 17 x 46.6 cm
Fundación Cultural Televisa, Mexico City REG 21 PJ 106

155
Xipe Totec
Coatlalpaneca, ca. 1250–1521
Fired clay, 17 x 22 cm
Museo Nacional de Antropología, INAH, Mexico City 10-56517

156
Xochipilli pectoral
Mixtec, ca. 1200–1521
Gold, 4.2 x 7.3 cm
Museo de las Culturas de Oaxaca, INAH 10-106163

157
Tlaloc
Huave, ca. 1500
Fired clay, 88 x 37.5 cm
Museo Nacional de Antropología, INAH, Mexico City 10-76360

158
Lip-plug with the figure of a cox-cox bird
Mixtec, ca. 1200–1521
Gold and jade, h. 4.3 cm, diam. 1.1 cm
Museo de las Culturas de Oaxaca, INAH 10-105540

159
Bell pendant with the figure of a bat
Mixtec, ca. 1500
Gold, 5.5 x 4.5 cm
Museo de las Culturas de Oaxaca, INAH 10-105430

160
Cast gold in the form of a crested bird's head
Mixtec-Zapotec, ca. 1450
Cast gold, 6 x 3.6 cm
Princeton University Art Museum, Gift of the Hans A. Widenmann, Class of 1918, and Dorothy Widenmann Foundation y1972-37

161
Gold sheet shaped as a feather
Mixtec, ca. 1200–1521
Gold, 35.1 x 8 cm
Museo de las Culturas de Oaxaca, INAH 10-105724

162
Head band
Mixtec, ca. 1200–1521
Gold, h. 5 cm, diam. 19.5 cm
Museo de las Culturas de Oaxaca, INAH 10-105723

163
Ehecatl bell pendant
Mixtec, ca. 1200–1521
Gold, 5 x 4 x 2 cm
American Museum of Natural History, New York 30.3/2304

164
Butterfly nose ornament
Mixtec, ca. 1200–1521
Gold, 4.5 x 6.5 x 0.5 cm
Museo Nacional de Antropología, INAH, Mexico City 10-3312

165
Shield pectoral
Mixtec, ca. 900–1200
Gold and turquoise, 8 x 8.4 x 0.6 cm
Museo Nacional de Antropología, INAH, Mexico City 10-3317

166
Disk
Mixtec, ca. 1325–1521
Gold and turquoise, diam. 20.8 cm
Museo Nacional de Antropología, INAH, Mexico City 10-4594

167
Effigy vessel
Mixtec, ca. 1250–1521
Fired clay, h. 29.4 cm, diam. 25 cm
Museo Nacional de Antropología, INAH, Mexico City 10-79148

168
Polychrome tripod plate
Mixtec, ca. 1500
Fired clay and pigment, h. 13.5 cm, diam. 34.6 cm
Museo Nacional de Antropología, INAH, Mexico City 10-79133

169
Vessel in the form of an eagle
Eastern Nahua, ca. 1450
Ceramic with brown, red, and ochre slips on cream ground, h. 20.9 cm,
w. 21.5 cm, diam. at rim 10.5 cm
Princeton University Art Museum, Bequest of Gilbert S. McClintoch,
By exchange y1990-13

170
Temalacatl
Mixtec, ca. 1250–1521
Stone, diam. 86.5 cm
Museo de las Culturas de Oaxaca, INAH 10-105130

171
Xantil, figure representing the god Xiuhtecuhtli in seated position
Mixtec, ca. 1000–1521
Fired clay, 47 x 18 x 26 cm
National Museum of the American Indian, Smithsonian Institution,
Washington, D.C. 22/1603

172
Plaque with ritual scenes
Mixtec, ca. 1325–1521
Wood, shell, and turquoise inlay, 18 x 42 cm
Museo de las Culturas de Oaxaca, INAH 10-362584

173
Chicomecoatl plaque
Aztec, ca. 1500
Stone, 107 x 40.5 x 9.5 cm
Museo Nacional de Antropología, INAH, Mexico City 10-613348

174
Anthropomorphic effigy vessel
Huaxtec, ca. 1250–1521
Fired clay, h. 18.5 cm, diam. 25.5 cm
Museo Municipal Arqueológico de Tuxpan REG 432 PJ 1

175
Polychrome vessel
Totonaca, ca. 600–900
Fired clay, h. 16 cm, diam. 19 cm
Museo Nacional de Antropología, INAH, Mexico City 10-78683

176
Head from figure of a deity (Macuilxochitl)
Aztec, ca. 1440–1521
Buff orange pottery, 27.9 x 21.3 cm
Yale University Art Gallery, New Haven, Bequest from the Estate of
Alice M. Kaplan 2001.83.1

177
Life-death figure (apotheosis)
Huaxtec, ca. 900–1250
Stone, 158 x 67 x 22.9 cm
Brooklyn Museum, New York, Henry L. Batterman Fund and the Frank Sherman
Benson Fund 37.2897PA

178
Goddess with descending god headdress
Huaxtec, ca. 1250–1521
Stone, 133 x 58.5 x 25 cm
Museo Municipal Arqueológico de Tuxpan REG.4373 N.76

179
Warriors
Tarascan, ca. 1250–1521
Fired clay, 26 x 21 x 13 cm
Museo Regional Michoacano "Dr. Nicolás Calderón," INAH, Morelia 10-224210

180
Copper disk
Tarascan, ca. 1250–1521
Copper, diam. 19.5 cm
Museo Nacional de Antropología, INAH, Mexico City 10-396909

181
Disk
Tarascan, ca. 1250–1521
Silver, diam. 18.5 cm
Museo Regional de Guadalajara, INAH 10-304232

182
Coyote
Tarascan, ca. 1250–1521
Stone, 52 x 22 x 18 cm
Museo Nacional de Antropología, INAH, Mexico City 10-168261

183
Feather
Tarascan, ca. 1250–1521
Gold, 24 x 6.5 cm
Museo Nacional de Antropología, INAH, Mexico City 10-396927

184
Throne in the shape of a coyote
Tarascan, ca. 1250–1521
Stone, 70 x 48 x 112.5 cm
Museo Regional Michoacano "Dr. Nicolás Calderón," INAH, Morelia 10-83992

185
Chacmool
Tarascan, ca. 1250–1521
Stone, 84 x 150 x 48 cm
Museo Nacional de Antropología, INAH, Mexico City 10-1609

186
Polychrome pot with handle
Tarascan, ca. 1250–1521
Fired clay, 8.5 x 16.8 cm
Museo Nacional de Antropología, INAH, Mexico City 10-76294

187
Polychrome vessel with spout
Tarascan, ca. 1250–1521
Fired clay, 17.1 x 13.2 x 8.5 cm
Museo Nacional de Antropología, INAH, Mexico City 10-44633

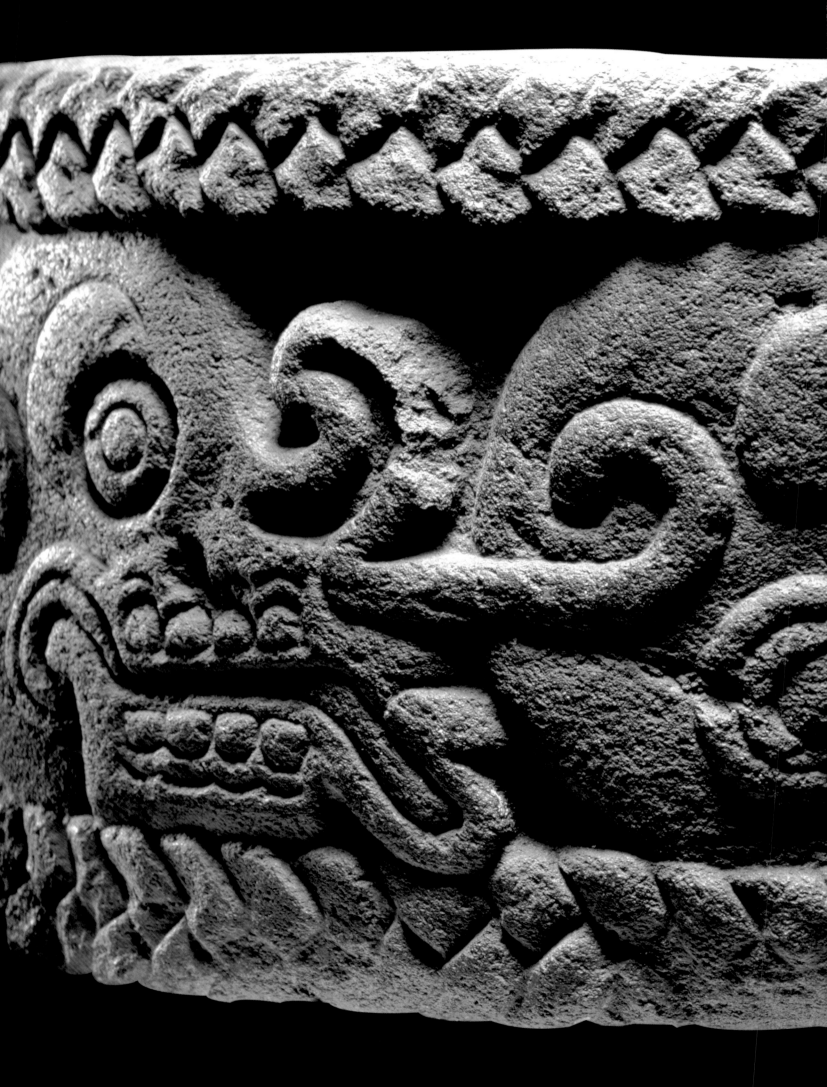

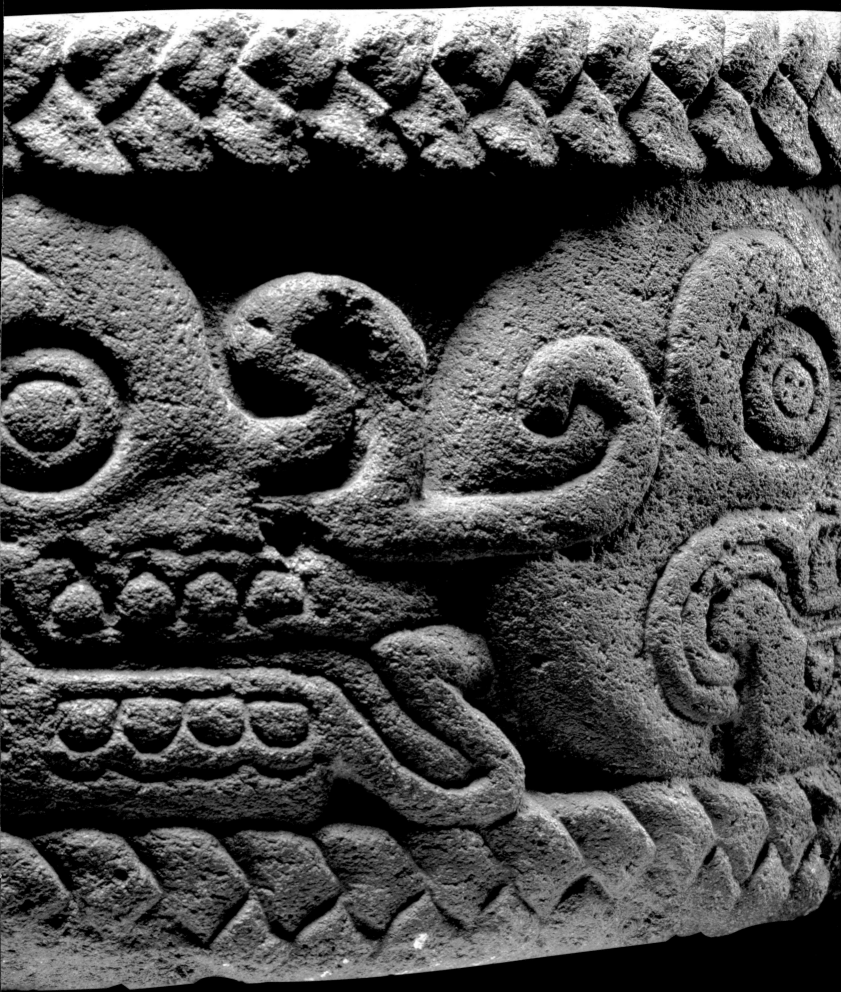

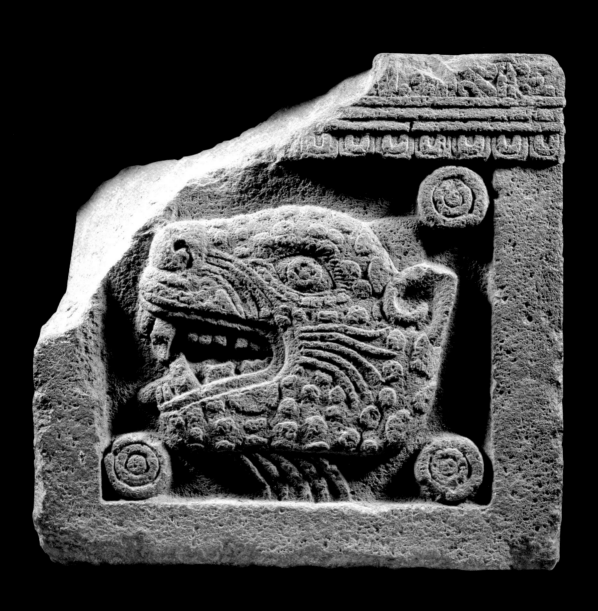

188
Polychrome vessel
Tarascan, ca. 1250–1521
Fired clay, 20 x 15.4 cm
Museo Nacional de Antropología, INAH, Mexico City 10-76010

189
Coyote sculpture
Tarascan, ca. 1200–1521
Stone, 43.5 x 17 x 14 cm
American Museum of Natural History, New York 30/2455

190
Techcatl in the shape of an animal
Tarascan, ca. 1200–1521
Volcanic stone, 67 x 29 x 44 cm
American Museum of Natural History, New York 30.3/2561

191
Chacmool
Tarascan, ca. 1200–1521
Stone, 27 x 35.5 x 17 cm
American Museum of Natural History, New York 30/6156

192
Atrium cross
Colonial, ca. 1600
Stone, 156 x 91 x 36 cm
Museo Regional de Tlaxcala, INAH 10-341001

193
Chalice lid
Colonial, ca. 1540
Feathers and bark, diam. 28 cm
Museo Nacional de Antropología, INAH, Mexico City 10-220923

194
Ceremonial tripod plate
Aztec-Colonial, ca. 1530
Fired clay, h. 10 cm, diam. 23.5 cm
Museo Nacional de Antropología, INAH, Mexico City 10-81584

195
Pendant in the shape of a shield
Aztec-Mixtec, ca. 1500
Gold, silver, and copper, 10.5 x 8.5 cm
Museo Baluarte de Santiago, INAH, Veracruz 10-213084

196
Bracelet
Aztec-Mixtec, ca. 1500
Gold, silver, and copper, h. 2.8 cm, diam. 8 cm
Museo Baluarte de Santiago, INAH, Veracruz 10-213110

Bracelet
Aztec-Mixtec, ca. 1500
Gold, silver, and copper, h. 3 cm, diam. 8.2 cm
Museo Baluarte de Santiago, INAH, Veracruz 10-213111

197
Teponaztli
Colonial, ca. 1521–1600
Wood and canine molars, 22 x 25 x 88 cm
Museo Nacional de Antropología, INAH, Mexico City 10-220924

198
Mirror or portable altar
Colonial, ca. 1521–30
Wood, obsidian, paint, and gilding, 31.5 x 28.5 x 2.8 cm
Dumbarton Oaks Research Library and Collection, Harvard University,
Washington, D.C. PC.B.78

199
Lienzo de Quetzpalan
Colonial-Puebla, late 16th century
Cotton and pigment, 154 x 183 x 53 cm
Fundación Cultural Televisa, Mexico City REG 21 PJ 403

Bibliography

Acosta, José de. *Historia natural y moral de las Indias.* Seville, 1590.

Agrinier, Pierre. "Mirador-Plumajillo, Chiapas y sus relaciones con cuatro sitios del horizonte olmeca de Veracruz, Chiapas y la costa de Guatemala." *Arqueología* 2 (1989), pp. 19–36.

Alcina Franch, José, Miguel León-Portilla, and Eduardo Matos Moctezuma. *Azteca Mexica, las culturas del México antiguo.* Madrid, 1992.

Alva Ixtlilxochitl, Fernando de. *Obras históricas 1600–1640.* 2 vols. Mexico City, 1975–77.

Alvarado Tezozomoc, Fernando. *Crónica Mexicayotl.* Mexico City, 1975.

Anales de Tlaltelolco. Unos anales históricos de la nación Mexicana. Mexico City, 1980.

Anawalt, Patricia Rieff. *Indian Clothing before Cortés.* Norman, Oklahoma, 1981.

Anders, Ferdinand, Maarten Jansen, and Luis Reyes Garcia. *Religión, costumbres e historia de los antiguos Mexicanos. Libro explicativo del llamado Códice Vaticano A.* Mexico City, 1996.

Anton, Ferdinand. *Women in Pre-Columbian America.* New York, 1973.

Bantel, Linda. *The Alice M. Kaplan Collection.* New York, 1981.

Baquedano, Elizabeth. *Aztec Sculpture.* London, 1984.

Barjau, Luis. *El mito mexicano de las edades.* Mexico City, 1998.

Barlow, Robert H. "La Crónica X: Versiones coloniales de la historia de los mexica tenochca." *Revista Mexicana de estudios antropológicos* (1945), vol. 7, nos. 1–3, pp. 65–87.

____. *La Extensión del imperio de los Culhua Mexica.* Edited by Jesús Monjarás Ruiz et al. México City, 1992.

____. *The Extent of the Empire of the Culhua Mexico,* reprint ed. New York, 1978.

____. "Tlatelolco en el periodo Tepaneca." In *Tlatelolco. Fuentes e historia.* 2 vols. Mexico City, 1989.

Benson, Elizabeth P., ed. *The Olmec and Their Neighbors.* Washington, D.C., 1981.

Berdan, Frances F., and Patricia R. Anawalt. *The Codex Mendoza.* 4 vols. Berkeley, 1992.

Berdan, Frances F., et al. *Aztec Imperial Strategies.* Washington, D.C., 1996.

Boehm de Lameiras, Brigitte. *Formación del estado en el México prehispánico.* Mexico City, 1986.

Boone, Elizabeth H. *Stories in Red and Black: Pictorial Histories of the Aztecs and Mixtecs.* Austin, 2000.

____, ed. *The Art and Iconography of Late Post-Classic Central Mexico.* Washington, D.C., 1982.

____, ed. *The Aztec Templo Mayor.* Washington, D.C., 1987.

Bray, Warwick. *Everyday Life of the Aztecs.* New York and London, 1968.

Brumfiel, Elizabeth M. "Huitzilopochtli's Conquest: Aztec Ideology in the Archaeological Record." *Cambridge Archaeological Journal* 8 (1998), pp. 3–14.

Carrasco, David. *City of Sacrifice. The Aztec Empire and the Role of Violence in Civilizations.* Boston, 1999.

Carrasco Pizana, Pedro. *Los Otomies.* Mexico City, 1979.

Caso, Alfonso. *The Aztecs, People of the Sun.* Norman, Oklahoma, 1970.

____. *El pueblo del sol.* 2nd ed. Popular Collection 104. Mexico City, 1974.

Castillo, Cristóbal del. *Historia de la venida de los mexicanos y otros pueblos.* Translated by Federico Navarrete. Mexico City, 1991.

Chimalpáhin, Domingo. *Las ocho relaciones y el memorial de Colhuacan,* vol. 1. Translated by Rafael Tena. Mexico City, 1998.

Clendinnen, Inga. *Aztecs: An Interpretation.* New York, 1991.

Cobean, Robert H., et al. "High-precision trace-element characterization of major Mesoamerican obsidian sources and further analyses of artifacts from San Lorenzo Tenochtitlán, Mexico." *Latin American Antiquity* 2 (1) (1991), pp. 69–91.

Codex Azcatitlan. 2 vols. Introduction by Robert Barlow and Michel Graulich. Paris, 1995.

Codex Duran. Mexico City, 1990.

Codex Fejérváry-Mayer. Facsimile. Mexico City and Graz, 1994.

Codex Tro-Cortesianus (Codex Madrid), Museo de América Madrid. Facsimile. Introduction by Ferdinand Anders. Graz, 1967.

Codex Vatican A. Facsimile. Graz, 1996.

Códice Chimalpopoca. Anales de Cuauhtitlan y Leyenda de los soles. Translated by Primo Feliciano Velásquez. Mexico City, 1992.

Códice Mendocino o Colección de Mendoza. Mexico City, 1979.

Códice Ramírez. In Fernando Alvarado Tezozomoc, *Crónica Mexicana.* Mexico City, 1980.

Códice Tira de la Peregrinación or *Códice Boturini.* Facsimile. Introduction by Dinorah Lejarazu and Manuel Herman. Mexico City, 1991.

Códice Xólotl. Edited by Charles E. Dibble. Mexico City, 1951.

Coe, Michael D. *America's First Civilization, Discovering the Olmec.* New York and Washington, D.C., 1968.

Contreras Martínez, José Eduardo. "Los murales y cerámica policromos de la zona arqueológica de Ocotelulco, Tlaxcala." In *Mixteca-Puebla: Discoveries and Research in Mesoamerican Art and Archaeology.* Edited by Henry B. Nicholson and Eloise Quiñones Keber. Culver City, California, 1994.

Corona Núñez, José. *Mitología Tarasca*. Mexico City, 1957.

Cortés, Hernán. *Cartas de Relación*. Mexico City, 1983.

Covarrubias, Miguel. *Indian Art of Mexico and Central America*. New York, 1957.

Cyphers, Ann. *Escultura olmeca de San Lorenzo Tenochtitlán*. Mexico City, 2004.

Díaz del Castillo, Bernal. *Historia verdadera de la conquista de la Nueva España*. 2 vols. Edited by Miguel Léon-Portilla. Madrid, 1984.

Dioses del México Antiguo. Exh. cat. Antiguo Colegio de San Ildefonso, Mexico City, 1995.

Doutrelaine, M. Le Colonel. "La Pierre de Tlanepantla." In *Archives de la Commission Scientifique du Mexique*, tome 3. Paris, 1867, pp. 111–120.

Dumond, D. E. and Florencia Müller. "Classic to Postclassic in Highland Central Mexico." *Science*, vol. 175, pp. 1208–15.

Durán, Diego. *Book of the Gods and Rites and the Ancient Calendar*. Translated and edited by Fernando Horcasitas and Doris Heyden. Norman, Oklahoma, 1971.

____. *Historia de las Indias de Nueva España e Islas de Tierra Firme*. 2 vols. Mexico City, 1995.

Early, D. T. "Ancient American Goldsmiths." *Natural History* (October 1956).

Easby, Elizabeth Kennedy, and John F. Scott, eds. *Before Cortés: Sculpture of Middle America*. Metropolitan Museum of Art, New York, 1970.

Eggebrecht, Eva and Arne, eds. *Glanz und Untergang des Alten Mexiko: Die Azteken und ihre Vorläufer*. 2 vols. Exh. cat. Roemer- und Pelizaeus-Museum, Hildesheim, 1986.

Ekholm, Gordon. *Ancient Mexico and Central America, Companion Book to the Hall of Mexico and Central America*. American Museum of Natural History. New York, 1970.

Emmerich, André. *Sweat of the Sun and Tears of the Moon; Gold and Silver in Pre-Columbian Art*. Seattle, 1965.

Evans, Susan T. "Aztec Royal Pleasure Parks: Conspicuous Consumption and Elite Status Rivalry." *Studies in the History of Gardens and Designed Landscapes* 20 (2000), pp. 206–28.

Evans, Susan Toby, and David L. Webster, eds. *Archaeology of Ancient Mexico and Central America: An Encyclopedia*. New York, 2001.

Fernández, Justino. *Coatlicue. Estética del arte indígena antiguo*. Mexico City, 1954.

____. *Estética del arte mexicano*. Mexico City, 1972.

Flores Villatorio, María Dolores. "Escultura Antropomorfa, Chac Mool" and "Máscara Antropomorfa." In *Arte Precolombino de México*. Milan, 1990.

Fox, John Gerard. "Playing with Power: Ballcourts and Political Ritual in Southern Mesoamerica." *Current Anthropology* 37 (3) (June 1996), pp. 483–509.

Fuente, Beatriz de la. "El arte prehispánico: un siglo de historia." In *Memorias de la Academia Mexicana de la historia correspondiente a la Real de Madrid*. Mexico City, 1999, pp. 79–100.

____. "El arte prehispánico visto por los europeos del siglo XIX." *Revista de la Universidad de México*, vol. 29 (1983), pp. 2–7.

____. "La crítica y el arte prehispánico." In *Las humanidades en México, 1950-1975*. Mexico City, 1978, pp. 93–101.

____. *Peldaños en la conciencia. Rostros en la plástica prehispánica*. Art Collection 38. Mexico City, 1985.

García Cook, Ángel. "Las Fases Texcalac y Tlaxcala o Posclásico de Tlaxcala." In *Antología de Tlaxcala*, vol. 1. Mexico City, 1996, pp. 311–20.

Gendrop, Paul. *Arte prehispánico en Mesoamérica*. Mexico City, 1979.

Gerhard, Peter. *Geografía histórica de la Nueva España 1519-1821*. Mexico City, 1986.

Gibson, Charles. *Los Aztecs bajo el dominio español, 1519-1810*. Mexico City, 1967.

González Torres, Yólotl. "Huitzilopochtli." In *Oxford Encyclopedia of Mesoamerican Cultures*, vol. 2. Edited by David Carrasco. New York and Oxford, 2001, pp. 21–23.

Graulich, Michel. *Ritos aztecas: las fiestas de las veintenas*. Mexico City, 1999.

Grove, David C. "The Olmec Paintings of Oxtotitlán Cave, Guerrero, Mexico." In *Studies in Pre-Columbian Art and Archaeology* 6. Washington, D.C., 1970.

____. "Olmec Altars and Myths." *Archaeology* 26 (1973), pp. 128–35.

Gruzinski, Serge. *Painting the Conquest: The Mexican Indians and the European Renaissance*. Paris, 1992.

Handbook of the Robert Woods Bliss Collection of Pre-Columbian Art. Washington, D.C., 1963.

Hassig, Ross. *Aztec Warfare: Imperial Expansion and Political Control*. Norman, Oklahoma, 1988.

Hernández, Gilda. "Iconografía de las Copas Polícromas Cholultecas." *Arqueología*, no. 13-14 (1995).

Hers, Marie-Areti. "Chicomóztoc. Un Mito Revisado." In *Arqueología Mexicana,*, vol. 10. Mexico City, 2002.

____. *Los toltecas en tierras chichimecas*. Mexico City, 1989.

Heyden, Doris. "Las Cuevas de Teotihuacan." In *Arqueología Mexicana*, vol. 6. Mexico City, 1998.

____. "Historia de los Mexicanos por sus pinturas." In *Teogonía e historia de los mexicanos. Tres opúsculos del siglo XVI*. Edited by Ángel Ma. Garibay K. Mexico City, 1965.

____. *Historia Tolteca-Chichimeca*. Copenhagen, 1942.

_____. "An Interpretation of the Cave underneath the Pyramid of the Sun in Teotihuacan, Mexico." *American Antiquity*, vol. 40, no. 2 (April 1975), pp. 131–47.

Historia del arte mexicano, vol. 1, tome 3, *Arte prehispánico*. Mexico City, 1982.

Kelemen, Pál. *Medieval American Art. Masterpieces of the New World before Columbus*. 3rd ed. 2 vols. New York, 1969.

Kirchhoff, Paul, Lina Odena Güemes, and Luis Reyes García. *Historia Tolteca-Chichimeca*. Mexico City, 1989.

Krickeberg, Walter. *Las antiguas culturas mexicanas*. Mexico City, 1961.

_____. *Mitos y leyendas de los Aztecas, Incas, Mayas y Muiscas*. Mexico City, 1971.

Kubler, George. *Aesthetic Recognition of Ancient Amerindian Art*. New Haven and London, 1991.

_____. *The Art and Architecture of Ancient America*. Harmondsworth, 1962.

_____. "The Cycle of Life and Death in Metropolitan Aztec Sculpture." In *Studies in Ancient American and European Art*. Edited by Thomas F. Reese. New Haven and London, 1985, pp. 219–24.

León-Portilla, Miguel. *De Teotihuacan a los Aztecas. Antología de fuentes e interpretaciones históricas*. Mexico City, 1971.

_____. *La Filosofía Náhuatl estudiada en sus Fuentes*. Mexico City, 1983.

_____. "Mitos de los orígenes en Mesoamérica." In *Arqueología Mexicana*, vol. 10. Mexico City, 2002.

Levenson, Jay A., ed. *Circa 1492: Art in the Age of Exploration*. Exh. cat. National Gallery of Art, Washington, D.C., 1991.

Lind, Michael D. "Cholula and Mixteca Polychromes: Two Mixteca-Puebla Regional Sub-styles." In *Mixteca-Puebla: Discoveries and Research in Mesoamerican Art and Archaeology*. Edited by Henry B. Nicholson and Eloise Quiñones Keber. Culver City, California, 1994, pp. 79–100.

Lockhart, James. *The Nahuas after the Conquest: A Social and Cultural History of the Indians of Central Mexico, Sixteenth through Eighteenth Centuries*. Stanford, 1992.

Lombardo de Ruiz, Sonia, et al. *Arte precolombino de México*. Milan and Madrid, 1990.

López Austin, Alfredo. *Cuerpo humano e ideología. Las concepciones de los antiguos Nahuas*. 2 vols. Mexico City, 1984.

_____. "La historia de Teotihuacan." In *Teotihuacan*. Mexico City, 1989, pp. 13–35.

_____. *Tamoanchan y Tlalocan*. Mexico City, 1994.

López Austin, Alfredo, and Leonardo López Luján. *El pasado indígena*. Mexico City, 2001.

López Luján, Leonardo. *La recuperación mexica del pasado teotihuacano*. Mexico City, 1989.

Lothrop, S. K. *Robert Woods Bliss Collection: Pre-Columbian Art*. London, 1957.

Lumholtz, Carl. *Unknown Mexico; a record of five years' exploration among the tribes of the western Sierra Madre; in the tierra caliente of Tepic and Jalisco; and among the Tarascos of Michoacan*. New York, 1902.

Manrique, Leonardo, and Noemí Castillo, eds. *Homenaje al Doctor Ignacio Bernal*, Scientific Collection 333, History Series, Instituto Nacional de Antropología e Historia. Mexico City, 1997.

Manuscrit Tovar. Origines et croyances des Indiens du Mexique. Graz, 1972.

Manzanilla, Linda. *Anatomía de un conjunto residencial teotihuacano en Oztoyahualco*. 2 vols. Mexico City, 1993.

_____. "Gobierno corporativo en Teotihuacan: una revisión del concepto 'palacio' aplicado a la gran urbe prehispánica." *Anales de antropología*, vol. 35 (2002), pp. 157–90.

_____. "Teotihuacan: Urban Archetype, Cosmic Model." In *Emergence and Change in Early Urban Societies*. New York, 1997, pp. 109–31.

Manzanilla, Linda, Claudia López, and AnnCorinne Freter. "Dating Results from Excavations in Quarry Tunnels behind the Pyramid of the Sun at Teotihuacan." *Ancient Mesoamerica*, vol. 7, no. 2 (Fall 1996), pp. 245–66.

Manzanilla, Linda, and Leonardo López Luján. "Exploraciones en un posible palacio de Teotihuacan: el Proyecto Xalla (2000–2001)." *Mexicon* 23, vol. 13, no. 3 (June 2001), pp. 58–61.

_____, eds. *Historia antigua de México*. 3 vols. Mexico City, 1994.

Marquina, Ignacio. *Arquitectura prehispánica*. 2 vols. Mexico City, 1951.

Mateos Higuera, Salvador. *Los Dioses creadores. Enciclopedia gráfica del México antiguo*, vol. 2. Mexico City, 1993.

Matos Moctezuma, Eduardo. "Los mexica y llegaron los españoles." In *Mexico en el mundo de las colecciones de arte*, vol. 2, *Mesoamérica*. Mexico City, 1994, pp. 179–243.

_____. "Las seis Coyolxauhqui: variaciones sobre un mismo tema." *Estudios de Cutura Náhuatl* 21 (1991), pp. 15–29.

_____. *El Templo Mayor: Excavaciones y estudios*. Mexico City, 1982.

Matos Moctezuma, Eduardo, and Felipe Solís Olguín. *Aztecs*. London, 2002.

Matos Moctezuma, Eduardo, et al. *Dioses del México antiguo*. Mexico City, 1995.

McCafferty, Geoffrey G. "Cholula (Puebla, Mexico)." In *Archaeology of Ancient Mexico and Central America: An Encyclopedia*. Edited by Susan Toby Evans and David L. Webster. New York, 2001, pp. 138–42.

Mena, Ramon. "Dos notables monumentos. Piedra ciclográfica de Tlalnepantla. Lapida de Tuxpan." In *Monografías arqueológicas*. Mexico City, 1911.

Messmacher, Miguel. "Los patrones de asentamiento y la arquitectura de Cholula." In *Cholula reporte preeliminar*. Mexico City, 1967.

Miller, Mary, and Karl Taube. *The Gods and Symbols of Ancient Mexico and the Maya: An Illustrated Dictionary of Mesoamerican Religion.* London, 1993.

Millon, René. *Urbanization at Teotihuacan, Mexico,* Part 1: *The Teotihuacan Map.* Austin, 1973.

Müller, Florencia. *La alfarería de Cholula.* Serie Arqueología. Mexico City, 1978.

Muñoz Camargo, Diego. *Historia de Tlaxcala.* Edited by Germán Vázquez Chamorro. Madrid, 2003.

Navarrete Linares, Federico. "La migración mexica: ¿invención o historia?" In *Códices y documentos sobre México.* Scientific Collection 409. Mexico City, 2000, pp. 303–22.

____. "Vivir en el universo de los Nahuas." In *Arqueología Mexicana,* vol. 10. Mexico City, 2002.

Neff, Hector, et al. "Neutron Activation Analysis of Late Postclassic Polychrome Pottery from Central Mexico." In *Mixteca-Puebla: Discoveries and Research in Mesoamerican Art and Archaeology.* Edited by Henry B. Nicholson and Eloise Quiñones Keber. Culver City, California, 1994, pp. 117–42.

Nicholson, Henry B., ed. *The Origins of Religious Art and Iconography in Preclassic Mesoamerica.* Los Angeles, 1967.

Nicholson, Henry B., and Eloise Quiñones Keber. "Introduction." In *Mixteca-Puebla: Discoveries and Research in Mesoamerican Art and Archaeology.* Edited by Nicholson and Quiñones Keber. Culver City, California, 1994.

____, eds. *Art of Aztec Mexico: Treasures of Tenochtitlan.* Exh. cat. National Gallery of Art, Washington, D.C., 1983.

Noguera, Eduardo. *La cerámica arqueológica de Cholula.* Mexico City, 1954.

Olivier, Guilhem. *Mockeries and Metamorphoses of an Aztec God: Tezcatlipoca, the "Lord of the Smoking Mirror."* Translated by Michel Besson. Boulder, Colorado, 2003.

Paillés, Maricruz. "Proyecto arqueológico Las Bocas, Puebla." Report filed to the Coordinación Nacional de Arqueología, INAH, 1998.

Parsons, Lee. *Pre-Columbian Art.* New York, 1980.

Pasztory, Esther. *Aztec Art.* Norman, Oklahoma, 1983.

Pérez, Zevallos, and Juan Manuel. *Xochimilco ayer.* Mexico City, 2002.

Pires-Ferreira, Jane. "Shell and Iron-Ore Mirror Exchange in Formative Mesoamerica, with Comments on Other Commodities." In *The Early Mesoamerican Village.* Edited by K. V. Flannery. New York, 1976, pp. 306–11.

Plunket, Patricia. "Cholula y su cerámica posclásica: Algunas perspectivas." In *Arqueología,* no. 13–14 (1995).

Plunket, Patricia, and Gabriela Uruñuela. "Preclassic Household Patterns Preserved under Volcanic Ash at Tetimpa, Puebla, Mexico." *Latin American Antiquity,* vol. 9, no. 4 (1998), pp. 287–309.

____. "Puebla-Tlaxcala Region." In *Archaeology of Ancient Mexico and Central America: An Encyclopedia.* Edited by Susan Toby Evans and David L. Webster. New York, 2001.

Pohl, John M.D., and Bruce E. Byland. "The Mixteca-Puebla Style and Early Postclassic Socio-Political Interaction." In *Mixteca-Puebla: Discoveries and Research in Mesoamerican Art and Archaeology.* Edited by Henry B. Nicholson and Eloise Quiñones Keber. Culver City, California, 1994, pp. 189–200.

Porter, James B. "Olmec Colossal Heads as Recarved Thrones: 'Mutilation,' Revolution and Recarving." *RES: Anthropology and Aesthetics* (1989), pp. 17–18, 23–29.

Porter, Muriel. *The Aztec, Maya, and their Predecessors.* New York, 1972.

Präkolumbische Kunst aus Mexiko und Mittelamerika. Exh. cat. Haus der Kunst, Munich, 1958.

Precolumbian Art in New York: Selections from Private Collections. New York, 1969.

Quiñones Keber, Eloise, ed. *Representing Ritual: Performance, Text and Image in the Work of Sahagún.* Boulder, Colorado, 2002.

Reilly, F. Kent, III. "The Shaman in Transformation Pose: A Study of the Theme of Rulership in Olmec Art." *Record of The Art Museum, Princeton University* 48 (2) (1989), pp. 4–21.

Relación de Michoacán. Michoacan, 2000.

Relaciones geográficas del Siglo XVI: México, vols. 6–8. Mexico City, 1986.

Rice, Maurice. *Ancient American Art, 500 BC–AD 1500, The Catalog of an Exhibition of the Art of the Pre-European Americas.* Exh. cat. Santa Barbara Museum of Art, California, 1942.

Ricoeur, Paul. *Tiempo y narración,* vol. 3, *El tiempo narrado.* Mexico, 1996.

Sáenz González, Olga, ed. *México en el mundo de las colecciones de arte.* 2 vols. Mexico City, 1994.

Sahagún, Bernardino de. *Historia general de las cosas de Nueva España.* 4 vols. Sepan Cuántos Collection 300. Mexico City, 1969.

____. *Florentine Codex. General History of the Things of New Spain.* 13 vols. Translated and edited by Charles E. Dibble and Arthur J. O. Anderson. Salt Lake City, 1950–81.

Sanders, William T., Jeffrey R. Parsons, and Robert S. Santley. *The Basin of Mexico: Ecological Processes in the Evolution of Civilization.* New York and San Francisco, 1979.

Saville, Marshall H. *The Goldsmith's Art in Ancient Mexico.* New York, 1920.

Schonfeld, Wendy. *Die Azteken und ihre Vorlaüfer Glanz und Untergang des Alten Mexico.* 2 vols. Exh. cat. Roemer- und Pelizaeus-Museum, Hildesheim, 1986.

Serra Puche, Mari Carmen. "Objetos de Obsidiana y otros cristales en el México antiguo." In *Cristales y obsidiana prehispánicos.* Edited by Mari Carmen Serra Puche and Felipe Solís Olguín. Mexico City, 1994, pp. 73–216.

_____. *La Cerámica de Xochitécatl*. Mexico City, 2004.

Sisson, Edward B., and T. Gerald Lilly. "The Mural of the Chimales and the Codex Borgia." In *Mixteca-Puebla: Discoveries and Research in Mesoamerican Art and Archaeology*. Edited by Henry B. Nicholson and Eloise Quiñones Keber. Culver City, California, 1994, pp. 25–44.

Smith, Michael E. "Aztec City Planning." In *Encyclopaedia of the History of Non-Western Science, Technology, and Medicine*. Revised Internet ed. Edited by Helaine Selin.

_____. *The Aztecs*. 2nd ed. Oxford, 2003.

_____. "Life in the Provinces of the Aztec Empire." *Scientific American* 277 (3) (1997), pp. 56–63.

_____. "Mixteca-Puebla Style." In *Archaeology of Ancient Mexico and Central America: An Encyclopedia*. Edited by Susan Toby Evans and David L. Webster. New York, 2001.

Smith, Michael E., and Frances F. Berdan, eds. *The Postclassic Mesoamerican World*. Salt Lake City, 2003.

Smith, Michael E., Jennifer Wharton, and Jan Marie Olson. "Aztec Feasts, Rituals, and Markets: Political Uses of Ceramic Vessels in a Commercial Economy." In *The Archaeology and Politics of Food and Feasting in Early States and Empires*. Edited by Tamara Bray. New York, 2003, pp. 235–68.

Solís Olguín, Felipe. *La Cultura del Maíz*. Mexico City, 1998.

_____. "La Piedra del Sol." In *Arqueología Mexicana*, vol. 7. Mexico City, 2000, pp. 32–39.

Soruco Saenz, E. "Una cueva ceremonial en Teotihuacan." Unpublished master's degree thesis, Escuela Nacional de Antropología e Historia, 1985.

Soustelle, Jacques. *El arte del México antiguo*. Barcelona, 1969.

_____. *El Universo de los Aztecas*. Mexico City, 1982.

Stirling, Matthew W. "Monumental sculpture of southern Veracruz and Tabasco." In *Handbook of Middle American Indians*, vol. 3. Austin, 1965, pp. 716–38.

Suarez Cruz, Sergio. "El Policromo Laca de Cholula, Puebla." In *Mixteca-Puebla: Discoveries and Research in Mesoamerican Art and Archaeology*. Edited by Henry B. Nicholson and Eloise Quiñones Keber. Culver City, California, 1994, pp. 45–52.

Symonds, Stacey, Ann Cyphers, and Roberto Lunagómez. *Asentamiento prehispánico en San Lorenzo Tenochtitlán*. Mexico City, 2002.

Thompson, J. Eric S., Francis B. Richardson, and Frank E. Comparato, eds. *Collected Works in Mesoamerican Linguistics and Archaeology*, vol. 4. 2nd ed. Culver City, California, 1993.

Torquemada, Juan de. *Monarquía Indiana*. 7 vols. Mexico City, 1975.

Toscano, Salvador. *Arte precolombino de México y de la América Central*. 4th ed. Mexico City, 1984.

Tovar, Juan de. *The Tovar Calendar: An Illustrated Mexican Manuscript, c. 1585*. Edited by George Kubler and Charles Gibson. New Haven, 1951.

Townsend, Richard F. *The Aztecs*. New York and London, 1992.

Vaillant, George. *The Aztecs of Mexico*. New York, 1941.

Viesca, Carlos. *Ticiotl, conceptos médicos de los antiguos Mexicanos*, vol. 1. Mexico City, 1997.

Von Winning, Hasso. *Pre-Columbian Art of Mexico and Central America*. New York, 1968.

Westheim, Paul. *Ideas fundamentales del arte prehispánico en México*. 3rd ed. Mexico City, 1986.

_____. *Obras maestras del México antiguo*. 3rd ed. Mexico City, 1990.

_____. *Escultura y cerámica del México antiguo*. 2nd ed. Mexico City, 1991.

White, Andrew Dickson. *Pre-Columbian Art of Latin America*. Ithaca, New York, 1966.

Whittington, E. Michael, ed. *The Sport of Life and Death: The Mesoamerican Ballgame*. New York, 2001.

Williams, Howell, and Robert F. Heizer. "Sources of Rocks Used in Olmec Monuments." In *Contributions of the University of California Archaeological Research Facility*, vol. 1. Berkeley, 1965, pp. 1–39.

Wolf, Eric R., ed. *The Valley of Mexico: Studies of Pre-Hispanic Ecology and Society*. Albuquerque, 1976.

Photo Credits